Italian Renaissance Art

A Sourcebook

Marilyn Bradshaw

Ohio University

PEARSON

Prentice
Hall

Upper Saddle River, New Jersey, 07458

Library of Congress Cataloging-in-Publication Data
Bradshaw, Marilyn.
 Italian Renaissance art: a sourcebook / Marilyn Bradshaw.
 p. cm.
 Includes bibliographical references and index.
 ISBN 0-13-606128-1 (alk. paper)
 1. Art, Italian. 2. Art, Renaissance--Italy. I. Title.

N6915.B73 2008
709.45'09024--dc22 2008017399

Editor-in-Chief: Sarah Touborg
Senior Sponsoring Editor: Helen Ronan
Editorial Assistant: Carla Worner
Marketing Manager: Wendy Gordon
Senior Managing Editor: Mary Rottino
Project Manager: Barbara Marttine Cappuccio
Senior Operations Specialist: Brian Mackey
Senior Art Director: Pat Smythe
Composition: Marilyn Bradshaw
Cover Design: William Schneider
Cover Image: © William Schneider
Full Service Project Management: Black Dot Group
Printer/Binder: Courier Kendalville
Cover Printer: Phoenix Color, Corp.

Credits and acknowledgments borrowed from other sources and reproduced, with
permission, in this textbook appear on page 360.

Pearson Education Ltd., London
Pearson Education Singapore, Pte. Ltd
Pearson Education, Canada, Ltd
Pearson Education–Japan
Pearson Education Australia PTY, Limited
Pearson Education North Asia Ltd
Pearson Educatión de Mexico, S.A. de C.V.
Pearson Education Malaysia, Pte. Ltd
Pearson Education Upper Saddle River, New Jersey

10 9 8 7 6 5 4 3 2 1
ISBN-13: 978- 0-13- 606128-1
ISBN-10: 0-13- 606128-1

Contents

Preface

Italian Renaissance Art: A Sourcebook is designed to give readers skills as well as information. It is intended to tell readers not what to think, but rather what to consider in studying the art of this period. In one volume, this book pulls together overviews of artists' careers with timelines of their activities and commentary on significant works. The book can stand alone or can be used to supplement other art history materials. It is a new genre of textbook, which makes a feature of the kind of contextual, explanatory information that forms only a small part of most survey texts.

The format encourages the cross-reading of sections that will show the many interconnections among artists and patrons within a historical context. Information is easy to find within the body of the text, and the extensively detailed index assists further in making connections between people and ideas. Such a layered presentation of information allows readers to construct a dynamic picture of the period and encourages an active role in looking at and thinking about Italian Renaissance art.

Chronologies of the lives and works of forty-eight artists are the core of the book, with the dates derived from the works themselves, from contracts, and from other contemporary documents. Structured as they are, these timelines crisply reveal the scope and development of an artist's career: how much work was required for a talented artist to become successful and well-known, for instance, or how he came to appeal to a particular kind of patron, and how historical circumstance and connections, and even luck, shaped his life and work.

Supporting the artists' chronologies are chapters devoted to history notes and a glossary of terms.

The history notes track changes (and observe continuities) in the political and social environment of the period, an active and eventful four hundred years. Because the circumstances of the larger world are inevitably, in one way or another, reflected in the work of contemporary artists, the history notes provide a greater understanding of why, and for whom, Renaissance artists made the work they did. Also bearing upon the production of artists from the Duecento to the Cinquecento are ideas no longer as familiar as they once were. Many of these are in the glossaries, which provide definitions of terms and concepts, with examples. The glossaries, like the history notes, make more vivid the art of the time, by connecting it to then-current thought.

As a means of developing a fuller idea of the art of the period, this book includes many drawings, diagrams, and line art. Among these are family trees of notable patrons, floor plans of monuments where a number of artists worked simultaneously, or sometimes over a period of years, and informational graphics accompanying discussions of techniques and of works that are no longer intact, or no longer readily legible, or (as in the case of some chapels) not often completely described.

The chapters in the concluding part of the book provide in-depth information on select examples of Renaissance patrons and cities. Treated like case studies, the patrons (the courtly as well as the corporate) and three cities (Florence, Venice, and Rome) were significant to the careers of many artists covered in the previous chapters, and the collection of compendia in this last part of the book is meant to further analysis and inquiry of issues concerning Renaissance art.

Marilyn Bradshaw

Acknowledgments

Without the encouragement of Robert Thoresen and Bud Therien at Prentice Hall, Professor Judith Perani of Ohio University, and my mentor, Dr. Bruce Cole, this book would not have been undertaken. Nor could it have been completed without the support of Ohio University and the editorial guidance and expertise of Helen Ronan and Sarah Touborg at Prentice Hall. The academic reviewers of the manuscript, Brian A. Curran of Pennsylvania State University, Sean Roberts of Tufts University, and an anonymous reader, offered insightful and helpful comments, for which I am grateful, and Becky Dodson and her team at Black Dot Group and Barbara Cappuccio at Prentice Hall were supportive in all aspects of production. The content and shape of this book are indebted to the research of many scholars and the recommendations of students who have taken my classes. Barbara Bays and Katie Kempton will always have my deepest appreciation for the critiquing of various drafts. The images of William Schneider, both photographic and didactic, are an essential part of this book, as are his good humor and tireless energy, which have made our collaborative effort enjoyable. I thank also my family for their love, patience, and understanding of the time it takes to complete a book.

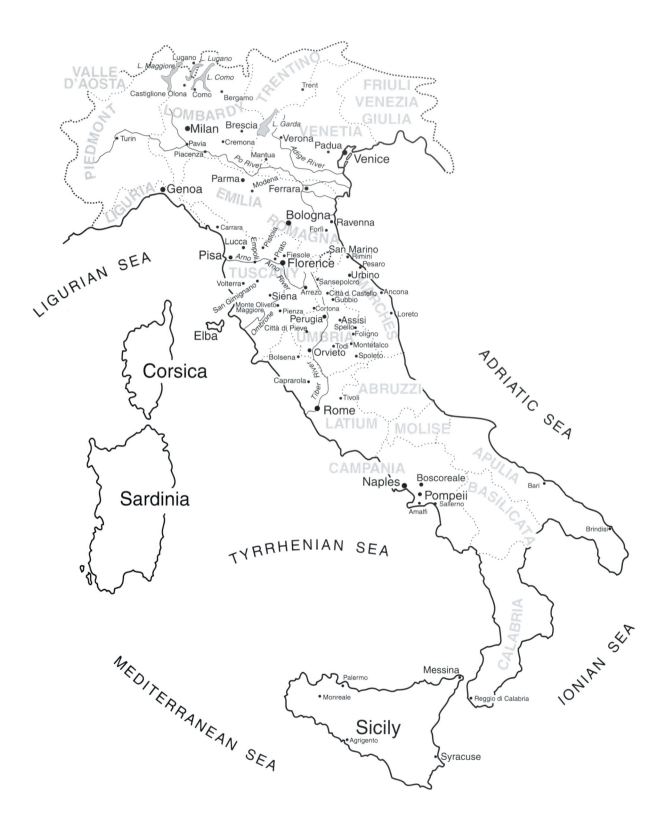

Duecento Italian Art Part One

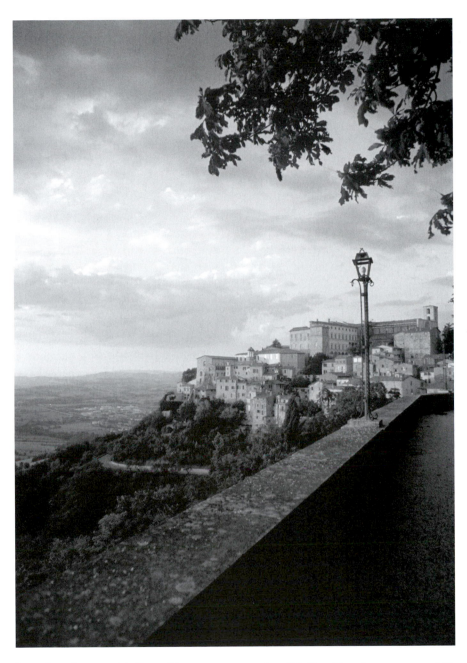

I–1. Todi in Umbria. Geography, size, and water supply are characteristics that distinguish Italian towns from each other. Typical of many communes of the 13ᵀᴴ– and 14ᵀᴴ–centuries, the picturesque town of Todi overlooks a valley. Hilltops provided communes a strategic advantage for military defense, but the towns tended to sprawl along the spine of the hill and were limited in the area they could cover. Having a dependable water supply was often problematic for such locations. Both the hill towns of Siena and Perugia had difficulty providing townspeople with a public source of water. Florence, however, is in a valley, and a river runs through the town, while Venice is fully surrounded by the sea and could be entered only by boat until the 19ᵀᴴ century (see fig. 65–2). Venice built cisterns to collect rainwater, and these were made for every public square. In contrast, a great fountain was typically erected in the main public square of most towns, but are everywhere in Rome.

Part One focuses chiefly on Tuscan art, showing a range of works created for active towns whose political and economic status fostered many commissions. The information that follows on selected Duecento artists and international affairs will provide a foundation for the study of Italian Renaissance art, while the discussions of mosaic and tempera panel techniques underscore the significance of these mediums for patrons and the diligence required of artists. The history notes and the glossary of terms are meant to show the interdependence

I–2. LUCCHESE SCHOOL (S. Michele Crucifix Master). *S. Michele Crucifix*, second half, 12ᵀᴴ c., tempera on panel, 11'8.8" x 10'.5" (360 x 306 cm), S. Michele in Foro, Lucca. Large wooden crucifixes often consisted of several pieces of wood (see fig. 3–1). The apron was typically part of the vertical plank on which Christ was painted, but the cimasa and terminals were sometimes separate pieces attached to the cross bars by wooden dowels. In this crucifix stones adorn the belt of the loincloth, and a three-dimensional effect was created for the head of Christ with a circular disk for the halo. Halos were attached with glue or nails and sometimes inset with stones and carved in relief.

of the history of art and events in Italy and Europe during this period.

With the empire and papacy embroiled over the Investiture Disputes (1075–1122) about the secular and spiritual power of the papacy, the feudal system broke down in Tuscany (11ᵀᴴ c.), and towns enjoyed some freedom in developing commercial interests and self-government. Communes supporting the emperor, such as Pisa, Lucca, and Siena, thrived in the 11ᵀᴴ and 12ᵀᴴ centuries. About midway through the following century, the Duecento (13ᵀᴴ c.), communes supporting the papacy, such as Florence, began to gain some control of Tuscany with the rise of the Angevin dynasty and the end of the Hohenstaufen empire (see fig. II–8). In this period towns like Pisa, Siena, and Florence would begin to shape their history and destiny, with their pride and military combats aimed at subduing their neighbors while paying some allegiance to imperial or papal overlords.

Great importance was assigned to the antique origins of Italian towns in this era, with Florence tracing her ancestry to Florinus, the soldier-hero of Roman nobility, and Venice tracing hers to legendary Trojans. As Florence grew in the 13ᵀᴴ and 14ᵀᴴ centuries, its citizens focused their attention on what they thought was another, even more concrete reflection of their Roman past: the cherished, octagonal structure they believed had once been the pagan temple of the god Mars, but had since become their venerable baptistery—a building central to Florentine religious and civic life and, most importantly, the shrine of the town's patron saint, John the Baptist (see figs.

2–3, 3–2). Like the Florentines, nearby citizens in the rival commune of Siena also boasted antique heritage, claiming that their founders were the twin sons of Remus (twin of Romulus and co-founder of Rome), and in 1260 they dedicated Siena to the Virgin Mary, whose image as the regal Queen of Siena was placed everywhere throughout the town (see figs. II–1, 12–2, 13–1). The identities of these two communes were thus gloriously traced to antiquity but piously tied to the mighty protection of major Christian saints; in Florence, the image of the Baptist appeared even on the highly valued gold coinage (see fig. 1–2). In Venice images of the Virgin Mary were placed on every important landmark, as Venetians believed that their city was founded in 421 on the feast day of the Annunciation (25 March) and that the Virgin had protected the lagoon dwellers ever since. By the late–9ᵀᴴ century, Mark the Evangelist had become their great patron saint. According to Venetian lore, his relics had been secretly transported to the city from Alexandria in a plot divinely inspired. Citizens justified this theft and the sacking of Constantinople in 1204 as their destiny. No longer subordinate to the Byzantine Empire, Venice was to become a formidable sea power (see BYZANTIUM, Duecento Glossary). Not until the early–15ᵀᴴ century, however, would she produce artists as renowned as Cimabue or Giovanni Pisano.

During this period, dynastic alliances of the landed aristocracy and the military victories of religious and political entities helped to shape lordly courts and burgeoning city-states, affecting the tastes and the demands of patronage throughout Europe, as artists were called upon to create new art for the church and state and for private and public display. Two of the most significant types of Duecento church art were tabernacles and cru-

cifixes. Among the most cherished pieces of church furniture, these giant works were adorned with images that changed in the second half of the 13TH century, partly in response to the teachings of the influential mendicant orders, especially the orders founded by S. Francis of Assisi (1182–1226) and S. Dominic (1170–1221).

The size and material of a crucifix depended upon its function. Portable liturgical crucifixes, which were carried in processions, usually had images on both sides of the cross, and were fashioned in varying sizes in wood and in precious metals. Such crosses were kept on the altars of small chapels and in sacristies when they were not being used on feast days. Whereas the origins of the portable crucifix can be traced to early Christian art, the origins of large, stationary crucifixes (those intended to be hung from beams or attached to main altars and choir screens) are found in 12TH–century Tuscany. By the mid–13TH century, about the time that Coppo painted the *S. Chiara Crucifix* (see fig. I–3), Tuscan crucifixes had acquired a distinctive look: Christ dominates a cutout cross with the stretch of his arms and great length of his body; his lower torso is flanked by tiny Passion stories or by grieving followers, especially the Virgin Mary and John the Evangelist, the source of which is Byzantine. Inspired by the large figures of Christ in the fresco and mosaic decoration of churches (see fig. 1–5), Tuscan crucifixes likewise depict Christ as a colossal figure who is of superhuman size compared with the small people depicted elsewhere on the apron and in the terminals of the cross.

While the great influx into Italy of Greek artists and icons from Constantinople in the early–13TH century established a taste for graceful and refined images of the holy Mother and Child (see fig. 1–1), the disciples of Francis favored paintings that portrayed the highly venerated figures as both elegant and regal but more humanly approachable. The new style emerging in Tuscan art therefore was to portray the images of Mary and Christ as less remote than Greek icons and as figures who are seemingly closer to the spiritual and psychological space of worshippers.

A mixture of pagan and Christian myths became firmly embedded within the historical fabric of competitive medieval communes as time-honored folklore was recorded in the private journals of successful, educated merchants; typically, such businessmen writers were proud citizens who wanted to leave records of their commune's history and achievements for posterity. The Florentine merchant Giovanni Villani (1275–1348), whose chronicle is valuable for studying Italian art and history, thought of himself as a disciple of the ancient Roman writers Virgil and Livy. In contemporary discourses on the visual arts, a similar admiration for antiquity will later appear in the writings of humanist poets like Dante (d. 1321), Petrarch (d. 1374), and Boccaccio (d. 1375). Each compared the Florentine painter Giotto di Bondone (d. 1337) to artists of antiquity, for Giotto's portrayal of the human condition reminded them of ideas and visual images they found in the literature and monuments of antiquity (see Giotto).

I–3. COPPO DI MARCOVALDO. *S. Chiara Crucifix*, ca. 1261, wood, 9'7.4" x 8'1.3" (293 x 247 cm), Pinacoteca Civica, San Gimignano. Large painted wooden crucifixes measuring more than ten feet tall were commonly suspended from church ceilings. These were often hung in the chancel above the high altar or from the ceiling of the nave. In addition, large crucifixes were also attached to the back of the main altar (see fig. I–2) or to the choir screen (*iconostasis*) in front of the altar. Because of their great size and distinctive shape, such crucifixes were easily seen from church doorways. Thus, worshippers were focused on the colossal figure of Christ and the Eucharistic message upon entering a church (see Coppo di Marcovaldo, CRUCIFIXES). Revered crucifixes and images of the crucifixion often became the repository of sacred relics, mainly because they allude to the redemptive power of the crucifixion and to the real presence of Christ in the holy Eucharist. A cavity in the head of the wooden Gero Crucifix (9TH c., Cologne) holds a consecrated wafer, for instance, and a fragment of the True Cross is imbedded in the apse mosaic of S. Clemente, Rome (see fig. 1–4).

Campo dei Miracoli, Pisa

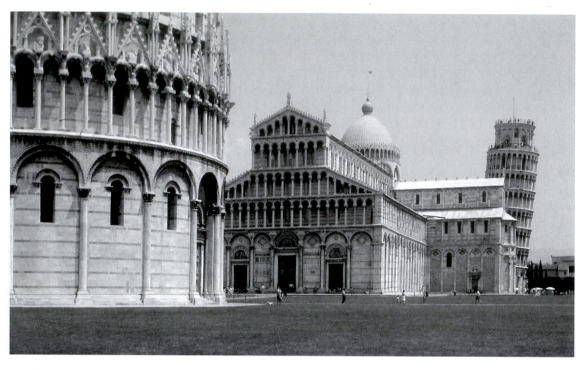

I-4. Campo dei Miracoli (Field of Miracles), Pisa. Projecting a splendor that seems to reflect upon Pisa's maritime success in the Duecento, these religious buildings meld traits of French Gothic (pointed arches, pinnacles), Romanesque (round arches, blind arcades), and Moorish style (inlaid geometric patterns). Near the baptistery (foreground, see fig. 7–2) is the cathedral (begun 1063) and the Campo Santo, the cemetery compound (begun 1278; not shown here). In the distance is the most famous Pisan building, the campanile (bell tower), ca. 1173–1350, with seven bells. Called the Leaning Tower, the eight-story tower rises 179' (54.5 m) above ground level and was built on a weak, shallow foundation, as were the other buildings. When the tower began to sink during construction, builders counteracted the movement by stacking the upper stories in a curve to offset the sway. The tilt (about 4.5' in 1350) is now about 17.5' from vertical.

Like other Tuscan communes that had Etruscan and Roman heritage, Pisa had ancient monuments that inspired artists of the Duecento. The figural reliefs on marble Roman sarcophagi (coffins), many reused as burial tombs, became a source of study for sculptors, which is especially evident in the work of Nicola Pisano (see fig. 7–1).

Well situated near the Ligurian sea, Pisa is at the junction of the Arno and Serchio rivers. Her name means "outlet" in Etruscan, and the town was first settled by Etruscans and then by Romans (3ʳᵈ C. BCE). By the 9ᵗʰ century, Pisa had a strong navy and healthy maritime trade, enjoying all the mercantile benefits of being a port city. As the seat of the archbishopric (from 1092), the town would undertake major building programs (see fig. I–4). And after acquiring possessions from Genoa (1258), her chief rival, Pisa became a preeminent Mediterranean sea power, strengthening her lucrative trade routes with Spain and North Africa. But

Genoa destroyed Pisa's fleet in 1284, and Pisa never fully recovered. During her zenith, the city attracted artists from all parts of Italy and the Greek Empire to work on mosaic, metal, and stone projects. Nicola Pisano created his masterwork here in 1260 (see fig. 7–1), while his son Giovanni completed an even grander pulpit for the cathedral in 1311. The decline of Pisa began in the 14ᵗʰ c., with the town depleted by the bubonic plague (see BLACK DEATH, Trecento History Notes) and weakened by conflicts with Florence. In 1406 Pisa was defeated by Florence, who in the 16ᵗʰ c. would refashion Pisa into her ideal colony.

1204 **SACK OF CONSTANTINOPLE.** The Byzantine city of Constantinople (modern Istanbul) falls during the Fourth Crusade (13 April). Looting the city repaid the Venetians, whose galleys transported the crusaders. Venice later saw the event as their destiny. The Byzantine objects (and Greek artists) that then entered Italy greatly influenced Italian art (see fig. 1–1).

1210 **INNOCENT III APPROVES THE FRIARS MINOR.** The popular Francis of Assisi (1182–1226) receives papal approval for the Friars Minor, who follow the Gospel and imitate the life of Christ, living in great poverty.

ARISTOTLE TRANSLATED. Aristotle's *Metaphysics* is translated from Greek into Latin.

1215 **FOURTH LATERAN COUNCIL CONVENES.** Among the decrees of the council is the observance of transubstantiation of the Eucharist (a consecrated Host changes to the body of Christ).

1216 **HONORIUS III APPROVES THE DOMINICAN ORDER.**

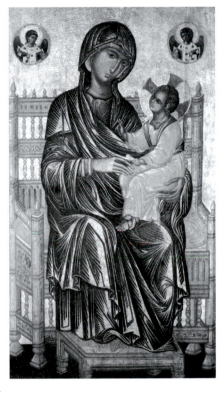

The Spaniard Domingo (Dominic) de Guzmán (ca. 1170–1221) and followers receive papal approval; Honorius intended the new Order of Friars Preachers to fight heresy (see DOMINICANS, Duecento Glossary).

1218 **CRUSADE IN SPAIN.** Pope Honorius III sponsors a crusade against the Moors (Muslims from North Africa) in Spain, whom he tries to expel from the country.

1223 **FRANCISCAN RULE APPROVED.** This final form of his Rule, stressing absolute poverty, is the second time Francis rewrote his Rule. Pope Honorius III officially confirms it in this year (see FRANCISCANS, Duecento Glossary).

1228 **JERUSALEM IN HANDS OF CRUSADERS.** The sultan of Egypt agrees to peace and grants control of Jerusalem to Christian crusaders. Jerusalem was important to Christians because it was the city Jesus of Nazareth entered in triumph (Palm Sunday), where he was imprisoned, and outside of which he was crucified. According to one tradition, it was thought that in the valley of Jehoshaphat, near

1–1. BYZANTINE MASTER. *Enthroned Madonna and Child*, late–13TH c., tempera on panel, 51.7″ x 30.3″ (131.2 x 76.9 cm), gift of Mrs. Otto Kahn, National Gallery of Art, Washington, D.C. This painting, likely by a Greek artist working in Italy, represents Byzantine style (see BYZANTIUM, Duecento Glossary) and depicts the *Virgin Hodegetria* (see VIRGIN HODEGETRIA and THEOTOKOS, Duecento Glossary). The formality of the type, which had a long tradition, is reflected in the rigid postures and placement of the figures: the Virgin's right eye is in the center of her halo, and it is also on the vertical axis of the painting. Mary and Christ are portrayed as enthroned royalty, signifying their special roles as the Virgin Mother of God and the child Messiah. Shown as a small adult, Christ gives his mother a sign of benediction and holds a scroll, his clothes resembling those of ancient Roman emperors. Unique to Christ are the three red bars that appear solely on his halo, signifying the cross of his crucifixion and the three Persons of the Trinity. Alluding to the ethereal realm where these holy figures dwell are the two half-length angels in *tondi* (circular frames), holding orbs and scepters (see ANGELS, Duecento Glossary). For tempera technique, see Cimabue.

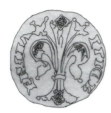

1–2. Drawings after the gold florin minted in Florence in 1252. Since the time of Charlemagne (9$^{\text{TH}}$ c.), the accounting coin in Europe was the lira, worth 240 silver denari. However, the lira had become greatly devalued by the 12$^{\text{TH}}$ century because the silver content of coins used in exchange (denari) varied, based on where and by whom these were minted. The minting of gold brought greater certainty to international exchange, and the Florentine fiorino (little flower) was notably stable. It remained so until the fall of the Florentine republic (mid–16$^{\text{TH}}$ c.), and its stability contributed to successful ventures of merchants and bankers. Pictured on the obverse (front) is the fleur-de-lis, and on the reverse is the patron saint of Florence, John the Baptist.

the city, Christ's second coming would occur. When Christians went to Jerusalem, they visited places they considered holy: (1) the Church of the Holy Sepulcher, built on the site where the rock of Christ's tomb was found according to Emperor Constantine; (2) the Via Dolorosa (road of mourning or sorrow), the road which Christ walked from the court of Pilate's palace to Mount Calvary. This is where criminals were executed, and the spot where Christ was crucified was called Golgotha (Aramaic for skull) because according to one tradition this is where Adam's skull was found.

FRANCIS OF ASSISI CANONIZED. Pope Gregory IX canonizes Francis (d. 1226) only two years after his death (see SAINT, Duecento Glossary), and commissions his biography from Thomas of Celano, a follower who knew Francis. Celano's first version and his second (1244) were both rejected. *Legenda Maior*, the biography by the Franciscan Bonaventure (1260), was commissioned and officially accepted by the Church.

1231 **INQUISITION.** Pope Gregory IX inaugurates the papal inquisition, placing authority in the hands of the papacy in combating heresy (in 1252 torture was authorized).

1233 **SERVITES FOUNDED.** Seven wealthy Florentines found the Order of the Servites (Servants of Mary) (see SERVITES, Duecento Glossary).

1234 **DECRETALS OF GREGORY IX.** Pope Gregory IX publishes his *Decretals*, the source of canon law until the early–20$^{\text{TH}}$ century.

DOMINIC CANONIZED. Gregory IX canonizes Domingo de Guzmán, who died (1221) in Bologna. Nicola Pisano designed his tomb (1264), *Arca di S. Domenico*, in S. Domenico Maggiore, Bologna.

1244 **LATIN KINGDOM LOSES JERUSALEM TO TURKS.** Jerusalem was important to Islamic tradition, chiefly because it is the site of the Dome of the Rock. The Islamic sanctuary was built over the ruined Temple of Solomon (Old Testament king of the Israelites, whose father was King David). Solomon's Temple was destroyed by the Roman Emperor Titus in the Sack of Jerusalem of CE 70.

1252 **GOLD COIN MINTED IN FLORENCE.** Florence mints the florin (see fig. 1–2), which bears the image of her patron saint, John the Baptist.

GOLD COIN MINTED IN GENOA. The seafaring Genoese mint a gold coin, called the genovino.

1256 **AUGUSTINIAN HERMITS APPROVED.** Pope Alexander IV founds the Augustinian hermits (friars), who follow the Rule of S. Augustine (see AUGUSTINIANS, Duecento Glossary).

CLARE OF ASSISI CANONIZED. Pope Alexander IV canonizes Clare (1194–1253), a follower of Francis and founder of the Poor Clares (Franciscan nuns). Her emblem is the monstrance (a see-through vessel that holds a consecrated Host); she saved her town when she showed a monstrance to invading Saracen mercenaries hired by Emperor Frederick II to overtake Assisi.

1261 LATIN EMPIRE IN CONSTANTINOPLE ENDS. Michael VIII Palaeologus of Nicaea, the Byzantine emperor, retakes Constantinople (see entry 1204) (see CONSTANTINOPLE, Duecento Glossary). It remains in Byzantine hands until 1453, when it fell to Ottoman Turks.

1263 MASS AT BOLSENA. According to tradition, a Bohemian priest uncertain about the truth of transubstantiation was celebrating Mass in the town of Bolsena in Italy. Praying for a sign to quell his disbelief, he saw blood drip from the Host onto the altar cloth (corporal). The linen cloth was then venerated as miraculous proof of the real presence of Christ in the consecrated Host.

1264 FEAST OF CORPUS CHRISTI. Influenced by the tradition of the miracle at Bolsena, Pope Urban IV institutes the Feast of Corpus Christi (the Body of Christ) in the Latin Church. Urban also ordered that a church be built in Orvieto (near Bolsena) to house the miraculous linen cloth.

1265 DANTE ALIGHIERI IS BORN IN FLORENCE. See fig. 1–3.

1274 THOMAS OF AQUINAS DIES. The famous Dominican dies en route to the council at Lyons (called by Pope Gregory X). His two most significant writings, *Summa contra Gentiles* and *Summa theologica*, his last and unfinished treatise, influenced both Church doctrine and the visual arts. Usually depicted in a Dominican habit with a star on his chest, Thomas sometimes holds a book, chalice, lily, or has a dove by his ear.

1275 MARCO POLO IN CHINA. The seafaring Polo family of Venice arrives at the court of Kublai Khan in Peking. This was the first voyage to China for Marco (1254–1324), whose adventures in the Far East were recorded at the end of the century and published in many languages due to their popularity.

1278 NICHOLAS III REBUILDS THE SANCTA SANCTORUM. In the rebuilt private chapel of the pope (the *Sancta Sanctorum*) in the papal (Lateran) palace in Rome, Pope Nicholas enshrines the sacred *Acheropita* (a reputed true portrait of Christ).

1284 GOLD DUCAT MINTED. Venice mints the gold ducat.

1291 SACK OF ACRE (AKKO). The last Christian outpost (a port city in the province of Galilee) is taken by the Mameluks of North Africa.

1293 ORDINANCES OF JUSTICE. In Florence the role of the guilds in government strengthens, while the power of the magnates (nobles) weakens.

1297 VENETIAN SERRATA. Patrician autocracy is established in Venice, allowing only nobles to govern the city. The Venetian population was divided into three social groups (estates): ruling nobles (about 5% of the population); *cittadini* (citizens) (about 5%), mostly merchants, who could prove their family had not been manual laborers; and *popolani*, or the rest of the people.

1298 GOLDEN LEGEND COMPILED. By this year, the Dominican archbishop of Genoa, Jacobus de Voragine

1–3. This sketch of Dante Alighieri, crowned as a poet laureate, shows his distinctive profile, the long, pointed nose and square jaw. Although Dante (1265–1321) was exiled from Florence in 1302 for anti-papal sentiments, and never returned, Florence would later honor him. By 1283 he had married an upper-class Florentine woman, Gemma Donati, with whom he had four children. But he had a consuming platonic passion for the noblewoman Bice (Dante called her Beatrice), the daughter of Folco Portinari and wife of Simone dei Bardi. When she died (1290), he became fixed on the idea that she had gone to heaven. His masterwork, the *Divine Comedy* (see Trecento History Notes 1306), focuses on a journey to God that takes Dante through hell, purgatory, and heaven; the Latin poet Virgil is his guide through the underworld and Beatrice, his guide in heaven.

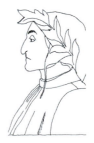

(1230–98), writes *Legenda Aurea* (Golden Legend). His compilation of the lives of Christian saints, organized around the Church calendar, becomes an essential source for visual imagery. The most popular saints of the *Golden Legend* were the Virgin and Christ and those near these two, such as the 12 apostles, whose names and the emblems with which they were associated follow: (1) Peter, papal keys and tiara; (2) Andrew, saltire cross; (3) James the Major, pilgrim's staff and conch shell; (4) John, eagle and chalice with snake; (5) Thomas, spear or sword; (6) James Minor, fuller's club; (7) Philip, crosier (pastoral staff); (8) Bartholomew, knife; (9) Matthew, winged man and sword; (10) Simon, sword or saw; (11) Jude Thaddeus, lance; and (12) Judas, money bag.

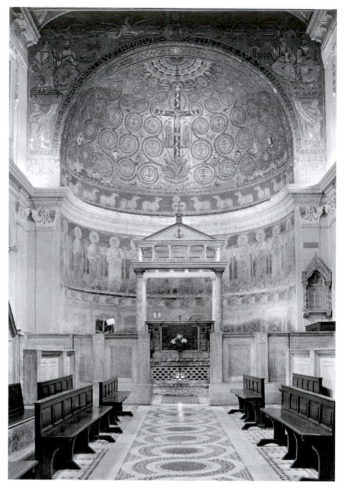

1–4. *The Cross of True Life*, apse mosaic, ca. 1120, S. Clemente, Rome. Fifty scrolling vines spreading across the apse form a lush image that imitates mosaics of early Christian churches in Rome, while the mourning Virgin and John Evangelist standing beside the cross derive from Byzantine sources. In this Tree of Life image the crucified Christ is the central focus, with the message inscribed below the scrolls: "This vine shall be a symbol of the Church of Christ, which the law makes wither but which the Cross brings to life." Embedded in the body of Christ are a fragment of the Cross and two saints' teeth. For penance and in search of holy relics, many people during the next centuries would take pilgrimages to places associated with Jesus (see 1228).

1–5. BYZANTINE MASTER. *Madonna and Child*, 12ᵀᴴ century, mosaic (with over-life-size figures), apse, Cathedral of Torcello (an island near Venice). This Byzantine *Virgin Hodegetria* appears to float because of the vast glittering background surrounding the figures. Light is reflected off the curved semicircular shape of the apse and the gold glass tesserae, which are set at angles into the mortar (see fig. 3–2). Beneath the Virgin and Child are the apostles, who stand like regimented soldiers in a curved

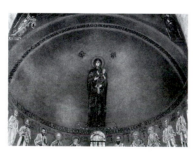

flank. The combination of these figures indicates that this is not a historical narrative, showing the young mother and her child after his birth, but a devotional image in which the Virgin Queen (the *Regina Coeli*) appears with the Messiah as a dazzling apparition in the gilded sky. Cimabue's *Maestà* would make this type of image more tangibly real (see fig. 4–1). Creating mosaics in the Byzantine manner was a difficult process, well known in Venice because of the resident Greek artists (nearby Murano would become famous for its glass production). The process requires skilled glassworkers, and when Florence commissioned the baptistery mosaics they sought out artisans in Venice for the work (see fig. 3–2).

Duecento Glossary

In the Duecento, the Roman Catholic Church had the sense of an urgent need to reform the Church, to quell heresies in Europe (such as the Albegensians in France), and to take control of the Holy Land then under the command of Muslims. Strengthening the authority of the Church and galvanizing the faithful entailed fighting heretics and infidels, granting indulgences to pilgrims and awards to soldiers, and creating new holy celebrations (i.e., the Feast of Corpus Christi) in the calendar of the Roman Catholic Church.

In this period, religion was as central to the lives of individuals as it had been in the previous four centuries, but the secular clergy and cloistered monks could not alone attend to the needs of the rising population in urban centers. Towns like Pisa, Siena, Venice, and Florence grew significantly, with the improvement of commerce and the accountability of the newly minted gold coins. The answer to the religious needs of the period was found in the spirituality of the mendicant orders (Franciscans, Dominicans, Carmelites, Servites), which brought the religious close to people—many of whom were illiterate—through their sermons, teachings, and residences, which were often in the poorer areas of town. Stories of the mystical experiences of Francis encouraged devotion. The Duecento saw a rise in devotional images, especially with the influx of Byzantine spoils and Greek artists to Italy.

Whether for public or private use, or for religious or secular purposes, the function of Duecento Italian art was related to the cultural and social needs of the period. The following terms are meant to provide a framework for studying the art and its history.

ANGELS — The belief that there are nine choirs of angels divided into three major categories appears in the 6TH–century writings of Pseudo-Dionysius (his *De hierarchia celesti* [The Celestial Hierarchies] was translated from Greek into Latin in the 11TH c.). The Dominican Thomas Aquinas later adopted the same order in his influential treatise *Summa theologica* (begun 1266). In the first category are the counselors: **seraphim** (representing divine love, they are red and depicted with only a head and wings), **cherubim** (symbolizing divine wisdom, they are blue and depicted with only a head and wings), and **thrones** (representing the justice and majesty of God, they sometimes sit on thrones or hold scales, towers, or mandorlas). In the second category are the governors: **dominations** (symbolizing God's power, they direct the virtues and powers and have crowns, scepters, orbs, crosses, and swords), **virtues** (exemplifying extreme courage, they wear armor, carry swords or spears, and hold banners or shields), and **powers** (guardians of heaven, they wear armor and carry shields and flaming swords). In the third are the messenger angels: **principalities** (protectors of religion and rulers, they wear armor and carry a scepter, a cross, a lily, or palms), **archangels** (seven in number, they appear as winged humans), and **angels** (often shown with musical instruments or instruments of the Passion). Nine choirs of angels are depicted in the ceiling mosaic of Florence Baptistery (see fig. 2–3).

2–1. FOLLOWER OF ANDREA PISANO. *Music*, ca. 1350, marble in high relief on a background of diamond-shaped blue majolica, 2'10.3" x 2.8" (87 x 63 cm), from the second level, east wall, Florence Campanile (since 1965, Museo dell'Opera del Duomo, Florence). *Music* accompanied six other personifications of the Liberal Arts on the Florence bell tower. She has a box instrument, a psaltry, whose strings were plucked by the musician's fingers. Of ancient near Eastern and Egyptian origin, the instrument was imported to Europe. By the Trecento, angels in images of the *Maestà* are depicted holding stringed instruments like the psaltry.

2–2. San Miniato al Monte (lower story of the facade), Florence. Reformed Benedictines rebuilt the church of S. Miniato (1013), where the first Florentine martyr (Miniato) was buried. About sixty years later (1093), a new facade was begun, and by 1373 the Cluniac Benedictines were replaced by Olivetans, who also follow the Rule of Benedict (the monk seen here wears the habit of the reformed Benedictines). The round arches, geometric patterns, and combined green and white marble that adorn this facade influenced the facing of Florence Baptistery (see fig. 2–3).

AUGUSTINIANS — The Order of Augustinian Canons (or Canons Regular) was approved in the mid–11TH c. Unlike Church canons residing at a cathedral, collegiate, or parish church, Augustinian canons lived in communities requiring different regulations. Their rule was thus based on S. Augustine of Hippo's writings concerning communal life and was named after this distinguished 4TH–c. Church Doctor (see LATIN CHURCH FATHERS, Trecento Glossary). In mid–13TH–c. Italy, diverse groups of hermits were brought together by Pope Alexander IV for the purpose of creating one community of hermit-friars, following the Rule of S. Augustine. These Augustinian friars became known for their scholarship and teaching in the 14TH and 15TH c. because of the acclaimed humanists who belonged to the order. In the 16TH c., Augustinian friars became mendicants on the decision of Pope Pius V (see fig. 2–5).

BAPTISTERY — A room or building where baptismal rites are performed is called a baptistery. In Tuscany, these were usually buildings unattached to churches, and often of octagonal shape (see fig. 2–3). They played an important role in both the spiritual and civic life of citizens; in Florence, for every child born, an entry was kept in the baptistery records and a bean was dropped into an urn recording the gender of the child (black for a boy and white for a girl).

BENEDICT OF NURSIA — Considered the father of Western monasticism (chiefly because of the Rule he wrote), Benedict (ca. 480–ca. 547) was born into a wealthy, noble family at Norcia, near Spoleto (in Umbria); he had a twin sister, Scholastica, who is venerated as the first Benedictine nun. Benedict was educated in Rome, but apparently left the city before the age of twenty to escape its corruption. He went to live in the village of Enfide near Subiaco (about forty miles from Rome), accompanied by a servant, his nurse since childhood. His first miracle happened there, when through prayer he

fully repaired a sieve that his nurse had broken into bits. The miracle brought so much unwanted attention for Benedict that he soon retreated to a cave at Subiaco, where he dressed like a monk (in a habit given to him by the monk Romanus) and lived for three years as a hermit. As his ascetic and spiritual life attracted devout lay people who sought to join him, he set up twelve communities (monasteries), each with twelve men and a leader (superior); he led an additional community and was the spiritual father (abbot) of all thirteen. Schools for children became an important part of these monasteries. While the site of these first communities was Subiaco, Monte Cassino (about eighty miles south of Rome, and near Naples) is where Benedict founded and was abbot of a large monastery (ca. 529), and where he wrote the Rule of the Benedictine Order, emphasizing three monastic vows: poverty, chastity, and obedience. According to his Rule, monks were to devote their daily lives to praying, reading sacred texts, and doing manual work, and they were to remain until death in the same community. Each community was to be self-sufficient, an independent unit from the outside world, with no monk having personal possessions, but all goods held in common. Benedict established a monk's routine organized around the *opus Dei* (the work of God), as he called it: the eight daily services of public prayer (Divine Office) sung communally by the monks. Very little specific information is known about Benedict's personal life, but as his legend grew after his death he was remembered for his power to heal (and exorcize), to perform miracles, and to prophesy. The best source to learn about his life is the second book of Pope Gregory the Great's *Dialogues* (ca. 593), in which he recorded in some detail Benedict's miracles; his writings were the basis for the legendary stories of Benedict that

followed. In art, Benedict is often pictured as an old, white-bearded man in a black habit (original Benedictines) or in a white habit (later, reformed Benedictines) (see fig. 2–4); as abbot, he has a pastoral staff and sometimes wears a mitre (bishop's peaked hat). Scholastica (Benedict's sister) is remembered as the head of the first convent of Benedictine nuns and pictured in a black habit and with a lily, crucifix, or white dove (Benedict saw her soul ascend as a dove to heaven). For stories of Benedict and Scholastica, see Voragine's *Golden Legend*.

BENEDICTINES — Called Black Monks (after the color of their habit), these religious live by the Rule that Benedict wrote for the monks of Monte Cassino. They became great patrons of learning and the arts, believing in the didactic significance of visual imagery. In France the Benedictine Rule was influential from the 8TH c., becoming the major code of conduct for monastic life; in Italy, the Rule was prominent only after the 10TH c., after the Order was reformed by the Cluniacs. Among the reformed Benedictine communities considered new orders are the Camaldolese (see Lorenzo Monaco), Carthusians, Cistercians, and Vallombrosans.

2–3. Baptistery of S. Giovanni in Florence (Florence Duomo is to the east of the baptistery; on the south side of the baptistery is the portal with Andrea Pisano's gilt-bronze doors) (see fig. 9–1). Trecento Florentines like Giovanni Villani (1275–1348) thought this was an ancient temple of Mars, and as such one of the oldest buildings in town. Yet, the present structure replaced a 5TH–c. church, with the bulk of the building phase carried out between 1050 and 1150. The geometric green and white marble facing was added by 1150, and by 1293 all artistic activities at the baptistery were under the supervision of the most important guild in town, the merchants of imported cloth (Calimala).

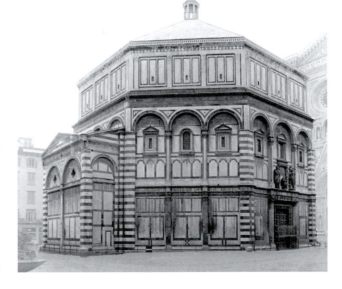

2–4. Benedictine monk (reformed) and nun.

2–5. Augustinian friar.

2–6. Carmelite monk and nun.

BENEDICTION — A blessing given by the clergy, it is also the abbreviation for Benediction of the Blessed Sacrament, a service in the Roman Catholic Church during which the congregation is blessed with the sign of the Cross made with a consecrated Host (held in a monstrance or vessel). Images of Christ giving the benediction show the index and second finger of his right hand raised, with his thumb also raised or crossed over his other fingers; these three fingers stand for the three Persons of the Trinity (Father, Son, and Holy Spirit).

BERNARD OF CLAIRVAUX — Born into a noble Burgundian family, Bernard (1091–1153) joined the Cistercian (reformed Benedictine) monastery at Cîteaux, France, and later became the founder (in 1115) and abbot of the monastery at Clairvaux (a daughter house of Cîteaux Abbey). Eloquent and persuasive, he preached the Second Crusade. He is also known for his mystical visions and devotional hymns to the Virgin Mary, which influenced Marian imagery.

BIBLE — Christianity is a book religion, and the canonical text is called the Bible, which is divided into two major parts: the Old Testament (Jewish scriptures) and the New Testament (Christian scriptures). The Vulgate (Jerome's Latin translation) became the official Roman Catholic Bible. Protestant Bibles vary, with most omitting the apocrypha (about 14 books, such as Judith, Tobit, and Susanna). Martin Luther's German translation was completed in the early–16TH c. and the English King James version in the early–17TH c.

BYZANTIUM — The Greek city on the Bosphorus named Byzantium was refashioned in 330 by Constantine to create a new (second) capital of the Roman Empire, Constantinople (see CONSTANTINE and CONSTANTINOPLE below). This city became the center of what would later be called the Byzantine Empire.

CARMELITES — The Order of Our Lady of Mt. Carmel, called Carmelites, was founded in the late–12TH c. by crusaders devoted to the Virgin. They had become hermits on Mt. Carmel in the tradition of Elijah, an Old Testament prophet. (According to tradition, the children of Elijah's children lived on Mt. Carmel; they were baptized by apostles and protected by the Virgin.) Around 1206, the Carmelites were granted their strict rule by Albert, the Patriarch of Jerusalem. Pope Honorius III approved the Rule on 30 January 1226, and the Carmelites were permitted to wear a white habit in 1286. Carmelite houses were established in Pisa (1248), Siena (1256), and Florence (1260), where Filippo Lippi entered the monastery in 1414 (see Filippo Lippi). Pope Eugene IV mitigated the Rule in 1432. An order of Carmelite nuns was begun in the 15TH c. (see fig. 2–6).

CHARLEMAGNE — Charles the Great (742–814) bore two crowns. When his father (Pepin) died in 768, he and his brother (Carloman) inherited the kingdom of the Franks, which they shared until Carloman's death in 771. In 800 Charlemagne was crowned ruler of the Latin Empire by the pope in Rome (the last Latin emperor had been deposed in 476). For his service to the Church, he was to become the first of the royal saints and was canonized in 1168.

CLERGY — Unlike laity (laypeople), clergy devote themselves to the service of God and are ordained to perform liturgical duties. In contrast to the religious who follow a Rule and live in monasteries, secular clergy live in the world.

COMMUNE — Self-governing municipalities (commonwealths) in Italy are called communes. The independence of towns depended on rights granted by rulers, or overlords, such as the emperor or pope. Communes controlled their own government, trade, and taxation.

COMPAGNIA — As towns increased in size, lay brotherhoods, or *compagnie* (confraternities), increased in number during this period. They were commonly devotional and performed social good. In Venice such groups are called *scuole*.

CONSTANTINE — Emperor Constantine (d. 337) brought unity to the ancient Roman Empire that had been divided by Diocletian. He is considered the first Christian emperor. His mother, Helena, is remembered as making a journey to the Holy Land to find the True Cross of Jesus (see CRUSADES and fig. 16–1).

CONSTANTINOPLE — In 395 the empire was divided into two parts—the West (Latin) and the East (Byzantine or Greek). Constantinople was the seat of the Byzantine Empire and Rome, the seat of the Latin. Goths sacked Rome in 410 (the capitol was moved to Ravenna), and the old Roman Empire ended when the last emperor was deposed in 476. (The Latin Empire would not be rejuvenated until the rule of Charlemagne.) The Byzantine Empire remained strong until Constantinople came under Latin rule in 1204, when crusaders sacked the city. It stayed under Latin control until it was retaken in 1261 by the Byzantine emperor. In 1453, Constantinople fell to the Ottoman Turks and was renamed Istanbul.

CRUSADES — The First Crusade was launched in 1095 to retake the Holy Land (places in Galilee and Judea associated with Jesus and the early Church). In art crusaders appear as soldiers, with red crosses on white flags (symbolic of Christ's Resurrection).

CULT OF THE VIRGIN MARY — From the Duecento, the Virgin acquired great veneration. She was the patron saint of cities, churches, nobles, and poor people. Everyone loved the Virgin. Honored above all women, she was praised as the Mother of God, the Bride of Christ, the Queen of Heaven, and the Intercessor of all humanity. Yet, the canonical Bible records very little about Mary, chiefly giving attention to the Virgin in stories of the birth of Christ (and the infancy of Christ, as recounted in the Gospel of Luke), the first public miracle of Christ at Cana, and the Crucifixion. In these events the Virgin Mary says few words, and details about her life are almost nonexistent. The cult of the Virgin was inspired, therefore, not only by the Bible stories of Mary but also by APOCRYPHAL writings (see Trecento Glossary), that give homey details about her childhood and her life after the death of Christ.

DOMINICANS — Members of the Dominican Order follow the Rule of Augustine. Founded by a Spanish nobleman named Dominic (Domingo de Guzmán, 1170–1221), the order was confirmed by Pope Honorius III in 1216. The friar-preachers, called Black Friars because of their black habit, were entrusted with the Inquisition begun by Pope Gregory IX in 1229. The Dominican painter-friar Fra Angelico entered the order in 1419 (see fig. 2–7).

EMPEROR — The restoration of the Latin Empire (see entries for CONSTANTINOPLE and CHARLEMAGNE) gave its ruler the power to grant titles to the imperial territories (in Germany and Italy) to favored people.

2–7. Dominican friar and nun.

2–8. Franciscan friar and Poor Clare.

2–9. Servite friar and nun.

2–10. ALBERTO ARNOLDI. *Baptism*, ca. 1345, marble in high relief on a background of diamond-shaped blue majolica, 2'10.3" x 2'1" (87 x 63.5 cm), from the second level, north wall of the Florence Campanile (Museo dell'Opera del Duomo, Florence). Baptism is one of the seven sacraments (sacred obligations) ordained by Jesus, according to Catholic doctrine. It is the act by which an individual enters the fellowship of the Church (see the entry for SACRAMENTS).

2–11. ALBERTO ARNOLDI. *Confirmation*, ca. 1345 (see fig. 2–10 for size, materials, and location).

2–12. ALBERTO ARNOLDI. *Eucharist*, ca. 1345 (see fig. 2–10 for size, materials, and location). One of the seven sacraments, Eucharist is one of two rites (the other is baptism) considered essential for salvation. In this relief, a priest consecrates the Host at the altar, holding it high above his head, while an acolyte kneels behind him. The head of a lion, facing outward from beneath these two figures, symbolizes the supernatural power of the Church.

EUCHARIST — This is the central act of Christian worship, also called the Mass, Holy Communion, or Last Supper. It is performed by a priest and perpetually remembers the communion of the apostles instituted by Christ at the Last Supper (see the entry for SACRAMENTS).

FLAGELLANTS — The first flagellant groups—devoted to the scourging of Christ—were formed in Italy and Germany about 1260. In the story of his Passion, this occurred after the crowd called for his crucifixion; Pilate then ordered his soldiers to scourge (beat with whips) Christ. In compassion for Christ, flagellants as a group would privately, and publically, scourge themselves.

FRANCISCANS — Followers of the teachings of Francis of Assisi (1182–1226) were first called Friars Minor. With two companions, Francis formed the first society around 1209. When Pope Innocent III sanctioned the Rule of the Order of Friars Minor in 1210, Francis had eleven disciples. He rewrote the Rule (1221), and Pope Honorius III confirmed the final form (29 December 1223). Francis had visions of Christ, and taught brotherly love and devotion to nature, which influenced the types of images created for worship. Clare of Assisi and her followers, called the Poor Clares (see fig. 2–8), were installed in a house next to the church of San Damiano in Assisi in 1215; they were guided by the mysticism of Francis and

diligently followed the monastic vows, living in utmost poverty. The original Rule of Francis stressed poverty and intense devotion, but members would later argue over the exact meaning of poverty for the order, as they lavishly decorated the church of S. Francesco in Assisi (see fig. 9–4).

FRESCO — To decorate the walls of churches and palaces, Duecento artists were called in to paint murals (frescoes), an alternative to creating mosaics. The technique required apprentices, skilled assistants, and a master artist, who set up the workshop on site (see Giotto).

GOSPELS — The first four books of the New Testament constitute the Gospels, the story of Christ according to writers Matthew, Mark, Luke, and John. These four men are called Evangelists (writers of the Word). Matthew became identified as a converted tax collector who was one of Christ's apostles; Mark was considered Peter's interpreter, according to one tradition, as retold by the early Christian writer Eusebius; Luke was thought to have been both a physician (S. Paul greeted him as such, see Col 4:14) and an artist, who painted his own vision of the Madonna and Child (he was to become the patron saint of artists); John was thought to have been the beloved apostle of Christ, the only apostle present at the crucifixion. All the Evangelists but John were thought to have been martyred (according to

his legend, he was taken—body and soul—into heaven). In art the Evangelists are identified with symbols deriving from Ezekiel's vision (Ez 10:14): man, lion, ox, and eagle, called the Tetramorphs. Each animal relates to the opening of the Gospel with which it is linked: Matthew (winged man) focuses first on Christ's genealogy; Mark (lion, a desert animal), the Baptist in the wilderness; Luke (ox, a sacrificial animal), sacrifice in the temple; and John (eagle, linked to heaven), beginning of time.

MAESTÀ — Images of the Virgin and Child enthroned with Mary as *Regina Coeli* (Queen of Heaven) are also called the Virgin in Majesty or *Maestà*. These were popular in Italy from the Duecento.

MEDITATIONS ON CHRIST — Once attributed to the Franciscan Bonaventure, *Meditations on the Life of Christ* is now ascribed to Pseudo-Bonaventure, an anonymous Franciscan writer, who authored the manuscript in the late–13TH c. Filled with inspirational readings pertaining to Christ's life and God's plan, it has passages meant to inspire compassion for Christ's Passion. Many visual images were inspired by the vivid descriptions of the manuscript.

MENDICANT ORDERS — From the Latin word *mendicus* (beggar), mendicants owned no property in common, as did Benedictines. Instead, property of the mendicant orders was held in trust by the papacy. When mendicants left the monastery to attend to the spiritual and physical needs of the lay community, they depended upon the largesse of others. They were much less removed from society than cloistered Benedictine monks or even the reformed Benedictines (i.e., Camaldolese and Vallombrosans). Their contact with laypeople (preaching, teaching, attending the sick, missionary work) sparked a general increase in religious fervor, and their patronage contributed to the transformation of devotional images. Many mendicant churches would be considered among the most important churches in Renaissance Italy, with the mother house of the Franciscans (see fig. 9–4) one of the richest churches in Umbria.

MONASTICISM — Monks living in a community that is isolated from the world are said to be cloistered (enclosed). Before Benedict of Nursia, most monasteries followed the Rule of the Master. Benedict's set of regulations governing cloistered monks in rural communities brought great order and stability to monasticism.

ORIGINAL SIN — The biblical first parents, Adam and Eve, committed the first sin by disobeying God (eating the forbidden fruit of knowledge); they fell from grace and were evicted from Eden, with no hope of reentering Paradise. Christ, as the Redeemer of humankind, was called the

2–13. ALBERTO ARNOLDI. *Confession*, ca. 1345 (see fig. 2–10 for size, materials, and location). Penance (confession), one of the seven sacraments, involves confessing sins to God through a priest and atoning (doing penance) for the sins to receive absolution.

2–14. ALBERTO ARNOLDI. *Marriage*, ca. 1345 (see fig. 2–10 for size, materials, and location). Marriage is one of the seven sacraments. The three lobes beneath the people signify the Trinity and the Church and allude to the importance of marriage and family in a Christian society.

2–15. ALBERTO ARNOLDI. *Extreme Unction*, ca. 1345 (see fig. 2–10 for size, materials, and location). Extreme unction is called the last rite because it is the final religious ceremony that a bishop or a priest administers to a dying person in a state of grace. Arnoldi's *Extreme Unction* depicts a deathbed scene where a priest has already administered the *viaticum* (the Holy Communion, meant to provide grace and fortitude for passage into eternity).

2–16. This illustration is of the *Volto Santo* (Face of Christ), a venerated relic enshrined in Lucca Cathedral (S. Martino). The polychrome wooden sculpture was probably executed in the mid–11ᵀᴴ c., although legend dates it to the time of Christ's death. The long tunic of Christ was favored by the Eastern Church and appears in early Christian art (*Crucifixion*, 8ᵀᴴ c., S. Maria Antiqua). During the Feast of the Holy Cross, which occurs on 13 September, the month of its arrival in Lucca, the *Volto Santo* is adorned with precious materials and carried in processions throughout the streets of Lucca. In 1482 Matteo Civitali built a freestanding small chapel, the Tempietto, to encase the *Volto Santo*.

second Adam and Mary, the second Eve. Adam's skull often appears at the foot of Christ's cross, and Christ's blood on the skull symbolizes redemption.

POPE — Like S. Peter, considered the first bishop (pontiff) of Rome, the pope is the bishop of Rome and the spiritual leader of the Latin Church (supreme pontiff). He is elected by the Sacred College of Cardinals. In art he is distinguished by a pointed hat, a tiara (by the 14ᵀᴴ c. it is ringed with three crowns).

SACRAMENTS — The Catholic Church identifies 7 sacraments (see figs. 2–10 to 2–15) as divinely instituted sacred obligations (outward signs that signify and confer grace): (1) baptism; (2) confirmation; (3) the Eucharist, or Holy Communion; (4) confession (penance); (5) holy ordination (for clergy); (6) marriage (for laity); and (7) extreme unction (last rites). Some sacraments were often pictured (the baptism of Christ and the Last Supper).

SAINT — For an individual to be sanctified (canonized) by the pope, a formal process has been followed since the 10ᵀᴴ c. Early Christian martyrs were automatically included in the list of saints, while others had to be deceased, beatified, and have at least two verified miracles (i.e., stigmatization of Francis of Assisi). In art, halos indicate sainthood, while rays around the head signify beatification, a step below sanctification (approval by the pope is necessary for beatification, bestowed after the individual's death).

SERVITES — In 1233 seven wealthy Florentines who called themselves the Servants of the Blessed Virgin Mary founded the Servites. They followed the Rule of S. Augustine and recorded

seeing the Virgin during the Feast of the Assumption, who told them to retreat from the world to do her service. The Servite Order was recognized in 1259, with an Order of Servite nuns founded in 1260 (see fig. 2–9). Pope Benedict XI formally approved the Order in 1304.

TEMPERA — (See Cimabue.)

THEOTOKOS — The Virgin Mary was declared the "bearer of God" at the ecumenical Council of Ephesus (431), affirming that she was the mother of the divine Christ. The dual nature of Christ as human and divine was decreed at the Council of Chalcedon (451). Byzantine images of the regal Virgin and Christ child frequently provided the models upon which Duecento images in Italy relied (see VIRGIN HODEGETRIA).

TYPOLOGY — In art, images show how events of the New Testament are prefigured in the Old. In the popular book *Speculum humanae salvationis* (Mirror of Human Salvation) images and text stress the significance of the Redemption for human salvation and the need for humans to fear eternal damnation.

VIRGIN HODEGETRIA — A miraculous (lost) image in Constantinople thought to have been the work of S. Luke the Evangelist was called the *Virgin Hodegetria*. In this image the Virgin Mother presents to the faithful the Son of God, who is held by her left arm while she points to him with her right hand; she is thus the indicator of the way to salvation (*Hodegetria*). Copied many times, it became a popular Byzantine type in Duecento Italy (see figs. 1–1, 1–5, 4–1).

VOLTO SANTO — A sculpture of the crucified Christ thought to be the work of Nicodemus (follower of Christ) is revered as the *Volto Santo* (see fig. 2–16).

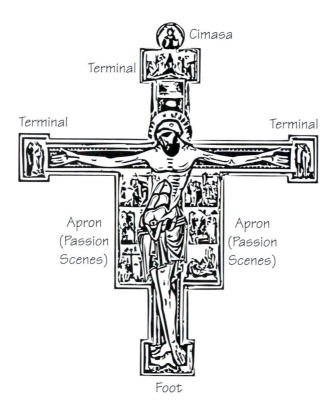

Cimasa

Terminal

Terminal

Terminal

Apron
(Passion
Scenes)

Apron
(Passion
Scenes)

Foot

3–1. Diagram of Coppo di Marcovaldo's *S. Chiara Crucifix*, ca. 1261, wood, 9'7.4" x 8'1.3" (293 x 247 cm), Pinacoteca Civica, San Gimignano (see fig. I–3). Images of the final days of Christ on earth and of his mourners are depicted on Coppo's crucifix: *The Redeemer* is in the *cimasa*, above the scene of the *Ascension*. In the terminals are *Mary and John Evangelist* (left) and *The Three Marys* (right). On the apron are six scenes: (left, from the top) the *Kiss of Judas, Flagellation*, and *Christ Ascending the Cross*, and (right, from the top) *Christ before Annas and Caiaphas, Mocking of Christ*, and *Lamentation*.

Coppo di Marcovaldo (ca. 1230–ca. 1276) is the first Florentine Duecento (13ᵀᴴ c.) artist known by name, with approximately a half-dozen records attesting to his whereabouts between 1260 and 1276. Both a painter and a designer of mosaics, his best-known work is a mosaic in the Baptistery of S. Giovanni, Florence: Christ the *Pantocrator* (sovereign judge) of the *Last Judgment* (see fig. 3–2). In its dark, heavy outlines, the figure stylistically resembles Christ in the *S. Chiara Crucifix* (see fig. 3–1), a work more fully accepted as his. While the context of the two figures is different, both reveal Coppo's penchant for dramatic narrative. Christ appears not as a victor over death in the *S. Chiara Crucifix*, but as a haunting human corpse. His style reflects an interest in Byzantine art (the influx of Greek artists in Italy increased significantly during his time), and he had a sensitive approach to the heartfelt themes important to the mendicant orders, particularly the Franciscans and Servites, for whom he worked. Countless Tuscan artists were to display traits of Coppo, including Cimabue and Giotto.

ca. 1230 — Born in Florence.

1260 — Coppo is a conscripted soldier who fights against the Sienese at the battle of Montaperti.

1261 — Coppo executes the large (about 7' x 4') tempera panel, *Madonna del Bordone* (called the Madonna

In the Duecento, flat panels shaped like crosses and with painted images of the crucified Christ were to replace three-dimensional sculptures of the crucified Christ (the then most famous sculpture in Italy was the *Volto Santo* [11ᵀᴴ c.], enshrined in Lucca Cathedral). The new type of crucifix, as seen in Coppo's *S. Chiara Crucifix*, has wood pieces attached to the cross at symbolically significant places beside the life-size image of Christ (the head, hands, feet, and side of Christ, the places of his wounds) (see fig. 3–1). These pieces of wood were decorated with figural and non-figural imagery; figural scenes on the aprons, for instance, were often devoted to stories of Christ's earthly ordeal. The significance of these crucifixes is tied to a decree of the Fourth Lateran Council of 1215 (observance of transubstantiation of the Eucharist) and to the miracle of the Mass at Bolsena of 1263 (see Duecento History Notes 1215 and 1263).

of the Pilgrim's Staff), for the Servite church of S. Maria dei Servi in Siena. It is inscribed on the frame "Coppo of Florence painted this in 1261." Mary appears as the regal *Hodegetria* (indicator of the way to salvation), a type of Byzantine image of the Virgin presenting the Son of God ("the Word made flesh"). This is the first important image of the Virgin Queen of Heaven enthroned as Queen of Siena (see Duccio). Parts of the painting were altered in the early Trecento (14ᵀᴴ c.) when the faces of Christ and the Virgin were repainted in the style of Duccio. Twenty years after Coppo's *Madonna del Bordone*, Cimabue created in Florence a similar image of the Virgin Mary (see fig. 4–1).

ca. 1262 — For a Franciscan convent church outside the town walls of San Gimignano, Coppo paints a large wooden cross that is nearly ten feet high (see fig. 3–1). The convent of S. Chiara (Clare) was founded in 1261 by nuns belonging to the Second Franciscan Order. They were called Poor Clares and known as Minoresses. Coppo's *Crucifix* was highly valued by the nuns and when they moved into town (1493) they took the crucifix with them. Two types of crucifixes were fashionable in the Duecento: one presented Christ suffering in death (*Christus patiens*) and the other triumphing over death (*Christus triumphans*). Coppo painted the suffering type for the Poor Clares, emphasizing the physical side of the dual-natured Christ and showing the effects of wrenching pain on a now-lifeless body. Coppo's provocative image must have aroused the deepest sympathy in grief-struck worshippers, who may have wrung their hands like the Virgin Mary over the suffering Christ. Lively figures, no bigger than the size of Christ's opened hands, act out engaging

dramas on the apron of the cross. These scenes all reflect Coppo's knowledge of Byzantine narrative art and his interest in humanizing biblical events.

1265 — Coppo settles in Pistoia (about 20 miles west of Florence) and works in the cathedral, collaborating with a priest painter on (lost) frescoes in the S. Jacopo Chapel. Cathedral records (1269, 1274, 1276) show that he painted panels, frescoes, and two crucifixes (one for the cathedral choir and another for the S. Michele Chapel).

ca. 1268 — In Orvieto, Coppo paints the *Enthroned Madonna and Child* for a newly completed Servite church. The Siena *Madonna del Bordone* (1261) and the Orvieto panel are nearly identical in their regal demeanor, elegant, gilded clothes, and in the gesture of Christ, who blesses Mary. Their many similarities reflect the importance of this type of image for the Servite Order. Yet, the Orvieto panel is more stylistically coherent than the Siena *Madonna del Bordone*. It shows Coppo's creation of more volumetric figures and three-dimensional space. Giotto later displayed similar interests, but to a much greater degree, in his *Maestà*, ca. 1310 (Uffizi Gallery, Florence).

1274 — For the cathedral choir of Pistoia, Coppo works (with son Salerno, released from debtors' prison to help) on a crucifix and panels.

1275 — In Pistoia, Coppo signs and dates a (lost) Madonna and Child for the cathedral.

1276 — Coppo is paid for paintings in Pistoia Cathedral (the money helps repay Salerno's debt to the Commune). Coppo is not mentioned in Pistoia records after the year 1276.

Mosaic Technique

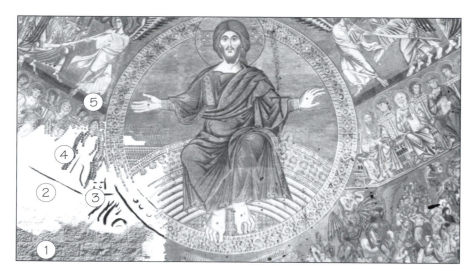

3–2. Stratified layers of a mosaic are identified here in a detail of the cupola mosaic of the *Last Judgment* in the Florence Baptistery (see figs. 2–3, 3–3).

KEY TO DIAGRAM.
1 Masonry wall
2 Plaster
3 Detailed drawing applied to plaster
4 Insertion of tesserae
5 Completed design

As refurbishment of the Baptistery of S. Giovanni (see fig. 2–3) proceeded in the 11TH century, the building was consecrated the cathedral of the city in 1059 by Pope Nicholas 11. Formerly the Bishop of Florence (1045–58), Nicholas kept the see of Florence during his papal reign (1058–61). S. Giovanni served as the cathedral until the bishop's throne was transferred to S. Reparata (12TH c.). Thereafter, the baptistery continued to function as the only baptistery in Florence, and it was the center of religious and civic activities.

Mosaic decoration of the interior began in the early–13TH century and was completed in about a hundred years. Payment came from a special tax and donations on S. John's Day and from the coffers of the powerful Calimala, the guild of merchants of imported cloth (also called the merchants' guild), who were placed in charge of the operation of the baptistery by 1293.

Florentine artists may have designed the impressive baptistery mosaics, but Venetian specialists were almost certainly imported to execute and to train local artists in the process. The city of Venice was renowned for her exquisitely decorated churches, like the Basilica of S. Marco (see fig. 66–6), and for the expertise of her artisans, who had studied glassmaking and learned the style and the skills of creating mosaics from Byzantine artisans who had settled in, and around, Venice after the sack of Constantinople in 1204 (see fig. 1–5).

Making glass mosaics was not a simple undertaking, but a complex and expensive process. Creating the desired colors of glass, coordinating the colors, and setting and securing the tesserae (pieces of glass) were well-guarded shop secrets, the mastery of which required diligent practice. According to the 12TH–c. Benedictine craftsman-monk, Theophilus, glass was made by mixing one part sand with two parts ashes. In his treatise, *De diversis artibus* (On Divers Arts), Theophilus specified that sand and ashes were to be fritted (partially fused), by placing the mixture over a low fire and stirring it for one full day and night.

An inscription records that Fra Jacopo began the mosaics on the arch of the apse (ca. 1225). The Florentine Coppo di Marcovaldo is traditionally thought to have designed the Pantocrator of the *Last Judgment* (ca. 1270s), and Venetian artists, Constantinus and his son, were brought in to work on the cupola mosaics (1301). By 1330, the mosaics were completed when Villani wrote about S. Giovanni: "By many people which have journeyed through the world [the baptistery] is said to be the most beautiful temple or duomo of any that may be found; and in our times the histories in mosaic have been completed" (*Cronica* 1:60).

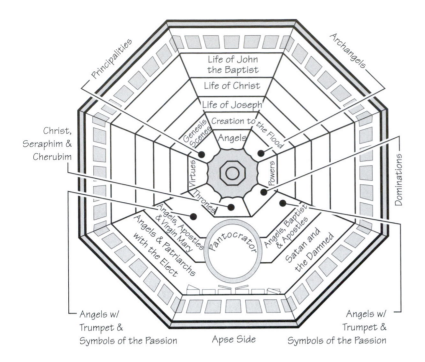

Life of John
the Baptist

Life of Christ

Life of Joseph

Creation to the Flood

Genesis Scenes

Angels

Principalities

Archangels

Christ,
Seraphim &
Cherubim

Virtues

Thrones

Powers

Dominations

Angels, Apostles
& Virgin Mary

Angels & Patriarchs
with the Elect

Pantocrator

Angels, Baptist
& Apostles

Satan and
the Damned

Angels w/
Trumpet &
Symbols of the Passion

Apse Side

Angels w/
Trumpet &
Symbols of the Passion

noted that the color is determined by the length of time the molten glass stays on the fire. This clear, simple statement, taken at face value, belies the difficulty involved. Theophilus therefore gave detailed instructions for making durable glass of a desired color by meticulously specifying how to prepare the ovens, make the pots for boiling liquids, monitor the heat, and create the proper air flow to the mixture. However, the most cherished formulae were undoubtedly the best guarded, unrecorded shop secrets. Thirteenth-century Florentines were not known as skillful mosaicists; therefore, working with master mosaicists who were brought to Florence gave local artists the chance to practice the technique. In Renaissance Florence the Gesuati monks became master glassmakers, creating stained glass windows and executing mosaics to the design of Florentine artists.

When the mixture was next placed over a red-hot fire, it turned into molten glass. Achieving partial fusion was a slow process that should not be rushed, according to Theophilus. Modern ingredients typically associated with making glass are lime and soda (or potash). These are not named in Theophilus' treatise, but they are contained in the ash of beechwood trees, which he recommended using.

Gilded glass, which dominates the design of the baptistery cupola, is costly because a layer of gold leaf is embedded between sheets of clear glass. Achieving the variety of colored glass that can be seen in the cupola was painstaking and complicated because color is determined by the presence of metal oxides and by how much air gets filtered through the liquid. The presence of iron can turn glass from white to red, for instance, depending on its state of oxidation and upon the absence of other metal oxides. Theophilus

Preliminary designs were applied to walls, either by drawing directly on the surface or by transferring designs from drawings. Once the glass had been made, broken into the desired shapes and sizes, and organized by color, the tesserae were set into wet mortar, often at angles depending upon the effects desired and the shape of the wall. (Glass pieces set at different angles produce a sparkling effect.) Similar to creating a fresco (see Giotto), work typically started at the top of the wall or the center of a vault and proceeded downward.

3-3. Diagram of the vault, Florence Baptistery (see fig. 2–3). Nearly eight stories high, its apex about 98.5′ (30 m) from the ground, the vault is covered in glittering mosaics that still make a lasting impression on beholders. The ceiling is divided into concentric bands that flank Coppo's Pantocrator of the *Last Judgment* (see fig. 3–2), which faces the cathedral and is the dominant figure of the ceiling. Nine choirs of angels are depicted on the highest band (see ANGELS, Duecento Glossary), and Baptist scenes are in a register taller than the others and closer to onlookers in the baptistery.

Cimabue

According to Giorgio Vasari (1511–74), the author of the *Lives of the Artists* (published in 1555 and 1568), the story of Italian art can be divided into three periods, beginning with the life of Cimabue (ca. 1240–1302). In Vasari's estimate the noble Cimabue changed the course of Italian painting by surpassing the Greek (Byzantine) masters working in his native Florence. It was Cimabue, we are told, who brought light to a bleak and dismal period in art. Tradition remembers Cimabue as the master of Giotto; however, it seems very unlikely they had a teacher and pupil relationship.

ca. 1250 — Born in Florence, Cenni di Pepo will be called Cimabue in documents. He may have been trained in Coppo di Marcovaldo's shop.

1272 — Cimabue is recorded in Rome.

1273 — About this year, Cimabue creates the earliest work assigned to him, the *Crucifix* above the high altar of S. Domenico in Arezzo.

1277 — Cimabue is likely called to Assisi, where his first frescoes were in the choir of the upper church of S. Francesco, narratives of the Virgin: *Annunciation of the Death of Mary*, *Dormition*, *Assumption*, and *Coronation*. Also in the choir are his two large frescoes of crucifixion scenes. He afterward created frescoes in the lower basilica of S. Francesco.

ca. 1280 — Cimabue paints the *Maestà* (Our Lady in Majesty) for the Vallombrosan church of S. Trinità, Florence (see fig. 4–1). His prototype was Byzantine (see fig. 1–1).

ca. 1285 — Cimabue paints the large *Crucifix* for S. Croce, Florence (Museum of S. Croce).

1287 — In Bologna, he paints an altarpiece, the *Madonna dei Servi*, for S. Maria dei Servi.

1288 — For the Hospital of S. Maria Nuova in Florence, he executes an altarpiece.

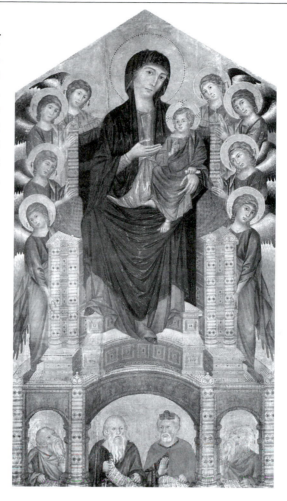

4–1. CIMABUE. *Maestà*, ca. 1280, tempera on panel, 12'7.5" x 7'3.8" (385 x 223 cm), Uffizi Gallery, Florence. Under the arches at the base of the Virgin's throne are four Old Testament prophets holding scrolls: Jeremiah, Abraham, David, and Isaiah. The placement of these figures beneath the throne signals a preliminary stage in the development of predella panels (see fig. 4–7).

ca. 1300 — An altarpiece of the *Maestà* for S. Francesco in Pisa (Louvre, Paris) was likely executed by his shop on the master's design.

1301 — Cimabue works on the apse mosaic (begun by Francesco da S. Simone) of Pisa Cathedral. Only one figure, *S. John the Evangelist*, shows his style.

1302 — By March, Cimabue had died in Pisa.

Tempera Panel Painting Technique

Cimabue created works in different mediums, but he was chiefly a painter of frescoes (Assisi) and panels. Like Coppo di Marcovaldo, he traveled outside his native Florence to gain experience and find employment. Also like Coppo, his major commissions were from the mendicant orders (Franciscans, Dominicans, and Servites). Both artists have been linked to the mosaic cycle in Florence Baptistery, although their contribution cannot be confirmed. However, Cimabue is recorded as having worked on the mosaics in Pisa Cathedral. Nevertheless, the greatest quantity of their work was done in tempera on wood panel. Both created the two most significant devotional pieces of church decor in Duecento Tuscany: enormous crosses (see fig. 3–1) and giant tabernacles (see fig. 4–1). These moveable pieces rivaled the brilliant luster of the permanently positioned stained glass windows and gilded mosaics in churches.

The following summarizes information in Cennino Cennini's *Il libro dell'arte* (The Craftsman's Handbook), written about 1390. Cennino is thought to have been a pupil of the Florentine painter Agnolo Gaddi, whose father, Taddeo, was trained by the famous Giotto.

SELECTION OF WOODEN BOARDS

In discussing paintings on panels, or anconas as he called them, Cennino recommended that the planks be cut from poplar, linden, or willow trees. He cautioned painters about problems that would arise from leaving rotten knots in the wood and recommended that all greasy areas be removed by planing the boards until the surface was smooth.

ATTACHING THE JOINS OF BOARDS

Boards were held together by several means: (1) with dowels driven into the edges (joins) of adjacent boards, (2) with small wooden plates attached to the backs of boards that spanned the joins of the boards, and (3) with wooden forms in the shape of butterflies that fill cavities notched into the adjoining boards. All these methods effectively bridge the joins between the wooden planks.

GESSO GROSSO AND GESSO SOTTILE

After the boards had been joined, framed, and sanded, the painter was instructed to add gesso to the surface. Gesso consists of parchment glue and slaked plaster. Usually two different types of gesso were applied: a thick gesso, called grosso, and a thinner gesso, called sottile. The first gesso layers were grosso, which prepared the surface, and the final layers of sottile gesso provided a hard, unyielding surface that could be smoothly sanded to a marble-like finish

(Cennino equated it to ivory). Often, linen soaked with gesso was placed between the gesso layers to strengthen the surface. The panel was now ready for the many layers of paint that followed.

CHARCOAL

Cennino recommended that the design on the ancona be drawn with charcoal attached to a stick. Once the drawing was completed, he recommended that the painter reinforce it with a water-diluted ink applied with a miniver brush. (This type of brush was to be made from the long hairs of the tips of minivers' tails; minivers are European ermines.) Afterward the painter was to sweep the charcoal clean from the surface.

GILDING

Gilding was to be done in mild, damp weather. Gold leaf was prepared by flattening a chunk of gold into very thin sheets (about 100 sheets, or leaves, could be made from a florin). The gold sheets were cut into square shapes and applied to a surface bole (clay containing iron-oxide, giving it a reddish-brown appearance), which had been burnished (with linen, for example) and coated with a mixture of water and egg whites. The bole was applied to the gessoed panel with a water-based adhesive, such as glue, gum, or egg whites (a process sometimes called water gilding). Once secured to the bole, the gold leaf could be burnished. The surface could also be decorated with engraved designs, frequently made with punches stamped into the gilded surface. The gold leaf could also be covered with paint that was scraped off (*sgraffitto*) to show the gold and give the look of cloth woven with gold thread (shot silk).

UNDERPAINTING

Once the gilding was secure, painters were to begin underpainting. Usually *terra verde* (green earth) was used for areas that were to represent flesh and for outlining figures.

THE FINAL LAYERS

After the underpainting was completed, painters were to apply layers of tempera. Small brushes were to be used to apply short, parallel strokes of tempered pigment. Cennino recommended that painters execute buildings and draperies before faces, and that colors be tempered with the yolk of an egg. (Egg yolk dries quickly and becomes very hard and binding.)

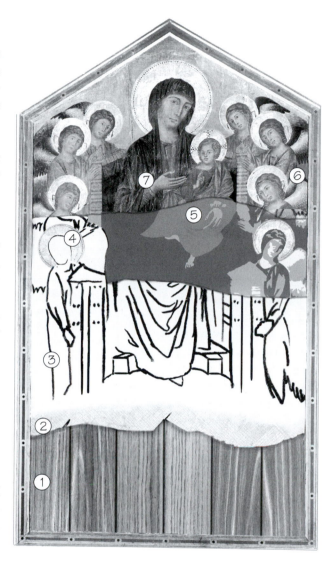

4–2. This diagram illustrates the tempera panel process.

KEY TO DIAGRAM.

1 Poplar panel
2 Layers of gesso and linen
3 Underdrawing
4 Gold leaf
5 Underpainting
6 Final tempera layers
7 Mordant gilding

Cimabue's tabernacle-shaped altarpiece is composed of six large vertical planks. He used the shape to call attention to the venerated Madonna and Child, with Mary the dominant figure of the painting: she is depicted larger than human size and placed along the central axis. Her elegant face attracts attention because of its great size and prominent position under the peak of the frame. As the *Virgin Hodegetria* type, she points to the blessing Messiah. All but two of Cimabue's angels incline their heads toward Mary and Christ, and they all hold onto the throne, a suggestion of their role as angels who intercede in human affairs (see ANGELS, Duecento Glossary).

SHELL GOLD AND MORDANT GILDING

Gold was sometimes painted on surfaces, using powdered gold mixed with water and gum arabic; because the liquid was mixed in a shell, the term used to identify this type of gilding is shell gold. Mordant gilding (gold leaf applied to an adhesive laid onto the painted surface) was one of the last applications to a tempera painting. It creates highlights that make garments look like satiny, gold-embroidered materials. The gilded areas, which stand out in relief, reflect light, giving the effect of shimmering streaks. Such shimmering effects in Byzantine panels (see fig. 1–1) and in Cimabue's (see fig. 4–1) give the holy figures an appearance of ethereality.

Cennino instructed painters to be very certain of what they were to paint because corrections are difficult to make when using tempered pigments. The process dictated by Cennino is exacting, requires time, and demands diligence.

Altarpiece Shapes

ANTEPENDIUM. An antependium is rectangular in shape and was placed in front of an altar table. Antependiums were executed from the twelfth through the fifteenth centuries, with the greatest number commissioned in the Duecento. The materials for this type altarpiece shape vary. Some are simple, of painted wood panels, and some were made of precious metals, like the silver altar that was executed for the Baptistery of S. Giovanni in Florence.

DOSSAL. Dossals have the same simple, rectangular shape as antependiums, but were placed on top and at the back of altar tables; dossals had a widespread use from around 1240.

TABERNACLE. Gable-shaped paintings, called tabernacles, are remindful of the pointed arches of Gothic architecture. Executed in all sizes, tabernacle altarpieces such as Cimabue's *Maestà* (see fig. 3–1), commissioned for the high altar of a church, were usually large-scale paintings measuring between seven and nine feet tall. This altarpiece type was introduced into Tuscany about 1260.

DIPTYCH. Two panels joined together are called diptychs. Many small-scale, hinged, moveable panels, commissioned for churches and for domestic chapels, have survived. Because of their light weight, diptychs used for private devotion were sometimes carried on journeys. From the fifteenth century, portrait diptychs were often commissioned, with emblems and imagery associated with the patron on the outer panels (see Piero della Francesca).

TRIPTYCH. Three panels joined together are called triptychs. The outer panels, called wings, are each typically half as wide as the larger central panel. If the wings are hinged they can be closed over the central panel, providing additional surfaces for images and protection for the important central panel (see Fra Angelico).

POLYPTYCH. Multiple panels joined together, often of varying size, are called polyptychs. Above the main panels are pinnacle panels that are typically smaller and frequently have depictions of half-length figures. Beneath the main panels is a predella (foot), which was sometimes made of double and triple tiers. Narratives about the subjects of the main panels usually appear in the predella.

4–3. Antependium and dossal shape.

4–4. Tabernacle shape.

4–5. Diptych shape.

4–6. Triptych shape.

Pinnacles

E. Polyptych

Predella

4–7. Polyptych shape.

5–1. This illustration of the apse in S. Maria in Trastevere, Rome, shows Pietro Cavallini's mosaics, late 1290s (highlighted, from the left): *Birth of the Virgin*, *Annunciation*, *Nativity*, *Adoration of the Magi*, *Presentation in the Temple*, and *Dormition*. Below is a votive image of the patron. Above are mosaics by another artist (in gray) of the *Enthroned Christ and the Virgin* (1140), framed by candlesticks, Evangelist symbols (Mark, Matthew, John, and Luke), and prophets (Isaiah and Jeremiah).

Unrivaled in Duecento Rome by any other painter or mosaicist, Pietro Cavallini (ca. 1240–ca. 1340) received significant commissions during the period when a strong pope, Nicholas III (1277–80), began transforming Rome into an imperial papal city. Nicholas called upon artists like Cavallini and Torriti to refurbish the frescoes and mosaics of decaying early Christian monuments and to create new decoration for the highly revered churches in Rome. Cavallini's important fresco project in the immense basilica of S. Paolo fuori le Mura (S. Paul's Outside the Walls) influenced artists like Giotto. Commissioned by popes, cardinals, princes, and kings, and working well into the fourteenth century (his son wrote that he lived to be a hundred), Cavallini was honored with burial in S. Paolo fuori le Mura (an ex-traordinary acclaim for an artist). However famous he was (see Ghiberti's *Commentaries*), Cavallini's contribution is nonetheless blurred by the irreparable damage and loss of major works, and by Vasari's misstatement that he was a disciple of Giotto.

ca. 1240 — Pietro di Cerroni (later called Cavallini) is born in Rome.

1273 — Cavallini is a witness in a legal agreement (2 October), which is preserved in the archives of S. Maria Maggiore, Rome.

ca. 1278 — Pope Nicholas III commissions Cavallini to paint frescoes in a major Roman church, S. Paolo fuori le Mura, where tradition alleges S.

Scenes of the Virgin in S. Maria in Trastevere (see fig. 5–1), drawn from Bible stories and apocryphal texts, have motifs showing Cavallini's knowledge of Byzantine art and the cycle of Marian images by Torriti in S. Maria Maggiore (see fig. 6–1). Cavallini's patron, Bertoldo Stefaneschi, kneels beside his family crest in a votive image placed directly beneath the scenes of the *Nativity* and *Presentation*. Bertoldo is himself presented to the Virgin and Child by Peter, who touches his head, and Paul (the patron saints of Rome). Cardinal Giacomo Gaetani Stefaneschi, the patron's brother, composed the lines beneath Cavallini's mosaics. Placing narratives (see fig. 5–1) at the foot of a formal, iconic image, like *Christ and the Virgin Enthroned*, inspired a similar format in panel paintings, which, from about 1300, have smaller, illusionistic narrative panels beneath the main panel in an area called the predella (see figs. 4–7, 12–3, 12–4).

Paul's body is buried. Cavallini worked on about eighty frescoes, retouching and repainting existing work and creating new compositions. Although the frescoes were destroyed by fire in 1823, prints and watercolors record two registers of forty-two scenes on each nave wall. Stories from the Acts (late 1270s), mostly about Paul, were on the north wall and Genesis and Exodus scenes (1280s) were on the south. One west wall scene has also been attributed to Cavallini.

ca. 1290 — During the reign of Pope Nicholas IV (1288–92), Cavallini paints frescoes (perhaps for Cardinal Chole, d. 1292) of Old and New Testament scenes (destroyed 18TH c.) in the nave of S. Cecilia in Trastevere. Although the *Last Judgment* is missing large areas of paint, choir benches protected much of the fresco, which exhibits Cavallini's superb craftsmanship and sensitivity for creating modeled, natural-looking human flesh and dramatic expression. The rediscovery of the fresco (in 1900) changed the evaluation of Cavallini's contributions to Roman art.

late 1290s — In S. Maria in Trastevere, Rome, Cavallini creates narrative mosaics beneath an existing, grand iconic image, *Christ and the Virgin Enthroned* (1140), in which Christ is depicted as the Pantocrator and the Virgin as bride, mother, queen, and intercessor (see fig. 5–1). (Mary holds a text inscribed with words recited in celebrations of the Feast of the Assumption.) Beneath this formal, staid image are Cavallini's narrative mosaics, which exhibit serene elegance, dramatic naturalism, and an interest in illusionism that makes them seem fluidly executed, like frescoes.

ca. 1300 — Cavallini paints the apse fresco depicting Christ with the Virgin and Ss. George, Peter, and Sebastian in S. Giorgio in Velabro, Rome (attributed to Cavallini on the basis of style).

1302 — A tomb fresco for Franciscan Cardinal Matteo d'Acquasparta in S. Maria in Aracoeli, Rome, is attributed to Cavallini on the basis of style.

1308 — In Naples, Cavallini is working (June) for King Charles II (1285–1309), and later (December) for his son Robert (1309–43). The Neapolitan court was a vital art center under the Angevin dynasty. King Charles II attracted Cavallini by paying an annual salary of thirty ounces of gold, plus money for a house (two ounces of gold).

ca. 1320 — Cavallini paints frescoes in S. Maria Donna Regina in Naples for Queen Mary of Hungary. On the west wall is a unique image of the Virgin (the Apocalypse woman) with Passion symbols.

ca. 1325 — For Pope John XXII, Cavallini executes a facade mosaic (finished 1330, destroyed 1823) for S. Paolo fuori le Mura, Rome. Cavallini was later buried in S. Paolo, where he had created his major works.

Jacopo Torriti

6–1. This illustration shows the *Coronation of the Virgin*, ca. 1295, in S. Maria Maggiore, Rome. Jacopo Torriti's design gives the impression that a mystical event appears above the high altar. Repeated circles (spiraling vines) and the celestial realm of the divine couple enhance the illusion that Christ and the Virgin are suspended in heavenly space before saints, patrons, and worshippers. With her hands raised toward the majestic Christ, Mary is the Intercessor for mankind. The cult of Mary grew in enormous proportions across Europe after the Crusades to the Holy Land in the 11ᵀᴴ and 12ᵀᴴ centuries. Bernard of Clairvaux (1090–1153) envisioned Mary as the bride of the Old Testament Song of Songs. Although Bernard was not the first to identify the Virgin as Christ's bride, his writings were a popular source for Marian images (see CULT OF THE VIRGIN MARY, Duecento Glossary).

Although little is recorded about the Roman artist Jacopo Torriti (active 1270–1300), and many of his works have been lost, he is remembered as an expert mural painter and designer of mosaics who worked in two active art centers, Assisi and Rome. His most notable accomplishment was the grand apse mosaic in S. Maria Maggiore in Rome, commissioned by Pope Nicholas IV (1288–92).

early work — On stylistic grounds it seems that Jacopo worked in S. Francesco at Assisi on frescoes in the upper church. Scenes from Genesis (the *Creation of the World*, the *Creation of Adam*, and the *Creation of Eve*) and a vault fresco, *Christ and the Virgin with Ss. John the Baptist and Francis*, have been attributed to him and dated as early as the 1270s and as late as the 1290s.

Because tradition held that Mary was bodily assumed into heaven, no church claimed to have the sacred body of the Virgin. Yet churches were frequently dedicated to Mary, who was thought to intervene in the affairs of humans. A 13TH–c. legend relates how S. Maria Maggiore was miraculously founded by the Virgin. Mary appeared in a dream to Pope Liberius (352–66) and a wealthy patrician, named John (the financier). She told them to build a church on the Esquiline Hill where a miraculous August snow would mark the site (see Masolino). In the church that was, according to legend, miraculously founded by Mary, Torriti's mosaic of the *Coronation of the Virgin* appears in the apse showing the Virgin assumed into heaven in the presence of angels (see fig. 6–1). Crowned by Christ, Mary reigns as the Queen of Heaven and intercedes for humanity, as suggested by the gesture of her raised hands. (See Lorenzo Monaco for a variation on Torriti's design.)

1291 — In S. Giovanni in Laterano (S. John of the Lateran) Jacopo dates and signs his name (JACOBVS TORRITI PICTOR) on the apse mosaic. (A replica of Torriti's mosaic was made before the apse was relocated and the mosaic was destroyed in 1883.) Torriti's mosaic has been linked with the projects undertaken by the Franciscan pope Nicholas IV to rebuild and redecorate the 4TH–century apse and facade of the Lateran, which had originally been built by Emperor Constantine the Great. (As the bishop of Rome, a pope took special interest in the Lateran because it was the cathedral of Rome and the pope's titled church.) According to an inscription, redecoration of the Lateran during the tenure of Nicholas IV was completed in 1291. It is unclear whether Torriti, a notable painter of murals, executed designs for trained mosaicists or executed the mosaics himself. However, the enormous importance of the project was linked to the desire of Nicholas IV to build an imperial papal Rome by refurbishing and rebuilding its early churches—such plans had begun under the Roman pope Nicholas III (see Duecento History Notes 1278).

ca. 1295 — Torriti's apse mosaic in S. Maria Maggiore in Rome, *Coronation of the Virgin* (see fig. 6–1), is dated around 1295 on the basis of style and an inscription (lost). S. Maria Maggiore is one of the four patriarchal churches of Rome (the other three are S. Peter's, the Lateran, and S. Paul's Outside the Walls). Under Pope Nicholas IV, the early Christian basilica (5TH c.) was given a transept with a polygonal apse. Torriti's design for the new apse reflects the pope's interest in combining late antique and early Christian motifs with the themes and papal insignia of the new imperial Rome. Torriti drew from the rich tradition of 5TH–century mosaics, incorporating foli-

ate vines spiraling around partridges, peacocks, eagles, cranes, and all manner of birds to fashion an elaborate stunning celestial field for Mary and Christ, who are embraced by angels holding a mandorla-like frame around them. Torriti also drew inspiration from the 12TH–century apse mosaic in S. Maria in Trastevere (see fig. 5–1), which shows the regal couple seated on the same bench. But rather than embrace Mary, Christ places a crown upon her head in Torriti's design. Beneath the *Coronation* is the *Dormition*, flanked by four scenes: the *Annunciation*, *Nativity*, *Adoration of the Magi*, and *Presentation in the Temple* (the *Annunciation* and *Presentation in the Temple* are not shown in the illustration). In the late 1290s Cavallini designed stories of the Virgin (see fig. 5–1) after Torriti's, with fewer figures and far less detail. Because Torriti's *Dormition* is placed out of chronological sequence, it calls attention to the special role of the Virgin's translation into heaven. Tradition records that during the Dormition (sleep) the Virgin's soul was taken by the Archangel Michael to Christ who later returned it to her chaste body before she was assumed into heaven (see ASSUMPTION, Quattrocento Glossary). Torriti's lively image gives the illusion that the Virgin has just risen to heaven, where she pleads for humankind. Kneeling below are the penitent figures of Nicholas IV and Cardinal Giacomo Colonna.

1296 — Jacopo designs a mosaic (destroyed) for Arnolfo di Cambio's marble tomb of Pope Boniface VIII in Old S. Peter's in Rome.

1300 — Jacopo Torriti dies sometime before 1300.

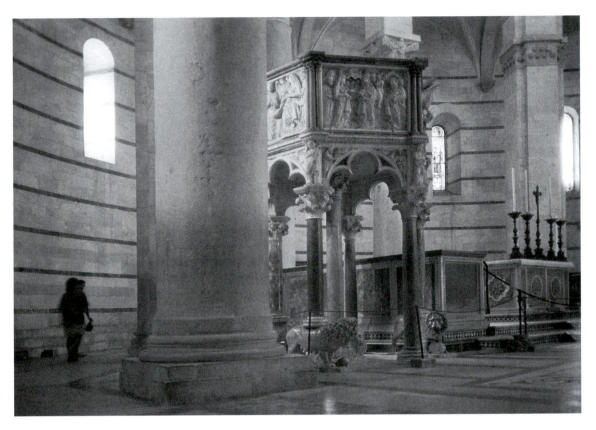

7–1. NICOLA PISANO. Pulpit, 1260, marble, h. 15' (457 cm), Pisa Baptistery. Three stone monuments in the Pisa baptistery are important to the ritual of baptism: (1) the baptismal font—a low, wide octagonal basin created by Guido Bigarelli da Como in 1246—where baptism was performed in the center of the building; (2) the altar of 1159; and (3) Nicola Pisano's pulpit for the readings of the Gospel at an eagle lectern positioned between and above the scenes of the *Crucifixion* and the *Last Judgment*. The style of all three monuments is considered Tuscan Romanesque (Roman-like) because of their solid, massive form and repeated units (the multiple relief panels of the pulpit). Seven marble columns supporting the raised dais of Nicola's pulpit echo the colossal supports of the baptistery, two of which are seen here in the foreground. Life-sized, robust lions, which carry three of the pulpit columns on their backs, appear to be pacing around the pulpit. Their poses and the facets of the hexagonal parapet encourage people to physically move around the pulpit. The panel facing us depicts *Presentation in the Temple*. On a relief of the *Last Judgment* Nicola inscribed his name, date (Pisan style), and a laudatory evaluation of his work (In the year 1260 Nicola Pisano carved this noble work. May so greatly gifted a hand be praised as it deserves).

Nicola Pisano (ca. 1230–by 1284) moved to Tuscany in the mid–thirteenth century, where he assimilated stylistic elements of southern and central Italy with those of French Gothic. He was undoubtedly the most influential Tuscan sculptor of marble in the Duecento. He and members of his shop received notable commissions from church and civic authorities, ranging from tombs and pulpits (see fig. 7–1) to piazza fountains. What is most distinct about Nicola's works is that they responded to the preachings of Francis of Assisi, giving more tangible reality to inert forms than do Byzantine works.

ca. 1230 — Born in the region of Apulia (southern Italy), Nicola moved (by 1250) to Pisa, the city after which he was nicknamed. No records about specific

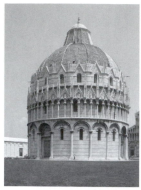

7–2. DIOTISALVI. Baptistery of S. Giovanni in Pisa, begun 1153, marble (the main entrance faces east and the front of the cathedral). Most Tuscan baptisteries are not attached to other buildings. Nicola Pisano redesigned the dome and increased the height of the baptistery (ca. 1260–64). Giovanni Pisano created the Gothic-like traceried gables of the second and third levels (completed 1278). Nicola's pulpit was originally placed on the right (north) side of the baptismal font. (The main portal is on the east side.) After the Council of Trent (1560s), the pulpit was moved to the left (south) side of the baptistery, where it has remained. Through gesture and motif, Nicola's panels lead people counterclockwise around the pulpit, from the *Last Judgment* (which was originally close to the main portal) to the *Nativity*.

work in southern Italy exist, but it is surmised that he became knowledgeable about Roman art while working in the Apulian workshops of his patron, Holy Roman Emperor Frederick II Hohenstaufen (1212–50).

1260 — Nicola completes his masterwork, a freestanding pulpit commissioned by Archbishop Federigo Visconti (ca. 1255) for Pisa Baptistery (see fig. 7–1). Tuscan Romanesque pulpits were commonly attached to supports, such as choir screens or nave columns, and the parapets often had geometric and foliate patterns combined with tiny animal or human heads (as in the Pisa Baptistery font). However, in the mid–12TH c., the sculptor Guglielmo designed a rectangular pulpit (1162) with scenes of Christ supported on columns carried by lions for Pisa Cathedral. (The pulpit was moved to Cagliari Cathedral, where it was reassembled in 1312, and remade as two pulpits in 1670.) Nicola's freestanding pulpit differs from Guglielmo's because of its hexagonal shape and the more monumental figures. Individual units of Nicola's pulpit are clearly separated from each other (triple red marble columns frame each relief panel of the pulpit), and the function of the units is visually clear (green and red marble supports are distinguished from the predominantly white marble parapet that they support). Nicola's figures furthermore provide visually tangible images to illustrate the readings from the Gospel. The implied movement of Nicola's design would have complemented the priest's words and would have contributed to making the sacred ritual a living drama. Once, the liveliness of the panels was enhanced by the addition of pigments and enamel, particularly to the eyes and hair of the figures and to the background (residual traces of pigment can be seen on the sky of the *Adoration*). Such coloring

would have given the stark-white figures a livelier appearance, especially to those walking around the pulpit and standing close to the projecting knees, elbows, heads, and twinkling stars. Few, if any, other pulpits predating Nicola's were executed with such naturalistic figures. That Nicola was influenced by classical style and motif is evident in the classical pediment and in the reclining Virgin of the *Nativity* and in a figure personifying the cardinal virtue Fortitude; their poses resemble two figures (Phaedra and Hippolytus) on a Roman sarcophagus at Pisa, which was later to become the coffin of Countess Beatrice.

ca. 1261 — Nicola completes relief panels (begun around 1258) for the left-hand facade portal of Lucca Cathedral (S. Martino).

ca. 1264 — In Bologna, for S. Domenico Maggiore, Nicola designs a tomb for the corpse of S. Dominic (*Arca di S. Domenico*), who had died in Bologna (see Duecento History Notes 1234).

1265 — Nicola signs a contract (29 September) to execute an octagonal pulpit for Siena Cathedral (completed 1268). Among the assistants working with him were his son Giovanni (see Giovanni Pisano) and Arnolfo di Cambio.

1273 — In Pistoia, Nicola is working on a font for the Church of S. Giovanni Fuorcivitas.

1278 — In Perugia, Nicola completes work on the Fontana Maggiore (great fountain), which is outdoors in the main piazza and in front of the town hall.

1284 — Nicola dies sometime before this year. His son Giovanni continues to work as a sculptor, receiving contracts as significant as Nicola's had been.

Giovanni Pisano

Nicola Pisano's son and brightest pupil, Giovanni (late 1240s–by 1319), continued the family tradition, but created forms that more openly imitated French court art, which became fashionable in Naples at the Angevin court of Charles of Anjou (Charles I), the king of Naples (1265–85) and of Sicily (1265–82). Tuscan painters were influenced by both father and son sculptors. Florentines, like Giotto, found sources in Nicola Pisano's classically inspired, stately patricians. The Sienese, Duccio and Simone Martini, were inspired by Giovanni's elegant and expressive statues (see fig. 8–1) and by his richly detailed narrative reliefs.

late 1240s — Giovanni is born in Pisa.

1265 — By this date, Giovanni is a skilled assistant of his father, for whom he is working on the octagonal pulpit (completed 1268) for the Siena Duomo. During this period, Giovanni became familiar with the style of Arnolfo di Cambio, who also worked with Nicola. The Siena pulpit is much more complex than the one in Pisa, and the lively naturalism is surely indebted to French sculpture.

1278 — An inscription on the Fontana Maggiore in Perugia names Giovanni (and his father) as sculptors of the great fountain.

1284 — Nicola dies sometime before 1284.

1285 — By 1285, Giovanni is awarded citizenship in Siena, granting him immunity from taxation, and he thus renounces his Pisan citizenship.

1287 — In a document of the board of works of Siena Cathedral, Giovanni is called the *capomaestro* (headmaster). Many sculptures destined for the facade are attributed to him on stylistic grounds, and dated between 1284 and 1299 (see fig. 8–3). From 1295, Giovanni accepted work outside Siena, which he permanently left in 1299, after having been severely criticized by the General Council in 1297 because the cathedral facade was still incomplete.

8–1. GIOVANNI PISANO. Pulpit, ca. 1297–1301, marble, S. Andrea, Pistoia. The position of two lions and Atlas (or Adam) at the base were perhaps changed when the pulpit was moved (1600s) from its original position beside the nave column in the second bay from the altar (south side) to its present position between columns of the third and fourth bays (north side). Lecterns were likely placed above the columns with the lions: one between the panels of *Crucifixion* and *Last Judgment* (for reading the Epistles) and the other between *Adoration of the Magi* and *Massacre of the Innocents* (for the Gospels). Shown here are the *Massacre* and *Crucifixion* panels.

1301 — For S. Andrea in Pistoia, Giovanni completes a polygonal pulpit (see fig. 8–1). On the fascia (beneath the narrative panels) is an inscription recording the completion date and the names of the patron (Arnoldus), the administrators (Andrea Vitello and Tino di Vitale), and the artist. The inscription also notes that Giovanni was born in Pisa, the son of Nicola, and that he had achieved greater skill

8-2. Facade, Siena Duomo (cathedral), 1226–1382. The Duomo replaced a smaller church on this site, consecrated to the Virgin's Assumption and enlarged several times. Giovanni Pisano was involved in the construction of the lower facade (1284–99). His marble statues were placed on piers many feet above the pavement. For these figures to be appealing from such height, he designed the heads to angle outward from the bodies, and he polished and deeply undercut the marble to produce strong highlight and heavy shadows that change depending on the sun's position in the sky (see fig. 8–3).

than his father and more mastery than other sculptors. Less compartmentalized than Nicola's Pisa pulpit, the Pistoia pulpit shows a greater interest in lively dramas and excited crowds, and the deeply undercut marble produces stronger contrasts between the highlights and shadows, making it stylistically closer to Nicola's Siena pulpit on which Giovanni worked. However, the Pistoia figures have more sharply angled limbs, twisted forms, and exaggerated gestures, heightening the drama portrayed (this is especially evident in the figures of the *Massacre of the Innocents* panel).

1302 —In Pisa, Giovanni is commissioned to execute a pulpit (completed December 1311) for the cathedral, which is much larger than his father's pulpit for the baptistery (see fig. 7–1).

ca. 1305 — Giovanni executes marble statues, *Madonna and Child* and two *Angels*, for the altar of Enrico Scrovegni's palace chapel in Padua (see Giotto).

1312 —Henry of Luxemburg (crowned Emperor Henry VII in 1312) commissions a tomb for his wife, Margaret of Luxemburg (d. Genoa, 1311). Giovanni created a tomb for Margaret in S. Francesco di Castelletto in Genoa about 1313. Henry VII also commissioned Giovanni to execute the *Madonna di Arrigo* for the Porta di S. Ranieri in Pisa Cathedral.

ca. 1312 —Giovanni creates a marble sculpture, *Madonna della Cintola* (Holy Girdle, or Belt), for Prato Cathedral, where the belt was housed.

1319 —Giovanni dies sometime before this year.

8–3. GIOVANNI PISANO. *Prophets*, ca. 1284–99, marble, each about 5′11″ (180 cm), from the facade of Siena Cathedral (since 1965, Museo dell'Opera del Duomo, Siena) (see fig. 8–2). The nearest prophet has an animated, lifelike quality due to the stretching and craning of his body (his neck seems to spring almost ninety degrees forward from his bowed shoulders). Claw-like hands call attention to his scroll, reminding worshippers of Old Testament prophecies, which he seems to be uttering, as he stares with furious, excited eyes. Donatello's prophets (ca. 1415–36) for the Florence Campanile reflect his study of Giovanni's sculptures.

Trecento Italian Art Part Two

influenced subsequent developments in Tuscan and Umbrian art.

The rising number of 14ᵀᴴ–century patrons who sought religious art for private and public places included (besides the individual patron) the communes and devotional and professional groups who hired artists to create images of the holy figures to whom they were especially devoted (patron saints). The character of this type of patronage becomes clear in studying Simone Martini's *Maestà* for the Siena town hall (see fig. 13–1), the Marian altarpieces of the Lorenzetti brothers for Siena Cathedral (see figs. 14–2, 14–3), and Andrea di Cione's great marble tabernacle that enshrines a miraculous image in Orsanmichele, Florence (see figs. 15–1, 15–2). In this period, visual personifications of Virtues and Vices as exemplars of moral and immoral behavior were meant to instruct society. Committing deadly sins was unforgivable by the Church, and the intention of inserting images of vices in such scenes as Giotto's *Last Judgment* (Scrovegni Chapel, Padua) was to forewarn individuals and show the punishment of an inevitable and eternal damnation that awaited the guilty. For the well-being of the commune, sculptural images of Virtues were placed in public areas such as the baptistery doors (see fig. 9–1) and cathedral bell tower (campanile) of Florence (see figs. 10–1 to 10–3 and 10–5 to 10–8). Because Virtues and Vices figure prominently in the succeeding parts of the book, an analysis of the attributes commonly tied to them is included in

Siena, a commune that grew prosperous through trade and banking, dominated the surrounding countryside long before Florence became a preeminent force in Tuscany. Siena reached her prime in the first half of the 14ᵀᴴ century, and although she never completely recovered from the devastating plague of 1348 in which one-third of the population died, the city produced painters like Duccio, Simone Martini, and the Lorenzetti brothers, who

II-1. View of the Palazzo Pubblico (town hall), Siena (see figs. II-4, II-5, 14-1). A strong magnate base merged with new merchant money in 13ᵀᴴ–c. Siena, and the oligarchy that ruled Siena was more sympathetic to the emperor and Ghibelline causes than were the priors of Florence (who were mostly Guelf supporters of the pope by the 14ᵀᴴ c.). Unlike the Florentines, the Sienese were far more receptive to the notion and display of aristocratic courtly life, which partly explains their fascination with French art and their decision to make the Virgin Mary the Queen of Siena (see Duccio). Siena rises about 1056 feet above a rolling, verdant countryside renowned for its plentiful orchards and productive vineyards (see fig. II-6). Since its settlement as an Etruscan (2ᴺᴰ c. BCE) and Roman colony, citizens, farmers, merchants, pilgrims, and visitors to Siena have approached the fortified town by slowly ascending spiraling roads carved around the steep, mineral-rich hills. As Ambrogio was painting the frescoes in the Palazzo Pubblico (see figs. II-2, II-3), the campanile had just been completed and a new bell was hung in 1348. Called the *Mangia*, it was rung to announce a council meeting.

Sala della Pace, Palazzo Pubblico, Siena

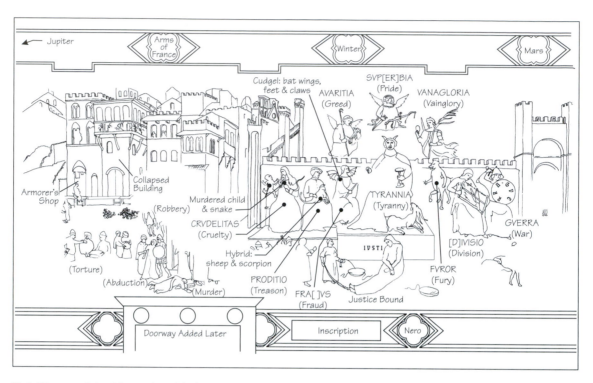

II–2. Diagram of the right portion of Ambrogio Lorenzetti's *Allegory of War* (for the location of this wall, see the ground plan of the town hall illustrated in fig. II–4). In the central (the oldest) section of the town hall is the Sala del Mappamondo (Great Council Chamber) with Simone Martini's *Maestà* on the end wall (see fig. 13–1). Next door in the Sala della Pace are Ambrogio Lorenzetti's frescoes, which were commissioned by the governors of Siena in 1338. The secular allegories (see also fig. II–3) complement Simone's *Maestà* in the Great Council Chamber, where the Virgin and Child are shown attended by saints and angels. In the Sala della Pace an enthroned Zeus-like personification of Siena as *Buon Comune* (Good Government) is seated above the twin sons of Remus and attended by his court of Virtues (see fig. II–3). Facing in the direction of the Virgin in the adjoining room is Tyranny, the antithesis of *Buon Comune*. This figure wears armor beneath his cloak and has horns like a devil and tusks like a wild boar. In his hands are deadly weapons: a dagger (partly visible) and a chalice of poison. The Vices of Tyranny emphasize particular faults that threaten the peace and prosperity of a healthy commune. Beneath Tyranny is an image of a bedraggled Justice, whose hands and feet are bound. Her scales have been broken apart and the cords are severed. An inscription in the border below Justice describes a warring city ruled by Tyranny and torn apart by fury, cruelty, fraud, and treason. ("There, where Justice is bound, no one is ever in accord for the Common Good, nor pulls the cord [of concord, shown in the Allegory of Good Government] straight; therefore, it is fitting that Tyranny prevails. She [he], in order to carry out her [his] iniquity, neither wills nor acts in disaccord with the filthy nature of the Vices, who are shown here conjoined with her [him]. She [he] banishes those who are ready to do good and calls around herself [himself] every evil schemer. She [he] always protects the assailant, the robber, and those who hate peace, so that her [his] every laud lies waste.")

the glossary and in these pages devoted to the Sala della Pace in the Siena town hall (see figs. II–2 to II–4). While most sacred imagery was generally concerned with the patron's hope of redemption for family, ancestors, and heirs, civic imagery was generally focused upon the positive rewards that could be gleaned from good communal government. The image of Justice was displayed prominently.

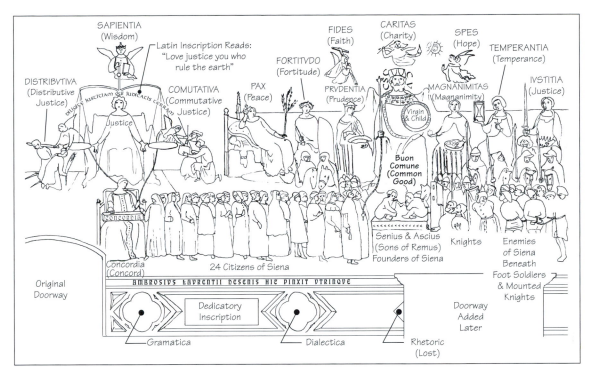

SAPIENTIA (Wisdom)

Latin Inscription Reads: "Love justice you who rule the earth"

DISTRIBVTIVA (Distributive Justice)

COMUTATIVA (Commutative Justice)

Justice

PAX (Peace)

FORTITVDO (Fortitude)

FIDES (Faith)

CARITAS (Charity)

PRVDENTIA (Prudence)

SPES (Hope)

TEMPERANTIA (Temperance)

MAGNANIMITAS (Magnanimity)

IVSTITIA (Justice)

Virgin & Child

Buon Comune (Common Good)

Concordia (Concord)

24 Citizens of Siena

Senius & Ascius (Sons of Remus) Founders of Siena

Knights

Enemies of Siena Beneath Foot Soldiers & Mounted Knights

Original Doorway

AMBROSIVS LAVRENTII DESENIS HIC PINXIT VTRINQVE

Dedicatory Inscription

Doorway Added Later

Gramatica

Dialectica

Rhetoric (Lost)

II–3. Diagram of the *Allegory of Good Government*, north wall, Sala della Pace (Peace), Palazzo Pubblico, Siena (see fig. II–4). An inscription beneath a double file of citizens identifies Ambrogio Lorenzetti as the Sienese painter of the fresco: AMBROSIVS LAVRENTII DESENIS HIC PINXIT VTRINQVE, who was hired to decorate the room. The door (left) originally led to the palace apartments of the Nine (executive board of nine citizens, the chief governing body that represented a council of about 300 citizens). They deliberated in the Sala della Pace. The dedicatory inscription on this north wall suggests the importance assigned to virtuous leadership where justice presides. ("Wherever this holy virtue [Justice] rules, she induces to unity the many souls [of citizens], and these—gathered together for such a purpose—make the Common Good their master [Lord]. In order to govern his state, he chooses never to keep his eyes turned from the splendorous faces of the virtues who sit around him. Thus, taxes, tributes, and lordships of towns are offered to him in triumph. For without war, every civil result duly follows—useful, necessary, and pleasurable.") The largest figure pictured on this wall symbolizes both *Buon Comune* (Common Good) and Siena because around his head are the initials CSC CV, which stand for COMUNE SENARUM CIVITAS VIRGINIS (Commune of Siena, the City of the Virgin) and inscribed on his shield are the words of the city seal (the Virgin protects Siena, which she has long marked for favor).

Allegory of Peace

Sala della Pace

Allegory of War

Allegory of Good Government

Original Entrance

Simone Martini's Maestà

Sala del Mappamondo (Great Council Chamber)

Sala della Pace

Wing of the Podestà

Chapel of the Nine

Campo

II–4. Ground plan (2ND floor), Palazzo Pubblico, Siena (built ca. 1284–1310).

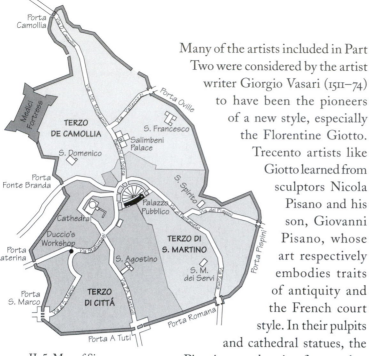

II–5. Map of Siena. Siena is divided by three prominent hill ridges, which naturally separate the town into three districts: the Camollia, Città (oldest and wealthiest), and S. Martino. Each has a *gonfaloniere maestro* (head administrator) and is subdivided into contrade (districts). Fourteenth–century Siena had 42 contrade, but these were reduced to 23 (16ᵀᴴ c.), and then to the present 17 (in 1675). When, after an 18-month siege (1554–55), the Florentine Duke Cosimo I conquered Siena, he had a fortress built at the edge of town. Florence stifled Siena by stopping all new construction and halting the prosperous Sienese banking and cloth trade.

Many of the artists included in Part Two were considered by the artist writer Giorgio Vasari (1511–74) to have been the pioneers of a new style, especially the Florentine Giotto. Trecento artists like Giotto learned from sculptors Nicola Pisano and his son, Giovanni Pisano, whose art respectively embodies traits of antiquity and the French court style. In their pulpits and cathedral statues, the Pisani created active figures that seem to perform dramas carried out expressly for worshippers. Among the most significant artists to succeed these two sculptors were two painter brothers, Ambrogio and Pietro Lorenzetti. Firmly rooted in the style and technique of their Sienese painter ancestors Duccio and Simone Martini, who created a graceful and fluid art that generally favored the French courtly style, the Lorenzetti brothers also valued the type of drama displayed in Giotto's weighty, and sometimes ponderous forms. With their keen sensitivity toward nature, the brothers forged pathways the Florentines and Sienese had but barely fathomed, and their contribution to sacred and secular art has yet to be fully appreciated. Unfortunately, the careers of both brothers were likely short-

ened by the raging Black Death, which reduced most Tuscan towns to half their population (see Trecento History Notes 1348). Almost no survey book does justice to the artists of the late–14ᵀᴴ c., those who followed the Lorenzetti. These artists are usually thought of as having lesser talent. Andrea di Cione and Agnolo Gaddi should never comfortably be considered in this light. Giotto's and the Lorenzetti's rich legacy were well understood by these Florentines, and Andrea di Cione's grand tabernacle in Orsanmichele and Agnolo's ceremonial frescoes for the high altar chapel of Santa Croce (see figs. 16–1, 16–2, 16–4) should always be included in the context of early Renaissance art as it was defined by the artists who preceded them, and are represented in Parts One and Two of this book.

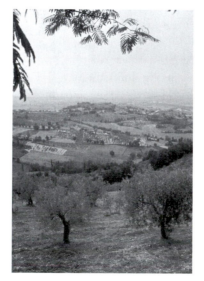

II–6. Hillside near Siena. Proceeds from orchards and vineyards were vital to the Sienese economy and a chief reason the imagery of Ambrogio Lorenzetti in the Sala della Pace lavishes attention on depicting a fertile countryside, dotted with busy workers. The depictions of the rolling countryside of Siena in the paintings of the Lorenzetti show that an interest in the natural world was gaining some momentum during their time. In the first quarter of the 15ᵀᴴ c., Florentine artists studied works by the Lorenzetti that embodied ideas associated with antiquity (the depiction of natural phenomena and human pathos). Masaccio and Donatello were particularly sensitive to Ambrogio's statuesque figures and panoramic landscapes and to Pietro's complex perspectival studies and use of bold gestures and confrontational actions to express dramatic moments.

Last Judgment, Orvieto Cathedral

Among frequently commissioned religious themes in Duecento and Trecento Italy is the second coming of Christ, who returns to judge the living and the dead. In these Last Judgment images Christ is depicted as the Pantocrator (sovereign judge), distinguished from all other figures by his size and the glory that surrounds him. Often this scene is part of a series of events portrayed on panels and executed in small scale. In churches the theme was sometimes executed in large scale and on a west wall, as in the Florence Baptistery and Scrovegni Chapel (see figs. 3–2, II–3). The only Gospel writer to describe the event is Matthew. In his account, Christ will return, "And he will send out his angels with a loud trumpet call, and they will gather his elect from the four winds, from one end of heaven to the other" (Mt 24:31). No one knows exactly when he will return, "neither the angels of heaven, nor the Son, but only the Father" (Mt 24:36). However, upon his return, he will resurrect the dead, and judge the dead and the living, consigning each person to eternal life in the kingdom of heaven or to eternal torment by the devil and his demons in hell (Mt 25:31–46). "When the Son of Man comes in his glory, and all the angels with him, then he will sit on the throne of his glory. All the nations will be gathered before him, and he will separate people one from another as a shepherd separates the sheep from the goats, and he will put the sheep on his right hand and the goats at the left" (Mt 25:31–33). In the Scrovegni Chapel, Giotto lavished attention on the hell scene, showing a chaotic region, inventive and overflowing with physical tortures. Heaven was typically shown with static order and serenity, however, as it appears in Maitani's marble relief (see fig. II–7). According to Matthew, Christ told the twelve apostles they would sit on thrones with him at the judgment (Mt 19:28). Giotto depicted them in a semicircular arrangement, as did Maitani in his Orvieto relief. In many places Maitani depicted the elect kneeling and gazing upwards with hands raised in prayer, gestures associated with the Virtue Hope (see fig. 10–2). Luca Signorelli would enliven both realms, thus inspiring Michelangelo's *Last Judgment* in the Sistine Chapel (see fig. 51–13).

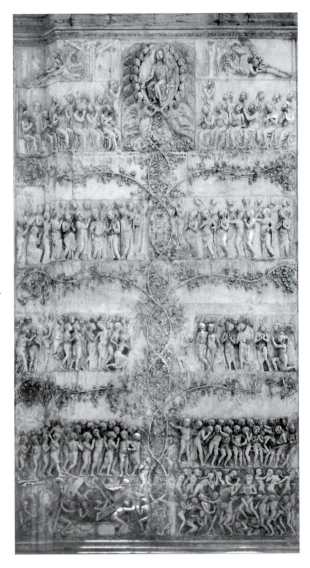

II–7. LORENZO MAITANI. *Last Judgment*, ca. 1310–30, marble, facade (pier to the right of the southwest door), Orvieto Cathedral. At the top of this giant relief is Christ sitting in judgment in a mandorla that angels support, with the Virgin (left) and John the Baptist (right) interceding for humanity, while angels blow trumpets (upper corners). At the top of the panel, beside the angels and flanking Christ, the instruments of the Passion are depicted (cross, lance, crown of thorns, scourges) (see INSTRUMENTS OF CHRIST'S PASSION, Trecento Glossary). The elect appear in flanks beneath Christ, and at the bottom of the frieze the dead rise from tombs (left) and the damned are driven into Hell (right).

Kingdoms and Political Powers in Trecento Italy

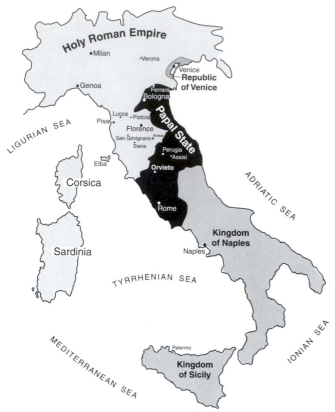

II–8. This map shows the division of kingdoms and political powers in early–14ᵀᴴ–c. Italy (Orvieto is part of the Papal State). The division of territories changed in the 15ᵀᴴ c., with Venice gaining territory on the mainland (see fig. 18–8).

Thirteenth–century Italian cities were divided between those who supported the papacy (Guelphs), and those who supported the Empire (Ghibellines). An alliance with the papacy and the Angevin kings of Naples provided Florence the political and military strength to control Tuscany in the late–13ᵀᴴ century. However, after the Guelphs had achieved a secure hold over Florence, internal strife split the party into feuding factions called the Blacks and Whites. As a White, Dante was exiled from Florence in 1302 (see Trecento History Notes 1306). The Papal State (the *patrimonium* of S. Peter) came under the direct secular control of the pope (see PAPAL STATE, Quattrocento Glossary). The original territory included Rome and the surrounding countryside (see fig. II–8). Pepin the Great (754) allowed the papacy to claim the former exarchate of Ravenna, and through gift, purchase, and conquest, land in Umbria, Marches, Emilia, and Romagna was absorbed into the Papal State. From the 11ᵀᴴ to the early–16ᵀᴴ century, the borders and governance of the territory were fiercely challenged. Umbrian towns in the middle of this tract, although more provincial than free Tuscan communes, prospered from local industry and venerated shrines, like that of the sacred corporal at Orvieto (see Duecento History Notes 1263 and fig. II–9).

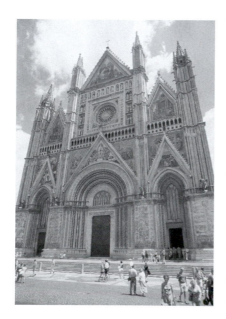

II–9. Facade (west side), Orvieto Cathedral, begun 1290 (facade finished 17ᵀᴴ c.). The cathedral was first based on a Romanesque design that became Gothic (pointed arches) under Lorenzo Maitani (*capomaestro* in 1310). Among the artists in charge of the early building phases were Andrea Pisano (ca. 1347–48), Andrea Pisano's son, Nino (1349), and Orcagna (1359). The marble reliefs of the facade were based on Maitani's design and begun ca. 1320; they depict the biblical history of humans, with scenes of creation, stories of Abraham and David, stories of the Life of Christ, and the Last Judgment, Hell, and Paradise (see fig. II–7). The splendid Gothic building resembles a giant reliquary, and was perhaps meant to appear as it does because it houses the precious relic of the miracle at Bolsena (in 1263), the corporal (linen cloth) on which the Host miraculously bled (see Duecento History Notes 1263). Pope Julius II stopped here (1506) to venerate the holy cloth in the Chapel of the Corporal. Directly opposite this chapel is the chapel with Luca Signorelli's murals to which his posthumous fame became inextricably linked. In four large lunettes Luca portrayed the individual scenes that appear combined on the southwest pier of the church (see fig. 41–4).

1300 JUBILEE YEAR. Pope Boniface VIII inaugurates the first papal Jubilee in Rome, granting indulgences to pilgrims visiting holy shrines.

MEDITATIONS ON THE LIFE OF CHRIST. About this time, the Franciscan Bonaventure (d. 1274) is credited with writing this book, which became a source for devotional imagery (see Duecento Glossary).

1304 BIRTH OF PETRARCA. Francesco Petrarca (Petrarch) is born in Arezzo (see entry 1341). Eight years later, his exiled Florentine father moved to Avignon where he became a notary.

1306 THE DIVINE COMEDY. Exiled from Florence (1302) Dante Alighieri (1265–1321) lives in northern Italy, where he begins *Commedia* (later called *Divina commedia*), with three parts: *Inferno* (Hell), *Purgatorio* (Purgatory), and *Paradiso* (Paradise). Dante dedicated *Commedia* to his patron Cangrande della Scala (see fig. 1–3).

1307 IMPRISONMENT OF KNIGHTS OF THE TEMPLE (THE TEMPLARS). Philip IV of France imprisons the grand master and members of the Templars, who were then tortured into confessing blasphemy and devil worship on 13 October. The Templars had been founded in Jerusalem as the Poor Knights of Christ in 1119.

1309 PAPACY IN AVIGNON. Pope Clement V had intended, it seems, to move the curia back to Rome but instead stayed in France, accepting the recommendation of the French king (Philip IV) that the curia reside in the town of Avignon. Because Avignon belonged not to France but to the Angevin kings of Naples, who were vassals of the Holy See, a temporary relocation there was reasonable. However, the curia remained in Avignon until 1378.

KNIGHTS OF S. JOHN OF RHODES. The Knights of S. John of Jerusalem (the Hospitalers) move from Cyprus to Rhodes and become the Knights of S. John of Rhodes. Following the Rule of S. Augustine, they were the oldest (founded in 1095) of three military orders connected with the Latin Church in the Holy Land (the Hospitalers received papal approval of their order in 1113). Although linked to the hospital of S. John in Jerusalem, the order had become chiefly military by 1200, when charged with defending the Latin Kingdom of Jerusalem against infidels.

1312 SUPPRESSION OF THE TEMPLARS. Clement V suppresses the Templars (Order of the Knights of the Temple). Members were executed, and the order's assets were to be redistributed to the Knights of S. John

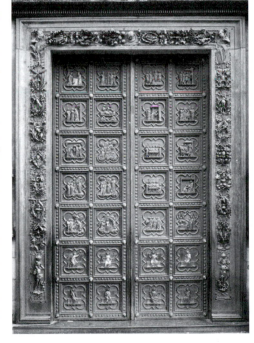

9–1. ANDREA PISANO. *Scenes of John the Baptist*, 1330–36, gilded bronze, 15'11.4" x 9'2.4" (480 x 280 cm), south portal of the Baptistery of S. Giovanni, Florence (see fig. 2–3). Originally on the east side, the doors were moved ca. 1425 to make way for Ghiberti's first bronze doors (see entry 1330). Inside the quatrefoil frames are stories of John the Baptist (upper five rows), patron saint of Florence and the saint to whom baptisteries are dedicated, and personifications of eight Virtues (bottom two rows).

9–2. Doge's Palace, Venice, 1340–1438 (the south wing shown here was begun in 1341; continuation of the building along the side facing the Piazzetta dates to 1424). This is the town hall in Venice, which was the palace of the doge (duke), who was elected for life to head the government; its construction was paid for by the government. Behind the palace (north side) is the doge's chapel, the five-domed church of San Marco. It was built by the government to house the body of the second (the first was Theodore) patron saint of Venice, the Evangelist Mark (his body was stolen from Alexandria and brought to Venice about 829). In contrast to contemporary Italian town halls, this building has the look of an airy and elegant Gothic palace rather than of a rusticated stone fortress, common for town halls in the city-states of Tuscany. A winged lion, the symbol of S. Mark, became the emblem of Venice, images of which appear many places throughout the Doge's Palace. Poised on a colossal column in the piazzetta, a giant antique bronze lion greets visitors arriving from the sea.

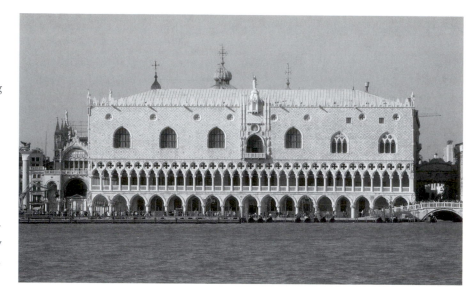

of Jerusalem (the Hospitalers). However, in France and England the knights' assets were confiscated by the ruling monarchs.

1323 **MEMBERSHIP IN GREAT COUNCIL OF VENICE DECLARED HEREDITARY.** The highest council in Venice is officially limited in its membership to the heirs of nobles.

1325 **MIRROR OF HUMAN SALVATION.** *Speculum humanae salvationis* (Mirror of Human Salvation), published by 1325, is filled with miniatures accompanied by explanatory text; the book focuses on the TYPOLOGY of the Bible (see Duecento Glossary). By 1500, several hundred copies of the work appeared in German, French, English, and Dutch translations.

1330 **BRONZE DOORS ON FLORENCE BAPTISTERY.** A foreigner from Pisa designs and casts gilded bronze doors for the main (east) portal of Florence Baptistery, with imagery honoring the patron saint of Florence. No Florentine artist then had the expertise to create such a large bronze project. However, in the following century, Florentine Lorenzo Ghiberti created two sets of doors in bronze for the baptistery, the last fully gilded.

1337 **HUNDRED YEARS' WAR.** The Hundred Years' War (1337–1453), comprising many battles and truces between France and England, begins. The war concerned ascension to the French crown and possession of French territories.

1341 **PETRARCH CROWNED POET LAUREATE AT ROME.** The senate crowns Petrarch (1304–74) poet laureate at the Capitoline Hill. Petrarch recovered many classical works and became a forerunner of the humanist movement.

1346 **FLORENTINE BANKS CRASH.** The Bardi and Peruzzi banking houses lent money to Edward III (king of England) to finance the war against Philip IV (king of France) in what is called the Hundred Years' War. In 1339 when Edward was unable to repay his debts and customers withdrew their money, the bank-

ing companies failed. The Peruzzi and Bardi had bank branches as far away as Spain, North Africa, and Jerusalem. According to Giovanni Villani (*Cronica* 12:55), they controlled much of Europe's trade, and their failure caused the discredit of many other businesses. Between 1338 and 1346 about three hundred manufacturers, bankers, and merchants went bankrupt.

1348 THE BLACK DEATH. In the most severe epidemic of the bubonic plague and in the recurrent epidemics, 35 to 65% of the Italian population perished. Florence and other Tuscan towns were economically more prosperous before the plague years that wiped out many peasant laborers. Unable to attend to individual deaths, towns dug mass graves during the epidemic of the bubonic plague. The population in Florence, about 95,000 in 1338, was decreased to 40,000 in 1427.

AVIGNON PURCHASED BY PAPACY. Pope Clement VI entrenches the papacy in Avignon, purchasing the city from Queen Joanna I of Naples. He also enlarged the palace of the pope in Avignon.

1350 JUBILEE YEAR. Pope Clement VI sanctions the celebration of Jubilee years in Rome at intervals of 50 rather than 100 years. Pilgrims who visit holy shrines in Rome are granted indulgences.

BOCCACCIO WRITES DECAMERON. A renowned poet and humanist, the Florentine Giovanni Boccaccio (1313–75), owes his enduring fame primarily to his prose, and he has been called the greatest Italian storyteller. In his *Il Decamerone* (The Decameron) Boccaccio comments about the dire situation of hundreds of corpses stacked upon each other, filling vast grave pits during the plague years.

1370 BRIDGETTINE ORDER APPROVED. The Swedish noblewoman Bridget (1303–73) founded the order about 1346. From childhood, Bridget had visions about Christ's life that would become famous. Her vision of the Virgin praying before the newborn Child, whose naked

9–3. Campo, Siena. This view into the main square of Siena shows the Palazzo Pubblico (town hall) with its tower (see figs. II–1, 14–1). The Campo slopes upward from the palace and was paved with brickwork (ca. 1327–49) divided into nine sections resembling a fan, and alluding to good government under the Nine, the priors who lived in the palace while they held public office.

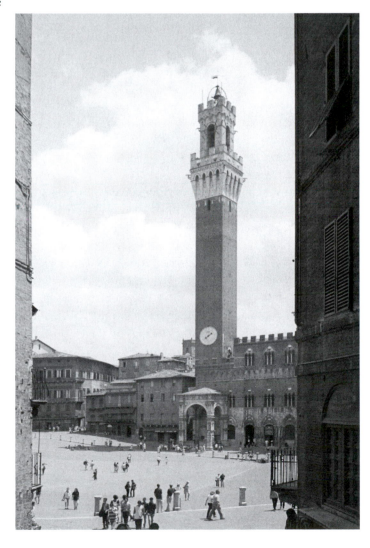

9–4. S. Francesco, Assisi. In 1228 Francis of Assisi (d. 1226) was canonized. To honor the occasion, Pope Gregory IX founded the mother church of the Franciscan Order, a grand monument of two superimposed churches, whose foundations were dug into the rock of a steep hillside in Assisi. The lower basilica, which supports the upper, is like a giant crypt, with its high altar rising over S. Francis's grave. In 1253 Pope Innocent IV consecrated the double basilica, and under Pope Nicholas IV (Master General of the Franciscan Order) S. Francesco became a papal church (1288). A flurry of fresco decoration in chapels and on the walls of both basilicas followed. However, work was nearly halted when Ghibelline (imperial) troops captured Assisi (1319–21) and stole the papal treasury. In 1322 Guelph Perugia recaptured Assisi, but a papal interdict was imposed (1321–59), with brief suspensions, until the papal treasury was recovered. Decoration of both basilicas was largely completed by 1325—after the papacy took up residency in Avignon (1309) but before the bubonic plague (Black Death) of ca. 1348.

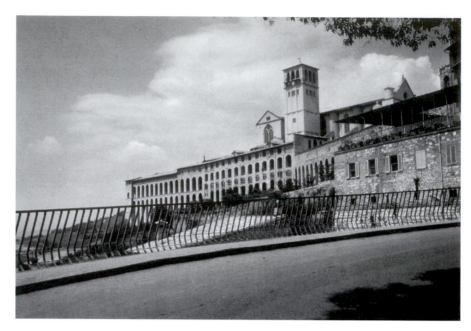

body is surrounded by bright light, influenced the iconography of Nativity scenes. Bridget was canonized in 1391.

1372 FEAST OF THE PRESENTATION OF THE VIRGIN. The feast is instituted in the Latin Church.

1378 THE GREAT SCHISM BEGINS. Shortly after his election, Pope Urban VI seems to have gone mad and was overcome by bouts of irrational behavior. Another man was elected pope, marking the beginning of the Great Schism (division), with more than one man claiming to be the rightful pope.

1385 WAR OF CHIOGGIA. Defeating her rival Genoa at Chioggia, Venice now fully controlled trade on the Mediterranean.

1386 VENICE ACQUIRES CORFU. Enjoying Aegean conquests in the 13TH and 14TH centuries, Venice turned to the mainland in the 15TH c., conquering towns in northern Italy.

1387 FEAST OF THE VISITATION. Pope Urban VI introduces the Feast of the Visitation into the Latin Church. Franciscans had first celebrated the event in 1263.

1390 IL LIBRO DELL'ARTE. About this year, Cennino d'Andrea Cennini dedicates his painting manual to saints and to the memory of painters, Giotto and Taddeo and Agnolo Gaddi (father and son).

1396 MANUEL CHRYSOLARAS IN ITALY. The Greek humanist and scholar Chrysolaras introduces Greek into the curriculum in Florence.

1397 MEDICI BANK FOUNDED. Giovanni di Bicci de' Medici founds the family bank in Florence. Giovanni's banking business was modeled after the Florentine Peruzzi and Bardi houses. His son Cosimo would come to control branches of the family bank in London, Bruges, Lyons, Geneva, Avignon, Milan, Venice, and Rome, and would finance popes and nobles.

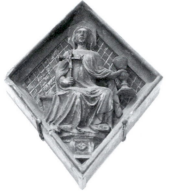

10–1, 10–2, and 10–3. FOLLOWER OF ANDREA PISANO. *Faith* (left), *Hope* (center), and *Charity* (right), ca. 1345, marble in high relief on a background of diamond-shaped blue majolica, 2'1.3" x 2'.8" (87 x 63 cm), each from the second level, south wall of the Florence Campanile (since 1965, Museo dell'Opera del Duomo, Florence). The figures of these reliefs depict the three theological virtues (virtues are given hexagonal halos rather than circular ones). *Faith* holds a crucifix close to her heart and, with her other hand, extends an enormous chalice, which refers to the sacrament of the Eucharist (see fig. 2–12). *Hope* is a winged, praying woman. Suspended at the apex of the lozenge is a crown, referring to eternal salvation. *Charity* is given a cornucopia and a heart. She is given a prominent position on the south side of the Florence Campanile. According to the Scriptures, love (charity) is the greatest virtue. These reliefs were meant to inspire wealthy Florentines to perform good deeds and charitable acts.

In the Trecento, power struggles between church and state that began in the Duecento escalated. Knowing the outcome of issues that set the pope against the emperor and the royal house of France—a fight concerning the control of secular and religious matters—is fundamental for an understanding of this period. When secular rulers openly challenged the Church, and the papacy was quasi-garrisoned for many years at Avignon, the Church became too weak to avoid the Great Schism during which multiple popes claimed to be the rightful leader of the Roman Catholic world. These fissures in the Latin Church weakened the notion of papal infallibility. Nevertheless, the greatest leveler of the century was the bubonic plague (Black Death) that reduced most towns by at least half their total population. Towns became unhealthy places to live, the breeding grounds of pestilence, and human values were tested by the uncontrollable forces of famine and disease. The call for visual imagery pleading for spiritual interces-

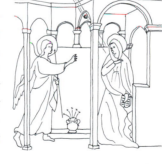

10–4. Line drawing after Duccio's *Annunciation*, *Maestà*, Siena Cathedral (see fig. 12–2). In Italian art Gabriel usually appears before Mary inside her house or under a loggia, as can be seen here. Occasionally, the meeting occurs in a church (especially in Northern art). By the 15TH century, the Virgin was commonly depicted in her bedroom or in an antechamber near her bedroom. Approaching from the left, Gabriel may carry a scepter and stand as he greets Mary, but often is shown kneeling before her. White lilies are carried by the archangel or they appear nearby in a vase, symbolizing Mary's purity. In Sienese art Gabriel may hold an olive branch (Simone Martini's *Annunciation*, 1333, Uffizi Gallery, Florence). Mary is often kneeling in prayer, or sitting (or standing, as here) with a book opened on a lectern or in her lap. Even when the book is closed, her finger usually marks a page, suggesting that she was reading prophetic passages foretelling the Virgin birth, such as the words of Isaiah, "Behold a Virgin shall conceive" (Is 7:14). In most scenes the mystery of the Incarnation is shown with a dove (symbolizing the Holy Spirit) flying toward Mary. This is the moment when Mary is overshadowed by the power of God, as the Holy Spirit descends upon her, and golden beams (symbolizing divine light) define a path from God to the dove (see ANNUNCIATION, Trecento Glossary).

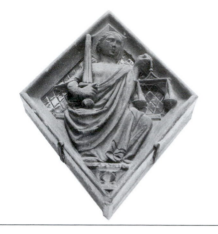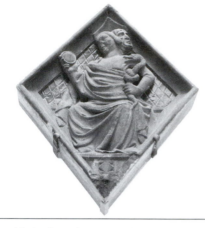

10-5, 10-6. WORKSHOP OF ANDREA PISANO. *Justice* (left) and *Prudence* (right), ca. 1345. (See fig. 10–1 for information on size, materials, and location.)

CARDINAL VIRTUES. Of the four cardinal virtues, justice was thought to be the key to communal harmony and the most important cardinal virtue in the Renaissance. *Justice* appears here (see fig. 10–5) with the sword and scales, symbols that are nearly always present in scenes of the Last Judgment: the archangel Michael holds the scales (a symbol of impartiality) and brandishes a sword (unyielding power). *Prudence* is personified here (see fig. 10–6) as a seated woman with two faces (called a Janus figure). In one hand she has a snake (symbolic of wisdom), and in the other a convex mirror (symbolizing her broad perspective and ability to reflect upon the true appearance of things). The double heads allude to the ability of hindsight and foresight. (Continued on page 45.)

sion thus increased as did the veneration of protector saints. In this period, there was no real separation between church and state and the decoration of such municipal buildings as town halls and market places pertained to Christian ideals, with civic (cardinal) virtues displayed beside the religious (theological) virtues. Throughout the 14TH c., an interest in the discoveries of the pagan world escalated, as poets like Dante and humanists like Petrarch were to take great interest in ancient writers and in the natural world itself. Dante brought respectability to the vernacular (Italian) language, and Petrarch understood better than his predecessors about the historical distance separating antiquity from his own time. Their writings inspired generations of visual artists.

Trecento Europe witnessed not only France and England embarking upon a long, demanding war that eventually destroyed major banking houses in Florence, but also the struggles for domination between Tuscan city-states allied to either the pope (Guelphs) or the emperor (Ghibellines), with Lucca, Pisa, Pistoia, Siena, and Florence in combat with each other. In this period, Venetian galleys triumphed in the Mediterranean, as commercial exchange with the Orient increased. Greek artists and scholars continued to enter Italy in this period, and the movement of art and artists across the Alps, especially after the papal court was

established at Avignon, brought about a broadening of vision to local artists. Venice, Naples, and Milan imported French, German, and Italian artists to carry out state and church commissions, while Florence, but especially Siena, experienced the strengthening of local families of artists who were to undertake the major projects in town: the building and rebuilding and decoration of town halls, churches, campaniles, and baptisteries. The greatest setback for all sectors of society was the Black Death, the outcome of which affected art patronage and the type of works commissioned as well as the way workshops restructured after the loss of master artists.

ANGEVIN — The French House of Anjou (Angevins) played an important part in the history of Naples in the Trecento.

ANNUNCIATION — Among the most frequently depicted images in the Renaissance is the announcement of the birth of the Messiah, which is called the Annunciation. Only one Gospel writer of the Bible, Luke, mentions the story of the archangel Gabriel foretelling the birth of Jesus. According to Luke, six months after John the Baptist was conceived, God sent Gabriel to Nazareth to tell the Virgin Mary (of the house of David), who was engaged to Joseph, that she had been chosen to bear the son of God. The archangel's words provoked several responses from Mary. Gabriel greeted

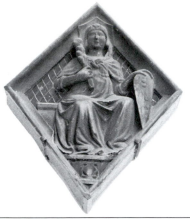

10–7, 10–8. WORKSHOP OF ANDREA PISANO. *Fortitude* (left) and *Temperance* (right), ca. 1345. (See fig. 10–1 for information on size, materials, and location.)

her by saying, AVE MARIA GRATIA PLENA DOMINUS TECUM (Hail Mary, favored one, the Lord is with you). In art these words are frequently inscribed in Latin on Gabriel's scroll, around the borders of Mary's gown, and near the heads of both Gabriel and Mary. Annunciation images are not always alike, although most derive from the sequence of events that Luke described (see fig. 10–4). After Gabriel's salutation to Mary, she was puzzled, "[and] was much perplexed by his words and pondered what sort of greeting this might be. The angel said to her, 'Do not be afraid, Mary, for you have found favor with God. And now, you will conceive in your womb and bear a son, and you will name him Jesus. He will be great, and will be called the Son of the Most High, and the Lord God will give to him the throne of his ancestor David. He will reign over the house of Jacob forever, and of his kingdom there will be no end.' Mary said to the angel, 'How can this be, since I am a virgin?' The angel said to her, 'The Holy Spirit will come upon you, and the power of the Most High will overshadow you; therefore the child to be born will be holy; he will be called Son of God. And now, your relative Elizabeth in her old age has also conceived a son; and this is the sixth month for her who was said to be barren. For nothing will be impossible with God.' Then Mary said, 'Here am I, the servant of the Lord [ECCE ANCILLA DOMINI]; let it be with me according to

your word.' Then the angel departed from her" (Lk 1:29–38). The Annunciation (Feast of the Annunciation, 25 March) was considered a fresh beginning for Christians and was celebrated as the first day of the calendar year in many towns (in Tuscany, until the 18TH c.).

APOCRYPHA — Dated from 200 BCE to 100 CE, these books (about 14) were called apocrypha (Gk. *apokryphos*, hidden) by Greek-speaking Jews of the period because they were thought to have hidden meaning. They are included in Catholic (Old Testament) and Hebrew Bibles, but not in most Protestant Bibles (see BIBLE, Duecento Glossary).

APOCRYPHAL — When the Bible canon was set in the 4TH–century councils of north Africa, some hundred texts by Christian authors, written between the second and fourth centuries, were not included in the canon. Commonly called the Apocryphal New Testament, the forms of these texts (gospels, acts, apocalypses, and letters) are similar to the New Testament canonical books. Some of these apocryphal writings became especially popular because they filled noticeable gaps of information about Mary and Christ in the Bible, and because they embellished Bible stories, providing intrigue and intimacy, especially in the extraordinary tales of Christ's miraculous childhood. The need to learn more about the central figure of Christianity

The cardinal virtue fortitude represents courageous strength. She is often dressed for battle, with a lion (a symbol of courage and strength) emblazoned on her shield. *Fortitude* appears here (see fig. 10–7) with a club and shield, and she wears a lion's skin over her head and around her shoulders, referring to the attire of Hercules. Temperance, the fourth cardinal virtue, connotes balance and moderation in actions and tastes, especially concerning liquor, lust, and warfare. *Temperance* appears here (see fig. 10–8) with two pitchers that refer to moderation in the consumption of (or abstinence from) alcohol, for she pours liquid from one pitcher to another, mixing water with wine (see VIRTUES, Trecento Glossary).

INSTRUMENTS OF CHRIST'S PASSION. Often pictured in devotional images of the Man of Sorrows are the following: (1) thirty pieces of silver, refers to the betrayal of the apostle Judas; (2) seamless robe, lantern, or torch, refers to the night hours when Christ was taken captive; (3) rooster, refers to Peter's denial (three times) of knowing Christ; (4) column, hands tied by ropes, and whips, refer to the scourging, or flagellation, of Christ; (5) crown of thorns, purple robe, and faces spitting, refer to the mocking of Christ; (6) cross, refers to Christ's crucifixion, and in some visual images it is the object around which the other instruments are placed; (7) hammer and nails, refer to the nailing of his body to the cross; (8) lance with vinegar sponge at the end, refers to the sip given to Christ while he was on the cross; (9) spear, refers to the wound in his side, meant to determine if he were still alive; (10) dice, refer to the game soldiers played for his seamless robe; (11) ladder, refers to the way he was lowered from the cross (see PASSION, Trecento Glossary).

and the Mother of God was thus satisfied by two early Christian apocryphal texts in particular: *The Infancy Gospel of Thomas* and *The Infancy Gospel of James* (*Protoevangelion*), called *The Book of James*. These two texts (and the Gospel of Luke) helped shape two apocryphal Latin texts of medieval origin, *The Gospel of the Birth of Mary* and *The Gospel of Pseudo-Matthew* (once attributed to the apostle Matthew).

CAMPANILE — Every church and communal palace (see fig. 14–1) had a bell tower (*campanile*); that of the commune sounded the call to arms or assembly. Many private palaces had tall lookout towers (few remain). All these towers created a distinctive Trecento skyline.

INDULGENCES — Granted by the Church, these can fully or partly remit punishment (penance) of mortal sins.

INTERCESSOR — Saints became personally linked to corporations (see Laudesi, fig. 15–1) and individuals.

LATIN CHURCH FATHERS — In the Latin Church, four early theologians are singled out for their contributions (they are called Church Fathers or Doctors): Ambrose (ca. 339–397), Jerome (ca. 341–420), Augustine of Hippo (354–430), and Pope Gregory the Great (ca. 540–604).

OPERA — The board of works (supervisors of projects) is called the *opera*.

PASSION — Passion (suffering) in Christ's life occurred during the week of his entry to Jerusalem (Palm Sunday), ending with his crucifixion (Good Friday); events that occurred afterward, from his Resurrection, are called Post-Passion.

RELIC — Since the 9TH c., the bodies of saints (any part) and authenticated

objects of saints have been consecrated, enshrined (in reliquaries), and revered.

VICES — According to Augustine of Hippo, sins are thoughts or deeds against God's law (see fig. II–2). Deadly vices are sins that merit eternal damnation, as opposed to venial sins, which are forgivable. Among the first texts to discuss the notion of seven deadly sins was the *Psychomachia* by the early Christian poet, Prudentius (348–405), in which an allegorical battle is fought between the good and evil forces of the human soul. These forces (personified as women) struggle to control the soul. The traditional seven deadly sins are gluttony, sloth, luxury (lust), pride, wrath, envy, and avarice (greed). In addition, the vices of despair, inconstancy, idolatry, injustice, and folly (see fig. II–3), as well as harshness, rebellion, and cowardice are coupled with virtues in visual imagery. In the Trecento, vices were often personified as men, as in Giotto's images of *Folly* and *Injustice* in the Scrovegni Chapel, Padua.

VIRTUES — The Latin Church Father Ambrose selected moral virtues from Plato's *Republic*, attached Christian values to them, and called them the cardinal virtues: justice, prudence, fortitude, and temperance (see figs. II–3, 10–5 to 10–8, 11–4). These are distinct from the theological virtues identified as faith, hope, and love in S. Paul's hymn on Christian love (1 Cor 13:13). Love was equated with charity. Although the theological virtues are given preference over the cardinal virtues, both frequently appear together. In the Trecento, humility (pictured on Andrea Pisano's bronze doors) was considered the source of all virtues. By the Quattrocento, other virtues such as concord, patience, gentleness, purity, and obedience were also extolled; all of these were thought to derive from the cardinal and theological virtues.

In the eyes of the literary giants of his age—Dante, Petrarch, and Boccaccio—Giotto (ca. 1267–1337) had an exceptional talent for depicting the human condition in a way that reminded them of ancient art, and his work visually paralleled their own. About fifty years after Giotto's death, Florentine artists began to ascribe a powerful importance to his legacy, picturing him as the cornerstone of Italian art. Cennino Cennini (*Il libro dell'arte*, ca. 1390) considered Giotto the most skillful artist of all time and credited him with modernizing painting by changing it from Greek (Byzantine) to Latin.

ca. 1267 — Giotto is thought to have been born in Colle di Vespignano (about twelve miles north of Florence), sometime between 1266 and 1270.

1300 — It is thought that Giotto worked in S. Francesco in Assisi before 1300, but this cannot be confirmed by written records.

ca. 1300 — In Florence, Giotto paints a crucifix for the large Dominican church, S. Maria Novella. The *S. Maria Novella Crucifix* would change the way most Florentines depicted the *Christus patiens* type.

About the turn of the century, Giotto was in Rome to paint the Loggia delle Benedizioni in the Lateran Palace for Pope Boniface VIII (Vasari mentions the loggia decoration).

1301 — In Florence (May), Giotto becomes a house owner in the quarter of S. Maria Novella. By this year,

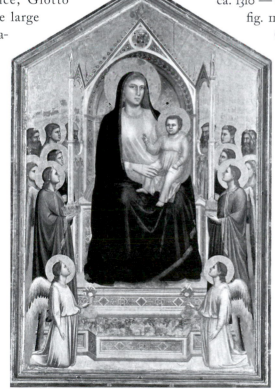

Giotto has married Ciuta, the daughter of the Florentine Lapo del Pela. The couple had four sons and four daughters. About this time it seems that Giotto worked for Franciscans, creating a crucifix (Tempio Malatestiano) and (lost) frescoes for S. Francesco in Rimini.

1303 — Giotto begins working for Enrico degli Scrovegni in Padua, where he creates his renowned masterwork in fresco (see figs. 11–3, 11–4). It is likely that he also executed (lost) frescoes for the chapter house of S. Antonio in Padua. It is thought that these frescoes may have preceded his work for Scrovegni.

1309 — A citizen of Assisi repays a debt that both he and Giotto owed, which may mean that Giotto had been working in the Basilica of S. Francesco. In Padua, Giotto painted frescoes (ca. 1309–12) of the zodiacal signs (destroyed) in the town hall.

ca. 1310 — Giotto paints his *Maestà* (see fig. 11–1) for the main altar of the Ognissanti (All Saints) church in Florence. His work reflects a knowledge of two earlier Maestà images in Florentine churches, Cimabue's (see fig. 4–1) in S. Trinità

11–1. GIOTTO.

Maestà, ca. 1310, tempera on panel, 10'8" x 6'8.1" (325 x 204 cm), Uffizi Gallery, Florence. Giotto learned from sculptors Nicola Pisano and Arnolfo di Cambio how to create a monumental figure, and seamlessly melded the Virgin's multiple roles as *Hodegetria*, Queen of Heaven, Intercessor, and the Throne of Wisdom upon which Christ sits.

In the figure of the Virgin, Giotto created the quintessential intercessor for humankind. Her nearly transparent tunic reveals a fleshy matron, who must have seemed like many of the petitioners who beseeched her help. With ever-watchful eyes fixed upon worshippers standing before her, this Virgin Mary is less remote than Duccio's elegant *Maestà* and more tangibly real than Cimabue's ethereal *Maestà*.

(ca. 1280) and Duccio's in S. Maria Novella (ca. 1285). Vasari judged that Giotto's was the best. A believably three-dimensional setting is created in Giotto's painting, where openings in the sides of Mary's throne, showing the heads and bodies of two men in the background, give the illusion that people surround the structure, and that those in the background are far away from the kneeling angels. Giotto's Virgin Queen—her royalty and chastity are symbolized by the crown and white roses and lilies held by angels—overwhelms her delicate Gothic throne, with its pointed arches and pinnacles. Mary is so large that her size seems to increase while the relative size of attending figures diminishes. Giotto emphasized the human nature of Christ as the Word made flesh by revealing his body beneath his sheer garment, and by the touch of Mary's hand around his leg.

1311 — In Florence, Giotto is called emancipated (legally independent).

1312 — Giotto completes a (lost) panel for S. Domenico in Prato, rents out a loom in Florence, and likely leaves for Rome (1312–13), where he works on the Navicella mosaic in Old S. Peter's. Records show that Cardinal Giacomo Gaetani Stefaneschi paid Giotto (2,200 gold florins) for the Navicella mosaic.

1313 — Giotto is in Florence (until 1315).

1318 — Giotto's son Francesco, as his father's business agent, assigns land to his sister Bice, a member of the third order of the Dominicans.

1320 — In Florence Giotto is inscribed in the Arte dei Medici e Speziali (guild of doctors and pharmacists), the guild that painters joined. He likely begins work on frescoes in the Bardi and Peruzzi chapels. About this time, for Cardinal Stefaneschi, he made one of the largest altarpieces of the time for 800 gold florins: a double-sided painting for Old S. Peter's (Pinacoteca Vaticana, Rome).

1321 — Giotto leases and purchases land in Colle di Vespignano, and records his daughter's dowry there (1326). Such records show his sound business acumen.

1328 — For the next three years, King Robert I of Naples pays Giotto an annual salary, and in 1330 King Robert would call him *familiaris et fidelis noster* (our faithful and familiar friend).

1331 — In Naples Giotto receives payments for a (lost) panel and for frescoes in the Castelnuovo, Naples: the S. Barbara Chapel (fragments) and a cycle (lost) of *Uomini famosi* (Famous Men) in the Great Hall (Sala dei Baroni).

1332 — In Naples (until 1333) Giotto is granted a tax exemption and annual pension from King Robert.

1334 — Giotto is named *capomaestro* (headmaster) of Florence Cathedral and the city architect for the new walls, fortifications, and all other public works. Giotto created a design (Uffizi Gallery, Florence) for the campanile, whose cornerstone is laid on 18 July.

1337 — Giotto returns from Milan, where he was sent by the Florentine government to work for Duke Azzone Visconti. His (lost) work in the ducal palace has been described as a fresco depicting worldly glory. Giotto dies in Florence (8 January). Around 1340 Giovanni Villani recorded that Giotto was buried "with great honors" at the commune's expense in the Duomo (*Cronica* 11:12), which, at the time, was an unusually important homage for an artist.

Fresco Painting Technique

Knowledge of fresco technique depends greatly upon discoveries made during conservation and restoration efforts. Handbooks recording 14ᵀᴴ–c. workshop practices, like Cennino Cennini's *Il libro dell' arte*, also offer invaluable information (see Trecento History Notes 1390). Cennini's recommendations follow.

MASONRY WALL

Preparing the wall is the first step in making a fresco (#1). This process involves roughening the surface of the wall (stone or brick) to increase the adhesion of the first plaster layer.

INITIAL PLASTER LAYERS

The initial plaster coats consist of one part lime to three parts coarse sand and water (#2). Reeds were sometimes placed crosswise to insulate the plaster from the moisture in the wall (water is among the most potentially damaging threats to the durability and life of fresco pigments).

ARRICCIO OR BASE COAT

A new, usually smoother, plaster coat, called the *arriccio* or the base coat, was added next (#3). The base coat layer provides a moisture barrier for the final layer, and it is the surface upon which Giotto and his contemporaries drew designs freehand. However, they also transferred prepared designs. This was done in a couple of ways: by laying a full-sized drawing (cartoon) against the plaster and incising the design with a sharp instrument, or by pricking pin holes in the surface of the cartoon through which charcoal was dusted onto the plaster, leaving dotted guidelines (these procedures were frequently used after the mid–fifteenth century).

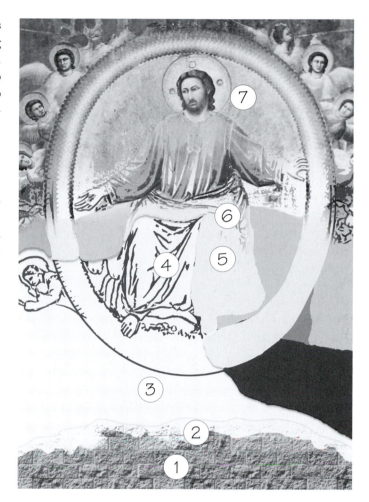

11–2. This illustration of the fresco process uses a detail of Giotto's *Last Judgment*, showing Christ as the *Pantocrator*, Scrovegni Chapel, Padua.

SINOPIA

Designs on the *arriccio* were often reinforced with a red earth pigment called *sinoper*. Thus, the name sinopia is given to such preparatory drawings on the *arriccio* layer (#4).

GIORNATA

After the preparatory designs were completed, fresh plaster was added in sections (patches) to those areas that could be completed in one painting session (called a *giornata* or day's work) (#5).

KEY TO DIAGRAM.
1 Masonry wall
2 Initial plaster layers
3 *Arriccio* (base coat)
4 Sinopia (preparatory design on the *arriccio*)
5 *Giornata*: a section of the final plaster (*intonaco*)
6 Underdrawings on the *intonaco*
7 Final painted layers

Fresco Painting Technique

Frescoes were popular in the temperate, dry regions of Italy, especially in Tuscany. They were frequently commissioned because fresco is inexpensive for the cost of the materials needed to cover yards of wall space (for instance, fresco is much less costly than mosaic, stained glass, marble, precious stones, or cast metals). Large-scale fresco paintings can be seen from great distances; contributing to the easy visibility of the paintings is the nature of fresco colors, which are generally clear, bright, and luminous. When pigments are applied in wet fresco technique, they literally fuse with the plaster. Once the plaster dries, the pigments are locked into the plaster, making fresco a durable medium that will last for centuries if not unduly exposed to water and harsh elements. To make corrections to freshly laid color, Cennini suggested that painters should take a large brush dipped in water and draw it over the surface of the plaster to withdraw the pigment.

UNDERDRAWINGS ON INTONACO

Because these final plaster coats cover the preparatory designs completely, underdrawings were often resketched onto the fresh plaster as guides for executing the final design (#6).

FINAL PAINTED LAYERS

In *buon fresco* (true or wet fresco technique), painters applied ground pigments mixed with water to fresh sections of plaster. This is the final painted design on the *intonaco* (#7).

GENERAL PROCEDURE

Fresco painters began their work at the top of a wall and worked downward so that dripping plaster and paint did not damage already completed work. Before each new plaster coat was added, the existing coat was roughened so that the next layer could bond securely to it. With decreased proportions of sand added to the lime and water mixture, each successive coat of plaster applied to the wall had a finer and smoother texture. Marble dust in the final layer (*intonaco*) created the smoothest and finest surface of all.

Cennini recommended that the *intonaco* layer be worked over with a spade and trowel so that it became "like an ointment." It takes an experienced craftsman to be able to apply plaster in very thin, smooth layers.

BUON FRESCO AND FRESCO SECCO

In the *buon fresco* technique, painters monitored the dampness of each *giornata* so that they could apply pigments when the surface was not too wet nor too dry. Monitoring the dampness of the wall and artificially controlling the dampness (i.e., applying wet strips of cloth to an overly dry wall), helps to ensure that colors—such as those used to depict garments—will be consistent when applied in different painting sessions. Certain pigments, however, could not be applied in *buon fresco* technique and had to be applied to the dry wall with a binding vehicle, such as egg yolk (called the *fresco secco* technique).

PIGMENTS

Cennini recommended that colors should be prepared by adding a small amount of pigment to water (when applied to wet plaster, colors immediately sink into the surface, where they are locked during the setting process). Colors were to be divided into three dishes establishing medium, light, and dark color values so that the greatest illusion of volume could be created through modeling (a practice also used for tempera painting).

Faces received the most careful attention and took the longest time to complete. After drawing or transferring a design, *verdaccio* (a mixture of ochre and cinabrese) was mixed with clear water and applied with a fine bristle brush to define features. Cennini advised that brushes be made from thin bristles and be able to fit into the quill of a goose feather. *Verdaccio* was followed by *terra verde*, a green earth pigment, for shading faces or drapery.

After applying the *terra verde*, *verdaccio* was used to sharpen the outlines and give depth and volume to the facial features. Cennini instructed painters to use lime white thinned with water to define and emphasize the prominent areas of a face. Finally, a flesh color was applied to the cheeks and lips to complete the face.

Scrovegni Chapel, Padua

Giotto's masterwork in fresco was created for Enrico Scrovegni, who in 1300 bought land for a palace and family chapel in Padua (about 25 miles southwest of Venice). The commune of Padua in the mid–13ᵀᴴ c. was a thriving center of spiritual and intellectual pilgrimage. One of the most well-loved Franciscan friar-preachers, a Spaniard known as Antony of Padua, had died there in 1231. Antony was venerated for his oratorical eloquence and legendary miracles, and a basilica in Padua (called the Santo)—built soon after his death to enshrine the relics of Antony (canonized in 1232)—became one of the most popular pilgrimage sites in Italy.

The university in Padua (founded 1222), the second oldest in Italy, was widely recognized for its faculties of law, medicine, classics, and physical science, drawing scholars and students from afar.

The prosperous Enrico Scrovegni came from a wealthy Paduan banking family. However, Enrico's father, Rinaldo, had an unsavory reputation as a flagrant usurer, and Dante placed him in the seventh circle of hell in *The Divine Comedy* (vol. 1: *The Inferno*, XVII. 64–76) (see Trecento History Notes 1306). Thus, Enrico's chapel was consecrated (most likely on the Feast of the Annunciation, 25 March 1305) to honor the Virgin and the city and to atone for family sins. Giotto began his work (ca. 1303) by painting the ceiling with a celestial blue field, spotted with stars and ten roundels of the Redeemer, Madonna and Child, John the Baptist, and seven prophets. Three decorative

11–3. This diagram shows the entrance and north walls of the Scrovegni Chapel. From 1278, processions from the cathedral arrived at the old Roman arena where Annunciation dramas were enacted. After 1305, it seems that the chapel hosted part of the feast day celebrations, and Enrico invited clergy and guests inside the chapel. The chapel was built next to but apart from the palace (now destroyed), and is called Scrovegni after the patron, and Arena after the old Roman arena which it faces. The chapel could be entered both from the palace side (north side of the chapel) and from the west entrance. In March 1303 the chapel was dedicated to the Virgin Mary of Charity (S. Maria della Carità). One year later, Pope Benedict XI (1 March 1304) granted indulgences to penitent pilgrims visiting the chapel on the following Marian feast days: the Nativity, Annunciation, Purification, and Assumption.

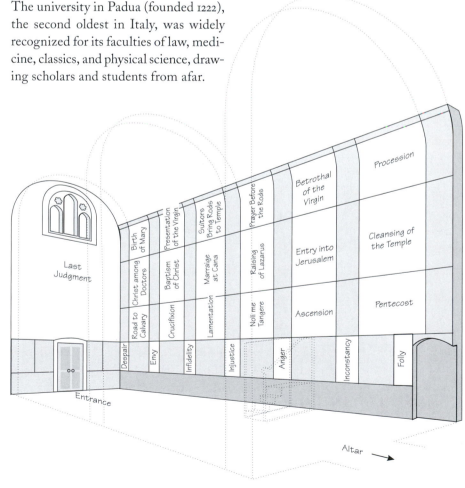

Scrovegni Chapel, Padua

11–4. The diagram shows the fenestrated south and altar walls. Apse frescoes of the Virgin's Dormition, Funeral, and Assumption were painted by a follower of Giotto (the Master of the Scrovegni Choir). About 1305 Giovanni Pisano, perhaps on the recommendation of Giotto, executed marble statues for the chapel: two *Angels* (holding candles) and a *Madonna and Child* inscribed JOH.IS MAGISTRI NICOLI. Doors were later added above the *Annunciation* for a dove or an actor (as Gabriel) to enter the chapel in the staging of the Annunciation drama. For the consecration of the chapel (thought to have been 25 March 1305, on the Feast of the Annunciation), Enrico received permission from the Venetian government (16 March 1305) for the loan of tapestries from S. Marco. (The wall hangings were likely intended to decorate the choir, whose walls were not completed until long after Giotto's frescoes were finished.)

bands that divide the ceiling (see figs. 11–3, 11–4) contain images of saints, angels, and the Evangelists. Along the top row of the side walls are scenes of Mary's family, with the first story beside the altar wall. On the second and third rows are twenty-four scenes of Christ's life: the infancy, ministry and miracles, Passion, and post-Passion stories. Deadly sins and holy virtues decorate the dado (wainscot), and above the entrance is a Last Judgment scene (a traditional theme for the west wall of a church), where Enrico presents a model of his chapel to his patron saint, the Virgin Mary of Charity, flanked by Gabriel and the Virgin Annunciate (also identified as John the Evangelist and Mary Magdalene); the dedication relates to Rinaldo's sin of usury, which was condemned by the church. It is thought that Giotto designed the simple, barrel-vaulted chapel, giving it few windows and

providing broad flat surfaces which are ideal for painting frescoes. His paintings are visually and symbolically related to the function of the chapel and to pilgrimage, with the overarching theme of the cycle—focusing on charity and the hope of salvation—poignantly expressed in the figures of virtues, which are close to a visitor's eye level.

In 1336 Enrico Scrovegni died in Venice (20 August), where he had lived in exile since 1320, after the rival Carrara family took control of Padua. According to his last request, Enrico's body was sent back to Padua for burial; his tomb faces Giotto's great Last Judgment scene.

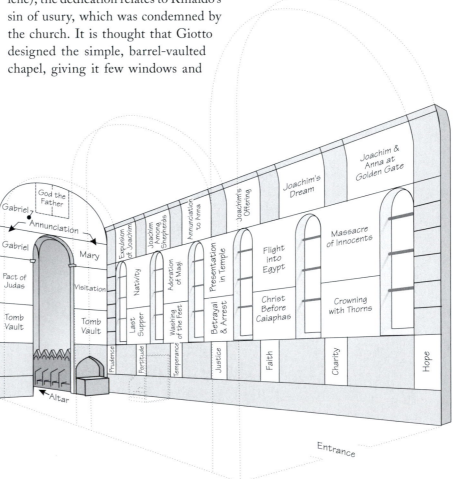

However significant foreign artists were to the story of Sienese painting, Duccio di Buoninsegna (ca. 1260–1319) superseded them, articulating the distinctive vocabulary that nurtured two centuries of local Sienese artists, from Simone Martini to Ambrogio Lorenzetti and Sassetta. Duccio's art blends the Italo-Byzantine legacy of Coppo and Cimabue with the storytelling ability of the renowned Giotto, whose pictorial world—with its measured spaces and human dramas populated with boulder-like bodies—was considered by Giotto's contemporaries to reflect life itself. But unlike Giotto, Duccio enriched his narratives with shimmering veils of delicate pastel colors, golden skies, and slender, elegant aristocrats. Silken-clad people glide through city streets and over country roads and seem to leave barely any human imprint upon the ground. The tangibility of Duccio's pictorial reality is suggested, instead, by the familiar, anecdotal details drawn from nature. Duccio infused his art with the elegance found in Byzantine icons and the illusionism of Greco-Roman art, and he more fully embraced the style of Roman artists like Cavallini than the gravely sober style of Giotto.

ca. 1260 — Duccio is born in Siena; his painter father is named Buoninsegna.

1278 — Duccio is listed as the painter of twelve wooden panels used as book covers for documents of the Biccherna (the treasury, which also oversaw administrative offices such as those involved with the buildings, roads, and citizen militia of Siena).

1280 — Duccio (probably the painter, although the profession of the accused is not mentioned) is fined one hundred lire, the first and largest of many fines levied against him in his lifetime. Although the reason for this fine is unclear, some infractions have been identified: he was accused of violating town ordinances (1299), refusing to join the citizen militia and, apparently, practicing witchcraft (1302).

1285 — On 15 April Duccio is contracted to execute a large tempera painting, 14'9" x 9'6" (450 x 290 cm), depicting the *Maestà*. His patron was the Società della Vergine, the lay brotherhood called the Laudesi, of the Dominican church of S. Maria Novella in Florence. Founded by the Dominican Peter Martyr, the Laudesi venerated the Virgin, singing her hymns (see fig. 15–1). Duccio received about 85 florins for his painting. Until the late–19TH century, the *Maestà* was attributed to Cimabue (based on the *Lives* of Vasari), and became known as the Rucellai Madonna after the family chapel where it was moved in 1681 (now Uffizi Gallery, Florence). Ornamental details lavished on the work—the thirty, tiny roundels containing busts of Christ and saints revered by the Laudesi, the shimmering gold fringe on the Virgin's blue silk mantle, and the finely patterned silk cloth embellished with borders of pseudo-kufic script—call attention to the delicate and intricate patterns that became a hallmark of Duccio and Sienese painting. Such rich fabrics reflect both the commercial prosperity of Florence and the devotion of the patrons.

1288 — A contract for the large stained-glass window (ca. 22' in diameter) in the apsidal wall of Siena Duomo is awarded. It is thought that Duccio designed the window (see fig. 12–1), whose placement near the high altar is especially important because of two scenes, the Assumption and Coronation of the Virgin, which held special significance in Siena. Just as Christ had crowned Mary the Queen of Heaven, the Sienese head of government, Buonaguida Lucari, declared her the Queen of the commune in a solemn ceremony at the high altar of the Duomo on 1 September 1260, the eve of a battle with Florence at Montaperti (see Coppo di Marcovaldo). From that day, the Virgin was both the spiritual and secular head of Siena.

12–1. Line drawing of Duccio's window for Siena Duomo.

12–2 (below). This diagram of Duccio's *Maestà* shows the side that faced the nave (front). Although its original appearance is unknown because of the disbursement and loss of panels and frame, it is likely that the shape was influenced by Gothic architecture and resembled Siena Cathedral. Duccio's prayer for peace and favor is inscribed around the base of the throne, below the Virgin's feet: MATER S[AN]C[T]A DEI / SIS CAUSA SENIS REQUIEI . SIS DUCIO VITA TE QUIA / PINXIT ITA (Holy Mother of God, give peace to Siena and eternal life to Duccio because he painted you thus).

12–3 (opposite page). This reconstruction shows the back of the *Maestà*, which faced the apse of the choir. Eight stories of Christ's ministry have been linked to the predella (the Baptism of Christ and Temptation in the Wilderness, however, are noticeably absent). In this reconstruction the (lost) Baptism appears at the bottom left of the predella upon which the large *Maestà* was set.

1295 — Searching for the legendary river Diana—thought to run beneath the streets of Siena—the Cathedral Operaio (supervisor of works) grants Duccio, Giovanni Pisano, and three stonemasons the authority to sink a well for a fountain (Fonte d'Oville). However, not until the Quattrocento, with the Fonte Gaia (1414–19) designed by Jacopo della Quercia for the Piazza del Campo, was the first dependable water supply brought to the center of Siena.

1308 — A contract (9 October) is signed between the head of the cathedral workshop and Duccio di Buoninsegna, a painter and Sienese citizen, who promises to complete the high altarpiece of Siena Duomo without interruption and without embarking on other projects before finishing the said altarpiece. (It has been suggested that this was not Duccio's initial contract and that he had probably begun work on the altarpiece before 1308.) In 1311 Duccio's great *Maestà* was completed, costing the incredible amount of three thousand gold florins, according to one contemporary account. The altarpiece was the second to replace a miraculous image believed responsible for Siena's victory over Florence at Montaperti (1260), and at whose altar the city keys were given to the Virgin. Although highly venerated, the image of the 1260s (now called the *Madonna degli Occhi Grossi*) was replaced by Guido da Siena's *Madonna delle Grazie* in the 1270s. Then, in 1311, Duccio's double-sided altarpiece (see figs. 12–2, 12–3) became the most important portrait of Siena's Queen and

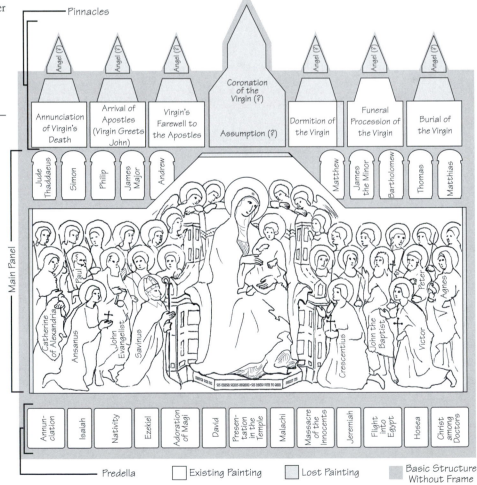

Intercessor in the Duomo, when it was prominently installed on the high altar. With a lordly demeanor and dominating form, Duccio's Virgin Queen reigns over a heavenly community of 10 saints, 16 angels, and 4 archangels. Mary faces the nave and embraces all who stand before her. The wide, splayed arms of her throne are like the expansive mantle of a Madonna of Mercy—opened, welcoming, and protective. Holding a demure Christ child upon her lap, the Virgin nods while listening attentively to the pleas of four Sienese patron saints kneeling before her (Ansanus, Savinus, Crescentius, and Victor). Predella panels depict stories of Christ's infancy, interspersed with images of Hebrew prophets. Half-length images of 10 apostles (the other two, John and Peter,

stand beside Mary's throne) appear above the main panel, and above these figures are stories of Mary's life after the Crucifixion. The pinnacles surely held images of angels, important in the stories of the Dormition, Assumption, and Coronation. A second contract states that Duccio was to paint thirty-four images of Christ (thought to be the main panel and pinnacle scenes) and panels of angels on the back side of the *Maestà*. The dispersal (and loss) of predella and pinnacle panels has fostered debate about the identification and the order of the scenes belonging to the predellas and pinnacles. In most reconstructions of the *Maestà*, Lazarus is placed on the right end of the predella; however, here the Transfiguration is placed at the right end because the subject links stylistically and

Duccio's *Maestà* (now Opera del Duomo, Siena) was executed in tempera on panel, and measures 7' x 13' (213.4 x 396.3 cm). By the 16TH c., Duccio's style was out of vogue and his *Maestà* was moved from the high altar to the left transept of the Duomo (1506). In 1771 the predella was sawn from the frame, the pinnacles were removed, and the main panel was cut into seven vertical strips, following the vertical divisions of scenes on the back. The front was then sliced away from the back. The front main panel is made of eleven vertical planks (2.8" thick), the back main panel has five horizontal planks (about .5" thick), and the planks of the front and back were originally nailed together from the back. Neither predella was attached to the main panel, and each was made of one large horizontal plank. Only the pinnacle panels were, perhaps, painted front and back on the same board.

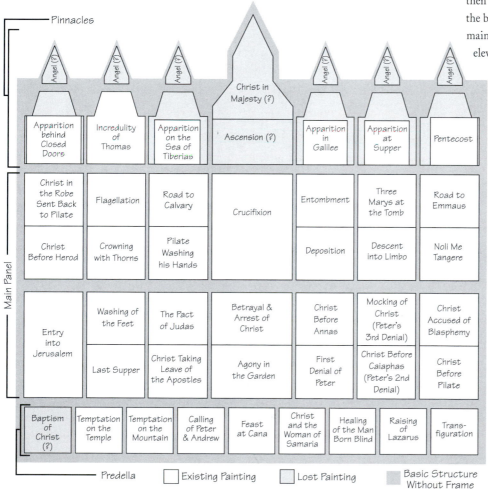

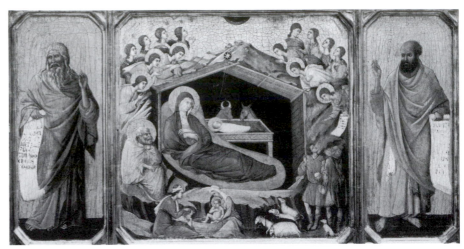

12–4. DUCCIO. *Nativity with Prophets Isaiah and Ezekiel* (from the front predella of the *Maestà*) (see fig. 12–2), 1308–11, tempera on panel, National Gallery of Art (Mellon Collection), Washington, D.C. *Nativity*, 17.3" x 17.5" (43.8 x 44.4 cm) and *Prophets*, 17.3" x 6.5" (43.8 x 16.5 cm). Duccio's *Nativity* still has its original framing, and once faced Nicola Pisano's pulpit (1265–68) in Siena Cathedral. Remarkably similar in composition, the Nativity scenes of the pulpit and *Maestà* show the Virgin reclining by a rock cave in Byzantine style (Duccio added a shed), surrounded by angels. Christ is depicted twice in both, lying in his manger and being bathed by two midwives. Duccio's lyrical composition is simpler and more fluid than Nicola's. Duccio's prophets, like Nicola's figures, frame scenes, but are poised and more refined.

Images of Mary were commissioned for both the Duomo and the Palazzo Pubblico (town hall), and the most venerated feast in Siena became the Assumption, which was celebrated for three days.

symbolically with scenes above: the appearance of Christ to Mary Magdalene (*Noli me tangere*) and to the disciples on the road to Emmaus. Furthermore, the scene of Lazarus relates to Limbo and the Marys at the Tomb.

Several chroniclers describe the jubilant events of 9 June 1311 when the *Maestà* was triumphantly taken to the cathedral from Duccio's shop on the outskirts of Siena at the old city gate on the Via Stalloreggi. Shops were closed, and a caravan of proud citizens gathered to pay homage to their Queen as they marched to the sound of trumpets, bagpipes, and castanets played by the commune's own musicians. Borne high for all to see, the sumptuous *Maestà* was carried through narrow, winding streets like the spoils of a victorious military campaign. Every church and state official and all the people were there. Candles were lit and prayers were offered to God and to the Virgin Mother "that she might help to preserve and increase the peace and well-being of the city and its jurisdiction, as she was the advocate and protection of said city, and deliver it from all danger and wickedness directed against it" (Agnolo di Tura, *Cronica*). The grace and elegance of Duccio's *Maestà* gave Siena a modern style and forged a communal identity for the Queen of Siena. In

response, Coppo's *Madonna del Bordone* was soon repainted in Duccio's style.

Few works of Duccio are documented, and few are known to have preceded the commission for the *Maestà*. Duccio received this, his most important commission, likely because of another (lost) *Maestà* completed by him in 1302 for the chapel of the Nove (nine governors of Siena) in the Palazzo Pubblico. The narrative predella of the Palazzo Pubblico painting may have provided a model for the shape of the Duomo *Maestà*, which has the earliest surviving narrative predella (see Cimabue ca. 1300). Yet, the sheer size and quantity of Duccio's predella and pinnacle scenes set the *Maestà* apart from all earlier panel paintings, and the closest contemporary parallel—with multiple stories about Mary and Christ—is Giotto's fresco cycle in the Scrovegni Chapel in Padua, which Duccio must surely have known. Common to both works is the symbolic and stylistic correlation between scenes.

1319 — By October, Duccio has died, and his children (seven sons and one daughter) formally declare that their inheritance is to go to their mother (Taviana), who is still living. Two of Duccio's sons became painters, but their work is apparently undocumented.

More cosmopolitan than his contemporaries, Simone Martini (ca. 1284–1344) traveled farther and more often than did most artists of his time, and he was called to two major intellectual centers outside Tuscany: the royal Angevin court in Naples and the papal court at Avignon, where he painted a portrait for Petrarch. While Simone's birthplace and whereabouts before 1315 are uncertain, his art shows Tuscan traits and familiarity with the work of Duccio and Giotto and the Roman Cavallini as well as French artists. He married into a family of Sienese painters, collaborated with his brother-in-law (Lippo Memmi), and spent most of his life in Siena, where he was awarded important contracts by the commune.

1284 — Vasari noted that a memorial plaque in a Sienese church recorded his age as sixty in 1344.

her three-dimensional gilded halo (created by thick plaster shaped with a decorative mold) brightens her face, calling attention to her clothes, which are bejeweled (her brooch is a piece of three-dimensional glass set into the plaster). Such an ornamented garment sharply contrasts with the severe blue mantle covering the head and body of Duccio's Virgin. Less passive than in Duccio's *Maestà*, the Christ child

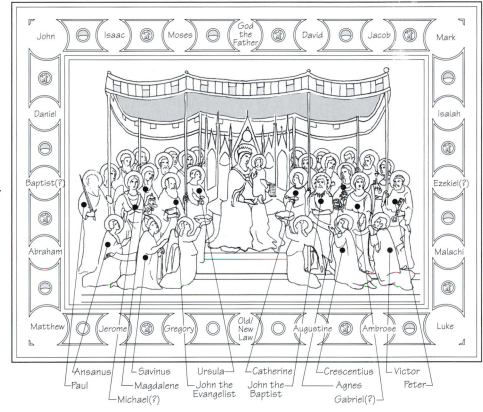

13-1. This diagram after Simone Martini's *Maestà* (see entry 1315) identifies venerated Sienese saints in the front two rows. The large *tondi* (medallions) in the borders display images of the four Evangelists (corners), four Church Fathers (bottom), ten prophets (top and sides), Old and New Law (bottom), and God the Father (top). In the smaller *tondi* are crests of Siena: the Commune (the *balzana*, black over white) and the Popolo (a white, rampant lion on a red field). Among the earlier images depicted on the far wall opposite the *Maestà* were subject towns; these now faced the Virgin, terrestrial ruler of Siena.

ca. 1315 — The first record of Simone is an inscription on a large mural in Palazzo Pubblico, Siena's town hall (see fig. 13–1). His work dominates the entire end wall of the second floor assembly hall and closely resembles Duccio's recently completed *Maestà* in Siena Duomo; yet, Simone's image is ingeniously tailored to fit the needs of a government building in which Mary appears as a secular queen. Mary sits elevated from the saints and wears a crown (she has no crown in Duccio's *Maestà*). The shiny surface of

Records suggest that Simone was paid (1321) to make repairs on his *Maestà* in the Siena town hall. It is thought that he first painted his mural as though it were a tempera panel. The plaster therefore got too dry and lost its freshness, and the figures darkened soon afterward. Sections repainted in true fresco (perhaps in 1321) have noticeably more luminous flesh: the heads and hands of the Virgin, Child, kneeling angels, and Saints Ursula, Catherine, Ansanus, and Crescentius.

French Cardinal Montefiore (see entry 1317), as papal legate to Hungary, quelled unrest over the succession to the Hungarian throne, securing the crown for Charles Robert (the grandson of Charles II of Anjou) in 1308. For the imagery in his intended burial chapel, Montefiore thus chose stories of Martin (a 4TH-c. Hungarian soldier who became bishop of Tours and the patron saint of France) because of his own ties with Hungary and the French Angevins and because Martin's life has parallels with that of the patron of Assisi, S. Francis.

stands on this Virgin's knee under a giant canopy that covers the holy couple and most of their court. Two angels and ten apostles are in the back row (Peter and John are in the second row), angels, saints, and archangels are in the middle ground, and Siena's four beloved patron saints kneel in the front. The glinting effects of the semiprecious gems, glass tesserae, and gilded *pastiglie* (raised, patterned gesso) of the throne, garments, and halos enliven this court and further an illusion that the canopy is rippled by the wind. An insignia of an emperor, the canopy distinguishes Mary as the Queen of Siena (emblems of Siena appear in the border of the canopy) and makes this work different from any previous *Maestà*. An airy quality created by the tall canopy suggests a deeper, less restrictive space than in Duccio's *Maestà*. As Siena's Queen and Intercessor, the regal Virgin presents the blessing Child, whose scroll (made of parchment glued to the plaster) is inscribed: DILIGI / TE JUSTI / TIAM QU[I] / IUDICI[A] / TIS TER / RAM (love justice you who rule the earth). The throne steps and the scrolls of the patron saints bear inscriptions (partly lost) that ask the Virgin to give Siena protection, peace, and prosperity. Her response, which appears on the lowest band above the frame, offers help to the pious Sienese who govern justly and fairly. It warns against letting the powerful deceive or oppress the weak.

ca. 1317 — Hired by King Robert of Anjou of Naples, Simone completes a large gabled tempera altarpiece, *S. Louis of Toulouse*, for the convent church of the Poor Clares (S. Chiara) in Naples.

In the lower basilica of S. Francesco at Assisi, Simone executes frescoes in the S. Martin Chapel, originally intended as the burial chapel for Cardinal Gentile da Montefiore (d. 1312).

1319 — Living in Pisa, Simone signs a large polyptych for the Dominican church of S. Caterina (Museo Nazionale di S. Mateo, Pisa).

1320 — Simone creates a polyptych for the Dominicans of Orvieto and is paid (1321) to repair or rework his *Maestà* in the Siena town hall (see fig. 13–1).

1323 — Payment records (28 April, 30 June) show that Simone is in the Siena town hall, creating paintings (unidentified) in the loggia for Count Ruggero, the Captain of War, and a (lost) S. Christopher with the family crest of the podesta (chief magistrate) in the Sala Biccherna.

1324 — Simone marries Giovanna, the daughter of painter Memmo di Filippuccio and sister of Lippo Memmi (Simone's partner).

1327 — Duke Carlo of Calabria (Robert of Anjou's son) commissions Simone to paint two standards (given to Siena).

1333 — For the important altar of S. Ansanus in Siena Duomo, Simone and Lippo Memmi (his collaborator) sign and date *Annunciation with Ansanus and Margaret* (since 1799, Uffizi Gallery, Florence). The modern frame (late–19TH c.) has part of the original inscription.

ca. 1336 — Simone is living at the papal court in Avignon, which he likely visited earlier (ca. 1335). His courtly style, which exhibited French traits, gave him a significant advantage over other Italian painters. Few works are securely attributed to this period.

1344 — Simone dies at Avignon; his wife and brother return to Siena.

Pietro and Ambrogio Lorenzetti 14

14–1. Overview of the Siena Campo. All roads inside Siena converge upon a unique fan-shaped piazza called the Campo (field), the largest piazza in Tuscany, which is faced by an array of palaces made of earthen red brick, some with gently curving facades. Conspicuous among these is the town hall, the Palazzo Pubblico, begun around 1290. Just as the Duomo of Siena stands out because of its contrasting stripes of white and black marble (the colors of Siena) and because it is the tallest building on the highest hill in town, the Palazzo Pubblico dominates its setting in the Campo because of a statuesque campanile (ca. 1325–48), which rises to the level of the Duomo on the hill above (see fig. 8–2). The Duomo and the Palazzo Pubblico represent the most important religious and civic centers of Siena and the Lorenzetti brothers, Pietro and Ambrogio, contributed to their decoration, which melds religion and politics in a uniquely Sienese manner.

The versatile and highly respected Lorenzetti brothers of Siena, Pietro (active 1306–45) and Ambrogio (active 1317–48), produced important works for the main religious and civic centers of Siena, the Duomo and the Palazzo Pubblico, and changed the look of Sienese art after Simone Martini left for Avignon (1336). Ambrogio's frescoes in the Sala della Pace (Room of Peace) of the Palazzo Pubblico distinguish him as one of Italy's finest fresco painters. There, in an inventive tribute to his native Siena, Ambrogio depicted a panoramic view of a prosperous commune sparked by a lively, entrepreneurial spirit. It seems that Pietro worked outside Siena more than Ambrogio (who worked in Florence in the 1320s, but remained in Siena after 1336, where he was awarded major commissions by the commune), and his highly emotive and innovative works, especially the Passion frescoes in Assisi, reveal a keen observer of such natural phenomena as shooting stars, cast shadows, and reflected light. Pietro's experimentation with trompe l'oeil demonstrates his avid study of perspective, as well. The art of the Lorenzetti brothers made an indelible impression upon later artists, particularly the Florentine sculptor Donatello.

14–2. PIETRO LORENZETTI. *Birth of the Virgin*, 1342, tempera on panel, 6'1.5" x 5'11.5" (187 x 182 cm). Executed for Siena Duomo (Museo dell'Opera del Duomo, Siena). Wings (lost) and predella panels (dispersed), with images of Ss. Savinus and Bartholomew (an early patron saint of Siena), were once attached to the main panel. Pietro's depiction of the first bath of Mary is like that of the Christ Child in Duccio's *Nativity* panel of the *Maestà* (see fig. 12–4), then on the high altar of Siena Duomo. But Pietro's is a homey, joyful event, which takes place in the bedroom of a contemporary Sienese palace, complete with bed curtains, checked bedspread, and bright ceramic floor tiles. Yet the room also resembles a church, with its star-studded groin vaulting and the sky-lit cloister behind Joachim. Pietro's interest in perspective and compassionate human drama—traits he learned well from the art of Duccio, Simone Martini, and Giotto— are fully developed in this painting, which is stylistically close to the south transept frescoes in S. Francesco, Assisi.

ca. 1290 — Pietro is born about 1290 in Siena and Ambrogio is born about 1295.

ca. 1315 — Pietro executes a fictive altarpiece in fresco, *Virgin and Child with Ss. John the Baptist and Francis*, for the chapel of Cardinal Napoleone Orsini off the south transept in the lower Basilica of S. Francesco at Assisi.

1319 — Ambrogio creates one of his earliest works, the small *Madonna and Child*, for the Pieve of Vico l'Abate (Museo Arcivescovile, Florence). The date is inscribed beneath Mary's gown.

1320 — For Bishop Guido Tarlati of Arezzo, Pietro creates the large (nearly 10 square feet) polyptych, *Madonna and Child with Saints*, *Annunciation*, and *Assumption*, for the Abbey of S. Maria in Arezzo. Pietro remained in Arezzo until about 1324.

1324 — Ambrogio sells land in Siena; about this time he also executes frescoes in the Chapter House of S. Francesco in Siena. Pietro paints a Crucifixion fresco (damaged) in S. Francesco, Siena.

1327 — Ambrogio is inscribed in the Arte dei Medici e Speziali in Florence. Two panels with scenes of S. Nicholas (showing Simone Martini's influence), created for S. Procolo, Florence (since 1819, Uffizi Gallery, Florence), are attributed to him.

1329 — Pietro completes one of the largest early Trecento Sienese polyptychs (now dismembered) for the Carmelites of S. Maria del Monte Carmelo, Siena. Pietro's lively panoramic view of people meandering through nature is without precedent, but was surely inspired by the Passion scenes on the back of Duccio's *Maestà* (1311) for Siena Duomo.

1333 — Pietro receives a contract for an altarpiece of S. Savinus in Siena Duomo (see 1342). (A document records that a master was paid to translate the legend of S. Savinus into Italian for Pietro's use.)

1335 — Ambrogio and Pietro complete an important (destroyed) fresco cycle depicting stories of the Virgin for the facade of the civic hospital in Siena, S. Maria della Scala.

Ambrogio begins a (lost) fresco cycle of the Virgin, similar to the hospital frescoes, for the Siena Duomo.

1337 — Ambrogio executes (lost) frescoes of Roman stories on the outer walls of the Palazzo Pubblico, Siena. Ambrogio had unofficially replaced Simone Martini (in Avignon from about 1336) as the painter of the commune. Unlike Venice, Siena had no communal post or stipend for a painter; however, Simone, and Ambrogio after him, repeatedly received contracts from the Siena commune.

1330s — Pietro executes frescoes (completed by 1342) in the south transept of the Lower Basilica of S. Francesco, Assisi. These are eleven Passion scenes covering the vault and the entrance wall to the Orsini Chapel.

14-4. This diagram shows the hypothetical location of Marian altars in Siena Duomo in the 14ᵀᴴ c. In 1317 it was decided to enlarge the chancel to the east, and the relics of four patron saints of Siena (Ansanus, Savinus, Crescentius, and Victor) were moved from the crypt to altars in the church, flanking Duccio's *Maestà* (see fig. 12–2). Altarpieces for the saints closest to the Virgin in Duccio's *Maestà* (Savinus and Crescentius) were contracted from the Lorenzetti and placed closest to the nave, beyond the choir screen, making them more accessible to the laity.

KEY TO DIAGRAM.

A. Duccio, *Maestà*, 1308–11 (high altar)
B. Simone Martini, *Annunciation*, 1333 (S. Ansanus altar)
C. Pietro Lorenzetti, *Birth of the Virgin*, 1342 (S. Savinus altar)
D. Ambrogio Lorenzetti, *Purification*, 1342 (S. Crescentius altar)
E. Bulgarini, *Nativity*, 1351 (S. Victor altar)
F. Nicola Pisano, pulpit, 1265–68.

1338 — Ambrogio begins a major fresco cycle in the Palazzo Pubblico, his masterwork depicting panoramic scenes of good and bad government in the Sala della Pace (see figs. II–2 to II–4).

Pietro pays the Siena commune (as he had in 1337) for the right to carry arms. Pietro returns to Assisi (ca. 1338) to paint the Passion frescoes in the south transept of the lower basilica of S. Francesco, his most remarkable paintings.

1340 — Pietro signs and dates *Virgin and Child Enthroned with Eight Angels* (Uffizi Gallery, Florence), an altarpiece for the Confraternity of S. Bartholomew, which was associated with the church of S. Francesco, Pistoia. The date inscribed on the painting is very damaged.

1342 — Pietro completes the triptych *Birth of the Virgin* (see fig. 14–2) for the altar of S. Savinus in the north transept of Siena Duomo (see fig. 14–4). (The painting was removed when a new altar was installed, ca. 1651.) Pietro's figures sensitively express the human response to extraordinary events: a melancholic Anne pulls her right knee toward her chest and tilts her head downward as she appears to contemplate the destiny of the newborn Mary; Joachim, patiently waiting in the vestibule, expresses his anticipation by eagerly leaning close to the young messenger for news of his daughter's birth. Anne is as strikingly large in this scene as Duccio's Virgin in

the *Nativity* (see fig. 12–4), the *Maestà* panel with which Pietro's was, no doubt, often compared. Yet Pietro provided more space in his scene, and the fictive architecture—suggesting distant chambers and rooms in the foreground that are convincingly large enough to hold ten active figures—is related to the architecture of the frame, giving worshippers the sense that they are watching an intimate scene as through a window.

Ambrogio completes the large *Purification of the Virgin and Presentation in the Temple* (see fig. 14–3), commissioned in 1337 for the altar of S. Crescentius in the Siena Duomo. Ambrogio's elaborate temple, embellished with inlaid designs of colored marble, complemented Nicola's pulpit scenes, the *Nativity* and *Adoration of the Magi*, which it faced (see fig. 14–4). Ambrogio's scene—less intimate than Pietro's but more expressly dramatic in gesture and human interaction—creates a luxurious space for stately figures, and Mary's regal bearing is remindful of her role as the Queen of Siena.

1344 — Ambrogio creates two works for the Siena town hall: a (lost) rotating map, called *Mappamondo*, and an Annunciation panel (Pinacoteca, Siena). Pietro may still be in Assisi working on the Passion cycle; the last record of him in Siena concerns a land transaction.

1347 — Ambrogio is elected to the Sienese Council of the Paciari.

1348 — Ambrogio makes a will. It is thought that he died in this year. Both brothers were likely the unfortunate victims of the bubonic plague, which swept through Europe in the 1340s (see Trecento History Notes 1348).

Andrea di Cione

Andrea di Cione (?1315–68) is one of several important late–14TH c. artists who came from a family of artists; his expertise as a painter, sculptor, and architect earned him noteworthy commissions in Florence during the aftermath of the Black Death (1348), which reduced the population of Florence by almost one half, and greatly affected the patronage of the last three decades of the century. Andrea first worked as a painter and was named among the best of the city (1349), receiving important commissions for frescoes and panel paintings in Florence before he was commissioned to create a large shrine for a miraculous image housed at Orsanmichele (see fig. 15–1). Andrea's notable contribution to Florentine art was his ability to supervise painting and sculpture workshops in the creation of large projects.

ca. 1315 — Andrea is born in Florence. Little is known about his origins, but he had two painter brothers, Nardo (d. ca. 1366) and Jacopo (d. 1398), and a sculptor brother, Matteo (d. 1389). His nickname, Orcagna, stands for *archangelo* (archangel).

15–1. This illustration shows the front (west side) of Andrea di Cione's marble tabernacle (1352–60) in Orsanmichele, Florence. It was commissioned by the *Compagnia dei Laudesi della Madonna di Orsanmichele* to enshrine Bernardo Daddi's altarpiece, the *Madonna delle Grazie* (executed in 1347 to replace a miraculous image, which began performing miracles on 3 July 1292, according to Villani [*Cronica* 7:155], though they likely occurred earlier, before the founding of a *Compagnia* at Orsanmichele in 1291). The *Madonna delle Grazie* was the most popular, miracle-working image in Florence.

wall of the prison, the Carcere delle Stinche.

1344 — Andrea (Andreas Cionis) is inscribed in the Arte dei Medici e Speziali in Florence. He executes a large fresco cycle (fragments, Museo S. Croce, Florence) of the *Triumph of Death*, *Last Judgment*, and *Hell* for the Franciscan church of S. Croce, Florence.

1349 — According to Ghiberti, Andrea painted a fresco cycle (ca. 1349–53) in the chancel of the Dominican church of S. Maria Novella in Florence, depicting the life of the Virgin Mary and S. John the Baptist. This was the largest fresco commission to this date in Florence and involved the participation of about five different artists (because of extensive damage, Domenico Ghirlandaio was later hired to replace the frescoes with the same subjects, which he did in 1486–90).

1352 — Andrea joins the Arte di Pietra e Legname (the guild of stonemasons and carpenters), after beginning work on a large marble tabernacle (see fig. 15–1) commissioned to replace Giovanni di Balduccio's shrine (1333) for the *Madonna delle Grazie* in Orsanmichele, Florence. Orsanmichele was a granary and devotional site that held a miraculous image of Mary and an altar (1343) dedicated to S. Anna (Florentines

ca. 1343 — Andrea creates a painting (lost) for the Compagnia di Gesù Pellegrino in S. Maria Novella, Florence, and a fresco of the Expulsion of the Duke of Athens (Palazzo Vecchio, Florence) on the entry

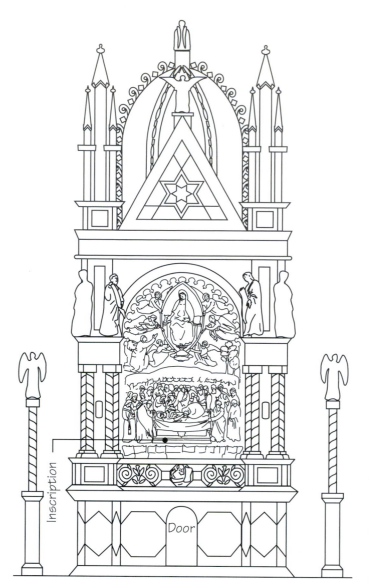

Inscription

Door

15–2. This illustration of the back (east side) of Andrea di Cione's marble tabernacle (see fig. 15–1), bearing Andrea's name and date (1359), shows the Burial and Assumption of the Virgin, with Mary giving the *cintola* (belt) to S. Thomas.

shrine include a magnificent dome, supported on a drum and topped by a statue of S. Michael (whose head nearly touches the vault, where his halo is painted), and a basement level (entry is on the east side, see fig. 15–2), which allowed musicians and singers to chant, unseen, during evening vespers. The marble statues, high reliefs, and sparkling gold, enamel, and colored-marble inlays create a decorative, luminescent quality that is stunning when light (natural and candle light) illuminates the tabernacle.

1357 — Andrea signs and dates a tempera altarpiece (begun 1354) of Christ in Majesty giving keys to Peter and a book to S. Thomas Aquinas (in this theme, Paul usually receives the book from the figure of Christ). The altarpiece was commissioned for the Strozzi family chapel in S. Maria Novella. This is among Andrea's most important Florentine works and creates an ensemble with the frescoes in the Strozzi chapel: *Last Judgment*, *Paradise*, and *Hell* (imagery based on Dante's *Divine Comedy*) executed by Nardo (Andrea's brother). During the next years (1357–67), Andrea helps plan the construction of the Florence Duomo.

1359 — Andrea is appointed *capomaestro* of the stonemasons' workshop at Orvieto Cathedral (a post he held for one year). He paints a fresco of the *Last Supper* (ca. 1360) in the refectory of the Augustinian church of S. Spirito in Florence, and a large altarpiece (ca. 1365), *The Pentecost* (Museo dell'Accademia, Florence).

1368 — By this date, Andrea is gravely ill and forfeits the commission for a large tabernacle of S. Matthew (Jacopo di Cione completed the work on Andrea's design) (Uffizi Gallery, Florence), commissioned by the Arte del Cambio. The date of Andrea's death is unrecorded.

believed that Anna answered their prayers when the tyrant Duke of Athens was driven from Florence on her feast day). Andrea's work on the new tabernacle for the *Madonna delle Grazie* spanned eight years, and it is thought that he carved the main reliefs himself (*Dormition* and *Assumption of the Virgin*), designed the other reliefs, and supervised a large workshop of trained sculptors in creating the complex structure, which resembles a miniature Gothic building. The sumptuous elegance of Andrea's shrine elevated the image, restricting it from the touch of adoring hands. His style forecasts the late Trecento taste for densely populated stories with graceful figures. Distinguishing features of the

Agnolo Gaddi

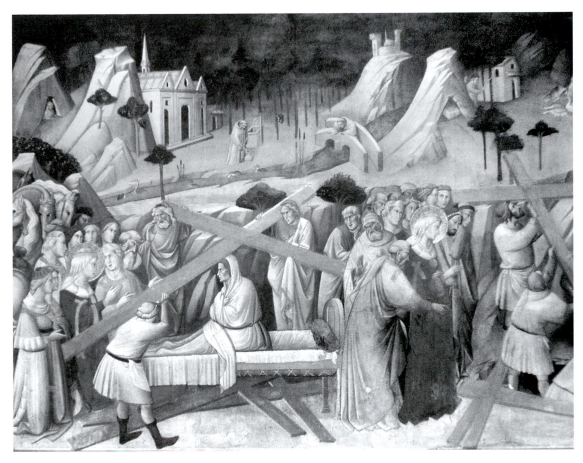

16–1. AGNOLO GADDI. *S. Helena Finding and Proving the True Cross* (detail), ca. 1388–93, fresco, chancel (south wall), S. Croce, Florence. S. Helena (Constantine's mother) is in Jerusalem, searching for the cross on which Christ was crucified. Helena supervises the unearthing of the three crosses (right), and then finds the True Cross when it revives a dead man (left).

From 1385 until 1396, Agnolo Gaddi (active 1369–96) managed a very large workshop, and his style became visibly prominent in Florence. His paintings and designs (for sculptures and stained-glass windows) were created for the most important monuments in town, such as the Duomo, S. Croce, and Loggia dei Lanzi. The third generation in a family of painters, Agnolo was the son of Taddeo Gaddi (active ca. 1326–66), who trained with Giotto. Agnolo himself surely studied the great master, learning Giotto's art of storytelling from his works in S. Croce. But rather than replicate Giotto's limited palette and somber figures, Agnolo instead created spirited narratives (see fig. 16–1) with elegant figures and fluid, graceful movements that were highly popular in the large churches of the mendicant orders like S. Croce. At the end of the Trecento, Agnolo Gaddi's works plotted a new course for Florentine art, and his interest in perspective and descriptive landscape settings, showing his knowledge of the Lorenzetti, prepared the way for a future generation of painters like Masolino and Masaccio.

1369 — In Rome Agnolo is working with his painter brother Giovanni (who inherited Taddeo's workshop) and Giovanni da Milano, making decorations for Pope Urban V in the Vatican.

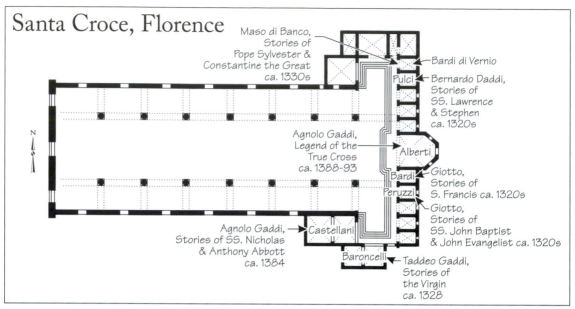

Santa Croce, Florence

Maso di Banco, Stories of Pope Sylvester & Constantine the Great ca. 1330s

Bardi di Vernio

Pulci

Bernardo Daddi, Stories of SS. Lawrence & Stephen ca. 1320s

Agnolo Gaddi, Legend of the True Cross ca. 1388-93

Alberti

Bardi

Peruzzi

Giotto, Stories of S. Francis ca. 1320s

Giotto, Stories of SS. John Baptist & John Evangelist ca. 1320s

Agnolo Gaddi, Stories of SS. Nicholas & Anthony Abbott ca. 1384

Castellani

Baroncelli

Taddeo Gaddi, Stories of the Virgin ca. 1328

16–2. This ground plan of S. Croce, Florence, identifies the chapels decorated in the early Trecento by Giotto and his followers. One of his most sought-after students was Taddeo Gaddi, who created murals in the large Baroncelli Chapel. Taddeo's son, Agnolo, among the best fresco painters in the last decades of the Trecento, was awarded the most prestigious commission in S. Croce, the decoration of the chancel, the largest chapel in the church. The architecture of S. Croce, its long nave and tall, pointed arches, directs visitors to the chancel, where walls of frescoes are punctuated by stained-glass windows, both meant to interrelate (see fig. 16–4).

1381 — Agnolo is considered for communal office (and again in 1391).

1382 — Agnolo is among those considered for the council of the Arte dei Medici e Speziali.

1383 — Agnolo receives payment (27 June) for designing two sculptures (carved by Jacopo di Piero Guidi) for the Loggia della Signoria (Loggia dei Lanzi), Florence. He also receives payments (February and August 1384) for creating designs for relief sculptures of virtues for the Loggia della Signoria.

1384 — About this time Agnolo is commissioned to execute frescoes in the Castellani Chapel in S. Croce (see fig. 16–2). The following year Agnolo inherited his father's (Taddeo's) workshop when his brother Giovanni died. It was among the largest, most efficient workshops in Florence, and served Agnolo well in producing large mural cycles.

1386 — Agnolo is paid (March) for designs of *Prudence* and *Charity* for the Loggia della Signoria (the relief sculptures were carved by Giovan-

ni d'Ambrogio and Jacopo di Piero Guidi).

1387 — Agnolo is inscribed in the Company of S. Luke (confraternity to which artists belonged) in Florence.

1388 — About this time Agnolo begins work on the Legend of the True Cross in the choir of S. Croce (see fig. 16–2), his masterwork and grandest fresco cycle (completed ca. 1393). Since 1348, the Alberti, a wealthy Florentine banking family, were patrons of the chancel, and the Alberti family crest (crossed chains on a black field) flanks the entry to the chancel (see fig. 16–4). Yet, the Franciscans refused to grant the family burial rights in the chancel because it served as the friars' choir. Therefore, Agnolo's frescoes were designed, above all, for the Franciscans of S. Croce. Dividing the side walls of the chancel into eight fields, Agnolo painted sixteen inventive scenes about the origin, theft, recovery, and return of Christ's cross to Jerusalem (see Piero della Francesca for the story). S. Helena's adventures (see fig. 16–1) in the Holy Land are among the most expressive images created by Agnolo. A dense

retinue of courtly figures surround the dominant Helena, framing and calling attention to her actions. Agnolo's narratives (whose stories read from right to left on the lower register of the south wall) lead worshippers toward the altar, as does the landscape, which is deeper and more fully developed than the settings of his earlier works. The murals are easily read from far away because the arrangement of repeated forms (such as the crosses) links the foreground with the distant background. Agnolo's lively pageantry established a visual and iconographic precedent for a popular subject in Franciscan churches, and his cycle in S. Croce influenced the works of later artists like Masolino (S. Stefano, Empoli, 1424), Cenni di Ser Francesco Cenni (S. Francesco, Volterra, 1430), and Piero della Francesca (S. Francesco, Arezzo, 1452–66).

1390 — Agnolo gilds and paints two facade statues (lost), executed by Pietro di Giovanni Tedesco for Florence Duomo.

1392 — After completing frescoes in the Palazzo Datini in Prato, Agnolo seeks payment for his work. In the parish church of S. Stefano in Prato, he begins frescoes (completed 1395) of the Virgin and the legend of the Virgin's *cintola* in the chapel of the Sacra Cintola. In October a Florentine tax collector (attempting to collect back taxes) is assaulted by Agnolo, who incurs a large fine (600 lire). Agnolo escapes (November) an attempted arrest in Prato Cathedral, and claims poverty (December), pleading for the fine to be rescinded. His patron, Francesco Datini, loans him bedding (November 1393).

1394 — Agnolo designs two stained-glass windows (executed by Don Leonardo Simone) for Florence Duomo. He receives payments (1394, 1395) from the Calimala for a painting, likely the Enthroned Madonna and Child with Ss. Benedict, Peter, John the Baptist, and Miniato (since 1929, Contini-Bonacosi Collection [temporarily Pitti Palace], Florence), for the crypt altar of S. Miniato in S. Miniato al Monte, Florence.

1395 — Agnolo is paid (June) for an Assumption fresco (lost) on the Prato Duomo facade. He also designs a stained-glass window and four statues (carved by Pietro di Giovanni Tedesco and Niccolò di Pietro Lamberti) for the Florence Duomo. With Pesello, he creates monuments in the Florence Duomo to Pietro Farnese (d. 1363) (fragment) and to John Hawkwood (d. 1394) (a lost work, part fresco and part marble relief).

1396 — On 16 October Agnolo is buried in S. Croce, Florence.

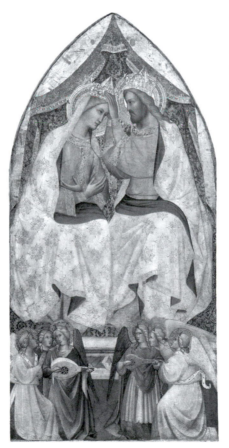

16–3. AGNOLO GADDI. *The Coronation of the Virgin*, ca. late 1380s, tempera on panel, 5'4" x 2'73" (162.6 x 79.4 cm), Samuel H. Kress Collection, National Gallery of Art, Washington, D.C. Agnolo's style in the True Cross cycle reflects his maturity as a narrative painter. Paintings close in date, like the Washington *Coronation*, display Agnolo's predilection for blond figures, pastel colors, and careful balance between decorative motifs and narrative drama. Christ's gentle placement of the crown on Mary's head and the seamless bond between Mother and Son are echoed in the two groups of closely joined angels in the foreground (see ANGELS, Duecento Glossary). The stringed instruments played by the angels are lutes (imported to Europe during the Crusades, lutes have a shape different from the psaltry, see fig. 2–1). Two angels appear to be plucking the strings with their fingers, two others sing along, and the two in the foreground clasp their hands in prayer, like images of hope (see fig. 10–2). The music is to be understood as divine because the setting is in heaven.

16–4. Nave and presbytery of S. Croce, begun 1294 (replacing the small church of 1228; consecrated 1443), Florence. From 1328, the Franciscans were made the custodians of the Holy Sepulcher (Christ's tomb in Jerusalem). The dedication of the church is to the Holy Cross. This view is toward the chancel of the church (see fig. 16–2), where Agnolo Gaddi's frescoes of the Legend of the True Cross appear (1388–93). The most visible frescoes from the nave are two miraculous events depicted near the entrance to the chancel: Giotto's fresco of the *Stigmata of S. Francis*, above the Bardi Chapel, and the *Assumption of the Virgin*, above the Tolosini Chapel, which had frescoes by Giotto that were whitewashed in the 18TH c. (chapel inherited by the Spinelli family in 1441 and later by the Sloane family). The *Assumption of the Virgin*, attributed to Giotto, is now thought to be the work of Giovanni di Bonino. South of the chancel in the Bardi Chapel are stories of Francis (see Giotto) and vault images of Franciscan virtues: poverty, chastity, and obedience.

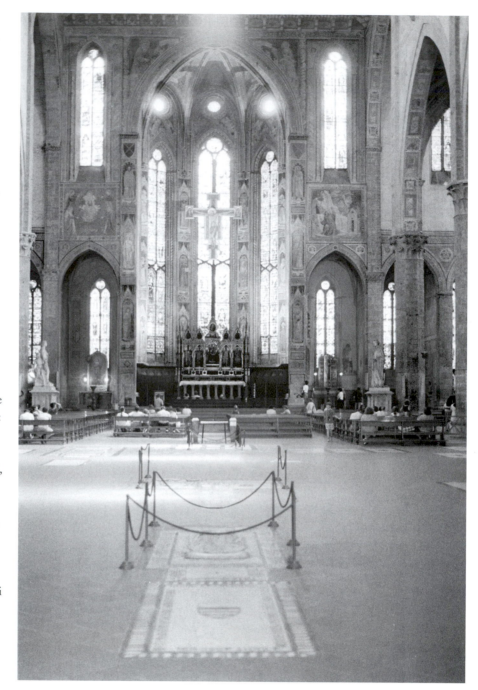

Among the most important churches in Florence, S. Croce had a big square in front of the entrance to the church that hosted many events: this is where heretics and vanities were burned, jousts were held among competing teams of the city's wards (from the 14TH c.), and costumed tournaments celebrated families like the Medici. The Franciscans settled here because of the poor. This quarter had the largest slum and workers' residence in Florence. It was the heart of the wool industry and the home of the dyers and wool workers (combers, carders, and weavers), who had no trade guild, but were the backbone of the wool business from which the merchant bankers grew very wealthy.

Quattrocento Italian Art Part Three

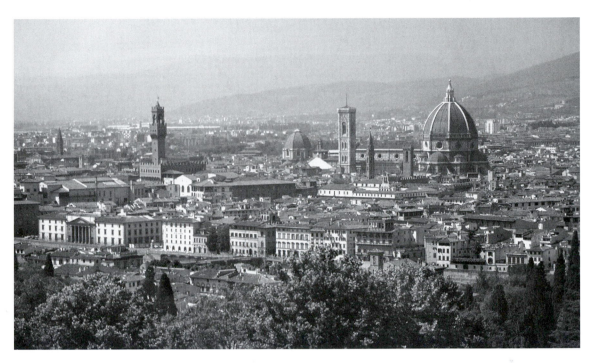

More than other communes or duchies, Florence gained a reputation in the Quattrocento (15ᵀᴴ c.) for offering artists a variety of employment. Florentine patrons provided a steady flow of contracts for aspiring master artists, while patrons in other communes and duchies, such as Siena and Milan, actively sought work by artists from Florence. The major focus of Part Three is on Florentine art and artists, for the range of art is representative, and the large number of artists and the quantity of art produced in Florence exceeded that of most major centers.

By the 1430s, political control of Florence had passed from the landed aristocrats (magnates) to entrepreneurial merchant bankers, such as Cosimo de' Medici, with the major trade guilds regulat-

III–1. View of Florence, as seen from the Olivetan church of S. Miniato al Monte (see figs. 2–2 and 62–7, #31). According to Gregorio Dati (1362–1435) in *Istoria di Firenze dall'anno* MCCCLXXX *all'anno* MCCCCV (History of Florence from 1380 to 1405), the virtuous acts of her citizens supported the government of Florence, whose glory was due to the intercession of the Virgin, the Baptist, and the grace of God. Dati's description of a representative government reveals a pragmatic structure whereby Florence was divided into four districts, or *quartieri* (quarters): S. Spirito, S. Croce, S. Maria Novella, and S. Giovanni, each subdivided into four *gonfaloni* (neighborhoods), making 16 in total. Nine men governed Florence for two-month periods (bearing some resemblance to the Sienese government): two priors (eight in total) were elected from each district and one standard-bearer of justice was elected from one of the four districts; membership in the guilds was a prerequisite for holding office (see Florentine Guilds). As in other cities (see Venetian Palaces and Scuole, fig. 66–6), Florentine guilds upheld communal duties by commissioning art. In Florence this included hiring sculptors to create marble and bronze statues of patron saints for public display at Orsanmichele (see fig. 63–1). Late Quattrocento Florence was eulogized as the home of great artists, the powerful Medici family, and republican government, with the beauty of the city praised both by its residents and by its visitors. In 1527, the Venetian ambassador Marco Foscari wrote: "There is in my opinion no region more sweet or pleasing than that wherein Florence is placed, for Florence is situated in a plain surrounded on all sides by hills and mountains."

ing city government. The most highly esteemed guilds sponsored sizable building campaigns, and communal funds were routinely allocated for the embellishment of Florence. Private patronage was encouraged, and wealthy families, like the Sassetti and Tornabuoni, enthusiastically sponsored projects, purchased chapels, and commissioned decoration in more than one church and in different *gonfaloni*. Young artists were drawn to Florence, where they could train with master artists and pursue their profession in a prosperous city.

In 1472, when Andrea del Verrocchio was working on the *Tomb of Giovanni and Pietro de' Medici* (see fig. III–2) and on the bronze statues for Orsanmichele (*Incredulity of Thomas*) (see fig. 36–1), both Leonardo da Vinci and Pietro Perugino were connected to his shop. Florence was at this time unrivaled in art and prosperity, according to Benedetto Dei (1418–92), a Florentine goldsmith and merchant, who traveled to the Near East and throughout Italy. Dei wrote that "Beautiful Florence has all seven of the fundamental things a city requires for perfection. First of all, it enjoys complete liberty; second, it has a large, rich, and elegantly dressed population; third, it has a river

with clear, pure water, and mills within the circuit of walls; fourth, it rules over towns, castles, lands, people, and communes; fifth, it has a university, and both Greek and accounting are taught; sixth, it has masters in every art; seventh and last of all, it has banks and business agents all over the world. Venetian, Milanese, Genoese, Neapolitan, Sienese, try to compare your cities with this one!"

Benedetto Dei was proud of his native Florence and thought that no other city he had visited could compare. To show that Florence was exceptional for its artistic activity, he listed master painters and sculptors by name and counted the various trade shops in the city, where it seems that artists (painters and sculptors) outnumbered the other tradesmen, except those in the cloth business. According to Dei, Florence had "270 shops of the wool guild . . . 83 lordly shops of the silk guild . . . 33 banks . . . 84 shops of woodworkers, in inlay and carving . . . 54 shops for stone, dressed and rough, and masters of carving and relief and half relief and foliage, inside and outside the city . . . 70 shops of butchers . . . 8 poulterers . . . 39 shops of goldbeaters and silver filigree, and expert masters of wax images the equal of the world . . . [and] 44 shops of goldsmiths and silversmiths."

III–2. ANDREA DEL VERROCCHIO. *Tomb of Giovanni and Piero de' Medici*, 1470–73, h. 10'1.5" (257.8 cm), S. Lorenzo, Florence (see Andrea del Verrocchio 1470). This very expensive tomb in which brothers Giovanni (d. 23 December 1463) and Piero de' Medici (d. 2 December 1469) were interred together is shown here from the back (as seen in the Old Sacristy), beyond which is the large, private Medici chapel dedicated to Cosmas and Damian (see fig. 19–2, #1, #8, and #20). Giovanni di Averardo (Cosimo de' Medici's father) commissioned both chapels (for the Medici genealogy, see fig. 61–2). Distinct from the floor tombs of S. Croce (see fig. 16–4), every facet of this monumental tomb has *all'antica* elements (see ALL'ANTICA, Quattrocento Glossary). Two garland-framed *tondi* (one on each face) and the marble plinth are inscribed in the manner of antiquity: the tondo facing the Chapel of Cosmas and Damian names the deceased (PETRO / ET JOHANNI DE / MEDICIS / COSMI P.P.F. / H.M.H.N.S.) and the tondo facing the sacristy gives their ages at death, in years, months, and days (PET. VIX. / AN. LIII M. V D. XV / IOHAN. AN. XLII M. III / D. XXVIII). Inscribed on the marble plinth (the inscription begins on the side facing the Chapel of Cosmas and Damian) are the patrons' names (Lorenzo and Giuliano) and the date 1472: LAURENT. ET IVL. PETRI F. / POSVER. / PATRI PATRVO QVE / MCCCCLXXII.

1401 COMPETITION FOR FLORENCE BAPTISTERY DOORS. The Calimala guild holds a competition for the second bronze doors of the Florence Baptistery; Lorenzo Ghiberti is awarded the commission (see fig. 18–1).

1402 MILANESE THREAT ENDS. On 3 September Milan's protracted threat to Florence ends when Duke Giangaleazzo Visconti dies of the plague. Giangaleazzo had become the single ruler of the County of Milan in 1385; he then brought Lombardy and Emilia under his rule, and in 1395 was crowned duke and hereditary ruler of Milan by the German Emperor Wencelaus. Between 1398 and 1402, he increased his territories, adding the towns of Siena, Pisa, Perugia, Spoleto, Assisi, and Bologna. After Giangaleazzo's death, Florentines celebrated their freedom, believing they were chosen people.

1403 PRAISE OF FLORENCE. Classical scholar Leonardo Bruni (1370–1444) writes *Laudatio florentinae urbis* (In Praise of the City of Florence). The chancellor of Florence from 1427 until his death, he was bestowed the laurel at his death.

1405 VENICE CONTROLS PADUA. Padua (conquered in 1399 by Venice) is placed under the control of the Venetian senate, and the university at Padua becomes the center of education for the Venetian realm.

1406 FLORENCE TAKES OVER PISA. Florence purchased Pisa from the Visconti, but when the city rebelled it was subdued in this year, giving Florence free access to the mouth of the Arno and increasing the hope of establishing an independent maritime trade outlet.

1411 FLORENCE ACQUIRES CORTONA. King Ladislas of Naples sells to Florence the commune of Cortona, which he had conquered in 1409.

1414 FLORENCE ESCAPES NEAPOLITAN CONTROL. Florence enters a prosperous period after escaping the threat of King Ladislas of Naples (1386–1414), who was poised to take control of the city when he signed a peace treaty with Florence (Ladislas died soon afterward of the plague). Florentines considered themselves twice blessed because they had earlier escaped the threat of Giangaleazzo Visconti (see entry 1402).

17–1. DONATELLO. *S. George*, ca. 1415–17, marble, h. 6'10.3" (209 cm), Museo del Bargello, Florence. Commissioned by the guild of armorers and shield bearers for Orsanmichele, Florence (see fig. 63–1). Dressed as a Christian knight in a suit of protective armor, S. George is a tower of valiant strength. He is prepared for doing battle, with nearly his entire body (arms, elbows, torso, thighs, and knees) covered with plates of metal, molded leather guards, and overlapping leather straps (thongs). His left hand steadies a large shield adorned simply with the pattern of the cross. Distinct from *condottieri* like Erasmo da Narni, for whom Donatello later created an equestrian statue (see fig. 21–7), George is in many ways the antithesis of the contemporary, mercenary hero. Instead, his ideal form portrays virtuous and unfettered strength. Florence had neither a standing army nor lordly ruler, and thus depended upon the will of its citizens. Donatello's *George* exhibits the type of quintessential courage Florentines believed could save them from tyrannical rulers: the Visconti of Milan (see entry 1402) or Ladislas of Naples (see entry 1414).

17–2. Crests of the House of Visconti of Milan. By 1419, Duke Filippo Maria Visconti was in full control of a duchy that was recovering from heavy taxation under his father (Giangaleazzo) and divisive rule under the *condottieri* (soldiers of fortune) who gained power after Giangaleazzo's death (in 1402) (see fig. V–1). Strife over the issue of succession weakened the rule of Giovanni Maria (Giangaleazzo's first son and heir, who was murdered in 1412). But with the death of Facino Cane (1412), the most powerful of the Milanese generals, Filippo Maria claimed his hereditary title and took charge of the duchy; he married Beatrice (Cane's widow), galvanized the military, and enriched the fortunes of Milan by usurping neighboring states. (Beatrice was murdered on a false charge of adultery in 1418.)

COUNCIL OF CONSTANCE. The council called to end the Great Schism (more than one man claimed to be pope) becomes thoroughly embroiled in political deals and betrayals. (Popes were elected by different conclaves, creating three lines: Pisa, Rome, and Avignon.) Forced to abdicate, John XXIII (Pisa line) fled the council disguised as a groom, but was returned as the council's prisoner; charged with gross misconduct, he was formally deposed and imprisoned in Germany (1416). Giovanni de' Bicci (Medici) and Niccolò da Uzzano negotiated John's freedom, but John was labeled an antipope (see fig. 69–5). Agreeing to abdicate in 1415, Gregory XII (Rome line) was allowed to convoke a fresh council and have his pontifical acts ratified by the united College of Cardinals. Deposing Benedict XIII (Avignon line) in 1417, the council was ended in 1418 (see fig. 69–4).

1419 MILAN THREATENS FLORENCE. Duke Filippo Maria Visconti of Milan begins a political expansion that threatens Florence.

MARTIN V STAYS IN FLORENCE. With his route to Rome blocked, Pope Martin stops in Mantua and then in Florence, staying 18 months in the papal apartments at S. Maria Novella.

DECORATION IN DOGE'S PALACE, VENICE. The decoration of the palace is underway, with that of the Great Council Hall finished. Artists on this project included Gentile da Fabriano and Pisanello.

1420 PAPAL CURIA RETURNS TO ROME. Martin found Rome in a deplor-able state and began an aggressive rebuilding campaign, according to his biographer Platina. The Medici and other Florentine banking houses negotiated profitable loans by financing his new plans.

1421 FLORENCE ACQUIRES LIVORNO. For 100,000 gold florins, Florence acquires the seaport of Livorno (Leghorn) from Genoa.

MILAN TAKES GENOA. Capitalizing on their peace treaty with Florence (1420), Milan takes Genoa.

1422 COUNT OF URBINO, AN HONORARY CITIZEN. For his military support of Florence, Count Guidantonio da Montefeltro of Urbino is made an honorary citizen of Florence.

1423 BRUNI TRANSLATES PLATO. Bruni translates *Phaedrus*.

HOLY YEAR IN ROME. Pope Martin V declares a holy year.

1424 FLORENCE LOSES FORLÌ. After Filippo Maria Visconti takes Forlì, Florence suffers reversals of fortune in their war with Milan (1423–28); territory in Romagna is lost (1424), and the Florentine troop commander is taken prisoner at the rout of Zagonara.

1425 BATTLE OF ANGHIARI. Fighting the Milanese, Florence loses a battle at Anghiari and enters an alliance with Venice and the papacy against Milan. During this strife, many artists left Florence, including Masolino (went to Hungary) and Donatello and Masaccio (both in Pisa in 1426).

1426 PEACE TREATY NEGOTIATED. Pope

Martin v negotiates a peace treaty with Florence, Venice, and Milan (30 December) in which Venice visibly benefits: she was to gain Brescian lands from Milan, and Florence was to be free of threats from Milan. Several Florentine artists worked in Venice during the alliance between Venice and Florence: Donatello, Uccello, Lippi, and Andrea Castagno.

1427 MILAN WARS WITH FLORENCE. In the spring of this year, Filippo Maria Visconti of Milan starts a war with Florence. Milan and Venice (ally of Florence) fought at Maclodio (near Brescia); the skirmish was won by the *condottiere* Francesco Carmagnola, gaining Bergamo for the Venetians (see entry 1431).

INSTITUTION OF CATASTO. Florence initiates the *catasto* (a census for levying property taxes) to fund the ongoing war with the Milanese. This was the first tax on property (not income) in Europe. Every Florentine household was to list family members (and ages), assets (property and investments), and debts. Deductions were allowed for the primary dwelling, debts, and dependents (the elderly and children). While the cost of war (1424–25) had crippled Florence, the catasto helped replenish the public coffers and financed both the expansion and defense of Florentine borders.

1428 FLORENCE AND MILAN NEGOTIATE A PEACE TREATY. Negotiating a new peace treaty with Milan, Florence begins funding military efforts with tax money. According to Giovanni Morelli's chronicle, war with Milan cost Florence about 70,000 lire a month before 1427.

1429 FILELFO JOINS THE FLORENTINE STUDIO. Franceso Filelfo (1398–1481) is appointed to a chair in the *Studio fiorentino* (the university), but had serious disagreements with Florentine humanists. He later worked in Milan for the Visconti and then the Sforza.

1431 LEAGUE UNITES AGAINST MILAN. A general accord against the Visconti of Milan is reached by Florence, Venice, and the papacy. Venice and Milan warred until 1433, with Venice executing the famed *condottiere* Carmagnola (see 1427) for treason in 1432.

POLICIES OF POPE MARTIN. Martin restores order to Rome by political alliances, exercising ecclesiastical prerogatives, exerting power over Naples, and reconciling the rival *condottieri* who controlled Rome.

PAPAL ELECTION. Martin v dies in Rome (20 February) and is succeeded by Gabriele Condulmer of Venice (Eugene iv). Donatello created the brass tomb monument for Martin in S. Giovanni in Laterano, Rome, the church of the bishop (the pope) of Rome.

JOAN OF ARC IS EXECUTED. During the Hundred Years' War, the soldier-heroine Joan of Arc fought on the battlefield for France, fulfilling her oath to drive the English from Orleans. Captured by Burgundians and sold to the English, Joan was executed for heresy and witchcraft. After a papal commission reversed the verdict, she was canonized by Pope Calixtus iii in 1456.

17–3. Crest of the House of Sforza of Milan. Filippo Maria Visconti's death in 1447 brought chaos to Milan because he left no male heir (see fig. V–2). His castle was sacked, valued possessions were looted, and succession to the duchy was contested. Two important rulers claimed the throne: King Charles vii of France revived the French claim to Milan (Giangaleazzo's daughter Valentina married Charles vii's uncle) and Alfonso the Magnanimous of Aragon (king of Naples) produced a will declaring that he was the rightful heir. Meanwhile, Venice took from the Milanese the towns of Bergamo, Brescia, and Ravenna, and marched against Milan. To halt the Venetian advancement the citizens of Milan formed the Ambrosian League, hiring Francesco Sforza as their general. Opposed to Venetian domination of northern Italy, Cosimo de' Medici in Florence acknowledged Sforza as the new leader of Milan. Sforza had married Visconti's daughter (see entry 1441).

17–4. Insignia of the Holy Roman Emperor (crown, orb, and scepter). In 1411, Sigismund of Luxemburg (1368–1437), son of Charles IV, held titles to the kingdom of the Germans and the kingdom of Hungary, and he was also the heir apparent (through Wencelaus) to the kingdom of Bohemia. His reign over Germany and Hungary was turbulent, and his lack of military strategy lost Dalmatia to Venice. Notorious for his subterfuge, he gave John Huss safe conduct to the Council of Constance (1415), but stood by while Huss was tried and burned at the stake. After persuading John XXIII (Pisa line) to call the council, ostensibly to end the Great Schism, he handed John over to his enemies upon his arrival. When Wencelaus died in 1431, the Bohemian crown that rightly belonged to Sigismund was kept from him (until 1436). With little hope of finding support in Italy, he left after holing up in Siena for six months (in 1431). Two years later he returned to be crowned Holy Roman Emperor by Eugene IV in Rome (31 May 1433).

COUNCIL OF BASLE. Elected at Constance by a reforming council (1417), Martin V agreed to hold another reforming council after his return to Rome. In 1431 he called for the Council in Basle, but died before it was convened. This council lasted eight years (1431–39).

1432 **EUGENE DISSOLVES THE COUNCIL OF BASLE.** Addressing two major issues (quelling the Hussite threat in Bohemia and limiting papal power), the Council of Basle is chiefly focused on sanctioning the new pope. Pope Eugene IV thus called for it to be ended.

1433 **MILAN & FLORENCE SIGN TREATY.**

COSIMO DE' MEDICI EXILED. Pictured as an inept diplomat by his enemies, Cosimo is exiled to Padua for ten years; he moved the family bank to Venice.

SIGISMUND CROWNED HOLY ROMAN EMPEROR. Eugene crowns Sigismund in Rome (see fig. 17–4). Although Sigismund would attempt to strengthen the empire, wars with German barons and religious uprisings in Bohemia thwarted his efforts.

ALBERTI WRITES DE STATUA. Leon Battista writes *De statua* (On the Statue) a discourse on sculpture and the first Renaissance canon on the proportions of the body.

1434 **EUGENE IV ARRIVES IN FLORENCE.** In May a rebellion erupts in Rome, compelling the pope to flee in disguise and seek refuge in Florence. He arrived there with a depleted Curia.

COSIMO RETURNS TO FLORENCE. The powerful Maso Albizzi (d. 1417) was succeeded by his son Rinaldo Albizzi, who headed Florentine politics at the death of Niccolò da Uzzano in 1432. Not as politically sharp as Maso, Rinaldo attacked Cosimo de' Medici, and arranged for his exile (see entry 1433). Yet Rinaldo and his supporters failed to control the government, pursued a costly, unpopular war with Lucca, and underestimated the number of Medici supporters in Florence, who gained control of the government in 1434, recalled Cosimo, and banished Rinaldo.

FLORENCE IN LEAGUE WITH VENICE. Florence and Venice combat the Milanese threat in Romagna and Tuscany.

1435 **PEACE WITH MILAN.** Duke Filippo Maria Visconti of Milan signs a new treaty with Florence (10 August), initiating a period of peace and prosperity for the Florentines. Visconti had already lost Brescia and Bergamo to Venice and Genoa revolted (in 1435). In addition, the famed *condottiere* Francesco Sforza, deprived of marriage to the duke's daughter, turned against the Milanese by offering his services to the Venetians.

ALBERTI WRITES PAINTING TREATISE. Leon Battista Alberti writes his treatise *De pictura* (On Painting) in Latin, dedicating the manuscript to Marchese Gianfrancesco Gonzaga of Mantua (see fig. V–2); Alberti later translated the text into Italian (*Della pittura*, 1436). This is the first systematic exposition of the rules of painters'

perspective discussing both the theory and practice of painting.

1436 **MILAN AT WAR WITH FLORENCE.** Milan (led by *condottiere* Piccinino) had defeated Florence at Imola in 1434. Hostilities between Florence and Milan began again in 1436 and lasted four more years, until the battle at Anghiari (29 June 1440), which brought an end to the long conflict between the two powers (see entry 1440).

1437 **NICCOLÒ NICCOLI DIES IN FLORENCE.** About half the library (about 400 volumes) of the Florentine humanist was bequeathed to the convent of S. Marco in Florence.

1438 **COUNCIL OF FERRARA.** An ecumenical council is convened in Ferrara (8 January) for the purpose of bringing together the East (represented by the patriarch, emperor, and scholars, like Plethon and his pupil Bessarion) and the West (Eugene IV, who befriended the Greeks and was responsible for the council). To escape the plague and for political and financial reasons, the council moved to Florence.

1439 **COUNCIL OF FLORENCE.** The ecumenical council meets in Florence between February and July.

LORENZO VALLA ON FREEDOM OF THE WILL. In Florence, the humanist Valla writes (1435–43) on the compatibility of the divine plan and man's freedom.

ALBERTI'S DELLA FAMILIA. *Della familia* (On the Family) (written 1433–39) discusses an individual's contribution to society.

1440 **INVENTION OF MOVEABLE TYPE.** In Germany Johannes Gutenberg invents the art of printing with moveable type (see 1456).

DONATION OF CONSTANTINE FOUND A FORGERY. Lorenzo Valla writes *De falso credita et ementita Constantini donatione declamatio*, proving that the document from Emperor Constantine to Pope Sylvester (called the donation of Constantine) was an 8TH–c. forgery. Based on this document, the papacy had claimed ownership of land in Italy, including the kingdoms of Naples and Sicily (Trinacria). Ownership had allowed popes to crown rulers and receive monetary and military tributes from the ruling lords.

BATTLE OF ANGHIARI. Florence defeated the Milanese (under the leadership of *condottiere* Piccinino) at Anghiari without bloodshed. According to Machiavelli, "Only one man died, and not from wounds or any other heroic enterprise, but from falling from his horse and being trampled to death" (*History of Italy*, 1520–25).

1441 **VISCONTI AND SFORZA MARRIAGE.** Bianca Maria Visconti marries Francesco Sforza. After resisting his daughter's marriage to Sforza for many years, Duke Filippo Visconti of Milan finally approved the union, giving the town of Cremona as part of the dowry. Because she was an illegitimate child of Filippo Maria, Francesco's later claim to the duchy was challenged (see fig. 17–3).

1442 **CONQUEST OF NAPLES.** Conquering Naples, Alfonso of Aragon defeats René of Anjou, who fled.

17–5. Insignia of the Pope (tiara and keys). Politically inept, Pope Eugene IV met increasingly hostile resistance at the council. Unable to relocate to friendlier and familiar ground in Bologna, the pope dissolved the council on 18 December 1431. Refusing to end its business, the council tried Eugene for contumacious behavior in 1432. On 15 December 1433, Eugene was forced to recognize the existence and power of the council and to withdraw his bull of dissolution. In May 1434 a rebellion erupted in Rome, compelling the pope to flee in disguise and seek refuge in Florence. He arrived with a depleted Curia, having lost control of the Papal State and Christendom. In 1439 council members in Basle (one cardinal and thirty–two electors) formally revived the Great Schism: they deposed Eugene IV (25 June) and elected as antipope Amadeus VIII, duke of Savoy (5 November), crowned Felix V (24 June), who abdicated ten years later and was declared an antipope (see fig. 66–2).

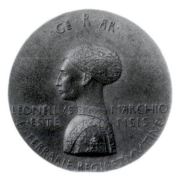

17–6. ANTONIO PISANELLO. *Marchese Leonello d'Este of Ferrara*, obverse (front), 1444, bronze, cast, d. 10.05 cm, National Gallery of Art, Washington, D.C. Marchese Leonello d'Este (1407–50) hired Pisanello to create this medal to commemorate his marriage to Maria of Aragon (d. 1449); she was Leonello's second wife. Margarita Gonzaga, his first wife, had died at the age of twenty-one in 1439; her brother was the famed *condottiere* Ludovico III, Marchese of Mantua (see fig. V–3). Lineage was important to Leonello, who as the illegitimate son of Niccolò III was legitimated by the pope. His alliance with the House of Aragon appears in the inscription, which reads from the top: GE[NER] R[EGIS] AR[AGONUM] (son-in-law of the king of Aragon); LEONELLVS MARCHIO ESTENSIS (Marchese Leonello d'Este); D[OMINUS] FERRARIE REGII ET MVTINE (Lord of Ferrara, Reggio, and Modena).

1443 POPE EUGENE IV RETURNS TO ROME. Having resided nine years in Florence, Eugene returns to Rome after recognizing Alfonso's claim to Naples, reconciling differences with Aeneas Silvius Piccolomini (later Pius II), and securing a union with the Greek Church.

ALFONSO BECOMES KING OF NAPLES. Eugene IV invests Alfonso I (called "the Magnanimous") of Aragon with the kingdom of Naples.

1444 BERNARDINO OF SIENA DIES. The Franciscan reformer Bernardino da Masa (b. 1380) dies in Siena.

1446 JEWS IN FLORENCE ORDERED TO WEAR BADGES. An edict of the Signoria mandates that all Jews (except moneylenders) wear yellow badges.

1447 FILIPPO MARIA VISCONTI DIES.

POPE EUGENE IV DIES. Eugene IV dies at the peak of his secular and ecclesiastical power; he is succeeded by Tommaso Parentucelli of Sarzanza (Nicholas V, d. 1455). The new bibliophile pope had tight connections to the humanist circle in Florence and was determined during his tenure that Rome should become the imperial capital of arts and letters: he thus sponsored new construction and drew artists and humanists to the Leonine (Vatican) city.

1450 SFORZA DECLARED DUKE OF MILAN. By popular acclamation, Francesco Sforza becomes the duke of Milan. When the Ambrosian republic fell apart in 1450, Francesco had already been openly ruling Milan (with Cosimo's support).

DEATH OF LEONELLO D'ESTE (see figs. 17–6, 17–7).

HOLY YEAR IN ROME. By this date many of Pope Nicholas V's projects had been completed, including Fra Angelico's frescoes for the his private chapel (S. Nicholas Chapel) in the Vatican apartments, with its frescoes dedicated to stories of Stephen and Lawrence (the body of S. Stephen was discovered in 1447 in S. Maria in Aracoeli, Rome). During the Holy Year hundreds of pilgrims died when the Ponte S. Angelo fell. This was the major ponte (bridge) that crossed the Tiber River near S. Peter's (see fig. 67–3).

1452 GIANNOZZO MANETTI IN FLORENCE. In this year Manetti completes his optimistic discourse on the human condition, *On the Dignity and Excellence of Man* (published in 1532; condemned by the Inquisition in 1584). A disciple of the Augustinian humanist Ambrogio Traversari, the Florentine Manetti delivered the funeral oration for Bruni in 1444, but was exiled from Florence in 1453 for opposing Cosimo de' Medici.

BORSO D'ESTE DUKE OF MODENA.

ALBERTI COMPLETES DE RE AEDIFICATORIA. Alberti's manuscript (begun ca. 1440) discusses the theory and practice of building. The treatise was later published in Florence in 1487.

1453 CONSTANTINOPLE IS SACKED. Ottoman Turks under Sultan Mehmed II sack the city.

HUNDRED YEARS' WAR ENDS. The

long war between France and England (begun 1337) is ended.

1454 PEACE OF LODI. Two years before the Peace of Lodi, Venice and Naples had signed a pact against Milan and Florence (in 1452). In the following year, Florence called for the help of René of Anjou to thwart the Neapolitan invasion of Tuscany and Francesco Sforza successfully fought for and regained territory in Lombardy that the Venetians had taken from Milan in the previous years. However, during the war with the Ottoman Turks, a peace agreement (Peace of Lodi) is reached between Venice, Florence, Milan, Naples, and the papacy (9 April 1454). Since the primary objective of the agreement was to prevent Italian wars and foreign intervention, the treaty superseded all previous pacts. (Once bitter enemies, Florence and Milan were to remain close allies for forty some years.)

1455 POPE NICHOLAS V DIES. Francesco Borgia of the Spanish family from Zativa succeeds Nicholas V; his papal title is Calixtus III. The most famous Borgia pope would be Alexander VI (see entry 1492).

1456 GUTENBERG BIBLE. Johann Gutenberg, Johann Fust, and Peter Schöffer produce a Latin Bible (variously called the Gutenberg, Mazarin, and 42-Line Bible); it was the earliest known volume printed with moveable metal type in Germany. By 1470 presses using moveable type were introduced into Italy (see entry 1465), and book publishing houses were established by the end of the century. Aldus Manutius (1450–

1515) founded the Aldine Press in Venice (ca. 1494) to publish Greek and Latin classical texts in their original language, and he employed distinguished classical scholars as editors and compilers of the texts. The publication of these first editions coincided with the increased interest in classical imagery in literary and pictorial form.

1458 PAPAL ELECTION. Succeeding Pope Calixtus III is the humanist scholar, Aeneas Sylvius Piccolomini of Corsignano (r. 1458–64), who adopts the title Pius II.

1459 COUNCIL OF MANTUA. Pope Pius II calls a conference meant to further the alliance of Western princes against the Turks.

1461 KING CHARLES VII OF FRANCE DIES. King Charles is succeeded by his son Louis XI (remembered for his efficiency and civil reforms), who ruled for 12 years. He was succeeded at his death by his son Charles VIII, who invaded Italy to claim the throne of Naples (1494).

1462 FIRST PUBLIC BANK IN PERUGIA.

PIUS II CREATES PIENZA. Pope Pius II redesigns his native Corsignano and changes the name of the town to Pienza.

FICINO ACQUIRES VILLA CAREGGI. In appreciation of his scholarship, Cosimo de' Medici gives the villa in Careggi to Marsilio Ficino (1433–99), the son of Cosimo's physician. The villa became the future home of the Platonic academy in Florence (see entry 1469).

1463 BESSARION IN VENICE. Cardinal

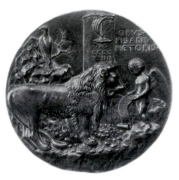

17–7. ANTONIO PISANELLO. *Marchese Leonello d'Este of Ferrara*, reverse (back) (see fig. 17–6), 1444, bronze, cast, d. 10.05 cm, National Gallery of Art, Washington, D.C. Inscribed is Pisanello's name and the date in Roman numerals. The imagery seems to be lighthearted. A winged child (putto), who holds a scroll with musical notation, is thought to be teaching the lion to sing (the lion stands for Leonello). The falcon is an insignia of the family, and the full-blown sail alludes to strength in weathering storms. Leonello died at the age of forty-three in Ferrara, where he created an unrivaled cultural center, influenced by such humanists as Guarino da Verona (arrived in Ferrara in 1430 as Leonello's tutor and professor at the university) and many notable artists invited to the court by Leonello (Pisanello, Jacopo Bellini, Mantegna, Piero della Francesca, Rogier van der Weyden, and Alberti).

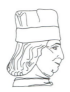

17–8. Illustration after Francesco del Cossa's images of the smiling Borso depicted in the Hall of Months, Villa Schifanoia, Ferrara. Like Leonello (see fig. V–3), Borso d'Este (1413–71) was an illegitimate son of Niccolò III (d. 1441). He succeeded Leonello as ruler of Ferrara in 1450 and was invested as the duke of Modena and Reggio by the Holy Roman Emperor Frederick III. In Borso's court in Ferrara were two distinctive painters, Cosimo Tura (1431–95) and Francesco del Cossa (1435–77), and two famed humanist scholars, Guarino da Verona (1374–1460) and Pellegrino Prisciani (1435–1518); when the Villa Schifanoia was refurbished, these men were responsible for the conception and execution of frescoes that glorified Borso's rule, praising his just and good government and his military prowess. Six days before his death, Borso was created the duke of Ferrara by Pope Paul II (on 14 August 1471). The hereditary title ensured the Este family continued leadership of Ferrara (see fig. 17–9).

Bessarion is elected to the Scuola Grande dei Battuti della Carità; he then promised to the Scuola his reliquary containing fragments of Christ's robe and the cross on which Christ was crucified.

1464 **COSIMO THE ELDER DIES.** Cosimo dies in the villa at Careggi (1 August); his son Piero takes over the family business (see fig. 61–2).

PAPAL ELECTION. Pius II dies in Ancona, waiting for the military support to launch a crusade against the Ottoman Turks. Succeeding Pius was Paul II (r. 1464–71) of the Venetian Barbo family.

FILARETE'S TREATISE. In 1464 the Florentine sculptor and architect Antonio Averlino, who adopted the Greek name Filarete ("love of virtue"), completes his treatise on architecture while he was working in Milan (1450–65) for Duke Francesco Sforza, to whom he dedicated the treatise. In the treatise, *Trattato di architettura* (begun 1460), Filarete describes an ideal city, which he called Sforzinda after the Sforza. Filarete also presented his work to Piero de' Medici (Cosimo's son) and to Galeazzo Maria Sforza (Francesco Sforza's son).

1465 **FIRST PRINTING PRESS IN ITALY.** The first printing press is established at the monastery at Subiaco (near Rome) by German immigrants; in 1467 books were printed in Rome and in 1469 in Venice, where the printing trade was to flourish and paper production was notable.

WAR BETWEEN VENICE AND THE TURKS. During this war, the Levantine trade in the Mediterranean was halted and Florentine firms suffered losses, with some bankrupted. To save the overextended family business, Piero closed the Medici bank in Venice and called in debts, causing widespread hostility in Florence.

1466 **FRANCESCO SFORZA DIES.** On 8 March Duke Francesco Sforza of Milan dies and is succeeded by his son Galeazzo.

COSIMO DECLARED PATER PATRIAE. In March the government bestows an honorific title on Cosimo de' Medici (see fig. 61–1).

ANTI-MEDICI REVOLT. Four prominent Florentines (Luca Pitti, Agnolo Acciaiuoli, Niccolò Soderini, and Dietisalvi Neroni) considered Piero de' Medici too inexperienced in matters of government and had attempted to undermine his authority since 1465. Antagonism between the factions nearly provoked a civil war in Florence as troops from Ferrara approached Florence to support the anti-Medici rebels. However, Luca Pitti (see fig. 64–6) negotiated a reconciliation with Piero. With Piero's sanction, the Signoria pardoned Luca and exiled the other rebels, who went to Venice, where they employed the captain-general of the Venetian troops, Bartolommeo Colleoni (see fig. 36–5); Count Federico II da Montefeltro of Urbino was hired to fight for Florence. The battle of Imola (1468) ended the struggle between the two factions, gaining the fortresses of Sarzana and Sarzanello for the Florentines.

1467 **FLORENCE CHANCELLOR LANDINO.**

The humanist poet Cristoforo Landino (1424–98), chair of poetry and rhetoric at the university (*Studio fiorentino*) and member of the Platonic academy in Florence, becomes the chancellor of the city. His commentary on Dante's *Divine Comedy* (published in 1481) was illustrated with engravings after Botticelli's designs.

1468 **LIBRARY OF BESSARION.** Cardinal Bessarion leaves his considerable library to the republic of Venice.

1469 **FICINO TRANSLATES PLATO.** The humanist, philosopher, scholar, and tutor of Cosimo's sons, Marsilio Ficino, completes Latin translations (begun 1466) of Plato's Greek *Dialogues* (revised and printed in 1484). Ficino started the Platonic academy in Florence. It was loosely organized and similar to a religious community, with informal conversations, lectures, readings, and banquets. Ficino's greatest patrons were Cosimo and Cosimo's grandson Lorenzo.

PIERO DE' MEDICI DIES. With Piero's death, his eldest son, Lorenzo, takes over the family.

FERDINAND AND ISABELLA MARRY. The union between Ferdinand of Aragon and Isabella of Castile joined two wealthy provinces, initiating Spain's unification.

1470 **PRINTING PRESS IS INTRODUCED IN FRANCE.**

LORENZO DE' MEDICI KNIGHTED.

1471 **PAPAL ELECTION.** Sixtus IV (r. 1471–84), Francesco Della Rovere of Savona, succeeds Pope Paul II.

ERCOLE I D'ESTE, DUKE OF FERRARA. Ercole succeeds his half-brother Borso d'Este as Duke of Ferrara (see fig. 17–9). A military leader, statesman, and zealous patron, he built and redecorated churches, supported an extension of Ferrara (called the Herculean Addition), and generously supported court scholars and artists, like Prisciani and Ercole de' Roberti (d. 1496).

1472 **FLORENCE SACKS VOLTERRA.** Disputes with Florentine businessmen over contracts concerning their rights to mine alum in Volterra led to the city's revolt. Under Lorenzo de' Medici's order, Federico II da Montefeltro and his troops quashed the uprising in Volterra. A peace agreement was signed, but misdirected troops sacked the town (Montefeltro hanged the leaders responsible).

1473 **LORENZO DE' MEDICI REFOUNDS UNIVERSITY OF FLORENCE.**

1475 **JOUST IN FLORENCE.** A tournament is hosted by Giuliano de' Medici. (Medici also hosted jousts in 1455 and 1469.)

1476 **ASSASSINATION OF DUKE GALEAZZO SFORZA OF MILAN.** Unpopular for his repressive policies, Galeazzo Maria is assassinated. In the years following the murder of his brother, Ludovico (Il Moro) was the de facto ruler of Milan as the regent for his young nephew, Giangaleazzo (1469–94), who succeeded Galeazzo.

1477 **CAXTON BEGINS PRINTING PRESS IN ENGLAND.**

1478 **PAZZI CONSPIRACY IN FLORENCE.** On 26 April, a murder plot against

17-9. Crest of the Este Family of Ferrara. Ferrara became a duchy in 1471, during the reign of Borso d'Este (see figs. 17–8, V–3). Borso had no heirs, and the throne went to his half-brother Ercole I (see entry 1471). Dynastic marriage in the House of Este linked the family with preeminent courts of Italy (Malatesta of Rimini, Sforza of Milan, Gonzaga of Mantua, Montefeltro of Urbino). They were also linked to the papacy when Duke Alfonso I (son of Ercole I and heir to the duchy) married Lucrezia Borgia (the daughter of Pope Alexander VI). All three Este brothers (Leonello, Borso, and Ercole I) were notable art patrons. Their descendants Isabella d'Este (1474–1539) and Alfonso I (1476–1534) learned from them how to acquire for their own collections the art of classical antiquity and the art of contemporary artists considered to be the best in their profession.

17–10. FLORENTINE ART-
IST. *Bust of Giuliano de'
Medici*, marble, Museo
del Bargello, Florence.
With the death of his
brother Giuliano,
Lorenzo had to make
serious decisions con-
cerning the future
of the fam-
ily. In the 1470s,
branches of the
Medici bank
suffered high fi-
nancial losses from
bad management,
exacerbated by the
Pazzi war. To salvage
the family business,
Lorenzo closed bank
branches (Bruges, Lon-
don, and Lyons) and
took large repayments
in cash—others were
forbidden to do so—
from the Communal
Bank (1482 and 1488–89)
to bolster his finances
and avoid bankruptcy
(see entry 1495). On his
deathbed he called for
and received absolu-
tion from Savonarola,
who the year before
had spoken of Lorenzo
(although not by name)
as a tyrant, perverter of
law, exploiter of the fisc,
and oppressor of the
poor. Lorenzo was bur-
ied in the Old Sacristy
of S. Lorenzo with his
ancestors. The bodies of
Lorenzo and his brother
Giuliano were moved
(in 1559) to the New
Sacristy, designed by
Michelangelo.

the Medici was carried out dur-
ing High Mass in the cathedral:
Giuliano died, but Lorenzo es-
caped into the north sacristy. The
wealthy Florentine Francesco
Pazzi led the attack, backed
by powerful men outside
Florence, including Pope
Sixtus IV, who had earlier
replaced the Medici
with the Pazzi as his
new bankers, Count
Girolamo Riar-
io (nephew of Sixtus),
Giovanni Battista da
Montesecco (a captain
working for Riario), and Frances-
co Salviati (archbishop of Pisa).

1479 VENETIAN TRADE REVIVED. Venice
signs treaty with Ottoman Sultan
Mehmed II reviving their trade
with the Aegean.

1480 POLITIAN AT THE STUDIO. Lorenzo
de' Medici appoints Angelo Po-
liziano (called Politian) to the
Greek and Latin Chair at the
university.

POPE SIXTUS IV LIFTS THE INTER-
DICT ON FLORENCE.

1483 KING LOUIS XI OF FRANCE DIES.
Charles of Anjou, called the Af-
fable (b. 1470), succeeds his father
as King Charles VIII.

1484 PAPAL ELECTION. Innocent VIII
(r. 1484–92) of the Cibo family of
Genoa succeeds Sixtus. Milan
and Florence upset his efforts to
install a relative on the Neapolitan
throne.

PEACE OF BAGNOLO. While Venice
and the papacy were at war with
the Este of Ferrara (1482–84),

intending to divide the duchy be-
tween them, Lorenzo de' Medici
joined Milan and Naples to force
a truce (7 August 1484).

1485 FICINO'S NEO–PLATONIC WRITINGS.
Ficino's *Theologica platonica de
immortalitate animarum* (Platonic
Theory on the Immortality of
the Soul) seeks to reconcile the
ideas of Plato, Neoplatonism, and
Christianity.

1488 GIOVANNI PICO DELLA MIRANDOLA
IN FLORENCE. The humanist-
philosopher Pico, having written
Oration on the Dignity of Man (ca.
1486), dedicates the *Heptaplus*
(sevenfold interpretation of Gen-
esis) to Lorenzo de' Medici.

1489 VENICE ACQUIRES THE ISLAND OF
CYPRUS.

1490 SAVONAROLA ARRIVES IN FLORENCE.
Invited by Lorenzo de' Medici,
the Dominican Girolamo Savon-
arola returns to Florence, where
he preaches in the cathedral.

1491 LUDOVICO SFORZA MARRIES BEA-
TRICE D'ESTE. Between 1479 and
1493, Ludovico (Il Moro) cata-
pulted the Sforza to power and
legitimacy through marriages
linking his court at Milan with
the Este of Ferrara (he married
Beatrice d'Este and his niece
Anna Maria married Alfonso I
d'Este) and the Habsburg Empire
(his niece Bianca Maria married
Emperor Maximilian I).

1492 COLUMBUS SAILS TO WEST INDIES.
Aiming to sail the world, Genoese
Cristoforo Columbo (1451–1506),
funded by Isabella and Ferdinand
of Spain, lands in the Indies.

CHRISTIAN SPAIN CAPTURES GRANADA. With the expulsion of Muslims from Spain also came that of the Jews.

GIOVANNI DE' MEDICI BECOMES A CARDINAL. Named cardinal deacon in 1489 by Pope Innocent VIII, Giovanni (later Pope Leo x), aged 17, leaves Florence to officially join the Sacred College in Rome.

LORENZO DE' MEDICI DIES IN FLORENCE. At the age of 43, after heading his family for 20-some years, Lorenzo dies (8 April) at the Villa Medici in Careggi. He had long suffered from asthma, arthritis, acute gout, and stomach and kidney diseases.

PIERO INHERITS MEDICI DYNASTY. Less politically astute than his father, Piero quickly distances some of the more powerful Medicean supporters.

PAPAL ELECTION. Alexander VI (r. 1492–1503), from the Spanish Borgia family of Valencia, succeeds Innocent VIII.

1493 ALEXANDER VI DIVIDES NEW WORLD. Spanish-born, Pope Alexander VI divides land and treasures of the new world between the Spanish and Portugese crowns.

MARTIN SANUDO WRITES ABOUT VENICE. A Venetian patrician, Sanudo (1466-1536) writes *Laus urbis Venetae* (Praise of the City of Venice), giving firsthand information about the city, its inhabitants, and local customs.

1494 CHARLES VIII INVADES ITALY. Ludovico Sforza of Milan called upon the French to reconquer the kingdom of Naples, and Charles of Anjou (Charles VIII of France since 1483) entered Lombardy with an army of more than 30,000 men to do the job. (Charles belonged to the Angevin line that still claimed the Neapolitan throne.)

PIERO DE' MEDICI EXPELLED. Because Piero backed the king of Naples, the French retaliated by invading Florentine territory; Piero capitulated, handing over the fortresses at Sarzana, Sarzanello, Pietrasanta, and Ripafrutta. Acting without the government's consent, he was accused of treachery and summoned to the town hall, where he went with armed men. He was barred from entering, the bell was sounded to call people into the piazza, and the crowd railed against him. Piero and his brothers fled from the town.

PISA SURRENDERS TO CHARLES. After taking Pisa, King Charles VIII of France marches into Florence (17 November), and resides in the Medici palace. Negotiating with the Florentines, he demanded money and that he be allowed to retain Florentine possessions, including Pisa; he also asked that Piero de' Medici be allowed to return. Florence rejected the demands and threatened warfare (Charles left town 28 November).

NEW CONSTITUTION IN FLORENCE. Florence becomes a republic.

1495 LORENZO DE' MEDICI POSTHUMOUSLY CHARGED. Declaring that Lorenzo had improperly taken money (74,948 *fiorini larghi*) from the Communal Bank, the Flor-

FRA GIROLAMO SAVONAROLA (1452–98). Savonarola, whose grandfather had been the court physician of the Este in Ferrara, entered the Dominican Order in Bologna in 1475. Eight years later he went to Florence as a lector, staying there for five years. During a second trip to Florence (1490–98), he became the most popular preacher in town, drawing large crowds to the cathedral. In 1491 he became the esteemed prior of San Marco and was named in 1493 the vicar–general of the Dominican Order in Tuscany by Pope Alexander VI, who supported his planned reforms. Savonarola's high-pitched, fevered proclamations against sin and corruption reached broad audiences from diverse intellectual, social, and economic backgrounds. After the Medici were exiled and Florence became a republic again, Savonarola was hailed a prophet for having forecast troubles in Italy that culminated in the invasion and demands of King Charles VIII. Savonarola was one of the most powerful men in Florence in the 1490s, and he gave the opening address in 1496 for the new Florentine government.

17-11. Illustration of Fra Girolamo Savonarola wearing the black Dominican habit of his order. Recognizable by his piercing eyes and gaunt, sunken cheeks, the preacher-reformer Savonarola is perhaps most easily distinguished by his boney, hook-shaped nose. During the peak of his influence, it seems highly likely that his denouncements and reservations about art affected religious and secular commissions in Florence between 1494 and 1497. He convinced many Florentines to burn vanities (indecent art, books, mirrors, jewelry, and apparel) in large open bonfires during Lent (the most famous bonfire of vanities was 7 February 1497). To encourage citizens to give up such possessions, he sent young boys dressed as angels in white robes into the neighborhoods to collect the objects.

entine government demanded repayment.

CHARLES VIII RETURNS TO FRANCE. King Charles VIII is driven from Italy by the Holy League (Venice, Milan, Emperor Maximilian, and Pope Alexander VI), whose troops were led by Captain General Francesco II Gonzaga of Mantua. Charles died without an heir; his cousin (the duke of Orleans), a descendant of Charles V (d. 1380), was crowned Louis XII in 1498.

1497 **SAVONAROLA ACCUSED OF HERESY.** Franciscans close to Alexander VI accuse Savonarola of heresy. Though summoned to Rome, he refused to go; Alexander then excommunicated him and threatened the Florentines against letting him preach in the cathedral.

JACOPO DE' BARBARI'S PIANTA DI VENEZIA. About this time, Barbari (ca. 1460–ca. 1516) begins the *View of Venice*, a monumental woodcut completed in 1500. It became the most famous picture of the city, notable for its careful details.

1498 **EXECUTION OF SAVONAROLA.** Savonarola and two supporters are arrested in San Marco. Imprisoned, tortured, and tried by government officials of Florence and ecclesiastical commissioners from Rome, they were found guilty of heresy and hanged and burned in the Piazza della Signoria (23 May). In protest against the friar, the Signoria ordered the bell of S. Marco (called the *Piagnona*) to be dragged through the streets. Savonarola's followers were called the *Piagnoni* (whiners or snivelers).

MACHIAVELLI IS SECRETARY OF FLORENCE. Niccolò Machiavelli (1469–1527) is appointed Secretary of the Second Chancery of the Signoria. He served the republic until 1512 when the Medici (supported by Pope Julius II) returned to power, and he was soon discharged from office.

VESPASIANO DA BISTICCI DIES. The Florentine manuscript copier and bookseller Vespasiano, who began about 1482 to compile his *Vite* (biographies of 103 notable men, including popes, rulers, bishops, statesmen, and writers), dies in Florence. He had great admiration for Cosimo de' Medici.

1499 **CESARE BORGIA.** Cesare Borgia (1475–1507), son of Rodrigo Borgia (Alexander VI), begins a military campaign to subdue rebellious towns in the Papal State.

KING LOUIS XII OF FRANCE TAKES MILAN. Louis drives out Ludovico Sforza twice from Milan.

VENICE LOSES MODON, LEPANTO, AND CORONE TO TURKS.

PORTUGUESE DISCOVER ROUTE TO INDIA.

HYPNEROTOMACHIA POLIPHILI. In Venice Aldus Manutius (1450–1515) publishes the philosophical romance by the Dominican friar Francesco Colonna, *Hypnerotomachia Poliphili*, notable for its woodcut images (see Cinquecento History Notes 1509).

With the return of Pope Martin v to Rome early in the century, and the end of the Great Schism, the papacy made the Eternal City its permanent home and began to rebuild and refurbish cherished monuments. This marks the beginning of a new Rome. Central to the health of most towns in the Quattrocento was the civic pride of its citizens. In this regard, the visual arts served as the vehicle for expressing personal and corporate identity (see fig. 18–1). For the Church, state, and corporate groups, ancient models provided an exciting source of forms and motifs that were used to enrich the mythology of the princes and the communes as well as wealthy or learned individuals. Five major powers (Milan, Venice, Florence, Naples, and the papacy) dominated political affairs. There were frequent internal power struggles in this century, with new duchies created where strong *condottieri* were the heads of state, as in Ferrara (1471) and Urbino (1474). Politics in southern Italy had wide-reaching effects when Alfonso of Aragon (king of Naples, 1442–58) wrested the Kingdom of Naples (including Sardinia and Sicily) from René I of Anjou; Italy then suffered a series of invasions from outside forces starting in 1494, with King Charles VIII of France (grand nephew of René) leading his troops down the peninsula to claim the Kingdom of Naples (see figs. 18–8, V–6).

ADORATION OF THE MAGI — In the Quattrocento this was an important religious theme. Brotherhoods devoted to its celebration would have processions on the feast day, reenacting the sacred event. Cosimo de' Medici, a member of the Compagnia dei Magi in Florence, hired Benozzo Gozzoli to paint the walls of his palace chapel with the story of the *Procession of the Magi*. According to the biblical account, wise men from the East (Gk. *magos*), a learned class in ancient Persia, came to Jerusalem searching for the child who had been born the king of the Jews, called the Messiah (Christ); they had observed

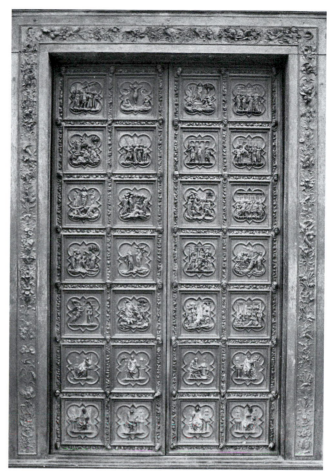

18–1. LORENZO GHIBERTI. *Scenes of the Life of Christ*, 1403–24, gilded bronze, 15' x 8'3" (457.2 x 251 cm), without frame, north doors, Florence Baptistery. These bronze doors were of great civic pride to Florentines: they were created by a Florentine and they had a new look. Ghiberti's patrons, the Calimala (see fig. 63–3), decided in 1403 to move Andrea Pisano's doors (see fig. 9–1) to the south side of the baptistery, giving Ghiberti's doors the place of honor on the east. His contract called for Gospel stories, rather than the Old Testament scenes originally planned, and he executed 20 panels depicting New Testament stories and 8 panels of the four Evangelists and four Latin Church Fathers. Above the *Nativity* and *Adoration of the Magi* (scenes near his self-portrait), he inscribed his name: OPUS LAURENTII FLORENTINI (see fig. 20–1). The Calimala then decided in 1452 that the beauty of Ghiberti's newest doors (see fig. 20–5), with their golden *all'antica* figures, deemed them worthy of replacing these doors (moved to the north side).

18–2. PIERO DELLA FRANCESCA. *Baptism of Christ*, ca. early 1450s, tempera on panel, 5'5.8" x 3'9.7" (167 x 116 cm), National Gallery, London. Trecento images sometimes show Jesus submerged to his waist in the Jordan River, but here he stands firmly on land just beyond the water, perhaps in reference to the tradition that God caused the river to leave its bed. Piero's *Baptism* calls to mind the words of the Baptist in the Gospel of John, describing how the Holy Spirit descended and stayed upon Jesus. No previous depiction shows the dove so stationary or immobile. The serenity of the moment is further enhanced by the symmetry and stillness of Jesus and the attending angels, all of whom resemble polished, pearly white antique marble statues. The perspectival arrangement of the trees and the geometrical pattern of the figures creates such regularity that nothing—not the implied movement of John, nor the man disrobing behind him—will change, and the peaceful balance of this mystical moment will never be thrown into flux.

his star rising and had come to pay him homage (Mt 2:1–2). When the king of Judea, Herod of Ascalon, learned that the Messiah had been born, he worried that this newborn king would usurp his throne. In questioning the chief priests and scribes of the Jews about where the birth was to take place, Herod learned that a prophet (Micah) had predicted that in Bethlehem (Mi 5:2–5) "shall come a ruler who is to shepherd my people Israel" (Mt 2:6). Herod secretly summoned the Magi to discover when they first saw the star and asked that they continue their search. When they found the Messiah, they were to send Herod word because, he told them, he also wanted to pay homage to this child. According to Matthew, the Magi followed the star and found the Child with Mary in a house; they entered and knelt down before him, offering precious gifts of gold, frankincense, and myrrh (Mt 2:11). Voragine later interpreted the three gifts as symbolic of the special nature of the Child (*Golden Legend* 1:84); they represent his divinity (gold, the most precious metal), his prayerful soul (frankincense, or pure incense), and his uncorrupted flesh (myrrh, a balsam that preserves). According to New Testament apocryphal writings, the magi followed the star not to a house but to a cave, where they found Mary and the Child, to whom they gave precious gifts of gold, frankincense, and myrrh from leather pouches (*Book of James* 21:3–4). An angel warned the Magi in a dream not to return to Herod, and they went home by a different route (Mt 2:12). Matthew is the only canonical Gospel writer to record the visit of the Eastern astrologers, although it appears in the apocryphal writings. From the Medieval period, the Magi were identified as Caspar (oldest), Balthazar, and Melchior (youngest); they were considered men of great wisdom and were called kings (*Golden Legend* 1:79). Images of the Magi typically show a larger entourage, both in size and in the array of exotic animals. The long journey of the Magi, following the star in search of the newborn Messiah, was sometimes depicted as a continuous narrative, with the Magi stopping to get directions, as seen in Gentile da Fabriano's *Adoration of the Magi* (see fig. 22–1), for the sacristy of S. Trinità in Florence, ca. 1423. Scenes of the Magi frequently included a meandering trail of courtiers, small skirmishes between horsemen, and many portraits of contemporary people. Popularity of the subject continued through the Quattrocento, as seen in Leonardo da Vinci's unfinished *Adoration* (ca. 1482) and Filippino Lippi's *Adoration* (ca. 1496), both executed for S. Donato in Florence (both Uffizi Gallery, Florence) (see figs. 48–5, 48–6). From around the 4TH century in the West, the feast of Epiphany was celebrated on 6 January, the same date that pagans traditionally celebrated as New Year's Day. The liturgical color of the epiphany season is green.

ALL'ANTICA — Images that are *all'antica* (in the manner of antiquity) imitate or resemble ancient Greek or Roman art in motif (i.e., garlands, bucrania [architectural frieze of ox skulls], nude figures, classical orders) and style (il-

lusionism and three-dimensionality). The depiction of antique-like figures shows an understanding of anatomical structure, ponderation (weight distribution), and contrapposto (twisting of the body—shoulders and pelvis are at oblique angles to the spine—combined with the shifting of weight so that one leg supports while the other is relaxed and often bent).

ASSUMPTION — The Feast of the Virgin Mary's Assumption (15 August) was introduced into the Eastern Church by the Byzantine Emperor Maurice (582–602), and it entered the Latin Church calendar during the reign of Pope Sergius I (687–701). One popular tradition is that Mary did not die, but slept for three days before entering heaven. The issue of her death was debated for centuries after the Reformation. According to Voragine's *Golden Legend*, when Christ appeared to the apostles in the Valley of Jehoshaphat, he bid them peace and asked them what grace and honor should be conferred upon the Virgin; their response was that Christ should restore life to her body and enthrone her at his right hand for eternity (*Golden Legend* 2:82). The archangel Michael brought the Virgin's soul to Christ, who said: "Arise, my dear one, my dove, tabernacle of glory, vessel of life, heavenly temple! As you never knew the stain of sin through carnal intercourse, so you shall never suffer dissolution of the flesh in the tomb" (*Golden Legend* 2:82). Angels assumed (carried) the Virgin into heaven where she was crowned its Queen. Roses filled her open grave and her girdle (belt) fell down from heaven to the apostle Thomas, who was absent during her assumption. Scenes of the Assumption are often combined with the Dormition of the Virgin and the Burial, as in Andrea di Cione's relief (see fig. 15–2). Common to Assumption images are music-making angels playing a variety of instruments (see fig. 25–3).

BANDEROLE — A long, curling scroll or flag, sometimes attached to a staff or spear, is a banderole. These were popular in French Gothic art. In the early Quattrocento, such streamers are sometimes displayed with or carried by figures of angels, virtues, saints, or soldiers, and they often bear inscriptions (see fig. 66–5).

BAPTISM OF CHRIST — According to Matthew, Jesus was baptized by John the Baptist in the Jordan River. As Jesus came up from the water, "suddenly the heavens were opened to him and he saw the Spirit of God descending like a dove and alighting on him. And a voice from heaven said, 'This is my Son, the Beloved, with whom I am well pleased'" (Mt 3:13–17). The other three Gospel books concur in their accounts of the baptism (Mk 1:9–11, Lk 3:21–22, Jn 1:28–34). However, the Gospel of John records the event as told by John the Baptist, who pointed out to the crowd in Bethany after the baptism that Jesus was the "Lamb of God who takes away the sin of the world" (Jn 1:29). John the Baptist proclaimed that God had sent him to baptize with water, but that Jesus, the Messiah, would baptize with the Holy Spirit. According to the Baptist, he knew this was so because he saw the Spirit descend like a dove and stay upon Jesus (Jn 1:32–34). Quattrocento images of Christ's baptism often depict the Holy Ghost as a dove. Piero della Francesca's painting for the Pieve of S. Giovanni in Sansepolcro (see fig. 18–2) has a white dove descending upon Christ as John holds a cup near Christ's head (National Gallery, London). Verrocchio's painting (1470s) shows a dove descending from God's hands as John baptizes Christ in the Jordan River, while angels hold Christ's clothes (Uffizi Gallery, Florence).

18–3. LUCA DELLA ROBBIA. *Cantoria* (detail), 1431–38, marble, Museo dell'Opera del Duomo, Florence. This panel is from Luca's *Cantoria* for the Florence Duomo. These seven spirited child musicians dance, sing, and play cymbals, enacting a verse from Psalms: "Praise him with clanging cymbals; praise him with loud clashing cymbals!" (Ps 150:5). Their jubilation is linked to their function as decoration for a choir loft. Their excitement reflects Donatello's influence but not his interest in creating the viewpoint of someone looking up at them. Their classical dress and emotive gestures are the likely result of combining life studies with drawings of antique sculpture. The lifelike traits also found in Masaccio's work (see fig. 18–5) suggest that high value was placed on knowledge gleaned from nature and antiquity.

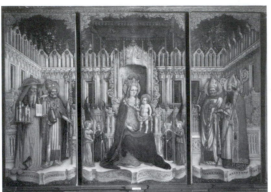

18–4. ANTONIO VIVARINI and GIOVANNI D'ALEMAGNA. *Madonna and Child with Saints*, 1446, oil on panel, 11'3.5" x 15'7.8" (344 x 477 cm), Accademia, Venice. This painting was created for the *albergo* (boardroom) of the Scuola Grande dei Battuti della Carità (a confraternity of flagellants), one of the oldest *scuole* in Venice. A miniature image of the *scuola's* meetinghouse is held by the figure of S. Jerome (far left). The three other Latin Church Fathers are also represented: Gregory (next to Jerome), Ambrose (who holds a scourge, symbolic of the penitent membership), and Augustine (far right). Four angels hold the poles supporting the canopy above Mary's throne, an image reminiscent of Simone Martini's *Maestà* (see fig. 13–1), created about 100 years earlier. The setting is a *hortus conclusus*, with the figures in a verdant garden enclosed by a crenellated marble wall. The presence of the sacred figures in a unified setting in which they all stand on the same platform creates a type of image called a *sacra conversazione*.

CANTORIA — A choir loft, called *cantoria*, is a piece of church furniture where organs are placed and singers stand. These were common to most Quattrocento churches and took on an oblong shape, similar to a sarcophagus. Donatello and Luca della Robbia were hired to create *cantorie* for the Florence Duomo (see fig. 18–3).

CAPOMAESTRO — Head supervisor of a project, especially architectural, is called *capomaestro*. Brunelleschi and Ghiberti were co-awarded this position for Florence Cathedral in 1420.

CONDOTTIERI — In the Quattrocento, a *condottiere* (pl. *condottieri*) was a well-to-do military commander (often a prince) for hire (see figs. 29–4, 29–5); he supplied soldiers and led them in battle(s) specified by his contract (*condotta*) (see figs. 29–4, 29–5). Invaluable to the warfare of this period, such men were hired especially by cities without standing armies. Venice employed famous *condottieri*, Francesco Gonzaga (Captain of Mantua, d. 1407), Erasmo da Narni from Padua (d. 1443), and Bartolommeo Colleoni from Bergamo (d. 1476); Donatello and Verrocchio created bronze equestrian memorials to Narni (see fig. 21–7) and Colleoni (see fig. 36–5). Milan (under the command of Francesco Sforza, a well-respected soldier) retained Marchese Ludovico Gonzaga of Mantua (d. 1478), Francesco Gonzaga's grandson; both Florence and Naples had also hired Ludovico (Milan offered the largest salary).

HORTUS CONCLUSUS — Since the medieval period, poetic descriptions of the maiden in the Song of Songs of the Old Testament have been associated with the Virgin Mary. Quattrocento imagery shows the interest of the period in picturing sacred figures in a natural world and in presenting Mary in a garden of thriving plants and flowers, often with a fountain: she is symbolic of the LILIUM INTER SPINAS, "lily among thorns" (Sg 2:2) and the FONS HORTUM, "fountain in my gardens" (Sg 4:15). Reference to her virginity and purity appear when the setting is a HORTUS CONCLUSUS, "close-locked garden" (Sg 4:12). In Annunciation scenes a cloistered garden with a locked gate refers to the words of the Old Testament prophet Ezekiel, who wrote of the PORTA CLAUSA, "close-locked gate" (Ez 44:1–2). An enclosed garden appears in Antonio Vivarini's *Madonna and Child with Saints* (see fig. 18–4).

INCREDULITY OF THOMAS — When the resurrected Christ appeared to the apostles (Lk 24:36–43, Jn 20:19–23, 1 Cor 15:5), Thomas was not present, so the apostles told him what they had seen. But Thomas was skeptical. "Unless I see the mark of the nails in his hands, and put my finger in the mark of the nails and my hand in his side, I will not believe." A week later his disciples were again in the house and Thomas was with them. Although the doors were shut, Jesus came and stood among them and said, "Peace be with you." Then he said to Thomas, "Put your finger here and see my hands. Reach out your hand and put it in my side. Do not doubt but believe" (Jn 20:25–27). John is the only Gospel writer to include the story of the doubting apostle Thomas, which symbolically contrasts with the story of

Mary Magdalene in which she was told not to touch Christ. *Noli me tangere* images were popular in the Renaissance chiefly because they offered penitents hope, for the repentant sinner Mary was the first to see the resurrected Christ. Doubting Thomas images gained popularity with patrons like the Mercanzia (Merchants' court) in Florence, where tangible proof was required for the adjudication of disputes (see Florentine Guilds). In early Renaissance art, Thomas touches the wound in Christ's side, as in Duccio's *Maestà* panel (see fig. 18–6), but he usually does not touch another part of Christ's body. Instead, he holds his gown back, away from the body of Christ, as in Andrea del Verrocchio's image (see fig. 36–1). The figure of Christ is usually shown raising his right arm above the head of Thomas, showing the wound in his hand, and pulling open his gown to reveal the wound in his side. While some images show ten apostles flanking Thomas and Christ, the number of apostles varies (in many images only Christ and Thomas are depicted). Although the setting may also vary, the primary focus is always upon the display of Christ's wounds.

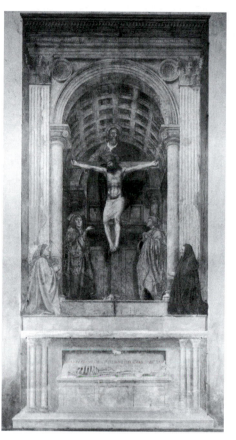

LAST SUPPER — This theme was created in large and small scale, and was frequently painted on the walls of refectories (dining halls of cloistered orders). In the upper room of a house in Jerusalem, Christ and the apostles celebrated the Feast of Passover (Mk 14:12–16, Lk 22:7–13), the Jewish commemoration of the Exodus (deliverance of the Israelites from Egypt). A roasted lamb with unleavened bread and bitter herbs was the traditional Passover meal (the remains of which were afterward burnt). While they were eating, Christ told the apostles that one of them would betray him (Mt 26:20–21, Mk 14:17–18). Perplexed by Christ's proclamation (Lk 22:23, Jn 13:21–22), each apostle responded that surely he was not the one (Mt 26:22, Mk 14:19). Christ told them, "The one who has dipped his hand into the bowl with me will betray me" (Mt 26:23). This important meal marked the institution of the Eucharist, and the first communion of the apostles. "While they were eating, Jesus took a loaf of bread, and after blessing it he broke it, gave it to the disciples, and said, 'Take, eat; this is my body.' Then

18–5. MASACCIO. *The Holy Trinity*, ca. 1427. Fresco, 21'10.7" x 10'4.8" (667 x 317 cm), S. Maria Novella, Florence. When redesigning the church (1564–75), Vasari installed a tabernacle over this painting. Not until the mid–19TH c. was the fresco uncovered: the upper part was transferred to the entrance wall, but the tomb image was obscured until 1950. After restoration (1951), the whole fresco was reinstalled in its original location. Irreparably damaged areas can be seen at the edges and above the tomb. This is Masaccio's most innovative and fully illusionistic work. Inspired by Brunelleschi's architecture, it shows patrons kneeling in devotional prayer outside the chapel. At the base of the fresco is a skeleton on a bier, with the following inscription: IO FU G[I]A QUEL CHE VOI S[I]ETE: E QUEL CHI SON[O] VOI A[N]CO[RA] SARETE ("I was once that which you are, and that which I am you will also be"), suggesting this is a sepulcher monument. No document dates the painting or names the patrons, but the life-size, kneeling figures are thought to be members of the Lenzi family. John the Evangelist and the Virgin are standing inside the sacred space; she looks toward viewers while pointing to her crucified Son. God the Father looms above Christ, with the Holy Spirit (white dove) between them. The painting is best seen from across the church and beyond the arcade of the right side aisle. From this position the one-point perspective (the vanishing point is in the middle of the ledge on which the patrons kneel, and at eye-level) and the *all'antica* pilasters and columns can be seen in relation to the nave arcade in this Gothic church; here, Masaccio's fresco looks like a three-dimensional chapel. It is unique because there are no other chapels in the side aisle.

18–6. After Duccio's *Incredulity of Thomas*, *Maestà*, Museo Opera del Duomo, Siena.

18–7. LUCA DELLA ROBBIA. *Crest of the Arte della Seta or Por S. Maria* (silk guild), ca. 1450, glazed terracotta, Orsanmichele, Florence (see Florentine Guilds). Luca was a respected sculptor of marble (see fig. 18–3) and bronze, but in the early 1440s he began experimenting with brightly colored tin-glazed terracotta for purposes other than purely decorative. His formula was kept absolutely secret, but his reasons for turning to ceramics rather than marble was perhaps partly based on the longevity and look of tin-glazed terracotta outdoors. With his enameled sculptures, he established a highly successful family business.

he took a cup, and after giving thanks he gave it to them, saying, 'Drink from it, all of you; for this is my blood of the covenant, which is poured out for many for the forgiveness of sins'" (Mt 26:26–29). Common to the Last Supper theme are restless apostles, turning to each other, wondering who among them will betray Christ. Three apostles are distinctly identifiable: Judas Iscariot, Peter, and John. The young, contemplative John is shown next to Christ, leaning (or sleeping) on his breast or arm, and is described as Christ's most faithful, beloved apostle (*Meditations on the Life of Christ*, ch. 73). In early Quattrocento depictions of the Last Supper, Judas often lacks a halo. Facing Christ and the apostles in Andrea del Castagno's *Last Supper* (see fig. 30–1), he sits on the opposite side of a long table. Leonardo placed Judas among the apostles, but his shadowed form pulls away from the others. Peter is often the most expressive apostle at the Passover meal, with his passionate gestures foretelling events that followed. Christ later told Peter that he would three times deny knowing Christ that very night, before the cock crowed at daybreak (Mt 26:34, Mk 14:30, Lk 22:34, Jn 13:38).

MAIOLICA — Tin-glazed terracotta, called maiolica (after a Spanish term), was inspired by Spanish, Islamic, and Chinese ceramic wares imported chiefly through Venice and Sicily since the 12TH c. Italian potters soon began imitating these pieces, and Luca della Robbia created a revolutionary use for the material (see fig. 18–7).

MANDORLA — The word (It. almond) refers to an almond-shaped aureole in the form of golden-colored rays around the figures of God, Christ, and the Virgin Mary in such themes as the Annunciation (God), Transfiguration (Christ), and Assumption (Mary).

NATIVITY — The biblical story of the birth of Christ appears only in the Gospel of Luke. It begins with the engaged couple, Joseph and Mary, traveling from Nazareth to Bethlehem to register as husband and wife (according to the tax edict imposed by the Roman Emperor Augustus, each man had to register in his native town, which was Bethlehem for Joseph, a descendant of the family of King David), according to Luke (2:1–5). Mary was pregnant when they arrived in Bethlehem, where she gave birth to her firstborn and laid him in a manger because no room was available for them at the inn (Lk 2:6–7). An angel appeared in brilliant light before shepherds who lived in the fields and told them of the birth of the newborn savior, about whom a host of angels then sang praises (Lk 2:8–14). After the angels returned to heaven, the shepherds hastily ran to find the swaddled infant who they were told was lying in a manger in Bethlehem. When they reached the Savior child, they repeated what they had learned from the angels "and all who heard it were amazed at what the shepherds told them. But Mary treasured all these words and pondered them in her heart" (Lk 2:15–20). Renaissance artists often depicted Mary looking solemn and contemplative, as though pondering the destiny of the Child. Mary shown under a shed in a rocky setting resembling a cave has its source not in the Bible but in the apocryphal *Book of James* (12:14). According to this text, when Joseph went to Bethlehem, he took his sons and Mary, who followed them on a donkey. When she felt that the birth was near, they all stopped and Mary was taken down from the donkey and placed in a cave, where she stayed with the sons while Joseph searched for a Hebrew midwife to help with the birth (*Book of James* 13:1). Just as Joseph returned with a midwife, a bright cloud, which had descended upon the cave,

suddenly became a blazing white light, and when the light dissipated, they saw the newborn infant suckling the breast of Mary (*Book of James* 14:9–12). A second midwife, Salome, who had not witnessed the miraculous birth, demanded proof that Mary was a virgin; when Salome conducted a gynecological inspection to learn the truth of Mary's virginity, her hand withered, causing her excruciating pain. Only after Salome had supplicated herself, professing her faith in the virgin birth, was the use of her hand restored by touching the Child (*Book of James* 14:17–28). Although two midwives are often depicted in Italian images from the thirteenth to the fifteenth centuries (see fig. 12–4), the depiction of the apocryphal Salome was later condemned by the Council of Trent (1543). An ox and a donkey are introduced into the nativity story through the apocryphal *Gospel of Pseudo-Matthew*. The animals are in the stable when Mary places the Child in a manger three days after his birth, and the animals worshipped him, thus fulfilling the prophecy of the Old Testament prophet, Isaiah: "the ox knows his owner, and the donkey its master's crib" (Is 1:3). Giotto and other artists often depicted the two animals near the crib, sometimes eating from it; the ox came to symbolize the new law of the New Testament and the donkey, the old law of the Old Testament. Images of the Nativity often drew from not just one, but many sources, including popular texts and sermons of the time. Joseph shown seated in the foreground, for instance, derives from MEDITATIONS ON THE LIFE OF CHRIST (see Trecento Glossary) by the Pseudo-Bonaventure. In this version Mary held onto a column, while Joseph remained seated, having prepared all that he could for the birth of the Child. Then Joseph arose and placed hay near Mary's feet, and shortly afterward the Son of God silently appeared, without causing Mary

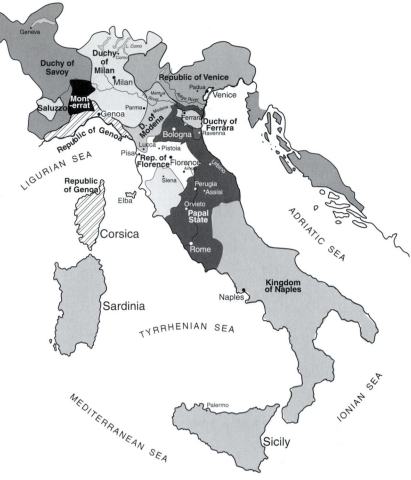

pain or lesion. Renaissance painters often placed Joseph to one side, away from the activity around Christ's manger, and occasionally included a column support, referring to the *Meditations*. In many Quattrocento paintings, Mary kneels in prayer over the newborn Christ child, lying on bare ground with rays of golden light emanating from his small body, as in Ghirlandaio's painting for the Sassetti Chapel, ca. 1485 (S. Trinità, Florence). This type of image seems inspired by the *Revelations* of S. Bridget of Sweden (see Trecento History Notes 1370). According to her *Revelations*, when all was ready for the birth of the Child, and Mary was kneeling in prayer, "the Child was suddenly born, surrounded by a light so bright that it completely eclipsed Joseph's feeble candle." This vision was very popular in northern European art, where Joseph is shown holding a candle and Mary kneels before the Child.

18–8. This map shows 15ᵀᴴ–c. Italy divided into kingdoms, duchies, republics, and the Papal State (see fig. II–8).

Wealthy patrons of the Quattrocento employed artists to create images of the Adoration of the Magi and Nativity in which they had portraits of themselves shown kneeling in prayer. The most famous in Florence came from the Netherlands. Created by Hugo van der Goes about 1476, it was commissioned by Tomasso Portinari, and shows the family depicted on the side panels.

By 354, the Feast of the Nativity (Christmas) was celebrated in the West on 25 December, the date of the winter solstice, according to the Julian calendar. (The date of celebration in the East is 6 January, under the Alexandrian calendar.) Francis of Assisi placed a crib in the church in Greccio (1223), which began a tradition in the West of displaying nativity scenes in churches during the octave of Christmas. The liturgical color is white.

OSPEDALE (HOSPITAL) — The building of hospitals increased in the Quattrocento. Public and private funds supported them, with communes like Florence having nearly 40 by the mid–15TH c. Their function was to care for the sick poor, plague victims, specific groups (pilgrims, tradesmen, etc.), and orphans (see fig. 18–9). Infant mortality was very high in orphanages: about 50% of the children survived their first year, and only about 30% lived to the age of five.

PAPAL STATE — This is territory (see figs. II–8, 18–8) thought to belong to the Church, based on the belief that Constantine the Great donated land to the pope (see Quattrocento History Notes 1440). This land was difficult to control and fell into the hands of different lords. In the late–1490s, Cesare Borgia launched military campaigns to retake it for Alexander VI (see Quattrocento History Notes 1499).

PASTIGLIA — Raised, patterned gesso added to panels or walls, called *pastiglia*, was popular in Venetian painting and can be seen in the gilded breastplate of Jacobello del Fiore's *Justice* (see fig. 66–5).

PATRON — The commissioner of a work is a patron: e.g., silk guild (see fig. 18–9), Lenzi (see fig. 18–5).

PERSPECTIVE — An invention of the Quattrocento is one-point (linear or mathematical) perspective, a tool to create the illusion of three-dimensional space on a two-dimensional surface; its creator is thought to have been Brunelleschi. This artificial method can create a unified fictive space in which parallel lines, made to recede at the same angle,

will converge at one focal point, the vanishing point (see fig. 18–5).

RILIEVO STIACCIATO — A relief that is physically shallow and looks rough and lumpy is called *rilievo stiacciato* (flattened or beaten relief).

SACRA CONVERSAZIONE — Saints gathered in communion around the Virgin and Child in a unified setting (see fig. 18–4) is called a *sacra conversazione*.

18–9. FILIPPO BRUNELLESCHI. Ospedale degli Innocenti (Foundling Hospital), Piazza Le Due Fontane, Florence, marble and stucco, begun 1419 (opened 1445); Andrea della Robbia added glazed terracotta medallions (1487) to the loggia spandrels; two bays (the last on each side) were added (19TH c.). Commissioned by the silk guild (see figs. 18–7, 63–6), the complex included a church (consecrated in 1451), an infirmary, and the living quarters for the prior, orphans, and male and female attendants. The complex was enlarged several times to accommodate the growing needs of the orphanage (such as the incorporation of the hospitals of the Scala and San Gallo). Ninety infants were brought to the orphanage in the first year. By 1560 about 450 children were in residence and 870 infants were living with wet nurses outside the orphanage. In contrast to most civic architecture, such as Palazzo Vecchio (see fig. 62–1), Brunelleschi's design for the Innocenti is openly inviting. This view shows the midday sunlight shining through the arcade and casting bright arcs along the white stucco walls of the orphanage (part of which is now a museum). Filippo intended the loggia to reflect the consistency of his design: the measurements of the arches are based on a module, and mathematical proportions were applied throughout the building. Filippo's plans for the piazza were not fully realized during his lifetime (see Brunelleschi entry 1419).

Filippo Brunelleschi

Giorgio Vasari never met Filippo Brunelleschi (1377–1446), but he considered him a homely man, like Giotto, lacking grace or refined features. Nonetheless, he thought that Filippo's unfortunate looks were greatly compensated by his rich imagination and uncommon courage, and he thus thanked Filippo for resurrecting classical traits in Tuscan architecture and for accomplishing daunting feats that were far beyond the capabilities of others. A few Florentine artists quickly adopted Filippo's aesthetic preference for Roman over Gothic style, and he is sometimes given credit for influencing the designs of classical architecture and street scenes that painters, like Masaccio and Masolino, included in their frescoes and panel paintings, such as Masaccio's *The Holy Trinity* (see fig. 18–5). In the dedicatory prologue of *Della pittura* (1436), Leon Battista Alberti applauded five contemporary Florentine artists whose genius in art rivaled antiquity; Filippo comes first in his list, followed by Donato [Donatello], Nencio [Ghiberti], Luca [della Robbia], and Masaccio. Remembered as the man who demonstrated how to create one-point perspective, Filippo has garnered the respect of generations of artists and writers. While praising his classical design and engineering skills, scholars marvel over the mechanical devices he conceived to hoist up heavy materials for construction work as well as delicate objects (like small children) for liturgical dramatizations. When a new visual identity was needed in Cinquecento (16ᵀᴴ c.) imperial papal Rome, artists (Bramante, Raphael, Michelangelo) drew upon Brunelleschi's legacy, and Michelangelo's design for the majestic dome of S. Peter's was a tribute to the esteemed dome in his native Florence, the work for which Filippo is best known.

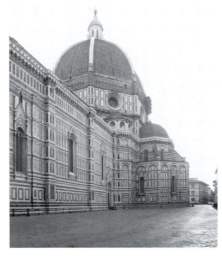

1377 — Filippo is born into an upper-middle-class family in Florence. His mother, Giuliana, came from the wealthy Spini family, whose fortune was amassed from the wool trade and whose town palace overlooked the River Arno near the church of S. Trinità (see fig. 62–7, #26). Filippo's father, Ser Brunellesco Lippi, was a notary.

1398 — Filippo matriculates in the silk guild (18 December), the guild to which goldsmiths belonged.

1399 — In the shop of the goldsmith Lunardo di Matteo Ducci da Pistoia, Filippo creates figures for the altar of S. Jacopo in Pistoia Cathedral.

1401 — Filippo and six other artists compete for the commission to execute the second bronze doors of the Florence Baptistery and are given one year to complete a bronze relief of the Sacrifice of Abraham. In his *Vita di Filippo Brunelleschi* (1480s), Antonio di Tuccio Manetti wrote that both Filippo and Ghiberti were awarded the commission, but Filippo declined the collaboration; in *I commentarii* Ghiberti recorded that he was the sole winner. Only Ghiberti's and Filippo's competition reliefs have survived (Museo del Bargello, Florence). Filippo's panel (cast in seven sections) reflects a sensitive interpretation of the story and focuses upon the tense, dramatic moment when an angel physically restrains Abraham, who is seconds away from severing the throat of his young son Isaac (see Lorenzo Ghiberti 1401).

1404 — Filippo is inscribed as a master goldsmith in Florence (2 July). He and other masters advise the Opera del Duomo about cathedral buttresses.

19–1. FILIPPO BRUNELLESCHI. Dome, S. Maria del Fiore, 1420–36, Florence; lantern design, 1436 (Michelozzo built the lantern, 1466–67). Brunelleschi's simpler design for the facing of the drum harmonizes with, but is less intricate than, the earlier facing.

On 25 March 1436, Pope Eugene IV (then living in Florence at S. Maria Novella) consecrates the Duomo. (The dome, nearly completed and the eight-sided oculus closed, was consecrated on 30 August by the bishop of Fiesole.) In the prologue of *Della pittura* (1436), Alberti praised Filippo for his ingenuity in constructing a dome "ample enough to cover with its shadow all Tuscan people, and constructed without the aid of centering or great quantity of wood." Filippo displayed his practical nature in both the design and construction; his untraditional scaffolding, which was braced from the octagonal drum, progressed upward as the dome was built in horizontal courses. The panels of the dome were made of interlocking brickwork (herringbone pattern) for strength. The dome has a double shell (or two domes) to decrease weight and outward thrust and to allow access for maintenance work to be done between the two shells, where he built stairways and passages. A complex rib system supports the panels of the dome. (Continued on page 93.)

1406 — The Opera dismisses Filippo as a consultant to their office because of his absence from Florence. It seems that he was traveling during this period to Rome (perhaps with Donatello) and other cities.

ca. 1409 — For the Gondi Chapel in S. Maria Novella, Florence, Filippo makes a wooden crucifix (dated about 1409–20 on stylistic grounds).

1415 — In Pisa, Filippo repairs a bridge.

Filippo and Donatello receive a contract from the Opera (9 October) to execute a bronze statue for a Duomo buttress.

1416 — Filippo is asked to return lead to the Opera. Apparently, the bronze statue commissioned in 1415 was not executed, and the lead alloted to Filippo for the casting was needed for another work.

1417 — The Opera asks Filippo's opinion about constructing a dome for Florence Cathedral.

Filippo adopts an heir, Andrea di Lazzaro Cavalcanti, who is nicknamed Il Buggiano after his hometown (Borgo a Buggiano). Il Buggiano was to collaborate with Filippo on several projects.

1418 — Filippo starts the Barbadori Chapel (finished ca. 1423; altered in the 18TH c.) in S. Felicità, Florence.

1419 — For the silk guild, to which he belongs (see 1398), Filippo begins work on the Ospedale degli Innocenti, an orphanage for foundlings (see figs. 18–9, 62–7, #15). In its clarity and precision, the design helped to change the face of Florentine buildings (see fig. 18–9). Windows with classical pediments (fin. 1439) are placed at regular intervals over the loggia. Such regularity in design and classical articulation of the windows did not appear in Florentine civic buildings prior to Filippo's design, and the consistent repetition, mathematical coordination, and classical articulation of the architectural units—Corinthian columns of the arcade (nine original openings), domes in the square bays of the portico, and pediments over windows—reminded Filippo's contemporaries of antique buildings (including the baptistery and S. Miniato, which were thought to have Roman roots). The inspiration for an exterior loggia may have come from Early Christian architecture, such as the atrium of Old S. Peter's in Rome, or from Florentine architecture, such as the Loggia del Bigallo or Loggia dei Lanzi. Covered porches protected against severe weather, which was important to this orphanage, where foundlings were left anonymously on the porch in a pila (basin) beneath an open window. Filippo planned for covered arcades to be a unifying element in the open square that he proposed in front of the orphanage. Such an open space emphasizes the civic function of the orphanage and accommodated the fairs and the pilgrims who visited SS. Annunziata. Adding loggias to existing buildings in the square was meant to unify and enclose the space; however, the piazza was not cleared until 1519, and the loggias were not built until the 16TH c.

1420 — Filippo begins work (1 August) on the dome of the cathedral, where both he and Ghiberti are made *capomaestro*.

1421 — Filippo begins work on the S. Lorenzo Sacristy (see fig. 19–2). He is paid for a weight-lifting device in this year and in 1423.

1424 — Filippo is appointed director of works at the Ospedale degli Innocenti to expedite completion.

1425 — Construction of the cathedral dome changes from stones to bricks.

1426 — In Pisa, working for the Uffiziali del Mare (naval officials), Filippo is asked to alter the design of the Citadel (navy yard).

1427 — Officials consult Filippo about the dome of Volterra Baptistery.

1429 — Andrea Pazzi assumes patronage of the chapter house of S. Croce (Pazzi Chapel), designed by Filippo when portions of the church were being rebuilt following a dormitory fire of 1423.

Filippo and Lorenzo Ghiberti are commisssioned by the Opera (September) to create a model of the Duomo.

1430 — The Opera hires Filippo to execute an altar in the Duomo; he is also working on fortifications for Castellina, Rencina, and Staggia.

Filippo designs (1430–35) the Villa of Rusciano for the Florentine Luca Pitti; work on the project probably lasted for about five years. He also submitted a plan (among the first designs, but not executed) for Luca's town house in Florence, Palazzo Pitti (see fig. 64–6).

1432 — After building a full-scale wooden model of the dome for Florence Cathedral, complete with oculus and lantern, Filippo is commissioned to proceed with the lantern (December).

1434 — Filippo designs a central plan for the church of S. Maria degli Angeli in Florence. The plan shows an inventive articulation of the exterior wall niches (the building was not completed according to Filippo's design). In this year, Filippo refuses to pay dues to the guild of stonemasons and woodworkers.

1435 — In Pisa Filippo works with Battista d'Antonio on the bastion of the Porta al Parlascio.

1436 — Filippo designs (1428–36) the church of S. Spirito for the Augustinians, proposing that it overlook the River Arno (see fig. 62–7, #28). Construction began in 1444, but only a few columns were in place when Filippo died two years later. Similar to S. Lorenzo, S. Spirito is much smaller than the Franciscan church of S. Croce and the Dominican S. Maria Novella, and it is also based on the Early Christian basilican plan onto which a classical vocabulary was grafted. Yet, S. Spirito is lighter and more airy than S. Lorenzo. Although Filippo's designs were greatly altered (location, exterior appearance, and some interior details), his interest in giving the building an organic, sculptural appearance is reflected in the placement of semicircular chapels around the entire church and in the harmonic alignment of the nave columns with the half columns (rather than the flat pilasters at S. Lorenzo) along the aisle walls. The visual relationship of column to column emphasizes the unity of the building, as does the use of modular units and the consistent application of mathematical proportions.

1439 — Filippo designs a bastion at Vicopisano.

1440 — Filippo works on the Pisa Citadel and constructs the semicircular exedrae at the base of the Florence dome.

1446 — Filippo dies in Florence (15 April) and is buried in the Duomo. About forty years later, his biographer, the writer and architect (although no works are attributable) Antonio Manetti (d. 1497), praised his contributions.

FLORENCE DOME (cont.)
Eight major vertical stone ribs (visible from the street), which spring from the corners of the octagonal drum, are strengthened by sixteen (concealed) vertical stone ribs (two per each side of the octagon), all interlocked by horizontal stone and wooden beams. At three different levels large horizontal stone chains help to stabilize the dome. Filippo's contemporaries were greatly impressed with his engineering skills and novel approach to construction, for Alberti wrote in his prologue that people believed he had performed a seemingly impossible feat, which had no likely precedent in antiquity.

In his *Vita di Brunelleschi*, Antonio Manetti argued that by turning away from the methods of previous generations to search for answers in antiquity, Filippo brought beauty to the art of construction. He saw in Filippo's work a new scientific approach that could analyze Roman construction, and he considered him the pioneer architect of the Renaissance for formulating a set of rational rules that imitated the classical ideal.

S. Lorenzo, Florence

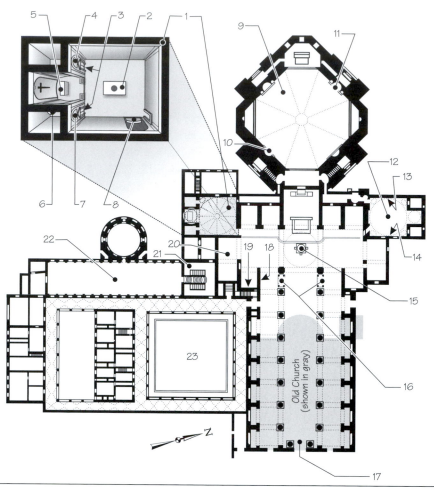

19–2. Ground plan, S. Lorenzo, Florence. In 1419 the new S. Lorenzo was started with a chapel dedicated to the benefactor's (Giovanni di Averardo de' Medici's) patron saint, John the Evangelist (see #1). The square-shaped room would function both as a sacristy and as a burial chapel for the Medici, who provided an endowment for special canons to celebrate perpetual masses for the dead. The marble tomb of Giovanni and his wife, Piccarda Bueri, created by Il Buggiano (Filippo's adopted son), is installed beneath the vesting table in the center of the sacristy (see #2). Because the tomb is carved with figural reliefs on the lid and sides and has inscriptions on two sides, it seems too decorated to be placed beneath the table. Yet, placing it beneath the circular opening of the dome is significant, as the tomb is thus linked with beseeching prayers for the dead. In Christian art the circle and light are symbolically equated with God and the dome with heaven.

In 1418 the Signoria approved the rebuilding and enlargement of S. Lorenzo (greatly damaged by fire in 1416). Ten years later, Filippo Brunelleschi had completed the first major work in the church: the sacristy (#1), where the date 1428 is inscribed on the lantern of the dome, and the Chapel of Cosmas and Damian (#20). His patron, Giovanni di Averardo de' Medici, living nearby on the Via Larga, had a vested interest in rebuilding his parish church and probably hired Filippo to redesign it entirely, although Michelozzo likely supervised the construction of the new choir and nave. After Giovanni's death (1429), his sons, Cosimo (d. 1464) and Lorenzo (d. 1440), paid for completing the sacristy.

Cosimo built a town house (begun 1445) that was even closer to S. Lorenzo than his father's house on the Via Larga (see Florentine Palaces) and continued the family's patronage of the church after his return from exile (in 1434). Cosimo agreed formally to sponsor all the building of the transept and choir in 1442. Although neighborhood families (the Ciai, da Fortuna, della Stufa, Ginori, Luca di Marco, Nelli, Neroni, and Rondinelli) sponsored the initial extension of S. Lorenzo and the building of family chapels around the transept, when Cosimo

1 Filippo Brunelleschi, Sacristy (now called the Old Sacristy) and burial chapel, 1422–28. (Donatello created images of the Evangelists in stucco relief in roundels on the lunettes and scenes of S. John the Evangelist in stucco relief in roundels on the pendentives; these are not shown in the diagram.)

2 Andrea Cavalcanti, called Buggiano, *Tomb of Giovanni di Bicci de' Medici and Piccarda Bueri* (the parents of Cosimo the Elder and Lorenzo il Vecchio), begun ca. 1433, marble (installed beneath the robing table).

3 Donatello, *Martyrs' Door* (left) and Michelozzo, *Apostles' Door* (right), 1434–43, bronze reliefs.

4 Michelozzo, the Medici saints, *Cosmas and Damian*, 1434–37, painted stucco lunette relief.

5 Altar (celestial hemisphere in the cupola over the altar, ca. 1420s).

6 Andrea del Verrocchio (or Antonio Rossellino), Lavabo, ca. 1465–66, marble.

7 Donatello, the deacon saints, *Stephen and Lawrence*, 1434–37, painted stucco lunette relief.

8 Andrea del Verrocchio, *Tomb of Piero and Giovanni de' Medici* (Cosimo the Elder's sons), 1472, bronze and marble.

9 Matteo Nigetti (from 1604), Ferdinando and Giuseppe Ruggieri (1740s), Chapel of the Princes, built for Grand Duke Ferdinando I on the 1602 design of Giovanni de' Medici (Ferdinando's son).

10 Pietro Tacca, *Grand Duke Cosimo II de' Medici* (d. 1621), 1626–ca. 1642, gilded bronze statue.

11 Pietro and Ferdinando Tacca, *Grand Duke Ferdinando I de' Medici* (d. 1609), 1626–31, gilded bronze statue.

12 Michelangelo, New Sacristy (called the Medici Chapel), 1519–34.

13 Michelangelo, *Tomb of Lorenzo de' Medici, the Duke of Urbino* (d. 1519), ca. 1534, marble.

14 Michelangelo, *Tomb of Giuliano de' Medici, the Duke of Nemours* (d. 1516), ca. 1533, marble.

15 Andrea del Verrocchio, *Tomb of Cosimo the Elder* (d. 1464), ca. 1465–67, polychrome marble.

16 Donatello, pulpits with bronze reliefs of the Passion, Post-Passion, and *Martyrdom of S. Lawrence*, 1460s.

17 Michelangelo, tribune (at the entrance to the church), 1531–32.

18 Agnolo Bronzino, *Martyrdom of S. Lawrence*, 1565–69, fresco.

19 Fra Filippo Lippi, *Annunciation* (Martelli Chapel), ca. 1440, tempera on panel.

20 Filippo Brunelleschi, Chapel of Cosmas and Damian (now called Chapel of the Relics), 1428.

21 Michelangelo, vestibule, Laurentian Library (executed by Ammannati), 1559.

22 Michelangelo, Reading Room, Laurentian Library, ca. 1524.

23 Filippo Brunelleschi, design of the cloister, 1420s.

became the major patron in 1442, he took over rights to the main altar and paid for construction costs of the transept and church up to what remained of the old church (see shaded area on diagram showing old church). Between 1457 and the 1470s the Romanesque church was demolished as the new church was built; the altar was consecrated in 1461, and the nave begun in 1463 (finished by 1480).

It seems that Cosimo's plans were for S. Lorenzo to become a Medici mausoleum; his tomb (see #15) occupies an important spot in the church. A burial site near Cosmio's tomb was secured for the favored Medici sculptor Donatello (d. 1466), and Cosimo's great-grandsons hired Michelangelo to create the New Sacristy (see #12), which functioned as a funerary chapel and is reminiscent of the Old Sacristy (although Michelangelo's design follows the basic form, the decoration of the walls and design of the dome deviate from Filippo's simpler plan; see Michelangelo). In the following centuries the grandest funerary chapel (Chapel of the Princes) was built behind the high altar (see #9). Lavishly decorated with semiprecious stones and gilded bronze, the chapel reflects the new status of the Medici, who rose from the rank of citizens to absolute rulers, reigning over not only Florence but all of Tuscany.

The story of S. Lorenzo became entwined with that of the Medici. Not only was the church physically close to the home of the Medici, but it became dear to Cosimo. His exile in Venice (1433) may have inspired him to patronize the church. In Venice, the venerated Ss. Giovanni e Paolo had just been completed and S. Maria dei Frari was nearing completion (finished late 1440s).

S. Maria del Fiore (Duomo), Florence

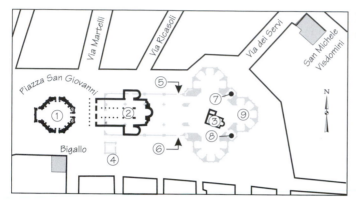

19–3. Plan of the Piazza S. Giovanni (also Piazza del Duomo), with the Duomo outlined in gray.

1 Baptistery of S. Giovanni
2 S. Reparata (destroyed 1293–1375)
3 S. Michele Visdomini (destroyed 1300–68)
4 Campanile (1334–59)
5 Porta della Mandorla of the Duomo
6 Porta dei Canonici of the Duomo
7 North Sacristy of the Duomo
8 South Sacristy of the Duomo
9 Tribune of S. Zenobius of the Duomo

According to tradition, new construction of Florence Cathedral (Duomo) followed the design of the sculptor Arnolfo di Cambio, who supervised the building from 1296 until his death, ca. 1310. (Arnolfo's name appears in a plaque on the Duomo's southwest corner and in a document of 1300 naming him as the cathedral builder.) After Arnolfo's death, several generations of master builders continued supervising the construction of the cathedral according to Arnolfo's plan. In 1334 Giotto was appointed the capomaestro and was commissioned as well to design the campanile (bell tower). After Giotto's death (1337), three men, including the sculptor Andrea Pisano, successively supervised construction of both buildings (see fig. 62–7, #1, #3). Between 1367 and 1419, a new model that varied from Arnolfo's plans was approved (for a vaulted nave and lengthening of the church). As the new cathedral was expanded eastward, it took up much more ground than S. Reparata (see fig. 19–3). The facade was pulled back, relocating it by several feet further to the east than the front of S. Reparata had been. Increasing the distance between the baptistery and the cathedral allowed more room for processions between the two buildings during special feast day celebrations. By the mid–15ᵀᴴ c., the cathedral had grown larger and more magnificently adorned than the baptistery, and it dominated the piazza as the spiritual center of Florence (see fig. 19–1). It was also becoming the geographical center of the commune as well, situated almost equidistant between the palace of Cosimo de' Medici (a civic and political hub) on the Via Larga to the north and the town hall (the civic and political gathering place of the people) to the south. The building never stopped functioning as a church during the new construction, which was executed over and around S. Reparata. As workers demolished the west end, they built a new facade to protect what remained of the old church, working both on the new facade and the east end. The new floor was laid about two meters higher than the floor of S. Reparata, which was then about one meter below street level. Workers used the dirt they excavated from the foundation trenches to level out the difference, and a temporary brick pavement was laid (the present marble floor was executed in the 16ᵀᴴ c.). Work progressed slowly because of interruptions, and the old apse of S. Reparata was left exposed in the middle of the new nave until 1439. Still, finding a way to enclose the enormous octagonal opening, which spanned about 138 feet, was the overwhelming problem in the early–15ᵀᴴ c. Although the dimensions and curvature of the cupola (dome) had been determined by the 1360s, the entire building had grown so much larger than Arnolfo's original plan that traditional building methods of timber centering were inadequate and unreasonably costly (the price of a forest) for creating a dome of such great size. The problem was not resolved until 1420, about seven years after the completion of the drum, when a model for a dome was accepted from Filippo Brunelleschi and Lorenzo Ghiberti. However, soon after their joint appointment as *capomaestro*, Filippo took complete control of the project (see entry 1432). Melding classical aesthetics with predetermined Gothic elements (pointed ribs and the faceted shape for the dome), Filippo emphasized the clarity and function of the parts (stark white ribs contrast with the red tiles covering the dome to define its parameters from every viewpoint, thus giving it a more hemispherical appearance). The crowning elements and strongest expression of antiquity are in the dome's lantern and the four semicircular exedrae supporting the walls of the drum, where Filippo had the greatest freedom to combine classical elements in an inventive way.

Lorenzo Ghiberti

Lorenzo Ghiberti (1378–1455) took a passionate interest in the story of Florentine art and how his contribution would help define its future development. He was well respected as a goldsmith, bronze-caster, sculptor, draftsman, architect, and writer. Yet it was his ability to direct large bronze-casting projects, acquire patronage from the most powerful Florentine guilds, and define an aesthetic that appealed to magnates, merchants, and scholarly humanists that gave him tremendous advantages over his fellow artists. Perhaps the greatest contribution of the talented Ghiberti was his creation of *all'antica* figures that meld—with a technical facility unrivaled by his peers or ancestors—the elegance of French Gothic style with the realism of ancient Roman art. Ghiberti negotiated lucrative contracts with corporate groups, acquired large shares in the Monte (communal bank), and amassed significant real estate holdings, affording him the means to write about art and retire to a country estate. His writings (*I commentarii*, ca. 1447) establish the beginnings of modern art history and include the artist's autobiography—the first of its kind. Divided into three parts, the first two books of *I commentarii* discuss ancient and modern art (from what was called the Dark Ages to Ghiberti's time), while the third describes the sciences recommended for sculptors to study: optics, anatomy, and proportion. According to Ghiberti, few important things were made in Florence that he did not design or devise, and his many designs (wax and clay models) for painters, sculptors, and stone carvers increased the value of their art. By the mid–16TH century, however, Ghiberti was better remembered for his writings than his singular achievements in art.

ca. 1381 — Ghiberti is born in Florence to Mona Fiore (daughter of a farm laborer) and Cione Paltami Ghiberti, the son of a notary. Mona left Cione and became the common-law wife of a goldsmith, Bartolo di Michele, called Bartoluccio (d. 1422), whom she married after Cione's death in 1406. Until late in his career, Ghiberti used his stepfather's name, signing documents as Lorenzo di Bartolo, Lorenzo di Bartoluccio, or Lorenzo di Bartolo Michele.

1400 — Having learned the goldsmith's trade from his stepfather, Bartoluccio, Ghiberti left Florence to avoid the plague (*I commentarii*) and went to Pesaro, where he assisted a painter.

1401 — Ghiberti and six others (Brunelleschi, Jacopo della Quercia, Niccolò di Pietro Lamberti, Simone da Colle, Niccolò di Luca Spinelli, and Francesco di Valdambrino) enter the competition for the second doors of the Florence Baptistery. Ghiberti won the contest for his design and for the technical virtuos-

20–1. LORENZO GHIBERTI. *Self-Portrait*, 1403–24, bronze, ca. 6" (15.2 cm), North Doors, Baptistery of S. Giovanni, Florence (see fig. 18–1). Lorenzo Ghiberti, the most enterprising young artist working in Florence in the first quarter of the Quattrocento, is seemingly watching over Florence and the many projects that were underway at the cathedral; his self-portrait is in the middle of the north doors, which were on the east side of the baptistery originally and faced the cathedral (see fig. 19–3). Ghiberti's commissions from the Calimala guild for work at the baptistery were among the largest bronze-casting contracts of the century, and he had the shop and foundry to fulfill the commissions, which was not the case for Florentine bronze sculptors of the previous century, which was why Andrea Pisano was called to Florence to create the first bronze doors of the baptistery (see fig. 9–1). Ghiberti is best remembered as the creator of his gilt-bronze doors for the Florence Baptistery, known as the *Gates of Paradise*. In writing about Ghiberti, Vasari (*Lives*) valued his art, but had less praise for him than for Brunelleschi and Donatello.

20–2. LORENZO GHIBERTI. *Jacob and Esau*, 1426–52, gilded bronze, 31.5 x 31.5" (80 x 80 cm), east door (middle panel), Florence Baptistery. This Genesis story begins in the upper right corner with the pregnant Rebecca praying because her unborn twins are struggling within her womb. God tells her that the older (Esau) will serve the younger (Jacob). Rebecca gives birth (background, left) and years later to fulfill God's will she counsels Jacob to disguise himself as his brother: he wears animal hides that simulate Esau's rough skin and thus deceives Isaac so that he (rather than Esau) is blessed (foreground, right). Esau had earlier sold his birthright to Jacob for food (center), and when he returned home he learned that he had also lost his father's blessing (foreground). Figures like the women who visit Rebecca during her confinement reflect Ghiberti's study of antique sculpture, but the slender proportions and graceful movement are hallmarks of his own style, which influenced many artists.

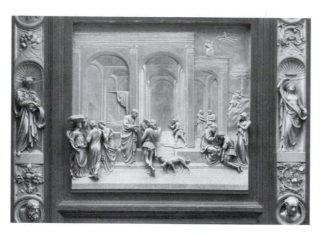

ity he demonstrated by casting the relief in one piece (with the addition of the figure of Isaac). On 23 November 1403, he co-signed a contract for the doors with his stepfather that required them to complete three reliefs each year. They did not fulfill these stipulations, however, and Ghiberti (alone) signed a more binding contract (1407), agreeing to work only on the doors and not to undertake other obligations unless the consuls of the Calimala approved. Listed among his assistants on the doors are Donatello, Ciuffagni, and Uccello. In 1424 the doors were installed (see fig. 18–1).

1404 — Ghiberti designs *Assumption of the Virgin* for a stained-glass roundel window in the center of the facade of Florence Duomo.

1409 — Ghiberti is inscribed in the goldsmiths' guild (3 August).

1412 — Ghiberti receives a commission from the Calimala (the patrons of his bronze baptistery doors) to create a bronze statue of S. John the Baptist for the guild's niche at Orsanmichele (see fig. 63–11). This was the first bronze statue at Orsanmichele (the earlier ones were marble). Cast in 1414, the statue was installed in 1416 (Ghiberti was paid for the gilding in 1417); Ghiberti's name is inscribed on the hem of John's cloak: OPVS LAVR[E]NTII.

1413 — Ghiberti recovers a part of his father's (Cione Paltami Ghiberti's) inheritance. When Cione died in 1406, relatives had disputed Ghiberti's rights to the inheritance (see 1444).

ca. 1415 — Ghiberti marries Marsilia (daughter of a wool carder).

1416 — Invited to Siena, Ghiberti is consulted about the baptismal font project for the Siena Baptistery (beneath the high altar of the Duomo). Returning to Siena (1 January 1417), he changed the original plan from marble to bronze reliefs. After sending a trial relief, he was contracted to design the font and two panels, which were delivered eleven years later (1427): *Baptism of Christ* and *John the Baptist before Herod and Herodias*. He was the only non-Sienese contracted for the project until one relief of Jacopo della Quercia's was reassigned to Donatello.

ca. 1417 — A son named Tommaso is born. He worked in Ghiberti's shop and is recorded for his work on the silver altar of the Florence Baptistery: he created the tabernacle niche (1443) for Michelozzo's *S. John the Baptist*.

1418 — Ghiberti enters a model (13 December) in the competition for the cupola of the Florence Duomo.

A son named Vittorio (d. 1496) is born to Ghiberti and his wife, Marsilia, in this year or in 1419, according to Ghiberti's tax returns of 1427 and 1430. Vittorio was an assistant and then a partner to Ghiberti in the execution of the second set of bronze doors for the baptistery (see fig. 20–4). Inheriting the family shop (1455), Vittorio completed the decoration of the

baptistery's portal reliefs after Ghiberti's death.

1419 — Ghiberti designs a mitre and morse (both lost) for Pope Martin v and a staircase for the papal apartments at S. Maria Novella, Florence. The Cambio orders a statue of Matthew for their niche at Orsanmichele (see fig. 63–13).

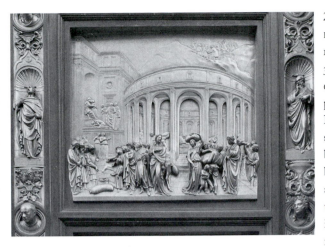

1420 — Appointed by the Opera of the Duomo, Ghiberti, Brunelleschi, and Battista d'Antonio share supervisory positions over the dome's construction; Ghiberti's responsibility ended in 1436.

1423 — Ghiberti enrolls in the painters' guild to work on stained-glass designs for the Florence Duomo. The Calimala decides to have his baptistery doors fire-gilded, which calls attention to the high reliefs and rhythmic movements of figure groups (see fig. 18–1), where the heads, figures, and architectural settings stand out in shining metallic contrast against the flat bronze backgrounds.

1424 — Ghiberti creates designs for two stained-glass windows (*Expulsion of Joachim* and *Death of the Virgin*) for the first nave bay in the Duomo. He travels to Venice to escape the plague.

1425 — The Calimala awards Ghiberti the contract for his second set of doors for the baptistery (called the Porta del Paradiso), installed 27 years later (1452). Ghiberti is to receive on account 200 florins annually, while his partner Michelozzo is to receive 100 florins. About 1424, Bruni (chancellor of Florence, 1427–44) submitted a scheme for the doors to Niccolò da Uzzano, proposing twenty Old Testament scenes and eight prophets. Yet, the plan that Ghiberti

instead followed was submitted, it seems, by the humanist Ambrogio Traversari.

The Arte della Lana (wool guild) commissions a bronze statue of Stephen (finished 1429) for Orsanmichele. Ghiberti is also working on the bronze *Tomb Slab of Fra Leonardo Dati*, 7'6.1" (229 cm), for S. Maria Novella, Florence (fin. by 9 July 1427); Leonardo Dati (d. 1425) had been the general of the Dominican Order.

1426 — Ghiberti joins the stonemasons' guild to receive contracts for marble works. For his work on the cathedral dome, he annually received 36 florins, while Brunelleschi received 100.

1427 — Ghiberti designs and the stonemason Filippo di Cristofano executes the *Tomb Slab of Bartolommeo Valori* (d. 1427) in S. Croce, Florence. Ghiberti had earlier designed and Filippo had carved the tomb slab for Lodovico degli Obizi (d. 1424) in S. Croce.

1428 — According to the Anonimo Magliabechiano, Ghiberti makes a gold setting for a famous ancient cornelian gem of Apollo and Marsyas. For Cosimo de' Medici and his brother Lorenzo, he completes a bronze shrine for the relics of saints (Protus, Hyacinth, and Nemesius) for S. Maria degli Angeli, Florence.

20–3. LORENZO GHIBERTI. *Joseph in Egypt*, 1426–52, gilded bronze, 31.5 x 31.5" (80 x 80 cm), east door (middle panel), Florence Baptistery. Of his many sons, Jacob loved Joseph best; Joseph's jealous brothers threw him into a well (background, top), covered his clothes in blood, and told their father he had been killed by an animal. Joseph was instead sold into slavery in Egypt, where he gained the Pharaoh's favor by interpreting dreams, saved Egypt from famine by establishing a granary, and was made governor. His brothers were among those who used the granary; on their second trip to buy corn (center) Joseph slipped a valuable cup inside the youngest son's sack (right) and accused him of stealing (left). Joseph later revealed his identity to his brothers (middle ground, left). Svelte and lyrical figures, open spaces, and quiet, dramatic moments visually link the two middle panels, as do the portraits of Lorenzo Ghiberti and son Vittorio (see fig. 20–4) and the one-point perspective created for the combined panels (the vanishing point lies between them).

East Doors (*Gates of Paradise*), Florence Baptistery

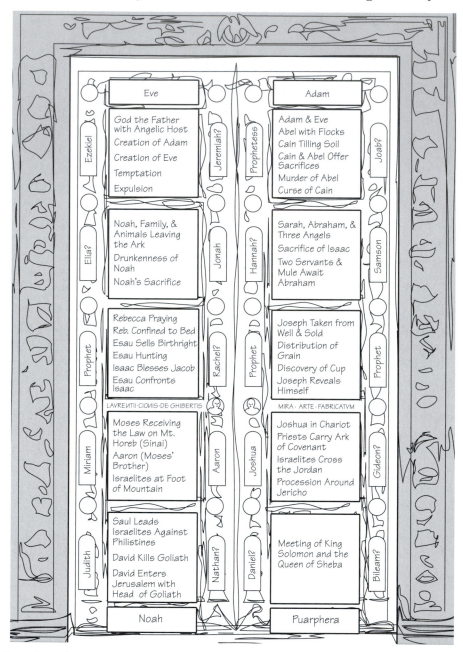

The diagram shows the layout of the doors with panels and named prophets:

Left door (top to bottom):

Eve

- God the Father with Angelic Host
- Creation of Adam
- Creation of Eve
- Temptation
- Expulsion

- Noah, Family, & Animals Leaving the Ark
- Drunkenness of Noah
- Noah's Sacrifice

- Rebecca Praying
- Reb. Confined to Bed
- Esau Sells Birthright
- Esau Hunting
- Isaac Blesses Jacob
- Esau Confronts Isaac

LAVRENTII·CIONIS·DE·GHIBERTIS

- Moses Receiving the Law on Mt. Horeb (Sinai)
- Aaron (Moses' Brother)
- Israelites at Foot of Mountain

- Saul Leads Israelites Against Philistines
- David Kills Goliath
- David Enters Jerusalem with Head of Goliath

Noah

Left frame prophets (top to bottom): Ezekiel, Elia?, Prophet, Miriam, Judith

Center-left frame (top to bottom): Jeremiah?, Jonah, Rachel?, Aaron, Nathan?

Right door (top to bottom):

Adam

- Adam & Eve
- Abel with Flocks
- Cain Tilling Soil
- Cain & Abel Offer Sacrifices
- Murder of Abel
- Curse of Cain

- Sarah, Abraham, & Three Angels
- Sacrifice of Isaac
- Two Servants & Mule Await Abraham

- Joseph Taken from Well & Sold
- Distribution of Grain
- Discovery of Cup
- Joseph Reveals Himself

MIRA · ARTE · FABRICATVM

- Joshua in Chariot
- Priests Carry Ark of Covenant
- Israelites Cross the Jordan
- Procession Around Jericho

- Meeting of King Solomon and the Queen of Sheba

Puarphera

Center-right frame prophets (top to bottom): Prophetess, Hannah?, Prophet, Joshua, Daniel?

Right frame (top to bottom): Joab?, Samson, Prophet, Gideon?, Bileam?

20–4. This figure shows the scenes of the Florence Baptistery east doors (the named prophets are after Krautheimer's identifications). Ghiberti changed the format of the second doors by altering the overall shape of the frames and reducing the number of panels. Rather than twenty-eight scenes in quatrefoil frames (see fig. 18–1), he designed ten panels with square formats, each depicting continuous narratives with multiple stories. At the top of the door frame is the Calimala eagle (see fig. 63–3). Portraits of Ghiberti (left) and his son Vittorio face the viewer in two roundels on the inside friezes of the doors (by the middle panels). They are thus linked visually to the themes about fathers and sons. Beneath *Jacob and Esau*, Ghiberti inscribed his name LAVRENTII CIONIS DE GHIBERTIS and that he was the son of Cione Ghiberti (see fig. 20–2); his pride in the doors appears beneath *Joseph*: MIRA ARTE FABRICATVM (created with marvelous skill) (see fig. 20–3).

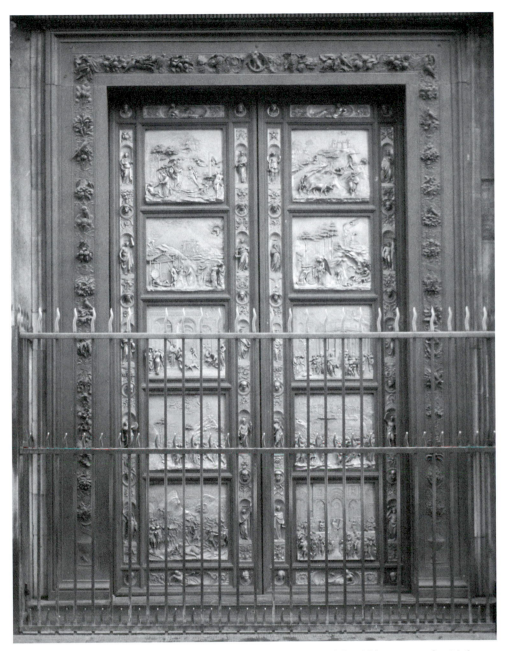

20–5. LORENZO GHIBERTI. *Scenes from the Old Testament*, 1426–52, gilded bronze, h. 16'8" x 9'5" (506 x 207 cm), with frame, east doors, Florence Baptistery. Ghiberti's designs for his second baptistery doors were inspired by the square format and complete gilding of the Siena narratives (see entry 1416) as well as by Donatello's RELIEVO STIACCIATO (see Quattrocento Glossary) technique in the marble *S. George and the Dragon* and the one-point perspective of Donatello's *Feast of Herod* (finished 1427), created for the Siena baptismal font. Ghiberti believed the scenes of the second doors imitated reality. Following the laws of nature, the figures that are in the foreground, and meant to be closest to an observer's space, are thus larger and more volumetric than those understood to be farther away. The less distinct background figures, executed in the *stiacciato* technique, were cast in very shallow relief (see figs. 20–2, 20–3).

In the second book of *I commentarii*, Lorenzo wrote that he considered the east doors his most noteworthy achievement, describing in detail the themes of the ten panels. A century later Vasari wrote that Michelangelo uttered after complete silence, "Oh divine work! Oh door worthy of heaven!" (*Lives*, 1558). This praise has more to do with the tradition that the doors of a baptistery were heaven's gates through which baptized Christians could enter paradise. (Until the reconstruction of the cathedral, a cemetery was situated south of the baptistery, which has significance for this medieval tradition.) In Vasari's day, Ghiberti's second set of doors was a rich source of inspiration for artists like Michelangelo and Cellini. Yet by the late–15TH c. Ghiberti was remembered as a lesser artist than Filippo Brunelleschi and Donatello, chiefly because of Filippo Brunelleschi's biographer (who wrote of Brunelleschi's superior talent) and the belief that Ghiberti's assistants (particularly Donatello) had contributed notably to the design and execution of the baptistery doors.

1430 — Ghiberti perhaps travels to Venice or to Rome about now (he had spent an earlier sojourn in Rome, about 1416).

1432 — Ghiberti designs a model for the altar of the Arte deli Linaiuoli e Rigattieri (linen drapers' guild). Fra Angelico painted the altarpiece (see fig. 26–1).

Ghiberti receives a commission (withdrawn in 1437) for the bronze sepulcher of S. Zenobius, Florence Duomo. The contract was renewed (1439), and the work completed in 1442.

1437 — Ten stories and 24 pieces of the frieze for Ghiberti's second set of baptistery doors have been cast and are ready for the surfaces to be cleaned.

1439 — On 4 July, in a payment record of the Calimala, the status of the narratives for Ghiberti's second baptistery doors is recorded as follows: *Cain and Abel* (finished), *Moses* (almost fin.), *Jacob and Esau* (fin.), *Joseph* (half fin.), *Solomon* (a quarter fin.).

1440 — The Calimala debates buying 1,700 pounds of fine bronze in Flanders for Ghiberti's second baptistery doors. (In 1445, 14,623 pounds of bronze was shipped from Bruges.)

1443 — Ghiberti designs stained-glass windows for the drum of the cathedral dome: *Ascension* (finished 1444), *Agony in the Garden* (fin. 1444), and *Presentation in the Temple* (fin. 1445). Four stories still remain to be finished for the second baptistery doors, and Ghiberti is given 18 months to complete the reliefs.

Ghiberti is elected to the Office of the Twelve in Florence (December).

1444 — Ghiberti is denounced as illegitimate (17 March), a status that would render him ineligible to hold public office. However, he refuted the charge, claiming that he was born in 1378 when his mother was married to Cione Paltami di Ser Buonaccorso Ghiberti (before she was Bartoluccio's common-law wife). He also claimed that Cione paid taxes in 1375, which established the eligibility of his heirs to hold office. Vindicated (16 April), he retained his office and began routinely calling himself Lorenzo di Cione di Ser Buonaccorso Ghiberti, also known as Lorenzo of Bartoluccio. His membership in the silk guild is canceled (30 April 1444) because of his false registration as the son of the guild member Bartoluccio, but he would later be reinstated (14 June 1446).

1447 — Ghiberti completes the ten relief panels for his second doors of the baptistery, but the friezes are to be recast. About now, he begins *I commentarii*.

1452 — The Calimala hires Ghiberti and Vittorio to gild the new doors (2 April). On 13 July, the Calimala decides to install them on the east portal.

1453 — Ghiberti and Vittorio are hired by the Calimala to execute the jambs, architrave, threshold, and step for Pisano's doors on the north face of the baptistery (12 February). In April, in lieu of the final payment (250 florins) for the baptistery doors, the Calimala gives Ghiberti and Vittorio the house and workshop where the bronze doors were created. Ghiberti retires to his manor house at San Giuliano a Settimo (purchased 5 January 1442).

1455 — After writing a will (26 November) naming Vittorio's daughters as his heirs, Ghiberti dies within days (1 December) and is buried in S. Croce (he purchased the tomb ca. 1431). Vittorio inherited Ghiberti's shop and was best known for his work at the baptistery.

Donatello

Caring little about his dwelling or appearance, Donatello (1386–1466) is remembered for having a sharp tongue and hot temper, lacking funds to pay his debts, and receiving the devoted patronage of Cosimo the Elder, who secured important projects and provided income for him in his old age. Donatello's early work reflects experimentation with optical illusion (*S. John the Evangelist* and *S. George and the Dragon*), while the late work sensitively portrays abstract ideas like penitence (*S. Mary Magdalene*) and fortitude and humility (*Judith*). Having an inexhaustible imagination for making human sense of his sometimes complex interpretations (bronze *David*) and reinterpreting traditional spiritual themes (S. Lorenzo bronze reliefs), Donatello, like Giotto, created tangibly real types: the most sensual of these rivaled antique Roman art and changed the direction of Florentine art. Although Michelangelo's marble *David* replaced Donatello's *Judith* in front of the Palazzo della Signoria in 1501, Donatello remained the most admired founder of Florentine art, and his work set the benchmark for such sculptors as Michelangelo and Benvenuto Cellini, whose exquisite statue of *Perseus* was a pendant piece for Donatello's *Judith* in the Loggia dei Lanzi.

1386 — According to his tax returns (1427 and 1433), Donato di Niccolò di Betto Bardi (Donatello) was born in this year to the Florentine wool carder Niccolò di Betto di Bardo and his wife, Ursa. Vasari gave the date of his birth as 1383.

1401 — In Pistoia, Donatello and a German artist (Anichino di Pietro) are named in a court record as participants in a street brawl (January). Donatello may have been working on the silver altar of S. Jacopo in the Pistoia Cathedral (see Brunelleschi 1399).

1402 — Antonio Manetti (*Vita di Filippo Brunelleschi*) wrote that Donatello and Brunelleschi were in Rome together, following the 1401 competition to design the bronze doors of the Baptistery of S. Giovanni. "To do their excavation, they had to hire porters and other laborers at great expense. No one else, in fact, did such work, nor was there anyone who understood why they were doing what they were. Such a lack of understanding was due to the fact that back then,

21–1. DONATELLO. *Prophet Habakkuk* (first called Zuccone in 1550), 1427–36, marble, 6'4.3" (195 cm), Museo dell'Opera del Duomo, Florence. This is Donatello's quintessential campanile statue and would be considered his masterwork in the following century. His shoulders tilt, the fingers of his hands seem to twitch, and his rippling right side suggests rustling movement. Muscular arms and broad shoulders display youthful virility, but this man does not seem young because of his balding head, wrinkled forehead, and toothless mouth. His glazed eyes suggest that he is obsessed with the fate of humanity, and doomsday warnings seem to spew through quivering lips. The dense fabric piled upon his left shoulder spills over his body and is upturned near the gnarled toes of his thick, right foot. His garment is like coarse animal hide or sackcloth compared to the silky fabric that flows smoothly to the ground and fully covers earlier statues of prophets by Andrea Pisano. Donatello instead created an outer cloak for this figure that resembles a mass of uncoiled vellum scrolls, the attributes of prophets. The ballooning, sail-like folds, which can be seen from far away, would likely have reminded people of the unsettling omens of Old Testament sages.

21–2 (right). DONATELLO. *Portrait of Niccolò da Uzzano*, ca. 1425–30, polychromed terracotta, 18.1" x 17.4" (46 x 44 cm), Museo del Bargello, Florence. Until the latest restoration (1984–85), it was thought that the bust was created from a death mask. Donatello instead used life molds: one for the face, another for the cranium, and the ears were modeled and attached separately. The bust should be seen above eye level, as portraits of the period were customarily exhibited. With the shoulders relaxed and his head tilted upward, the portrait of Niccolò combines conflicting traits of a banker-scholar: the alert businessman turns sharply to his left, but the musing scholar gazes off into space, his eyes half-closed.

just as in previous centuries, no one was interested in ancient building techniques. If any pagan author has ever explained the principles of this method, as Battista Alberti has done in our times, he has touched on little more than the mere basics. The real secrets of the art, which are peculiar to the master, must be the result either of practical investigation or of personal effort."

1404 — Donatello is among Ghiberti's assistants on the bronze doors of the Florence Baptistery.

1406 — Two documents (November 1406, February 1408) refer to a marble prophet by Donatello for the Porta della Mandorla, Florence Duomo.

1407 — Listed as an assistant of Ghiberti, Donatello has an annual salary of 75 florins; he leaves Ghiberti's shop in this year.

1408 — Donatello carves a marble David (finished 1409 but never installed) for a buttress on the Florence Duomo. He is commissioned (19 December 1416) to carve the marble *S. John the Evangelist* for the facade of the Duomo.

1411 — Donatello works (1411–13) on his first commission for a guild tabernacle at Orsanmichele, the marble *S. Mark* (see fig. 63–11) and creates a giant, terracotta buttress figure of Joshua for Florence Duomo.

1412 — In Florence, Donatello is inscribed in the Compagnia di S. Luca as an *orafo* (goldsmith) and *scarpellatore* (stonemason).

1415 — Donatello begins work on the statues for the Florence Campanile (see fig. 21–1). He works on his second marble statue for Orsanmichele, *S. George* (see fig. 17–1), which is completed for the armorers' guild in 1417.

1416 — The armorers' guild buys marble from the Opera for the tabernacle relief, *S. George and the Dragon* (finished ca. 1417).

A marble *David* by Donatello (often identified as the 1408 Duomo commission) is installed in the town hall (see fig. 21–3); money is allocated for gilding the statue, and an inscription (lost) pertaining to Florentine liberty is attached.

By 1416 Donatello had executed a polychromed wooden *Crucifix*, 5'6.1" x 5'8.1" (168 x 173 cm), for S. Croce, Florence.

21–3 (left). DONATELLO. *David*, ca. 1412, marble, 6'3.3" (191 cm), until 1781 Palazzo Vecchio; since 1874, Museo del Bargello, Florence. Wreathed in amaranth (once highlighted in gold), symbolizing eternal honor, David is the virtuous hero. Holding a sling in his right hand (the metal or leather straps are lost), he towers over his trophy: Goliath's head, with the stone that toppled the mighty Philistine embedded in the forehead. This David is thought to be the 1408 Duomo commission for a buttress statue, never installed because such a small figure would be difficult to see from the ground. (Two years later Donatello created a colossus for a Duomo buttress.) Although the swashbuckling pose of this confident young hero can be understood from a distance, the fineness and detail of the carving (the lacing on the leather jerkin and fringe—likely gilded—of his cape) suggest that it is not the 1408 statue but a later work commissioned for the town hall, where it could be studied closely. Installed in the Sala dell'Orologio (in 1416), this statue of a civic hero bore an inscription (lost): "God helps those who fight bravely for their country even against the most terrible foes." About three decades after creating this figure, Donatello designed a bronze *David*, intended for a less public setting. The figures offer an interesting comparison to each other (see figs. 21–4, 21–5).

1419 — Donatello, Nanni di Banco, and Brunelleschi submit a model for the cupola of Florence Duomo. Donatello is completing (ca. 1418–20) the sandstone *Marzocco* (heraldic lion) for the staircase to Pope Martin v's quarters in the Dominican convent of S. Maria Novella, Florence.

1422 — Donatello receives payment for two marble heads (prophet and sibyl) for the Porta della Mandorla, Duomo. Around this date he is working by himself (and later with Michelozzo) on the tomb of Baldassare Cossa (Pope John XXIII), Florence Baptistery. He is also working on a gilt-bronze statue, *S. Louis of Toulouse* (finished ca. 1425), for the Guelph party niche at Orsanmichele.

1423 — Donatello works on *Feast of Herod* (finished 1427), a gilt-bronze panel (originally contracted from Jacopo della Quercia) for the font of the Siena Baptistery (see Ghiberti 1416). He also created two font statues (*Hope* and *Faith*) and three putti (finished by 1429) for the font's tabernacle (designed by della Quercia). For the baptismal font in Orvieto Cathedral he is hired to create a (lost) gilt-copper statue of the Baptist.

1425 — In Florence Donatello and Michelozzo become partners (1425–34) and share studios near the Duomo (Via dei Servi and Via Calzaiuolo).

1426 — According to Michelozzo's catasto (tax return) of 1427, he and Donatello have a studio in Pisa (1426–28), where work is done on the marble *Tomb of Cardinal Rainaldo Brancacci* for S. Angelo a Nilo in Naples (Donatello created the *Assumption* relief). Donatello creates small-scale figures for Masaccio (see Masaccio 1426).

1427 — Donatello's catasto lists money due for the bronze (reliquary) bust of *S. Rossore* for the convent of Ognissanti and the bronze relief (*Feast of Herod*) for Siena (see entry 1423). Around this time, he is working on a marble relief of the *Ascension with Christ Giving the Keys to Peter*, and the terracotta bust *Niccolò da Uzzano* (see fig. 21–2). Until 1881 the bust was in the Palazzo Capponi, built by Uzzano and inherited by Neri Capponi (Uzzano's son-in-law).

1428 — Donatello creates (ca. 1428–30) the bronze *Tomb Slab of Giovanni Pecci*, Bishop of Grosseto (d. 1426), for Siena Duomo.

21–5. DONATELLO. *David*, ca. 1455, bronze, 5'2.3" (158 cm), Museo del Bargello, Florence (see fig. 21–4). An account of the marriage of Lorenzo de' Medici and Clarice Orsini in 1469 places Donatello's bronze *David* on a column (about 8' high) in the center of the Medici palace courtyard (fig. 64–3). Vasari noted that the statue stood on a marble base by Desiderio da Settignano (apparently lost). An inscription on the base (now lost, but recorded in a Medici manuscript) referred to Florentine liberty: "The victor is he who defends the country; God crushed the wrath of a huge enemy; Behold a boy has defeated a great tyrant. Conquer, O Citizens!" An inscription was needed: David's silky flesh is seemingly less about victory and more about sensuality, the exact opposite of Mary Magdalene's body (see fig. 21–6), whose rough, jagged surface may allude to the torments of sin, while the prayerful hands refer to her confession and penitence.

21–4. DONATELLO. *David* (see fig. 21–5). Visitors standing in the Medici court would have looked up at the confident face while those on the second story would have gazed down at the sleek form. The statue is now on a low pedestal, and the hat brim casts a shadow over the face, the body appears androgynous, and the figure seems more timid. Although considered the first life-size, freestanding bronze nude since antiquity, the figure is not fully naked but clothed in accessories (hat and greaves) that seem unrelated to the story of David and accentuate the soft flesh, youthful body, and lack of armor. It has been proposed that the oddities suggest the conflation of the biblical David and the classical god Mercury. (The floppy hat is like Mercury's petasos, and Goliath may refer to the hundred-eyed giant Argus, slain by Mercury.) As the Roman god of commerce and the arts, Mercury was significant to the Medici merchant-bankers, who patronized humanists and artists.

21–6. DONATELLO.
S. Mary Magdalene,
ca. 1455, polychromed
wood (white poplar),
6'2.5" (184 cm), Museo
dell'Opera del Duomo,
Florence. Donatello
created the quintes-
sential penitent saint
by emphasizing the
spiritual fervor of *Mary
Magdalene*, who stands
on uneven ground, lists
to one side, and raises
her hands in prayer.
Mary's penetrating
eyes, taut muscles,
dropped jaw, and
arcing fingers make
her seem to gasp and
quake, as though she is
experiencing physical
tremors. The figure has
often been described
as old and ugly but has
in fact the body of a
young woman, although
every trace of seductive
flesh has evaporated,
leaving behind a veneer
of weathered skin. It
seems that the figure is
visually meant to allude
to her flesh demate-
rializing into a pure
spirit. As flickering
candlelight glinted off
the gold highlights of
Mary's stringy hair
and tattered dress, her
spindly form would ap-
pear like a shaggy tree
sloughing its bark, and
her lanky figure, like an
undulating flame rising
from a burning candle.

1430 — Donatello, Brunelleschi, Ghi-
berti, and Michelozzo serve as military
engineers for Florence during the siege
of Lucca. Donatello is working on a
sandstone figure of *Dovizia*, represent-
ing Communal Wealth, later installed
on an ancient column erected (in 1430)
in the Mercato Vecchio.

1432 — Donatello is in Rome, where he
creates the marble Tabernacle of the
Sacrament in S. Peter's and the marble
Tomb of Giovanni Crivelli in S. Ma-
ria in Aracoeli. (Crivelli [d. 1432], the
archdeacon of Aquileia, was the papal
scriptor and abbreviator.)

1433 — Donatello is summoned back to
Florence to work on the outdoor pulpit of
the Pieve at Prato (contracted with Mi-
chelozzo in 1428; completed in 1438). On
the Feast of the Assumption, the Virgin's
girdle (belt) was displayed
from the pulpit. Donatello
rents Medici buildings for
a studio in Florence (de-
molished in 1446 to make
way for the new Palazzo
Medici) and is hired to
make a marble *Can-
toria* above the south
(old) sacristy door in
the Duomo; Luca was
earlier hired (in 1431)
for a *Cantoria* above the
north sacristy door (see
figs. 18–3, 19–3).

1434 — Donatello de-
signs *Coronation of the
Virgin* for a stained-
glass window in the
drum of Florence
Duomo.

1437 — Contracted
for bronze doors
for both sacristies in

the Florence Duomo, Donatello designs
a model (February), but never executes
the doors. (In 1445 the north door was
reassigned to Luca della Robbia, Miche-
lozzo, and Maso di Bartolommeo.)

Around this time, Donatello is work-
ing on the Cavalcanti *Annunciation* for
S. Croce, Florence. Donatello is also
working on sculptural projects (until
1443) in the sacristy (now Old Sacristy)
of S. Lorenzo, Florence (see fig. 19–2).
On the wall lunettes are stucco reliefs of
the Evangelists, in the pendentives are
stucco narratives of S. John the Evan-
gelist, and above the doors to the *lava-
mani* are stucco reliefs of Stephen and
Lawrence and Cosmas and Damian (by
Michelozzo). Donatello and Michel-
ozzo likely collaborated on designs for
the door surrounds, Donatello designed
the bronze Martyrs door, and Miche-
lozzo designed the Apostles door. Each
panel has two debating figures, content
which may have been inspired by the
debates of the ecumenical council in
Florence (in 1439).

1438 — Donatello signs and dates a
polychromed wood statue, *S. John the
Baptist*, 4'7.5" (141 cm), for S. Maria dei
Frari, Venice.

1439 — For the Florence Duomo,
Donatello creates a (lost) wax model
for the altar of S. Paul; Luca della
Robbia was later hired to carve
altar frontals for the chapels of S.
Peter (unfinished) and S. Paul (un-
executed).

1444 — Donatello transfers his studio
to Padua, ostensibly to work on the
bronze equestrian of Erasmo da Narni
(see fig. 21–7), for which payments were
made to him through Onofrio Strozzi
(son of the exiled Florentine Palla
Strozzi). Completed ca. 1450 (installed

1453), this was the first bronze equestrian statue since antiquity that fully glorified a soldier in an *all'antica* style. Donatello also creates the first life-size bronze Crucifix (casting begun 1444; final payment 23 June 1449); created for the Franciscan convent church of S. Antonio, it was installed in the middle of the church (moved to the choir entrance in 1487).

1445 — While living in Padua, Donatello visits Florence, where he and Luca appraise Buggiano's lavabo in the Duomo.

1446 — Donatello works (until 1453) on the new high altar of S. Antonio, Padua, for which he creates seven bronze figures (*Madonna and Child, Anthony, Francis, Louis of Toulouse, Prosdocimus, Daniel,* and *Justina*), four bronze relief panels (*Miracle of the Newborn Child, Miracle of the Mule, Miracle of the Wrathful Son, Miracle of the Miser's Heart*), a stone relief (*Entombment*), and fifteen bronze reliefs (*Imago Pietatis* [Christ with Angels], *Evangelist Symbols,* and *Angels*). Parts of the altar were temporarily displayed (June 1448, June 1450) to raise money for completing the altar, but the original appearance of the altar (finished 1477) remains uncertain (dismantled in 1579; rebuilt in 1895).

1451 — In Ferrara, Donatello appraises the *Equestrian Statue of Niccolò d'Este*, and enters negotiations in Modena for a gilt-bronze statue of Borso d'Este (see fig. 17–8). Donatello provides a model for the S. Anselmo shrine in Mantua (unexecuted).

1454 — Returning to Florence before the completion of the S. Antonio altar, Donatello rents property (in November) behind the Duomo that includes a studio and gardens (later rented by Verrocchio).

1455 — Donatello is sent on a business trip to Volterra by Giovanni de' Medici.

About this time he may have received Medici commissions for two bronze statues: *David* (see figs. 21–4, 21–5) and *Judith* (see fig. 21–8). Also around 1455 he creates the wood statue *Mary Magdalene* (see fig. 21–6), apparently for the Florence Baptistery, where it was seen in the 16th c.

1456 — For medical treatment, Donatello gives the Florentine physician Giovanni Chellini a bronze tondo relief, *Virgin and Child with Angels* (Victoria and Albert Museum, London), 11.1" (28.5 cm).

1457 — In Florence Donatello completes (24 October) a gilt-bronze statue, *S. John the Baptist*, in three pieces for Siena Duomo. He moved to Siena upon receiving the promise of a stipend for life from the Opera del Duomo. Among his official Duomo commissions was a marble tondo for the S. Calixtus Chapel: the foreshortened relief, *Madonna and Child with Angels* (finished 1458), 35 x 37.5" (89 x 95 cm), with Mary's head projecting above the perspectival surround of green marble inlay (Museo dell'Opera del Duomo, Siena). In 1458 he was asked to design bronze doors (abandoned) for the Duomo and a marble statue of S. Bernardino (not executed) for the Loggia di S. Paolo.

1459 — Returning to Florence, Donatello receives a pension from the Medici and works on bronze panels for S. Lorenzo.

1466 — On 13 December, Donatello dies in Florence and is buried in S. Lorenzo, near the tomb of Cosimo de' Medici.

21–7. DONATELLO. *Equestrian Statue of Gattamelata*, 1444–53, bronze statue, 11'2" x 12'8.5" (340 x 390 cm), west (front view), Piazza S. Antonio, Padua. Dedicated to S. Anthony of Padua, the Basilica of S. Antonio (Il Santo) was one of the most sacred pilgrimage sites in Quattrocento Italy. Donatello's statue is like a military guardian of the holy ground in front of the Santo and the shrines inside. Vasari claimed the statue was commissioned by the Venetian republic, but the bulk of the expense was apparently covered by Narni's family. The tomb was originally intended to be in the vertical base, but Narni's wife commissioned a funerary chapel in the Santo in 1456, dedicated to S. Francis and S. Bernardino, to hold the tombs of Erasmo (d. 1443) and his son (d. 1455).

Old Testament Heroine—Judith

A widow of wealth and beauty (see book of Judith, Old Testament Apocrypha), Judith lived in Bethulia, where the Assyrians had cut off her town's water supply. Convincing the elders not to surrender, Judith told them that with God's help she could save the Israelites from certain destruction in five days' time. The elders agreed to her plan. For the journey she took off her widow's weeds; then she bathed and anointed herself in rich oil, braided her hair and put on a tiara, donned festive clothes and slipped on jewelry, and prepared provisions for the journey. "She gave her maid a skin of wine and a flask of oil, and filled a bag with roasted grain, dried fig cakes, and fine bread" (Jdt 10:5). They went out the town gate, down the mountain, and across the valley to the Assyrian outpost, where they were taken into custody. Judith told the patrol that she was the daughter of Hebrews and had escaped the impending destruction of her people. She asked to see their commander, Holofernes. Judith told him that she had abandoned her people because they were about to break the laws of God by devouring food he forbade them to eat (sacred cows, wine, and oil). She told him that when her people carried out these unforgivable acts, God would help him destroy them. She explained that every night she had to go into the valley to pray before God, who would tell her when the sins had been committed; she would then tell Holofernes, who would have God's help in overthrowing the Israelites. Judith was given a place to stay in his tents and was offered both food and wine, but she had brought her own. On her first night in camp she got permission to go out unguarded to pray in the valley before dawn. For three days, she left camp after midnight without bodyguards. On the fourth day, Holofernes gave a banquet, inviting only his slaves and none of his soldiers. Judith was invited to join the banquet, and she wore her finest clothes. At the banquet Holofernes said to her, "Have a drink and be merry with us!" (Jdt 12:17). Judith replied, "I will gladly drink, my lord, because today is the greatest day in my whole life" (12:18). That day, Holofernes drank more wine than he had ever drunk in a single day. As night approached, everyone but Judith left the tent, and Holofernes soon fell into a stupor. Walking to his bed, she took the scimitar from the rail beside him. Grabbing locks of his hair, she prayed for strength and stuck his neck twice with all her might, and his head came off. She rolled the body from the bed, pulled down the bed canopy, and then waited a little while. Outside the tent, she gave the severed head to her maid, who put it inside the foodsack. The two women left the camp together for prayer, as was their custom before dawn. This time they went farther. Skirting the valley, they climbed up the mountain to the gates of Bethulia. Judith gave the bloody head to her people, telling them to display it on the parapet of the town wall. Discovering their leader's lifeless body, the Assyrians were horrified and ran in all directions.

21–8. DONATELLO. *Judith and Holofernes*, ca. 1455, bronze, 7'8.9" (236 cm), with base, Sala dei Gigli, Palazzo Vecchio, Florence. It was erected on a column in the Palazzo Medici, based on a note in Bartolommeo della Fonte's *Zibaldone*, ca. 1470. That the statue was a fountain decoration is based on holes in the wineskin (cushion) and in the bacchanalia reliefs of the triangular base through which water could flow. This montage is meant to simulate its appearance. Vasari thought *Judith* was cast for the Signoria and placed in the loggia, but it is mentioned in the Palazzo Medici gardens on 9 October 1495, from where it was to be removed (with its pedestal) by order of the government. Donatello's signature is on the edge of the wineskin near Holofernes' left hand: OP[VS] DONATELLI FLO. The statue group, often linked to the purchase of 956 pounds of copper and bronze in 1456, was cast in eleven pieces (including the base), thus facilitating the fire gilding of particular areas (traces of gilt remain on Judith).

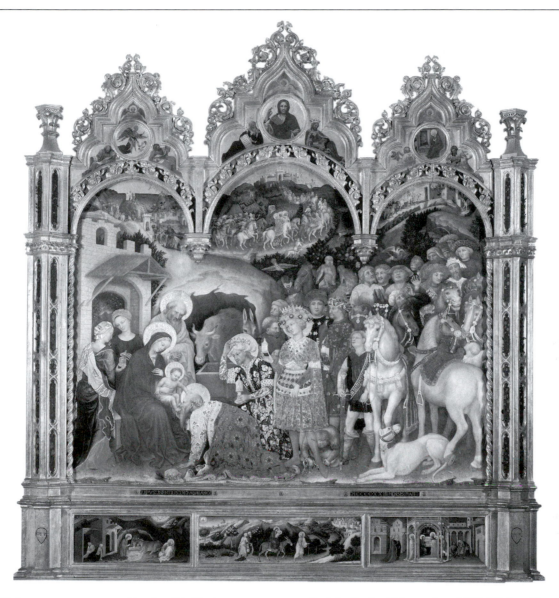

22–1. GENTILE DA FABRIANO. *Adoration of the Magi*, 1423, tempera on panel, whole 9'10.1" x 9'3" (300 x 282 cm), Uffizi Gallery (since 1919), Florence. Pictured in the background is the journey of the magi: standing on a tall rock, they sight the star (left lobe), they then journey to Herod's palace (middle lobe) and to Bethlehem (right lobe) (see ADORATION OF THE MAGI, Quattrocento Glossary). In the predella are these scenes: the *Nativity*, *Flight into Egypt*, and *Presentation in the Temple* (the original panel is in the Louvre, Paris). Pictured in roundels in the pinnacles are *Gabriel* (left), the *Blessing Redeemer* (center), and the *Annunciate Virgin* (right); the reclining figures beneath Gabriel are prophets *Ezekiel* and *Micah*, beneath the Redeemer are prophets *Moses* and *David*, and beneath the Virgin are prophets *Baruch* and *Isaiah*; each prophet (but David, who plays a harp) is identified by an inscribed text.

When the skillful Marchigian painter Gentile da Fabriano (ca. 1385–1427) entered Florence in 1419, he brought a unique vision. His art was fresh and exuberant, and no artist was then depicting the tactile qualities of material goods in quite the same way as Gentile. Inspiring Masaccio, and greatly influencing Masolino, Fra Angelico, and Domenico Veneziano, his art helped change the course of Venetian and

In the sacristy of the Vallombrosan church of S. Trinità is the tomb of Nofri (Onofrio) Strozzi, d. 1418, the patriarch of the Florentine family whose patronage of the sacristy dates to 1417. The Strozzi were bankers to the Neapolitan court, and in 1415 Palla (Nofri's son) was knighted by the king of Naples for his services to the court. Palla was perhaps the richest man in Florence in 1420; after completing the first sacristy (1421), he had a second sacristy and altar built in S. Trinità (1423–24), for which he commissioned Gentile's *Adoration of the Magi* (see fig. 22–1). It seems that Palla appears in the center of Gentile's painting holding a falcon, an emblem of the Strozzi (*strozziere* in Italian is falconer). Beside him is a young man staring out at the viewer, who may portray Palla's son Lorenzo. The Strozzi coat of arms (three cresent moons) appears twice on the altarpiece frame. Gentile signed his name and the date on the frame beneath the main panel. In June 1423, after completing his work in May, he received 150 gold florins from Palla Strozzi.

Florentine painting. The luminosity of his pastel palette (Orvieto *Madonna and Child*), creation of measured and complex spaces (*Pilgrims at the Tomb of Nicholas*, National Gallery of Art, Washington, D.C.), and display of light and shadow from natural and supernatural sources (*Nativity* predella, Uffizi Gallery, *Adoration of the Magi*) attracted rich humanist patrons, like Palla Strozzi. His splendid panels tantalize the senses with intricate brocades, ornate PASTIGLIA (see Quattrocento Glossary), lush vegetation, and an array of wildlife (see fig. 22–1). Lacking the austerity associated with the Florentine style, his art was fashionable with nobles and prelates, and his services were sought by Pope Martin v.

ca. 1385 — Gentile is born in Fabriano (about 45 miles northeast of Perugia). His father, Niccolò di Massio (d. 1400), entered the Silvestrine monastery in Castelvecchio soon after Gentile's mother died (ca. 1390). It seems that Gentile was raised by his grandfather, Giovanni.

1408 — No apprenticeship is documented, but Gentile moved to Venice in this year, where he painted a (lost) fresco of a historic Venetian naval battle in the Doge's Palace (1411). Although he worked for the Venetian government until about 1414, his fresco for the Doge's Palace was first painted over and then destroyed by the great fire of 1577.

1414 — Gentile becomes the court painter to Pandolfo Malatesta, lord of Brescia, where he works for the next five years (Brescia would come under Venetian control in 1423). Seeing his work in Brescia in 1418, and owning one of his paintings (a gift from Gentile), Pope Martin v invited Gentile to Rome, granting him (and seven others) safe passage to join him in Florence.

1419 — Gentile arrives in Florence, and two years later is inscribed in the painters' guild (November 1422). He rents a house in the S. Trinità quarter.

1420 — Gentile is in Fabriano, where he requests exemption from local taxes.

1423 — In Florence, Gentile signs and dates his *Adoration of the Magi* altarpiece (OPVS GENTILIS DE FABRIANO / MCCCXXIII MENSIS MAIJ) for Palla di Nofri Strozzi's family burial chapel in the sacristy of S. Trinità (see fig. 22–1). The impact of this panel (by an outsider) on Florentine painting was tremendous. Gentile captured the sense of wonderment of this theme through jumbled and foreshortened forms. In the foliate ornamentation of the frame and the dense fictive flowers of the pilasters, the lush, gilded brocades, and the range of exotic figures and animals, his painting corresponds more to Venetian and Lombardian taste than to Florentine.

1425 — Gentile signs and dates (inscription lost) the Quaratesi altarpiece, commissioned for the high altar of S. Niccolò sopr'Arno. In this work he melded his style with traits of the young Florentine painter Masaccio.

In Siena, Gentile creates a painting for the notaries' palace.

In Orvieto (October–December), Gentile paints a fresco, *Madonna and Child*, in the cathedral (left aisle, near the main doors).

1427 — In Rome, Gentile works for Martin v (late January to August), painting frescoes of S. John the Baptist (destroyed) along the nave of S. John of the Lateran. His annual wages were about 300 gold florins, but he worked for only six months. By October Gentile had died in Rome and was buried in S. Maria Nova, an Olivetan monastery (in the Roman Forum).

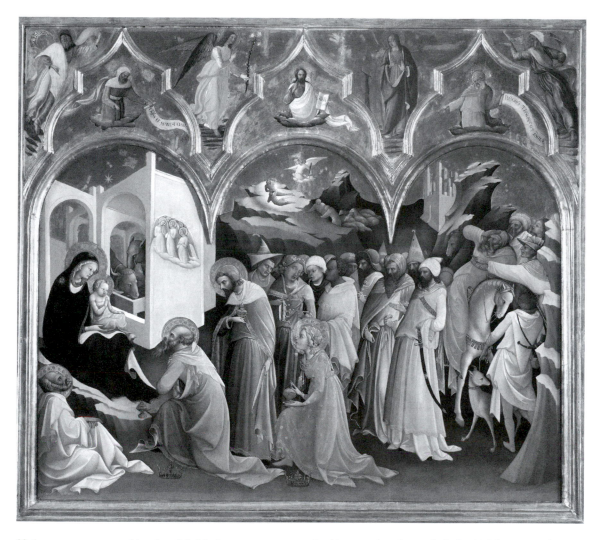

23–1. LORENZO MONACO. *Adoration of the Magi*, 1420–22, tempera and gold on panel: main panel, 3'9.3" x 5'6.9" (115 x 170 cm), Uffizi Gallery, Florence. In the pinnacles Lorenzo painted the *Blessing Redeemer* (center) and the prophets *Isaiah* (left) and *David* (right), identified by the biblical texts inscribed on their scrolls. Cosimo Rosselli later painted the other two prophets and *Annunciation* in the spandrels (1470s). This painting and the *Coronation* (see fig. 23–2) display themes that were important to the devotional needs of the early Quattrocento, and they were done by a painter-monk, one of several who stand out as extraordinary artists of the Quattrocento.

Whereas Gentile da Fabriano described a bountiful and detailed natural world in his *Adoration of the Magi* (see fig. 22–1), Lorenzo Monaco (ca. 1375–ca. 1424) envisioned the holy event unfolding on arid, uncultivated ground (see fig. 23–1). Boneless, dainty figures in diaphanous gowns are as thin and weight-less as the clothes they wear. Leaving no visible footprints, and unfettered by most of nature's laws, these figures offer a genteel, ethereal vision of Christian history. Like Gentile's painting, the narrative is displayed over a continuous field; yet the remnants of a triptych format, especially popular in Trecento

CAMALDOLESE ORDER.
S. Romuald of Ravenna (d. 1027) is famous for the hermitage he founded at Camaldoli (near Arezzo), ca. 1012. As a young man he entered the Benedictine Order in Ravenna, where he became the abbot of S. Apollinare-in-Classe. Growing disillusioned with laxity among the monks, he began reforming Benedictine houses. At Camaldoli he acquired land to build a hermitage, where he and his followers lived like hermit monks: they were devoted to extreme abstinence, penance, silence, and seclusion. (The white habits and scapulars for which the Camaldolese are known first appear at Camaldoli.) The order was officially approved by Pope Alexander II (1072) after Romuald's death, and Blessed Rudolph I (fourth prior of Camaldoli) wrote the first constitution (1080), mitigating practices set out by Romuald. By the Trecento, Camaldolese monasteries were founded in towns, and S. Maria degli Angeli in Florence was the largest urban house in Tuscany during Lorenzo Monaco's time (see entry 1392).

Tuscan art (see fig. 14–2), can be seen in the tripartite division suggested by the three lobes of the frame. Taking advantage of the implied separation, Lorenzo placed the Christ child to the far left, where the baby is the devotional focus of the painting. Near the shelter of an open-air stable, he is presented by the Virgin, adored by angels, and given the attention of a long, human train stretched across barren land. Simplicity, quiet sentiment, restrained emotions, and clarity of focus are hallmarks of Lorenzo, and only in the center of the painting is the sense of agitation suggested. Here, men of Asian and African physiognomies, who appear physically heavier than the others, express some restlessness. These men are puzzling over the arrival of a Messiah on earth; like the shepherds in the craggy rocks behind them (two of whom are bathed in the angel's radiant light while the other two are crawling upon stones in near pitch darkness), they are visibly more active than the other men. Compared with Gentile's panel, Lorenzo's painting more emphatically directs attention toward the Christ child. The sinuous contour lines of the humans, beasts, and rocks on the far right are tightly interlocked through corresponding curves. Visually linked to the other figures, they create a continuous, undulating wall of people. The liveliest, brightest colors are arrayed in the middle of the panel, where they shimmer like pools of colored light and stand out in sharp contrast to the drab earth. It seems that Lorenzo was trained by an artist like Agnolo Gaddi, from whom he would have learned coloring and the technique of layering glazes to create the luminous, cloth-of-silk (shot–silk) fabrics seen in this panel. However, Lorenzo's compositions are simpler and rely more on geometric structure than Agnolo's, and they more subtly express a greater range of human emotions. Lorenzo trained many artists,

and the melodious nature of his graceful style made a lasting impression upon Masolino and Fra Angelico.

ca. 1375 — The painter known as Lorenzo Monaco (the monk) is born Pietro di Giovanni. Almost nothing is known about his early life except he was from the parish of S. Michele Visdomini (near the Ospedale degli Innocenti), and entered the Camaldolese monastery of S. Maria degli Angeli in 1390.

1391 — Don Lorenzo di Giovanni completes the novitiate (10 December).

1392 — Taking solemn vows, Don Lorenzo is ordained subdeacon. (He was elevated to the deaconate four years later, in 1396.) Soon after taking solemn vows at S. Maria degli Angeli, Lorenzo lived outside the community but remained a religious throughout his life, with attachments to the house (see sidebar, **CAMALDOLESE ORDER**).

1396 — Under the name Piero di Giovanni, Lorenzo is listed as a painter in the books of the Company of S. Luke (as he was again in 1402).

1399 — Chiarco Ardinghelli commissions a painting (untraced) for a chapel (his second) in S. Maria del Carmine, Florence. Lorenzo Monaco, living outside the monastery, has established a painting workshop in town (producing panels, minatures, illuminations, and choir books), employing monastic and secular assistants (see Fra Angelico).

1410 — Lorenzo dates the altarpiece *Madonna Enthroned with Saints* for S. Bartolommeo at Monte Oliveto (Accademia, Florence).

1414 — Lorenzo dates and signs the altarpiece *Coronation of the Virgin* (see

fig. 23–2) for the high altar of his own monastery, S. Maria degli Angeli. A prototype for his work can be found in Jacopo Torriti's *Coronation of the Virgin* (see fig. 6–1). Lorenzo's arched, blue-starred bands make his work closer in spirit to Torriti's grand, apse mosaic in S. Maria Maggiore, Rome, where the regal couple seems also to float upon a celestial field, than to images of the popular theme that are more contemporary to Lorenzo's time (for a selected listing of these images, see sidebar, CORONATION OF THE VIRGIN).

1422 — Payments are made (22 January 1420 to 7 August 1422) to Lorenzo for an altarpiece for the new S. Egidio (see fig. 61–2, #14), a dependency of S. Maria degli Angeli. The rebuilt church (1418–20) was consecrated by Pope Martin V in 1420. For this prestigious commission Lorenzo was paid more money (182 gold florins) than he had previously received for a painting, and the work most often linked to the payments is *Adoration of the Magi* (see fig. 23–1). It would seem that Lorenzo's entourage in his *Adoration* was inspired by the arrival in Florence of the papal curia (in 1419) as well as the annual Festa de' Magi processions during Epiphany. In the late–15TH c. Lorenzo's *Adoration of the Magi* was altered: it was given a square format and the *Annunciation* and two prophets were added to the spandrels by the Florentine painter Cosimo Rosselli. It seems possible that the original frame was similar to Lorenzo's earlier *Coronation of the Virgin* (see fig. 23–2), and the painting may also have had both a predella and pilasters, like his *Coronation*.

Lorenzo begins work on an altarpiece (unfinished) commissioned by Palla di Nofri Strozzi for his family chapel in the sacristy of S. Trinità. Palla also commissioned Gentile to create *Adoration of the Magi* (see fig. 22–1). Although the main theme of Lorenzo's altarpiece is undocumented, it may have been a Deposition (see fig. 26–3). Lorenzo completed only the pinnacles: *Noli me tangere, Resurrection,* and *Three Marys at the Tomb* (Museo S. Marco, Florence). Three predella scenes are also linked to the altarpiece: *S. Nicholas Calming the Storm, Nativity of Christ,* and *Legend of S. Onuphrius* (Accademia, Florence).

Lorenzo made his fresco debut (ca. 1422) painting the Life of the Virgin in the Bartolini Salimbeni Chapel (dedicated to the Annunciate Virgin), S. Trinità, Florence (see fig. 62–7, #26). His frescoes of courtly scenes, such as the *Betrothal of the Virgin,* display affinities with Lorenzo Ghiberti's designs for the Florence Baptistery doors (see fig. 18–1). Although Lorenzo's *Betrothal* architecture is more extensive and his elegant figures are more subdued and plentiful, the people mesh visually with the loggia arches, like Ghiberti's figures in the *Cleansing of the Temple.* Lorenzo Monaco also painted an Annunciation altarpiece for the chapel that shows the unfortunate influence of Gentile. The lyrical, abstract qualities of Lorenzo's style remain pure in the predella scenes, but his delicate and aeriform figures in his *Annunciation* are now closer to Gentile's volumetric forms, and they collide with the setting: Mary is too large for the low roof and slender porch columns, and the leafy trees and blades of grass in the doorway (resembling Gentile's descriptive nature) seem incongruous next to the metallic, gold sky. The chapel was still incomplete in 1435, according to guild records of the Cambio (supervisors of the chapel).

1424 — By this date, it seems that Lorenzo had died in Florence. Records of S. Maria degli Angeli show that he was interred there.

Lorenzo Monaco's
Coronation of the Virgin

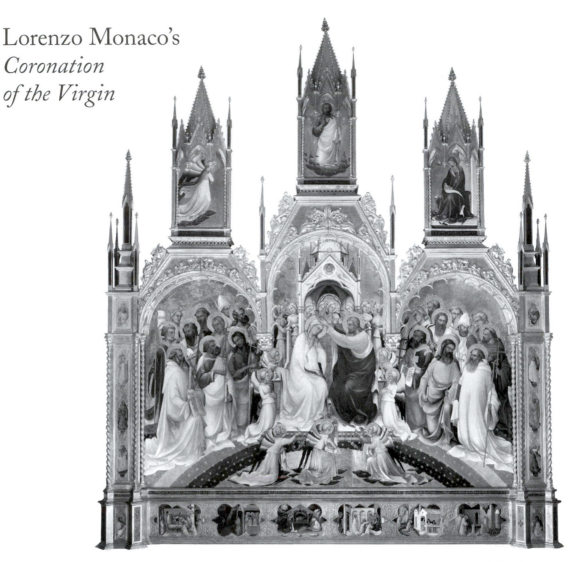

23–2. LORENZO MONACO. *Coronation of the Virgin*, 1414 (signed and dated), tempera and gold on panel, main panel 16'9.7" x 14'9.1" (512 x 450 cm); in the pinnacles are the *Blessing Redeemer* (center) and *Annunciation;* predella scenes include four stories of Benedict, flanking the *Nativity* and the *Adoration of the Magi;* in the pilasters are standing prophets, Uffizi Gallery (since 1846), Florence. Painted for the monastery church of S. Maria degli Angeli, the altarpiece was installed on the high altar (replaced by Alessandro Allori's *Coronation,* dated 1593). The three arches of the elaborate frame are vaulted, with the painting set back from the frame; similar to the canopy that rises above the holy couple, the vaults metaphorically honor and protect the entire entourage. The pinnacle frames (lost) were probably canopies. Graced with forty-six elegant figures, this is Lorenzo Monaco's largest altarpiece. Seventeen angels cluster behind the throne (nine clearly visible, with halos suggesting the others), while four more sing and kneel beside

the throne. Next to them are twenty saints (all male except the crowned figure in the last row on the left), divided into two flanks that are three rows deep. These elegant figures are bonded in the unfolding, solemn ritual, and the two kneeling angels censing in the foreground connote the sacred and honorific nature of the Virgin's coronation. The damage in the middle foreground (from the later addition of a tabernacle) obscures the middle angel, who plays what might be a portative organ. At the ends of the front row are the pillar saints of the Camaldolese Order: S. Benedict (left) and S. Romuald (right). Both wear the white habit of the Camaldolese, and the color is echoed in the luminous gowns of the Redeemer (pinnacle) and the Virgin. On the molding between the main panel and the predella is an inscription that includes the names of the artist monks (Lorenzo and his assistants) and the date February 1413 (Florentine style), which would be 1414 in modern style.

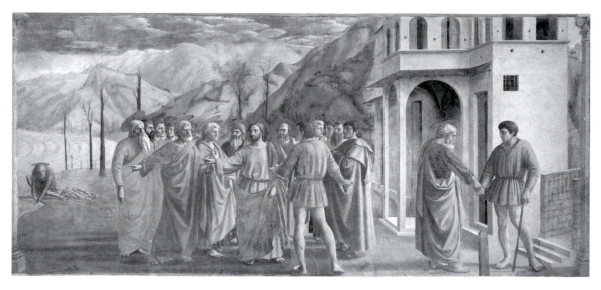

24–1. MASACCIO. *Tribute Money*, ca. 1427, fresco, 8'1.3" x 19'7.1" (247 x 597 cm), S. Maria del Carmine, Florence. According to Vasari, although Masolino was hired to paint the chapel, he died at the age of 37 before completing his contract, and Masaccio finished Masolino's works. Vasari's highest praise went to the *Tribute Money*, where he thought he saw Masaccio's self-portrait. In this revolutionary work, Masaccio turned to Donatello's stone relief of *S. George and the Dragon,* but created a much grander scene that visually integrates life-size, volumetric figures into an atmospheric setting. No artist until Leonardo da Vinci would advance Masaccio's pictorial experimentation with melding figures seamlessly into nature. The staggering of events in this continuous narrative encourages viewers to visually walk around figures and through the landscape: at Capernaum the tax collector asks for money, and Jesus sends Peter to the sea (far left), where he gets money from a fish to pay the tax (far right).

Perhaps the most remarkable fact about Masaccio (1401–28) is that he was in his twenties when he created the masterworks in the Brancacci Chapel (the Sistine ceiling of the 15ᵀᴴ c.) that became the touchstone for measuring Florentine chapel decoration. Although he died too young to become as sought-after as the popular Masolino, soon after his death his art was considered the basis for all that was good in Florentine Quattrocento painting. To his credit, he created works in the manner of the great Giotto, making mystical experiences soberly real, as can be seen in the painting of *S. Peter Healing with His Shadow* (see fig. 24–2), and his style was thoroughly modern in its *all'antica* appearance. The Corinthian capitals, Roman coffers, and one-point perspective in *The Holy Trinity*, S. Maria Novella (see fig. 18–5), were designed after Brunelleschi, and

the dramatic expression and atmospheric perspective in the *Martyrdom of S. Peter* and the *Tribute Money* (see fig. 24–1) were inspired by and partly derived from Donatello. Vasari (*Lives*, 1568), like Alberti (*Della pittura*, 1436), regarded him as the equal of ancient artists and among the founders of the "new style" in Quattrocento Florence (both writers also included Brunelleschi and Donatello). In his *Commentary on Dante* (1481), the Florentine Cristoforo Landino praised Masaccio for his perspective and measured, clear style that imitated nature and made figures come alive. Working chiefly for pragmatic businessmen and mendicant orders, Masaccio painted stocky, simply clad people, who bear a noble demeanor but are sometimes homely, and lack grace or refined features. His charismatic figures fully embrace nature's irregularities, expressively displayed in

Fictive light falls from the upper right in the altar wall scene of Peter healing with his shadow (see fig. 24–2), suggesting that the chapel window is its source (see fig. 24–3). Opposite this scene, Masolino's townscape has figures also seemingly illuminated by window light (see fig. 25–1). In his open piazza the portico of Solomon's Temple appears on the near side of a broad square, and resembles Orcagna's Loggia dei Lanzi in the Piazza della Signoria. In Masaccio's altar wall scene the ancient Temple of Solomon again appears, but resembles an *all'antica* Renaissance building, supported by a distinctive Corinthian column. Peter is shown walking away from the temple portico and through a narrow, medieval street, similar to those around the Carmine; his dramatic presence is a pictorial equivalent of Donatello's marble campanile figures. Masaccio is usually given credit for designing the fictive Corinthian pilasters in the Brancacci Chapel; like those of *The Holy Trinity* (see fig. 18–5), they resemble Brunelleschi's in the S. Lorenzo sacristy.

their hunched backs, sloping shoulders, down turned eyes, and bulbous noses. As respected as Masaccio has become, his story is nonetheless enigmatic. Vasari mistakenly placed his death in the year 1443 and overestimated his oeuvre by assigning works that have since been reattributed to Masolino (whose graceful figures are stylistically closer to Ghiberti than to Donatello). Issues of attribution and date remain difficult to resolve for works jointly assigned to both painters, and understanding their individual contributions is confounded by the poor condition of works such as the *S. Anna Metterza* (see fig. 25–4).

1401 — Tommaso di Ser Giovanni, later nicknamed Masaccio (big or hulking Tom), is born on 21 December in Castel San Giovanni (the modern San Giovanni Valdarno) to the notary Ser Giovanni di Mone Cassai and Monna Jacopa di Martinozzo, an innkeeper's daughter. Tomasso's family lives in the house of Masaccio's paternal grandfather, Mone di Andreuccio, who had a family business with his brother making marriage chests (*cassoni*) and variously sized boxes for domestic use.

1406 — Masaccio's father dies and his mother remarries the wealthy pharmacist Tedesco del Maestro Feo. Masaccio's brother Giovanni (nicknamed Lo Scheggia) is born; he became a painter and is best remembered for his *cassoni* and *spalliere* panels.

1418 — By this year, Masaccio (with his mother, sister, and brother) moves to Florence, following the death of his stepfather (1417).

1422 — In Florence, Masaccio is inscribed in the painters' guild (Arte dei Medici e Speziali) on 7 January; he pays two lire to the guild's steward (6 October), and is living in the parish of S. Niccolò sopr'Arno. He paints the S. Giovenale altarpiece, on which the date 1422 is inscribed.

Masaccio paints a monochromatic (terra verde) scene, *La Sagra*, depicting the consecration of the Carmine (destroyed ca. 1600), above the door in the cloister leading into the monastery church of S. Maria del Carmine, Florence. Masaccio's work likely began soon after the event, which occurred on 9 April 1422. Vasari noted that the fresco pictured the Piazza del Carmine with a procession of Florentines, including Brunelleschi, Donatello, Masolino, and Niccolò da Uzzano. Michelangelo and others made drawings after Masaccio's famous fresco. Also in the Carmine, Masaccio painted a pilaster image in the Serragli Chapel (destr. 1675), depicting S. Paul.

1424 — In Florence, Masaccio joins the Compagnia di S. Luca, the professional association of artists, to which chiefly painters belonged.

1425 — Masaccio is paid (5 June) for gilding processional candlesticks for Fiesole Cathedral. Around this date, he may have been working on an altarpiece panel, *S. Anna Metterza*, depicting the Madonna and Child with S. Anne.

1426 — Ser Giuliano di Colino degli Scarsi di San Giusto commissions Masaccio to execute an altarpiece (19 February) for his family chapel in S. Maria del Carmine, Pisa. Scarsi's account books show that Masaccio received eighty florins for his work, and Vasari recorded that the painting was installed in a chapel on the choir screen. Masaccio's fee was awarded in eight installments: ten florins (20 February); fifteen florins (23 March); ten florins (24 July), given to Donatello in Pisa; twenty-five florins (15 October), when he promised not to

undertake any other work until the altarpiece was completed; three lire on his account (9 November), paid to a tailor for a jerkin (a close-fitting, hip-length, sleeveless jacket); one florin (18 December), paid to Masaccio's apprentice Andrea di Giusto, as witnessed by Donatello; eight lire and five soldi (24 December), accepted for Masaccio by his apprentice Andrea di Giusto; and the balance of sixteen florins and fifteen soldi, given to Masaccio in the presence of the prior (26 December). Masaccio paid Donatello in July for small-scale figures; these were likely used for studying the effects of light on three-dimensional forms. Deep folds in the Pisa Madonna's cloak may reflect the use of such figures, and her thick mantle is gathered around the body in the style of Donatello's cloaked figures, especially the gilt-bronze *S. Louis of Toulouse* (1422–25 for Orsanmichele, Florence). The linear perspective and geometric organization of the narratives in the Pisa predella are painted equivalents of Brunelleschi's architecture: long, thin shadows function like the floor grids at S. Lorenzo. Calling attention to the temporal world, the shadows (of varying length, width, and density) make the time of day and distances between figures seem measurable and real. Sharply modeled pyramids and curved shields give the appearance of three-dimensional reality, and the staring eyes in the upside-down Peter (which are seemingly immersed in the broad, cast shadows of the executioners) add a ghastly chord to the stark, unfolding drama.

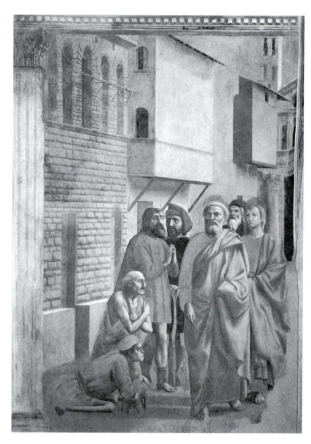

24–2. MASACCIO. *S. Peter* (with John) *Healing with His Shadow*, ca. 1427–28, fresco, 7'7.4" x 5'3.8" (232 x 162 cm), S. Maria del Carmine (see fig. 24–3, #12), Florence. In 15TH–c. Italian art, the apostle Peter was rarely the subject of pictorial cycles on the scale of the Brancacci Chapel; however, the patronage of the chapel and pro-papacy sentiments of Florence could explain why Peter was given such prominent visibility. Shown as Christ's faithful disciple and a penitent sinner, the prince of apostles and vicar of Christ, he preaches, baptizes, heals the infirm, resurrects the dead, distributes alms, and exposes impostors and heresy. In this scene Peter seems in a trance, walking solemnly down a street that is densely packed with people and buildings. Crippled and infirm men wait spellbound for his shadow to pass them; as it does, they rise cured of their ailments. This is the most dramatic and fathomable scene in the chapel because of the serious demeanor and closeness of the figures.

1427 — Masaccio likely begins work in the Brancacci Chapel, S. Maria del Carmine, Florence. Both Masolino and Masaccio had completed works in this church prior to their work in the Brancacci Chapel, and Masaccio joined Masolino, who had begun the project (see figs. 24–1, 24–2, 24–3, 25–1).

In Florence, Masaccio and his brother, Giovanni (Lo Scheggia), jointly submit tax records (29 July). Between the summer and early autumn, he probably began work on the wall fresco of *The Holy Trinity* in S. Maria Novella, Florence (see fig. 18–5).

1428 — Masaccio is in Rome. In his brother's catasto of 1429, Masaccio's name is canceled with a note in the margin stating that "dicessi è morto a Roma" (He is said to have died in Rome).

Brancacci Chapel, S. Maria del Carmine, Florence

KEY TO THE BRANCACCI CHAPEL FRESCOES.

A. *Four Evangelists (destroyed)

1 *Temptation of Adam and Eve* (214 x 89 cm), Gn 3:1–7

2 *Expulsion of Adam and Eve* (214 x 90 cm), Gn 3:22–24

3 *Calling of Peter and Andrew* (destroyed), Mt 4:18–20;
 Mk 1:16–18; Lk 5:1–11

4 *Navicella* (destroyed), Mt 14:22–33; Mk 6:45–52; Jn 6:16–21

5 **Tribute Money* (see fig. 32–1), Mt 17:24–27

6 *S. Peter Weeping after the Denial* (destroyed), Mt 26:69–75;
 Mk 14:66–72; Lk 22:54–62

7 *Jesus Appears to S. Peter and the Apostles: Pasce Oves Meas*
 (Feed My Lambs) (destroyed), Jn 21:15–17

8 *S. Peter Preaching* (247 x 166 cm), Acts 2:14–40

9 **S. Peter Baptizing* (247 x 172 cm), Acts 2:41

10 *S. Peter Healing the Cripple Beggar* (see fig. 33–1), Acts 3:1–10

11 *S. Peter* (with John) *Distributing Alms and Death of Ananias*
 (232 x 157 cm), Acts 5:1–11

12 **S. Peter Healing with His Shadow* (see fig. 32–1),
 Acts 5:12–16

13 *S. Peter Raising Tabitha* (see fig. 33–1), Acts 9:36–43

14 *S. Peter Delivered from Prison* (232 x 89 cm), Acts 12:6–11

15 *S. Paul Visiting S. Peter in Prison* (232 x 89 cm)***

16 **S. Peter Raising Theophilus' Son* (see #17)***

17 **S. Peter Enthroned* (whole register: 232 x 597 cm)***

18 *S. Peter* (with Paul) *and Simon the Magician* (see #19)***

19 *S. Peter Crucified* (whole register: 232 x 588 cm)***

20 Unidentified subject (mostly destroyed)

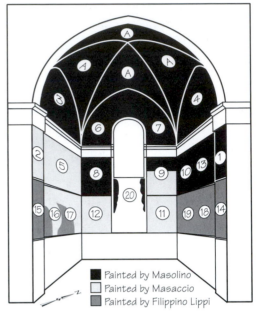

■ Painted by Masolino
□ Painted by Masaccio
▨ Painted by Filippino Lippi

*Attributed to Masolino by Vasari (*Lives*, 1568).

**Attributed to Masaccio by Vasari (*Lives*, 1568).

Vault and lunette frescoes (A, #3, #4, #6, #7) were
destroyed (1746–48) when the vault was redecorated;
a new window was then added to the chapel and the
entrance arch was redone.

***Stories from the apocryphal Acts of Peter (2ND c.).
These were recounted in Voragine's *Golden Legend*.

24–3. Scenes are numbered to show the general chronology of the events (depicted out of order). The chapel was built by funds that Pietro di Piuvichese Brancacci (d. 1367) bequeathed. (Added to the right transept of S. Maria del Carmine [see fig. 62–7, #27], Florence, the chapel was completed ca. 1389 by his son Antonio and dedicated to S. Peter, the patron saint of Pietro.)

Decoration of the chapel was not begun until after the wealthy silk merchant Felice Brancacci (1382–1450), nephew of Pietro di Piuvichese, inherited the rights to the chapel (1394); his will of 1422 stipulated that the chapel function as a burial site for the Brancacci. Although undocumented, the vault frescoes were likely begun ca. 1424, and on stylistic evidence the upper register scenes date to ca. 1427 (the visual and thematic coordination of the cycle suggests designs were done early in the project). According to Felice's will of 1432, work was still incomplete; he left town in 1434, and was condemned of conspiracy to overthrow the Medici government in 1435. Fresco decoration was suspended until ca. 1481, when Filippino was hired (see Filippino Lippi). Donatello's *Ascension with Christ Giving the Keys to Peter* was perhaps created for a freestanding altar. The chapel underwent many changes (17TH–18TH c.), including the addition of a marble floor and dado, and fig leaves for the genitalia of Adam and Eve. A major restoration occurred (1780–82) after the 1771 fire, and a recent restoration (1982–88) recovered fragments of lunette sinopias and frescoes on the altar wall and window embrasures (see above, #6, #7, #20).

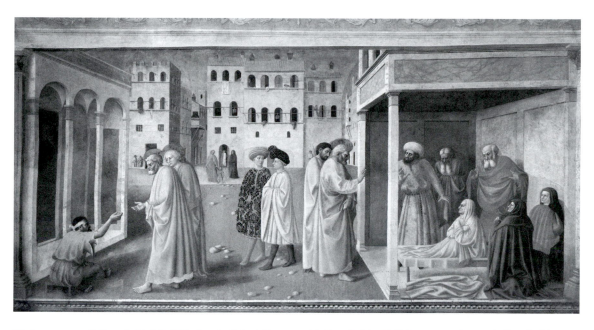

25–1. MASOLINO. *S. Peter* (with John) *Healing the Cripple Beggar and S. Peter Raising Tabitha*, ca. 1427, fresco, 8'1.3" x 19'3.5" (247 x 588 cm), S. Maria del Carmine (see fig. 24–3, #10, #13), Florence. Peter performs miracles in Jerusalem (on the left he cures a lame man), and in Joppa (on the right he brings the dead Tabitha back to life for her last rites).

Masolino da Panicale (ca. 1383–ca. 1440) was the painter-equivalent of Lorenzo Ghiberti; both artists had a propensity for designing sensuous, lithe figures and complex architectural settings. By the late 1420s, as his art became increasingly popular with lordly patrons and wealthy prelates, Masolino perfected an elegant type that suited him well for the remainder of his career. From Rome to Milan, his signature images of sweet and demure, fair-skinned, thin blonds graced the walls of chapels and palaces. More widely traveled than most of his contemporaries, he recorded famous sites in panoramic vistas, giving his impressions of ancient Roman architecture (aqueducts, columns, temples [Pantheon], theaters [Colosseum]) and contemporary buildings (Loggia dei Lanzi). The high point in his career was a court appointment in Hungary, followed by commissions from the Roman curia (Pope Martin v and Cardinals Branda Castiglione and Giordano Orsini). Yet, however significant Masolino's contribution to Italian art was, it has been diminished by issues of attribution (see Masaccio) and lost works.

1383 — Tommaso di Cristofano di Fino (from Panicale of Valdelsa, according to Vasari) is born in this year, according to the 1427 catasto of his father, who stated that his son was then working in Hungary. It has also been argued that he was born instead in Panicale of Valdarno, and around the year 1400 on the basis of his style.

1422 — Masolino rents a house in the S. Felicità district of Florence and is vouched for by the painter Francesco d'Antonio and the sculptor Bernardo Ciuffagni.

1423 — In Florence, Masolino is inscribed as a painter in the Arte dei Medici e Speziali (18 January). He paints the *Bremen Madonna of Humility*, on which the following is inscribed: O QUANTA. MISERICORDIA. é IN DIO. A. 1423 (How great is God's mercy, 1423). Also on the base of the frame are the family crests of the Carnesecchi (left) and Boni (right), indicating that the panel celebrates a bond (such as marriage) between the families.

S. Maria Maggiore Altarpiece Reconstruction

25–2 and 25–3. Reconstruction of the double-sided altarpiece for S. Maria Maggiore, Rome (the hypothetical front is on this page, the back is on page 121). Beneath the images of panels are titles, sizes, and locations of the works, which were executed in gold and tempera (mixed with oil on the wings). Physical evidence suggests the six panels were all once united. Vasari (*Lives*) saw an altarpiece he assigned to Masaccio in a chapel near the sacristy of the church, and described four saints with the Madonna of the Snow between them. The original location of the altarpiece (moved by Vasari's time) was likely on the high altar (dedicated to S. Matthias, one of the saints pictured). The work was sawn apart before all six panels were inventoried in 1653 in the Farnese Collection. Symbols indicate that Martin ordered the work: the Baptist's cross is on a column (his family emblem) and the founding of S. Maria Maggiore was significant to his rebuilding program. Stylistic evidence shows that Masolino was the artist hired to do the work. Five panels bear affinities with his work (continued on page 121)

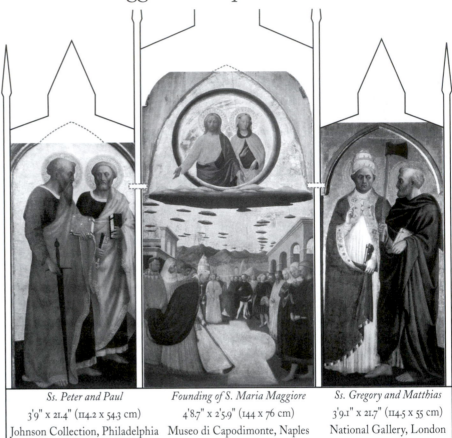

Ss. Peter and Paul	*Founding of S. Maria Maggiore*	*Ss. Gregory and Matthias*
3'9" x 21.4" (114.2 x 54.3 cm)	4'8.7" x 2'5.9" (144 x 76 cm)	3'9.1" x 21.7" (114.5 x 55 cm)
Johnson Collection, Philadelphia	Museo di Capodimonte, Naples	National Gallery, London

1424 — Masolino's name appears (7 September) in the *Libro rosso* (register/account book) of the Florentine confraternity of S. Luke (Compagnia di S. Luca). He receives 74 gold florins (2 November) for frescoes of the *Legend of the True Cross* in the chapel of the Confraternity of the Cross, in the Augustinian church of S. Stefano, Empoli. Masolino's name and payment appear in confraternity records of 1469 (the original account book is lost). Like the *Female Figures with S. Ives*, these frescoes were also defaced and whitewashed (18TH c.); but only the sinopias could be recovered in 1943. In the same church Masolino painted other frescoes, including *Madonna and Child with Two Angels,* returned to its original location above the doorway into the sacristy (in 1943).

For the baptistery of the Collegiata in Empoli Masolino painted a fresco of the Pietà; recovered from whitewash, it was detached (1948) and restored (1985). Attributed for many years to Masaccio, it is now generally thought to be the work of Masolino.

For the Carnesecchi Chapel in S. Maria Maggiore, Florence, Masolino executes panels (removed to S. Maria in Novoli, 1651): *Madonna and Child* (stolen in 1923; present location unknown) and *S. Julian* (S. Stefano al Ponte, Florence). Attributing the altarpiece to Masaccio, Vasari (*Lives*, 1568) noted that it included an image of S. Catherine and a predella, with stories of Catherine and Julian and the Nativity. Wearing an expensive, ermine-trimmed gown, S. Julian has the

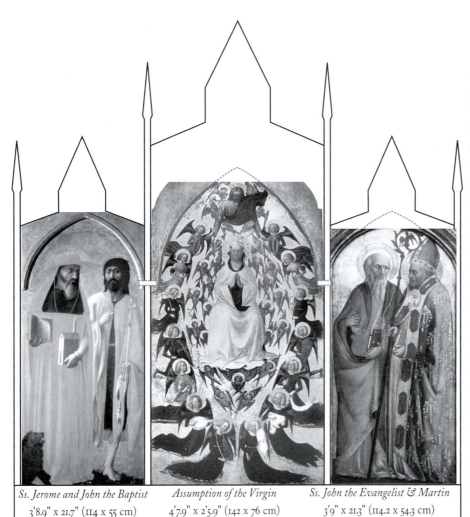

Ss. Jerome and John the Baptist	*Assumption of the Virgin*	*Ss. John the Evangelist & Martin*
3'8.9" x 21.7" (114 x 55 cm)	4'7.9" x 2'5.9" (142 x 76 cm)	3'9" x 21.3" (114.2 x 54.3 cm)
National Gallery, London	Museo di Capodimonte, Naples	Johnson Collection, Philadelphia

assured bearing of a noble soldier. With his right foot forward, one hand atop his sword, and the other resting on his belt, he guards the Virgin and her lively Child. Of similar size to the Virgin, this type of refined, monumental figure appears often in Masolino's oeuvre and was especially important for his commissioned series of famous men for Cardinal Orsini in Rome, ca. 1430. Julian must also have influenced Castagno's *Uomini Famosi* in the Villa Carducci (see fig. 30–2). About this time Masolino may have been awarded a commission for the *S. Anna Metterza* (see fig. 25–4).

1425 — While living in the parish of S. Firenze in Florence, Masolino is at work in S. Maria del Carmine, where he is paid by the *Compagnia delle Laude e di S. Agnese* (8 July) for work on props (clouds and angels) for the annual Ascension miracle play. He also paints a pilaster image of S. Peter in the Serragli Chapel (destroyed 1675). About this time he was perhaps hired to paint frescoes in Felice Brancacci's family chapel (see fig. 24–3). Although no contract exists, he may have begun work on the designs before taking a position in Hungary at the court of the Florentine *condottiere* Filippo Scolari (d. 1426), called Pippo Spano (see Castagno). Leaving for Hungary, he gives his power-of-attorney to banker Antonio di Pietro Benizzi (1 September).

1426 — Masolino stays in Hungary after Pippo Spano dies (27 December), but no works have yet been identified with this sojourn.

at S. Clemente; yet one panel (Jerome and John) was finished or created by another artist. In this montage the *Assumption* and *Founding* are reversed from most reconstructions (to reflect the central panels' relationship to the apse mosaic and their visual and thematic links with the side panels). In *Assumption of the Virgin*—the most finely designed panel of the ensemble—the Redeemer, Virgin, and angels form interlocking shapes, making the group appear to float above the gilded background. Resembling a jewel-like mandorla, the design is visually correlated to Torriti's iridescent *Coronation* (see fig. 6–1), which it would have faced. Significant to Pope Martin's rebuilding program, the *Founding* faced the nave, the more public part of the church: the tondo complements Torriti's image of the couple, and Christ's gesturing arm—pointing to Rome's patron saints—is aligned with S. Peter's keys and S. Paul's sword. In the final stages, and for thematic reasons, Masolino interchanged the saints of two panels (Peter with Paul and Martin with John).

1427 — In Florence, Masolino, the painter Francesco d'Antonio, and a butcher are sued by the goldsmith Lionardo di Donato Rucellai for outstanding debts (25 January). Masolino's father's catasto (7 July) declares his wife to be 45 years old and Masolino (in Hungary) to be 43.

Returning from Hungary (after late July 1427 and before May 1428), Masolino continues work in the Brancacci Chapel (see Masaccio).

1428 — About this time Masolino is hired to paint works for Roman churches: an altarpiece for S. Maria Maggiore (see figs. 25–2, 25–3) and frescoes for Branda Castiglione in S. Clemente, his Roman masterwork.

ca. 1430 — In Rome, Masolino begins a cycle of *Uomini famosi* (famous men) for Cardinal Giordano Orsini's palace on Monte Giordano (completed 1432; destroyed late–1480s). Some 300 nearly life-sized figures were executed (known through copies). The Florentine painter Paolo Uccello assisted him.

1432 — Masolino receives payments (17 October 1432, 30 June 1433) for his fresco, *Madonna and Child*, in S. Fortunato, Todi.

1435 — For Branda Castiglione, Masolino paints frescoes of the *Life of John the Baptist* in the baptistery chapel that Branda founded in the tower of his family castle, built into the steep hillside of Castiglione Olona (about 24 miles northwest of Milan). The date 1435 (repainted) on a baptistery arch is thought to record the inception or completion of the frescoes. Branda had begun building upon the ruins of the Castiglione castle in 1422, when he received permission from Pope Martin to replace the parish church of S. Lorenzo with the Collegiata, dedicated by Branda to the Virgin and Ss. Lawrence and Stephen (25 March 1425). Masolino's name is on the choir vault, but the vault frescoes of the *Life of the Virgin* are by his assistants and postdate the baptistery frescoes; he may have left (or died) before their completion. His assistants, the Sienese Vecchietta (ca. 1414–80) and the Florentine Paolo Schiavo (1397–1478) painted frescoes of Lawrence and Stephen on the apse walls.

1440 — According to Vasari, Masolino dies around this year (at the age of 37).

25–4. MASOLINO, MASACCIO. *S. Anna Metterza*, ca. 1424–25, tempera on panel, 5'8.9" x 3'4.5" (175 x 103 cm), Uffizi Gallery (since 1919), Florence. Inscribed (in Roman capitals) on the step of the podium are the archangel Gabriel's words to Mary (Lk 1:28–30): AVE MARIA GR[A]TIA PLENA DOMINVS TECVM BE[N]EDICTA TV (Hail Mary, favored one! The Lord is with you; you have found favor). Anne was a patron saint of Florence, and around her halo are words in Gothic script: S[ANTA] ANNA è DI NOSTRA DONNA FAST[IGIO] (S. Anne is the pinnacle of the Virgin). Masolino may have received the commission for this panel while he was working in Empoli (1424), although his commitments must have prohibited him from completing the work. He surely designed the panel; its simple composition foretells that of the S. Maria Maggiore *Assumption of the Virgin* (see fig. 25–3), but Masaccio finished the work, painting several figures (the Madonna, Child, and angel to the top right), although Vasari attributed the painting only to Masaccio (*Lives*, 1568). The poor condition of the painting makes issues of attribution and dating difficult to resolve, and the patronage and original location are unknown. Vasari recorded seeing the painting on an altar ("next to the door leading to the reception parlor of the nuns") in the church of S. Ambrogio, Florence (removed in 1813).

Fra Angelico

Fra Angelico (ca. 1395/1400–1455) is the best known priest-painter of the Renaissance. In 1982 Pope John Paul II beatified the Dominican, who was called Beato Angelico by Vasari's time. While he was in his forties, Angelico completed the S. Trinità *Deposition* (see fig. 26–3), demonstrating ideas found in Alberti's *Della pittura* (1436), such as one-point perspective and distant space, few and volumetric figures, *istoria,* and dramatic gestures. Yet Angelico's figures are as immobile as his landscape, which lacks any sign of wind, sound, or atmosphere. Exemplary of his finest devotional panels, the painting describes a crystalline nature, resembling a perfect, unspoiled, and luminous earthly realm. Few works attributed to Angelico are securely dated, but his style, which fuses the palette, elegance, and soft forms of Lorenzo Monaco and Masolino with the volumetric figures and measured space of Masaccio, is distinctly recognizable.

ca. 1395 — Guido di Pietro (Fra Angelico) is born near Vicchio in the Mugello (north of Florence). Vasari wrote that he was born in 1387 and entered the Dominican convent of Fiesole (with his younger brother), where he took the name Giovanni.

1417 — Still a layman, Guido di Pietro is not yet a member of the Dominican Order. On 31 October, Battista di Biagio San Guigni (a miniaturist) recommends Guido for membership in the Compagnia di S. Niccolò of S. Maria del Carmine, Florence. It is thought that Guido (called a painter from the parish of S. Michele Visdomini) was trained by Lorenzo Monaco or a painter in Lorenzo's shop.

1418 — Guido is paid on 28 January (five florins) and 15 February (seven florins) for an altarpiece for the Gherardini Chapel in S. Stefano al Ponte, Florence. The chapel decoration in S. Stefano (with two other chapels) was entrusted to Ambrogio di Baldese, with whom he may have trained.

ca. 1419 — In Fiesole, Guido di Pietro joins the Dominican Order.

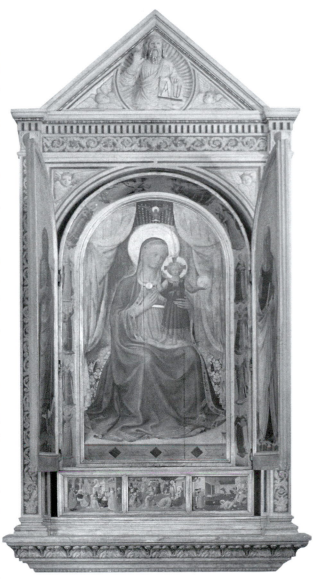

26–1. FRA ANGELICO. *Linaiuoli Altarpiece* (see fig. 34–2), 1433, tempera on panel, 17'2" x 8'9.9" (528 x 269 cm) (whole); 9'7" x 5'9.4" (292 x 176 cm) (central panel). The altarpiece was in the Linaiuoli guild hall until 1777 and has been in the Museo di S. Marco, Florence, since 1924. This type of altarpiece (a triptych with movable wings and a gable-shaped frame) was more popular in the previous century (see fig. 4–6), and more frequently commissioned in northern Europe than in Italy in the Quattrocento. Yet the monumentality of the Linaiuoli frame, the rounded arches of the panels, and the volumetric Virgin and Child and saints give the altarpiece a more Renaissance than Gothic appearance.

CONVENT OF S. MARCO. Fra Angelico moved here in 1441. The convent was founded by the Vallombrosans in the 13TH c. and came under the control of Sylvestrine monks. In 1436 the Sylvestrines were ousted by Pope Eugene IV, who installed the reformed Dominican friars (Observantists) of Fiesole in their place. Antonino Pierozzi (called Antoninus) was the most instrumental member of the reformed community, and he was Cosimo de Medici's spiritual advisor. With the pope's help and through large Medici donations of thousands of gold florins, the church and monastery of S. Marco were completely refurbished by Michelozzo and decorated by Angelico (1437–52). Vespasiano da Bisticci in his biography of Cosimo (ca. 1482–98) estimated that Cosimo spent more than 40,000 florins on S. Marco. Contributing to this vast expenditure was the establishment of the first public library in Italy at S. Marco, where humanists could study prized Greek and Roman texts collected by Niccolò Niccoli (d. 1437), a renowned bibliophile, whose library S. Marco was to own.

1423 — Guido is called Friar Giovanni in a payment (10 lire) record for painting a crucifix for the hospital of S. Maria Nuova, Florence.

1429 — The first document (30 March) connecting an identifiable painting by Fra Giovanni (called Angelico in the text that follows here) records a sum due to the community of S. Domenico, Fiesole, for an altarpiece in the convent of S. Peter Martyr, Florence.

Fra Benedetto (Angelico's brother) is ordained a priest (September 24). In this year Angelico is at the capitular reunion of the brethren of S. Domenico at Fiesole; he later attended four capitular reunions: January 1431, December 1432 and January 1433 (as vicar of the convent), and January 1435.

1431 — For a new oratory for S. Maria degli Angeli in Florence, Angelico is commissioned to paint a Last Judgment.

1432 — Angelico receives nine ducats (two for gilding) from the church of S. Alessandro in Brescia for an Annunciation to be painted in Florence by him.

1433 — Angelico is commissioned (11 January) to execute an altarpiece for the guild palace of the Arte dei Linaiuoli (linen drapers, secondhand dealers, and tailors) in the Piazza S. Andrea (see fig. 26–1). A wooden model was made from Lorenzo Ghiberti's design for the tabernacle (1432). Jacopo di Bartolommeo da Settignano and Simone di Nanni da Fiesole (Ghiberti's assistants) worked on the marble frame. Angelico was contracted (2 July) to use only the best and finest gold, blue, and silver available. He was to receive 190 gold florins for the price of materials and his expert craftsmanship. The tabernacle is larger than any other Florentine panel painting of this date. Because of its great

scale and the monumental images, it has been proposed that Ghiberti designed not only the frame but also the figures of the triptych. In addition, the sleek, elegant saints of the inner panels correspond stylistically to Ghiberti's bronze statues of Matthew (see fig. 63–13) and Stephen at Orsanmichele and designs for the second Florence Baptistery doors.

1434 — Angelico and Rossello di Jacopo Franchi assess (14 January) a tabernacle for S. Niccolò, Florence, by Stefano d'Antonio and Bicci di Lorenzo.

1436 — Angelico is hired by Sebastiano Benintendi to execute the *Lamentation*, 3'5.4" x 5'4.7" (105 x 164 cm), for the altar of the Compagnia of S. Maria della Croce al Tempio. He completed the work in 1441 (inscribed on Mary's gown).

1437 — Angelico paints a large triptych for the family of Bishop Benedetto Guidalotti (d. 1429) for the Chapel of S. Nicholas in S. Domenico, Perugia.

1438 — Michelozzo works at S. Marco. Fra Angelico is hired to paint the high altarpiece (see entry 1443) and the convent frescoes including the *Crucifixion* of the Chapter room, the *Annunciation* at the top of the stairs in the dormitory, cells of the friars and lay brothers, and the private double cell of Cosimo (some paintings were done by his assistants).

In this year he witnesses the will of the merchant Giovanni di Tommaso ser Cecco (Cortona, 26 March).

1440 — Angelico completes the *Deposition* (see fig. 26–3).

1441 — Angelico moves to S. Marco.

1442 — In the S. Marco chapter room, Angelico attends the joint capitular

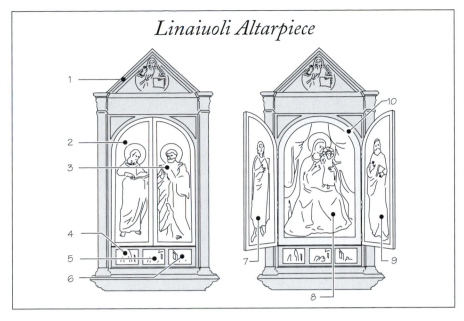

Linaiuoli Altarpiece

26–2. This diagram shows the exterior and interior views of the Linaiuoli Triptych (see fig. 26–1). Twelve music-making angels adorn the arch that frames the Virgin and Child, while the Holy Spirit, in the image of the dove, is above Mary's head and beneath the relief of the Redeemer in the gable. Images of Mark, the patron saint of the guild, appear on both the inside and outside panels of the altarpiece. When opened, an elegant image of the patron saint of Florence, S. John the Baptist, flanks the holy Virgin Mother and Child.

KEY TO DIAGRAM.

1 Frame designed by Lorenzo Ghiberti
2 *S. Mark*
3 *S. Peter*
4 *S. Peter Preaching and S. Mark Recording the Sermon*
5 *Adoration of the Magi*
6 *Martyrdom of S. Mark*
7 *S. John the Baptist*
8 *Virgin and Child Enthroned*
9 *S. Mark*
10 *Twelve Angels*

meeting of the communities of S. Marco and S. Domenico.

1443 — On the Feast of Epiphany (6 January), in an elaborate ceremony presided over by Eugene IV, the convent church of S. Marco is rededicated to the titular S. Mark the Evangelist and to the Medici saints Cosmas and Damian. Angelico's altarpiece, *Madonna and Child Enthroned with Saints*, called the S. Marco Altarpiece, is installed on the high altar.

1445 — In July, Angelico signs the act separating the communities of S. Marco (Florence) and S. Domenico (Fiesole). His workshop had been transferred to S. Marco by this time. (He retained a workshop in Fiesole until ca. 1440–45.)

Angelico is summoned to Rome by Pope Eugene IV. The pope had become familiar with Angelico's work while he was in Florence (1434–43), especially the high altarpiece and frescoes at S. Marco. In Rome Angelico began work in the Cappella Pavra, dedicated to S. Nicholas of Bari; his frescoes were later replaced (1542–45) by Michelangelo's frescoes of

Peter and Paul (Pauline Chapel), executed for the Farnese pope, Paul III.

1446 — Antonino Pierozzi (Antoninus) is appointed the archbishop of Florence (Vasari wrote that Angelico was first offered the position).

1447 — In March, Angelico completes frescoes in the Chapel of S. Peter (accessible from Old S. Peter's), commissioned by Eugene IV (d. 23 February 1437). In May he is working for the new pope (Nicholas V). During the summer he paints vault frescoes in the Cappella Nuova of Orvieto Cathedral, with Benozzo Gozzoli and two other collaborators: they complete two quadrants of the first bay (the Pantocrator and Apostles and the Virgin Mary) and supply cartoons for the two remaining quadrants (for which they receive 103 gold florins); Signorelli later painted there from Angelico's designs.

1448 — Angelico and Gozzoli begin work in the small, private chapel of Nicholas V. Angelico and collaborators were to paint the *studiolo* (small study) of Nicholas in 1449 (destroyed by Pope Julius II).

1450 — In Florence, Angelico paints the Silver Treasury in SS. Annunziata, ordered (1448) by Piero de' Medici; he succeeds his brother, Fra Benedetto (d. 1448), as prior of S. Domenico, Fiesole.

1452 — Angelico turns down the offer to paint the choir of S. Stefano, Prato (see Fra Filippo Lippi). In Rome, he likely paints (lost) frescoes in the Chapel of the Sacrament, Old Saint Peter's.

1454 — Fra Filippo Lippi, Domenico Veneziano, and Angelico are asked (2 December) to assess Benedetto Bonfigli's frescoes in the Palazzo dei Priori, Perugia. In 1462, Fra Filippo alone evaluated the frescoes.

1455 — Angelico dies in Rome (18 February) and is buried in the church of S. Maria Sopra Minerva, the Dominican convent where he was then living.

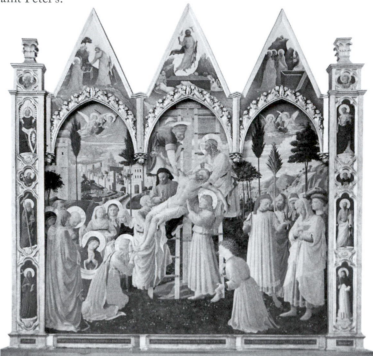

26–3. FRA ANGELICO. *Deposition*, ca. 1437–40, tempera on panel, 5'9.3" x 6'.9" (176 x 185 cm), S. Trinità until 1810, Museo di S. Marco (since 1919), Florence. Lorenzo Monaco was likely hired by Palla di Nofri Strozzi (ca. 1420) to execute this altarpiece for the sacristy of S. Trinità, but completed only the pinnacle paintings (*Resurrection*, *Three Marys at the Tomb*, and *Noli Me Tangere*), which are in reversed chronological order (see text below), and three panels thought to have formed the predella: *S. Nicholas Calming the Storm*, *Nativity*, and *Legend of S. Onuphrius* (see Lorenzo Monaco 1422). The foliate ornamentation is modern.

The inscriptions in Roman capitals on the frame of the *Deposition* are Angelico's; these are excerpts from the Divine Office for Holy Saturday, adapted from Scripture: (left) PLANGENT EVM QVASI VNIGENITVM QVIA INOCENS ("They shall mourn for him as for an only child, for he is innocent," Zec 12:10); (center) ESTIMATVS SVM CVM DESCENDENTIBVS IN LACVM ("I am counted among those who go down into the pit," Ps 88:4); (right) ECCE QVOMODO MORITVR IVSTVS ET NEMO PERCIPIT CORDE ("See how the just one dies and no one takes it to heart," Is 57:1). It seems that Angelico reversed the order of Lorenzo's pinnacle scenes to correlate with the main panel and the inscriptions: the empty tomb with the angel (right pinnacle) relates to the instruments of the Passion (crown of thorns and nails) displayed below, signifying Christ's triumph over torture and death. Some figures may be portraits. The kneeling man in the foreground is a Beato (see SAINT, Duecento Glossary), thought to show Alessio degli Strozzi; he faces the holy figures. Vasari saw a portrait of Michelozzo in the man on the right ladder (and, although unlikely, he is also thought to be Palla); Lorenzo Strozzi is thought to be the man (far right) in the contemporary hat.

Antonio Pisanello

Among the most clever artists of the period is Antonio Pisano (ca. 1395–1455), called Pisanello, the little Pisan, the finest court artist of his age. Praised by humanists and courtiers, he was a consummate draftsman and observer of nature, as shown by his sketchbook of foreshortened horses and exotic animals (*Codex Vallardi*, Louvre, Paris) and by his many study sheets of elaborate, plumed costumes, nude figures, and corpses of hanged men. Records show that he traveled extensively, working for every major court in Italy; however, a complete evaluation of his career is difficult because very little is known about his early training, and few of his important, large-scale works have survived intact. Still, his reinvention of the bronze portrait medal alone is worthy of singling him out (see figs. 17–6, 17–7). Both portable and double-sided, his medals—in distinction to ancient coins and early Quattrocento commemorative medals of ancient Roman emperors—immortalized court dignitaries who were then still living (see figs. 27–1 to 27–4).

ca. 1395 — Antonio is born in Pisa or Verona; his father (Puccio di Cerreto) was Pisan and his mother (Isabetta), Veronese. In his father's will of 1395 Antonio receives an inheritance (600 ducats). Until the early 1900s, Antonio was called Vittore (Vasari misnamed him).

1404 — Pisanello's father has died and his remarried mother moves the family to Verona.

1420 — By this year, Pisanello had created a (lost) fresco in the Great Council Hall, Doge's Palace, Venice.

1422 — By this year, Pisanello is living in Mantua and would receive payments from the court in 1425 and 1426.

1424 — Pisanello creates a fresco, the *Annunciation*, above the marble tomb of Niccolò Brenzoni in the church of S. Fermo Maggiore, Verona. About this time, he also paints (lost) frescoes in Pavia Castle for Duke Filippo Maria Visconti of Milan.

1431 — For Pope Eugene IV, Pisanello completes Gentile da Fabriano's (lost) frescoes in S. John of the Lateran, Rome (see Gentile 1427).

27-1, 27-2. ANTONIO PISANELLO. *Medal of Emperor John VIII Palaeologus*, front, or obverse side of the medal (left), 1438–39, bronze, dia. 4.1" (10.3 cm), British Museum, London, and back, or reverse (right), dia. 4" (10.1 cm), Cabinet des Medailles, Bibliotheque Nationale, Paris. This is thought to be Pisanello's first medal, and it portrays the Byzantine emperor John Palaeologus (r. 1425–48), who was in Italy for the ecumenical councils held at Ferrara in 1438 and at Florence in 1439 (see Quattrocento History Notes 1438, 1439). In a circle around the medal (front) are the emperor's titles inscribed in Greek. In the 1440s Pisanello created more than 20 portrait medals. That he thought of himself chiefly as a painter, however, appears in his signature on these medals. The Latin inscription on the back of the medal here reads OPVS PISANI PICTO / RIS (the work of Pisano the painter). Inscribed in Greek at the bottom is the emperor's name: John, king and emperor of the Romans, the Palaeologus. The emperor, distinguishable by the tall crown and peaked brim of his hat, is shown on horseback in the forest praying before a cross. Pisanello painted an image similar to this one showing the Roman soldier Placidius (baptized as Eustace) hunting in a forest, where Christ appears to him in the form of a crucifix between the antlers of a stag.

KINGDOM OF NAPLES.
In the 15ᵀᴴ c., rulership of Naples changed from the French House of Anjou (Angevin) to the House of Aragon. The Angevins first became rulers of Naples in 1265, when Charles I of Anjou, brother of King Louis IX of France, was crowned king of Naples. Charles soon imported French artists to create a court style for a French dynasty living on Italian soil. However, his grandson King Robert was to change court taste by adding Italian artists (see Giotto and Simone Martini), thus beginning a change in Angevin taste. In 1435 when Queen Joanna II died, the Neapolitan throne was fought over by Alfonso of Aragon (supported by the Visconti of Milan) and René of Anjou (supported by the pope). Seven years later, Alfonso took control of Naples (in 1442), and René fled the country. Pope Eugene IV agreed to crown Alfonso if he expelled Francesco Sforza from the March of Ancona, where Francesco had gone to fight for the Venetians. This marks the beginning of the Aragonese stronghold over southern Italy.

1433 — In Verona he paints the fresco *S. George and the Princess* for the Pellegrini Chapel in the church of S. Anastasia.

1438 — In Ferrara, Pisanello sketches the events and people at the ecumenical council, such as Byzantine Emperor John Palaeologus (see figs. 27–1, 27–2).

1439 — Venice considers Pisanello a traitor for supporting the ruler of Mantua, *condottiere* Gianfrancesco Gonzaga, who had worked for Venice but negotiated a contract with her enemy Milan.

1440 — Until 1444, he travels between the courts of Milan and Ferrara. In 1441, competing with Jacopo Bellini, he painted Leonello d'Este's portrait and later designed a medal (see fig. 17–6). In 1442, the republic of Venice named him,

with about 30 other prominent Veronese, as a traitor whose property was to be taken away. Not long afterward, his sentence was waived.

ca. 1447 — In Mantua (for Marchese Ludovico III Gonzaga), Pisanello creates frescoes (unfinished) of Arthurian tales in the reception hall, ducal palace. Whitewashed after the ceiling collapsed (1480), the frescoes were discovered in the 1960s. (For the Gonzaga, see fig. V–2.)

1449 — In Naples, at the Aragonese court, Pisanello works for King Alfonso I, the Magnanimous, creating medals for him and his courtiers (see figs. 27–3, 27–4).

1455 — Pisanello is dead by this year, according to his biography by Bartolomeo Fazio in *De Viris Illustribus*, dated 1456.

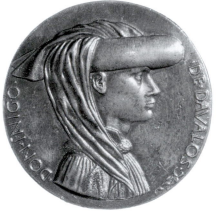

27–3 (front). ANTONIO PISANELO. *Don Iñigo d'Avalos*, master chamberlain of the kingdom of Naples, ca. 1449–50, bronze, d. 3.1"(7.85 cm), National Gallery of Art, Washington, D.C. Don d'Avalos, whose name is inscribed in Roman letters around the edge of the medal, DON INIGO DE DAVALOS, wears a fur-lined cloak. His hat has a hood (*chaperon*) attached to a padded circular form (*bourrelet*), with a long cloth or sash that was worn down or wrapped around the padded ring. When Alfonso conquered Naples in 1442, Avalos was with him, and he served an important role at Alfonso's court. Pisanello has portrayed Avalos here as noble and proud.

27–4 (back of 27–3). At the top of the medal is the Avalos coat of arms (a triple-towered castle), flanked by flowerstalks; in the center is a sphere showing a starry sky, mountains and woods, a couple of buildings, and rippling water at the bottom of the sphere. Inscribed in a semicircle beneath this image are the words PER VVI SE FA (for you it is made) and outside this, the words OPVS PISANI PICTORIS (the work of Pisano the painter), with an olive branch at the end. Pisanello's style changed in his late medals, with the low relief becoming more shallow, figures more volumetric, and raised edges higher, creating more dramatic shadows.

Remembered by posterity as less devout and more worldly than Fra Angelico or Lorenzo Monaco, the Carmelite painter Fra Filippo Lippi (ca. 1406–69) had an even greater influence on late Quattrocento painting than Masaccio, Masolino, or Angelico. His legacy can clearly be seen in the works of his followers, especially Botticelli and his own son, Filippino, who entered Botticelli's workshop after his father's death. Fra Filippo modernized the iconic theme of the Madonna and Child—as can be seen in his *Tarquinia Madonna and Child* of 1437—by placing the holy couple in a Florentine house, which gives the subject a domesticity that is more intimate and less timeless than the gilded images by Masolino and Masaccio. Filippo's figures were likely derived from life studies: the angels in his *Madonna and Child with Angels*, ca. 1455 (Uffizi Gallery, Florence), resemble mischievous youngsters and are unlike the reserved and formally distant angels of Angelico. Throughout his career Filippo was inclined to create spatially complicated arrangements; stimulated by the experiments of the Florentines

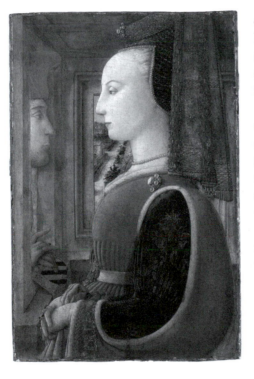

Masolino and Angelico and the Sienese Domenico di Bartolo, his own experimentation culminated in the Prato frescoes (see figs. 28-2, 28-3). Vasari thought that his lust for women sidetracked him, but noted that the high quality of his art nevertheless attracted the attention and support of Cosimo de' Medici, who hired, vouched for him, and paid his debts. Filippo's work appealed to the religious, especially the Carmelites and Benedictines, as well as wealthy Florentines, who commissioned works for their family chapels and palaces.

ca. 1406 — Around this year Filippo is born in Florence, the son of Tommaso di Lippo (d. ca. 1411), a butcher living near S. Maria del Carmine.

ca. 1414 — Filippo enters the convent of S. Maria del Carmine in Florence as a *fanciullo* (young boy); it seems he was sent there by his guardian, who was too poor to care for him.

1420 — Filippo begins his novitiate at S. Maria del Carmine.

1421 — Filippo completes his novitiate (18 June). No record of his early training as a painter exists, but he surely studied or

28-1. FRA FILIPPO LIPPI. *Portrait of a Man and a Woman at a Casement*, ca. 1436–45, tempera on panel, 25.3 x 16.5" (64.1 x 41.9 cm), Metropolitan Museum of Art, New York (since 1889). This undated painting, which seems to celebrate family, wealth, and prosperity, focuses upon a bejeweled woman. It has been attributed to Uccello, Piero della Francesca, and Cosimo Rosselli, but is now accepted as a work by Filippo. The painting is dated chiefly on style, and the patron, identified by the coat of arms beneath the man's fingers, is thought to be the Scolari, the family of the famous *condottiere* Pippo Spano. The couple may be Lorenzo Scolari and his wife, Angiola di Bernardo Sapiti (married in 1436; first child born in 1444). The woman is made to look exceptionally polished, like the finery and jewels she wears. Her blond hair—plucked from her forehead, pulled back tightly from her face, and held by a pearl-trimmed cap—reflects Florentine style. Her headdress (the saddle, or *sella*, made of wicker and shaped into two hornlike peaks) was fashionable in Flemish and French courts; it also appeared in northern Italian courts and was worn on special occasions in Florence. The elaborate cloth of the *sella* is a gold-embroidered damask that hangs on one side to the shoulder and on the other, beyond her waist.

PORTRAITURE.

Florentine portrait paintings of the first half of the Quattrocento commonly depict the sitter in profile. While the composition of Filippo's *Portrait of a Man and a Woman at a Casement* (see fig. 28–1) follows this convention, the elaborate description of the woman and her environment are different from most other portraits made in Florence during the period. She appears, not before a neutral background as was customary, but in a wood-paneled room filled with windows. The window behind her shows what seems to be a view of Florence, with a chapel (or convent), buildings, trees, mountains, and communal walls. Blocking the opening of a second window is the more active figure of a man with gesturing hands; a third window is the one through which viewers look at the couple (see entry ca. 1436).

helped Masolino and Masaccio at the Carmine, especially in the Brancacci Chapel (see fig. 24–3).

1429 — In the Carmelite S. Maria in Siena, Filippo serves as the deputy prior from November 1428 until August 1429.

1431 — In January, Filippo is called a painter ("frate Filippo di Tommaso dipintore") in the records of the Carmelites in Florence. He pays dues (31 May) to the Compagnia delle Laude e di S. Agnese, a confraternity linked to the Carmine.

A fresco fragment, *Reform of the Carmelite Rule* (S. Maria del Carmine, Florence), is placed in Filippo's early career. The painting shows the influence of Masaccio's work at the Carmine.

1434 — Payment records (February and July) place Filippo in Padua, working on cupboards for the Basilica of S. Antonio. In October he and Francesco Squarcione (master of Mantegna) evaluate work by local painters. Filippo executed (lost) paintings in S. Antonio and, it seems, in the chapel of the Palazzo del Podestà. When Filippo returned to Florence, he lived outside the monastery.

ca. 1436 — Filippo paints a double portrait (see fig. 28–1). Thought to celebrate the marriage of the couple or the birth of a child, it might instead commemorate the death of one of these individuals. The light from two openings illuminates both figures, but the man's head casts a shadow upon the window moldings (the woman casts no shadow). She is the larger, more brightly illuminated figure, and dominates our attention. Totally engulfed in expensive items, she portrays a type of material wealth surely meant to symbolize her inner beauty as well; the chapel behind her, symbolic of spiritual wealth, was likely meant to allude to her

piety through patronage and charity. The letters (It. *lealtà*, loyalty) sewn in gold threads and seed pearls on her left sleeve refer to a virtue that was valued in women.

1437 — Filippo completes the *Tarquinia Madonna and Child* for S. Maria di Cestello in Tarquinia. While the setting is similar to images by Flemish painters Campin (*Madonna of the Firescreen*, National Gallery, London) and Jan Van Eyck (*Lucca Madonna*, National Gallery, London) in which Mary is seated near an opened window in a domestic chamber, the intimacy between this mother and her husky child, lovingly wrapping his arms around her neck, more directly reflects the influence of works by the Sienese Lorenzetti brothers and, especially, Donatello's marble relief, the *Pazzi Madonna and Child* (ca. 1422).

1439 — Filippo completes his first major contract: *Madonna and Child with S. Frediano and S. Augustine* (Louvre, Paris) for the Barbadori Chapel in the sacristy of S. Spirito, Florence. Filippo was probably at work on the altarpiece by 8 March 1437, the date of a recorded payment. Filippo interjected a sense of narrative into the devotional theme, and portrayed himself on the left as a Carmelite friar, kneeling behind a marble dais.

In Florence, Francesco Maringhi, a canon of S. Lorenzo and rector of S. Ambrogio, hires Filippo to paint *Coronation of the Virgin* (Uffizi Gallery, Florence) for the high altar of S. Ambrogio, the convent church of Benedictine nuns and the main church of the S. Ambrogio parish. Filippo was paid about 400 lire for materials and labor. Lorenzo Ghiberti was hired to execute the frame, and the altarpiece was installed in January 1447. In a more informal arrangement of figures than was typical for this theme

at the time, angels and saints are interspersed with friars, Old Testament heroes, children, and the patron and painter. As Filippo had done in the Barbadori altarpiece, he painted himself looking out toward viewers from the left, but is shown here in the foreground. On the opposite side of the choir, Maringhi kneels beside John the Baptist, his patron saint, and prays to the Virgin; his ashen face and hands signify that he had died before the completion of the painting.

1440 — About this time Filippo completes the *Annunciation* for the chapel of the *Operai* (Martelli, Aldobrandini, and Taddei) (later renamed the Martelli Chapel) in S. Lorenzo, Florence. It has been proposed that the *Annunciation* (executed on two panels) was originally intended for another chapel, where the panels functioned as organ shutters or tabernacle doors (although no record confirms this). However, it seems more likely that from the start the two panels were linked and framed (the original frame is now lost); their rectangular shape follows Brunelleschi's plan for the chapel altarpieces at S. Lorenzo. On stylistic grounds the *Annunciation* dates about 1440, while Brunelleschi (d. 1446) was still alive but before Cosimo de' Medici undertook major patronage of the church (in 1442). A predella was later added to the altarpiece, with scenes devoted to S. Nicholas, the patron saint of Niccolò Martelli.

1442 — Filippo becomes rector of S. Quirico, Legnaia (near Florence).

ca. 1445 — In Florence, Cosimo de' Medici hires Filippo to create an altarpiece for the chapel of the novices (Novitiate Chapel) that he endowed at S. Croce in 1445. The chapel was dedicated to the Medici patron saints, Cosmas and Damian. In Filippo's altarpiece, *Madonna and Child with Saints* (since 1919, Uffizi Gallery, Florence), Cosmas and Damian are shown prominently seated next to the enthroned Madonna and Child rather than standing or kneeling before them, as saints were more commonly depicted in this theme. Two Franciscan saints (Francis and Anthony of Padua) partly overlap them, giving the impression they have scooted along the bench to be closer to the holy Mother and Child. (Cosimo and his twin were named after Cosmas and Damian, the twin brother physicians from Arabia martyred by the emperor Diocletian. The presence of these twin saints in Florentine works usually signals Medici patronage.)

Filippo is hired by Giovanni Benci to create the *Annunciation* (since 1838, Alte Pinakothek, Munich), ca. 1445–1455, for the main altar of the newly built convent church of the nuns of S. Maria delle Murate (begun 1439), Florence.

1447 — Filippo is paid for a panel of the patron saint of the Signoria; his *Vision of S. Bernard* (since 1854, National Gallery, London) was placed near the door to the chancellery, Palazzo della Signoria.

1451 — In Florence, Filippo sues Antonio del Branca of Perugia for 70 florins (the cost of the painting contracted 16 February 1450). Branca claimed it was late, poorly executed, and did not meet his specifications. Filippo won the case and was paid for the painting, intended for S. Domenico, Perugia.

Filippo is paid for materials used for repairing frescoes in the Palazzo della Signoria (19 April).

1452 — On 6 May, Filippo is hired by the Prato commune (with representation from the Opera del Sacro Cingolo [dialect for Cintola], Ceppo Vecchio,

PRATO CHOIR FRESCOES. Filippo's frescoes for the choir of S. Stefano, Prato (see fig. 28–2), were the most expensive chapel decoration in Quattrocento Italy. Filippo received 1,962 gold florins for labor and materials, with about 450 florins spent on gold leaf (around 5,000 sheets) and precious ultramarine blue pigment (both applied in fresco secco). A great part of the budget was thus devoted to costly materials that could produce a rich, shimmering surface, now difficult to fully imagine because of major losses. No sinopias or *spolveri* have been detected, but many pentimenti exist, suggesting that Filippo's panel painting technique of overlaying veils of tempered pigments was also his procedure for painting frescoes. Filippo designed the lower tier scenes to look as though the action extends around the corners of the choir (see fig. 28–3).

Choir Frescoes, S. Stefano, Prato

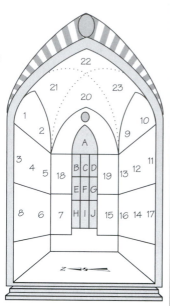

1. *Birth of Stephen* and *Devil Abducting Stephen and Substituting a Changeling*
2. *Bishop Julian Entrusting Stephen to a Wetnurse*
3. *Stephen* (departing for Cilicia) *Taking Leave of Bishop Julian*
4. *Stephen Embracing His Father* and *Stephen Exorcising a Demon*
5. *Stephen Disputing with Pharisees*
6. *Saul Holding Stephen's Garments*
7. *Martyrdom of Stephen by Stoning*
8. *Celebration of the Relics of Stephen*
9. *Birth of John the Baptist*
10. *Naming of John*
11. *John Taking Leave of Parents*
12. *John Praying to an Angel in the Wilderness*
13. *John Baptizing* (?) and *John Preaching to the Multitude*
14. *Salome Dancing*
15. *Beheading of the Baptist*
16. *Salome Receiving John the Baptist's Head*
17. *Salome Presenting John's Head to Herodias*
18. *Giovanni Gualberto*
19. *Alberto da Trapani*
20. *John the Evangelist*
21. *Luke the Evangelist*
22. *Mark the Evangelist*
23. *Matthew the Evangelist*

KEY TO THE STAINED-GLASS WINDOW IMAGES

A. *The Virgin Consigning her Cintola* (belt) *to the Apostle Thomas*

B *John the Baptist*	E *Paul*	H *Catherine of Alexandria*
C *Lawrence*	F *Peter*	I *Mary Magdalene*
D *Stephen*	G *Andrew*	J *Lucia*

The patron's coat of arms (the commune of Prato) appears on the entrance wall and window wall.

28–2. In this diagram of Filippo's choir frescoes the scenes are numbered chronologically. For the fee of 316 florins, Fra Lorenzo da Pelago created the stained-glass window on designs by Filippo. The parish church and baptistery of S. Stefano had a seminary headed by a provost, was an important pilgrimage site (housing the holy belt of the Virgin since 1174, a stone from Stephen's martyrdom, and the slab on which John was decapitated), and became a cathedral in 1653.

and Ceppo Nuovo) to paint frescoes in the choir of S. Stefano (the parish church and baptistery) in Prato (see figs. 28–2, 28–3). Although Lorenzo Monaco designed the choir window (a replacement was now arranged), the choir had never been painted. Fra Angelico was first offered the job.

1453 — Filippo is hired by the prosperous and charitable Ceppo Nuovo (also patrons of the S. Stefano commission) to oversee the building of a stone tabernacle over a wellhead in a courtyard of the Palazzo Datini in Prato, where the Ceppo had their headquarters. Filippo also created a painting for the tabernacle depicting the *Madonna del Ceppo*.

Filippo's *S. Jerome* for Lorenzo Manetti is turned over to eccelestical authorities for evaluation.

1454 — In S. Stefano, Prato, Filippo repairs the frescoes of Agnolo Gaddi damaged during the in-stallation of an organ in the Sacro Cingolo Chapel (housing the holy belt of the Virgin).

1455 — Sometime before this year, Filippo forged Giovanni di Francesco Cervelliera's name to a receipt, and the case was brought to trial in 1455. Records show that Giovanni entered Filippo's shop in 1440, and two years later Filippo owed him forty florins. To settle the debt, a substantial job restoring a painting by Giotto was offered to Giovanni, who later claimed that he was never compensated. However, a receipt with his signature was produced. The case between the two men was tried in the archbishop's court (1455), and it seems that both men were jailed and tortured on the rack, when Filippo confessed (19 May) to the forgery. Despite appeals, Filippo's beneficence at Legnaia and his rectorship at S. Niccolò ai Fieri were taken away by the archbishop of Florence (Antonino Pierozzi). About this year, Filippo completes the *Adoration of the Magi* tondo (see fig. 31–3), also attributed to Angelico.

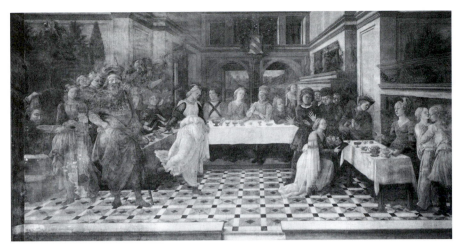

28–3. FRA FILIPPO LIPPI. *Feast of Herod*, ca. 1461–63, south wall, choir, S. Stefano, Prato (see fig. 28–2, #14, #16, #17). In this continuous narrative, showing Salome three times (beginning in the middle with her dance for Herod), Filippo invites viewers into the scene through the open railing that illusionistically projects into our space; the device is comparable to the placement of the Madonna in front of the window embrasure in *Madonna and Child with Two Angels*, ca. 1455–65 (Uffizi Gallery, Florence). *Buon fresco* combined with *fresco secco* gave Filippo great flexibility, but caused problems, especially in this scene, where the musicians and guests at the table (left) and two people behind Herod (right) now appear like ghosts.

1456 — Filippo is temporarily released (12 May) from his work in the chancel of S. Stefano, Prato, to create a triptych of the Madonna and Child with saints for Giovanni di Cosimo de' Medici. The painting was to be a diplomatic gift for King Alfonso of Naples.

1457 — Domenico Veneziano and Filippo evaluate Pesellino's *Trinity with Ss. Mamas, James the Great, Zeno, and Jerome* for a confraternity in Pistoia (National Gallery, London). After Pesellino's death (1458), Filippo finished the work (1460).

1458 — The nun Lucrezia Buti and Filippo have a son, Filippino, who was born probably in the winter of this year.

1459 — On 23 December Lucrezia and her sister Spinetta Buti, with 3 other nuns, renew their vows before the episcopal vicar in Prato (Lucrezia and Spinetta entered the convent of S. Margareta ca. 1454).

ca. 1460 — For the Medici, Filippo painted two devotional panels of the Virgin Mary Adoring the Child in the wilderness: one for the chapel in the Palazzo Medici (executed after Gozzoli's frescoes) and another for Piero de' Medici's cell in the monastery at Camaldoli. (Vasari thought the patron was Piero's wife, Lucrezia.) Filled with flora and felled trees, both paintings are steeped in Christian repentance and salvation symbolism. Filippo's inventive compositions, which seem like pastiche variations on scenes of the Nativity, are like visual sermons, with devotional readings and commentary interwoven.

1461 — On 8 May, the behavior of Filippo (and his lawyer, Piero d'Antonio di ser Vannozzo) is publically denounced.

1462 — Filippo evaluates Bonfigli's frescoes in the Palazzo dei Priori, Perugia. Filippo had been asked initially to assess the frescoes with Domenico Veneziano and Fra Angelico (in 1454).

1465 — Filippo is living with Lucrezia and Spinetta (they returned to his house in 1461). Lucrezia gives birth to a daughter, Alessandra.

1466 — Having received his second major fresco commission, Filippo begins the chancel of Spoleto Cathedral. Working with him are his young son (Filippino) and Fra Diamante, the Carmelite friar (became a Vallombrosan in 1460), who had been his main assistant in Prato.

1469 — Filippo dies (10 October) in Spoleto and is buried in the cathedral. Fra Diamante completes the frescoes.

In 1464, the Florentine Sandro Botticelli enters Filippo's shop in Prato.

S. Francis of Assisi—A Biography

Still a very popular saint in the Quattrocento, Francis was depicted by Fra Filippo (see entry ca. 1445) and his legendary life was pictured by Benozzo Gozzoli and Domenico Ghirlandaio (see figs. 34–3, 38–1).

1181 About this year, Giovanni Bernardone (Francis, the founder of the Order of Friars Minor) is born in Assisi, the son of the wealthy cloth merchant Pietro Bernardone. Christened Giovanni, he was called Francesco because of family ties with France (his mother was Provençal). Francis soon was known for his poetry, generosity, and extravagant clothing.

1202 Francis is imprisoned in Perugia (Assisi and Perugia are at war), where he becomes seriously ill. His father buys his freedom.

1204 Francis suffers a long illness. Upon recovering, he made a pilgrimage to Rome, traveling as a humble, poor man, without the conveniences enjoyed by his social class. His goal was to become a knight in the papal army of Count Walter of Brienne, but he was unsuccessful.

1205 Francis leaves for war in Apulia, but returns the next day after having a vision in Spoleto (near Assisi). Francis then went into seclusion. While meditating in the ruins of S. Damiano, he heard a crucifix speak to him, telling him to repair the church. Francis appropriated goods from his father's shop to restore the church.

1206 In conflict with his father, Francis leaves home to live in a cave. He is declared insane, dragged before the bishop, and publicly disinherited by his father. Francis takes off his clothes (revealing a hairshirt), throws them at his father's feet, and leaves for Gubbio to care for lepers. When he returned to Assisi, he donned a hermit's habit and lived outside Assisi at the Portiuncula (plot of land), where there was a chapel called S. Maria degli Angeli.

1209 After hearing the gospel at Mass, Francis becomes a barefoot preacher. Two brothers (Bernard and Peter Catanii) and a man named Giles join Francis, whose brotherhood and missionary work begin.

1210 By this date, Francis and eleven companions have undertaken several missions. After writing a Rule for his Brotherhood of Poverty, Francis leaves for Rome with his followers to seek approval of the Rule. (Tradition records that Pope Innocent III accepted the Rule because in a dream he saw Francis and Dominic supporting the basilica of S. John of the Lateran, the pope's church. Innocent interpreted the dream to mean that the two would help to strengthen the Latin Church.) Upon Innocent's orders, Francis accepts the tonsure and deaconate.

1215 The Second Order of S. Francis, the Sisters of S. Clare (Poor Clares), are founded at S. Damiano. Francis and his followers leave on missions to Istria, Dalmatia, Spain (1212–15).

1216 Pope Honorius III grants indulgences for the Portiuncula.

1217 A Chapter is held at Portiuncula. The friars then leave on missions: Giles for Tunis, Elias for Syria, and Francis for France (however, Francis went to Florence and stayed in Italy).

1219 In the next couple of years Francis embarks on missions (Acre, Damietta, and the Holy Land), during which he visits the Sultan.

1221 Pope Honorius III approves the Rule of the Third Order (lay members of the order [tertiaries], who lived in the secular world).

1223 Pope Honorius III approves the second Rule of the Franciscans (composed by Francis at Fonte Colombo). In December, Francis institutes the Christmas crib during the midnight Mass at Greccio. For Francis, the doll in the crib was mystically transformed into Jesus.

1224 Francis' illness causes him to turn over leadership of the Order to Brother Elias of Cortona. Francis retreats to La Verna to fast for forty days in honor of the Virgin. There, he receives the stigmata.

1226 Francis suffers from an eye disease and poor health; he dies (3 October) at the Portiuncula, and is buried at S. Giorgio, Assisi.

1228 Pope Gregory IX canonizes Francis.

1230 S. Francis' remains are translated to the new basilica of S. Francesco in Assisi.

Paolo Uccello

Considered the most enthusiastic student of perspectival studies in his time, Paolo Uccello (ca. 1397–1475) was a generation younger than Brunelleschi and Ghiberti, and closer in age to Donatello, Masaccio, and Fra Angelico. By the time Fra Filippo had begun to receive major commissions in Florence in the late 1430s, Paolo was already at work on a series of projects for the Florence Duomo, where his training in bronze (with Ghiberti) and mosaic (in Venice) surely helped to secure the important commissions. Remembered for his unique approach to creating monumental forms in fresco, such as the Florence Duomo *Cenotaph of Sir John Hawkwood* (see fig. 29–4), his forté was in designing fantastic history scenes, the *Rout of San Romano* for the Palazzo Medici (see fig. 29–3) and the Creation stories in the Green Cloister, S. Maria Novella, Florence. In his preface to Dante (1481), Landino described him as a "good composer and varied, great master of animals and landscapes, skillful in foreshortening, because he understood perspective well."

ca. 1397 — Paolo is born to Antonia (daughter of Giovanni Castello del Beccuto) and Dono di Paolo, the son of a barber and surgeon from Pratovecchio. (The birth-date is based on Paolo's 1427 tax return.) Vasari noted that Paolo di Dono was fond of animals, especially birds, after whom he was nicknamed Uccello (It. bird).

1412 — Paolo is listed as an assistant (*garzone di bottega*) in the shop of Lorenzo Ghiberti, with whom he worked, it seems, until 1416. (It is also thought that his apprenticeship began in 1404 or 1407.)

1414 — Paolo is inscribed in books of the Company of S. Luke.

1415 — Paolo is inscribed (15 October) in the Arte dei Medici e Speziali; he entered without paying fees because his father belonged to the guild (1365) and had become a citizen of Florence in 1373. Paolo is living in the popolo (neighborhood) of S. Maria Nepoticosa.

1425 — Residing in the S. Maria Novella area, Paolo makes a will that leaves everything to the Hospital of S. Maria Nuova. He requests to be buried in the tomb his father purchased for himself and his heirs in the church of S. Spirito. About this time Paolo may have painted vault frescoes of the evangelists and an image of the Annunciation above Masolino's altarpiece in the Carnesecchi Chapel in S. Maria Maggiore, Florence, according to Vasari.

29–1. PAOLO UCCELLO. *Resurrection of Christ*, ca. 1443, design for the stained glass, dia. 15'4.3" (468 cm), cupola drum, Duomo, Florence. The fluid curves of Christ's arcing body and his windswept gown, decorated with large floral designs in the fabric, are stylistic traits found in Paolo's other works in fresco and panel. Easily read from a distance, the design shows his ability to create patterns that complement the tondo shape. While the soldiers are stationary in this scene, the resurrected Christ instead appears on tiptoes and is seeming to float upward from the tomb. The image visually alludes to Christ as pure light, for he resembles the bright, blue-white flame that rises from a burning candle.

29–2. Nave, Duomo, Florence. This view shows the north wall of the cathedral and the equestrian monuments by Paolo Uccello (right) and Andrea Castagno (left) (see figs. 29–4, 29–5). In 1524 Lorenzo di Credi restored the frescoes, painting borders around both images. The cenotaphs were restored again in 1688. They were removed from the wall in 1842, transferred to canvas, and hung on the west wall. In 1947 both paintings were rehung on the north wall of the church in their original places, but are now lower (by about 5') than they were originally. The original positioning placed Uccello's *Hawkwood* closer to the high altar and Castagno's *Niccolò da Tolentino* closer to the main entrance.

Paolo moves to Venice, where he was to remain until 1430. Records show that he worked on the facade mosaics of S. Marco in 1427, but only his image of S. Peter (now destroyed) is documented.

1431 — Returning to Florence, Paolo makes a tax declaration (January).

1432 — When Paolo requests work in the Florence Duomo, officials write to Pietro Beccanugi (Florentine ambassador to Venice) about Paolo's expertise in mosaic work.

About now, Paolo begins work on chiefly monochromatic frescoes depicting scenes from Genesis in the small cloister, called the Green Cloister (*Chiostro Verde*), of the Dominican church of S. Maria Novella, Florence (see fig. 32–2). His frescoes were executed during two distinct sessions, with the earliest work stylistically similar to Lorenzo Ghiberti's panels of the first bronze doors for the Florence Baptistery. Ghiberti greatly influenced (it has been suggested, too, that he designed) the sinopias of *Creation of the Animals* and *Creation of Adam* and *Creation of Eve* and *Temptation of Adam and Eve*. Also influential were Masolino's elegant figures in the Brancacci Chapel

(see fig. 25–1), particularly the slender, sinuous Adam and Eve (*Temptation*).

1434 — Paolo is at work in the Florence Duomo, making a cartoon for a window in the S. Zenobius Chapel.

1436 — Paolo receives a commission for the *Cenotaph of Sir John Hawkwood*, which he signed in the middle of the fresco (see fig. 29–4). A drawing attributed to him that has been associated with the commission may be the earliest squared drawing in existence. (Torn and in poor condition, it was likely a working drawing.) Masaccio had earlier used a system of squaring in *The Holy Trinity* fresco in S. Maria Novella (see fig. 18–5), but no drawings have been linked to his fresco.

1442 — In his declaration to the Tax Office in Florence, Paolo states that he is living in the quarter of S. Giovanni in the gonfalon of the Green Dragon, that he owns a house in the Via della Scala (purchased for 100 florins in 1434), a small property in the neighborhood of Florence, and has 168 florins in the Monte (bank). He also rents a workshop in the Via delle Terme for 6 florins a year.

1443 — Documents discuss the completion of four heads of prophets for the clockface in the Duomo, Florence.

Paolo receives commissions (1443–44) to design cartoons for four stained-glass windows in the cupola of the Duomo: *Annunciation, Nativity, Resurrection* (see fig. 29–1), and *Ascension* (Ghiberti's design for the Ascension was used). Paolo's knowledge of mosaics and his other work in the cathedral could have secured the

job; Donatello, Ghiberti, and Castagno were also hired to execute designs.

1445 — Summoned by Donatello, Paolo goes to Padua, where he paints figures of giants in terra verde for one ducat each on the entry to the Casa Vitaliani of the Eremitani.

1446 — Paolo returns to Florence and lives near the church of Ognissanti.

In the late 1440s, Paolo was engaged in painting frescoes depicting monastic life (now in poor condition) in the cloister of the Olivetan church of S. Miniato al Monte, Florence.

About this time, he is again painting frescoes in the Green Cloister of S. Maria Novella, Florence. He first painted *The Flood* in the lunette and then *Sacrifice of Noah* and *Drunkenness of Noah* below.

1450 — In Florence, Paolo is paid for a tabernacle in the church of Ognissanti.

1451 — Paolo gives a petition to the Calimala and later evaluates a tabernacle painted by Stefano d'Antonio.

1453 — Paolo and his wife, Tomassa di Benedetto Malifici, have a son, Donato. The birth of a daughter, Antonia, is recorded in 1456.

Paolo receives payment for painting a fresco of the Blessed Andrea Corsini in the library of the Duomo, Florence.

ca. 1459 — Paolo executes the third of three battle panels depicting a famous skirmish in the war between Florence and Lucca in which Florentine forces fought Sienese troops (allies of Lucca) near the tower of San Romano on 1 June 1432. Based on style, the first two were made in the late–1430s (see fig. 29–3). The dates and original location of the panels are debated, but they were originally lunette-shaped and the first two were likely made for Cosimo de' Medici after the death of his friend, the famous *condottiere* Niccolò da Tolentino, and before his new palace was built. Based on style and costume, the third panel (Louvre, Paris) is distinctly later in date and was perhaps made during the completion of Cosimo's new palace.

1465 — In Urbino, Paolo paints a predella, thought to be *Profanation of the Host* (Palazzo Ducale, Urbino), for which he received several payments (1465–68); the work has been linked to Justus of Ghent's altarpiece, *Communion of the Apostles*.

1469 — In his tax declaration, Paolo writes: "I find myself old and ailing, my wife is ill, and I can no longer work."

1475 — According to the Anonimo Gaddiano, in this year on 10 August Paolo died in a hospital. He was buried in his father's tomb in S. Spirito, following the stipulations of Paolo's will.

29–3. PAOLO UCCELLO. *Rout of San Romano*, ca. late–1430s, tempera and foil on panel, 5'11.7" x 10'7.1" (182 x 323 cm), Uffizi Gallery, Florence. This is the central panel of three battle paintings. It shows the Sienese commander Bernardino della Carda being thrown from his horse; Paolo signed his name on the fallen saddle in the left corner: PAVLI VGIELI OPVS. His interest in perspective is shown in the broken lances and toppled horses and soldiers, laid out in a grid on the bloodless battlefield. The panel resembles a tapestry in the tightly interlocking forms and richly designed surfaces (the silver armor would have glistened in darkness) and is the equivalent of Gozzoli's frescoes, executed about twenty years later in the Medici Palace chapel.

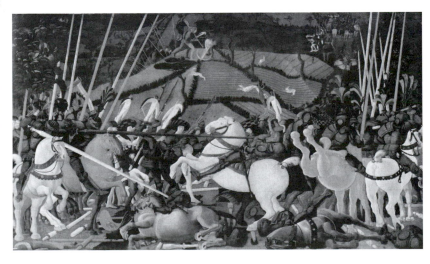

Condottieri

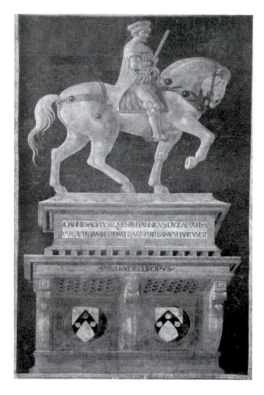

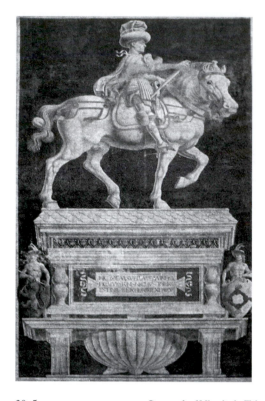

29–4. PAOLO UCCELLO. *Cenotaph of Sir John Hawkwood*, 1436, fresco (transferred to canvas), 26'10.9" x 17'2.8" (820 x 515 cm) with border, Duomo, Florence (see fig. 29–2 for the original positions of the cenotaphs, which are reversed here). Two years after conferring honorary citizenship on the Englishman John Hawkwood (Giovanni Acuto), a captain of war employed by Florence, the Signoria voted (1393) to have a marble statue erected in the Duomo to honor the soldier who had beaten the Milanese. When he died (1394), he was given an expensive state funeral (costing 410 florins) and buried temporarily in the Duomo, where a tomb monument was planned. His body was sent back to England on King Richard II's request (1395), but the commune hired (December 1395) Agnolo Gaddi and Giuliano d'Arrigo (Pesello) to prepare a design for the sculpture (later executed in fresco). A new, grander memorial to the soldier was planned (13 July 1433) when Brunelleschi's dome was under construction. The plans changed again, and Paolo was hired (30 May 1436), the year the Duomo was reconsecrated, to create a fresco in terra verde to replace Gaddi's. On 28 June 1436, it was decided that Paolo's fresco should be replaced, and he was told to paint another (6 July). Finishing the work, he was paid 15 florins for both versions (31 August), but had to revise the inscription letters (17 December). He signed on the entablature PAVLI VCELLI OPVS (the work of Paolo of the birds).

29–5. ANDREA DEL CASTAGNO. *Cenotaph of Niccolò da Tolentino*, 1456, fresco (transferred to canvas), 27'4" x 16'9.7" (833 x 512 cm) with border, Duomo, Florence. In 1435 the commune decided to erect a marble memorial to Niccolò da Tolentino (d. 1435). Twenty years later, a fresco cenotaph (rather than a statue) was ordered as a pendant to Uccello's *Hawkwood* (see fig. 29–4), but Castagno's equestrian fresco was to simulate marble rather than bronze. (Paolo's was meant to simulate a three-dimensional bronze statue, and the inspiration for his statuesque horse was perhaps derived from the monumental antique bronze horses on the Basilica of S. Marco, which Paolo must have studied in Venice during his stay there, from 1425–30.) Although both horses are headed in gait toward the high altar, alluding to the direction of church ceremonial processions and the pledge of faith and loyalty these soldiers made in their contract to Florence, Castagno's horse is far more lively and appears to turn its enormous head toward viewers. The laudatory, *all'antica* epitaph on Tolentino's tomb (HIC QVEM SVBLIMEM IN EQVO PICTVM CERNIS NICOLAVS EST TOLENTINVS INCLITVS DVX FLORENTINI EXERCITVS) was inspired by Hawkwood's (IOANNES ACVTVS EQVES BRITTANICVS DVX AETATIS S / VAE CAVITISSIMVS ET REI MILITARIS PERITISSIMVS HABITVS EST). Hollow-eyed, nude shield-bearers stand on the plinth to present emblems of Florence and Tolentino.

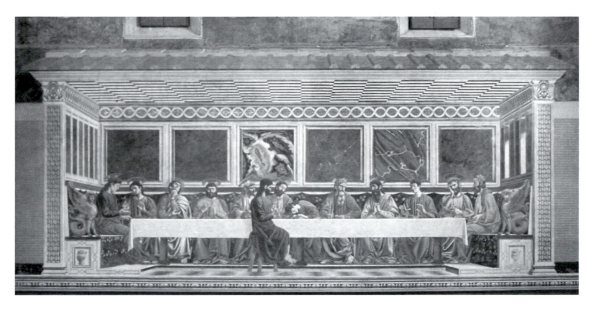

30–1. ANDREA DEL CASTAGNO. *Last Supper*, ca. 1447, fresco, 15'5" x 32' (470 x 975.3 cm), S. Apollonia, Florence. In the refectory (dining hall) of cloistered Benedictine nuns, Castagno depicted Christ with his apostles at their last meal together. Seated on a bench are eleven men and Jesus, whose names are all inscribed (added later) beneath their feet (only the names of Christ, Judas, and the end figures are missing): (left to right) James the Less, Philip, Thomas, James Major, Peter, Christ, John, Andrew, Bartholomew, Thaddeus, Simon, and Matthew. Judas sits alone, opposite the others. Castagno's images allowed the Benedictine nuns who took their meals in the refectory to meditate upon the communal meal and see it in perspective with the *Resurrection* (not shown here), the fresco above and slightly to the left of the *Last Supper*, the brightest part of the entire wall (see entry 1447).

The art of Andrea del Castagno (1419–57) was equally esteemed by religious and secular patrons. Sensitive to Masaccio's dramatic brand of storytelling and Donatello's commanding figures, Castagno created emotive figure types that are generally earthier than Masaccio's and stiffer than Donatello's. But his art is no less dramatic, for he experimented with painting on curved surfaces and using low vantage points that help infuse lively mobility into the telling gestures of his seemingly rigid figures. While he blended traits of ancient Roman art with contemporary Florentine style, Castagno was inspired fundamentally by the pillars of Florentine art, Coppo di Marcovaldo and Giotto. He found the spine for his own style in the raw energy and forthrightness of Trecento art, and he adapted the heavy, riveting lines of Coppo's style (S. Chiara Crucifix and the giant Pantocrator in the Florentine Baptistery) and the direct, uncluttered simplicity of Giotto's (Scrovegni Chapel). Never

prone to paint delicate, pretty people, he instead rendered figures who display the arduous nature of their lives through expressive faces, gestures, and demeanor. In his late works, statuesque, large-boned, weathered, and coarse-featured people portray extreme emotional states: the rugged, toothless Jerome, for instance, shows a man reeling during a sublime revelation of the Trinity, and the remorseful Julian is shown with a downcast glance and contorted left hand that display his gnawing anguish for having unwittingly murdered his parents (see entry 1455).

1419 — Andrea Castagno is born to Lagia and Bartolo di Simone di Bargiella in the village of Castagno (northeast of Florence). His grandfather descended from one of the oldest families in the village, and his father owned a house, some acreage and pasture, and chestnut woods just outside Castagno, for which Andrea was nicknamed.

Central to Castagno's *Last Supper* (fig. 30–1) and to words of Jesus in the Gospel of John are the expressions of Peter and Judas: Peter's left hand (considered the sinister hand) covers up his right, alluding to his future denial, and Judas has beady eyes and a hooked beard, suggesting the devil has overtaken him. One figure that helps link the imagery of the apostles' last meal with the upper wall Passion scenes is Matthew (apostle and gospel writer) on the far right. Sitting taller than the others, Matthew has thick, broad hands that direct attention toward Christ and the upper wall scenes; his stare is transfixed like that of the hollow-eyed sphinxes at the corners of the bench. Considered guardians of the mysteries of religion, these hybrids (lion with a woman's head and breasts, and wings) allude to the mystical nature of Christ's human and divine form. On the far left are three apostles (James Minor, Philip, and Thomas), whose demeanor and gestures suggest they may be discussing the Resurrection, Ascension, and the second coming of Christ.

1423 — Andrea's family leaves Castagno, escaping the Milanese army of Giangaleazzo Visconti, which crossed the Apennines on its march to Florence.

1427 — Bartolo (Castagno's father) files a statement in the Tax Office in Corella (in the Mugello), stating that his son Andrea is six years old, but it is more likely that he was instead eight.

1437 — Bartolo files a tax statement in Castagno, listing Andrea as a dependent (the last time Andrea is listed as such).

1440 — After defeating the Milanese at Anghiari (29 June), the commune hired Castagno to paint the members of the Albizzi conspiracy who betrayed Florence by joining the Milanese. For his images on the facade of the Palazzo del Podestà (removed 1494) that depicted each man hanging by one foot, he was nicknamed Anderino degli Impicchati, "Andrea of the Hanged Men." (Vasari later mistakenly identified his images as the Pazzi conspirators of 1478.)

1442 — In Venice, Castagno is contracted (with Francesco da Faenza) to paint apse frescoes in the S. Tarasio Chapel in the Benedictine convent church of S. Zaccaria. His frescoes include figures of the Evangelists, S. John the Baptist, S. Zacharias, and God the Father. For the Mascoli Chapel in S. Marco, he created a mosaic design of the *Death of the Virgin*. Decoration of the chapel was supervised by the Venetian painter Michele Giambono.

1444 — Castagno receives 50 lire for his *Lamentation* cartoon for a stained-glass roundel for the cupola drum of Florence Duomo. In Florence, Castagno is inscribed (30 May) in the Arte dei Medici e Speziali, which met in the choir of S. Egidio (until 1450). He is living in the parish of S. Maria del Fiore.

1445 — Castagno receives a payment (30 April) from the guild of judges and notaries for a fresco portrait of Leonardo Bruni; the historian and Chancellor of Florence had died the year before. Made for the entrance of the guild palace, Bruni's image became one of many lawyer portraits created for the guild.

About this time he created a large fresco, *Enthroned Madonna and Child with Angels, Ss. John the Baptist and Jerome, and Two Youths from the Pazzi Household* (detached 1930; since 1974 Palazzo Pitti, Florence), for the altar in the chapel of the Castello Trebbio (dating of the fresco is based on the ages of the Pazzi children, Oretta and Renato).

1446 — Castagno is paid (8 lire, 3 soldi) by the *operai* of Florence Duomo for painting a Florentine lily and two putti above the cathedral organ. He is later paid for the gold (6 lire) to adorn the *Agnus Dei* (Lamb of God) image on the organ and the capitals of the organ case.

1447 — Castagno is paid 10 lire for his frescoes, *Three Virtues*, in the audience hall of the judges' and notaries' palace.

In 57 working sessions (*giornate*), Castagno decorated the end wall of the refectory of the cloistered Benedictine nuns of S. Apollonia with frescoes of the *Last Supper* (see fig. 30–1), *Resurrection*, *Crucifixion*, and *Entombment* (see LAST SUPPER, Quattrocento Glossary) (see also LAST SUPPER, sidebar).

1450 — Castagno is paid 104 lire for *Assumption of the Virgin with Ss. Miniatus and Julian* (Gemäldegallerie, Berlin) for S. Miniato fra le Torri.

1451 — By this year, Castagno finished the *Uomini famosi* cycle in the Villa Carducci at Legnaia (see fig. 30–2). The

wealthy merchant and banker Filippo di Giovanni Carducci acquired the 14TH–c. villa in 1427. Enlarging the villa, he hired Castagno to decorate the new loggia, but died before the paintings were completed. Castagno's 11 figures from biblical and secular history occupy two walls and appear to be standing under a loggia themselves. Castagno's statuesque *Adam and Eve* (with a hoe and distaff) were inspired by classical statues. The inscription beneath Eve refers to the fall and salvation of humanity: EVA. OMVS [NIVM]. MATER SVASIONE SVA. GENVS. PEREMIT [MALIS]. Two years after Carducci's death (28 July 1449), his nephew Andrea di Niccolò Carducci acquired the villa, which was sold by Andrea's widow to the Pandolfini.

In January, Castagno is hired to paint the east wall of the choir in S. Egidio (the church of the hospital of S. Maria Nuova), Florence. (Domenico Veneziano had executed frescoes, 1439–ca. 1446, on the west wall of the choir.) Castagno was to receive 100 gold florins for three frescoes: *Annunciation*, *Presentation in the Temple*, and *Death of the Virgin* (destroyed, except a fragment of *Death of the Virgin*). While working on these (1451–53), he lived in the hospital of S. Maria Nuova, where he was also given a room for his workshop. The convent paid for his taxes, debts to the painters' guild, and fresco materials (plaster, ultramarine, varnish, and gold), but he left his work unfinished, perhaps because of an unresolved disagreement with his patrons.

ca. 1453 — Castagno paints the *Crucifixion* for a cloister in the convent of S. Maria degli Angeli, Florence.

1454 — From Castagno's design of a large Inferno scene for SS. Annunziata, Alesso Baldovinetti made a (destroyed) canvas painting for which he charged 40 lire. Alesso recorded that it was filled with many nudes and hellish furies and made for the Lord of Mantua, who was then the *condottiere* Ludovico III Gonzaga.

Taking six assistants to Rome, Castagno works in the papal palace of Nicholas V (see Angelico, who also worked for Nicholas); the work is thought to be the frescoes of illusionistic loggias in the Biblioteca Graeca that resemble antique architectural settings, with swags, bucrania, urns, birds, coffered ceilings, and receding floor tiles.

1455 — In Florence, Castagno is paid (July and August) for (destroyed) frescoes, *Lazarus*, *Martha*, and *Mary Magdalene*, on the altar wall in Orlando de' Medici's chapel in SS. Annunziata. In the same church he paints two other frescoes: *Penitent S. Julian Receiving Absolution from Christ* (Gagliani Chapel) and *Trinity Appearing to Ss. Jerome, Paula, and Eustochium* (Corboli Chapel).

ca. 1455 — Castagno paints *David* on a leather shield (National Gallery of Art, Washington, D.C.).

1456 — For the Florence Duomo, Castagno completes the equestrian fresco portrait of *condottiere* Niccolò da Tolentino (see fig. 29–5), ordered by the commune.

1457 — Castagno finishes (10 May) the *Last Supper* fresco in the monastery refectory of S. Maria Nuova, Florence.

In Florence, Castagno dies of the plague (19 August), with many debts in his name; he was buried with his wife (died eleven days before him) at S. Maria Nuova. Vasari thought he was buried dishonorably at S. Maria Novella for murdering Domenico Veneziano.

UOMINI FAMOSI.

Cycles of *Uomini famosi* (famous people) had become popular in palace decoration by the 14TH c.: Giotto painted a series of large-scale figures in the Great Hall of King Robert I of Naples (ca. 1331), and Masolino designed about 300 small-scale images for Cardinal Giordano Orsini's palace in Rome (ca. 1432). What distinguishes Castagno's from previous cycles is primarily the inclusion of three women among the soldiers and poets, the authority and sculptural monumentality of the figures, and the *all'antica* style that imitates Roman villa decoration as described by the ancient Roman architect Vitruvius in his ten-volume corpus, *De architectura* (On Architecture). Castagno's images influenced other artists, especially his two angels holding back canopy curtains (see the angels in Antonio and Piero del Pollaiuolo's fresco, Cardinal of Portugal Chapel, 1466, S. Miniato al Monte, Florence; Baldovinetti's angels, *The Holy Trinity with Saints*, 1471, for S. Trinità, Florence; and Piero della Francesca's angels in *Madonna del Parto*, ca. 1455–65, Monterchi).

Uomini Famosi, Villa Carducci, Florence

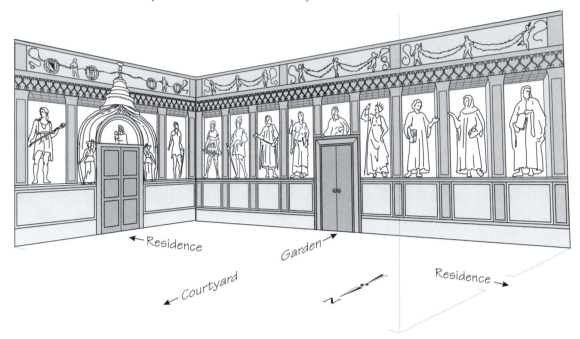

30–2. This diagram reconstructs Castagno's *Uomini famosi* (ca. 1449–51) that decorated a room about 50' long and 25' wide in the Villa Carducci, Legnaia (outskirts of Florence). Following Alberti's treatise, *De re aedificatoria* (On Architecture, 1450), Castagno created an *all'antica* setting. No decoration remains on the west wall, and the east and south walls both have extensive paint losses. The open side of the loggia faced a court, but was closed in the 1480s by the Pandolfini (see entry 1451), who added swags, putti, and family crests above the figures on the east wall (and perhaps the door beneath Esther).

Filippo Carducci twice held the highest government post in the city; he was *gonfaloniere di giustizia* (Standard Bearer of Justice) in 1417 and 1439. For his contribution to the Council of Florence (1439), he was granted the right by the emperor of Constantinople to display the imperial Greek double eagle on his family crest.

Carducci's erudition and civic pride appear in his choice of figures esteemed for their valor and active contribution to the betterment of society (whose origin can be traced to the first parents, Adam and Eve, shown on the north wall). Six figures on the south wall had direct links to Florence (see below).

Florentine Military Commanders (south wall, from the left)
Pippo Spano (1369–1426): DOMINVS PHLIPPVS HISPANVS DE SCOLARIS RELATOR VICTORIE THEVCRO[RUM] ("scourge of the Turks")
Farinata Degli Uberti (13ᵀᴴ c.): DOMINVS FARINATA DEVBRTIS SVE PATRIE LIBERATOR ("liberator of the father land")
Niccolò Acciaiuoli (d. 1365): MAGNVS THETRARCHA D'ACCIAROLIS NEAPOLETA[NI] REGNI DISPENSATOR ("steward of the Kingdom of Naples")
Famous Women (south wall, middle three figures)
Cumaean Sibyl (prophetess of Cumae in southern Italy): CVMANA QVE PROPHETAVIT ADVENTVM [CHRISTI] ("prophesied the birth of Christ")
Queen Esther (Old Testament heroine): inscription missing
Queen Tomyris (ancient Persian queen): [THOMIR TARTA]RA VINDICAVIT SE DEFILIO ETPATRIAM LIBERAVIT SVAM ("liberator of her people")
Florentine Poets (south wall, three figures on the right)
Dante (1265–1321): DANTES DI ALEGIERIS FLORETINI (Dante Alighieri, Florentine)
Petrarca (1304–74): DOMINVS FRANCISCHVS PETRARCHA (Lord Francesco Petrarca)
Boccaccio (1313–75): DOMINVS IOHANNES BOCCACCIVS (Lord Giovanni Boccaccio)

The luminous color of Domenico Veneziano (ca. 1405–61) is as important to the story of Quattrocento Italian painting as the transmission of Byzantine elements by such artists as Paolo Veneziano, Coppo di Marcovaldo, and Cimabue for Trecento style. Traits in Domenico's art (the study of light and nature, preference for delicate pastel colors, and creation of fair-skinned, monumental figures), seen in his *S. Lucy Altarpiece* (see fig. 31–1), suggest that he was inspired by the works of Gentile, but especially by Masaccio and Masolino, combining the simplicity and focus of Masaccio's compositions with the blonder palette and complex fictive settings of Masolino. Yet Domenico's illusionism is more developed than Masolino's, and his figures, though gentler and more elegant, are as monumental as Masaccio's. In the *S. Lucy Altarpiece* the great size of Mary and Christ gives them a commanding presence; they are comparable to the sizable *Madonna and Child* in Masaccio's Pisa altarpiece, who seem to grow larger and closer to those who focus their meditation upon them, and they are distant relatives of Antonio Vivarini's *Madonna and Child with Saints*, executed for the Scuola della Carità in Venice (see fig. 18–4). But Domenico has modernized the *Hodegetria* type, and Mary and her child are more approachable. Symbolic of *Ecclesia* (the Church), Mary is at once a giant tabernacle framed by the shell motif of the exedrae behind her and a divine temple goddess seated upon her throne. This painting also projects the attendant saints into the

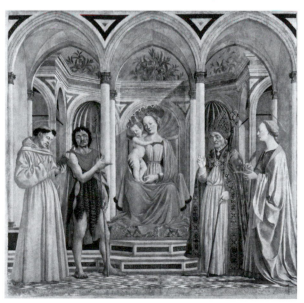

viewer's space because the entablature of the loggia (rising above Mary) appears to touch the surface of the painting at the upper edge, but the saints stand in front of the columns that support the loggia, causing the foreshortened tiles beneath their feet to seemingly project into our realm. Domenico's volumetric figures and subtle, convincing illusionism—most tangibly felt in the sunlit court, peacock blue sky, and swaying orange trees suggestive of springtime—appealed to Florentine taste. In his journal (*Zibaldone*, 1470s), the merchant Giovanni Rucellai (patron of Leon Battista Alberti) included Domenico's name among the list of artists whose works he owned, and whom he thought were for a long time the best artists in Florence and Italy.

1405 — Although Vasari wrote that Domenico di Bartolomeo da Venezia was born in this year, his birthdate is often placed about 1410. Yet no records identify either the date or place of his birth.

late 1420s — Domenico's early training is uncertain, but he may have been in Rome in the late 1420s, where it seems highly probable he worked with Masolino (ca. 1428–31) at the church of S. Clemente; traits of Masolino's style appear later in Domenico's work.

early 1430s — Domenico paints a street tabernacle at the Canto de' Carnesecchi (near S. Maria Novella) for the Carnescchi family (Vasari noted that this was his earliest work in

31–1. DOMENICO VENEZIANO. *Madonna and Child with Ss. Francis, John the Baptist, Zenobius, and Lucy* (*S. Lucy Altarpiece*, main panel), ca. mid–1440s, tempera on panel, 6'10" x 7' (209 x 216 cm), Uffizi Gallery, Florence (see fig. 31–4).

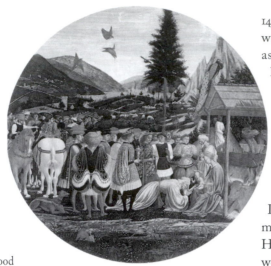

31–2. DOMENICO VENEZIANO. *Adoration of the Magi*, ca. early–1440s, tempera on panel, dia. 32.8" (84 cm). Gemäldegalerie, Berlin. This is perhaps the first large tondo of the Adoration of the Magi, and its round shape must surely derive from paintings associated with round trays of food given to new mothers to celebrate a child's birth (*deschi da parto*). Similar to the themes depicted in such paintings, the Adoration celebrates new life and the giving of gifts. In contrast to Lorenzo Monaco's scene (see fig. 23–1), Domenico's is filled with more costly brocades and fur-trimmed garments that are reminiscent of the luxury displayed in Gentile's (see fig. 22–1). Yet the deep landscape that believably recedes behind these figures is distinct. It appears to have been modeled after Masolino's panoramic views in S. Clemente, Rome (*Crucifixion*, ca. 1431), and the Castiglione Olona Baptistery (*Baptism*, 1435), where the hilly north Italian terrain is described. Still, Domenico's lake and fields appear to recede more logically.

Florence). Three fragments remain of the frescoed niche: the central image of the enthroned Virgin and Child and the heads of two saints painted on the sides of the tabernacle. Images of the Virgin and Child were commonly painted on street and countryside tabernacles. What makes Domenico's work distinctive is the simplicity and clear, geometrical organization of the scene, characteristics found in the *S. Anna Metterza* by Masaccio and Masolino (see fig. 25–4). In Domenico's fresco, God the Father appears as a bearded, white-haired man whose foreshortened form hovers above the regal images of Mary and the Child; shown nude and standing on his mother's lap, the blond-haired, muscular infant raises his right hand in benediction. Between the outstretched arms of God, which form the sides of an isosceles triangle, is the foreshortened image of the Holy Ghost as a white dove, whose wing tips touch the arms of God. In 1513 Francesco Baldovinetti attributed this important tabernacle to his father, Alesso, who had completed some of Domenico's work (see entry 1445).

1437 — Domenico paints frescoes in the Baglioni Palace, Perugia. These were destroyed by 1550, as Vasari noted (*Lives*).

1438 — From Perugia (1 April) Domenico writes to Piero de' Medici in Ferrara, asking for work in Florence; he had heard that Cosimo (Piero's father) was about to commission a magnificent altarpiece for S. Marco, and he wanted to execute the painting (Angelico got the contract). Asking Piero to recommend him, he said that he knew good master painters were already in Florence (naming Angelico and Lippi), but they had pressing commitments (citing Lippi's S. Spirito contract). His letter suggests that he had previously worked in Florence (likely for Piero).

1439 — In Florence (spring), Domenico paints frescoes in the choir of S. Egidio. On 22 August he receives 44 florins for the (lost) *Meeting at the Golden Gate*. Piero della Francesca is among his assistants, and is paid 2 florins, 3 lire (12 September) from Domenico's account.

early 1440s — In this period, Domenico paints the *Adoration of the Magi* tondo, perhaps for Piero de' Medici (see fig. 31–2). An entry in the 1492 Medici inventory describes a tondo painting of the Story of the Magi (valued at 20 florins), which is thought to be this painting. However, it is attributed to Pesellino and recorded as two braccia high (about 40 inches), which is slightly larger than Domenico's work.

1441 — Domenico paints the (lost) *Birth of the Virgin* at S. Egidio, begun in 1439. He received more money for this fresco (60 florins) than for painting the first fresco (see entry 1439), suggesting that his works had become more highly valued; he seems to have been better paid than his painter colleagues, Castagno (received 100 florins for three frescoes at S. Egidio) and Alesso Baldovinetti (received 20 florins for the *Nativity* in the cloister at SS. Annunziata).

1444 — Domenico obtains a loan from Marco Parenti, the client who contracted two wedding chests (see entry 1447).

1445 — Domenico receives an advance payment of 10 florins (1 June) from S. Egidio, perhaps for his third choir fresco, *Marriage of the Virgin*. This fresco was finished by Baldovinetti in 1461.

About this year, it seems that Domenico began work on the *S. Lucy Altarpiece* (see figs. 31–1, 31–4) for Niccolò da Uzzano (see fig. 21–2). On the steps of the throne beneath Mary's feet is a dedicatory inscription that names Domenico as the artist: AVE MARIA (middle top step) / OPVS DOMINICI DE / VENETIIS / HO MATER DEI MISERERE MEI / DATVM EST (Hail Mary, Mother of Mercy, Domenico from Venice dedicates this work to you).

ca. 1447 — According to Vasari, Domenico was working on frescoes in Loreto with Piero della Francesca.

1447 — Domenico receives 50 florins for two (untraced) chests (*cassoni*), contracted by Marco Parenti for his marriage to Caterina Strozzi. (The bride's family usually paid for such chests, but after providing a dowry of over 1,000 florins her family was unable or unwilling to pay for the chests.) Domenico was paid for materials and labor in 18 installments (1447–48). The large number of payments may indicate that he was responsible for all parts of the project: designing and painting the panels as well as preparing and assembling the wood.

ca. 1450 — In Florence, Domenico paints a fresco of the figures of *Ss. John the Baptist and Francis of Assisi* (Museo di S. Croce, Florence) for the Cavalcanti Chapel, S. Croce. His work shows that cartoons were used to transfer the full-scale design (*spolveri* are visible).

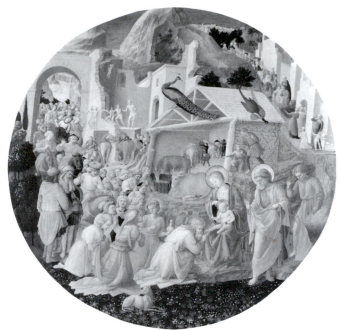

Domenico's figures are shown *di sotto in su* (seen from below) and are more dramatic than the saints of the *S. Lucy Altarpiece*, perhaps reflecting Castagno's influence combined with Domenico's continued studies in perspective. Originally attached to the choir screen, these frescoes were severely damaged when it was dismantled (1560s). The Cavalcanti ordered Donatello's *Annunciation* of ca. 1433 (placed near their graves).

1454 — Domenico, Fra Angelico, and Fra Filippo Lippi are asked to evaluate Benedetto Bonfigli's frescoes in the Palazzo dei Priori, Perugia.

1455 — Domenico is living in the S. Paolo parish of the S. Maria Novella quarter, where he leases a house. Not far away is the Rucellai Palace (see fig. 64–4).

1457 — Domenico and Filippo are in Pistoia to evaluate the *Trinity Altarpiece* by Florentine painter Pesellino (d. 1458).

1461 — Domenico dies on 15 May, according to records of the Arte dei Medici e Speziali and the office of the *grascia* (regulated activities of artisans); he died a pauper and was buried in the church of S. Piero Gattolino (Oltrarno).

31–3. FRA ANGELICO AND FILIPPO LIPPI. *Adoration of the Magi*, ca. 1435–55, tempera on panel, dia. 4'6" (137.2 cm). National Gallery of Art, Washington, D.C. An entry in the 1492 Medici inventory records a large tondo by Angelico of the Magi with offerings; framed in gold and valued at 100 florins, this is the highest assessment of a painting in the inventory. The tondo here is likely the painting described. While stylistic traits of Angelico are visible, the design shows the hand of Filippo and his interest in creating a deep space for the meandering Magi and entourage; his model was surely Domenico's *Adoration* (see fig. 31–2). Filippo's tondo also displays a rich variety of garments and exotic animals, but his deep space lacks the logic of Domenico's.

S. *Lucy Altarpiece* Reconstructed

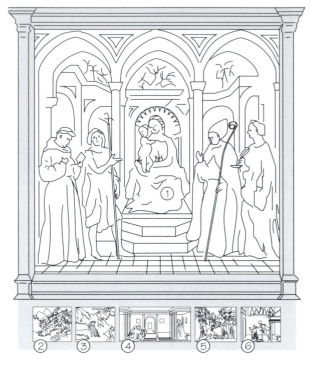

31–4. Reconstruction of the *S. Lucy Altarpiece* (see fig. 39–1). In this *sacra conversazione* is a community of holy saints who lived in different periods. In such devotional paintings (see SACRA CONVERSAZIONE, Quattrocento Glossary) the saints functioned as intercessory figures for the patrons; the saints here were revered by all Florentines (especially S. John the Baptist and S. Zenobius, the first bishop of Florence). Episodes from the saints' lives are portrayed in the predella. The key below includes the titles, dimensions, and locations of the panels.

KEY TO THE DIAGRAM.

1 *Virgin and Child with Ss. Francis, John the Baptist, Zenobius, and Lucy*, 6'10" x 7' (209 x 216 cm) (A)

2 *S. Francis Receiving the Stigmata*, 10.9" x 12" (26.7 x 30.5 cm) (B)

3 *Vocation of S. John the Baptist*, 11.1" x 12.8" (28.5 x 32.5 cm) (B)

4 *Annunciation*, 10.8" x 21.3" (27.3 x 54 cm) (C)

5 *Miracle of Zenobius*, 11.3" x 12.8" (28.6 x 32.5 cm) (C)

6 *Martyrdom of Lucy*, 10.3" x 11.5" (26.5 x 29.5 cm) (D)

 (A) Uffizi Gallery, Florence

 (B) National Gallery of Art, Washington, D.C.

 (C) Fitzwilliam Museum, Cambridge

 (D) Gemäldegalerie, Berlin

HISTORY OF THE ALTARPIECE: Vasari attributed the *S. Lucy Altarpiece* to Francesco Pesellino (1550), then to Domenico (1568). Although he praised Domenico for his painting, he combined the biographies of Domenico and Castagno in the same chapter of his *Lives*, giving greater attention to Castagno. He thought that Domenico was an outsider, brought to Florence to work at S. Egidio because of his new technique of painting in oil. Vasari also repeated a popular myth that jealousy made Castagno kill Domenico. However, Castagno died four years before Domenico. Both artists surely influenced each other, although they never worked side by side as Vasari believed they had done.

The great tragedy concerning the art of Domenico is that too many works are lost, too few are dated, and the surviving paintings no longer have the final, deli-

cate touches of gold and pigment that distinguished his unique style. His extant masterwork in panel is the *S. Lucy Altarpiece*, commissioned for the high altar of S. Lucia de' Magnoli in Florence (on the Via de' Bardi). The 11ᵀᴴ–c. Benedictine church had been acquired by Olivetan monks (a reform branch of the Benedictines) in 1373. In the 14ᵀᴴ c., while the Uzzano family had patronage of both the church and main chapel, the Sienese painter Pietro Lorenzetti created the high altarpiece of S. Lucy (1332). His altarpiece was removed to the sacristy during the remodeling of the church (15ᵀᴴ c.). Although no written documents confirm the contract, it seems that Niccolò da Uzzano was responsible for the complete redecoration of the main altar chapel, hiring Bicci di Lorenzo to execute frescoes of S. Lucy and Domenico Veneziano to create the altarpiece. Domenico's painting stayed on the main altar until the late–17ᵀᴴ c.; it was moved to the Bigallo in the 18ᵀᴴ c. When it entered the Uffizi Gallery (1862), the predella had been removed (see the key for the locations of the five predella panels) and the main panel was damaged from overcleaning (surface paint is missing).

Considered the first art theorist of the Italian Renaissance, Leon Battista Alberti (1404–72) was a humanist, architect, poet, mathematician, painter, and member of one of the most prosperous families of the bourgeois aristocracy in Florence, whose wealth came from trading and banking. The first modern architect, his twofold contribution—his writings on art and his architectural designs—changed the course of Italian art.

1404 — Born in Genoa, Leon Battista is the illegitimate son of Lorenzo Alberti, a Florentine in exile.

1414 — The Alberti are in Venice, where Lorenzo heads a branch of his family's trading business. Leon was in boarding school in Padua (1415).

1421 — While Leon Battista is in Bologna studying canon law, his father dies in Padua. Relatives take his inheritance, leaving him no monetary support.

1424 — Continuing his studies of the Greek and Latin classics, Alberti writes the comedy *Philodoxeus*, introduced as the work of Lepidus (fictitious Roman playwright). In 1434 he claimed authorship.

1426 — Alberti enters the service of Cardinal Albergati in Bologna. The ban on his family was lifted at the request of Pope Martin v (22 October 1428).

1432 — In Rome, Alberti is appointed an apostolic abbreviator for Eugene iv. Around 1433–34, he wrote *Della famiglia* (On the Family), adding a fourth book (concerning friendship) to the treatise in 1443.

1434 — During the unrest in Rome, Alberti moves to Florence with Pope Eugene, where he wrote *De pictura* in Latin in 1435, followed by the vernacular version of the text (1436).

1436 — Alberti moves to Bologna with Pope Eugene, and traveled with the papal curia to the Council of Ferrara in 1438, after which he attended the Council of Florence in 1439.

1442 — Invited to Ferrara by Leonello d'Este, Alberti gives advice on the equestrian monument honoring Leonello's father, Niccolò. (He earlier wrote a treatise on horses, which he dedicated to Leonello.) Alberti followed Pope Eugene back to Rome in 1443.

1444 — Alberti works on the ten books of *De re aedificatoria* (On Architecture), which he presented to Pope Nicholas v in 1452 (pubished 1485 in Florence).

1450 — Employed by Sigismondo Malatesta of Rimini, Alberti renovates the church of S. Francesco, Rimini. During the pontificate of Nicholas v (1447–55), he was likely involved in the designs for the repair and rebuilding of churches, walls, aqueducts, the Vatican apartments, and S. Peter's in Rome.

1453 — Alberti completes designs for the Palazzo Rucellai (see fig. 64–4).

32–1. LEON BATTISTA ALBERTI. Facade, ca. 1458–70, S. Maria Novella, Florence. Giovanni Rucellai hired Alberti to complete the partially finished Gothic facade of S. Maria Novella. Alberti's design has a harmonious, classical appearance: he added a triumphal arch for the main entrance, volutes to fuse the narrow upper story with the broad lower half, and a Greek pediment to cap the second story. The friezes have emblems of the Rucellai (poppy seeds, boats) intertwined with those of the Medici (diamond rings), linking the two families (Bernardo Rucellai married Lorenzo de' Medici's sister Lucrezia in 1466) (see also fig. 32–2).

1459 — Alberti accompanies the humanist Pope Pius II (1458–64) to Mantua, where Ludovico Gonzaga hires him to build S. Sebastiano. He later sent plans for the new design of S. Andrea.

1467 — In Florence, Alberti designs the shrine of the

Holy Sepulcher in S. Pancrazio for the Rucellai.

1470 — Ludovico III Gonzaga puts Alberti in charge of the tribune at SS. Annunziata in Florence.

1472 — Alberti dies in Rome.

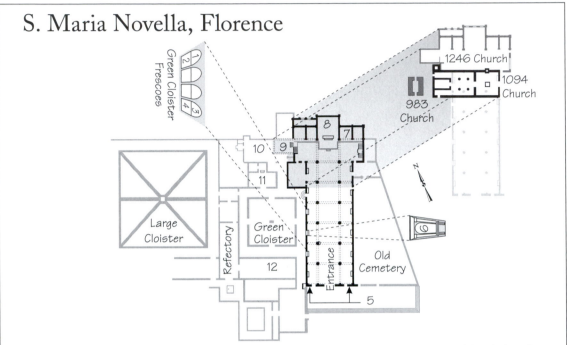

S. Maria Novella, Florence

32-2. Ground plan of the complex of the Dominican church of S. Maria Novella, Florence. Enlarged details show the different buildings on this site (and their dates) that preceded the current church as well as the placements of Paolo Uccello's frescoes in the Green Cloister (Choistro Verde) and Masaccio's *The Holy Trinity* fresco along the west interior wall. Identified also are the extant major fresco projects of the Trecento (post Black Death) and of the Quattrocento.

KEY TO THE DIAGRAM.

1 Green Cloister frescoes: Uccello, *Creation of Animals and Creation of Adam*, ca. 1430s

2 Green Cloister frescoes: Uccello, *Creation of Eve and Temptation of Adam and Eve*, ca. 1430s

3 Green Cloister frescoes: Uccello, *Deluge and Recession of the Waters*, ca. 1440s

4 Green Cloister frescoes: Uccello, *Sacrifice of Noah and Drunkenness of Noah*, ca. 1440s

5 Leon Battista Alberti, facade design, 1458–70 (see fig. 32–1)

6 Masaccio, *The Holy Trinity*, fresco, ca. 1427 (see fig. 18–5)

7 Strozzi Chapel (see figs. 39–4, 39–5): Filippino Lippi, *Ss. John the Evangelist and Philip* (side wall frescoes), *Allegorical Figures* (altar wall frescoes), *Madonna and Child with Ss. John and Philip* (stained-glass design), 1487–1502; Benedetto da Maiano, *Tomb of Filippo Strozzi* (black stone coffin), 1491–93

8 Tornabuoni Chapel (see figs. 38–3 to 38–5): Domenico Ghirlandaio, *Ss. Mary and John the Baptist* (side walls) and the *Coronation of the Virgin, Donors, and Saints* (altar wall), 1486–90, fresco (high altarpiece by Domenico Ghirlandaio)

9 Old Strozzi Chapel: frescoes by Nardo di Cione, *Last Judgment*, *Heaven*, and *Hell*, 1350s, and altarpiece by Andrea di Cione (Orcagna), *Enthroned Christ with the Virgin Mary and Saints*, 1354–57

10 Cloister of the Dead

11 Chapter House (called the Spanish Chapel): frescoes by Andrea da Firenze, ca. 1366-68

12 Hospice

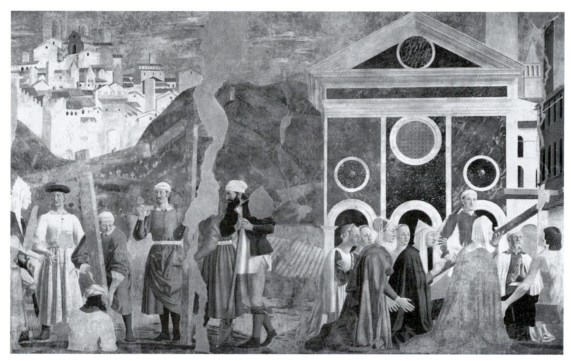

33–1. PIERO DELLA FRANCESCA. *Empress S. Helena and the Discovery of the Crosses* and *Miracle of the True Cross* (detail), ca. 1450–66, fresco, whole tier: 11'8.1" x 24'6.1" (356 x 747 cm), S. Francesco, Arezzo. Vasari called Piero the greatest geometrician of his day, a declaration supported by the clarity and proportion in this design of the worshipful Helena kneeling before the cross that brings a dead young man back to life (see fig. 33–4, #8). Nearly lost among the crowd in Agnolo's fresco (see fig. 16–1), Helena is singled out here by her cone-shaped hat. Her journey to Palestine is thematically and visually linked to the scenes directly opposite, where the Queen of Sheba visits King Solomon (see fig. 33–4, #2). The scenes of both walls display pomp and ceremony amid the miracles revealed. Like Helena, the queen also kneels in worship, envisioning the significance of the wood in the footbridge outside Solomon's palace (she counseled Solomon to bury the wood). In *Death of Adam* (see fig. 33–4, #1) a branch planted over Adam's grave grew into the wood used for Christ's Cross. Facing this scene is the barefoot Heraclius returning the Cross to Jerusalem (see fig. 33–4, #10). The symbolic coupling of the lunette scenes recalls the tradition that Christ (the second Adam) was crucified on Mount Calvary, where Adam was buried.

Piero della Francesca (ca. 1412–92) worked as easily for court dignitaries as for provincial municipalities. Celebrated both as a painter and geometrician, his mathematical treatises surely inspired Leonardo and were the products of many years of study and his direct contact with the architect Leon Battista Alberti (their paths intersected on several occasions, at Urbino, Ferrara, and Rimini). While Piero is now often considered the exemplary Renaissance artist, and his work in Rome, Arezzo, and Urbino established his renown during his own lifetime, he stayed close to his home in the provincial Borgo San Sepolcro for most of his life. Greatly influenced by his master Domenico Veneziano (whom he assisted in 1439 at S. Egidio, Florence, and from whom he acquired valuable knowledge about executing large-scale fresco projects), Piero's frescoes of the 1450s in S. Francesco in Arezzo (see fig. 33–1) and in S. Francesco (Tempio Malatestiano) in Rimini display extraordinary luminosity and pageantry, demonstrating his consummate skill and debt to Domenico's style. Yet, he took years to finish paintings because of his technique and procedure, and many of his works are therefore difficult to date precisely.

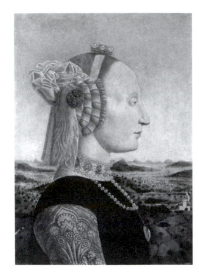

33–2. PIERO DELLA FRANCESCA. *Battista Sforza*, ca. 1474, oil on panel, 18.5" x 13.3" (47 x 33.6 cm), Uffizi Gallery (since 1773), Florence. Piero's format (see fig. 33–3) was inspired by antique portrait medals and contemporary ruler portraits. Married in 1459, Battista was Federico II da Montefeltro's second wife and bore him many daughters and one son, Guidobaldo, who succeeded Federico as duke of Urbino in 1482. Only 26 years old when she died in 1472, Battista is shown here in a posthumous portrait (Piero used a death mask). Her monumental form, exquisite clothes, and large, expensive jewels reflect upon her nobility and virtue and the wealth and honor of her husband, for she is depicted as the quintessential ruling consort.

Although he was among the most important Quattrocento Italian artists, he was nearly forgotten after the time of Vasari. However, in the late–19TH c. Piero was rediscovered, and his serenely balanced compositions with their monumental, stereometric figures, whose actions seem forever suspended in time, were studied afresh by artists like Paul Cézanne.

ca. 1412 — Piero di Benedetto (called Piero) is born to Romana di Pierino di Carlo da Monterchi and Benedetto di Piero di Benedetto de la Francesca in Borgo San Sepolcro (now Sansepolcro) (called Borgo in the following entries), about 24 miles east of Arezzo. (Vasari thought he was born in 1406.)

1431 — In Borgo, Piero is paid for painting processional candle poles; he worked with Antonio d'Anghiari (local painter) on various projects ca. 1432–38, including the high altarpiece for S. Francesco (not finished). (The Sienese Sassetta later got the job, and completed it in 1444.)

1439 — In Florence, Piero is paid by Domenico Veneziano (for whom he likely had worked in Perugia) for his assistance at the church of S. Egidio.

1442 — This is the first year in which Piero's name appears among the list of those eligible to become priors in Borgo, where his family owned a business, houses, and farms. (Piero later bought several properties.)

1445 — In Borgo, Piero is hired (11 January) by the Confraternity of the Misericordia (for 150 gold florins) to paint a polyptych (his largest), *Our Lady of Mercy* (Museo Civico, Sansepolcro). Piero was told to use the finest gold and most ex-

pensive blue pigment (ultramarine), and was given three years to complete it. He instead took much longer, completing his work ca. 1460–65 (he received a partial payment through his brother in 1460).

late 1440s — In Ferrara, Piero paints frescoes (lost) in the Estense Castle and in S. Agostino for the ruling Este.

Piero works on *Baptism of Christ* (see fig. 18–2) for the Graziani family, likely intended for the Pieve of S. Giovanni in Borgo. Antonio d'Anghiari may have built the altarpiece, and the Sienese painter Matteo di Giovanni completed other panels for it (Museo Civico, Sansepolcro). In 1859, Piero's *Baptism* was sold from the altarpiece.

Vasari noted that before Piero went to Arezzo, he (and Veneziano) began painting the sacristy vault of S. Casa, Loreto, but left it unfinished. Signorelli (Piero's student) completed the work.

1450 — Piero signed and dated (PETRI DE / BVRGO / OPVS M / CCCCL) a *cartellino* attached to a tree trunk (lower right) in the panel painting depicting the Penitent S. Jerome (Gemäldegalerie, Berlin).

In Arezzo, Piero works on the frescoes of the True Cross (see fig. 33–4).

1451 — In Rimini, Piero dates a fresco of Lord Sigismondo Malatesta kneeling before his patron saint (Sigismondo of Burgundy) in S. Francesco (transformed by Alberti into Tempio Malatestiano).

ca. 1455 — According to Vasari, Piero painted frescoes in the Vatican Palace for Nicholas V, covered over by Raphael (Room of Heliodorus).

In this period, Piero designs *Madonna del Parto,* a fresco for the cemetery

chapel of S. Maria a Momentana (near Monterchi); the angels resemble those by Castagno on the east wall of the Villa Carducci (see fig. 30–2).

Piero signs (OPVS PETRI DE BVRGO SCI SEPVLCRI) the *Flagellation* (Palazzo Ducale, Urbino), of ca. late–1450s, perhaps for Federico II da Montefeltro of Urbino (see fig. 33–3) or Francesco Sforza.

1459 — Piero is paid for frescoes in the bedroom of Pius II (Vatican).

In Borgo (the town owned relics of the Holy Sepulcher), Piero works on the *Resurrection*, audience hall (built in 1458), Palazzo dei Conservatori (town hall). (The fresco was moved, perhaps ca. 1480–87, and reduced in size.) Although Piero's work pays some homage to the Sienese *Resurrection* (Duomo, Sansepolcro) created for S. Chiara in the 14TH c., his mystical scene is more natural. Christ's finely chiseled torso expresses an awakening energy, as he towers over the hillside like a majestic Olympian god. While he appears to be rising from his tomb, the guards look like they are sinking into the ground.

1460s — Piero paints a large altarpiece, *Virgin and Child and Ss. Anthony of Padua, John the Baptist, Francis, and Elizabeth of Hungary* (with double predella), for the Franciscan nuns of S. Antonio delle Monache, Perugia (Galleria Nazionale, Perugia). The remarkable gable *Annunciation* dominates the altarpiece.

1466 — In Arezzo, the Confraternity of the Annunciation hires Piero to paint a (lost) double-sided *gonfalone* of the Annunciation. In Bastia (in 1468) he completed the work and was paid.

1469 — In Urbino (guest of painter Giovanni Santi), Piero is asked by the

Confraternity of Corpus Domini to paint a polyptych, for which Uccello had painted the predella. (Justus of Ghent was hired in 1473.)

In Borgo, Piero receives a final payment of cash and land from his patrons (the friars of S. Agostino and Angelo di Giovanni di Simone and his brother Simone). They had hired him (4 October 1454) to create a double-sided polyptych for the high altar of S. Agostino (for 320 florins), portraying the Virgin and Child (lost) with saints (dispersed).

1470 — Piero owes back taxes in Borgo. Four years later, he was paid for (lost) frescoes in the Badia of Borgo (1474).

1474 — Federico II Montefeltro becomes duke of Urbino and hires Piero about this time to paint double-sided, hinged portraits of himself and his wife shown facing each other (see figs. 33–2, 33–3).

ca. 1475 — Piero creates a monumental votive image for Federico II da Montefeltro of Urbino, depicting the patron kneeling before the *Virgin and Child Enthroned with Saints* (Brera, Milan).

1478 — In Borgo, the Confraternity of the Misericordia hires Piero to paint an image of the Madonna in fresco (no further record).

1480 — Piero is a prior of Borgo (a position he had held since 1477); he is also a prior of the Confraternity of S. Bartolommeo (1475–82).

1492 — The Company of S. Benedetto (Book III of the Dead) records Piero's death and burial in the Badia, Borgo.

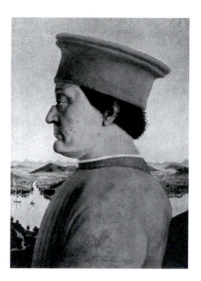

33–3. PIERO DELLA FRANCESCA. *Federico II da Montefeltro*, ca. 1474, oil on panel, 18.8" x 13.3" (47.5 x 33.6 cm), Uffizi Gallery (since 1773), Florence. Piero's panels of the duke and duchess are traditional 15TH–c. court portraits showing lordly authority through formal pose and costume (Federico wears cloth of crimson red, the most expensive dyestuff, and Battista wears a pearl-lined dress and costly jewelry). Yet his portraits are unique. They give greater insight into the character of the sitters than do previous state portraits, for he mitigated the courtly distance of the couple by including the grand panoramic view of the lively, breathtakingly beautiful countryside near Urbino, the terrain protected and ruled over by the couple (see fig. V–4).

Legend of the True Cross Cycle, Arezzo

HISTORY OF THE CHAPEL DECORATION.

1408 Baccio di Masi Bacci acquires patronage rights to the choir chapel in the Franciscan church of S. Francesco, Arezzo (see fig. 33–4).

1410 Requesting burial in the chapel (Baccio was instead buried in the Pieve of Arezzo in 1425), Lazzaro di Giovanni Bacci gives 500 florins for a stained-glass window (showing family and confraternity crests) and frescoes: Resurrection of Lazarus and Stigmatization of S. Francis (side walls) and Evangelists (vault).

1411 Baccio di Masi Bacci adds a codicil to his will, stipulating that his heirs are obliged to decorate the chapel upon his death; in 1412, he provided 500 florins for decoration that was to include a stained-glass window (by 1417, it was completed by Niccolò di Piero Tedesco, and cost about 460 florins). Baccio died in 1417.

1427 Frescoes are estimated to cost 600 florins (not yet begun). Municipal authorities insist (in 1427, 1430, and 1436) that the Bacci family fulfill their obligation to S. Francesco.

1447 An unnamed artist (perhaps Bicci di Lorenzo) is hired to execute choir frescoes; Bicci painted the *Last Judgment* and *Evangelists*, additional figures, and ornamental borders. Due to illness, he returned to Florence (by 1450), and Piero took over the decoration. Bicci and Piero had both worked at S. Egidio, Florence.

1466 Although Piero had finished the frescoes in S. Francesco by this year, he was still demanding final payment in 1473 and 1486.

33–4. This diagram identifies scenes of Piero's fresco cycle of the True Cross (see also Agnolo Gaddi, fig. 16–1). His literary sources were chiefly the Bible and Jacopo da Voragine's *Golden Legend*. The stories are numbered in chronological order, and the chapel diagram shows that they were not placed in sequence; instead, they are linked by thematic and visual correspondences. This is evident in the two historical battle scenes facing each other (lowest side wall registers) and in the scenes of messenger angels flanking the window (*Annunciation* and *Dream of Constantine*).

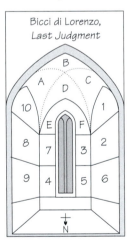

Bicci di Lorenzo, Last Judgment

KEY TO TRUE CROSS CYCLE, AREZZO (paintings by Piero unless indicated).

Bicci di Lorenzo, *Evangelists*: A (*Mark*), B (*Matthew*), C (*Luke*), D (*John*)

Giovanni da Piamonte, after Piero: E (prophet?), F (prophet?)

1 *Adam Sends Seth for the Oil of Mercy*; *Seth in Paradise*; *Death of Adam*
2 *Queen of Sheba Adores the Wood*; *Meeting of King Solomon and Queen of Sheba*
3 (Giovanni da Piamonte, after Piero) *Solomon's Workmen Carry Away the Wood*
4 *Annunciation*
5 (Giovanni da Piamonte, after Piero) *Dream of Constantine the Great*
6 *Victory of Emperor Constantine the Great Under the Sign of the Cross*
7 *Judas Raised from the Well*
8 *Empress S. Helena and the Discovery of the Crosses*; *Miracle of the True Cross* (see fig. 33–1)
9 *Emperor Heraclius Defeats the Persians*; *Execution of the Persian King Chosröes*
10 *Emperor Heraclius Returns the True Cross to Jerusalem*

Piero's cycle (along with Bicci's *Last Judgment* on the chapel entrance wall) offered the worshipper a vicarious pilgrimage to the Holy Land to better meditate upon the miraculous power of the Cross and the significance of Christ's sacrifice in the story of human salvation. While contemporary portraits and distinctly Eastern hats and robes (Piero saw such clothes at the ecumenical Council of Florence in 1439) populate his scenes, bringing currency to the medieval tale, the geometric design of the figures, compositions, and settings creates timeless, eternally suspended action that concentrates foremost on the miraculous, curative, and universal power of the Cross. Yet the cycle's general message may also underscore the conciliar goal of unifying the Greek and Latin Church, an urgent endeavor after the fall of Constantinople in 1453 and the purpose of the councils of Ferrara and Florence.

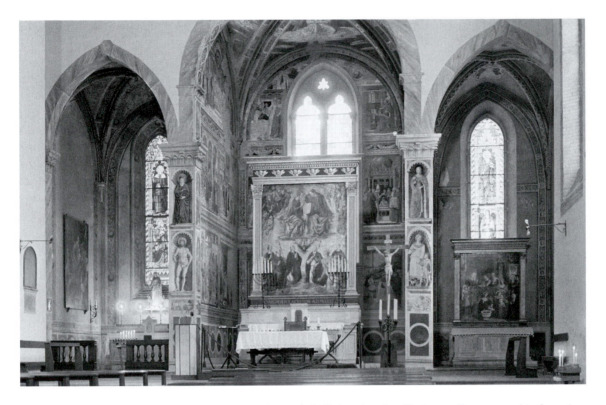

34-1. BENOZZO GOZZOLI. *Stories of S. Augustine*, 1464–65, fresco, choir, S. Agostino, San Gimignano. Benozzo was hired to paint the choir chapel by Fra Domenico Strambi, who acquired patronage rights in 1464. The community at S. Agostino was officially declared an Observant (reformed) Augustinian congregation in 1483, the same year that the high altarpiece, a tempera panel depicting the *Coronation of the Virgin with Saints*, 10'2.9" x 8'2.4" (312 x 250 cm), was signed and dated by Piero del Pollaiuolo.

The early association of Benozzo Gozzoli (ca. 1420–97) with the painter Fra Angelico and sculptor Lorenzo Ghiberti furnished him with the technical skills necessary to develop a distinctive style and flourishing career. In addition, traveling to Orvieto and Rome in Angelico's company introduced a future patronage for him outside Florence. While his work for the Medici in Florence brought respectful attention, his commissions in provincial towns were generally of a larger scope and came steadily to him as word spread about his inclination to finish projects in a timely manner—in contrast to other artists, like Fra Filippo Lippi or Piero della Francesca. An invaluable asset to Benozzo's success was his ability to satisfy corporate patrons by including flattering, recognizable portraits amid homey, anecdotal details. Above all his considerable skills, his expertise in fresco production, knowledge of Albertian perspective, and rich classical vocabulary endeared him to many patrons outside Florence.

ca. 1420 — Benozzo di Lese di Sandro (Benozzo Gozzoli) is born in Florence, where his parents, Lese (a tailor) and Mea, lived with Lese's father. His surname was Ghozzoli (Vasari called him Gozzoli in his 1568 ed.), but he signed works "Benozzo di Lese" and "Benozzo da Firenze."

1439 — Benozzo is paid by the Company of S. Agnese of S. Maria del Carmine in Florence for painting the (lost) *Ascension of Christ* on a shroud.

1440 — In Florence, Benozzo assists Fra Angelico for about two years, painting frescoes in S. Marco.

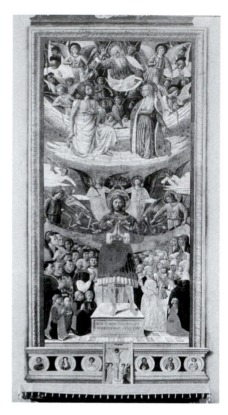

34–2. BENOZZO
GOZZOLI. *S. Sebastian
Interceding for San
Gimignano*, inscribed
28 July 1464, fresco,
17'1.9" x 8'1.7" (523 x 248
cm), S. Agostino, San
Gimignano. This fresco
could as easily have been
produced as an embroi-
dered textile, *gonfalone*,
manuscript illumina-
tion, or panel painting.
Benozzo was proficient
in all these mediums.
He was hired by the
commune to show
Sebastian protecting
the townspeople from
plague; the legendary
martyr Sebastian sur-
vived being repeatedly
shot with arrows (plague
victims associated their
pains with arrows).

1445 — In Florence, he is hired by Ghiberti to work on the baptistery.

1447 — By 23 May, Benozzo has been in Rome for three months, where he is working as Fra Angelico's assistant in S. Peter's.

1448 — Benozzo works as Angelico's associate in the S. Brizio Chapel in the Orvieto Cathedral.

1449 — In Rome, as chief assistant to Angelico, Benozzo works on the decoration of the S. Nicholas Chapel, Vatican Palace.

1450 — In Montefalco, he creates three works for the monastery church of S. Fortunato (outskirts): the high altarpiece, *Madonna della Cintola* (Pinacoteca Vaticana, Rome); a lunette fresco, *Madonna and Child with Ss. Francis and Bernardino*; and a (partially lost) wall fresco, *Enthroned Madonna and Child*, his earliest signed and dated work (on the throne: BENOZII FLORE[N]TIA [M]CCCCL).

1452 — In Montefalco, he finishes frescoes in the Chapel of S. Jerome and the choir of S. Francesco (see fig. 34–3)

1453 — In Viterbo, Benozzo signs and dates (lost) frescoes in S. Rosa.

1456 — Benozzo signs and dates (OPVS BENOZI DE FLOR[EN]TIA MCCCLVI) *Madonna of Humility with Saints* (Galleria Nazionale, Perugia) for the Collegio di S. Girolamo (*Sapienza Nuova*) in Perugia, founded in 1427 by Bishop Guidalotti (d. 1429); his family hired Benozzo (Guidalotti crests are on the panel).

1457 — In Rome, Benozzo and Salvadore de Valencia create works for Pius II's coronation: 2 standards, various flags, 2 pallia, 57 benches for cardinals, and 8 traveling baskets (for 250 gold florins).

1459 — In Cosimo de' Medici's new palace chapel, Benozzo paints the *Procession of the Magi*. Considered his masterwork, the ensemble of paintings emulates tapestries and is crammed with images of humans, animals, castles, birds, and foliage that were meaningful to the Medici and stimulate contemplation of divine and natural events. The winding procession unfolds on the east wall and leads onlookers clockwise around the room to the paradisal grove painted in the altar alcove, with adoring angels poised on flanking walls beside the altar.

1461 — In Florence, Benozzo is hired (23 October) by the Confraternity of the Purification to paint *Enthroned Madonna and Child with Saints and Angels* for 300 lire (National Gallery, London).

Around this time he marries and buys a house in Florence.

1464 — In San Gimignano, Benozzo works on the S. Agostino choir frescoes (see figs. 34–1, 34–4) and *S. Sebastian* (see fig. 34–2). His Sebastian, who was more commonly shown suffering, is depicted with his cloak—stretched like a canopy by angels—shielding citizens from deadly plague arrows hurled from heaven by an angry God. The intercessory figures of the Redeemer and Virgin Mother appear in heaven, pleading for the town, which had particularly bad plague years in the early 1460s, as suggested here by the size and quantity of arrows.

1466 — In Terni, Benozzo executes the panel painting *Marriage of S. Catherine* for S. Francesco. In the Collegiata of

San Gimignano, for the Chapel of Sebastian on the entrance wall of the church, he completes the fresco *Martyrdom of S. Sebastian*, signed and dated (18 January 1466) on the fictive frame.

1467 — In San Gimignano, he restores paintings, including Memmi's *Maestà* (1317) in the town hall council chamber. In Certaldo he paints frescoes (with Giusto d'Andrea) for an outdoor tabernacle for the *giustiziati* (condemned ones); before execution, convicted criminals were brought here to pray.

Benozzo is hired to complete the Pisa Campo Santo frescoes begun by Pietro di Puccio.

1468 — Benozzo's contract for Pisa is expanded to 24 frescoes. He moved his workshop and household to Pisa (father, wife, and 7 children), and bought a house (1472), which he kept until his death.

1479 — Escaping the plague in Pisa, Benozzo paints an outdoor tabernacle at Legoli (near Pisa).

1480 — In his *catasto* he states that he is 60 years old and owns a house in Pisa and one in Florence.

1484 — Benozzo completes his most remarkable work, the Campo Santo frescoes in Pisa, executed from ca. 1469–84. He received 9,900 lire, 24 florins; each fresco cost about 66 florins.

Near Castelfiorentino, Benozzo executes a roadside tabernacle, called *Madonna Della Tosse* (of Coughs), for the Prior of Castlenuovo, Grazia di Francesco. The frescoed walls depict the *Enthroned Madonna and Child with Ss. Peter, Catherine, Margaret and Paul* (center), *Dormition* (left), and *Assumption with Thomas and the Holy Girdle* (right).

1491 — Near Castelfiorentino, Benozzo (with two sons) completes a roadside tabernacle, called *Tabernacle of the Visitation*, for the Prior of Castlenuovo, Grazia di Francesco, his former patron.

1497 — Benozzo returned to Florence in 1495. For lack of work or to escape the plague, he moved to Pistoia in 1497, where he died (4 October) and was buried in the cloister of the convent of S. Domenico.

CHOIR, S. FRANCESCO, MONTEFALCO.

34–3. This diagram identifies the choir frescoes of S. Francesco and the key corresponds to numbers in the diagram. This was Benozzo's first major cycle in Umbria; the themes generally follow the sequence in Bonaventure's official biography of Francis, *Legenda maior* (except *Sermon to the Birds* follows *Death of the Knight of Celano* in the text). The window scenes focus on miracles and revelations (see *Dream of Francis*, #2): *Stigmatization of Francis* (two panels, #12) alludes to spiritual light accompanying the natural light that beams into the sanctuary, and the *Seraph Crucifix* (#12 A) above the window is related visually and symbolically to *Francis in Glory* (#15).

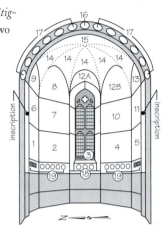

KEY TO THE DIAGRAM.

1 *Birth of Francis, Prophecy of the Pilgrim* (neither at Assisi nor in Bonaventure), *Francis and the Simpleton*

2 *Francis Giving Clothes to Poor Knight, Dream of Francis*

3 *Conversion of Francis in S. Damiano* (fresco or stained glass destroyed)

4 *Francis Renounces Worldly Possessions*

5 *Vision of Dominic, Meeting of Francis and Dominic* (not at Assisi)

6 *Dream of Innocent III, Confirmation of the Rule*

7 *Expulsion of the Demons from Arezzo*

8 *Trial by Fire Before the Sultan* (not in Bonaventure)

9 *Miracle of the Crib at Greccio*

10 *Sermon to Birds, Blessing of Montefalco* (not at Assisi)

11 *Death of the Knight of Celano*

12 *Stigmatization of Francis* (Seraph [A], Francis [B])

13 *Death of Francis and the Verification of the Stigmata*

14 (from left) *Ss. Louis, Elizabeth of Hungary* (inscri. s.ROSA.VITS), *Bernardino, Clare of Assisi* (inscri. CATARINA), *Anthony of Padua*

15 *Francis in Glory*

16 *Francis* (showing the Stigmata)

17 *Twelve Disciples of Francis*

18 *Petrarch, Dante, Giotto*

19 *Portraits of Franciscans* (including Bonaventure)

S. Agostino, San Gimignano

34–4. This diagram shows the division of vault and wall scenes in the choir frescoes of S. Agostino, San Gimignano (see fig. 34–1). Visually more complex than the Montefalco cycle, with many more buildings and figures, Benozzo's work here reflects his ability to synthesize stylistic traits he learned from the masters he knew very well, Fra Angelico and Lorenzo Ghiberti. But he also drew from the Prato frescoes (1452–65) of Fra Filippo Lippi, that seamlessly blend contemporary portraits into sacred scenes, and the Arezzo frescoes (1450s) of Piero, whose classical architecture and weighty, statuesque forms (see fig. 33–1) impressed Benozzo.

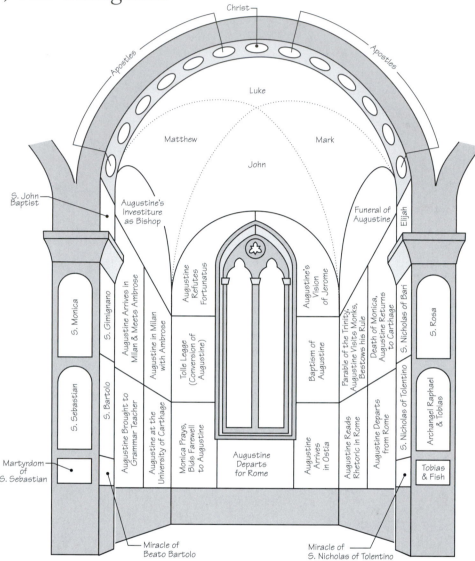

Already known for his work in Montefalco and Florence (Medici Palace chapel), the middle-aged Benozzo guaranteed his future with provincial patrons through the execution of this cycle, devoted to the Latin Church Doctor Augustine (354–430), who became Bishop of Hippo (ca. 396), and under whose rule communities of hermit friars were founded in Duecento Italy (see AUGUSTINIANS, Duecento Glossary). Also included in the chapel imagery are figures of the Evangelists (quadrants), Christ and the Apostles (intrados), and Augustinian saints. Augustine's story begins with the far left scene on the lower register of the left wall and continues chronologically around the chapel (left to right),

moving upward in successive bands; the final scene is the *Funeral of Augustine* in the upper right lunette. Benozzo's source for the early life of Augustine was the saint's autobiographical *Confessions* in which he laments the decadence of his pagan youth, and thanks God for his conversion to Christianity and praises his mother (S. Monica) for the positive influence she provided. The rich details of Augustine's story is matched by Benozzo's proclivity to embellish his scenes, although sometimes too often with incidental detail. Vasari praised him for his depiction of animals, perspective, landscape, and ornamentation and admired his ability to secure important commissions, particularly from the Medici family.

35–1. Cardinal of Portugal's Chapel, S. Miniato al Monte, Florence. Shown here are the cardinal's tomb (right), Baldovinetti's *Annunciation* (left), and a copy of the altarpiece (center) by the Pollaiuolo brothers: *Ss. Vincent, James, and Eustace*, 1466–67, tempera/oil on panel, 5'7.8" x 5'10.5" (172 x 179 cm), Uffizi Gallery, Florence. The Pollaiuolo brothers created an image for onlookers to envision these saints standing inside the elevated church of S. Miniato (see fig. 2–2), for beyond them is a parapet with a bronze fence that imitates the actual gate of the chapel, and the picturesque landscape looks like the Arno valley. Both brothers were contracted (20 October 1466) and received 100 florins for their work. On the basis of style, Antonio created the design for the painting.

Of the Pollaiuolo brothers, the work of Antonio (ca. 1431–98) is better known than that of Piero (ca. 1441–96). During their lives, both were singled out by the humanist Ugolino Verino in his epigrams that liken Florentine artists to the ancient Greeks (ca. 1488). However, only Antonio is mentioned by name: "The two distinguished brothers, Pollaiuolo by name, are both good sculptors, but one also paints. Antonio casts bronze faces that seem to be alive, and with soft wax he molds lifelike statues." Vasari believed that their humble father was too poor to provide a liberal education for his sons and instead set up apprenticeships: Antonio went to Ghiberti's workshop and Piero to Andrea del Castagno's. Vasari also noted that the young Antonio excelled as Vittorio's (Lorenzo Ghiberti's son) assistant, opened his own shop, and grew prosperous from wealthy patrons. While his work for the Medici Palace (see entry 1460) and Florence Baptistery (see entry 1458) brought him acclaim, many of Antonio's paintings and metal works have disappeared (the latter melted down for the city's wartime use, according to Vasari). Attribution issues are thus problematic, and discerning the hands of the brothers is difficult in joint projects like the S. Miniato altarpiece (see fig. 35–1). Antonio had the larger shop in Florence, but shared commissions occupied both shops, and the brothers frequently exchanged designs with each other and their assistants. From the 1470s such practices were common in Florence (see Perugino). The brothers worked chiefly in Florence for most of their lives, with Antonio also establishing a shop in Rome in

LABORS OF HERCULES. In his 1494 letter to Virginio Orsini (see entry 1494), Antonio del Pollaiuolo noted that he had always been attached to the Medici family, and his brother Piero and he created the labors of Hercules in 1460 for the great hall in the palace. Hercules was a popular Florentine hero, and his image appears in reliefs on the bell tower and the Porta della Mandorla (north door) of the Florence Cathedral. The Medici favored the communal hero, and Piero the Gouty (or his brother Giovanni) perhaps commissioned the canvases for the palace. Two small oil panel paintings are thought to be either preparatory studies or copies after the Hercules canvases because the tiny scenes depict *Hercules and Antaeus* and *Hercules and the Hydra* (both Uffizi Gallery, Florence). The intricate design and meticulous details of the panoramic settings, with tiny animals, shrubs, and vegetation, reflect the work of someone trained as a goldsmith.

1484 (supervised by Piero) to fulfill the contract for Sixtus IV's tomb (see fig. 35–3), a commission which may have come about through Lorenzo de' Medici's influence. The versatile Antonio worked as a sculptor, designer, engraver, painter, and burgeoning architect (see entries 1491, 1495), and is best remembered for his anatomical studies and expressive figures in all mediums.

ca. 1431 — Antonio (del Pollaiuolo, "of the poulterer") is born in Florence, according to the 1433 tax report of his poultry-keeper father (Jacopo di Antonio di Giovanni Benci), who noted that the child was then a year and a half old. (Piero was about 10 years younger than Antonio.)

late 1440s — Antonio was likely trained as a goldsmith and metalworker in Ghiberti's shop and may have worked with Vittorio on the frieze surrounding the east doors (see Lorenzo Ghiberti). In 1455 Vittorio inherited his father's (Lorenzo's) shop (frieze finished in 1466).

1457 — Antonio is hired (with Betto di Francesco Betti and Militarro Dei) to create the silver crucifix in the Florence Baptistery. He is also working on a (lost) reliquary for the arm of S. Pancrazio.

1458 — Antonio works on designs for gold and silk embroidered vestments for the Florence Baptistery (27 panels are housed in the Opera del Duomo Museum, Florence). Antonio's designs for the liturgical garments included one cope, one chasuble, and two tunics. Paolo da Verona embroidered Antonio's vestment designs: he took 26 years to complete the work (1460–86), which he did in close stitch, making the embroideries appear more like paintings.

1460 — For the Medici palace in Florence, Piero and Antonio work on three (lost)

Hercules canvases, recorded in the 1492 Medici inventory as Hercules lifting Antaeus, Hercules wrestling with the lion, and Hercules killing the Hydra, each 6 braccia square (or about 11'5" x 11'5").

1465 — About this year, Antonio designs an engraving, called *Battle of the Nudes*, with ten naked men entangled in a mesh of axes, sabers, daggers, and bows; they are divided into four struggling groups equally locked in deadly combat that will perhaps leave only one man standing. This print demonstrates Antonio's skill as a draftsman-engraver and may exist for teaching anatomy lessons, thus explaining the exaggerated muscles, tendons, ribs, grimaces, and postures. But it also satisfied an increasing Florentine taste for classical subjects. Antonio's nudes are battling in a shallow field where the tall stalks and grape vines direct attention to the fighters, whose postures resemble the figures on antique Greek vases and Roman sarcophagi.

1466 — Antonio is inscribed in the goldsmiths' guild in Florence.

1467 — In the tomb chapel of the Cardinal of Portugal (d. 1459), S. Miniato al Monte, Florence, the brothers complete the altar painting (see fig. 35–1) and frescoes of angels holding back curtains.

1469 — Antonio (with his brother Piero and Antonio Rossellino) designs Salutati's suit of armor for the tournament celebrating Lorenzo de' Medici's engagement to Clarice Orsini.

Vouching for Antonio, who was owed money for his candlesticks in Pistoia Cathedral, Jacopo di Orsino Lanfredini wrote (ca. 1461–69): "Antonio is the principal master of the city [Florence] and in the opinion of all intelligent people perhaps there was never one better."

About 1469, and perhaps after a trip to Rome, Antonio painted frescoes in the ground floor hall of the Lanfredini country house (Villa Gallina) in Arcetri, near Florence: an *all'antica* frieze of dancing nudes on the upper tier and architectural perspectives on the dado, showing arches with sculptures on pedestals behind which are passageways resembling those of the Roman Colosseum.

Piero is hired to create *Virtues* for the Mercanzia Palace (see Botticelli).

Antonio receives 90 florins for his designs of baptistery vestments (a payment of 90 florins is also recorded in 1480).

1471 — In Florence, Piero paints a portrait, *Giangaleazzo Maria Sforza*, for Lorenzo de' Medici (Uffizi Gallery, Florence).

1472 — In Florence, Piero joins the Company of S. Luke as a painter. For the Florentine state, he designs a (lost) silver helmet (showing Hercules defeating a griffin, the symbol of Volterra), a gift to Lord Federico II da Montefeltro of Urbino (see fig. 33–3) for his military service in quelling the revolt in Volterra.

1473 — In the records of the Company of S. Luke, Antonio is listed as a painter and goldsmith.

ca. 1475 — Antonio creates the small bronze statue *Hercules and Antaeus* (see fig. 35–2), perhaps for Lorenzo de' Medici. Studies (charcoal and pen and ink) attributed to Antonio suggest they were drawn after life and wax models, as was the *Hercules and Antaeus* sculpture.

1475 — For Antonio Pucci's family oratory in SS. Annunziata, Florence, built to enshrine an arm bone of Sebastian, Antonio and Piero complete a large oil painting, *Martyrdom of S. Sebas-*

tian. Vasari (*Lives*) noted the date and that the saint was a portrait of Gino di Ludovico Capponi. The technique and landscape of this panel—only slightly smaller than Piero del Pollaiuolo's 1483 *Coronation*—reflect the influence of Piero della Francesca and such Netherlandish artists as Justus von Ghent.

1477 — Piero submits a competition model for the Forteguerri monument, Pistoia Cathedral (Verrocchio was awarded the contract). On 24 December, Piero is hired to paint the altarpiece for the chapel of S. Bernard in the Florence town hall, an offer soon withdrawn and given instead to Leonardo da Vinci.

1478 — Antonio is hired to create the *Birth of the Baptist* relief for the Silver Altar, Florence Baptistery. Vasari thought the figure of S. John the Baptist (by Michelozzo) was Antonio's, and the most beautiful figure on the Silver Altar.

1482 — Piero is hired to paint one wall (never begun) of the Sala dei Gigli, Palazzo Signoria.

1483 — Piero signs and dates his large *Coronation of the Virgin with Saints* for the high altar of S. Agostino, San Gimignano (see fig. 34–1).

1484 — Piero moves to Rome about this year, after Cardinal Giuliano delle Rovere hired Antonio to create a tomb for his uncle (Francesco della Rovere), Sixtus IV (d. 12 August 1484), to be placed in the chapel Sixtus built in S. Peter's before his death (destroyed 1606). Here, Perugino painted a fresco above the altar showing *Sixtus Presented by Peter to the Virgin and Child, with Ss. Paul, Francis, and Anthony of Padua*, and the great bronze freestanding floor tomb was installed in the center of the chapel. When seen from above

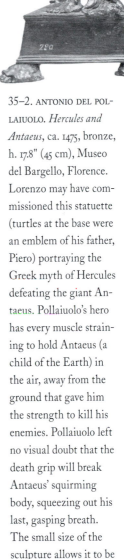

35–2. ANTONIO DEL POLLAIUOLO. *Hercules and Antaeus*, ca. 1475, bronze, h. 17.8" (45 cm), Museo del Bargello, Florence. Lorenzo may have commissioned this statuette (turtles at the base were an emblem of his father, Piero) portraying the Greek myth of Hercules defeating the giant Antaeus. Pollaiuolo's hero has every muscle straining to hold Antaeus (a child of the Earth) in the air, away from the ground that gave him the strength to kill his enemies. Pollaiuolo left no visual doubt that the death grip will break Antaeus' squirming body, squeezing out his last, gasping breath. The small size of the sculpture allows it to be rotated, revealing the narrative details that can be seen only from certain viewpoints.

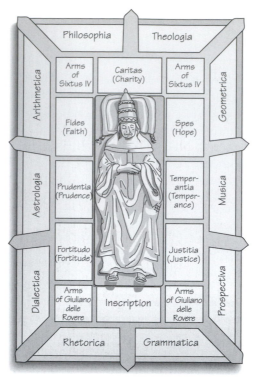

(see fig. 35–3), it resembles a highly embellished metal book cover, with the images of the Liberal Arts on the base providing a foundation that suits the recumbent scholar and bibliophile, who was a former general of the Franciscan Order. Before his papal election, Sixtus had taught philosophy and theology at universities, and personifications of both appear near his head. His papal accomplishments included restoring monuments in Rome, building the Sistine Chapel (see Perugino), establishing the Sistine choir (and Rome as a center for music), collecting manuscripts of antiquity, and installing Bartolomeo Sacchi (called Platina) as the first librarian of the Vatican Library. Between 1475 and 1481, Sixtus contributed books to the Latin and Greek libraries (increasing the holdings nearly threefold by 1484), provided offices and staff to run them, and completed the decoration of the library rooms (except the Greek Library, painted by Andrea del Castagno during the reign of Nicholas v). Sixtus' tomb glorifies his papal rule and scholarly command of sacred and secular matters.

Antonio has shops in Florence and Rome, 1484–96.

1489 — Lorenzo de' Medici writes to his ambassador in Rome, Giovanni Lanfredini, that Antonio will discuss a matter with him.

1491 — From Rome, Antonio submits a competition entry for the design of the facade of the Florence Duomo.

1493 — In Rome, Giuliano della Rovere writes Antonio a letter of introduction to Piero de' Medici in Florence, for the artist was in Rome when Lorenzo died and Piero became the head of the Medici family (Antonio needed help with his affairs in Florence).

Completing the tomb of Sixtus (1493), Antonio is hired by Cardinal Cibo to create a tomb for his uncle, Pope Innocent VIII. Innocent's remains were interred in the new tomb on 30 January 1498.

1494 — From Rome, Antonio writes to Virginio Orsini (in Bracciano), suggesting that he create for him an equestrian monument rather than a bronze portrait bust. Antonio also asks Virginio to solicit Piero de' Medici's approval for Antonio to return to his property outside Florence (roads were closed because of an epidemic).

1495 — In Florence, Antonio submits a model for the sacristy dome of the church of S. Spirito.

1496 — Piero dies in Rome in this year. Antonio remains in Rome to work on Innocent VIII's tomb. On 4 February 1498, Antonio died in Rome.

35–3. This diagram shows an overhead view of Pope Sixtus IV's floor tomb by the Pollaiuolo brothers (1484–93), ordered by Giuliano Rovere (Julius II, 1503–13) for S. Peter's, Rome. Virtues flank the effigy, and on the chamfered support are images of ten Liberal Arts, signifying the pursuit of human knowledge and divine revelation. Study of the liberal arts originated in antiquity, and in the 5ᵀᴴ c. the number was set at 7 and allegorized in Capella's *Marriage of Philology and Mercury*. Following the antique model, secular studies at medieval universities were divided into two main branches: the trivium and quadrivium. Students began with the trivium (grammar [centered on literature], dialectic [logic], and rhetoric [included the study of law]). In the quadrivium were the higher studies (arithmetic, geometry [with natural history and geography], astrology, and music). The Bachelor of Arts was awarded for completing the trivium and the Master of Arts, the quadrivium. Philosophy was considered the mother of the arts, perspective was a branch of philosophy, and theology was studied only after completing the quadrivium.

The greatest rival of the Pollaiuolo brothers was Andrea del Verrocchio (ca. 1435–88), the goldsmith, draftsman, painter, sculptor, and founder, who had the facility to create small and monumental sculptures, apparently in a wider range of materials (wood, marble, bronze, and terracotta). For most of his career, he enjoyed constant patronage from powerful corporations and wealthy individuals, particularly Lorenzo de' Medici. Vasari considered his work hard, crude, and labored, but elevated Verrocchio above mere craftsmen because of his extraordinary study and diligence. While his early training was as a goldsmith, it seems that he may have also worked with the painter Baldovinetti and the sculptors Desiderio and Antonio Rossellino. By 1470 he was producing sculptures of greater size and civic prominence than the Pollaiuolo brothers, for with the help of the Medici he was awarded the important Mercanzia commission at Orsanmichele for the bronze figures of the *Incredulity of Thomas* (see fig. 36–1). Like Donatello, his greatest posthumous rival, Verrocchio created art imbued with antiquity, and his ability to design lifelike heroes

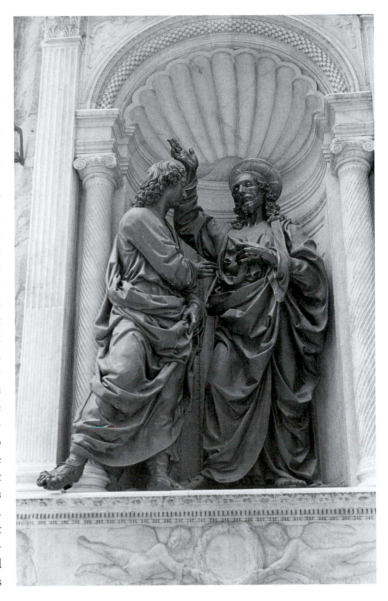

36–1. ANDREA DEL VERROCCHIO. *Incredulity of Thomas*, 1466–83, gilded bronze, *Christ*, 7'6.5" (230 cm); *Thomas*, 7'6" (228.6 cm), tabernacle designed by Donatello, Orsanmichele (original statues in the museum), Florence. Created in the lost-wax technique (see fig. 36–6), the figures are not fully in the round but are, in effect, high relief sculptures, cast without backs to make them fit the cavity. They were created for the Mercanzia (merchants' supervisory body and tribunal). The silk merchant Goro Dati (1362–1435) wrote that the Mercanzia consisted of 7 men: a scholar of civil law from outside Florence and 6 counselors (chosen from the wisest and most distinguished and knowledgeable citizens). Five were selected from the major guilds (excluding the judges and furriers, who apparently did not help found the Mercanzia) and one from the 14 minor. In resolving commercial disputes, the decisions of the magistracy were to be fair and irrevocable. The search for tangible proof in making such decisions underscores how poignant the theme of Thomas was for the counselors of the court. For these statues Verrocchio studied the work of Nanni di Banco and Donatello at Orsanmichele, but Ghiberti's stern *S. John* made the greatest impression.

36–2. ANDREA DEL VERROCCHIO. *Putto with Dolphin*, ca. 1471, bronze, h. 26.4" (67 cm), Palazzo Vecchio, Florence. Verrocchio created an expressive and mutable putto that is both celebratory and apprehensive, depending upon the angle of view. While the base of Pollaiuolo's statuette of *Hercules and Antaeus* (see fig. 35–2) is triangular and encourages three major viewpoints, with the three turtles (Medici emblem) signifying steady movement, Verrocchio's is spherical, and the putto was part of a larger monument (fountain) that encouraged viewers to encircle the serpentine statue. More than either Donatello or Pollaiuolo, Verrocchio gave lifelike energy and presence to his antique themes (see entry ca. 1471).

displaying both extraordinary strength and human vulnerability, such as the prideful shepherd boy David (see fig. 36–4) or the headstrong general Colleoni (see fig. 36–5), made his art meaningful to humanists and businessmen alike. In the 1470s his large painting workshop was the most active in Florence. Tradition connects Botticelli, Ghirlandaio, and Signorelli with the shop, and Verrocchio's most notable pupils were Perugino, Leonardo, and Lorenzo di Credi. His influence was widely spread in the late Quattrocento, reaching Rome and Umbria through Perugino, whose knowledge of his master's style and workshop practices inspired the course of Umbrian painting. Leonardo left Florence in 1482. When he returned 17 years later, he overshadowed his master, thus, sadly, blurring the memory of Verrocchio's important contributions to Florentine art.

ca. 1435 — In Florence, Andrea is the fifth child (of eight) born to Gemma and Michele di Francesco Cioni, a fornaciaio (kiln worker) in the stonemasons' guild, who by 1451 was a customs' agent.

1452 — Andrea is named as the stone-throwing assailant of Antonio di Domenico, a fourteen-year-old wool laborer in Florence. He was later absolved of the manslaughter charges against him (in 1453).

ca. 1453 — It seems that Andrea was trained as a goldsmith in Antonio Dei's shop, but may also have worked with goldsmith Francesco di Luca Verrocchio, after whom he was likely nicknamed.

1457 — Verrocchio files a joint tax return with his brother Tommaso, noting that he was trained as a goldsmith, but left the profession for lack of work; Antonio Dei went bankrupt in this year.

early 1460s — The early marble works attributed to Verrocchio were influenced by Desiderio da Settignano (1428–64) and the Rossellino brothers: Bernardo (ca. 1407–64) and Antonio (1427–79).

ca. 1460 — It seems that Verrocchio is working on the marble lavabo (font where the priest washes his hands before celebrating Mass), h. 5'5.8" (167 cm), in the Old Sacristy, S. Lorenzo, Florence. In the lunette relief are Piero de' Medici's emblems: a falcon holding a diamond ring with a ribbon around it inscribed with the word *semper*.

1461 — Competing with Giuliano da Maiano (1432–90) and Desiderio da Settignano, Verrocchio submits a model for the Chapel of the Madonna della Tavola in Orvieto Cathedral.

1464 — Verrocchio creates a marble portrait of Francesco Sassetti, also attributed to Antonio Rossellino (Museo Bargello, Florence).

1466 — In Florence, the Mercanzia (merchants' tribunal) hires Verrocchio to create bronze statues for the Orsanmichele niche they purchased in 1463 (see figs. 36–1, 63–11). Verrocchio's *Incredulity of Thomas* took many years to complete. Christ was the first figure, cast in 1470–76 and chased in 1476–79. The figure of Thomas was cast in 1479 and chased in 1479–80 and 1483. The primary point of view for these figures is the same as for Donatello's *S. Louis of Toulouse*, which previously occupied the niche: the sculptures are best understood when they are approached from the north, the direction of the cathedral. From this vantage point the monumental Christ, who is standing on a pedestal that increases his stature, towers over Thomas. His head rises to the base of the conch shell and his right hand, lifted well over

the head of Thomas, aligns with the ridges of the shell, making him appear all the more majestic. It is the biblical moment when Christ tells Thomas not to doubt but to put his hand into the wound. Thomas replied "My Lord and my God!" (inscribed in Latin on the hem of his cloak) (Jn 20: 28). Admonishing him, Christ said: "Have you believed because you have seen me? Blessed are those who have not seen and yet have come to believe" (inscribed in Latin on his cloak) (Jn 20:29). Verrocchio made the tension and exchange of words immediately clear to onlookers approaching from the north, whereas the drama unfolds more slowly for those coming from the town hall (south), who can at first see only the back of Thomas' right shoulder and his outstretched leg. The last words on Thomas' hem, ET SALVATOR GENTIVM (savior of mankind), refer not to his words in the Gospel text but to the sacrificial Christ as the Redeemer of all humanity. When Verrocchio was working on the statue of Christ for the Mercanzia niche at Orsanmichele, Leonardo and Perugino were in his shop. The works of both artists reflect their mastery of Verrocchio's skillful design of drapery that expresses the underlying drama of the theme. Two figures in Perugino's *Delivery of the Keys to Peter* of 1482 (see fig. 42–1) nearly copy the distinctive pose of the *Doubting Thomas*.

1467 — On 22 October, a memorial ceremony for the reinterment of Cosimo de' Medici is held in S. Lorenzo, Florence. Cosimo had died three years earlier (1 August 1464), and his body was placed the following day in the crypt of S. Lorenzo (in the pier beneath the main crossing of the church), according to the contemporary memoirs of the Florentine Marco Parenti. Cosimo's son Piero hired Verrocchio to adorn the pier in the crypt and to create a memorial plaque for the floor in the church directly above the tomb, thus making Cosimo's grave site apparent from the nave (see fig. 19–2). Because the plaque is near the high altar and beneath the large dome, its position in the church is of significance. Composed of geometric patterns in bronze, white marble, and green and red porphyry, the floor plaque is dominated by circles, mandorlas, and interlocking ovals of white marble enclosed within a square border of dark stone (see fig. 36–3). Simple inscriptions appear on two *tabulae ansatae*: the lower gives Cosimo's age at death (according to the ancient Roman tradition, it is inscribed in years, months, and days) and the upper gives the honorific title granted by the Signoria in the tradition of Roman antiquity (this title was first bestowed upon such Roman Republican heroes as Cicero and Julius Caesar, and later upon every Roman emperor).

In 1467, Verrocchio is hired to cast a gilded copper ball (installed 27 May 1471) for the lantern of the dome of Florence Cathedral. Struck several times by lightning, the ball fell in 1600 and was replaced with a larger one in 1602.

1468 — Verrocchio submits a competition design to the Mercanzia for the contract to paint Virtues in their palace. Piero del Pollaiuolo got the contract.

Verrocchio completes the bronze candelabrum, h. 5'1.4" (156 cm), for the chapel in the Sala dell' Udienza, Palazzo della Signoria, Florence (Rijksmuseum, Amsterdam). It was cast in three pieces and inscribed: MAGGIO / E GIUGNO / MCCCCLXVIII (May and June 1468).

1469 — Verrocchio paints a standard for Lorenzo de' Medici for the joust

36–3. Illustration showing the design of Cosimo de' Medici's commemorative floor plaque in the nave of S. Lorenzo, Florence. Andrea del Verrocchio's plaque, 10'5.3" x 10'5.3" (318 x 318 cm), is unlike other funeral floor slabs, both in its design and in the inscriptions honoring Cosimo; the inscriptions were defaced by order of the Signoria during the Medici expulsions (1494 and 1527), but have been reinscribed. The upper inscription is now COSMVS MEDICES / HIC SIT VS EST / DECRETO PVBLICO / PATER PATRIAE, but originally bore the simpler epitaph COSMVS MEDICES / PVBLICO DECRETO / PATER PATRIAE. In the manner of ancient Rome, Cosimo was thus declared the patriarch of the Florence Republic. The declaration nurtured the idea that one family could rule Florence.

(7 February) celebrating his engagement to Clarice Orsini.

1470 — Lorenzo and Giuliano de' Medici (Cosimo's grandsons) hire Verrocchio to design an *arcosolium* (sarcophagus in an arched niche, an ancient Roman form) for their deceased father and paternal uncle (Piero and Giovanni). Installed between the Old Sacristy and the Chapel of Cosmas and Damian in S. Lorenzo (see figs. III–2, 19–2), the sarcophagus sits on a white marble plinth, is made of bronze and very costly red and green porphyry (the materials used in Cosimo's memorial plaque), and is surrounded by an archway of white marble embellished with *all'antica* figural designs. The monumental tomb ensemble suggests the grandeur of antiquity more than any other Florentine tomb to this date. Verrocchio seamlessly incorporated Christian and classical motifs into his design, melding Medici insignia (diamond rings and tortoises) with pagan and Christian emblems signifying paradise (palm fronds and olive branches) and fertility and rebirth (vines and acanthus).

ca. 1470 — Verrocchio creates his bronze *David* (see fig. 36–4), which was later sold by Giuliano and Lorenzo de' Medici to the Florentine government for 150 florins (10 May 1476). Placed in front of the entrance to the Sala dei Gigli in the town hall, the statue was set on a columned pedestal with Goliath's head installed between David's feet. However, the giant's head was cast separately and may have been intended to be positioned underneath the sword, creating a broader base for the statue group and a view that would fully show the uplifted foot of David. Yet the gruesome story is more immediately telescoped with the head of Goliath placed between David's feet,

and in this position its gory presence quickly calls attention to the powerful young shepherd boy who now overpowers the bodiless trophy. The many feelings described by David's face and body are understood only by viewing the figure from different angles. His drawn sword, jutting elbow, and the flexed, long fingers that grip his left hip show this *David* alert and confrontational. Every muscle of his body is tensed and his contrapposto stance strained, for his elbow seemingly pivots forward and his left heel rises upward allowing him to turn and face onlookers approaching from his left side. Unlike Donatello's withdrawn and pensive *David* (see fig. 21–5), whose relaxed foot rests on the giant's head, this figure is more open but more guarded; in his readiness for action he is akin to Castagno's *David* (National Gallery of Art, Washington, D.C.). Gold highlights in his hair and on his clothes (many are now missing) enhance the sparkle and verve of the confident, victorious youth, whose luminous face and silky, taut skin show Verrocchio's interest in creating surfaces that reflect light and enliven his figures.

ca. 1471 — Verrocchio designs a bronze *Putto and Dolphin* for the Medici villa at Careggi (see fig. 36–2). Vasari had the statue moved (1550–68) to the town hall, where it became the centerpiece of the courtyard fountain that Vasari designed and Ammanati executed. Vasari noted about Verrocchio (*Lives*) that he studied ancient sculpture in Rome and skillfully restored an antique figure of Marsyas for Lorenzo de' Medici.

1472 — Verrocchio is listed in the Compagnia di S. Luca, Florence.

ca. 1473 — In Florence, Verrocchio executes the oil panel of the *Baptism of Christ* for the monastery church of S.

36–4. ANDREA DEL VERROCCHIO. *David*, ca. 1470, bronze, h. 4'1.3" (125 cm), Museo del Bargello, Florence. David's thick curls embody his energy, as they appear to spring outward from the temples and call attention to his face. Verrocchio's *David* confronts the viewer head on, Donatello's makes no eye contact (see fig. 21–5), and Castagno's looks away, toward something unseen (National Gallery of Art, Washington, D.C.). In the jutting elbow and determined face, Verrocchio created formidable figures in the shepherd boy David and the old soldier Colleoni (see fig. 36–5).

Salvi, where his brother was the abbot. Leonardo painted an angel (far left), and some of the background of the painting. Like his *David* (see fig. 36–4), Verrocchio's *Baptism of Christ* would also have had a shimmering appearance. But the loss of final paint layers has reduced the translucent sheen of both the figures and landscape.

About this time, it seems that Verrocchio designs the sphinxes on Mino da Fiesole's pulpit in Prato Cathedral.

ca. 1475 — Verrocchio creates a marble bust, *Lady with a Bunch of Flowers* (see fig. 48–4). The unidentified sitter is thought to be Lucrezia Donati (platonic love of Lorenzo de' Medici) or Ginevra de' Benci (see fig. 48–2).

In the mid–1470s, Verrocchio made portrait busts of Giuliano and Lorenzo de' Medici in polychromed terracotta (National Gallery of Art, Washington, D.C.). These date before the Pazzi conspiracy, which left Giuliano dead and Lorenzo wounded (see Quattrocento History Notes 1478).

1476 — Verrocchio submits a model for the funerary monument of Cardinal Niccolò Forteguerri (d. 1473) in Pistoia. However, Piero del Pollaiuolo submitted an alternate model in 1477, and the board chose his over Verrocchio's. When their decision was protested, Lorenzo de' Medici was asked by the board to choose the better of the two models for the price. Verrocchio was awarded the final contract and worked on the monument until he left Florence for work in Venice in 1483 (the tomb was still unfinished at his death). Lorenzo di Credi was asked to complete the project, which he did in 1489; the marble figures by Verrocchio and his shop are generally agreed to include *Christ*, *Angels* (supporting the *mandorla*),

Faith, and *Hope*. In 1753, the monument was moved and given a different form.

1478 — Verrocchio is awarded the commission for the high relief silver panel, *Decapitation of S. John the Baptist* (fin. 1480; installed 1483), for the right side of the Silver Altar in the Florence Baptistery (Museo dell'Opera del Duomo, Florence). Antonio Pollaiuolo was hired to create the *Birth of the Baptist* relief for the left side (1478). The commissions of the 1470s were meant to complete this important project, begun in the 14ᵀᴴ c.

ca. 1478 — Verrocchio is hired to paint a Madonna and Child for Pistoia Cathedral. Lorenzo di Credi created the painting, named *Madonna di Piazza*, from Verrocchio's cartoon (finished 1485).

1481 — Verrocchio is hired by the Signory of Venice to execute the bronze equestrian statue of *condottiere* Bartolommeo Colleoni (whose sepulcher was erected in his native Bergamo). Verrocchio went to Venice to begin the work in 1486, but died two years later without completing the project. His will stipulated that his collaborator Lorenzo de' Credi was to finish his work, but it was completed by the Venetian sculptor and bronzefounder Alessandro Leopardi.

Verrocchio works for King Matthias Corvinus of Hungary, creating reliefs of Alexander the Great and Darius.

1488 — In June, Verrocchio dies in Venice. His body was taken back to Florence for burial in the family chapel in S. Ambrogio. Vasari recorded the (lost) tomb inscription: SER MICHELIS DI CIONIS ET SVORVM / HIC OSSA JACENT ANDREAE VERROCHI QVI OBIT VENETIIS MCCCLXXXVIII (Ser Michele di Cione and his relatives. Here lie the bones of Andrea del Verrocchio, who died in Venice in 1488).

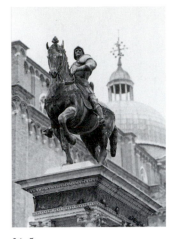

36–5. ANDREA DEL VERROCCHIO. *Bartolommeo Colleoni* (see also fig. 36–6). This front view of the statue shows Colleoni (1400–76) looking down at canal travelers moving along the route connecting the Piazza S. Marco with the open waterway (behind the soldier is the Dominican church of Ss. John and Paul in Venice). Symbolic of fortitude and strength, and of controlling both the sea and land for Venice, Colleoni does not sit in the middle of his horse, as does Narni in Donatello's monument (see fig. 21–7), but is closer to the animal's head, where he has power over the horse and is poised for confrontation. The sense of a striding horse is displayed through the horse's raised leg and the rider's uneven shoulders, indicating that weight has shifted from one side to the other, responding to the forward movement of the horse.

Lost-Wax Technique of Bronze Casting

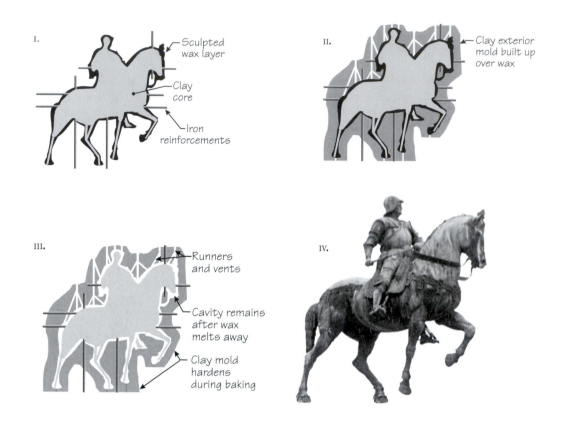

I.
— Sculpted wax layer
— Clay core
— Iron reinforcements

II.
— Clay exterior mold built up over wax

III.
— Runners and vents
— Cavity remains after wax melts away
— Clay mold hardens during baking

IV.

36–6. The above illustrations (I, II, III) are based on Andrea del Verrocchio's *Bartolommeo Colleoni*, 1476–96, bronze statue, 13' (426.7 cm), Campo Ss. Giovanni e Paolo, Venice (IV; see also fig. 36–5). The lost-wax technique of Andrea del Verrocchio's Colleoni monument could be used to create small- to large-scale bronzes. Benvenuto Cellini (1540–90) gave detailed information about the process, and is a source for the following information.

I A clay core in the shape of the statue is made slightly smaller than the final work will be. It is reinforced by an iron framework and baked to harden the clay. After the core has cooled, wax (shown here in black) is applied to the clay surface and sculpted to the desired final form. Iron bars, nails, or other methods physically connect the core to the outer wax mold to hold the core in place during the casting process.

II Layers of clay are applied to the wax surface and built up sufficiently to withstand the eventual weight of the molten metal. Large molds are often further reinforced on the outside with iron hoops so that the mold does not burst under the weight of molten metal.

III The mold assembly is baked to harden the shape of the exterior (final) clay mold; much of the wax is melted away (lost). The mold is then cooled and prepared for the pouring of the molten metal. When the metal is poured into the mold, it fills the space formerly occupied by the sculpted wax. After cooling, the outer mold is broken away to reveal the metal casting.

IV After the runners and vents (see III above) are removed, holes and damaged areas are repaired. The surface is then chased (smoothed and polished) with abrasive materials. Gilding, incisions, and patinas are added in the final stages. Large equestrian monuments (such as Donatello's and Verrocchio's statues) were heavy and unwieldy to cast. In the method described above, the core remains inside the statue unless it can be broken and removed through openings in the bronze.

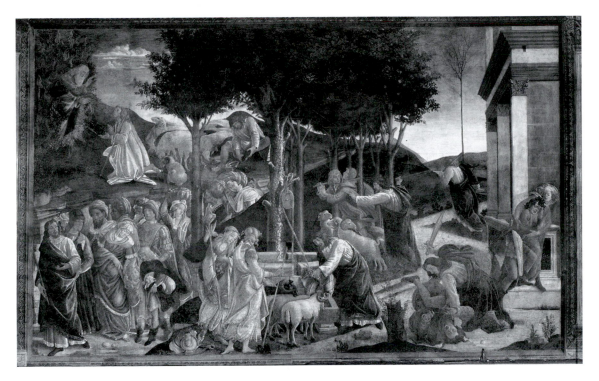

37–1. SANDRO BOTTICELLI. *Trials of Moses*, 1481, fresco, 11'5.5" x 18'8.5" (349.3 x 562.6 cm), Sistine Chapel, Vatican, Rome (see fig. 42–3). The Old Testament leader Moses appears seven times in a sequence of events from Exodus. After killing the Egyptian taskmaster who attacked a Hebrew (right foreground), Moses fled (right background) to Midian (2:11–15), where he drove away shepherds preventing the seven daughters of Jethro (priest of Midian) from watering their flock (center). Moses then drew water for the sheep (2:16–17), and later married one of the daughters, Zipporah (2:21). Watching over Jethro's flock at Mt. Horab, he saw a burning bush that was not consumed by the fire (left background). From this bush God's voice told him to remove his sandals for he was on holy ground (background), and to save the Israelites from slavery in Egypt by leading them (left foreground) to the land of milk and honey (3:1–10). Botticelli's fresco was indebted to Ghiberti's east door panels, and scenes like *Joseph in Egypt* (see fig. 20–3), where the large granary in the middle of the panel both visually links and separates the figure groups of different episodes. The stone well is Botticelli's focal point, reinforced by the cluster of tall trees; and like Ghiberti, he also created open spaces and quiet and dramatic moments. Yet his female figures are closer to Fra Filippo; their long limbs, flowing hair, and lyrical grace, however, are distinctive hallmarks of Botticelli.

During his lifetime, the fame of painter and draftsman Sandro Botticelli (ca. 1445–1510) was at its height in the last two decades of the Quattrocento. In 1482, after completing frescoes in the Sistine Chapel for Pope Sixtus IV (see figs. 42–3, 42–4), he returned from Rome to his native Florence and to a stream of important commissions and never left the city again. A favored painter of the Medici and Vespucci families, he was highly recommended to lordly patrons Lodovico ("Il Moro") Sforza of Milan and Isabella d'Este of Mantua. Yet the bulk of his work was executed in Florence for Florentines, and he is now most often remembered for his paintings of pagan mythologies and ethereal Madonnas. Fra Luca Pacioli (1494), renowned mathematician, listed him first among Florentine artists for his skilled proportioning with level and compasses; Ugolino Verino (1503) compared him to the ancient Greek

37-2. SANDRO BOT-
TICELLI. *Adoration of the
Magi*, ca. 1476, tempera
on panel, 3'7.8" x 4'4.8"
(III x 134 cm), Uffizi
Gallery, Florence. In
contrast to the Adora-
tion images of Lorenzo
Monaco (see fig. 23-1)
and Gentile (see fig.
22-1), which place Mary
and the Messiah in the
far left foreground with
the Magi occupying the
breadth of the composi-
tion, Botticelli elevated
them in the middle
ground, with any view
of the background
blocked except at the
edges of the painting.
Here Joseph overlooks
Mary and the Child,
giving him a more
prominent position, as
in the Adoration images
of Veneziano and Fra
Angelico and Fra Filip-
po (see figs. 31-2, 31-3).
Both Botticelli and
Filippino (see fig. 48-6)
included contemporary
portraits, a trait that
had become important
to the depiction of the
theme (see Botticelli
1476), but is apparently
missing in Leonardo's
work (see fig. 48-5).

painter Zeuxis; Vasari (1555) thought the pope placed him in charge of the Sistine frescoes and that his work was better than his competitors. Nevertheless, Botticelli was eclipsed by Raphael and Michelangelo, and memory of him faded over the next 300 years as many of his works became misidentified. Not until the late-19TH c. was he again perceived as an important Renaissance master, when studies on Florence and the Medici appeared and his works were displayed in major collections. Still, the broad significance of his influence has yet to be fully explored.

1445 — Alessandro (Sandro) di Mariano Filipepi is born to Smeralda and Mariano di Vanni di Amadeo Filipepi (a leather tanner) in the Ognissanti quarter of Florence. He is the seventh of eight children (only Sandro and three brothers lived into adulthood). The Filipepi boys were called "del Botticello" (of the little keg) after the nickname, "il Botticello," of their eldest brother, Giovanni, who supported the family; as a broker in the shares of the Monte (Florentine public debt), he was well-to-do financially. Vasari thought the nickname belonged to a goldsmith who trained Sandro.

ca. 1460 — Botticelli enters the workshop of Fra Filippo Lippi in Prato and was to stay there until ca. 1467; during these years, he surely helped with the choir frescoes in S. Stefano (see fig. 28-2).

1470 — In his *Memorie istoriche*, Benedetto Dei writes that Botticelli has a shop in Florence. When Piero del Pollaiuolo falls behind his schedule for producing the Mercanzia paintings of Virtues, Botticelli is hired on Tommaso Soderini's recommendation to paint *Fortitude* (Uffizi Gallery, Florence).

1472 — In the *Libro rosso* of the Confraternity of S. Luke, Botticelli is inscribed as a painter, with Filippino Lippi (Fra Filippo's son) in his shop. Botticelli's brother Antonio, who became a gold beater (*battiloro*) in 1467, is inscribed as a gilder and goldsmith.

1473 — Botticelli paints *S. Sebastian* (Gemäldegalerie, Berlin), a tempera panel mounted on a pillar (January 1474), S. Maria Maggiore, Florence.

ca. 1474 — Botticelli's *Man with a Medal of Cosimo de' Medici* (Uffizi Gallery, Florence) was in the collection of Carlo de' Medici (until 1666), but the attribution to Botticelli was not made until 1888.

1475 — Botticelli paints the (lost) banner (with an allegorical image of Minerva) that Giuliano de' Medici carried in the opening ceremony of the tornament in the Piazza S. Croce, Florence (the tournament celebrated the conclusion of a league between Florence, Venice, and Milan). Giuliano's victory in the joust and platonic devotion to his chivalric mistress (Simonetta Cattaneo, wife of Marco Vespucci) were celebrated in Poliziano's (Politian's) epic poem, *Stanze per la giostra di Giuliano de' Medici*.

1476 — Between 1470 and 1476, Botticelli was likely hired to paint the *Adoration of the Magi* (see fig. 37-2) for Guasparre del Lama's chapel (dedicated to the Epiphany) on the entry wall between the center and east doors of S. Maria Novella, Florence (see fig. 32-2). The date of the painting is based on style and Lama's history: a broker for the exchange guild, he built his chapel about 1470, but was condemned by the guild of fraud in 1476. Vasari highly praised Botticelli's painting and recognized the Medici in the guise of the Magi: Cosimo, the eldest king (Caspar), and Cosimo's grandson

Giuliano (Balthazar) and son Giovanni (Melchior). Yet the second king more closely resembles portraits of Cosimo's son Piero. A large figure unrelated to the entourage (right foreground) is thought to be Botticelli, but his great prominence makes this seem doubtful. However, Domenico Ghirlandaio displayed his self-portrait prominently in his frescoes in both the Sassetti Chapel and the Tornabuoni. After Lama's chapel passed through several hands, the Medici bought the painting (since 1796, Uffizi Gallery, Florence); attention was focused on the portraits, and it was attributed until 1845 to Domenico Ghirlandaio.

1477 — Botticelli completes a (lost) tondo for Benedetto Salutati, a gift shipped to Cardinal Francesco Gonzaga in Rome.

1478 — On the Palazzo del Capitano behind the town hall, Botticelli paints eight (lost) defamatory images of hanged Pazzi conspirators: Jacopo, Francesco, and Renato de' Pazzi, Archbishop Francesco Salviati of Pisa, Salviati's brother and cousin, Napoleone Francese, and Bernardo di Bandino Baroncelli (last two shown hung by one foot because they escaped). The traitors' images were above the door of the customhouse (Dogana), an ever-present reminder of Medici power (effaced 1494, with the Medici exile; destroyed 1495, with the town hall enlargement).

ca. 1478 — Botticelli and Filippino likely make designs for Giuliano da Maiano's and Francione's wood intarsia figures, *Dante* and *Petrarch,* for a door of the newly constructed Sala dei Gigli (Room of Lilies) in the town hall; citizens called before

the Signoria waited in this room before entering the Udienza (Audience Hall) next door.

1480 — For the Vespucci family, Botticelli paints a fresco of a life-size, seated figure of *S. Augustine* for the tramezzo (choir screen) in the church of Ognissanti, Florence. Domenico Ghirlandaio painted a pendant fresco, *S. Jerome* (see Ghirlandaio 1480).

1481 — In the loggia of the plague hospital of S. Martino alla Scala, Florence, Botticelli paints the *Annunciation* (fresco cut into 2 pieces with the loggia reconstruction) (since 1920 Uffizi Gallery, Florence).

Lorenzo di Pierfrancesco de' Medici hires Botticelli to illustrate Cristoforo Landino's edition of Dante's *Divine Comedy.* By 1491 he had completed 92 pen drawings. Lorenzo was to remain an important patron in Botticelli's career.

In Rome, Botticelli is working in the Sistine Chapel for Pope Sixtus IV (contract dated 27 October). He painted eight portraits of popes (one likely by his shop), two scenes of Moses (see figs. 37–1, 37–3), and one of Christ showing the purification of the leper and the temptations of Christ. Whether he worked in Verrocchio's shop as an assistant is unclear, but Verrocchio's

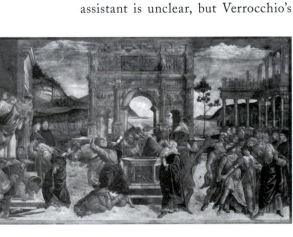

37–3. SANDRO BOTTICELLI. *Stoning of Moses; Punishment of Korah,* 1481–82, fresco, 11'5.5" x 18'8.5" (349.3 x 562.6 cm), Sistine Chapel, Vatican, Rome. In rebellion, Israelites (right) threaten to stone Moses (Nm 14:1–10). In the middle, Levite servants of the tabernacle are seeking priesthood; led by Korah, Dathan, and Abriam, they challenge the leadership of Moses and the priestly rights of his brother Aaron (and his heirs). A trial by censers follows in which the Lord was to reveal the holiest man (250 presumptive rebels were then swallowed by the earth and consumed by fire) (Nm 16:1–35). Botticelli shows the trial at an altar: Moses has a baton, Aaron (in the tiara) swings a censer, and only five rebels appear (Korah, Dathan, Abriam, and Aaron's two impious sons), who flail about, dropping their censers. Behind Moses is Eleazar (Aaron's pious son), swinging the censer of a fallen rebel, scattering the fire that had become holy with the rebels' sacrifice (Nm 16:36–38). Rather than the Sinai wilderness, Rome is the setting, and the towering arch resembles the Arch of Constantine.

SPALLIERE (wall panels). In Florence, Botticelli received contracts for a certain type of painting popular in well-to-do households. These were called *spalliere*: rectangular panel paintings placed in a room about shoulder height or eye level and set into wooden wainscoting or attached to furniture (often the backboards of chests, benches, or daybeds). The secular imagery of *spalliere* had a didactic purpose similar to panels of *cassoni* (wedding chests), whose stories focused on honor and the triumph of virtuous and heroic deeds.

Botticelli was characterized by Vasari as practical joker, talented man flourishing in the golden age of Lorenzo the Magnificent de' Medici, and crippled, useless old man, whose acquired wealth was lost by his carelessness and poor business practices. Botticelli never married and seems to have stayed close to his family. In 1494 he was living with his nephews and their families and his brother Simone on the Via Nuova (his parents' house). With his family, he bought a villa and vineyards outside Porta San Frediano.

influence appears in the physical features of his male figures and in the deep and sweeping drapery folds and volumetric figures of his Sistine frescoes. Moses is portrayed as the promulgator of the written law, and Christ, the legislator of the Gospel. The legitimacy of the popes as Christ's vicars on Earth is underscored in Botticelli's scene of Moses and Aaron by placing the biblical story in the Rome of Constantine. Each register has a Latin inscription (on the fictive molding above the register) pertaining to the continuous episodes depicted (see figs. 42–3, 42–4).

1482 — In Rome, he paints *Adoration of the Magi* (National Gallery of Art, Washington, D.C.).

Returning from Rome, Botticelli receives important commissions in Florence. He is commissioned (5 October 1482) to paint (with Ghirlandaio) the west wall of the Sala dei Gigli in the town hall. Domenico had first been hired to paint the east wall (see Ghirlandaio). Both Perugino and Biagio d'Antonio (replaced by Filippino Lippi) were to paint the north, and Piero del Pollaiuolo, the south. Only Domenico fulfilled his contract for the east wall. The other three walls were painted by Cosimo Rosselli (1490), each with pilasters and gilded fleurs-de-lis on a blue background.

Famous among his many *spalliere* are *Pallas* (or *Camilla*) *and the Centaur* and *Primavera* (Allegory of Spring) (both panels Uffizi Gallery, Florence). The latter shows the court of Venus and resembles in composition images of SACRA CONVERSAZIONE (see Quattrocento Glossary): Venus (with son Cupid hovering above) is substituted for Mary, and to her right are not Christian saints, but the Graces and Mercury, and to her left, Flora, Cloris, and Zephyr. A Medici inventory (1499) describes the painting in a white frame and installed

over a bed. Although Medici inventories do not reveal the exact patron or where paintings were first installed, Botticelli's works are often linked to Lorenzo di Pierfrancesco because they are listed in the villa (Castello) associated with him.

Botticelli creates *Venus and Mars*, 27.3" x 5'8.3" (69.2 x 173.4 cm), perhaps for the Vespucci (a pun on their name is shown by the wasps [It., *vespe*] in the upper corner). The tempera panel likely functioned as a *spalliera* showing Venus triumphant over Mars.

Besides frescoes and *spalliere*, Botticelli painted tondos, such as the *Madonna of the Magnificat*, for domestic settings. In these works he fused Christian imagery with pagan motifs (marble-like figures, streaming sashes, layers of gossamer cloth), as can be seen in the carved goblet, the *Tassa Farnese* (see fig. 37–5).

1483 — With Bartolomeo di Giovanni, Botticelli paints four *spalliere* depicting scenes of Nastagio degli Onesti from Boccaccio's *Decameron* for the marriage of Giannozzo di Antonio Pucci and Lucrezia Bini.

1485 — For Giovanni Bardi's chapel in S. Spirito, Botticelli paints *Madonna and Child with Ss. John Evangelist and John Baptist* (Staatliche Museen, Berlin).

ca. 1485 — While Botticelli's *Birth of Venus* (see fig. 37–4) was inspired by ancient sculpture, Greek poetry, and the *Stanze* of Politian, the painting is not dependent solely on one specific image or text. In composition it resembles such paintings of Baptism as Piero's (see fig. 18–2) and Verrocchio's (Uffizi Gallery, Florence), yet the figures are pagan deities who attend, not to Christ, but to Venus (*pudica*, the modest type). And she is riveting. Bot-

ticelli allowed no anecdotal vignettes to distract from the meditative power of this serene Venus, her pearlescent skin and gilded hair seeming to glow in unearthly radiance. Neither the cloth billowing about Hora nor the air rushing from the interlocked wind and breeze (Zephyr and Aura) disturbs this pensive goddess of love. She seems a perfect creature. In the tradition of Zeuxis, who combined the most perfect features of several models to create his Helen of Troy (described by Alberti in *Della pittura*), Botticelli designed an ideal, unique beauty. She is unlike Piero's ideal forms, lacking the symmetry and the proportion of his figures (her neck is too long and broad, a shoulder slopes, one arm is oversized), yet her combined features display lyrical grace and call attention to the flowing lines of her sinuous body and luxuriant hair. Both lithe and monumental, this figure type impressed Jacopo Pontormo.

1487 — For the Sala dell'Udienza del Magistrato dei Massai de Camera (in the Bargello), Botticelli paints *Madonna of the Pomegranate* (Uffizi Gallery, Florence), a tondo still in its original frame.

ca. 1488 — Hired by the guild of doctors and apothecaries, patrons of the church of S. Barnaba in Florence, Botticelli painted the high altarpiece, *Madonna and Child Enthroned with Four Angels and Ss. Catherine, Ambrose, Barnabus, John the Baptist, Augustine, and Michael* (since 1919, Uffizi Gallery, Florence).

1489 — For the chapel of Benedetto di Ser Francesco Guardi in the Cistercian church of Cestello (now S. Maria Maddalena dei Pazzi), Botticelli paints the *Annunciation* (Uffizi Gallery, Florence), completed in 1491. Also created for the same church

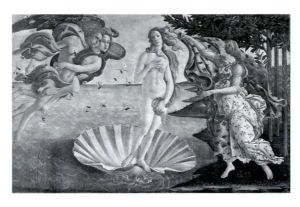

were Domenico Ghirlandaio's *Visitation with Ss. Mary Jacobi and Mary Salome* (Louvre, Paris), finished in 1491 for the chapel of Lorenzo Tornabuoni, and Perugino's *Vision of S. Bernard* (Pinacoteca, Munich), commissioned in 1489 (finished 1493) for the Nasi Chapel.

ca. 1490 — Botticelli paints (lost) frescoes of mythological subjects for Lorenzo de' Medici's villa at Spedaletto (see Ghirlandaio).

1491 — With Lorenzo di Credi, Domenico Ghirlandaio, Perugino, and Baldovinetti, Botticelli judges new facade designs for the Duomo.

ca. 1491 — Botticelli paints frescoes in the Villa Lemmi (fragments are in the Louvre, Paris), celebrating Lorenzo Tornabuoni's second marriage.

1494 — Fra Luca Pacioli's *Summa de arithmetica, geometria, proportioni et proportionalità* (published in Venice) mentions Botticelli as an able master of perspective. Luca also singled out the Florentine painters Domenico Ghirlandaio and Filippino Lippi.

ca. 1495 — Botticelli works for Lorenzo di Pierfrancesco de' Medici.

Botticelli paints the *Lamentation* (Pinacoteca, Munich) for S. Paolino, Florence. Five mourners surround the dead Christ

37–4. SANDRO BOTTICELLI. *Birth of Venus*, ca. 1485, tempera on canvas, 5'8" x 9'1.7" (172.5 x 278.5 cm), Uffizi Gallery, Florence. In the 19TH c. the painting was titled *Birth of Venus*, but it depicts instead her arrival at Cythera. As the Roman goddess of love, Venus was linked to the Greek goddess Aphrodite, whose birth came about when Cronus cut off the genitals of Uranus, casting them into the sea (see Hesiod's *Theogony*, ll. 180–200). Born of the white sea foam that was formed around the immortal flesh, Aphrodite (Gk. *aphros*, foam) emerged from the sea. Breezes took her to Cythera and to Cyprus. Inspired also by Politian's *Stanze*, the painting shows Venus at Cythera, where the Horae (Hours) awaited her (only one Hora appears here). Shown in a contrapposto stance, her right leg seeming to rise from the shell, Venus will soon alight on the shore. As natural as the setting may appear, none of the figures is earthbound. Even broad and massive Hora defies the laws of nature. With her weight fully on her toes, and her toes touching the soil, she nevertheless makes no imprint on the grass.

(the Virgin, John the Evangelist, Mary Magdalene, and two Marys), joined by three saints who were not present at the Crucifixion, each with an attribute identifying the man: Jerome (rock), Paul (sword), and Peter (keys). The subject was a popular devotional theme (see LAMENTATION, Cinquecento Glossary). Vasari saw a Lamentation by Botticelli beside the chapel of the Panciatichi, S. Maria Maggiore (1568), thought to be the *Lamentation* in Milan (Museo Poldi Pezzoli), a work perhaps commissioned by Donato Cione and made for a pillar. Botticelli's Lamentations and Perugino's San Giusto *Pietà with Saints*, ca. 1493–97 (Uffizi Gallery, Florence), surely inspired Michelangelo's *S. Peter's Pietà*.

1497 — More than 300 Florentines (including Botticelli's brother Simone, but not Botticelli) sign a petition for the pope to rescind Savonarola's excommunication. Vasari thought Botticelli stopped painting because he was influenced by the friar.

ca. 1498 — Botticelli paints *Calumny of Apelles* (Uffizi Gallery, Florence), based on the classical writer Lucian's rhetorical essay on Slander, in which Lucian recounts the story of how false accusations were leveled against the Greek painter Apelles. Exonerated, Apelles made an allegorical painting of Slan-der, the iconography of which Lucian described in his essay. Botticelli made his *Calumny of Apelles* apparently for him-self and was perhaps inspired by Alberti's instructions in *Della pittura* (1436) about how to create *istoria* (narrative and allegorical themes) with invention.

Using the painting of Apelles as his example, Alberti described the major figures, all of whom appear in Botticelli's *Calumny of Apelles*. But Botticelli's painting does not copy Alberti: the most different is his figure of Truth, who is neither a shameful nor a modest young girl, but a statuesque woman fashioned after the goddess in *Birth of Venus*. The painting was acquired by Antonio Segni Guidi and was owned by his son Fabbio when Vasari saw it.

1501 — Inscribed in Greek on *Mystic Nativity* (National Gallery, London) is Botticelli's name, the year 1500 (old style), and a passage referring to the Apocalypse (Christ's Second Coming), as foretold in the Book of Revelation: "I, Alessandro, painted this picture at the end of the year 1500 [new style 1501], during the trouble in Italy in the half time after the time which was prophesied in the 11TH [chapter] of John and the second woe of the Apocalypse when the Devil was loosed upon the earth for three years and a half. Afterward he shall be put in chains according to the twelfth woe, and we shall see [him] trodden underfoot as in this picture."

1502 — Botticelli is recommended to Isabella d'Este (see Perugino).

1504 — In Florence (25 January), Botticelli, Filippino Lippi, Cosimo Rosselli, Leonardo, Perugino, Giuliano da Sangallo, and others discuss the site for Michelangelo's marble *David* (see Michelangelo).

1510 — Botticelli dies (17 May) and is buried at the Ognissanti.

37–5. *Tassa Farnese* (Farnese Cup), ca. 150–100 BCE, sardonyx (chalcedony) agate, 8" diameter (20.3 cm), Museo Nazionale, Naples. During his sojourn in Rome as an ambassador for Florence at the coronation of Pope Sixtus IV (in 1471), Lorenzo de' Medici bought this sardonyx goblet. It became the most prized object of his collection and was valued at 10,000 gold florins, an amount equal to the sum of all his antique vases. An allegorical scene is depicted that alludes to the fertility of the river Nile, with seven figures gathered around the large river god, including a recumbent Egyptian sphinx in the foreground. Artists studied this gem, and the two figures sailing overhead above the god must have inspired the zephyrs in Botticelli's *Birth of Venus* (see fig. 37–4) and Peter and Paul in Raphael's *Expulsion of Attila* (1514) (Stanza Heliodorus, Vatican, Rome). Lorenzo's antique gems and medals included those of his father (Piero) and grandfather (Cosimo, the Elder) and had grown to an impressive size by his death (1492). The chalcedony cup entered the Farnese collection with the marriage of Alessandro de' Medici's widow, Margaret of Austria, to Ottavio Farnese.

Domenico Ghirlandaio

The productive Domenico Ghirlandaio (1449–94) began as a goldsmith, but became a painter, learning techniques for creating panels, frescoes, and mosaics in the shop of Alesso Baldovinetti (Vasari, *Lives*). In the late–1470s his style came under the influence of Botticelli and Cosimo Rosselli, and he likely spent time in Verrocchio's shop when Perugino and Leonardo were there. A major change in his patronage occurred after the completion of his work in the Sistine Chapel, Rome. On his return to Florence he began to receive major commissions in the city (before he had worked mostly in the provinces, and chiefly with his brother Davide), and was to establish the largest family workshop in town. His reputation for professional competence and dependability served him well, as did his ability to describe Florence with detailed specificity. Particular features about the city and its people are still more easily gleaned from his works than they are from the works of contemporary painters like Botticelli, Filippino, or the Pollaiuolo brothers. To the delight of patrons like Giovanni Tornabuoni (see fig. 38–3), he gave visibility to his patron's piety, moral virtue, and communal beneficence through an unprecedented quantity of portraits blended with holy stories, the descriptive value of which kept his name alive and his art appealing, while Botticelli's slipped away.

1449 — One of three painter sons, Domenico is born to Tommasso di Currado di Doffo Bigordi and his first wife, Antonia. The birth year is based on the 1458 catasto of his grandfather, Currado di Doffo Bigordi, listing the ages of Domenico and his brother Davide

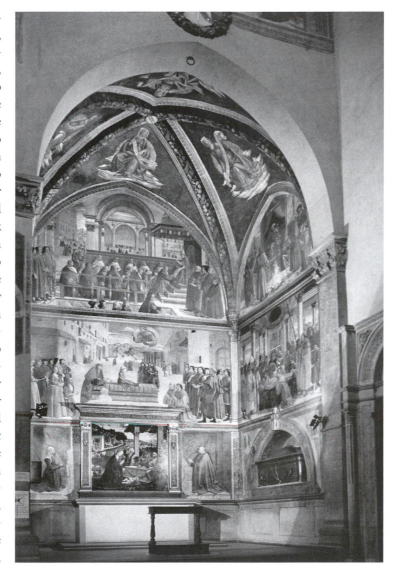

38–1. DOMENICO GHIRLANDAIO. Sassetti Chapel, 1479–85, fresco, S. Trinità, Florence. To the right is the portal (Ghiberti's design) to the sacristy funded by Palla Strozzi's family, where Gentile da Fabriano's *Adoration of the Magi* (see fig. 22–1) and Fra Angelico's *Deposition* (see fig. 26–3) were installed. In the Sassetti Chapel frescoes shown here, Domenico Ghirlandaio's self-portrait appears (hand on hip, right) in *Resurrection of the Roman Notary's Son* (see fig. 38–2).

(d. 1525) as nine and six. His painter brother Benedetto was born in 1460 (d. 1497). It seems that the sons were

Francesco Sassetti (see figs. 38–1, 38–2) was linked to the Medici through banking; he worked in the foreign offices in Avignon and Lyons, managed the Geneva branch (1447), and became a partner in the Florence bank (1482–84). Like Baldovinetti's portraits of the Medici with his patrons (the Gian-figliazzi) in the choir chapel in S. Trinità (1472–73), Domenico painted the Medici with the Sassetti. In the *Confirmation* (altar wall) Francesco and his son Federico stand (far right) beside Lorenzo de' Medici and Antonio Pucci. Ascending the stairs is the poet and tutor Politian with the Medici children: Giuliano (future duke of Nemours), Piero (future family head), and young Giovanni (future Pope Leo X). Francis is shown kneeling before Pope Honorius III in Rome; yet the buildings behind them are in Florence. Linking their city with Rome must have seemed fitting to Florentines because of their Roman ancestry; ca. 1480 Politian called Augustus the founder of Florence. As new Romans they aspired to be exemplars of civic and Christian virtues.

nicknamed del Ghirlandaio (*grillandaio*) after the fashionable goldsmiths' ornaments sold by their father that wealthy Florentine women wore in their hair.

1470 — Listed as an apprentice to a goldsmith, Domenico is admitted to the penitential (self-flagellants) Compagnia di S. Paolo, a religious fraternity for laymen to which his father and Lorenzo de' Medici also belonged. His brothers Davide and Benedetto became members.

1472 — Domenico and Davide are inscribed as painters in the register (*Libro rosso*) of the Confraternity of S. Luke in Florence. Vasari wrote that Domenico learned the skills of painting and mosaic from Alesso Baldovinetti. He may also have been an assistant or associate in Verrocchio's shop.

ca. 1472 — Domenico paints frescoes for the Vespucci in the Ognissanti.

ca. 1473 — Domenico paints *Ss. Jerome, Barbara, and Anthony Abbot* (apse fresco, right aisle), Pieve di S. Andrea, Cercina.

1475 —Domenico and Davide execute frescoes of philosophers and prophets in eight lunettes of the Latin library of Pope Sixtus IV (Vatican Palace, Rome), for which they are paid 65 gold ducats.

1476 — Don Isidoro del Sera, abbot of the Vallombrosan monastery at Passignano (near Florence), hires Domenico and Davide to paint a Last Supper on the refectory wall (damaged by paint losses and new additions, including the balustrade). Domenico created the design and painted the faces; they received 18 florins and their materials were provided.

ca. 1477 — Based on style, the frescoes in the S. Fina Chapel of the Collegiata, San

Gimignano, are attributed to Domenico and Davide. The chapel was built by Giuliano da Maiano to enshrine the body of the 13TH–c. penitent, a local girl named Fina, who after her death at the age of 15 performed miracles. Vault images show the four Evangelists, in the lunettes are the Latin Church Doctors, and the spandrels show Old Testament prophets. On the right chapel wall is *S. Gregory Announcing S. Fina's Death* and on the left, *Healing of the Nurse at S. Fina's Bier*, scenes displaying a penchant for landscape vistas, uncluttered rooms with measurable space, portraits of pious townspeople, and distinctive features of the town (the many towers behind S. Fina's bier).

1479 — In Florence, Domenico likely begins designs for frescoes in the Sassetti Chapel (see fig. 38–2) (see entry 1485).

1480 — For the refectory of the Umiliati of Ognissanti, Domenico paints and dates his *Last Supper* (detached 1966; sinopia recovered). The year 1480 is also inscribed on his fresco for the Vespucci, *S. Jerome*, 6'.5" x 3'10.9" (184 x 119 cm), attached to the church choir screen; Botticelli painted the pendant *S. Augustine*. With the removal of the choir screen (1564–65), their frescoes were detached, and moved to the nave walls (now restored and in the nave).

In May, Domenico marries Costanza di Bartolommeo Nucci, who brings a large dowry (1,000 florins) to the marriage.

1481 — Domenico colors and gilds candlesticks for the Florence Duomo. In the small refectory of the convent of S. Marco in Florence, Domenico's shop paints the *Last Supper* in fresco.

Domenico is hired (27 October) by Pope Sixtus IV to execute frescoes in the Sistine Chapel, Rome (see Perugino):

Calling of the First Apostles, Resurrection of Christ (destroyed when the door frame of the entrance wall collapsed in 1522), and nine portraits of popes (three likely by his shop).

1482 — Domenico is given an advance payment (17 September) and officially hired (5 October) to paint the east wall in the Sala dei Gigli, Palazzo della Signoria (see Botticelli) (see also fig. 42–8). He began by painting *S. Zenobius Enthroned with Ss. Eugenius and Crescentius and the Madonna, Child, and Angels*. On 18 April 1483 he was hired to paint images of Roman heroes in the lunettes: *Brutus, Mucius Scaevola, Camillus* (left) and *Decius, Scipio, Cicero* (right). These figures were inspired by an earlier fresco cycle of *Famous Men* (ca. 1390s; destroyed 1470s) in the Saletta (2ND floor), based on Petrarch's *De viris illustribus* and Filippo Villani's biographies of famous Florentines.

1483 — Domenico's son, Ridolfo, is born. He becomes a painter.

Domenico is hired to create an (unexecuted) altarpiece for the chapel of S. Bernard (2ND floor, town hall). He was not the first artist contracted: Piero Pollaiuolo was first hired, but his contract was reassigned to Leonardo a week later, with neither executing the painting (see Pollaiuolo 1477).

1484 — Domenico is emancipated (September) from his father, Tommasso.

1485 — Domenico completes (see 1479) frescoes in the burial chapel of Francesco Sassetti and Nera Corsi in S. Trinità (see fig. 38–1), with imagery that melds Christian and pagan motifs, and sibyls with saints (see fig. 46–2). For the altar he created the *Nativity*

Sassetti Chapel, S. Trinità, Florence

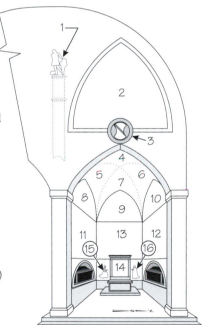

1 *David with the Head of Goliath*, inscribed on pedestal: SALVTI / PATRIAE / ET / CHRISTIA / NAE GLOR / IAE / E.S.S.P (At the behest of the senate and the people for the salvation of the fatherland and to the glory of Christendom)

2 *Augustus and the Tiburtine Sibyl* (whitewash removed ca. 1896)

3 Sassetti crest (flanking the crest are two slings with stones, referring to David and to the patron's name, which means "little stones")

4 *Cumaean Sibyl*, on scroll: HEC TESTE VIRGIL MAGNVS (With this as witness of the great Virgil)

5 *Sibyl* (no text visible)

6 *Agrippan Sibyl*, on scroll: INVISIBILE VERBVM PALPABITVR GERMINABIT (The invisible truth will laboriously sprout)

7 *Erythraean Sibyl*, on scroll: IN VLTIMA AVTEM ETATE (In the ultimate age)

8 *S. Francis Renounces Worldly Inheritance*

9 *Confirmation of the Franciscan Rule* (by Pope Honorius III) (shown in Florence)

10 *Trial by Fire Before the Sultan*

11 *Stigmatization of S. Francis*

12 *Death of S. Francis and the Verification of the Stigmata*

13 *Resurrection of the Roman Notary's Son* (shown in Florence)

14 *Adoration of the Shepherds*

15 *Nera Corsi Praying*

16 *Francesco Sassetti Praying*

Scenes #8–13 are numbered chronologically. Distinct from Gozzoli's frescoes of S. Francis at Montefalco (see fig. 34–3), are scenes #1, #2, #4–#7, and #13.

38–2. This diagram shows the Sassetti Chapel in S. Trinità, Florence, which had a dual dedication to the Nativity and S. Francis (Francesco's name saint). In the classically inspired arcosolia (see Verrocchio 1470) are coffins of black stone (touch stone or basanite) attributed to Giuliano da Sangallo (ca. 1484). Framing the coffins are pietra serena arches with reliefs highlighted in gold. Francesco Sassetti's has a scene of mourning, inspired by the death of Meleager, a pagan theme often depicted on antique Roman sarcophagi (see fig. 38–1 and entry 1485). (For the biography of S. Francis, see Fra Filippo Lippi.)

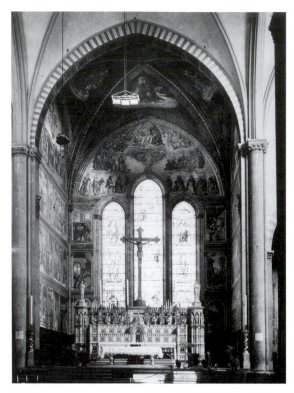

38-3. DOMENICO GHIRLANDAIO. Scenes of the Virgin and John the Baptist (see fig. 38-4), 1488-89, fresco, Tornabuoni Chapel, S. Maria Novella, Florence. Work on the high altar chapel of the Dominican church was begun in 1486, and the chapel was dedicated (22 December 1490) to the Coronation of the Virgin (the theme is depicted at the apex of the north wall). At the base of the north wall are portraits of the donors kneeling in prayer, Giovanni Tornabuoni and Francesca Pitti Tornabuoni; they married in 1467, and she died in Rome (1479) six years before the contract was awarded to Domenico Ghirlandaio. Wealthy and prominent Giovanni Tornabuoni (1428-97) had acquired control over the important chapel because he offered generous support to the church, and he was connected to the powerful Medici through blood, business, and politics: Lorenzo de' Medici was his nephew (Giovanni's sister Lucrezia was Lorenzo's mother); Giovanni managed the Medici bank in Rome, where he also administered the bank's affairs with the papal Curia from 1465 until he moved permanently back to Florence in 1484; and Lorenzo de' Medici brokered the marriage (15 June 1486) between Giovanni's only son, Lorenzo, and Giovanna degli Albizzi, the daughter of one of Florence's most venerable magnate families. The Albizzi (chiefly responsible for Cosimo the Elder's exile in 1433) had been bitter enemies of the Medici. The Tornabuoni-Albizzi marriage, which took place with great ceremony in S. Maria Novella, marked the peaceful reconciliation between the powerful families.

and *Adoration of the Shepherds*, 5'5.8" x 5'5.8" (167 x 167 cm), the focal point in the chapel, and inscribed the year 1485 in Roman numerals on the pillar behind Joseph. The sarcophagus is inscribed ENSE CADENS SOLYMO POMPEI FULVI[VS] / AVGVR / NVMEN AIT QVAE ME CONTEG[IT] VRNA DABIT (Fulvius, Pompey's augur, falling to the sword before Jerusalem, proclaims: "My tomb will produce a new deity"). In this year Domenico is hired to paint the Tornabuoni Chapel (see figs. 38-3 to 38-6).

1486 — Domenico's wife, Costanza, dies (January). In this same year he marries his second wife, Antonia di Ser Paolo di Simone Paoli.

Domenico paints *Coronation of the Virgin* for the high altar in S. Girolamo (outside Narni).

1487 — For the Tornabuoni palace, Domenico creates the large tondo *Adoration of the Magi* (Uffizi Gallery, Florence), dia. 5'7.8" (172 cm), dated 1487.

According to Vasari, Domenico restores the interior mosaic above the main door, Florence Duomo.

1488 — In Florence, Domenico completes (1 December) *Adoration of the Magi and Massacre of the Innocents* (1485) for Giovanni Tesori for the main altar of the church of the Ospedale degli Innocenti. Bartolomeo di Giovanni was hired (30 July) by the prior of the Ospedale to execute predella panels (Bartolomeo painted the Massacre in Domenico's main panel).

Michelangelo is a *garzone* in Domenico's shop (June). Apprenticed in April 1488, he may have helped in the Tornabuoni Chapel (see fig. 38-3).

1489 — Domenico and Davide are hired to execute in mosaic the *Annunciation* (finished within one year) above the Porta della Mandorla, Florence Duomo.

Of the many portraits Domenico painted during the decade of the 1480s, his most compassionate is *Old Man with a Young Boy* (Paris, Louvre), 24.7" x 18.3" (62.7 x 46.3 cm). Similar to a death mask, the metalpoint drawing on pink prepared paper (Nationalmuseum, Stockholm), 11.1" x 8.5" (28.1 x 21.5 cm), provided

Tornabuoni Chapel, Florence

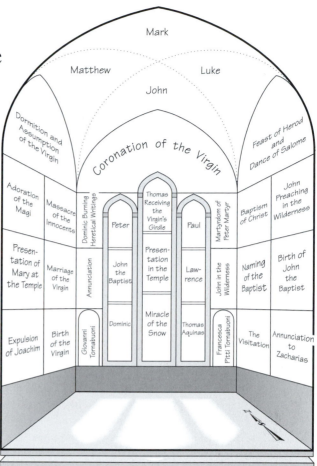

38–4. Diagram of the Tornabuoni Chapel frescoes and stained glass. An oculus above the windows was walled in for Domenico's *Coronation of the Virgin* (ca. 1488). He created designs for new windows (made by Alessandro Fiorentino, 1491), and a freestanding double-sided altarpiece, whose frame (by Baccio d'Agnolo) was shaped like a triumphal arch, topped by a lunette holding the tabernacle. Finished by his shop, the altarpiece was installed April 1494: (facing the nave) *Madonna and Child in Glory and Ss. Dominic, Michael, John the Baptist, and John the Evangelist* (Alte Pinakothek, Munich) and (facing the choir) *Resurrection of Christ* (destroyed by fire). Six panels of life-size saints flanked the main panels, left to right: (front) *Lawrence* and *Stephen*, (back) *Antoninus* and *Vincent of Ferrer*, (sides) *Catherine of Siena* and *Peter Martyr*; the (lost) predella had stories of these saints. Giovanni Tornabuoni's will of 1490 provided for tombs in the chapel, and this date is on the east wall in an epigraph (nearly illegible) above the right arch in *Annunciation to Zacharias*: AN MCCCCLXXXX QVO PVLCHERRIMA / CIVITAS OPIBVS VICTORIIS ARTIBVS / AEDIFICIIS QUE NOBILI COPIA / SALVBRITATE PACE PERFRVEBATVR (In the year 1490, when the most beautiful city [Florence], renowned for its deeds, victories, arts, and buildings, enjoyed health, peace, and wealth).

descriptive information (bulbous nose, bulging eyes, warts) for the balding old man.

ca. 1490 — Lorenzo de' Medici hires Botticelli, Filippino, and Perugino to paint murals (destroyed by fire) in his villa (perhaps in the great hall) at Spedaletto, near Volterra. Domenico's *Vulcan Forging Thunderbolts for Jupiter* was in the loggia, the only villa fresco described by Vasari.

Domenico paints a portrait of *Giovanna degli Albizzi* (see fig. 48–3).

1491 — In January, Domenico is one of several judges of the models and designs for the facade of the Florence Duomo (see Botticelli).

The overseers of works at the Florence Duomo request cartoons from Domenico and Davide, Botticelli, Gherardo, and Monte di Giovanni for the mosaics of the S. Zenobius Chapel.

Neri di Bicci, Baldovinetti, Filippo di Giuliano, and Domenico value Botticini's paintings (14 May) for the Company of S. Andrea of the White Habit, Empoli.

Domenico paints *Visitation with Ss. Mary Jacobi and Mary Salome* (Louvre, Paris), 5'7.8" x 5'5" (172 x 165 cm), for the chapel built by Lorenzo Tornabuoni (in memory of his dead wife, Giovanna degli Albizzi) in the church of Cestello (see Botticelli 1489).

1492 — Domenico restores the facade mosaic *Marriage of the Virgin*, Orvieto Cathedral (20 April).

1493/94 — Domenico and Davide, Jacopo Baldino, and Raffaello restore the 13TH-c. apse mosaic *Christ Enthroned Between Four Angels and Ss. Zenobius and James the Major* in Pistoia Cathedral. The apse and mosaic were destroyed in the 17TH c. Domenico executes frescoes in the tribune of Pisa Cathedral and restores Cimabue's apse mosaic.

1494 — Domenico dies of plague (11 January). Supervisors of Florence Duomo granted him a sepulcher at S. Maria Novella.

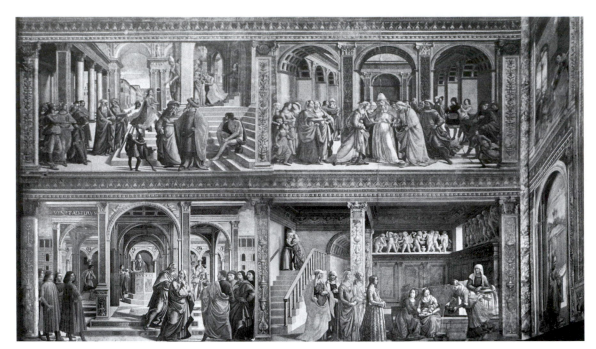

38–5. DOMENICO GHIRLANDAIO. Scenes of the Virgin, 1488–89, fresco (west wall), Tornabuoni Chapel, S. Maria Novella, Florence. In his imagery, Domenico merged Florentine sites, citizens, and families with the events of sacred history, placing recognizable portraits in the registers closest to viewers. In the lower register (left), the *Expulsion* is set in the Loggia of S. Paolo (it faces the church); in the foreground are Lorenzo Tornabuoni, Giovanni's only legitimate son (hand on hip, left), and Domenico Ghirlandaio (hand on hip, right). Leading a group of contemporary Florentine women in the *Birth of the Virgin* (lower right) (see fig. 38–6) is Ludovica Tornabuoni (Giovanni's daughter), who was to marry Alessandro Nasi (1491); he stands beside her brother. On the fictive wood paneling is the signature (*bighordi grillandai*), referring to the family of painters.

38–6. DOMENICO GHIRLANDAIO. *Birth of the Virgin*, ca. 1486, pen and brown ink on cream colored paper, 11" x 8" (21.3 x 28.5 cm), British Museum, London. Domenico's early drawing is different from the fresco. While the figures near the infant display great liveliness, the same figures, especially the five portraits in the center, are more noticeably stately and decorous in the fresco, where jubilation is expressed instead by the frieze of putti (not shown in the drawing).

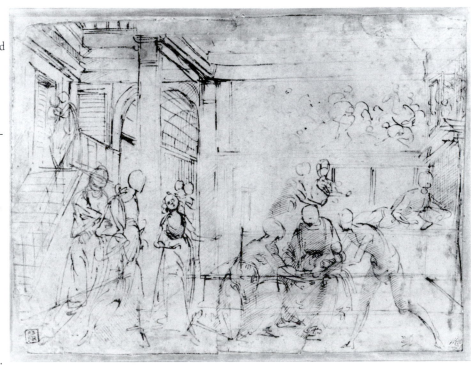

Characterized by Vasari as intelligent and inventive, Filippino Lippi (1458–1504) was the Florentine pride of Lorenzo de' Medici. Being the child of Fra Filippo and the pupil of Sandro Botticelli made him unique. In 1488 Lorenzo understood how Lippi's art exemplified refined Florentine taste and would be attractive to prelates and sent him to Rome. Unlike Ghirlandaio and Botticelli, Lippi had not worked in the Sistine Chapel in the early 1480s, and his Roman experience came nearly a decade after theirs. But like theirs, it was critical to his career. Steeped in the monuments of antiquity and the illusionism of Mantegna's Vatican frescoes and Pintoricchio's S. Maria in Aracoeli frescoes, Lippi's art changed. While his early art melded stylistic traits of his two painter teachers, Fra Filippo and Botticelli, the ideas of Leonardo and antiquity infused his mature style, and led to the extraordinary illusionism of the Carafa (see fig. 39–2) and Strozzi (see fig. 39–4) frescoes, works that inspired artists for 200 years, and more immediately Michelangelo's Sistine ceiling. Like his Florentine rivals, Lippi was an exceptionally good fresco and panel painter (and a more talented, prolific draftsman), receiving prestigious commissions until his early death.

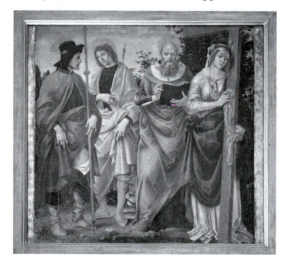

1458 — Filippino is born in Prato, perhaps in the winter of this year (1457 Florentine style), the child of the Carmelite monk Filippo Lippi and the nun Lucrezia Buti. Lucrezia renewed her vows in 1459 (convent of S. Margherita, Prato), but left the convent to live with Filippo before her daughter's (Alessandra's) birth in 1465.

1467 — Filippino is in Spoleto with his father, who was contracted for work in the cathedral chancel.

1469 — Fra Filippo dies in Spoleto. Vasari thought Filippino returned to Prato with Fra Diamante.

1472 — In the *Libro rosso* of the Confraternity of S. Luke, Filippino is inscribed as in Botticelli's workshop, "Filippo di Filippo da Prato dipintore chon Sandro Botticello."

1481 — Lippi is admitted to the Compagnia di San Paolo (see Ghirlandaio 1470); his name was deleted 23 April 1503. Around this year he paints an altarpiece for S. Michele in Foro, Lucca (see fig. 39–1).

1482 — Lippi is hired (September) by Nicola Bernardi to paint an altarpiece for S. Ponziano, Lucca, completed in 1483. Although not in Florence, he is contracted (31 De-

39–1. FILIPPINO LIPPI. *Ss. Roch, Sebastian, Jerome, and Helena* (top and sides cut), ca. 1481, tempera on panel, 4′11.1″ x 5′1″ (145 x 155 cm), S. Michele in Foro, Lucca. Lucca is likely where Lippi established his reputation, bringing with him Florentine style. His figures of Sebastian and Roch derive from Verrocchio's *Thomas* (see fig. 36–1), and Helena shows Botticelli's influence, although her physiognomy is softer, more delicate, and closer to Fra Filippo's; gazing downward, she gently holds the sacred wood, her veil protecting the holy relic from human touch (see fig. 33–1 for comparison). Lucca is the home of the *Volto Santo* (see fig. 2–16), and Helena's gestures reflect the town's devotion to the miraculous relic (in 1482 a new shrine was made for the Santo). Common to *sacra conversazione* images are saints (like Jerome) absorbed in devotional readings. Characteristic of Lippi is the formal and symbolic linkage of figures: the plague saints are shown in lively discourse, and all four figures are tied rhythmically through undulating drapery folds and the proximity (and the likeness) of hands.

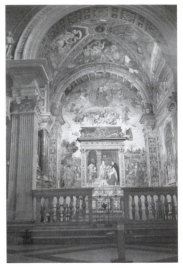

39–2. FILIPPINO LIPPI. Carafa Chapel, ca. 1488–93, fresco, S. Maria Sopra Minerva, Rome. In 1478 Cardinal Olivero Carafa (1430–1511), archbishop of Naples since 1458, and commander of the papal fleet, was named protector of the Dominican Order. He became the titled cardinal (1483) of S. Sabina, the most important Dominican church in Rome. Shortly afterward, he planned his burial chapel in S. Maria Sopra Minerva (see fig. 39–3), but he was buried in Naples. The focal point of the chapel is the Virgin in the Annunciation, shown in the altarpiece, in which S. Thomas Aquinas intercedes for Carafa, who kneels in veneration before the Annunciate Virgin.

cember) to paint the north wall (not executed) of the Sala dei Gigli in the town hall (see Botticelli 1482).

1483 — Although not named, Lippi was surely the painter hired (13 January) to create the *Annunciation* in two *tondi* for the audience chamber of San Gimignano's town hall.

ca. 1484 — Lippi executes a tempera panel, *Virgin and Child with Angels* (Casa di Risparmio, Florence). Unlike the San Gimignano *Annunciation* tondos or the Cleveland *Holy Family* tondo, ca. 1490s, the figures and architecture neither echo nor reinforce the round format, suggesting that he was experimenting with the shape.

Following the truce with the papacy in 1480, and recovery from the war with the papacy, new construction was begun and existing civic and religious buildings in Florence were embellished in the 1480s, with mural decoration enjoying renewed popularity. Although neither the patron nor the date is recorded, in the convent church of S. Maria del Carmine, Lippi completes frescoes in the Brancacci Chapel (see fig. 24–3). In the chapel was the 13ᵀᴴ–c. Byzantine icon (placed there after Felice Brancacci's exile in 1435 or his banishment as a rebel in 1458). The icon was a cult image, and the Compagnia della Madonna del Popolo was created about 1460 to care for it. Rather than Ghirlandaio (whose style was closer to Masaccio's), Lippi was selected to complete the frescoes perhaps because his father took holy vows at the Carmine. The scheme of Lippi's murals was surely predetermined by the existing frescoes, whose visual and symbolic coordination appears in the continuous narratives of the side walls, and he altered his style, blending Masaccio's drama and geometric structure with Masolino's

delicate, luminescent color. In finishing Masaccio's *Peter Raising Theophilus' Son*, he painted many portraits of Florentine men. On the north wall he painted his self-portrait, next to *Peter Delivered from Prison* and diagonally opposite the probable self-portrait of Masaccio (beside *Peter Enthroned*) and likely portraits of Masolino, Alberti, and Brunelleschi.

ca. 1485 — Lippi executes *Vision of Saint Bernard* for the Pugliese Chapel in the church of Le Campora at Marignolle.

1486 — On 20 February, Lippi completes his most important commission to this date, the *Enthroned Madonna and Child with Ss. John the Baptist, Victor, Bernard, and Zenobius*, 11'7.8"x 8'4.4" (355 x 255 cm), an altarpiece for the council chamber (Sala dei Dugento) in the town hall of Florence. He inscribed the date (Florentine style 1485) on the step: ANNO SALVTIS MCCCCLXXXV DIE XX FEBRVARI. The venerated saints were important to the civic and religious life of Florence: the Baptist was the town's patron saint; Florence defeated Pisa in the battle of Cascina on Victor's feast day (in 1364); the chapel of the Signoria (thus the town hall) was dedicated to Bernard; and Zenobius was the first bishop and a patron saint of Florence. Influence from Leonardo and the Flemish painters Memling and van der Goes can be seen in the treatment of nature.

1487 — Filippo Strozzi hires Lippi to decorate his chapel in S. Maria Novella, Florence (see figs. 39–4, 39–5); Lippi was to receive 300 gold florins for his work and expenses and to finish by 1 March 1490. The project got delayed.

Lippi is hired between 1487 and 1491 to create frescoes (destroyed 1820s) in Lorenzo de' Medici's villa at Spedaletto (see Ghirlandaio, ca. 1490).

Carafa Chapel, S. Maria Sopra Minerva, Rome

1 Tiburtine Sibyl: (scroll) NASCET[VR] CHRISTVS / IN BETALE / M (Christ will be born in Bethlehem)

2 Hellespontine Sibyl: (scroll of sibyl) [IE]SVS CHRISTVS NASCET / VR DE CASTA (Jesus Christ will be born to a chaste woman); (scroll of angel) IESVS / CHRIS / TVS / DEI / FILIVS / SERVA / TOR (Jesus Christ, the Son of God and Savior, from Augustine, *De civitate Dei*); (tablet of sibyl, which is nearly illegible) FLVMINA TVN LACT / IS TVNC FVMINA NETTA / RIS IB[A]VNT (Streams will flow with milk and sweet nectar, from Ovid, *Metamorphoses* I:III–II2)

3 Cumaean Sibyl: (scroll) IAM NOVA PR / OGENIES C[A]ELO D[E] / MITTITV / R ALTO (Now a new shoot will be sent out from the heights of heaven, from Virgil, *Fourth Eclogue*, 7)

4 Delphic Sibyl: (scroll) PROPH / ETA EX VIRGINI / NASCETVR (A prophet will be born to a Virgin)

5 *Annunciation to the Virgin Mary with S. Thomas Aquinas and Cardinal Carafa*

6 *Apostles Around the Virgin's Tomb* (S. Thomas in the left background)

7 *Assumption of the Virgin Mary*

8 *Miracle of the Crucifix, Vocation of S. Thomas Aquinas*

9 *Triumph of S. Thomas Aquinas*

10 *Tomb of Pope Paul IV Carafa*, 1566 (replaces Filippino's allegories of virtues conquering vices, as described by Vasari)

11 Papal bull of Pope Alexander VI (inscribed on marble tablet dated 14 June 1493) grants penitents worshipping in the chapel special indulgences on the Feast of the Virgin's Nativity and the Feast of Thomas Aquinas

12 Tomb vault of Carafa with *Stories of Virginia* (designs by Filippino, paintings by Raffaellino del Garbo)

39–3. Diagram of the Carafa Chapel frescoes (see fig. 39–2). Inscriptions are on the arch, DIVAE MARIAE VIRGINI ANNVNTIATAE ET DIVO THOME AQVINAT SACRVM (the dedication is to the Holy Virgin of the Annunciation and S. Thomas Aquinas), and on the keystone, OLIVERIVS / CARRAPHA / CAR NEAP / FECIT (Olivero Carafa, Cardinal of Naples, built this).

1488 — Lippi buys a building on Via degli Angioli (Alfani), which later becomes both home and shop. Lorenzo de' Medici pays 100 gold florins for a memorial in Spoleto Cathedral for Fra Filippo (buried there). Lippi designed the plaque; Politian wrote the epitaph. After Spoleto, Lippi travels to Rome (August), where Cardinal Olivero Carafa hired him (2 September) for 1,200 gold ducats to paint his chapel in S. Maria Sopra Minerva (see figs. 39–2, 39–3), consecrated to the Virgin of the Annunciation and to Thomas Aquinas (1225–74), Carafa's patron saint. Both the bibliophile cardinal and the Observant Dominicans venerated Aquinas: born into a noble family (distant relatives of the Carafa), Aquinas was a teacher, writer, and defender of the faith; and his voluminous *Summa Theologica* (1266–73) became central to Roman Catholic doctrine.

1491 — Lippi (not in Florence) submits a competition design for the Florence Duomo facade.

1492 — By this year, Lorenzo de' Medici hires Lippi to create murals (unfinished) for his new villa at Poggio a Caiano; the damaged *Sacrifice of Laocöon* (entry loggia, east wall) is all that remains.

ca. 1494 — Lippi marries Maddalena di Pietro Paolo de' Monti; they had five children (a daughter and four sons). His son Ruberto became a painter and Giovanni, a goldsmith and friend of Cellini.

1495 — With Duke Ludovico Sforza's approval, Lippi—recommended by an agent—is hired (7 March) by the Certosa of Pavia to create a Pietà painting (unfinished at his death). His contract was given to Albertinelli, who bought Lippi's panel from his wife. About this time, Filippino begins an altarpiece for the Tanai de' Nerli Chapel, S. Spirito, Florence.

1496 — Lippi completes *Adoration of the Magi* for the monastery church of S. Donato a Scopeto, Florence (see fig. 48–6) to replace Leonardo's (fig. 48–5).

1497 — Lippi signs and dates *Meeting at the Golden Gate*: MCCCCLXXXXVII PHILIPPINVVS DE FLORENTIA (Royal Museum, Copenhagen).

Lippi, Rosselli, Gozzoli, and Perugino evaluate Baldovinetti's frescoes in the chapel of the Gianfigliazzi, S. Trinità, Florence. Filippo Strozzi's second wife was a Gianfigliazzi. In this year Lippi wins legal action against the Strozzi for insufficient payment.

1498 — Lippi is hired (28 May) to paint an (unexecuted) altarpiece (Virgin and Saints) for the Great Council Hall, Palazzo della Signoria, Florence. The contract was reassigned to Fra Bartolommeo in 1510.

Lippi dates the street tabernacle *Madonna and Child with Ss. Anthony, Margaret, Catherine, and Stephen* at the corner of the Via del Mercatale in Prato (reconstructed, Museo Civico, Prato).

In June Lippi and others discuss repairing the lantern (struck by lightning, 1492) of the Florence Duomo.

1501 — Lippi signs and dates *Mystic Marriage of Catherine with Ss. John the Baptist, Peter, Paul, and Sebastian*, S. Domenico, Bologna.

1502 — For the council hall in the Palazzo Comunale in Prato, Lippi paints *Virgin and Child with Ss. Stephen and John the Baptist* (Museo Civico, Prato); the date inscribed on the painting is 1503.

1503 — Lippi signs and dates *S. Sebastian with John the Baptist and Francis* (Palazzo Bianco, Genoa) and *Madonna, Child, and Angels* (lunette) for the chapel of Napoleone Lomellini in S. Teodoro, Genoa.

For 200 gold scudi, he agrees to create (by Pentecost 1504) a double-sided painting for the high altar of SS. Annunziata, Florence. Only the top of the *Deposition* (Accademia, Florence) is finished at Lippi's death; Perugino completed this and painted other panels, 1505–6.

1504 — Lippi discusses the site for Michelangelo's *David* (see Botticelli).

On 20 April Lippi dies. On the day of his burial in S. Michele Visdomini, shops on Via dei Servi close.

Strozzi Chapel, S. Maria Novella, Florence

39–4. FILIPPINO LIPPI. Strozzi Chapel, 1487–1502, fresco, S. Maria Novella, Florence. Lippi signed (21 April 1487) a contract to paint frescoes (to be finished by March 1490) in the new chapel of Filippo Strozzi (1428–91), which is beside the choir in S. Maria Novella (see fig. 32–2). Lippi had earlier (1482) created designs for a *spalliera* for Strozzi, who must have allowed him to stop work on the chapel to begin the Carafa murals in Rome. Meanwhile, Benedetto da Maiano worked on Strozzi's chapel,

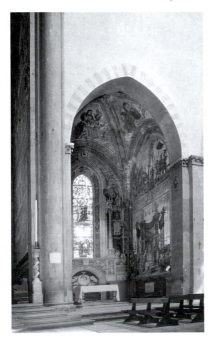

and construction of his palace (see fig. 64–5) began in 1489. From an honorable patrician family, Filippo's father and uncle Palla (see fig. 22–1) had been exiled from Florence by Cosimo de' Medici (1434); the ban was extended to include Strozzi sons (lifted in 1466). In exile Filippo became wealthy through banking, and invaluable to the Neapolitan throne; in 1479 he helped Lorenzo negotiate with Naples, thus building a new relationship with the Medici, after which he acquired the rights to the old Strozzi Chapel (1483) and his new chapel (1486).

39–5. **KEY TO THE CHAPEL FRESCOES.**
 Vault scenes: *Jacob* (1), *Abraham* (2), *Adam* (3), *Noah* (4)
5 *Crucifixion of S. Philip the Apostle in Hieropolis*
6 *S. Philip Exorcizes the Demon from the Temple*
7 *Martyrdom of S. John Evangelist in Boiling Oil*
8 *Raising of Drusiana* (signature and date)
9 Allegorical figures: *Virtues, Muses, Music*
10 *Madonna and Child with Ss. John the Evangelist and Philip* (stained-glass design by Filippino)
11 Benedetto da Maiano: *Tomb of Strozzi*, altar, floor, and *Madonna and Child* (altarpiece), 1495

Andrea Mantegna

Like the German painter Albrecht Dürer, Andrea Mantegna (1431–1506) was an expert printmaker, considered to be the best in Italy during his time. He was furthermore a distinguished painter of panels and murals and his archaeological approach to antiquity—inscribing works in Greek and in Latin—reflects knowledge he gained through friendships with humanists in Padua and Verona. At the Gonzaga court in Mantua, the ambitious Mantegna was more than a mere artisan. In 1472 Cardinal Francesco Gonzaga asked his father to send the artist to Poretta (where Francesco was taking the waters) so they could study his classical bronzes together; and in Mantua Lorenzo de' Medici stopped at the house of Mantegna (in 1483) to view his art and his antiquities. About this time Giovanni Santi wrote that he outstripped all the ancient artists, reigning foremost among his peers; by 1490 he had been granted the title Cornus Palatinus (Palatine Count), according to the inscription on the (lost) frescoes of Innocent VIII's Vatican chapel. Inspired in his early work by Donatello, he experimented with perspective, developing remarkable settings in the Ovetari Chapel, and his illusionism in the Camera Picta was unmatched by Florentine artists (see figs. 40–1, 40–2, 40–4). Highly esteemed by the Gonzaga, especially Ludovico and his granddaughter-in-law Isabella d'Este and her husband, Francesco II Gonzaga, Mantegna stayed nearly fifty years in Mantua, the birthplace of Virgil.

1431 — The son of a carpenter named Biagio, Andrea is likely born at Isola di Carturo, near Padua, his birth year based on an inscribed (lost) painting for S. Sofia, Padua, stating he was aged 17 in 1448.

1442 — In Padua, Andrea is the pupil of the painter Francesco Squarcione and is listed as his adopted son in records of the painters' guild.

1448 — Andrea contests the legality of Squarcione's adoption, receiving his freedom and the right to keep his earnings.

Mantegna and Niccolò Pizzolò (assisted Fra Filippo Lippi and Donatello in Padua) are contracted to execute half the frescoes in the burial chapel of Antonio Ovetari

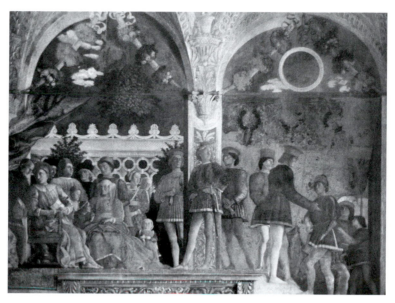

Fig. 40–1. ANDREA MANTEGNA. *Marchese Ludovico III Gonzaga with his Family and Courtiers*, 1465–74, fresco, Camera Picta (see also figs. 40–2, 40–4), Palazzo Ducale, Mantua. Vasari thought of Mantegna, not as a Paduan, but as a Mantuan, no doubt because of his ties to three generations of Gonzaga rulers in Mantua. Such court positions provided security but less freedom than most contemporary artists enjoyed, and Mantegna may have had second thoughts about taking the position (see entry 1460). Pisanello worked in the same palace for the same patron about 20 years before Mantegna, creating Arthurian tales in the great audience hall. However, the Camera Picta is a much smaller and more intimate room, and Mantegna's paintings are physically closer to viewers than are Pisanello's. This worked to Mantegna's advantage, as he brought this Gonzaga troop to life in its broad array of personalities. Pictured here are the ruling couple, Ludovico and his consort, Barbara of Brandenburg, the only two seated figures. Surounding them are their sons and daughters, dwarfs and courtiers, and the beseeching Mantuans (far right).

40–2. ANDREA MANTEGNA. *Meeting of the Gonzaga*, ca. 1465–74, oil on plaster, 26'6" x 26'6" (800 x 800 cm). Camera Picta (west wall), Palazzo Ducale, Mantua. Near these figures are putti holding a plaque dedicating the room to Marchese Ludovico III and his wife, Barbara of Brandenburg. A Gonzaga ambassador to Milan reported that the Milanese court thought the little room was exceptionally beautiful, and Ludovico Sforza felt slighted for not being portrayed, especially because men he thought less worthy than himself were pictured (the emperor and king of Denmark). An intimate Gonzaga picture gallery, the room is unique for the period; and this scene shows, not a specific, but an ideal meeting of people important to the marchese. (For the House of Gonzaga, see fig. V–2.)

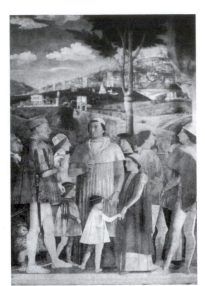

in the Eremitani, the Augustinian convent church in Padua near the Scrovegni Chapel (see Giotto). The Venetian Antonio Vivarini and his brother-in-law and partner, Giovanni d'Alemagna, were hired to create the remaining frescoes. Ovetari's will provided for the funding (his wife, Imperatrice Capodilista, administered the contract); on the walls were to be scenes of S. James Major and S. Christopher. After dissolving his partnership with Pizzolò (September), Mantegna was assigned three vault figures and all but one scene of S. James. In 1450 Giovanni d'Alemagna died, Vivarini withdrew from the Ovetari project in 1451, and in 1453 Pizzolò was killed.

1453 — Mantegna is hired to execute the *S. Luke Polyptych* in S. Giustina, Padua (Brera, Milan). About this time he marries Nicolosia, daughter of the Venetian painter Jacopo Bellini.

1457 — In charge of the Ovetari Chapel since 1454, Mantegna completes the murals (the frescoes are studied chiefly through photographs because only two works, *Assumption of the Virgin* and a scene of S. Christopher, survived the bomb of 1944 that destroyed much of the church). Not only did Venetian painters working in Padua influence Mantegna (Antonio Vivarini and Jacopo Bellini), but several Florentine painters in Padua (Fra Filippo Lippi and Uccello) and Venice (Castagno) influenced him as well. However, the sculptor Donatello most noticeably inspired the Ovetari paintings, especially the *all'antica* details of his *Equestrian Stat-*

ue of Gattamelata (see fig. 21–7); but his Santo reliefs had an even stronger influence on Mantegna's foreshortened, dramatic figures and complex arrangements of groups of figures within a measured and deep space modulated by the placement and the variety of the buildings.

1459 — In July, Mantegna completes the grand S. Zeno altarpiece (begun 1456), commissioned by Gregorio Correr for the high altar of the Benedictine church of S. Zeno in Verona. The main panel, 21'7.8" x 11'3.8" (660 x 345 cm), depicts the *Enthroned Madonna and Child with Saints*: on the left are Peter, Paul, John the Evangelist, and Zeno (bishop and patron saint of Verona) and on the right are John the Baptist, Gregory, Lawrence, and Benedict. In the predella are three scenes: the *Agony in the Garden* (Musée des Beaux-Arts, Tours), the *Crucifixion* (Louvre, Paris), and the *Resurrection* (Musée des Beaux-Arts, Tours).

Pope Pius II attends the Council of Mantua (see Quattrocento History Notes 1459); with him is Leon Battista Alberti, who will work for Ludovico III Gonzaga in Mantua and in Florence. Alberti's influence on Mantegna will be long lasting.

1460 — Mantegna becomes the court painter of Marchese Ludovico III Gonzaga of Mantua. Having earlier accepted the position, Mantegna delayed his move to Mantua until this year to finish the S. Zeno altarpiece. However, perhaps having reservations about the court

appointment, he bought a house in Padua and took on an apprentice in 1458. Yet Ludovico's offer, as recorded in a letter of 15 April 1458, was too attractive to refuse: he was to receive 180 ducats annually, a place for his family to live, enough food for six people, and moving expenses; and in 1459, he was granted the use of one of Ludovico's heraldic devices, a resplendent sun bearing the motto *per un sol desir* (with one desire). The artist thus came highly valued to the Gonzaga court. His duties included ephemeral decoration, court portraits, designs for fabrics and vessels, and panels and murals of religious and secular themes. For the (lost) small chapel in the Castel S. Giorgio he painted four remarkable panels: *Circumcision and Presentation of Christ*, *Adoration of the Magi*, and *Ascension* (all in the Uffizi Gallery, Florence), and the *Death of the Virgin* (Prado, Madrid), a fragment of which shows Christ holding the Virgin's soul (Pinacoteca, Ferrara). The *Adoration of the Magi* was above the altar, its curved surface enhancing the sense of movement and distance already traveled by the Magi, who are approaching the infant Christ. Mary is in a rock cave, as she often appears in Byzantine works, and one king is a black man, the first in this theme portrayed in Italian art, suggesting Mantegna was influenced by Northern art.

1465 — By June, Mantegna has begun the Camera Picta (called Camera degli Sposi), a room for private and official events completed in 1474 for Ludovico III Gonzaga. The vault is in fresco and the two main walls were painted with pigments mixed in oil (see figs. 40–1, 40–2). The entire decoration is a tour de force of illusionism. On the smooth, curved surface of

the vault are fictive gold mosaics, marble reliefs of pagan stories, and portraits of Roman rulers (see fig. 40–4). Gonzaga servants and putti are shown highly foreshortened and seeming to look down from a Pantheon-like oculus in the ceiling, a *di sotto in sù* view. Like Borso d'Este's *Hall of Months* (Palazzo Schifanoia, Ferrara, ca. 1466–70), this imagery combines portrait and allegory to portray Ludovico as the good and virtuous ruler of a prosperous realm. Yet these murals celebrate, more than anything else, the ideals of family and the Gonzaga dynasty.

1466 — Mantegna makes a trip to Florence (and another in 1467), where the foreshortened image of Mary in Castagno's (destroyed) *Death of the Virgin* in the church of S. Egidio must have inspired him, as did Donatello's sculpture in S. Lorenzo: the sacristy reliefs and his gilded bronze Passion reliefs, much later made into pulpits.

ca. 1467 — In his possession at his death, *Foreshortened Christ* (Brera, Milan), 2'2.8" x 2'8.9" (68 x 81 cm), painted in distemper on canvas, was likely inspired by Donatello's Passion reliefs that bring the figure of Christ close to worshippers. Mantegna's gripping image shows Christ's feet intruding into the viewer's space, graphically displaying wounded flesh and skin shredded from nails.

1488 — In Rome (first trip), Mantegna creates (destroyed 1780) murals for Pope Innocent VIII's Belvedere Chapel, Vatican Palace, 1489–90.

ca. 1495 — For Marchesa Isabella d'Este's *studiolo* (study) he creates

40–3. This illustration identifies individuals depicted in *Meeting of the Gonzaga* (fig. 40–2).

KEY TO DIAGRAM.

1 Ludovico III Gonzaga (b. 1412), second marchese of Mantua

2 Gianfrancesco Gonzaga (b. 1446, son of Ludovico)?

3 Francesco II Gonzaga (b. 1466, son of Federico I and grandson of Ludovico III), fourth marchese of Mantua, marries Isabella d'Este

4 Francesco Gonzaga (b. 1444, son of Ludovico III), named cardinal, 1461

5 Sigismondo Gonzaga (b. 1469, son of Federico I and grandson of Ludovico III), named cardinal, 1506

6 King Christian I of Denmark?

7 Ludovico Gonzaga (b. 1460), youngest son of Ludovico III, appointed bishop of Mantua, 1483

8 Emperor Frederick III?

9 Christian I of Denmark?

10 Federico I Gonzaga (b. 1441, son of Ludovico III), third marchese of Mantua

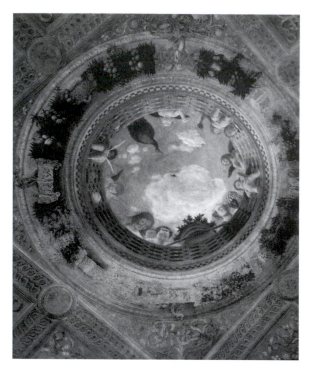

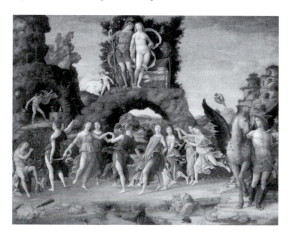

40–4 (left). ANDREA MANTEGNA. Ceiling (detail), Camera Picta, 1465–74, fresco, Palazzo Ducale, Mantua. Perhaps Mantegna's greatest experimentation with illusionism, his *di sotto in sù* view shows the type of sporting humor that later appeared in Mantua in the art of Giulio Romano (see fig. 55–1). Poised around the fictive oculus are about a dozen foreshortened figures, mostly young women and winged male babies (ancient Roman putti) spying on visitors. They poke their heads over the railing and through openings in the drum, threatening to invade an onlooker's space with the tossing of an apple or the nudging of the vase overhanging its support. Disgruntled visitors to the Council of Mantua in 1459, who left the city complaining about the bad air and lack of beauty, would have enjoyed Mantegna's fictive decoration had they returned.

40–5 (below). ANDREA MANTEGNA. *Parnassus*, ca. 1495–97, oil on canvas, 5'3.5" x 6'3.7" (159 x 192 cm), Louvre, Paris. Created for Isabella d'Este's *studiolo* in the south tower of Castel S. Giorgio, known as Palazzo Ducale since 1530 (the Camera Picta is in the north tower). Cabinets were installed (1508) in her *grotta* (a vaulted, cave-like room) to hold her collection (books, antique art, musical instruments), while paintings decorated the walls of her *studiolo* (see also Perugino). *Parnassus* celebrates the Gonzaga and Este union and alludes to the harmony of love and the arts, singling out five major Olympians: Venus and Mars, arms entwined, are atop a natural arch, while son Cupid blows darts at Vulcan; Apollo plays his lyre for the nine dancing Muses on Mt. Helicon (Isabella was called the tenth muse); Mercury nestles Pegasus, who is creating the Hippocrene (Horse Spring). The scene resembles high-relief cameos, each figure sharply defined and meticulously modeled. Vasari rightly observed that Mantegna's figures are more stone than flesh. The composition suggests he conceived figures as single pieces that he set upon a rarefied stage, his fresh mountain springs providing a visual reprieve from the stagnant, mosquito-infested waters of Mantua.

Parnassus (see fig. 40–5), and in 1502 he completed *Triumph of Virtue*. Married to Francesco II (11 Feb. 1490), Isabella raised seven children and ruled Mantua in her husband's absence. Well educated in Ferrara, a notable musician and respected art collector, she patronized humanists and artists, and purchased (1506) from Mantegna his valued Roman figure of Empress Faustina.

1496 — Mantegna finishes the festive *Madonna of Victory* (Louvre, Paris), 9'2.3" x 5'3" (280 x 160 cm), commemorating Marchese Francesco II Gonzaga's defeat of the French at Fornovo (1495). It is akin to the S. Zeno altarpiece, but with a triumphal foliate arch, whose fruits and birds are symbolic of redemption and paradise. For Francesco he likely also made the *Triumphs of Caesar* (ca. 1484–1505).

1504 — In the bronze *all'antica* self-portrait for his burial chapel he created (dedicated to S. John the Baptist) in S. Andrea, Mantua, the bare-chested artist wears only a laurel crown. Recalling an ancient tradition, he is likened to such famous classical artists as Zeuxis and Apelles. His bust is attached to a marble-framed porphyry tondo.

1506 — Mantegna dies in Mantua (13 September).

Luca Signorelli

Trained in the Sansepolcro workshop of Piero della Francesca, Luca Signorelli (ca. 1450–1523) was probably a fellow student with Perugino, with whom his artistic path intersected several times during the course of his long career. These two painters were given a special place in Vasari's story of Italian art because Perugino trained Raphael and Signorelli inspired Michelangelo. Vasari also claimed (inaccurately) that Luca was a distant cousin, the nephew of Vasari's grandfather, Lazzaro. In 1568 he concluded the second part of the *Lives*, not with Perugino as he had done in the first edition (1550), but with Signorelli, emphasizing that he was blessed with *terribilità*, inventiveness, and brilliance (traits he also ascribed to Michelangelo). Observing that Luca's works were held in the highest esteem while he was living, he surmised this was chiefly because of his ability to bring nude figures to life, an accomplishment unmatched by his peers. Luca's participation in the Sistine established his career. His inclusion surely reflects Pope Sixtus IV's favorable response to his Loreto murals. Giovanni Santi, Raphael's painter father, complimented him in *Cronaca rimata* (Rhymed Chronicle), ca. 1480–90, a poem giving an account of his patron's, Federico II da Montefeltro's, life at the Urbino court. Evaluating several generations of artists (including Masaccio and Piero della Francesca), Santi placed Signorelli and Perugino among the contemporary, highly admired painters:

> Two young ones, equal in their gifts and
> ages, Leonardo da Vinci and Perugino,
> That Piero from Pieve, godlike painter.
> Ghirlandaio, younger Filippino,
> Sandro di Botticelli, and from Cortona
> Luca, so special in his gifts and spirit.

ca. 1450 — Luca is born in Cortona, perhaps as early as 1444, to the painter Egidio di Luca di Ventura and Bartolomea Schiffi.

1470 — Luca decorates an organ in the Landi church in Cortona. According to Vasari, he was Piero della Francesca's pupil and dependent in Sansepolcro, and afterward lived with Lazzaro Vasari in Arezzo while collaborating there with Piero della Francesca.

ca. 1472 — Few paintings exist from Luca's early period. Vasari mentioned (lost) frescoes in the S. Barbara Chapel, S. Lorenzo, Arezzo, and (lost) processional standards for two confraternities.

1474 — Luca completes frescoes on the town hall of Città di Castello, but only fragments remain (*S. Paul*, Pinacoteca, Città di Castello).

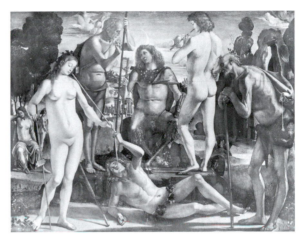

41–1. LUCA SIGNORELLI. *Court of Pan* (destroyed 1945), ca. 1491, oil on canvas, 6'4.4" x 8'5.1" (194 x 257 cm), formerly Kaiser Friedrich Museum, Berlin. The shepherd to Pan's right, who addresses the pagan god, has features that resemble portraits of Cosimo de' Medici (d. 1464). This man is meant to be distinguished from the others: his straight-legged pose is less natural than the contrapposto stances of the other figures, and he casts no shadows, standing on turf unlike the ground beneath the feet of the other figures. Above his head is an equestrian formed by clouds, perhaps a reference to past ages and an arcadian paradise. Inspired by classical literature, such anthropomorphic clouds also appear in Mantegna's works (*S. Sebastian*, Kunsthistorisches Museum, Vienna). Melding Christian and classical prototypes, Luca positioned the devotees of Pan like holy saints accompanying an enthroned Madonna, his nude young nymphs and shepherds resembling polished marble antique statues and sparsely clothed, gray-haired shepherds appearing like hermit saints (see Luca's *S. Onuphrius Altarpiece*, 1484, Museo Capitolare, Perugia).

41–2. Diagram of the entry (north interior) wall, Cappella Nuova, Orvieto Cathedral (see fig. 41–4).

41–3. LUCA SIGNORELLI. *Virgin and Child with Prophets*, ca. 1491, oil on panel, 5'6.9" x 3'10.3" (170 x 117.5 cm), Uffizi Gallery, Florence. Mary and Christ are in a verdant landscape that changes behind them to barren ground, antique buildings and four scantily clad shepherds playing reed flutes. Unaware of Christ, they represent the pagan world, distinguished by Church writers from the time of Mosaic Law and that of grace (under the Messiah). Luca shows all three realms, calling attention to Christ's sacrifice (see fig. 51–1). Plants near Mary are symbolic of her humility (violets), purity (chrysanthemums), and sorrow (cyclamen). With bare feet, she humbly sits on the ground, attending to the Messiah, whose nudity refers to the Word made flesh. Plants near Christ allude to his sacrifice (aconite) and to human salvation (mallow).

1477 — No documents confirm the dates of Luca's activity in the sacristy of S. John, church of S. Casa (the Holy House), Loreto, but his work is generally dated ca. 1477–82. An alternate theory places the frescoes after his work in the Sistine Chapel, ca. 1484–87. On the vault of the octagonal sacristy he painted four Evangelists and four Latin Church Fathers, each on a separate facet and with a music-making angel. On the octagonal walls he painted five paired apostles, *Incredulity of Thomas*, and *Conversion of Paul* (in the eighth field is a window).

1482 — Signorelli, Bartolomeo della Gatta, and others execute *Last Testament of Moses*, Sistine Chapel, Rome.

1484 — For Jacopo Vagnucci, a native of Cortona and the bishop of Perugia, Luca completes *S. Onuphrius Altarpiece*, depicting the Virgin and Child with Ss. Onuphrius, John the Baptist, Lawrence, and Ercolanus. Created for the Chapel of S. Onuphrius in S. Lorenzo (the cathedral), Luca's figures resemble the S. Casa apostles, and reflect his knowledge of Verrocchio's and the Pollaiuolos' styles to which he added stylistic traits of Carlo Crivelli (ca. 1435–95), Mantegna, and Hugo Van der Goes, typically adapting without imitating his sources.

ca. 1488 — For the Bichi Chapel (whitewashed and covered by a barrel vault, mid–18TH c.; uncovered, 1977) in S. Agostino, Siena, Luca creates images of sibyls in the vault.

ca. 1489 — Luca paints *Holy Family Tondo* (Uffizi Gallery, Florence), 4'.9" (124 cm), with solemn, bulky figures similar to the Loreto murals. This is likely the work Vasari saw in the Guelph party palace.

ca. 1490 — Luca signs a double-sided processional standard, likely for the church of S. Maria del Mercato, Fabriano (45 miles from Perugia). *Madonna del Latte* (front) is now cut apart from the *Flagellation* (back) (Brera, Milan). Luca's *Flagellation* resembles Piero della Francesca's *Flagellation* for the Urbino court (Palazzo Ducale, Urbino).

1491 — In Volterra Luca paints two oil panels with life-size figures and classical motifs (both Pinacoteca Civica, Volterra). *Annunciation* (signed and dated on the central pilaster) was executed for the altar in the oratory of the confraternity of the Virgin of the cathedral. *Virgin and Child with Ss. John the Baptist, Francis, Anthony of Padua, Peter, Jerome, Bonaventure* was for S. Francesco, and is dated on a *cartellino* beneath Mary's throne, whose base has a monochromatic frieze resembling an antique Roman sarcophagus.

ca. 1491 — Vasari noted that Luca created two works for Lorenzo de' Medici. One is identified as *Court of Pan*, an allegory about music and poetry (see fig. 41–1). Four nearly life-size woodland figures gather around the pagan satyr Pan, worshipped in Arcadia as the protector of flocks and the inventor of the syrinx (reed pipes). In the manner of antiquity, Luca created a young and handsome hybrid. His enthroned Pan holds the shepherd's crook and syrinx, and his head is crowned by two crescent moons and his shoulders are draped in a satiny cape sprinkled with stars. The second work linked to Lorenzo (see fig. 41–3) is described (Medici inventory, 1516) in the town palace of Lorenzo di Pierfrancesco (1463–1503), whose guardian was Lorenzo the Magnificent. Vasari saw the work at the Medici Villa at Castello.

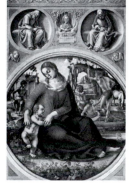

Cappella Nuova, Orvieto

41–4. This diagram of the Cappella Nuova (Chapel of the Madonna of S. Brizio since 1622) identifies Luca's frescoes and shows the two smaller incorporated chapels; relics of two saints are entombed in one chapel (west wall). When Luca began work in 1499 in the Cappella Nuova, two vault quadrants of the first bay had already been painted by Fra Angelico, but his work was left unfinished. Ten years before Luca was hired, Perugino was contracted to complete Angelico's work, but he never really started the project. Luca agreed to work for less money than Perugino, and he fulfilled his commitment quickly, completing the two remaining quadrants of the first bay with Angelico's cartoons, as stipulated by the patrons. Luca then submitted a proposal drawing (23 April 1500) for additional murals and was hired for 575 ducats and food and housing to decorate the remaining walls of the chapel. He finished in 1503, receiving the final payment in 1504. Angelico likely designed the placement for the Last Judgment scenes, and the content was perhaps decided when the chapel was first commissioned. Distinctly Luca, however, is his unique emphasis on the dynamic relationships of his predominantly nude, athletic figures. At the apex of the interior entrance wall (see fig. 41–2) is a big medallion (bearing a cross and the insignia of the cathedral *fabrica*).

Symbolic of the communion Host, it is held by an angel, high above his head, as he faces the Pantocrator and the altar, focusing worshippers on the significance of the institution of the Eucharist in the perpetual celebration of Christ's sacrifice for the redemption of humankind. The monumental white disk dominates the wall and can be seen while looking across the opposite chapel, which enshrines the miraculous corporal from the Mass of Bolsena (see Duecento History Notes 1263).

Luca signs the large oil panel *Circumcision of Christ*: LUCVS / CORTONENSIS / PINXIT (National Gallery, London). It was recorded (1558–1732) in the oratory of the Company of the Holy Name of Jesus of S. Francesco, Volterra. Vasari noted that Giovanni Bazzi, called Sodoma (1477–1549), repainted the Child.

Luca paints *Portrait of a Man* (Gemäldegalerie, Berlin). Shown bust-length, the man is thought to be a lawyer. Behind him are men scuffling and battling, perhaps alluding to the arbitration of conflicts.

ca. 1492 — Luca creates *S. Mary Magdalene Before Christ on the Cross* for the Annalena convent, Florence, with life-size figures of Christ and Mary in the foreground. Pilate's words (Jesus of Nazareth King of the Jews) are in Hebrew, Greek, and Latin on the plaque above Christ; the skull by the cross alludes to ORIGINAL SIN (see Duecento Glossary).

1494 — For the confraternity of the Holy Spirit in Urbino, Luca paints a two-sided canvas banner, with *Descent of the Holy Ghost* (front) and *Crucifixion* (back) (National Gallery of the Marches, Urbino).

1496 — Luca paints the *Adoration of the Shepherds* (National Gallery, London), recorded in S. Francesco, Città del Castello (16TH c.); his name is inscribed on a portico: LVCE. DE CORTONA. P.[ICTORIS] O.[PVS].

1497 — Luca paints murals in nine lunettes on the west side of the great cloister in the Olivetan mother house, Monteoliveto Maggiore (near Siena). He left for Orvieto in 1499; Sodoma finished the cycle.

1498 — For the Brozzi Chapel in S. Domenico, Città di Castello, Luca executes *Martyrdom of S. Sebastian* (Pinacoteca, Città di Castello), dated on the original frame. Several motifs were inspired by Florentines: the foreshortened figure of God and Sebastian are like Castagno's *Trinity* and Pollaiuolo's *Martyrdom of Sebastian*, and the street scene resembles Filippino's Nerli Altarpiece (ca. 1495–98), S. Spirito, Florence.

1499 — On 5 April Luca signs a contract for the Cappella Nuova, Orvieto Cathedral (see fig. 41–4).

ca. 1500 — Luca creates the monochromatic oil panel *Allegory of Abundance* (Uffizi Gallery, Florence).

1502 — Luca paints *Lamentation* for S. Margherita in Cortona (Museo Diocesano, Cortona).

1505/7 — For the confraternity of S. Anthony Abbot in Sansepolcro, Luca paints a canvas banner showing *Crucifixion with Saints* (John the Evangelist, Anthony Abbot, Mary Magdalene, and the fainted Virgin attended by Mary Cleophas and Mary Salome). On the reverse are colossal figures, *Ss. Anthony Abbot and Eligius*, with four miniature supplicant patrons (anonymous members of the confraternity) as flagellants (Pinacoteca Communale, Sansepolcro).

1506 — Luca executes a grand cartoon, *Judgment of Solomon,* for an (unexecuted) inlaid marble pavement, intended to cover the crossing where Duccio's *Maestà* once stood in Siena Cathedral.

1508 — In Bramante's house in Rome, Luca dines with the Umbrian painters Perugino, Pintoricchio, and Giovan Battista Caporali. All that remains of his work in the Vatican Palace (repainted by Raphael), is a grisaille figure above *Expulsion of Atilla.*

1509 — In Siena, Luca is named godfather to Pintoricchio's newborn son. For a room in Pandolfo Petrucci's Siena palace (Palazzo del Magnifico), Luca designs four wall murals of pagan subjects. Two frescoes were detached and transferred to canvas: *Triumph of Chastity* and *Coriolanus Persuaded by His Family to Spare Rome* (both National Gallery, London). Luca's name is inscribed on a *cartellino*: LVCAS CORITIV[S]. His two other murals (whitewashed or destroyed) were the *Calumny of Apelles* and the *Festival of Pan*. Pintoricchio designed the ceiling and two wall murals, Genga designed two wall murals, and Antonio Barili designed the carved woodwork. The works are all dated 1509, based on the year inscribed on a floor tile celebrating the marriage of Borghese Petrucci to Vittoria Piccolomini. Both families' arms appear on the woodwork and floor tiles.

1512 — Luca inscribes his name (LVCAS SIGNOREL /LVS

CORYTHONL /NSIS PINGEBAT) and date (MDXII) on two piers in *Communion of the Apostles*, a large altarpiece for the lay confraternity of the Blessed Jesus (Museo Diocesano, Cortona). An uncommon subject, it is similar to Justus of Ghent's *Communion of the Apostles* for Federico II Montefeltro, duke of Urbino, in which Christ offers holy wafers to the apostles (1474). Luca's Judas furtively places something (Vasari thought it to be a holy wafer) in his purse.

1515 — Luca is about 65 years old when he completes the large oil panel, *Virgin and Child with Saints* (Jerome, Sebastian, Christina, Nicholas) (National Gallery, London), for the newly built Chapel of S. Christina in S. Francesco at Montone (about 25 miles east of Cortona). On a *cartellino* he signed and dated the work (stating that he was a distinguished painter from Cortona) and named his patrons (physician Lodovicus de Rutenis and his wife, Tomasina). The work was to pay for past and future medical bills for Luca and his family. When dismantled, the main panel was separated from the predella (Brera Pinacoteca, Milan).

1519 — Luca is hired (19 September) by the confraternity of S. Jerome, Arezzo, to paint *Virgin and Child with Saints* (Jerome, Donatus, Stephen, Nicholas) *and Prophets* (David and two others), finished 1522 (Pinacoteca, Arezzo). Vasari noted that Niccolò Gamurrini (a judge in the Rotà), shown beside S. Nicholas, provided money for the altarpiece. After its delivery, it was decided that if (in 6 months) the blue of Mary's garment was found unacceptable, Guillaume Marcillat (1467–1529), the French glassmaker who had moved to Arezzo from Cortona (where he and Luca had professional dealings), would repaint it in ultramarine. Guillaume designed the stone altarpiece frame. A predella showing *Esther before Ahasuerus* and *Three Visions of the Triumph of Jerome* (National Gallery, London) has been linked to the altarpiece. The width of the predella (shorter than the main panel) and the paint application to the right edge suggest that it has been cut down.

1522 — For the Pieve di S. Martino, Foiano della Chiana (about 10 miles west of Cortona), Luca is hired to create *Coronation of the Virgin* (finished 1523), perhaps his last work, and chiefly by assistants.

1523 — Luca dies in Cortona (October 23/24).

Never accorded quite the fame that his pupil Raphael enjoyed, the Umbrian painter Pietro Perugino (1450–1523) was propelled to international recognition by the Franciscan Pope Sixtus IV, who assigned him murals in Old S. Peter's and the Sistine Chapel in the 1480s, with the *Delivery of the Keys to S. Peter* (see fig. 42–1) gaining immediate and broad acclaim. Perugino soon afterward became a favored painter of both Church and state. He worked for prominent nobles (Isabella d'Este and Ludovico Sforza), wealthy statesmen (Lorenzo de' Medici), and four different popes. Praised for his luminous color, graceful and serene figures, and verdant, rolling landscapes, he had more patrons than Botticelli or Signorelli and more commissions than his shop could execute in the decades of the 1480s and 1490s. The consummate businessman, his practicality and artistic sensitivity allowed him to work simultaneously on multiple contracts while managing workshops in Florence and Perugia, his adopted town (after which he was nicknamed, "the one from Perugia"). His paintings were always in demand during his lifetime, with important clients waiting years to receive his works (Isabella d'Este and the Perugia town governors). Yet, during the last two decades of his life, as Raphael and Michelangelo carried out the valued contracts of Pope Julius II in Rome, Perugino worked primarily in provincial towns, as did Signorelli. Although his career is better documented than many artists (Vasari listed about fifty paintings, and some 300 records exist), fascination with the talented Raphael has overshadowed a clear understanding of Perugino's sizable contribution to Italian art.

ca. 1450 — Named after his grandfather, Pietro Vannucci is born to well-off parents, Lucia di Jacopo Nunzio Betti and Cristoforo di Pietro Vannucci, in Castello della Pieve (modern Città della Pieve), a village under Perugia's control since 1198.

1470 — By this year, Perugino is likely in Florence and is probably working in Verrocchio's shop. Vasari thought that he was trained there, but he also wrote (in the life of Piero della Francesca) that Perugino and Luca Signorelli were Piero's pupils in Arezzo.

1472 — In Florence, Perugino's name appears in the *Libro rosso* of the Confraternity of S. Luke.

ca. 1475 — Perugino paints the oil panel *Adoration of the Magi*, likely the work that Vasari noted was made for the Servite Order in Perugia (National Gallery of Umbria, Perugia). It has stylistic traits

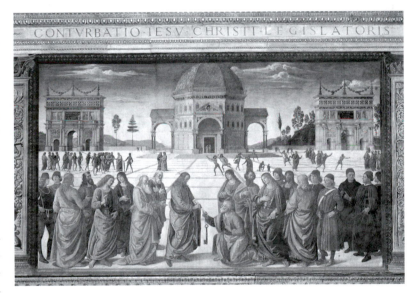

42–1. PIETRO PERUGINO. *Delivery of the Keys to S. Peter*, ca. 1482, fresco, 11'5.5" x 18'8.5" (349.3 x 562.6 cm), Sistine Chapel, Vatican, Rome. With these monumental figures, the broad and open piazza, *all'antica* architecture, and seemingly infinite space, Perugino surely inspired the artists Vasari cited as the creators of the modern style, Raphael and Michelangelo. Perugino's placement of this scene in Rome (see fig. 42–4), with Christ giving Peter two keys (insignia of the papacy: silver for earth and gold for heaven), underpinned the papal belief that the bishops of Rome are Peter's true successors.

Perugino signed a contract (27 October 1481) with three Florentine painters (Cosimo Rosselli, Botticelli, and Ghirlandaio) for ten paintings in the Sistine Chapel. Within three months, a document (17 January 1482) would call for an assessment of work already completed in four bays of the chapel. A third contract commissioned work from Bartolomeo della Gatta and Signorelli. Pintoricchio helped Perugino paint frescoes on the side walls, *Baptism of Christ* and *Circumcision of Moses' Son*, Bartolomeo della Gatta helped paint *Delivery of the Keys to S. Peter*, and both helped Perugino paint some images of popes on the upper register. We can imagine that in the early stages of this project a master plan was designed for painting the enormous chapel, allowing the artists to work in harmony. They collectively painted about 100 yards of wall in a short time, with each painter hiring his own assistants. This procedure effectively created independent shops within a larger shop that was likely overseen by Perugino (see figs. 42–3, 42–4).

common to Florentine, Umbrian, and Flemish artists.

1475 — Perugino receives five florins for (lost) work in the Great Hall of the Palazzo dei Priori (town hall), Perugia.

ca. 1478 — Once attributed to Fiorenzo di Lorenzo, but now thought to be by Perugino, *Pietà with Ss. Jerome and Mary Magdalene* (National Gallery of Umbria, Perugia) is a devotional image in tempera on linen, perhaps a processional banner (from the Franciscan convent church at Farneto).

1478 — Perugino paints *Ss. Roch, Sebastian, and Peter* (fresco fragment) for the parish church of S. Maria Assunta, Cerqueto (near Perugia). Signed and dated (read both as 1473 and 1478), his work shows knowledge of Verrocchio, Pollaiuolo, and Piero della Francesca in the stance, color, and musculature of Sebastian.

1479 — In Old S. Peter's, Rome, Perugino completes the (lost) apse fresco in the burial chapel (destroyed 1606) of Sixtus IV (d. 1484). Only a summary sketch after his *Assumption of the Virgin* exists. Sixtus later hired him for the Sistine murals.

1480 — Perugino is at work in the Sistine Chapel (see figs. 42–1, 42–3, 42–4).

1482 — Due to his Roman success a contract is awarded (5 October) to Perugino and Biagio d'Antonio for work in the Sala dei Gigli (see fig. 42–8), town hall, Florence. However, the contract was reassigned (31 December) to Filippino Lippi.

1483 — Perugino agrees (28 November) to paint an altarpiece in four months' time for the Decemviri Chapel (chapel of the priors), town hall, Perugia. The contract was withdrawn (31 December) when he left the city without beginning

work, was reinstated in 1485, and completed in 1496.

1484 — Perugino, Antoniazzo Romano, and others are paid (20 November) for banners, crests and other decorations for Pope Innocent VIII's coronation in Rome.

1485 — Perugino is in Città della Pieve. Work for Pope Innocent VIII is recorded in this year (26 May), and he becomes a citizen of Perugia (26 December).

1486 — Perugino joins the painters' guild in Perugia. In Assisi he paints the (fragment) *Crucifixion* fresco on the Chapel of the Porziuncola, S. Maria degli Angeli. In Florence he paints (lost) cloister frescoes and panels ca. 1486–97 for the Gesuati monks of S. Giusto alle Mura.

1487 — A judicial body (Otto di Custodia) finds Perugino guilty of assaulting someone (previous December). While he is fined, his co-defendant, Aulista d'Angelo, is flogged and exiled from Florence.

1489 — In Florence, Perugino is hired to paint *Vision of S. Bernard* (finished 1493) for the Nasi Chapel in S. Maria Maddalena in Cestello (see fig. 62–7, #13).

In Orvieto, Perugino is hired for 200 gold ducats to paint murals in the Cappella Nuova of the cathedral (see fig. 41–4); Angelico left the vault frescoes unfinished in 1447. When Perugino did not begin work, the patrons considered hiring other artists on two occasions: Antoniazzo in 1491 and Antonio da Viterbo in 1498. Each time Perugino convinced them he would fulfill his contract. However, in 1499 Signorelli was hired to paint the chapel (see Signorelli 1499).

ca. 1490 — Perugino paints frescoes in Lorenzo de' Medici's villa at Spedaletto (see Ghirlandaio ca. 1490).

1491 — In Florence, Perugino and others judge facade designs for the Duomo (see Botticelli 1491, Filippino 1491).

1492 — In Rome, Perugino, Antoniazzo, and Pier Matteo d'Amelia create decorations for Alexander VI's coronation.

1493 — In Florence, Perugino marries Chiara, the daughter of the architect and sculptor Luca Fancelli; Luca worked at the Mantuan court of Francesco II Gonzaga, the husband of Isabella d'Este.

Perugino signs and dates the large *Virgin and Child with Ss. John the Baptist and Sebastian* (Uffizi Gallery, Florence) for the chapel of Cornelia di Giovanni Martini Salviati da Venezia in the church of S. Domenico, Fiesole. Among his most admired works (Vasari noted that the figure of Sebastian was highly praised), this altarpiece was the model for another, in S. Agostino, Cremona: *Madonna and Child Enthroned with Ss. John the Evangelist and Augustine*, signed and dated 1494. Both represent a classical phase in Perugino's career in which he created monumental, sculptural figures seated in loggias before open landscapes with low horizon lines. Poised and noble in demeanor, the saints—through glance and gesture—engage worshippers, and their serenity encourages meditation.

1494 — In Venice, Perugino negotiates a commission for (never executed) murals of narratives and ducal portraits in the Grand Council Hall, Doge's Palace.

Perugino paints *Portrait of Francesco delle Opere* (Uffizi Gallery, Florence), brother of the gem-collector Giovanni delle Corniole (until 1815 attributed to Raphael).

1495 — In Florence, Perugino paints a panel of the *Lamentation* (Galleria Palatina, Palazzo Pitti, Florence) for the nuns of S. Chiara, signed and dated beneath the dead Christ. According to Vasari, Francesco del Pugliese wanted to buy this painting from the convent.

Perugino is in Venice, perhaps to paint a (lost) canvas for the Scuola di San Giovanni Evangelista (one of five great lay confraternities).

1496 — Perugino completes *Virgin and Child Enthroned with Ss. Ercolano, Costanzo, Lawrence, Louis of Toulouse* (Pinacoteca Vaticana) for the Chapel of the Priors, Perugia (see 1483).

In Florence, Perugino completes the *Crucifixion*, a mural in the chapter room of the Cistercian convent of S. Maria Maddalena in Cestello, which had been contracted by Dionigi and Giovanna Pucci (1492). For the same church he executed *Vision of S. Bernard* (see 1489).

1497 — Perugino completes an altarpiece (begun 1488) for S. Maria Nuova, Fano.

1500 — Perugino paints (begun 1495) a multiple-tiered polyptych for the church of S. Pietro, Perugia (National Gallery of Umbria, Perugia).

For the Certosa of Pavia (Carthusian monastery south of Milan), Perugino completes three panels for a two-storied polyptych: (lower tier) left, *Michael the*

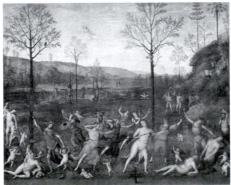

42–2. PIETRO PERUGINO. *Combat Between Love and Chastity*, completed 1505, oil on canvas, 5'2.8" x 6'3.1" (160 x 191 cm), Musée du Louvre, Paris. Since 1497, Isabella doggedly sought to have a painting by Perugino for her *studiolo*. Finally, in 1503 he signed a contract containing her detailed instructions about the theme and composition. In 1505 she paid to have the painting transported to Mantua, where she installed it beside two by Mantegna (see fig. 40–5). Rarely did Perugino paint violent actions or battles, and his figures seem more like dancers than like warriors. The frieze-like arrangement was perhaps inspired by Roman murals and marble reliefs, while the rhythmic, figure-locked groupings may have been more influenced by the explosive, intertwined figures of Michelangelo's and Leonardo's battle cartoons underway in the Palazzo della Signoria, Florence. When Perugino's painting was acquired by Cardinal Richelieu, a strip of canvas about 4.8" in height was added to the top to make it match the height of Mantegna's.

Sistine Chapel Wall Frescoes

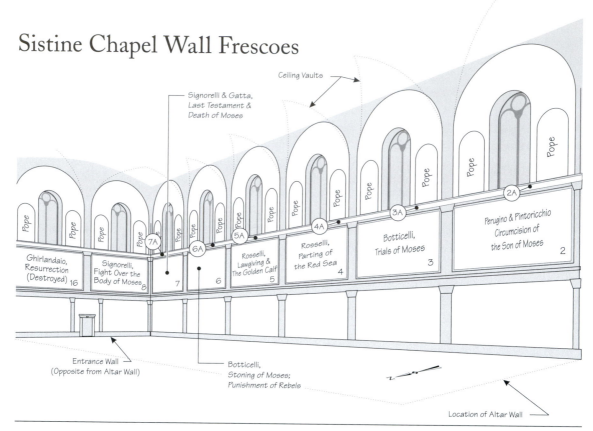

Ceiling Vaults

Signorelli & Gatta,
Last Testament &
Death of Moses

Pope · Pope · Pope · Pope · 7A · Pope · Pope · Pope · 6A · 5A · Pope · Pope · 4A · Pope · Pope · Pope · 3A · Pope · 2A · Pope

Perugino & Pintoricchio
Circumcision of
the Son of Moses 2

Botticelli,
Trials of Moses 3

Rosselli,
Parting of
the Red Sea 4

Rosselli,
Lawgiving &
The Golden Calf 5

6

7

Signorelli,
Fight Over the
Body of Moses 8

Ghirlandaio,
Resurrection
(Destroyed) 16

Entrance Wall
(Opposite from Altar Wall)

Botticelli,
Stoning of Moses;
Punishment of Rebels

Location of Altar Wall

Archangel; center, *Virgin and Child with Angels*; and right, *Tobias and Archangel Raphael*; (upper tier) *God in Glory*. Contracted by October 1497, his work was unfinished in May 1499 when Ludovico Sforza of Milan intervened; through an agent, Ludovico had sought both his and Filippino's work (see Filippino 1495).

Perugino is completing the Cambio murals in Perugia (see figs. 42–5, 42–6, 42–7).

1501 — Perugino is elected a prior in the Council of Ten in Perugia.

ca. 1503 — For the Confraternity of S. Joseph, Perugino finishes *Marriage of the Virgin* (contracted in 1499) for the Chapel of the Holy Ring, Perugia Cathedral (Musée des Beaux Arts, Caen), where Mary's ring was enshrined. Perugino's *Marriage* inspired Raphael's (1504) in Città di Castello.

1504 — In his native town, Perugino completes the gigantic mural *Adoration of the Magi*.

1505 — Perugino completes *Combat Between Love and Chastity* for Isabella d'Este (see fig. 42–2).

1506 — In Florence, Perugino completes the double-sided painting for the high altar of SS. Annunziata: *Deposition* (begun by Filippino) (Galleria dell'Accademia, Florence) and *Assumption*. Vasari criticized the *Assumption*, but it influenced Rosso's cloister mural at SS. Annunziata (see Rosso Fiorentino).

Perugino designs the stained-glass *Pentecost* for S. Spirito, Florence.

1508 — For Julius II, Perugino paints the ceiling of the Stanza dell'Incendio (see Raphael). In Rome he stayed in Domenico della Rovere's palace (*Lives*).

1521 — In Perugia, for the Camaldolese monastery church of S. Severino, Perugino completes a mural begun by Raphael (1505–7).

1523 — For S. Agostino, Perugia, Perugino creates an immense polyptych of about 20 panels that for 20 years received his periodic attention. Vasari noted the elaborate freestanding frame of the altarpiece.

In Fontignano (14 miles from Perugia), Perugino dies of the plague.

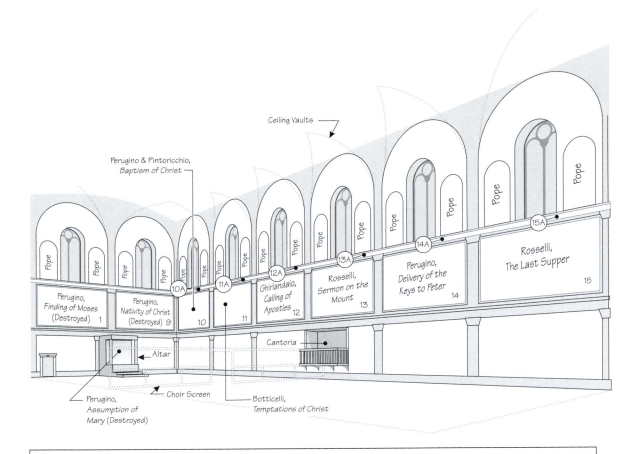

Ceiling Vaults

Perugino & Pintoricchio,
Baptism of Christ

Pope Pope Pope Pope Pope Pope Pope Pope Pope Pope Pope Pope Pope Pope Pope

10A 11A 12A 13A 14A 15A

Perugino,
Finding of Moses
(Destroyed) 1

Perugino,
Nativity of Christ
(Destroyed) 9

10

11

Ghirlandaio,
Calling of
Apostles 12

Rosselli,
Sermon on the
Mount 13

Perugino,
Delivery of the
Keys to Peter 14

Rosselli,
The Last Supper

15

Altar

Cantoria

Perugino,
Assumption of
Mary (Destroyed)

Choir Screen

Botticelli,
Temptations of Christ

42–3 (opposite page), 42–4 (above). These diagrams identify the artists and subjects of the Sistine Chapel wall frescoes, created ca. 1481–83. It is highly possible that the fresco production operated efficiently because of one organizing mind (very likely Perugino). Sixtus hired chiefly Florentine and Umbrian artists, who received 250 ducats per mural. Raphael later reported that he was offered 1,200 ducats for painting the Stanza dell'Incendio (see Raphael). At the conclusion of the project, Perugino had improved his visual and technical skills as a mural painter, and surely gained practical business skills in the process. The success and pattern of his work here helped shape his career and attract a broad range of patrons.

KEY TO THE LATIN INSCRIPTIONS ON THE ARCHITRAVES (REVEALED IN THE 1973–74 CLEANING) OF THE SISTINE CHAPEL.

SOUTH WALL MOSES SCENES

2A OBSERVATIO ANTIQVE REGENERATIONIS A MOISE PER CIRC-ONCISIONEM (Observance of the old generation through Moses' circumcision)

3A TEMPTATIO MOISI LEGIS SCRIPTAE LATORIS (Temptation [or Trials] of Moses, bearer of the written law)

4A CONGREGATIO POPVLI A MOISE LEGEM SCRIPTAM ACCEPTVRI (The people gather to receive the Mosaic written law)

5A PROMVLGATIO LEGIS SCRIPTE PER MOISEM (Promulgation of the written law through Moses)

6A CONTVRBATIO MOISI LEGIS SCRIPTE LATORIS (Rebellion against Moses, the lawgiver)

7A REPLICATIO LEGIS SCRIPTAE A MOISE (Moses explains the written law)

NORTH WALL CHRIST SCENES

10A INSTITVTIO NOVAE REGENERATIONIS A CHRISTO IN BAPTISMO (Institution of the new generation through Christ's baptism); Perugino's signature appears below: OPVS PETRI PERVSINI CASTRO PLEBIS

11A TEMPTATIO IESV CHRISTI LATORIS EVANGELICAE LEGIS (Temptation [or Trials] of Christ, bearer of the law of the Gospels)

12A CONGREGATIO POPVLI LEGEM EVANGELICAM RECEPTVRI (The people gather to receive the law of the Gospels)

13A PROMVLGATIO EVANGELICAE LEGIS PER CHRISTVM (Promulgation of the law of the Gospels through Christ)

14A CONTVRBATIO IESV CHRISTI LEGIS LATORIS (Rebellion against Christ, the legislator)

15A REPLICATIO LEGIS EVANGELICAE A CHRISTO (Christ explains the Gospels)

Sala d'Udienza, Collegio del Cambio, Perugia

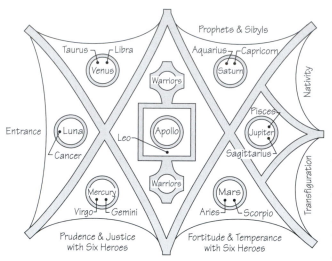

42–5 (above). This Cambio diagram shows the seven planetary gods and twelve zodiacal signs of the Audience Hall ceiling; while the geometric divisions derive from the fresco decoration in Nero's Golden House (discovered ca. 1480), Perugino's *all'antica* figures are chiefly derived from precious classical gems.

The many guilds (more than 40) of Perugia were considered in two broad categories. As in Florence (see Florentine Guilds), they were designated major or minor corporations, reflecting their importance to the communal government of Perugia. The Arte del Cambio (Guild of the Exchange), whose origin can be traced to the 13TH c., was a major corporation of bankers and money exchangers; they appraised and guaranteed the value of coinage in circulation and adjudicated both civil and mercantile cases. Their guild hall (Audience Hall) is near the town hall (Palazzo dei Priori) and is close to the cathedral on the most heavily traveled street in town (now, Corso Vannucci). In the 15TH c. the guild acquired additional rooms, one on each side of the hall. Three doors were installed in the 1450s, each giving access to the street, and with the grandest portal in the Audience Hall (see fig. 42–6). In this important room the Florentine Domenico del Tasso executed elegant intarsia panels (finished 1493) for the wainscoting, and Perugino was hired (1496) to paint murals—the humanist scholar

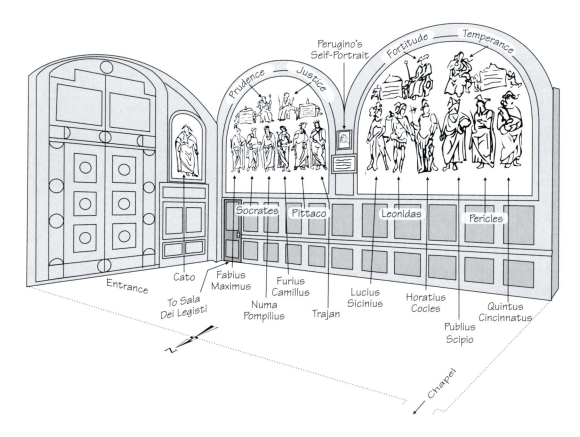

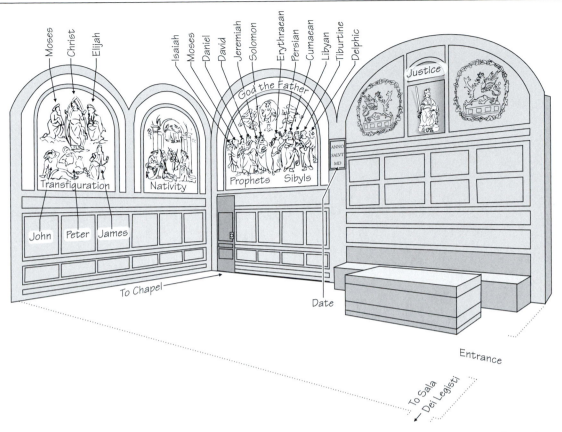

Moses Christ Elijah Isaiah Moses Daniel David Jeremiah Solomon Erythraean Persian Cumaean Libyan Tiburtine Delphic

God the Father

Justice

Transfiguration Nativity Prophets Sibyls

John Peter James

To Chapel

ANNO SALVT MD

Date

Entrance

To Sala Dei Legisti

42–6 (opposite page, bottom), 42–7 (this page, top). The Audience Hall diagrams identify four Greek and six Roman heroes with Cardinal Virtues on the south wall, Christian stories on the west, and God in Glory with Old Testament prophets and pagan sibyls on the north. Neither detail nor gesture detracts from Perugino's monumental statesmen, soldiers, and philosophers (see fig. 42–6), their gentle quietness alluding to honorable and courageous acts. Beside the door is the Roman Cato, symbolizing virtuous wisdom. Looking toward the judges' bench, he has these admonishing words inscribed near his feet: "Whether weaving words into a wreath of fame or pronouncing public judgments, leave your personal feelings aside. If your heart is torn by either love or hate you cannot maintain a proper neutrality."

Francesco Maturanzio selecting the classical themes and composing the inscriptions. In this room is Perugino's most complex and lustrous work, which surely inspired young Raphael's decoration of the Vatican Apartments (see Stanze of Raphael). On the wall opposite Perugino's self-portrait is an inscribed *all'antica* tablet: ANNO / SALVT[IS] / MD (In the year of our salvation 1500).

The Cambio tribunal sat beneath Benedetto da Maiano's statue of *Justice* (gilded terracotta) and emblems of Perugia and the Cambio (griffin perched on a chained money chest) (see fig. 42–7). Judges faced Perugino's poised, life-size figures, who were notable in ancient history and exemplary models of moral and civic virtue. Elevated above these men are personifications of the Cardinal Virtues seated beside inscribed plaques, whose passages suggest that justice was paramount to the activities in this audience hall (see fig. 42–6). The plaque of Prudence reads: "What, O goddess, have you in store for mankind? Tell us! I trust that you will not do anything that you might regret. I teach you to seek the truth and its hidden causes. Nothing can be accomplished through me but what is just." That of Justice reads: "If the just gods had created all men like these three [Camillus, Pittaco, Trajan], there would be no evil in the world. Worshipping me, the people advance in their peace as in war, but how great is their downfall without me."

Heroes of Antiquity in Town Halls

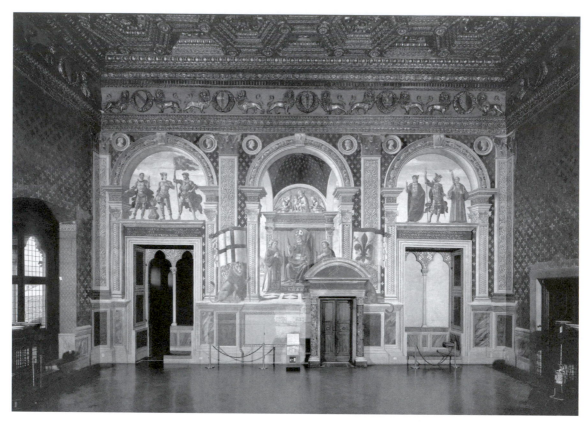

42–8. DOMENICO GHIRLANDAIO. *Zenobius Enthroned with Ss. Eugenius and Crescentius* (center); *Brutus, Mucius Scaevola, Camillus* (left); *Decius, Scipio, and Cicero* (right), 1482–83, fresco, east wall, Sala dei Gigli, Palazzo della Signoria, Florence. Perugino's Cambio images reflect his contact with Botticelli, Filippino, and Ghirlandaio, and they were directly inspired by Ghirlandaio's frescoes shown here for the Sala dei Gigli town hall (see Botticelli 1482, Perugino 1482).

In Quattrocento civic halls, artists were hired to paint narratives of ancient history and biblical stories as well as images related to the town's glory. Popular since the Trecento, pagan heroes and *uomini famosi* cycles became more frequently depicted in the Quattrocento, with humanists providing the inscriptions and painters and sculptors depicting figures that now more closely resembled the look of ancient statues and figural reliefs. On the east wall of the Sala dei Gigli (see fig. 42–8), the antechamber of the audience hall, Roman heroes are pictured in the lunettes, standing beneath triumphal arches; their names are inscribed on the entablature beneath them: (left) BRVTVS EGO ASSERTOR PATRIAE REGVMQ FVGATOR / VRO MANVM SPRET[IS ERRANTEM] SCAEVOLA FLAMMIS / HOSTE REFERET CAESO VICTRICIA SIGNA CAMILLVS (I am

Brutus, the liberator of my country and the bane of kings / I, Scaevola, burn my erring hand in flames I scorn / I, Camillus, have cut down the enemy and now bear the victorious standards). Inscribed on the right: SVM NATO EXEMPLVM DECIVS SVM VICTIMA ROME / SCIPIO SVM VICI HANNIBALEM POENOSQ SVBEGI / SVM CICERO TREMVIT NOSTRAS CATILINA SECVRES (I am Decius, an example to my son and a martyr for Rome / I am Scipio; I conquered Hannibal and subdued the Carthaginians / I am Cicero; Catiline quaked at my authority). About twenty years after Domenico Ghirlandaio painted the east wall figures, Leonardo and Michelangelo were hired to create battle scenes in the Room of the Five Hundred, a large hall on the floor beneath this room (see Leonardo 1503, Michelangelo 1503).

Carlo Crivelli

Carlo (Giovanni) Crivelli (early 1430s–1495) came from a family of painters, and although he was from Venice, he worked most of his life outside the city, choosing prosperous Ascoli Piceno as his home about 1478. There he created a masterwork, the *Annunciation Altarpiece* (see fig. 43–2) of 1486. He had a lucrative career making large gilded polyptychs that were popular in provincial towns long after the type had lost favor in Venice. His distinctive and inventive style and technically faultless execution of tempera panels appealed to an endless number of wealthy patrons in the Marches, where he worked mostly for mendicant orders, ecclesiastics, and nobles.

Early 1430s — Carlo is born in Venice to the painter Jacopo Crivelli (no work survives). Carlo's brother, Vittore (ca. 1444–1501), and his nephew (Vittore's son), Giacomo (1496–1502), were also painters.

In Venice Carlo became familiar with the tradition of Paolo Veneziano and the work of two important painting workshops: one run by Jacopo Bellini (ca. 1400–70/71) and the other by Antonio Vivarini (ca. 1418–76/84). His early art shows a mingling of influences from both shops, but a lasting impression was made by the art in nearby Padua. There he studied the bronze and terracotta reliefs of Donatello in the Santo and the art of painters trained in the shop of Francesco Squarcione: Andrea Mantegna, Marco Zoppo, and Giorgio Ciulinovich, called Schiavone.

1457 — By this date, a master painter in Venice, Carlo has a lawsuit brought against him for abducting the wife of a sailor; found guilty, he was fined and imprisoned (six months).

ca. 1460 — Carlo signs the panel *Virgin and Child* (*Madonna of the Passion*) for S. Lorenzo in Venice (Castelvecchio, Verona). His signature is on the fictive marble ledge, beneath the cloth.

1465 — Carlo is in Zara, Dalmatia, where he is recorded as having citizenship.

1468 — Living in Fermo, Carlo signs and dates an altarpiece, *Enthroned Virgin and Child with Ss. John the Baptist, Lawrence, Silvestro, and Francis of Assisi*, 3'73" x 6'2.8" (110 x 190 cm), con-

43–1. CARLO CRIVELLI. *Lamentation over the Dead Christ* (Pietà), 1473, tempera on panel, 33.8" x 20.9" (61 x 64 cm), Chapel of the Holy Sacrament, Duomo, Ascoli Piceno. This popular theme (see LAMENTATION, Cinquecento Glossary), showing the dead Christ supported by devoted followers, had a tradition of being placed at the top of Venetian altarpieces, as the foreshortened head of Mary Magdalene indicates. This is the central panel of the upper register of the three-tiered altarpiece commissioned by Bishop Caffarelli for the Ascoli Piceno Duomo. Carlo signed and dated his work (OPVS KAROLI CRIVELLI VENETI / 1473) on the central panel, depicting the *Enthroned Virgin and Child*. As a devotional image, *Lamentation over the Dead Christ* is evocative. The dead pale Christ faces his mother, now wrinkled and aged, their heads touching and tears rolling down Mary's cheeks. Carlo's Paduan training shows in the calligraphic treatment of surfaces, such as the Evangelist's blond ringlets and the Magdalene's strands of golden hair. In the manner of Venetian artists Jacobello del Fiore and Antonio Vivarini, Carlo developed an interest in the reflective and absorptive appearances of fabrics, shown here in his treatment of the silk cloth, marble parapet, and tooled gold background. Crivelli often included overly large fruit in scenes of Christ (see the *Annunciation*, fig. 43–2). In this polyptych, fruit appears in an *all'antica* swag hanging above the throne of the Virgin and Child. While the swag holds fruit from trees (apple, pear, peach), symbolic of salvation and paradise, it also has an earthy gourd, symbolic of the Resurrection.

tracted by Count Azzolini of Fermo for the church of S. Silvestro at Massa Fermana. Carlo's brother Vittore had become a citizen of Fermo by 1489.

1470 — For the church at Porto San Giorgio at Fermo, Carlo signs and dates a polyptych (dispersed), with the main panel showing the *Virgin and Child Enthroned* (National Gallery of Art, Washington, D.C.).

1473 — Hired by Bishop Caffarelli, Carlo completes a three-tiered polyptych for the Ascoli Piceno Duomo (S. Emidio), which is still in its original frame (see fig. 43–1). By 1478, Carlo was a citizen of Ascoli.

1482 — For the Camerino Duomo, Carlo signs and dates an altarpiece (main panels and predella, Brera, Milan).

1486 — In Ascoli Piceno, Carlo signs and dates the *Annunciation* (see fig. 43–2), its deep, fictive space perhaps based on designs of Jacopo Bellini (Paris and London sketchbooks). What is extraordinary about the narrative are the intricate patterns everywhere—even the street

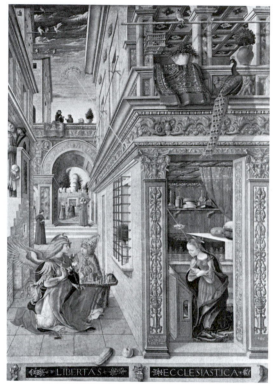

tiles outside Mary's room are marbled, and seem more fitting to an interior room. They connote the celebratory nature of his painting filled with expensive things, including Gabriel's exquisite gown, gilt ceiling coffers and Corinthian capitals, and Turkish carpets draped over ledges.

1490 — Carlo is knighted by Prince Ferdinand II of Capua. The following year (1491), referring to himself as a knight, he signed (OPVS CAROLI CRIVELLI VENETI MILES) and dated an altarpiece for the Chapel of S. Maria Consolazione, S. Francesco, Fabriano (National Gallery, London). The dedicatory inscription identifies the donor as Oradea (pictured as a miniature patron beside S. Francis), widow of Giovanni Becchetti.

1493 — For the church of S. Francesco, Fabriano, Carlo is contracted to paint the double-tiered altarpiece (Brera, Milan): *Coronation of the Virgin* (main panel) and the *Pietà* (top); for his work he received 250 ducats.

1495 — By this year Carlo has died.

43–2. CARLO CRIVELLI. *Annunciation*, 1486, egg tempera with some oil, transferred from panel to canvas, 7'9.5" x 4'9.8" (207 x 146.5 cm), National Gallery, London. On the fictive stone frame of the painting, Carlo inscribed LIBERTAS / ECCLESIASTICA (freedom under the Church), the title of the papal bull of Pope Sixtus IV (dated 19 July 1482) giving the right of self-government to Ascoli Piceno while it remained part of the Papal State. Townspeople learned of their new rights on the Feast of the Annunciation, 25 March, and they commissioned a painting for the Chapel of the Town Hall from Pietro Alemanno in 1484. Two years later, they hired Carlo to create a painting for the Franciscan church of Observant Friars, the Blessed Annunciation (SS. Annunziata), where an annual procession would go to celebrate the town's new rights. Carlo's *Annunciation* nestles the biblical event into the fabric of Ascoli, where the man reading in the distance (behind the parapet) may have just learned of the papal decision. Flanking the commemorative inscription on the fictive ledge are three coats of arms: those of the bishop of Ascoli, 1464–1500 (Prospero Caffarelli), the pope (Innocent VIII, who replaced Sixtus in 1484), and the town. Painted in trompe l'oeil on the fictive ledge are an apple and gourd, symbolic of Original Sin and Resurrection. Beside the Virgin Annunciate, Carlo inscribed his name (bottom, left pier) OPVS CARO / LI CRIVELLI / VENETI and (bottom, right pier) 1486. Beside Gabriel is S. Emidias, patron saint of Ascoli, presenting a model of the town.

Giovanni Bellini

Born into a family of gifted and versatile painters significant in the story of Venetian painting, Giovanni Bellini (ca. 1435–1516) is perhaps the best known of his kin. He outlived his famous brother Gentile (ca. 1430–1507) and was considerably more productive than his father, Jacopo (ca. 1400–1470/71), whose work shows the influence of Gentile da Fabriano. Jacopo's contribution to Venetian art can never be fully measured—too many of his works have been lost or compromised through damage or neglect—and yet, two stunning drawing books are credited to his name (British Museum, London, and Louvre, Paris). Included in these books are drawings by Giovanni that show his burgeoning genius. Although most of Giovanni's early works are undated, his early experimentation with oil painting led to his exploitation of its potential for creating luminous veils of shimmering light and reflection (see fig. 44–1). Giovanni lived his entire life in Venice and initiated a change in its art that took full advantage of the unique city. It was in his works and those of his followers that Venetian style was formed.

ca. 1435 — Giovanni is born in Venice to Anna Rinversi and Jacopo Bellini. The birth years of both Gentile and Giovanni are uncertain, but the concensus is that Gentile was the older brother.

1453 — Giovanni's sister Nicolosia (ca. 1429–75/80) marries Andrea Mantegna. The art of the inventive Mantegna had a great impact on that of Jacopo and his sons.

ca. 1459 — Giovanni and his brother, Gentile, and father, Jacopo, sign an altarpiece for the Gattamelata Chapel in S. Antonio, Padua.

1464 — Giovanni signs the (lost) altarpiece for the Scuola di San Gerolamo. About three years later (1467), he created one of his most striking devotional panels, the *Pietà* (Brera, Milan), showing Christ after his crucifixion and supported by the Virgin and John the Evangelist. Christ appears to be standing in a tomb, with the fictive marble ledge that separates

him from onlookers functioning also as an altar table; it calls attention to the Eucharist and the sacrifice of Christ for the redemption of humanity. Painted on the fictive marble is an inscribed *cartellino* ("When these swelling eyes evoke groans this work of Giovanni Bellini could shed tears"). The verse is adapted from an elegy (mournful or reflective poem) by the ancient Roman poet Propertius, and it suggests both that Giovanni is a skillful painter

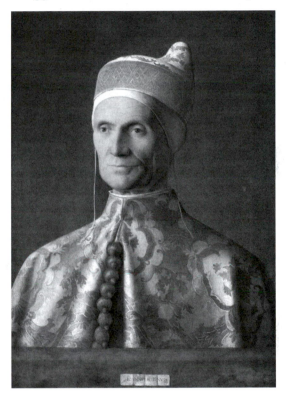

44–1. GIOVANNI BELLINI. *Doge Leonardo Loredan*, ca. 1501, oil on panel, 24.4" x 17.8" (62 x 45 cm), National Gallery, London (signed IOVANNES BELLINVS on the fictive *cartellino* attached to the simulated marble ledge in the foreground). Perhaps created the year of his election (in 1501), this portrait of Leonardo Loredan (1436–1521) has both a lifelike presence and a timeless permanence. His gaze takes on an ethereal quality, suspended as it is in rich blue ultramarine, remindful of the sea surrounding Venice. His torso is thick and heavy and broadly anchored in stiff, shimmering fabric of silk damask, a trademark cloth of Venice. This portrait seems to personify not only the office of head of state, but *La Serenissima* itself.

Why Gentile rather than Giovanni was awarded the contract for his paintings in the Scuola Grande di San Giovanni Evangelista as well as for other major confraternities, such as the Scuola Grande di San Marco (see entry 1507), had something to do with his successful work for Sultan Mehmed II (see fig. 45–3) in Istanbul. While his trip to the Ottoman court accounts partly for his broad fame, his ability to paint portraits was of chief importance to the confraternities, and Gentile's skill as a portraitist had been one main reason why he was sent to Istanbul. (Gentile made more self-portraits than did any other Quattrocento Venetian artist.) In addition, Gentile and Giovanni's father, Jacopo Bellini, had painted (lost) scenes for the confraternity of S. Giovanni Evangelista, between 1421 to the 1460s, which opened the possibility for his two sons to be awarded commissions by the most prestigious corporate groups in Venice. (Gentile belonged to the Scuola di S. Marco, and his portrait can be found in the painting that Giovanni finished in 1507.)

and that images can embody human traits, calling to mind the miraculous figures of the Virgin Mary that are said to weep tears.

ca. 1468 — For the church of S. Maria della Carità, Giovanni paints an altarpiece. About two years later, in 1470, the Scuola Grande di S. Marco hires him to paint the (unexecuted or destroyed) *Flood with Noah's Ark*. In the following year (1471), he inscribed the (lost) date on his *Pietà* in the Doge's Palace.

1474 — Giovanni dates the portrait of *Jörg Fugger* (Norton Simon Museum of Art, Pasadena). The following year Antonello da Messina is in Venice; his oil technique may have helped change the way Giovanni, who had already been experimenting with oil, painted his panels. By the 1480s Giovanni would be mixing his pigments almost solely with oil.

ca. 1475 — Giovanni creates the *Pesaro Altarpiece* (Museo Civico, Pesaro) and the *Transfiguration* (Capodimonte, Naples). These two works show his mastery in the creation of dewy, atmospheric landscape settings.

1479 — Gentile and Giovanni work in the Grand Council Hall, Doge's Palace, painting narratives on canvas. Gentile is sent to Istanbul, a representative of Venice, to paint Sultan Mehmed II's portrait (see fig. 45–3). Most of Gentile's work at the sultan's court is lost; he returned to Venice in 1480.

ca. 1480 — Giovanni paints the *S. Giobbe Altarpiece* (Accademia, Venice) for the hospital of S. Giobbe.

1482 — In Venice, Giovanni is exempted from paying fees to the painters' confraternity, the result of the acclaim he received from the government. He was

called "painter of our Dominion." In the records of the Scuola Grande di San Marco (1484), Giovanni is listed as a member. Both Gentile and Giovanni were members of the Scuola Grande della Misericordia, and Giovanni also belonged to the Scuola di San Cristoforo dei Mercanti (Gentile da Fabriano joined this scuola when he was in Venice).

1488 — Contracted by the Pesaro, Giovanni creates *Triptych of the Enthroned Virgin and Child with Ss. Peter, Nicholas, Benedict, and Mark* for the sacristy of the Frari in Venice, which he signs and dates.

In this year Gentile and Giovanni are working in the Grand Council Hall, Doge's Palace.

1496 — Isabella d'Este requests a painting from Giovanni, first through her husband's efforts and then through her agent (in 1501). Never fulfilling her request for a mythology, Giovanni instead created a Nativity that pleased her (see 1504).

1497 — Marchese Francesco Gonzaga of Mantua (Isabella d'Este's husband) asks Giovanni to paint a view of Paris; he refused because he had not seen the city. Francesco then asked that he paint a theme of his choosing, and he agreed.

1499 — Giovanni's son, Alvise, dies in this year; his wife, Ginevra, had died by this year.

1500 — Work for the Garzadori Chapel of S. John in S. Corona, Vicenza, is completed (chapel dedicated this year), for which Giovanni paints *Baptism of Christ*. In the following year (1501), Giovanni is working in the Doge's Palace. About this time he paints the portrait of *Doge Leonardo Loredan* (see fig. 44–1).

1504 — In Mantua, Isabella d'Este receives Giovanni's *Nativity*.

1505 — Giovanni completes *Enthroned Madonna and Child with Saints* for the church of S. Zaccaria, Venice, showing his refined skill at depicting monumental figures bathed in atmospheric, colored light and shadow.

1506 — From Venice, Albrecht Dürer writes to Pirckheimer that Giovanni Bellini is an old man, and the best painter in Venice.

1507 — Gentile dies in Venice. Giovanni completes Gentile's *S. Mark Preaching in Alexandria* for the Scuola Grande di S. Marco. Giovanni is paid for canvas paintings in the Audience Chamber in the Doge's Palace and is also called on to complete three unfinished works of Alvise Vivarini (d. 1507) in the Grand Council Hall, Doge's Palace.

1510 — Giovanni signs and dates the *Brera Altarpiece* (Madonna and Child before a landscape).

1513 — Giovanni signs the altarpiece *S. Jerome with Ss. Christopher and Louis of Toulouse* (S. Giovanni Crisostomo, Venice).

1514 — Giovanni paints *Feast of the Gods* (see fig. 44–3) for Duke Alfonso I d'Este of Ferrara (1476–1534), Isabella's brother (see fig. 17–9). The *invenzione* was that of the humanist Mario Equicola (see Titian).

1515 — Giovanni signs the canvas painting *Woman with a Mirror* (see fig. 44–2). In this year he is working in the Grand Council Hall, Doge's Palace, and is also contracted to paint the *Martyrdom of S. Mark* for the Scuola Grande of S. Marco (signed by his assistant Vittore Belliniano in 1526).

1516 — Giovanni dies in Venice (29 November).

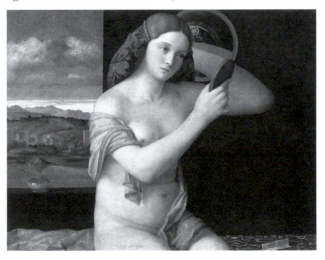

44–2. GIOVANNI BELLINI. *Woman with a Mirror*, 1515, panel, 24.4" x 31.1" (62 x 79 cm), Kunsthistorisches Museum, Vienna (signed on the folded paper beside the woman IOVANNES BELLINVS / FACIEBAT MDXV). At about 80 years old, Giovanni painted this intimate scene. Clothing the nude in luminous flesh rivaling nature's atmosphere, Bellini created a serene stillness through the placement and design of her form, with its overly long left arm (which makes her flesh seem all the more exposed), and the balanced relationship of transparent and reflective glass and silks, brocade, and Turkish textile. Unlike the *Feast of the Gods* (see fig. 44–3), this scene seems less about a particular individual or incident and more about physical and intellectual reflection and the passage of time. This woman is looking into the hand mirror, but does not hold it in position to see the back of her head, which the wall mirror shows; instead, she seems transfixed and is perhaps contemplating something of larger importance than the adjustment of her headdress. In his design Giovanni composed visual analogies between the woman and the landscape, showing linear and volumetric similarities between her round shoulder and the rolling terrain behind her, and in her pearl-edged brocaded scarf and the delicate ring of clouds adorning the sky at about the same level as her head. No ledge or barrier separates this woman from onlookers and she is seemingly in the same space as the viewer; yet she is completely removed from outsiders, locked in her thoughts and visually hemmed in by her arms and the overlapping frames of the circular mirrors.

Feast of the Gods

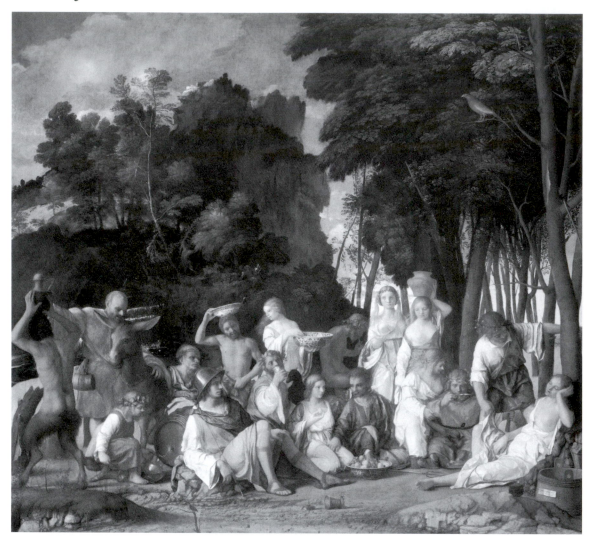

44–3. GIOVANNI BELLINI. *Feast of the Gods*, 1514, canvas, 5'6.9" x 6'2"(170 x 188 cm), Widener Collection, National Gallery of Art, Washington, D.C. (signed IOVANNES BELLINVS and dated). A creator of large narratives (for the *scuole* and Doge's Palace), Giovanni knew how to relate a work to its setting and how this painting would look above Alfonso's alabaster reliefs. His figures resemble an ancient marble frieze, their background once lined with trees (like those to the right), fencing off the figures from the background and encouraging an even greater closeness between Bellini's fictive world and that of visitors to Alfonso's *camerino*. (In repainting most of the background, Titian obliterated not only Bellini's trees, but also the iridescent sheen of golden light at sundown, the presence and color of which was important to the theme.) From Ovid (*Metamorphoses* and *Fasti*), the story portrayed is the feast of Bacchus (depicted as a child here, with grape leaves crowning his head). The moment shown is at the end of the day's celebration (grapes and quinces are in the foreground bowl); the day of the year is thought to be the winter solstice. Chaste Lotis is on the far right (her position reflects Bellini's knowledge of the Belvedere *Ariadne*) (see fig. 46–3). Her would-be seducer, Priapus, notorious for his large penis, is lifting her gown. To the far left is the donkey, whose bray will soon alert Lotis to the danger. Perhaps to please the patron, Giovanni lowered the necklines of two naiads (women standing to the right) and added attributes identifying the gods (i.e., caduceus with Mercury, eagle with Jupiter, pitchfork with Pluto, lute with Apollo). The couples represented (Proserpine sits beside Pluto and Ceres kneels next to Apollo) may refer to the theme of love and celebration of marriage and fertility, a theme that appears as well in Titian's *Bacchus and Ariadne*, also created for Alfonso's *camerino*.

Remembered principally for his large canvas paintings in Venetian *scuole*, Vittore Carpaccio (ca. 1465–1525/26) was the Domenico Ghirlandaio of Venice. Among the most colorful storytellers in the city, he filled his pictorial environments with precious and ordinary objects, showing their most intricate details, such as hand-worked fringe at the edges of fabrics (tablecloths, sheets, and bedcovers) and inlaid foliate designs in the wood of cupboards and cabinets (see fig. 45–1). Because of the bounty of items in his paintings and the precision with which he described these things, his works are studied as records of period furniture, dress, and accoutrements. A prolific artist, he fulfilled contracts for five major and two minor confraternities in Venice. Compared to other *scuole* painters, most of whom are not nearly as well remembered, like Giovanni Mansueti (1485–1526/27), Carpaccio created mesmerizing images. They show greater subtlety and invention in picturing tactile surfaces and bright light and cast shadows, and he produced masterful images of pageants and panoramic views, blending different vantage points into single scenes. Nevertheless, for all the many *scuole* contracts he received, he never became a distinguished portraitist, and perhaps to his detriment he gave almost equal value to figures, costumes, settings, and the details of everyday life. Although he outlived Giovanni Bellini by a decade, he was not the artist who would replace him. Instead, a new generation of painters, led by Giorgione, Sebastiano, and Titian, more closely followed Giovanni Bellini's lead.

ca. 1465 — Vittore is born to a merchant dealing in furs and animal skins.

1479 — Vittore is listed among Gentile's assistants in Istanbul, according to a book by Titian's nephew Cesare Vecellio, *Degli habiti antichi et moderni di tutto il mondo* (1590). Carpaccio seems not to have made the journey, but would draw upon the studies of Gentile and his assistants (see figs. 45–2, 45–3).

1488 — The Scuola di S. Orsola (Ursula) hires Vittore to paint narratives of the life of S. Ursula for the oratory (see fig. 45–1). Most of the canvases are dated. The first, which he signed, was completed in 1490 and the last, in 1496.

ca. 1494 — Vittore paints the canvas *Miracle of the Cross* for the Scuola di S. Giovanni Battista.

1496 — For S. Pietro Martire, Udine, he inscribes VICTORJS CHARPATJO / VENETJ OPUS / 1496 on his canvas *Blood of the Redeemer* (Museo Civico, Udine).

1502 — In Venice, Vittore completes a (lost) painting for the Sala dei Pregati, Doge's Palace. He signs and dates *Calling of Matthew* and *Funeral of S. Jerome*, both for the Scuola di S. Giorgio degli Schiavoni (the Dalmatians).

1504 — Vittore signs and dates the *Annunciation* for the Scuola degli Albanesi (the Albanians).

45–1. VITTORE CARPACCIO. *Dream of S. Ursula*, 1495, canvas, 9' x 8'9" (274 x 270 cm), Accademia, Venice. Asleep in her bed, Ursula is having a dream, the content of which this picture describes: an angel tells Ursula of her impending murder (he holds a palm symbolic of martyrdom and paradise). Ursula's room is homey and bare compared to the more luxuriously attired chambers of the series (see 1488 above), its appearance denoting the moral rigor of the virgin princess. Everything is orderly and every item is in its place: on the bench at the end of the bed rests Ursula's crown, beside her bed are slippers, and on the nearby wall is a devotional image (only the frame and votive candleholder in front of it can be seen). Showing the mystical nature of the story, Carpaccio not only made the angel more petite than Ursula, but also changed the vanishing points around the angel so that the floor and ceiling surrounding him appear both to sink and to rise, giving the impression that he is floating into her dream.

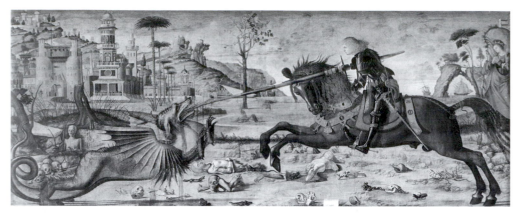

45–2. VITTORE CARPACCIO. *S. George and the Dragon*, 1504–7, oil on canvas, 4'7.5" x 11'9" (141 x 360 cm), Scuola di S. Giorgio degli Schiavoni, Venice. The hero of this scene (representing the outskirts of Selene in Libya) is George of Cappadocia (a patron saint of the *scuola*), shown plunging his lance through the head of a man-eating dragon. His action subdues the reptile and saves the princess from certain death (see fig. 17–1). Details of Carpaccio's setting are similar to Pisanello's fresco of George in S. Anastasia, Verona, but here the battlefield is a wide stretch of barren ground littered with small reptiles, many skulls, and a couple of half-eaten corpses. For the *scuola* series, Carpaccio depicted costumes of Mamluks and Ottoman Turks he likely derived from drawings that Gentile Bellini brought back from Istanbul in 1480. Several buildings in the series show his knowledge of Reeuwich's woodcut *View of Jerusalem* in Breydenbach's popular travel guide, *Peregrinationes* (published 1486).

Vittore enters a design for the contract to paint the *Presentation of the Virgin in the Temple* in the Scuola Grande della Carità. The design of Pasqualino Veneto was selected, but Titian later did the work.

1507 — In the Doge's Palace, Venice, Vittore works with Giovanni Bellini completing Alvise Vivarini's unfinished paintings for the Grand Council Hall. Also in this year he signs and dates the altarpiece, *S. Thomas Aquinas Enthroned Between Ss. Mark and Louis of Toulouse*, for S. Pietro Martire, Murano.

1508 — Vittore creates *Death of the Virgin* for S. Maria in Vado, Ferrara.

Giovanni Bellini asks Vittore Carpaccio, Lazzaro Bastiani, and Vittore Belliniano to decide the amount that should be paid for Giorgione's Fondaco frescoes (see Giorgione 1508).

1510 — Vittore signs and dates *Portrait of a Knight* (Thyssen-Bornemisza Collection, Madrid) and *Presentation of Christ in the Temple*, an altarpiece created for S. Giobbe, Venice (Accademia, Venice).

1511 — For the Scuola di S. Stefano, he creates *Ordination of S. Stephen* (Staatliche Museen, Berlin).

1513 — Vittore signs and dates *Disputation of S. Stephen* (Brera, Milan) for the Scuola di S. Stefano.

1516 — Vittore signs the *Lion of S. Mark* (Doge's Palace, Venice) for the Palazzo dei Camerlenghi.

1526 — By this year, Vittore has died in Venice.

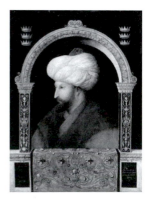

45–3. ATTRIBUTED TO GENTILE BELLINI. *Portrait of Sultan Mehmed II*, ca. 1480, canvas, 27.8 x 20.7" (70 x 52. cm), National Gallery, London. The army of Mehmed II (leader of the Ottoman Turks) conquered Constantinople in 1453, ending the very long reign of the Byzantine Empire, which lasted about eleven centuries (see CONSTANTINOPLE, Duecento Glossary). Like a portrait on a medal, Mehmed appears in profile. On the parapet is a carpet with trompe l'oeil jewels and (damaged) inscriptions at the corners. Three crowns refer to Mehmed's titles as emperor of Asia, Trebizond, and Great Greece. On the back of a portrait medal that Gentile designed for Mehmed, Gentile called himself Count Palatine, a title conferred by the sultan.

Cinquecento Italian Art Part Four

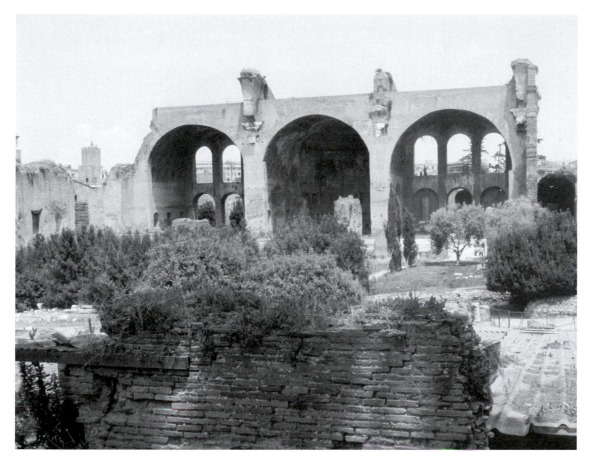

Sixteenth-century Rome became a major international court and center of artistic activity under papal leadership, starting with Julius II (1503-13) (see fig. 69–5). Its ancient monuments were the inspiration of artists called to Rome, and almost all new art produced in Rome, or elsewhere (see fig. IV–2), was influenced by pagan monuments of Rome's distant past. Working in this century were the artists who are still often valued as the best of the Renaissance: Titian, Leonardo, Raphael, and Michelangelo. In their time, these artists were treated as artistic geniuses, sought out by popes, lords, and kings, who honored and sometimes ennobled them. These artists shaped the tastes of their patrons and took a greater role in the ideation of projects than did their predecessors. Their art—from sketch to finished work—was considered the product of inspired thought.

Artistic activity flourished in this century even though warfare in Italy was more devastating than it had been in previous centuries, with France and Spain fighting for control of Italy and the Reformation threatening to topple the Latin Church. In this seminal time, artists

IV–1. Basilica of Maxentius (finished by Constantine), ca. 307–12, brick and concrete north aisle, each chamber 52' x 75.5' (15.8 x 23.6 m), Forum, Rome. The longitudinal plan of the law court, with an apse at one end, inspired the form of early Christian churches, such as S. Giovanni in Laterano; the use of coffers (recessed panels) in vaulted ceilings, seen here and in the Pantheon (see fig. 67–1), would reappear in 15TH–c. buildings but became far more prevalent in 16TH–c. buildings, such as those designed by Bramante and Giulio Romano. In the Middle Ages the Basilica of Maxentius became ruins when the nave and south aisle fell.

were in great demand, publishing houses increased in number and in their production of books, and the exploration of foreign land and sea worthiness began to alter the balance of power in Europe. By the century's end, Venice was in decline, Florence was under the absolute control of the Medici, and Rome, after having suffered extreme humiliation and stringent reforms, was about to embark on very costly art projects.

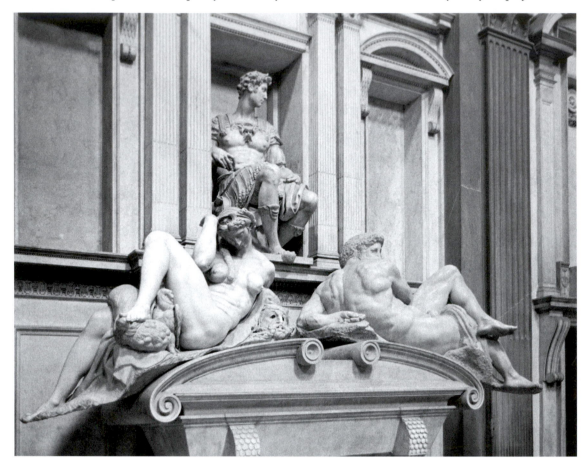

IV–2. MICHELANGELO. *Tomb of Giuliano de' Medici* (Duke of Nemours), with pendant figures *Night* (left) and *Day* (right), 1521–34, Medici Chapel (east wall), S. Lorenzo, Florence (see Michelangelo 1519). Hired by Pope Leo X to design a mortuary chapel for the Medici in Florence (see fig. 61–2), Michelangelo's monumental sculpture and classical architecture show the influence of ancient Roman art. His effigy of Giuliano is a seated general, dressed as Captain of the Papal Troops. Twisted in his chair and looking toward the door that opens into the transept of the church, Giuliano appears to be guarding the Medici tombs. His alertness is reminiscent of the effigy of Augustus (see fig. 69–1), but his long, crane-like neck and contorted torso reflect contemporary Mannerist tendencies (see MANIERA, Cinquecento Glossary). Michelangelo was an accomplished painter, sculptor, and architect when Benedetto Varchi asked him (and others) in 1546 about the merits of painting and sculpture, an argument (*paragone*) that reflects the competitive nature of 16ᵀᴴ–c. artists and philosophers. Michelangelo responded (1549): "I believe that painting is considered excellent in proportion as it approaches the effect of relief, while relief is considered bad in proportion as it approaches the effect of painting. I used to consider that sculpture was the lantern of painting and that between the two things there was the same difference as that between the sun and the moon. But now that I have read your book, in which, speaking as a philosopher, you say that things which have the same end are themselves the same, I have changed my opinion; and I now consider that painting and sculpture are one and the same thing, unless greater nobility be imparted by the necessity for a better judgment, greater difficulties of execution, stricter limitations and harder work. . . . Suffice that, since one and the other (that is to say, both painting and sculpture) proceed from the same faculty, it would be an easy matter to establish harmony between them and to let such disputes alone, for they occupy more time than the execution of the figures themselves."

1500 **TREATY OF GRANADA.** In a secret treaty (11 November), Ferdinand II of Aragon and Louis XII of France contrive to divide Naples between them. Ferdinand disregarded the treaty and broke relations with France. After the Battle of Garigliano (1503), Spain controlled Naples and drove the French from Italy (1504). Ferdinand's grandson, Charles V (1500–58), became the future king of Spain and most powerful monarch in Italy. Naples would become a viceroyalty of the Spanish crown.

1502 **SODERINI MADE GONFALONIERE FOR LIFE IN FLORENCE.** To establish the sense of stable leadership in Florence, the constitution of the new Republic calls for a permanent *gonfaloniere*, a titled leadership patterned after the Venetian dogeship.

1503 **CESARE BORGIA AT HEIGHT OF POWER.** Between 1498 and 1503, Cesare (1476–1507), the son of Alexander VI, expanded the temporal holdings of the papacy through his military campaigns in Romagna, Umbria, and Tuscany. He was the ideal, ruthless soldier-leader that Machiavelli later wrote about in *De Principatibus* (The Prince), ca. 1513–14.

DEATH OF POPE ALEXANDER VI. Alexander (Borgia) dies in Rome (18 August), perhaps of poisoning. Succeeding him is Pius III of Siena. Within a month Pius died (18 October), and Giuliano delle Rovere (nephew of Sixtus IV) became Pope Julius II (1 November).

1504 **CESARE BORGIA SURRENDERS TO JULIUS.** Handing over Romagna to Pope Julius II, Cesare Borgia is sent as a prisoner to Spain.

1505 **HIEROGLYPHICA PUBLISHED IN VENICE.** *Hieroglyphica* by the 4th–c. Alexandrian Horapollo Niliacus gained popularity with such humanists as Marsilio Ficino, who saw in Egyptian cryptograms esoteric symbols prefiguring Christianity. Influenced as well were Leon Battista Alberti (*De re aedificatoria*), Francesco Colonna (see 1509), and Andrea Alciato (see 1531).

1508 **LEAGUE OF CAMBRAI FORMED AGAINST VENICE.** Louis XII of France, Ferdinand of Aragon, Pope Julius II, and Emperor Maximilian join forces (10 December) to fight the Turks, and they formed a secret pact against Venice and her expansion on mainland Italy. At the Battle of Agnadello (Valià), Venice was defeated by the league and lost most of her mainland possessions (1509). Louis XII gained Cremona, Crema, Brescia, and Bergamo; Maximilian (for the empire) gained Padua, Verona, Vicenza,

46–1. RAPHAEL. Chigi Chapel, ca. 1512–14, S. Maria del Popolo, Rome. The church of S. Maria del Popolo was rebuilt by Pope Sixtus IV (uncle of Pope Julius II), and the church continued to receive della Rovere patronage after Sixtus' death. Shown here is the dome of the chapel built for the burial of Agostino Chigi and his family. Raphael designed all parts of the chapel, including the sculpture and architecture. According to the date on the dome, the mosaics were completed in 1516 (their planning began in 1513), with Luigi de Pace executing the mosaics from Raphael's drawings. In the center of the dome, God the Father—foreshortened, with raised, welcoming arms—looks like the mighty god Jupiter. Images of pagan gods (referring to planets) are accompanied by angels in the panels below.

46–2. Line drawing after *Fountain of the Sleeping Nymph* from Francesco Colonna's *Hypnerotomachia Poliphili* (The Strife of Love in a Dream), 1499, woodcut (inscribed in Greek, "The mother of all"). In Poliphilo's dream, he enters the realm of Queen Eleutherylida, where he finds beside an octagonal building a polished white marble fountain whose stone relief depicts a sleeping nymph. We read that she is shown reclining on a long sheet of cloth beside the trunk of an arbutus tree. Spurting from the nipple of her left breast is a jet of hot water, and from her right, a stream of cold. Watching over the nymph, a lustful satyr shades her by pulling downward on the tree's branches. Two satyr children stand nearby; one holds a vessel and the other, snakes.

Treviso, the Fruili; Francesco II d'Este (marchese of Mantua) regained Peschiera, Asola, Lonigo, towns ceded to Venice in 1441; Alfonso (duke of Ferrara) retook Rovigo (taken by Venice in 1484); Julius II took towns in the Romagna, including Faenza, Rimini, and Ravenna; Ferdinand of Aragon got control of ports in the Kingdom of Naples then held by Venice. Yet, the allies began to fight and by 1517 Venice had regained most of her possessions.

1509 VENETIAN COUNCIL PETITIONED FOR COPYRIGHT EXTENSION OF HYPNEROTOMACHIA POLIPHILI. Colonna's *Hypnerotomachia Poliphili* was published in Venice in 1499, but did not reach a broad audience until the first decades of the Cinquecento. Its many illustrations (172 woodcuts) set it apart from most texts, and its appearance helped change the manner in which books were subsequently published. The epic is thoroughly pagan in describing a dream that takes the main character (Poliphilo) on a fantastic journey to antiquity in pursuit of his love, Polia, a devotee of goddess Diana. Colonna's erotic text and imagery (fig. 46–2) inspired the imagination of artists and prompted commissions from nobility.

1510 IDEAL CARDINAL. Paolo Cortese (1465–1510), who succeeded Platina as librarian of the Vatican, writes *De Cardinalatu*, a guide to the life of the ideal cardinal, with its wealth and social and cultural obligations. Published in Rome soon after Cortese's death, the book has parallels with Castiglione's *Il libro del cortigiano* (see 1528).

FEDERICO II GONZAGA HOSTAGE OF JULIUS II. The son of Marchesa Isabella d'Este of Mantua, Federico (1500–1540), was held in Rome (1510–13) by the pope to ensure the good conduct of Federico's father, Marchese Francesco II of Mantua (military commander in the League of Cambrai [see 1508], captured and imprisoned by the Venetians, 1509–10). Vasari pointed out Federico's portrait in Raphael's *School of Athens*.

1511 HOLY LEAGUE FORMED AGAINST LOUIS XII. Julius II leads the allies of the Holy League (Switzerland, Spain, and Venice, later joined by England) against France.

1512 BATTLE OF RAVENNA. French forces defeat the Holy League, but are forced to retreat from Italy with the arrival of Swiss mercenaries in the employment of Julius.

SFORZA RETURN TO MILAN. With the French defeated at the battle of Novara, Massimiliano rules as duke of Milan under supervision of the Swiss.

SIEGE OF FLORENCE. Because Florence refused to join the Holy League, an army of Neapolitan and Spanish troops laid siege on the city and attacked nearby Prato, massacring the citizens.

RETURN OF THE MEDICI TO FLORENCE. Under threat of the Neapolitan and Spanish troops, *gonfaloniere* Piero Soderini abdicates his office (1 September). Medici troops led by Lorenzo the Magnificent's sons (Cardinal Giovanni and Giuliano) and his grandson (Piero's son Lorenzo) took over the city.

**ALFONSO D'ESTE OF FERRARA REC-
ONCILES WITH JULIUS II.**

1513 **MEDICI POPE.** On 11 March,
Cardinal Giovanni de' Medici
(son of Lorenzo the Magnificent)
becomes the first Medici pope,
Leo x; he succeeds Julius II.

EXOTIC ANIMALS IN ROME. During
Leo x's tenure, animals (giraffes
and lions) were imported from
the Sultan of Egypt. Hano the
elephant was Leo's favorite.

1514 **MACHIAVELLI'S DE PRINCIPA-
TIBUS** (The Prince). Machiavelli
dedicates his book to Lorenzo de'
Medici (Duke of Urbino), but had
earlier intended to dedicate it to
Giuliano (Duke of Nemours).

1515 **FRANCIS I KING OF FRANCE.** With
Louis XII's death, his second
cousin is crowned Francis I. Also
a descendant of Valentina Visconti
of Milan, he claimed the Milan
duchy. In this year, he defeats the
Swiss at the battle of Marignano,
and recovers Milan.

ENTRY OF LEO X IN FLORENCE.

**LEO X CONFERS DUCHY OF URBINO
ON NEPHEW LORENZO.** Pope Leo x
takes away the papal fiefdom of
the duchy of Urbino from Fran-
cesco della Rovere, who had sided
with the French, and confers it on
nephew Lorenzo de' Medici.

1516 **CHARLES BECOMES KING OF SPAIN.**
Grandson of Isabella and Fer-
dinand of Spain (mother's side)
and Mary of Burgundy and Em-
peror Maximilian I (father's side),
Charles would be elected Emperor
in 1519, a title he retained until his

death (1558). During his reign,
Spain was the preeminent nation
in Europe. Expanding holdings
in the Americas, he battled the
French and spent untold sums of
money suppressing Protestants.

CONCORDANT OF 1516. Leo x gives
Francis I control of the churches in
France (having the right of nomi-
nation to bishoprics, abbeys, and
priories increased his revenues).

**CARDINAL GIULIO DE' MEDICI HIRES
RAPHAEL TO DESIGN VILLA IN ROME**
(see **VILLA MADAMA**, sidebar).

1517 **FIFTH LATERAN COUNCIL.** The
council met from 1512 to 1517.

**LUTHER TACKS 95 THESES TO DOOR
OF CASTLE CHURCH, WITTENBERG.**
German priest Martin Luther
(1483–1546) begins the Reforma-
tion with his arguments attack-
ing the papal sale of indulgences.
While the Edict of Worms (1521)
outlawed Luther, the Edict of
Speyer (1526) rejected the edict.

1519 **LEO X SEEKS POLITICAL ADVICE
FROM MACHIAVELLI.**

**GIULIO DE' MEDICI GOVERNS FLOR-
ENCE.** Pope Leo x appoints his
cousin, Giulio de' Medici, gover-
nor of Florence.

1522 **POPE HADRIAN VI SUCCEEDS LEO.**
Following Leo x's death (1 Decem-
ber 1521), the conclave elected the
devout Adrian Dedal (9 January),
who became Hadrian VI. Born in
Utrecht, he had been the tutor,
regent, and viceroy of Charles v.

**MARTIN LUTHER DECLARED HERE-
TIC.** Declared a heretic at the Diet

VILLA MADAMA.
The creation of the
villa of Cardinal Giulio
de Medici on Monte
Mario (later Villa
Madama) was inspired
by the bull that his
cousin Leo x issued
(1516) encouraging
suburban building. In
1518–19, work began on
Raphael's revolutionary
design for the villa and
was continued after his
death (1520) by assistants
Antonio da Sangallo
Younger, Giulio Ro-
mano, and Giovanni da
Udine. Leo x's death
(1521) halted work,
which was resumed only
after Giulio became
pope. The gardens and
villa were never fully
finished according to
Raphael's plan, and the
villa was damaged dur-
ing the Sack of Rome.
Still, its grandeur was
admired, and it was
used as a rustic retreat
throughout the 16TH c.
After Clement's death
(1534), it went to Duke
Alessandro de' Medici,
and on his death, to his
wife, Margaret of Aus-
tria (named Madama
after her). In 1549 Queen
Catherine de' Medici
owned it; in 1550 she
granted it to Cardinal
Ippolito d'Este before
he became governor
of Tivoli. Catherine
gave it permanently to
Cardinal Alessandro
Farnese in 1555.

46–3. *Sleeping Ariadne*, 2ND C., Roman copy after Hellenistic original, marble, 5'3" x 6'4" (131 x 248 cm), Vatican Museums, Rome. When and where this work was discovered is uncertain, but in 1512, Julius II purchased the sculpture from the Maffei family. It was installed in the Cortile del Belvedere as a centerpiece for a fountain. For many years this figure was thought to depict Cleopatra, and Julius planned to have it installed in a nymphaeum in the Room of Cleopatra, near the Villa Belvedere (see Bramante). The sculpture collection of Julius was enlarged by popes Leo X and Clement VII. The artists brought to the papal court to fulfill commissions studied the antique works, especially figures such as the sleeping Ariadne, whose pose appears in Raphael's work and in that of the Venetians Giovanni Bellini, Giorgione, and Titian.

of Worms (8 May 1521), Luther is excommunicated by Hadrian VI.

1523 **LEAGUE AGAINST FRANCE.** Pope Hadrian VI joins (3 August) the alliance (the Empire, England, Austria, Milan, and Florence) against the French, who are expelled from Genoa and the Milanese.

GIULIO DE' MEDICI BECOMES POPE. Hadrian VI dies in Rome (14 September), and Giulio de' Medici is elected pope (19 November). The illegitimate son of Giuliano de' Medici, Giulio was raised by his uncle Lorenzo the Magnificent and was forced to leave Florence during the Medici exile (1494–1512); he becomes Clement VII.

1524 **FRANCIS I INVADES ITALY.** King Francis I of France takes Milan; imperial troops later took him prisoner at the battle of Pavia (1525). His release in 1526 was secured with the condition that he renounce all claims to Italy (see 1526).

VILLA BELVEDERE BECOMES A RETREAT FROM PLAGUE.

PEASANTS' REVOLT. Between 1524 and 1526, peasants in Europe rebel over their living conditions.

1526 **LEAGUE OF COGNAC.** On 25 May, the pope signs an alliance with France, Venice, Florence, and the Sforza (anxious to retake Milan) against Emperor Charles V.

1527 **SACK OF ROME.** For nine days (5–13 May), imperial troops sack Rome, while Clement VII takes refuge in Castel S. Angelo.

PAPAL RESIDENCE AT ORVIETO.

From December 1527 to June 1528, Clement and his papal court reside in Orvieto and Viterbo.

1528 **THE COURTIER.** Baldassare Castiglione, the Mantuan courtier, diplomat, and writer, completes *Il libro del cortigiano* (Book of the Courtier). Trained at the Milan court, which he left after the French invasion (in 1499), he worked (1504–13) for Guidobaldo da Montefeltro and Francesco Maria della Rovere at Urbino, where he composed his book.

1529 **FRANCE DEFEATED; POPE AND EMPEROR RECONCILE.** Defeated in Naples, France lost Milan and Genoa (taken in 1527 in their drive to Naples) and gave up all claim to Italian territories. (Charles V made the Sforza nominal leaders of Milan.) Peace was reached between the pope and emperor, and by July they jointly fought Protestants and the Ottoman Turks (overtaking much of Hungary, they were threatening Vienna).

SIEGE OF FLORENCE. Expelled in 1527, the Medici (joined by imperial troops) overtake Florence.

CLEMENT AND THE CASE OF HENRY VIII. Under pressure from Emperor Charles V, Clement VII reneges on an earlier decision to grant an annulment of the marriage of King Henry VIII to Catherine of Aragon, the aunt of Charles V.

CLEMENT CROWNS CHARLES IN BOLOGNA. This was the last time a pope would crown an emperor.

1531 **CLEMENT VII APPOINTS SEBASTIANO LUCIANI TO OFFICE OF PAPAL SEAL.**

The Venetian painter Sebastiano Luciani would now be known as Sebastiano "del Piombo."

BANDINELLI SHOP IN VATICAN. Florentine sculptor Baccio Bandinelli, a favorite of the Medici, has his shop in the Villa Belvedere.

ALCIATI'S EMBLEMATUM LIBER (Book of Emblems) **PUBLISHED.** Alciati's popular book was printed in most major centers: Augsburg (1531), Paris (1534), Venice (1546).

1532 **ALESSANDRO DE' MEDICI MADE DUKE OF FLORENCE.** Clement appoints Alessandro (his illegitimate son) duke of Florence; he had earlier made him governor (1531).

1533 **ALESSANDRO BUILDS FORTEZZA ALESSANDRA.** Antonio da Sangallo builds the impenetrable fortress (Fortezza da Basso) to keep the unpopular duke secure against the Florentine uprisings.

HENRY VIII MARRIES BOLEYN. Pope Clement VII declares Henry VIII excommunicate and his divorce and remarriage void. The church in England moved into schism as Lutheranism spread across Europe and into Scandinavia.

CATHERINE DE' MEDICI MARRIES PRINCE HENRY. The marriage was arranged by King Francis I of France and Pope Clement VII (Catherine's guardian). Catherine would stay in the shadow of Henry's mistress, Diana of Poitiers, until Henry's death (1559).

1534 **FOUNDING OF JESUIT ORDER.** Ignatius of Loyola, with six other churchmen, including Francis Xavier, founds the Company of Jesus (later the Society of Jesus) in Paris. Paul III approved the order in 1540, recognizing their counter-reformatory potential.

ELECTION OF PAUL III. With Clement VII's death (25 September), Alessandro Farnese, the oldest cardinal of the conclave, is unanimously elected pope (13 October); he took as his title Paul III. The new pope, who patronized artists, writers, and scholars and restored the university in Rome, was guilty of nepotism, making his 14-year-old grandson Alessandro cardinal in this year. However, Alessandro did not take full holy orders until 1564. In 1545, Paul made his 15-year-old grandson, Ranuccio, a cardinal and soon afterward a bishop.

PAOLO GIOVIO BECOMES THE PHYSICIAN TO POPE PAUL III. Paolo Giovio (1483–1552) had served as the papal physician to both Leo X and Clement VII. Recognized for his humanist, historical, and medical writings, Giovio became a consultant to patrons and artists, and he collaborated with artists on major projects in Rome, Florence, and Milan.

1535 **EMPEROR CHARLES TAKES MILAN.** With the death of Duke Francesco Maria II Sforza of Milan, Emperor Charles V declares his son duke of Milan.

PAUL III APPOINTS GRANDSON. At Ippolito de' Medici's death, Cardinal Alessandro becomes vice-chancellor of the Roman Church, an appointment for life bringing great revenue and residency in the Palazzo della Cancelleria. Vasari

ANDREA ALCIATO. Born in Alzata near Milan to a prominant family, Andrea Alciato (1492–1550), called Alciati, received his doctorate in law at Ferrara at the age of 24. Soon afterward, he taught law at Avignon and by invitation of King Francis I at Bourges. In Italy, he taught law in Bologna, Ferrara, and Pavia. His published interpretations of Roman law were considered exceptional, and his *Emblematum liber* was the first emblem book of the Cinquecento (see Cinquecento History Notes 1531). In this Book of Emblems are Latin poems combined with visual images, numbering about 100 in the earliest editions; this number had doubled by the early–17TH c. The coupled image and text are meant to express a moral message that must be intellectually reasoned through. Common to Alciati's book, and to those patterned after his, each page contains a short (usually classical) motto and a picture, with an epigram explaining the link between the text and the picture (see fig. 47-7).

46–4. *The Fourth Plate of the Muscles*, engraving, ca. 1543, from *De humani corporis fabrica*. Author of the treatise on anatomy, Andrea Vesalius (1514–64), a surgeon and anatomist, was born in Brabant. He studied at Louvain and Paris and went to Padua, where as lecturer on anatomy he changed the way human dissection was taught. In 1543 he publishes *De humani corporis fabrica* (On the Fabric of the Human Body), with illustrations by a pupil of Titian. In 1555, he received an appointment at the Spanish court as the physician to King Philip II, and in the same year he revised *Fabrica*. His survey of human anatomy was the first major undertaking since the writings of the ancient Greek Galen, whom he corrected on many points.

decorated the Roman palace with frescoes depicting stories of Paul III (1546).

1536 POPE PAUL III REVIVES THE CARNIVAL IN ROME.

1537 MURDER OF DUKE ALESSANDRO DE' MEDICI. Assassinating his cousin Alessandro, Lorenzino de' Medici is heralded as the new Brutus.

COSIMO DE' MEDICI IS DUKE OF FLORENCE. He reigned 32 years.

1538 PAUL III EXCOMMUNICATES HENRY VIII. Paul excommunicates Henry and places England under an interdict (see 1533).

1539 ROYAL ORDINANCE MAKES FRENCH LANGUAGE OF COURTS. All France is now under the jurisdiction of the royal courts, with French the language of the courts.

1543 VESALIUS PUBLISHES DE HUMANI CORPORIS FABRICA (see fig. 46–4).

1545 COUNCIL OF TRENT. Meeting at Trent in 25 sessions (1545–63), the 19TH Ecumenical Council enacted broad reforms and defined the differences between Catholicism and Protestantism.

1546 PARAGONE. Benedetto Varchi (1503–65), an intellectual at the Medici court in Florence, circulates among leading artists (Vasari, Michelangelo, Cellini, Pontormo, Bronzino) his *Paragone*, an inquiry concerning the merits of the arts; they were asked to compare painting to sculpture (see fig. IV–2).

SUMPTUARY LAWS IN FLORENCE.

Duke Cosimo de' Medici issues a law against excessive display of wealth. Foreign cloths were outlawed from use and women were allowed only one strand of pearls, one gold necklace and one gold belt, and three rings; the law was renewed in 1562.

1547 IN FRANCE KING FRANCIS I SUCCEEDED BY HENRY II.

1548 REBELLION IN AQUITAINE. Peasants revolt in Aquitaine, refusing to pay the salt tax (*gabelle*).

1549 PIRRO LIGORIO WORKS FOR IPPOLITO D'ESTE (see sidebar, right).

1550 ELECTION OF JULIUS III. With Paul III's death (November 1549), the Roman Giovanni Maria Ciocchi del Monte is elected pope (8 February), a compromise of the French and Farnese cardinals. Julius appointed Michelangelo chief architect of S. Peter's and built the exquisite Villa Giulia near the Porta del Popolo (Vasari works on this project). Julius III was to suppress the Council of Trent.

Vasari's first edition is published.

1551 PALESTRINA, CHOIRMASTER OF CAPPELLA GIULIA (see sidebar, right).

1552 TREATY OF PASSAU. While Emperor Charles V fought battles to return German states to Catholicism, Henry II of France becomes an ally of the Protestants, capturing Metz, Toul, and Verdun. Charles was forced to leave Germany and to sign a treaty granting Protestants religious liberty.

1554 PHILIP MARRIES MARY TUDOR.

Philip (Charles v's son) marries Mary Tudor, queen of England and eleven years his senior.

1555 DEATH OF POPE JULIUS III. With Julius III's death (23 March), the scholar and bibliophile Marcello Cervini is elected to the papacy.

ELECTION OF PAUL IV. Giampietro Carafa (aged 79), nephew of Cardinal Oliviero Carafa, succeeds Pope Marcellus II as Paul IV. Cofounder of the Theatines (with Gaetano di Thiene), he dedicated himself to strict poverty and the apostolic way of life and went about reforming abuses in the Church. As head of the reactivated Inquisition, he had no mercy for Lutherans. Spanish occupation of his native Naples ignited a bitter hatred of Spain, and his election went forward against the opposition of Charles v.

GIOVIO'S DIALOGO DELL'IMPRESE IS PUBLISHED IN ROME. Paolo Giovio (d. 1552; see 1534) composed *imprese* (personal mottos) for nobility.

PEACE OF AUGSBURG. The pact recognized the coexistence of Catholics and Lutherans in Germany. Under its terms, each German prince had the right to pick a religion for his state. Paul IV denounced the treaty as heretical.

PAUL IV RESTRICTS JEWS TO GHETTOS. The papal bull *Cum nimis absurdam* restricts Jews in cities to stay in their own quarters at night.

1556 CHARLES ABDICATES THRONE OF SPAIN TO SON PHILIP II.

LE IMAGINI DEGLI DEI DEGLI ANTICHI PUBLISHED IN VENICE. A translator of classical works into the vernacular at the Este court in Ferrara, Vicenzo Cartari (?1531–69) dedicated his popular handbook on pagan gods, *Images of Gods of Antiquity*, to Luigi d'Este. Focused on stories, symbols, and emblems of the gods, he drew on many sources: Ovid, Virgil, and Philostratus as well as late antique writers Martianus Capella (5TH c.) and Fulgentius (ca. 467–552). He was also indebted to Boccaccio (*Genealogia deorum*, 1373), Natale Conti (*Mythologiae*, 1551), and Gregorio Giraldi (*De deis gentium*, 1548). Cartari's *Imagini* was a source for Vasari's decorations in the Palazzo Vecchio (beg. after 1555). An enlarged edition of *Imagini* had woodcuts (1571).

1557 INDEX OF FORBIDDEN BOOKS CREATED BY POPE PAUL IV. Through the Congregation of the Inquisition, Paul created the index of forbidden books (revised 1559).

PAPAL WAR AGAINST SPAIN. On the ill advice of his nephew, Cardinal Carlo Carafa, and acting as a despotic ruler, Paul IV joins France in war against Spain; Duke Alva of Naples defeated the papal forces.

1558 CALAIS RETAKEN BY THE FRENCH. Duke Francis of Guise captures Calais, the last and only English territory in France.

ELIZABETH I IS NEW QUEEN OF ENGLAND. With the death of Mary Tudor, Elizabeth (daughter of Henry VIII and Anne Boleyn) becomes queen. Marriage would be proposed by Spain (to Philip II, widower of Mary Tudor) and France (to a young brother of

PALESTRINA. Julius III appoints Giovanni Pierluigi da Palestrina (ca. 1525–94) the choirmaster of the Cappella Giulia (choirboys) in S. Peter's, and he made him a member of the papal chapel so that he would have time to compose music. After the death of Julius (1555), Palestrina lost his position because he was not in Holy Orders and was married (Julius had set aside the rules for him).

PIRRO LIGORIO. Ligorio (1513–83), born into a noble family of Ferrara, moved to Rome in 1534. He undertook archaeological studies and in 1549 became the court archaeologist of Cardinal Ippolito II d'Este (the son of Lucrezia Borgia and Alfonso I of Ferrara). In Rome, Ligorio created frescoes, published maps of Rome (two of which reconstruct antique monuments), and oversaw the fountains in S. Peter's Square. His most remembered works are the gardens of the Villa d'Este and the paintings in the Casino of Pius IV. He returned to Ferrara in 1568, where he became the court antiquarian to Duke Alfonso II of Ferrara.

Francis II), negotiated by Medici Queen Catherine of France (see figs. V–6, 61–2).

1559 **PEACE OF CATEAU-CAMBRÉSIS.** This marks a truce (3 April) between France and Spain, ending 65 years of struggle (1494–1559) for control of Italy. Henry II of France restored Savoy and Piedmont to Spain's ally, Emmanuel-Philibert of Savoy, gave back Corsica to Genoa, and renounced his hereditary claim to Milan; Habsburg Spain became the dominant foreign power in Italy for the next 150 years. France managed to retain five fortresses, however, including Turin, Saluzzo, and Pignerol. France also retained the three bishoprics (Toul, Metz, and Verdun) captured from Charles V in 1552, and Calais, taken from the English in 1558.

DEATH OF POPE PAUL IV BRINGS ELECTION OF PIUS IV. Giovanni Angelo Medici from Milan (unrelated to the Florentine Medici) becomes pope. Paul IV's Spanish War depleted the papacy's coffers, and Pius allowed two of Paul's hated nephews to be tried and executed for murder. Expenditures of the war stopped the building of S. Peter's dome from 1556 to 1561.

DEATH OF KING HENRY II OF FRANCE. In a tornament joust celebrating the Peace of Cateau-Cambrésis, Henry is accidentally killed; son Francis II (aged 15) inherits the throne, and Queen Catherine de' Medici is Regent.

1560 **PHILIP II OF SPAIN MARRIES ELISABETH OF VALOIS.** Sealing the Peace of Cateau-Cambrésis (1559), Philip marries Elisabeth, the daughter of Henry II and Catherine de' Medici.

SPAIN GOES BANKRUPT. This is the second time Philip II went bankrupt (the first, in 1557). He went bankrupt twice more: in 1576 and 1596.

1561 **MADRID NEW CAPITAL OF SPAIN.** Philip II moves the court to Madrid, turning a village into the center of his government. In 1562 Titian completed *Rape of Europa* (Prado, Spain) for his palace. By his death, Philip owned about 30 paintings by Titian.

1562 **BULL CALLS FOR RECONVENING COUNCIL OF TRENT.** Concerned with the rapid growth of Calvinism, Pius IV reconvenes Trent.

MASSACRE AT VASSY. Struggles between Catholics and Huguenots (French Calvinists) at Vassy mark the beginning of bloody religious wars in France that will last intermittently until 1598 (Edict of Nantes), with many nobles taking up arms for the cause of Protestants.

1563 **LAST SESSION, COUNCIL OF TRENT.** In the last (25TH) session of the Council (suspended since 1552 and reconvened 18 January 1562), the decision of the Second Council of Nicea (in 787) about the legitimacy of images was affirmed.

ESCORIAL BUILT IN MADRID. The foundation stone is laid for the royal monastery and palace (finished 1584), built by Philip II of Spain.

1564 **DEATH OF CALVIN.** Frenchman John Calvin (1509–64) moved to Geneva, Switzerland. He expounded a theological system based on the belief in predestination: God predestines some to salvation, others to damnation.

1566 **ELECTION OF POPE PIUS V.** Giovanni Michele Ghislieri becomes Pius V. He gave the antique sculpture in the Villa Belvedere to Rome and private collectors, considering these too pagan for the papal palace (those in the Sculpture Court were left intact).

1568 **LIVES PUBLISHED.** In his second version of the *Lives*, Vasari greatly expanded his manuscript, significantly altering the life of Michelangelo and adding information on the academicians.

1572 **S. BARTHOLOMEW'S DAY MASSACRE.** A royal plot causes thousands of Huguenots to be slain.

GREGORY XIII ELECTED POPE. With the death of Pius V came the election of a Bolognese.

1574 **DEATH OF GIORGIO VASARI.** (See Vasari.)

DEATH OF GRAND DUKE COSIMO I.

With Julius II as Rome's reigning pontiff, the Eternal City underwent tremendous change in one decade (1503–13). Tied to his papacy was a major rebuilding of the Vatican complex, including the addition of a sculpture court for the Villa Belvedere (see fig. 49–3). Alberti had built the villa during the tenure of Pope Innocent VIII, who had little physical stamina for traveling and for whom it served as a retreat. For Alexander VI, it was the initial prison of Countess Caterina Sforza of Forlì (February to May 1500), who had been captured by Cesare Borgia. But it chiefly served Alexander as a guest house for minor dignitaries. For Julius, it was more valuable. He dined there, held celebrations and dramas, and escaped the plague. In 1510, the villa became the residence of his hostage Federico II Gonzaga, who was treated there like a royal prince.

ARCADIA — In art this is pictured as an ideal, bucolic setting linked to antiquity. A stimulus for such scenes appears at the end of the Quattrocento in Francesco Colonna's *Hypnerotomachia Poliphili* (see Cinquecento History Notes 1509), which displays an insatiable passion for monuments of pagan antiquity and the exquisite things of nature. The ruling

47–1. GIULIANO DA SANGALLO. Medici Villa, Poggio a Caiano (near Florence), ca. 1489–94, 1515–20. (The double staircase and large clock are 18TH-c. additions.) Giuliano da Sangallo (?1443–1516), a Florentine woodworker, became Lorenzo the Magnificent's favorite architect; his first projects for Lorenzo were the wood intarsia choir stalls (1470s) in the Palazzo Medici chapel. Families like the Medici enjoyed town houses and the luxury of country houses upon which architects could lavish classical motifs and develop exotic gardens. Giuliano's methodical studies of ancient Roman buildings inspired his designs for contemporary buildings, and the *all'antica* portico of the villa at Poggio a Caiano is remindful of the Roman Pantheon. The grand pediment stands out against the undecorated white walls of the villa, calling attention to its classical derivation in a manner similar to the *all'antica* window frames of the Palazzo Farnese (see fig. 47–9), designed by Giuliano's nephew Antonio. Classical themes adorn the portico (the frieze was perhaps designed by Bertoldo di Giovanni and the wall fresco under the portico, *Sacrifice of Laocöon*, is by Filippino Lippi). Not bound by restrictive communal building codes, Tuscan villa architecture of the late Quattrocento displays an enthusiasm for antique style that already thrived in cities like Venice and would appear in Cinquecento Rome in buildings like the Palazzo Farnese.

Rome of the Medici popes (Leo X and Clement VII), steeped in the luxury afforded by Julius' reign, underestimated the religious turmoil that would seriously threaten the Latin Church. In the same year that Martin Luther tacked up his theses at Wittenberg (1517), Alessandro Farnese (d. 1549) hired Sangallo to build him a palace in Rome (see fig. 47–8). Farnese was educated at Rome and Florence and had been made treasurer of the Roman Church (1492) and cardinal deacon (1493) by Pope Alexander VI. He gained the name "cardinal petticoat" during this period because his sister was the pope's mistress. He, too, had a Roman mistress, with whom he had four children. By 1519, when Farnese was ordained a priest, he had changed the manner of his private life and had become a member of the reform party in the papal curia. After his election to the papacy in 1534, he continued work on his palace. His zeal for antiquities reached its zenith in the 1540s, as he was acquiring whole collections and single pieces from excavations. However, in the last years of his papacy, he convened the Council of Trent (1545–63) to reform the Church, and in response to the great success of the Protestant Reformation.

47–2. APOLLONIOS. *Belvedere Torso* (Bacchus or Hercules), Greek, IST C. BCE, copy after original of the late–3ᴿᴰ or early–2ᴺᴰ C. BCE, marble, 5′2″ (157.5 cm), Vatican Museums, Rome. An inscription on the base of the statue reads: "Apollonios, son of Nestor, from Athens, has made this." In what specific year the torso entered the Vatican is unclear. Images of it appear in Quattrocento drawings, although it was more frequently copied by Cinquecento artists. Michelangelo's Sistine figures and his *Victory* (see fig. 51–12) reflect his great admiration for the form, which made a lasting impression on his art.

47–3. After Duccio's *Maestà* (*Deposition*).

wealthy in the Cinquecento aimed to enjoy a type of pagan paradise on earth akin to that of Poliphilo's dream. The Chigi, Gonzaga, Farnese, Este, and Medici, as well as Venetian nobles and the French king Francis I, turned their rural land holdings into lush retreats. They hired artist visionaries to acquire antique sculptures, decorate villas, and design aviaries and gardens with fountains and grottoes of the goddess Venus. When Francis I contracted copies of the most famous antique statues in the Belvedere, *Sleeping Ariadne* (see fig. 46–3) was among those selected, and it was cast in bronze from Primaticcio's models.

BELVEDERE TORSO — This was one of the most popular antique marble sculptures in the papal collection (see fig. 47–2); Michelangelo often referenced it, as did Rosso Fiorentino (see fig. 54–2).

CARTELLINO — A little piece of paper giving the appearance that it is attached to the surface of a painting (trompe l'oeil effect) is a *cartellino*; it was typically inscribed with the name of the artist, date, or a motto. The *cartellino* first appears in Flemish paintings (by Jan van Eyck and Petrus Christus) and is found in works influenced by Flemish models: i.e., Fra Filippo Lippi's *Tarquinia Madonna*, 1437 (National Gallery, Rome), Giovanni Bellini's *Pietà*, ca. 1468 (Brera, Milan), and Carlo Crivelli's *Madonna della Candeletta*, early 1490s (Brera, Milan).

DEPOSITION — In the time of Christ, Roman law allowed the corpses of executed criminals to decay in the open air. Jewish law dictated, however, that the bodies be removed by sunset and buried so that the rotting corpses did not despoil the land. Because Judaea was under Roman command, a Roman magistrate had to approve the removal of a criminal from the place of execution.

According to the Gospels, a wealthy man from Arimathea, named Joseph, who was a member of the Sanhedrin (Mk 15:43, Lk 23:50–51) and a disciple of Christ, sought Pilate's permission to take away the body of Christ on the evening of his execution (Mt 27:57–58, Mk 15:42–43, Lk 23:52, Jn 19:38). "Then Pilate wondered if he [Christ] were already dead; and summoning the centurion, he asked him whether he had been dead for some time. When he learned that he was dead, he granted the body to Joseph" (Mk 15:44–45). In the synoptic Gospels, only Joseph is mentioned in the burial of Christ, but Joseph and Nicodemus are both mentioned in the Gospel of John (19:39). Deposition images usually elaborate upon the Gospel texts and include Christ's close followers (Virgin Mother, John the Evangelist, Mary Magdalene, and two women named Mary), who stand near the cross and help to remove Christ's dead body. While standing on the ladder, supporting the dead weight of Christ with one arm and bracing himself with the other, which is swung behind the crossbar, Joseph lowers Christ into the hands of John. The Virgin tenderly kisses her son, Mary Magdalene lovingly holds his arm, and Nicodemus removes the nails from his feet in Duccio's image (see fig. 47–3). This subject was popular in the Quattrocento and Cinquecento, and the theme is typically filled with emotion and physical activity. By the 15ᵀᴴ c., images of the theme included portraits. In Fra Angelico's *Deposition* (see fig. 26–3) the men on the far right are wearing contemporary dress and the landscape resembles Tuscany. Pontormo later painted a self-portrait in his *Deposition* (see fig. 53–1).

DISEGNO — More than mere drawing, *disegno* (design) is the parent of the three arts: architecture, sculpture, and painting, according to Vasari. Similar to an

invenzione (or idea), *disegno* comes from the intellect and is the visible expression of inner thoughts.

EMBLEMS — Popular in the Cinquecento (see Alciati, Cinquecento History Notes 1531), emblem books focus on virtues and combine visual images with mottos and explanatory verse (see fig. 47–7).

ENTOMBMENT — According to the synoptic Gospels (Mt 27:59–60, Mk 15:46, Lk 23:53), the body of Christ was wrapped in a linen cloth (purchased by Joseph of Arimathea, according to Mark), and buried in a rock-hewn tomb (new, according to Luke) (Joseph's tomb, according to Matthew). Before leaving the grave site, Joseph rolled a great stone in front of the door to the tomb (Luke does not mention the stone or the door). The Gospel of John agrees that Joseph was permitted to remove the body of Christ (19:38), but states that Nicodemus was also present during the burial. "Nicodemus, who had at first come to Jesus by night, also came, bringing a mixture of myrrh and aloes, weighing about a hundred pounds. They took the body of Jesus and wrapped it with the spices in linen cloths, according to the burial custom of the Jews. Now there was a garden in the place where he was crucified, and in the garden there was a new tomb in which no one had ever been laid. And so, because it was the day of Preparation, and the tomb was nearby, they laid Jesus there" (Jn 19:39–42). Sitting near the tomb were Mary Magdalene and another woman named Mary (Mt 27:61), who saw where Joseph buried Christ (Mk 15:47, Lk 23:55), and they went away to prepare spices and ointments for Christ's body (Lk 23:56). In Duccio's panel (see fig. 47–5), Christ receives emotional farewells from the Virgin, whose face touches his, and from Mary Magdalene, who raises her arms in heartfelt lamentation. However, his body is not placed in a rock tomb, as described in the Gospels, but is lowered into a sarcophagus sitting before a craggy rock hill. Entombment images typically include the figures depicted in scenes of the Deposition and Lamentation (although only Joseph and Nicodemus are present in the Gospel texts). By the 15TH c., a rock tomb is often depicted in this theme. In Mantegna's *Resurrection* (1456–59, Musée des Beaux-Arts, Tours), from the S. Zeno altarpiece in Verona, the sarcophagus is set in front of a rock cave, and in Raphael's *Entombment* (1507, Borghese Gallery, Rome) Christ's body is carried toward a rock cave.

FLAGELLATION — Although Pilate addressed the crowd three times, say-

47–4. After Giotto's *Lamentation*, Scrovegni Chapel.

47–5. After Duccio's *Maestà* (*Entombment*).

47–6. After Niccoló di Pietro Gerini's *Resurrection*, ca. 1380s, Sacristy, S. Croce, Florence.

47–7. Line drawing after *Venus Standing on a Tortoise*, from Andrea Alciato's *Emblematum liber* (the figure appears in the 1531 unauthorized edition, folio 1, verso). The emblem is related to marriage and its motto is MULIERIS FAMAM, NON FORMAM, VULGATAM ESSE OPORTERE (The reputation of a woman, not her beauty, ought to be proclaimed). In the text placed beneath the figure is the inscription ALMA VENUS, QUAENAM HAEC FACIES? QUID DENOTAT ILLA / TESTUDO, MOLLI QUAM PEDE DIVA PREMIS? / ME SIC EFFINXIT PHIDIAS, SEXUMQUE REFERRI / FOEMINEUM NOSTRA IUSSIT AB EFFIGIE: / QUODQUE MANERE DOMI, ET TACITAS DECET ESSE / PUELLAS, /SUPPOSUIT PEDIBUS TALIA SIGNA MEIS (Bountiful Venus, what pray is this likeness? What is the significance of that tortoise on which, goddess, you set your gentle foot? Venus responds: "Phidias formed me thus, and he commanded that my sculpture represent the female sex; and because it is appropriate for women to remain at home and be silent, he placed such a symbol beneath my feet").

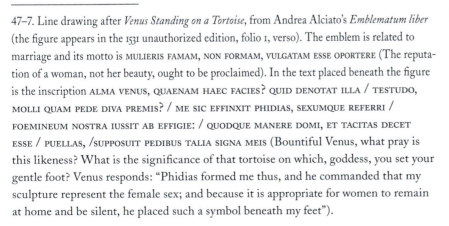

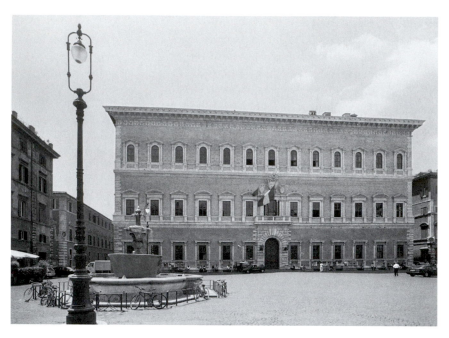

ing that he would order the flogging of Christ and then release him, the unruly crowd persisted in asking for the freedom of Barabbas and the crucifixion of Christ (Lk 23:18–22). All four Gospels record that after the crowd demanded the release of Barabbas, Pilate had Christ flogged (Mt 27:26, Mk 15:15, Jn 19:1). Although the story receives brief mention in the Bible, images of Christ's scourging, which were popular in the Quattrocento and Cinquecento, often show Christ wearing a loincloth and standing with his hands bound to a column (one of the instruments of the Passion), while two or three soldiers flog him (see Piero della Francesca's *Flagellation*, ca. 1460, National Gallery, Urbino). Christ's inner beauty and purity were thought to be reflected in his flesh. According to the *Meditations on the Life of Christ*, Christ was stripped naked, and he stood "before them all, in youthful grace and shamefacedness, beautiful in form above the sons of men, . . . [sustaining] the harsh and grievous scourges on His innocent, tender, pure, and lovely flesh" (ch. 76).

47–8 (front, top), 47–9 (east facade, bottom). ANTONIO DA SANGALLO THE YOUNGER AND MICHELANGELO. Palazzo Farnese, 1517–50, Rome. Antonio da Sangallo the Younger (nephew of Giuliano and Antonio the Elder) received a commission in 1517 from a newly appointed cardinal, Alessandro Farnese, to rebuild his palace in Rome. The projecting cornice and massive size of this freestanding building resemble the Palazzo Strozzi (see fig. 63–5). However, the rustication is almost nonexistent, except around the main portal and on the corners of the building. After Antonio da Sangallo died (1546), Michelangelo replaced him as the chief architect of the palace, and when Michelangelo died (1564) the palace was completed by two architects, Vignola and Giacomo della Porta, both knowledgeable about classical art. Cinquecento palaces were boldly articulated with classical elements, like the deeply carved pediments and segmental arches framing the windows of the Palazzo Farnese. In comparison, the classical elements on earlier palaces, like the Rucellai (see fig. 63–4), appear flat and less sculptural. In contrast to the Palazzo Strozzi, the facades of the Farnese have many more openings, 38 on the main facade and 45 on the east side of the building (see fig. 47–9). Each opening is articulated with an *all'antica* window frame that stands out sharply from, and casts shadows upon, the smooth flat wall.

IMPRESA — A personal device that includes a visual image and motto (a word or short expression) is called an *impresa*.

LAMENTATION — Scenes of the Lamentation are devotional images that portray grieving disciples and display Christ's dead body, emphasizing his wounds. The moment described is after Christ was taken down from the cross and before he was entombed. Lamentation images may depict the body of Christ placed across the Virgin's lap (called the *Pietà*, meaning pity) (see Michelangelo's *S. Peter's Pietà*, fig. 51–3). They may also show the body of Christ on the ground (see fig. 47–4) or on a stone slab (see Perugino's *Lamentation Over the Dead Christ*, 1495, for

S. Chiara, Florence, and Andrea del Sarto's *Lamentation*, 1524, for S. Pietro in Luco, near Florence) (both Galleria Palatina, Palazzo Pitti, Florence).

MANIERA — Vasari used the term positively. In the 20ᵀᴴ c., the term Mannerism was coined to designate the "mannered" art that emerged following Raphael's death, showing a decline from the monumental (or high) art of Leonardo, Raphael, and Michelangelo. Mannerism is now more often defined as reflective of spirited imagination or spirituality, as seen in Romano (see fig. 47–10) and Pontormo (see fig. 53–1).

RESURRECTION — According to the Gospel of Matthew, the chief priests and Pharisees went to Pilate on the sabbath to ask for a guard of soldiers to secure the tomb of Christ because they remembered that Christ had said that he would rise again after three days; therefore, they wanted the tomb to be secure so that Christ's disciples could not steal his body away, claiming that he rose from the dead (Mt 27:62–64). After Pilate granted them a guard, they went off to secure the tomb and seal the stone (Mt 27:65–66). Christ's resurrection is not described in the Bible, but the subject was popular in art. Images of the Resurrection usually show Christ standing above or on top of his tomb (which looks like a sarcophagus). He often holds a banner with the emblem of a cross, raises his right arm in triumph over death, and displays the nail and lance wounds inflicted upon him during his crucifixion. Soldiers guarding his tomb are asleep or have fallen backward, paralyzed by a blinding light emanating from Christ. Trecento images of this theme often include angels and a blazing, golden light that radiates from Christ in a *mandorla* (almond) shape, as in the *Resurrection* fresco attributed to Niccoló di Pietro Gerini (see fig. 47–6). In Andrea del Castagno's *Resurrection* fresco, 1447 (S. Apollonia, Florence), Christ is so luminous that the features of the nearest soldier are washed away by the bright light that covers his face. By the mid–fifteenth century, supernatural figures are not always depicted. No angels appear in Piero della Francesca's *Resurrection* for the Sansepolcro town hall, after 1458 (now Museo Civico, Sansepolcro), but the pale, iridescent skin and stark, piercing gaze of Christ make him seem otherwordly. In Donatello's *Resurrection*, 1460s (S. Lorenzo, Florence), Christ appears barely able to lift himself out of the tomb, and the burial shroud, which is still wound around him, seems to weigh heavily upon his head. Yet, Christ is so much larger than the guard of soldiers that all their armor and weapons are powerless to stop the spiritual event, and one soldier, grabbing hold of the sarcophagus near Christ's foot, gazes in wonderment as Christ emerges from his grave. The theme appears in Michelangelo drawings (British Museum, London, and Royal Library, Windsor) for a never-executed fresco in the New Sacristy, San Lorenzo, Florence. The Resurrection is celebrated on Easter Sunday at the culmination of Holy Week to commemorate the redemption of Original Sin through the sacrifice of Christ. This is the most ancient and important Christian feast of the liturgical

47–10. GIULIO ROMANO. Palazzo del Te (inner court), 1526–34, Mantua. This country retreat was built as a pleasure palace on an island connected to Mantua (see figs. 55–1, 55–2). The Gonzaga bred horses on the island, which in the time of the patron, Federico II (see Cinquecento History Notes 1510), were sought after by European courts and whose portraits are pictured in one of the grand salons of the palace. Federico II Gonzaga (who was bestowed the title duke by Emperor Charles V during the building of the palace) was the son of Isabella d'Este and Marchese Francesco II Gonzaga, who was still a boy in Mantegna's Camera Picta (see fig. 40–3, #3). Romano designed the palace rooms in four wings built in a square around a large court, behind which are gardens that end in an elaborate exedra. Romano's admiration of Bramante appears in the heavy, classical architecture of the Te, but his Mannerist tendencies appear in the playful way the elements are artfully designed (i.e., triglyphs seem ready to drop from position).

year (the liturgical color is white). Unlike Christmas, Easter Sunday is a moveable feast day that was historically linked with the Jewish Passover and was thus placed during the first full moon of Spring (between 21 March and 25 April). For several centuries in the early Christian churches of Jerusalem, Alexandria, and Rome, Easter Sunday was celebrated on different days. According to an old tradition, eggs (symbolic of rebirth) were blessed in churches on Easter (eggs were forbidden food during Lent).

TRANSFIGURATION — Jesus went to pray and took with him three apostles, Peter, John, and James Major. According to *Meditations on the Life of Christ*, they went to the top of Mount Tabor in Galilee (ch. 41). "While he was praying, the appearance of his face changed, and his clothes became dazzling white" (Lk 9:29). The three apostles then saw Moses and Elijah talking with Jesus. In art Moses often holds tablets, symbolic of the Old Testament, and Elijah holds a scroll, symbolic of the prophets. "They appeared in glory and were speaking of his departure, which he was about to accomplish at Jerusalem" (Lk 9:31). Soon after, a bright cloud shone over everyone and the voice of God descended from the cloud, saying "This is my Son, the Beloved; with him I am well pleased; listen to him" (Mt 17:5). The Gospels of Matthew, Mark, and Luke give accounts of the transfiguration of Jesus. But only Matthew describes the fear that overcame the apostles and that Jesus told them not to be afraid. "And when they looked up, they saw no one except Jesus himself

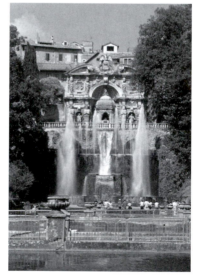

alone" (Mt 17:8). All three Gospel texts, Matthew, Mark, and Luke, record that as they were going down the mountain, Jesus ordered them to say nothing of what they saw. The Gospel of Matthew has the most detailed record of what happened next, when Jesus was asked why the scribes had said that Elijah must come first, before the Son of God. Jesus responded that "'Elijah has already come, and they did not recognize him, but they did to him whatever they pleased. So also the Son of Man is about to suffer at their hands.' Then the disciples understood that he was speaking to them about John the Baptist" (Mt 17:12–13). Duccio's *Transfiguration* (*Maestà*) depicts Jesus standing between Moses and Elijah, with the three apostles kneeling on the ground in front of them. While Giovanni Bellini's *Transfiguration of Christ* (Capodimonte, Naples), ca. 1475, follows the tradition for showing Jesus standing between Moses and Elijah, with the three apostles in front of them, Perugino's fresco of 1500, *Transfiguration of Christ* (Cambio, Perugia), shows Jesus, Moses, and Elijah as luminous, floating figures. Perugino's image became the customary way of describing them in Cinquecento Italian art. Raphael's *Transfiguration of Christ* (Pinacoteca, Vatican Museums, Rome), 1517, includes the Gospel episode which follows the descent from the mountain: the disciples are arguing with scribes while a father pleads with Jesus to heal his possessed son because the disciples were unable to cast out the demons (Mt 17:14–18). In 1456, during the reign of Pope Calixtus III, the feast of the Transfiguration (6 August) became a feast of the universal Church.

47–11. PIRRO LIGORIO. Gardens of the Villa d'Este at Tivoli with fish ponds (foreground) and *Fountain of Nature* (upper plateau in the distance) (hydraulic design by LeClerc), 1560s. The villa comprises part of a Franciscan monastery turned into the governor's palace. In 1550, when Cardinal Ippolito II d'Este (d. 1572) was installed as governor by Pope Julius III, he bought land on the hillside beneath the palace and commissioned Ligorio to transform the palace and grounds into a sumptuous estate. Work was mostly completed by 1572 when Pope Gregory XIII visited the villa. The *Fountain of Nature* had an image of Diana of Ephesus in the central niche (statue removed 17TH c.); her presence connoted bounty. Court archaeologist to Cardinal Ippolito, Ligorio studied Hadrian's villa near Tivoli, advising the cardinal about antiquities while designing the gardens, the antique imagery of which was meant to glorify the cardinal (see Cinquecento History Notes 1549).

No Renaissance artist is more broadly esteemed than the exceptionally gifted Leonardo (1452–1519). Interestingly, his first major acclaim came neither in Florence nor in Rome, but in Milan. Leonardo went there in 1482 to serve Ludovico "Il Moro" Sforza as a military engineer and city planner. While Botticelli, Ghirlandaio, and Perugino displayed their great merit as mural painters in the Sistine Chapel, Leonardo established his credibility at the Milan court, proving his skills in many fields. By the early 1490s he had become as valued in the Sforza court as was Andrea Mantegna in the Gonzaga court at Mantua. In 1493, the *Rime* of Milanese court poet Bernardo Bellincioni described him as the "Apelles from Florence." Half a century later Vasari (*Lives*) considered him exceptionally blessed above all men for his God-given beauty, grace, and talent. Until the 19TH c., the extent of his complete oeuvre was uncertain, with such works as the *Annunciation* (Uffizi Gallery, Florence) and *Portrait of Ginevra de' Benci* (see fig. 48–2) attributed to other artists. Contributing to problematic issues of attribution are Leonardo's habit of bringing few works to completion and the unfortunate loss of important projects (equestrian monument of Francesco Sforza in Milan and the Battle of Anghiari fresco for the Florence town hall). Still, his designs for paintings, sculptures, and architecture, and especially his writings on art concerning nature and the display of character, were broadly influential for centuries. His anatomical studies were the most advanced for his era, as were his canal designs for the governments of Florence and Venice. He worked for five lordly rulers (Ludovico Sforza, Cesare Borgia, King Francis I, and Giuliano and Lorenzo de' Medici [brother and nephew of Pope Leo X, respectively]), and his peripatetic nature is reflected in the five major divisions of his career: early Florentine period (1472–81/82), early Milanese period (1481/82–99), second Florentine period (1500–1508), second Milanese period (1508–13), and late period in Rome and France (1513–19). Although Leonardo's contribution to Italian painting is difficult to grasp given his many incomplete works, the comparisons that follow will show his novel treatment of popular themes.

1452 — Leonardo is born in Vinci (15 April), after which he would be known. He was the illegitimate son of Caterina (daughter of a local farmer) and Ser Piero di Antonio di Ser Piero da Vinci, a notary whose family owned property in the region. Soon after Leonardo's birth, his father married Albiera di Amadori and his mother married Piero del Vacca (1453); Leonardo was raised in his father's household (see 1457).

1457 — Antonio di Ser Piero da Vinci (d. 1465), Leonardo's paternal grandfather, files a tax declaration that gives information about Leonardo's origins and claims the child as a family member.

48–1. LEONARDO DA VINCI. *Mona Lisa*, ca. 1503, oil on panel, 2'6.4" x 20.8" (77 x 53 cm), Louvre, Paris. Like *Ginevra de' Benci* (see fig. 48–2), the sitter is outdoors, but her setting is more evocative with its vast, mysterious valley. Although devoid of jewelry, text, or emblems alluding to social status or moral beauty, she nevertheless displays a more definable character than Ghirlandaio's *Giovanna Albizzi* (see fig. 48–3).

48–2. LEONARDO DA VINCI. *Ginevra de' Benci* (obverse), ca. 1474–76, oil on panel, 15'" x 14.5" (38.1 x 37 cm), Ailsa Mellon Bruce Fund, National Gallery of Art, Washington, D.C. (since 1967). Identified as Ginevra de' Benci (1457–ca. 1520), this woman appears before a juniper bush (It. *ginepro*), a pun on her name and symbol of chastity. An educated beauty, well-loved in Florence, Ginevra was the platonic love of humanist Bernardo Bembo, Venetian ambassador to Florence (1474–76 and 1478–80). Portraits like this were made for new brides; yet this painting was likely ordered, not by her husband, but by Bembo. Unlike most Italian female portraits of the period (see fig. 48–3), Ginevra is shown outdoors and appears to be turning toward viewers, her hands folded over her body. Her hands are now missing because the panel was cut as indicated by the cropped imagery on the back of the panel, where an inscribed scroll wraps around an oval wreath (a laurel branch and palm frond tied together with a juniper sprig in the center); the scroll reads: VIRTVTEM FORMA DECORAT (Beauty adorns Virtue).

1469 — In Florence, Leonardo's father submits a tax declaration stating that he is working (as a notary) at the Palazzo del Podestà (see fig. 62–7, #6). Around this year, Leonardo likely entered Verrocchio's shop (he is recorded there in 1476).

1472 — Leonardo is inscribed in the Company of S. Luke in Florence.

ca. 1472 — Leonardo executes the *Annunciation* (Uffizi Gallery, Florence), 3'2.5" x 7'1.5" (98 x 217 cm), for the convent of S. Bartolomeo at Monteoliveto (outskirts of Florence). Created for either the sacristy or the refectory, the painting was attributed to Domenico Ghirlandaio until 1869. While the work suggests an artist familiar with Verrocchio's style and motifs (as seen in the lectern), the atmospheric perspective and dramatic encounter between Mary and Gabriel are Leonardesque. Radiographs show changes that suggest a reworking of the composition.

ca. 1473 — Leonardo works on the *Baptism* for S. Salvi (see Verrocchio).

ca. 1474 — Leonardo paints *Ginevra de' Benci* (see fig. 48–2), once attributed to

Lucas Cranach (18TH c., Liechtenstein Collection). Identification of the subject is based on the observation by Vasari and other 16TH-c. writers that Leonardo painted Ginevra d'Amerigo, a young woman of the wealthy Florentine Benci family, who married Luigi Niccolini at the age of 16 in 1474. The sitter's hands (panel has been cut) may have resembled those of Verrocchio's *Lady with a Bunch of Flowers* (see fig. 48–4).

1476 — In Florence, Leonardo is anonymously accused of sodomy, but is cleared of the charges.

1478 — The Florence government hires Leonardo (10 January) to create an (unexecuted) altarpiece for the chapel of S. Bernard in the Audience Hall, Palazzo della Signoria; the contract had earlier been awarded to Piero del Pollaiuolo. After Leonardo left Florence, the contract was reassigned to Domenico Ghirlandaio (in 1483), but he also never executed the altarpiece. Leonardo begins pages of writings and drawings that are later compiled into the *Codex Atlanticus* (Ambrosiana, Milan); the pages cover work throughout his career, some dating as late as 1518.

ca. 1480 — In the early 1480s, Leonardo probably began *Penitent S. Jerome*, an unfinished panel showing his interest in depicting the spiritual and emotional character of the reclusive saint (Vatican Picture Gallery, Rome). In the skeletal structure of the saint, Leonardo shows his knowledge of dissection.

1481 — Leonardo is commissioned by the monks of S. Donato a Scopeto to paint

an altarpiece within 30 months for the high altar of their monastery church. On 28 September 1481, he received his last payment, and although he had executed at least 15 preparatory drawings for the painting, his panel apparently never progressed beyond a detailed underdrawing with washes (fig. 48–5). (Vasari later wrote that Leonardo's unfinished *Adoration* was in the house of Amerigo de' Benci, the nephew of Ginevra and son of Leonardo's close friend, Giovanni de' Benci.) In 1496 the monks hired Filippino. More closely following the work of Leonardo and Botticelli (fig. 37–2) than that of Gentile (fig. 22–1) or Filippo (fig. 31–3), Filippino's *Adoration* (fig. 48–6) shows an arrangement of figures encircling the holy family (see Filippino Lippi 1496). Like Leonardo's, Filippino's crowd is excited and unsettled; their postures and gestures are nearly identical to Leonardo's figures, as they display an emotional fervor ranging from anticipation and puzzlement to humble reverence.

1482/83 — Leonardo moves to Milan to become Ludovico "Il Moro" Sforza's engineer and architect. Leonardo perhaps acquired his position at Ludovico's court through his letter of 1482 describing his skills. Claiming to be an inventor of war machinery, he declared that he could design all sorts of devices for attack and defense: he had plans for lightweight, portable bridges, waterways and underground tunnels, cannon, mortars, and catapults, and covered carts that could both annihilate enemies and resist attacks. Almost an afterthought, he offered his services as an architect, sculptor, and painter, noting that he could create the bronze horse Ludovico wanted built to memorialize his late father, Francesco I (see fig. V–1).

1483 — In Milan, Leonardo signs a contract for an altarpiece in S. Francesco Grande, *Madonna of the Rocks* (Louvre, Paris).

Leonardo works (1483–99) on an equestrian memorial to Ludovico's father, Francesco I (d. 1466), founder of the Sforza dynasty at the Milan court. Francesco's humble roots and aggressive takeover of Milan made him appear the usurper. The monument was meant to help legitimate the Sforza claim to the duchy.

1485 — Ludovico Sforza commissions a painting of the Madonna as a gift for King Matthias Corvinus of Hungary.

1487 — Leonardo, Bramante, and others enter a competition to design the lantern of the dome of Milan Cathedral; Leonardo withdrew in 1490.

48–4. ANDREA DEL VERROCCHIO. *Lady with a Bunch of Flowers*, ca. 1475, marble, h. 23.7" (60 cm), Museo del Bargello, Florence. Donning a 1470s hairstyle, this Florentine lady wears the sheer cloth of a summer dress. The inclusion of arms and hands is unique among 15TH-c. portrait sculpture, distinguishing this bust from previous portraits. Verrocchio's sitter is also more engaging than previous portrait busts: this large-boned and thick-necked woman has chiseled features, bushy eyebrows, and corkscrew curls massed around her face to enhance her lifelikeness. With her head tilted to her right, she appears to move the long, expressive fingers of her right hand, as though responding to someone or something.

48–3. DOMENICO GHIRLANDAIO. *Giovanna degli Albizzi*, ca. 1490, oil on panel, 2'5.8" x 19.5" (75.5 x 49.5 cm), Thyssen-Bornemisza Collection, Madrid. Portrayed here is the first wife of Lorenzo Tornabuoni (see fig. 38–5), who died in 1488, not quite 20 years old and pregnant or in childbirth with her second child (married 1486; first child born 1487). The profile portrait displays a well-to-do, pious young woman in a half-length view. Objects in the alcove—prayerbook, coral beads (symbolic of the Resurrection), gold brooch with ruby and pearls (similar to the one on her necklace)—allude to her social status and moral character; on the *cartellino* is the year of her death and a passage adapted from an epigram by the Roman poet Martial: ARS V TINAM MORES /ANIMVM QVE EFFINGERE / POSSES PVLCHRIOR IN TER / RIS NVLLA TABELLA FORET / MCCCCLXXXVIII (Art, would that you could represent character and mind. There would be no more beautiful painting on earth 1488). Her father-in-law, Giovanni Tornabuoni, provided for her tomb in the family chapel in 1490 (see fig. 38–3).

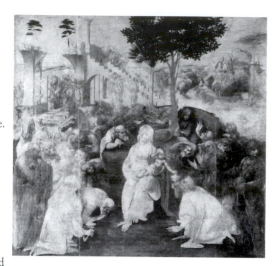

48–5. LEONARDO DA VINCI. *Adoration of the Magi*, begun 1481, oil underpainting and washes on panel, 7'11.8" x 8'.9" (243 x 246 cm), Uffizi Gallery, Florence. Hired by the monks of S. Donato a Scopeto to create this altarpiece, Leonardo left it unfinished when he went to Milan. Details of the underpainting show a complicated background of horses, people, and ruins and a foreground of larger figures who are all focused on the baby, many overcome by emotions as they grapple with the meaning of the birth. Rather than depict the type of shelter that appears in Botticelli's (see fig. 37–2) or Filippino's (see fig. 48–6), Leonardo placed a very large tree behind Mary and Christ, surely alluding to the tree of knowledge, whose fruit God forbade Adam and Eve to eat. As the new Adam and Eve, Mary and Jesus are positioned in the center, with the Magi and their entourage almost fully surrounding them. The scene thus focuses worshippers on the promise of human redemption from Original Sin, and it omits the many contemporary portraits that had become common to the theme.

ca. 1490 — Among Leonardo's portraits for the Milan court was a painting of Ludovico Sforza's mistress, Cecilia Gallerani, according to the court poet Bernardo Bellincioni (d. 1492). *Lady with an Ermine* (Czartoryski Museum, Cracow) is thought to portray Cecilia and may be the portrait that Bellincioni recorded seeing (describing the portrait, he noted that Cecilia "seemed to listen and not to speak").

1490 — Leonardo designs the stage set for a performance of Bellincioni's play *Feast of Paradise* to celebrate the marriage of Giangaleazzo Sforza and Isabella of Aragon. The ten-year-old Giacomo Salai becomes a member of Leonardo's household, and Leonardo visits Pavia with the Sienese Francesco di Giorgio di Martini, who was hired for his architectural expertise to work on Milan Cathedral.

1491 — Leonardo creates decorations for the marriage of Ludovico (Il Moro) Sforza and Beatrice d'Este (d. 1497) of Ferrara (sister of Isabella d'Este). Leonardo paints the portrait of Beatrice.

1493 — The full-scale drawing for the equestrian statue of Francesco II Sforza is exhibited in Milan, with the clay model finished by 30 December. This was the most consuming of Leonardo's Milan projects. Measuring 24 feet high, the model was 11 feet taller than Verrocchio's *Colleoni* (see fig. 36–5) and about 13 feet taller than Donatello's *Gattamelata* (see fig. 21–7). It took years to prepare for the casting. Molds were made, and the casting was slated to take place near S. Maria della Grazie, where Leonardo had a vineyard, a gift from Ludovico (1498). The French invasion in 1499 would prevent the monument from being cast.

1494 — Bronze meant for casting the equestrian monument of Francesco Sforza is sent to Ferrara for a cannon.

ca. 1495 — Leonardo is hired to create the *Last Supper* (finished 1498) for the convent of S. Maria delle Grazie, Milan. The mural was damaged by a doorway cut into the wall and the Allied bombs (1943) that nearly destroyed the room.

Leonardo decorates rooms in the Sforza Castle and visits Florence.

1496 — Leonardo seeks the commission for the bronze doors of Piacenza Cathedral.

1497 — In Milan, Leonardo creates the portrait of Lucrezia Crivelli, Ludovico Il Moro's new mistress at court.

1498 — Leonardo is in Genoa to advise about the harbor (March).

In Milan, Leonardo paints a tree arbor on the ceiling of the Sala delle Asse (northeast tower of the Sforza Castle), where in delicate foliate patterns the emblems of the Visconti and Sforza are intertwined, with their crests displayed in the center of the ceiling. His design gave the sense of an open-air retreat.

1499 — In September, the French invade Milan. When King Louis XII entered the city (October), he was crowned the new duke of Milan.

1499/1500 — Leonardo sends 600 gold florins to be deposited in his Florence account (December 1499). Stopping in Mantua and Venice on his way to Florence, he was the guest of the Gonzaga in Mantua, where he made a portrait of Isabella d'Este, giving her a copy. The Louvre portrait of *Isabella* (see fig. 48–7) may be a second copy after the original (see 1501). In his journey, Leonardo traveled with the renowned Luca Pacioli, the Franciscan mathematician from S. Francesco Grande, whom Leonardo met at the Sforza court; Pacioli's treatise (*De divina proportione*, dedicated to Ludovico Sforza) was illustrated with geometric forms by Leonardo.

1500 — Active in Florence are several artists whose work is familiar to Leonardo: Lorenzo di Credi, Botticelli, Filippino, and Perugino.

1501 — From Venice, Lorenzo Gusnasco da Pavia, the humanist agent of Isabella d'Este, sends the marchesa a Spanish lute (13 March). In his letter accompanying the lute, he praised the portrait of her Leonardo had shown him the year before, remarking that it looked exactly like her and was very well executed. Within the month Isabella wrote to Fra Pietro da Novellara, Vicar-General of the Carmelites in Florence (27 March), asking that he acquire another sketch of her portrait because her husband had given away her copy. She also wanted Leonardo to create a painting for her *studiolo* (see figs. 40–5, 42–2).

At SS. Annunziata in Florence, Leonardo works on a (lost) cartoon of the Madonna, Child, and S. Anna for the high altarpiece of the church. The cartoon was exhibited at the church, but the altarpiece was never executed. Filippino was later contracted (1503) to create the high altarpiece, which after his death was reassigned to Perugino (see Perugino 1506).

1502 — While Cesare Borgia (son of Pope Alexander VI) is on a campaign in central Italy under the pope's directive, Leonardo becomes the military engineer, traveling with Cesare and Machiavelli in Romagno. During his employment, he made maps of Umbria and Tuscany and the Chiana Valley (Uffizi Gallery, Gabinetto dei Disegni e delle Stampe, Florence). The later may relate to his work on designing a canal to link Florence with the sea.

1503 — Leonardo rejoins the Company of S. Luke in Florence and is hired by the board of supervisors of the town hall to create a mural, *Battle of Anghiari,* for the Room of the Five Hundred. Leonardo uses as his studio and living quarters the papal quarters in S. Maria Novella.

During this period, Leonardo begins his portrait *Mona Lisa* (see fig. 48–1), which he took with him to France and which has become his most famous work; it was acquired by Francis I in 1518.

In Florence, Leonardo works on the Arno canal project and the fortifications of Piombino.

1504 — Leonardo and others discuss the placement of Michelangelo's marble *David* (see Botticelli 1504).

1505 — Leonardo begins painting the *Battle of Anghiari* (6 June) in the Florence town hall.

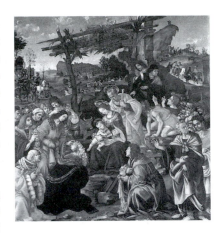

48–6. FILIPPINO LIPPI. *Adoration of the Magi,* 1496, oil on panel, 8'5.7"x 7'11.7" (258 x 243 cm), Uffizi Gallery, Florence. Hired to paint the S. Donato Altarpiece after Leonardo abandoned the project (see fig. 48–5), Filippino's *Adoration* derives from Leonardo's, whose young, curly-haired figures near the central tree may represent wingless angels without halos. Filippino's adaptation of these figures is in the young man kneeling on the rock (right), who twists around in response to the excitement nearby.

In his *Mona Lisa,* Leonardo pictured the woman in dim light under a loggia (the painting has been cut along the sides, but the base of one column is still visible). The distance is brighter, drawing attention to her, especially her hauntingly malleable features.

Duke Alfonso of Ferrara wants to buy from Leonardo the *Bacchus* promised to the cardinal of Rouen.

1506 — By this year, Leonardo had spent most of the 600 gold florins in his Florence account. French Governor Charles d'Amboise, Count de Chaumont, invites him to Milan, and Leonardo leaves Florence (30 May). He was granted permission by the Florence government to stay three months in Milan; the count requested extensions (in August and December).

1507 — Leonardo travels between Milan and Florence, compiling treatises on geometry, anatomy, water, mechanics, painting, and so forth.

1508 — In Florence, at the hospital of S. Maria Nuova Leonardo dissects the corpse of a man thought to be 100 years old. In Milan (April), he makes studies for the equestrian monument (sepulcher) of Gian Giacomo Trivulzio. With assistants, he completes a second version of *Virgin of the Rocks* (National Gallery, London). In the new work, colors are cooler, halos appear on the holy figures, John is given a cross, and the angel's hand no longer points toward the Baptist.

Leonardo paints (unfinished) *Madonna and Child with S. Anna* (Louvre, Paris), perhaps based on the (lost) cartoon he executed in Florence (see 1501); the work suffers from repainting and paint losses.

1510 — At the university in Pavia, Leonardo carries out human dissections and other scientific studies with the anatomist Marcantonio della Torre; Leonardo's book on anatomy is near completion.

1511 — Leonardo receives a stipend from Louis XII. Milan (in French control) is at war with Venice and Pope Julius II; Swiss troops invade the city (December).

1513 — Leonardo deposits money in his account at the hospital of S. Maria Nuova, Florence, before moving (from Milan) to Rome to serve Giuliano de' Medici, the brother of Pope Leo X. In Rome, Leonardo's studio is in the Villa Belvedere (see fig. 49–3).

Leonardo paints *John the Baptist*, a panel datable to about 1513–16 (Louvre, Paris). At his death, he had this panel with him in France.

1514 — Leonardo draws visions of the *Deluge.*

1515 — After his patron Giuliano de' Medici leaves Rome, Leonardo is expelled from the hospital of S. Spirito, where he intended to continue his anatomical studies. Accompanying Giuliano to Florence, Leonardo begins designs for a new Medici palace.

1516 — Leonardo's patron Giuliano de' Medici dies (17 March). In Rome, Leonardo measures the Basilica of S. Paul's Outside the Walls (August).

Accepting King Francis I's invitation to be his court painter, architect, and engineer, Leonardo moves to France and lives in Cloux (near Amboise).

1519 — Leonardo's will (23 April) bequeaths his books, instruments, and art to his disciple and companion Francesco Melzi. After Leonardo's death at Amboise (2 May), Melzi returned to his family villa near Milan, where he copied passages on painting from Leonardo's manuscripts, forming the *Codex Urbinas Latinus* (Biblioteca Vaticana, Rome).

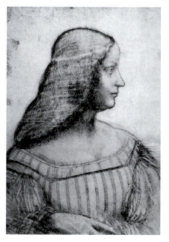

48–7. LEONARDO DA VINCI. *Cartoon for a Portrait of Isabella d'Este* (recto), ca. 1500, leadpoint, with black, red, and white chalk and pastel highlights, 2'.8" x 18.1" (63 x 46 cm), Louvre, Paris. The paper was prepared with bone-colored chalk and the drawing is pricked for transfer (probably not by Leonardo); the recto does not show pouncing dust, but the verso (back) is heavily rubbed (for a reverse image). Although there is a substantial reworking of the surface with chalks by a later hand, Leonardo's contribution appears in the fluid, organic relationship of the head—the puffy cheeks and double chin—to the soft, fleshy body, suggesting more physical energy and intellectual activity than appears in Piero's *Battista Sforza* (see fig. 33–2). In his paintings, Leonardo's layers of transparent oil glazes enlivened forms. Cartoons such as this were often presented to patrons (see entry 1501).

In 1505, Donato Bramante (ca. 1444–1514) was the most respected and influential artist in Rome. His experiences in Lombardy, where he had contact with Leonardo and Filarete, prepared him for designing the new look of the Eternal City that Julius II wanted Rome to acquire. More than Raphael or Michelangelo, Bramante had Julius' favor. As the pope's architect, his plans to rebuild papal Rome were intended to clothe it in a splendor fitting the ancient imperial city.

ca. 1444 — Born in Monte Asdrualdo (near Urbino), the son of a farmer, Donato began his career as a painter in Urbino. He left there in 1472.

1479 — By this year, Bramante is in Milan, working for about 20 years as a painter and an architect.

1485 — In Milan, Bramante, who refaced the exterior of the 9th–c. chapel of S. Satiro in 1482, designs a new church beside the little chapel. Dedicated to the Virgin and called S. Maria presso S. Satiro, the new basilica has a shallow choir (a site restriction) that through trompe l'oeil he made look much deeper.

1488 — Bramante is involved in the rebuilding of Pavia Cathedral, where Ludovico's brother, Cardinal Ascanio Sforza, was the bishop.

1492 — In Milan, Bramante designs the burial chapel of the Sforza family in S. Maria delle Grazie, where Leonardo painted his *Last Supper* in the refectory.

1500 — Bramante left Milan (1499) after the fall of the Sforzas. In Rome he creates the courtyard (finished 1504) of S. Maria della Pace for Cardinal Olivero Carafa (see figs. 39–2, 39–3), his design based on such antique buildings as the Colosseum.

1502 — Bramante begins work on the martyrium of S. Peter, establishing him as a pioneering architect (see fig. 49–2). Following the ideas of Vitruvius, his Tempietto (It., little temple) gives no hint of a medieval building, but signals the future of Cinquecento domed architecture in Rome. It garnered him the contract for new S. Peter's (see fig. 49–1), a church that was altered several times but retains his basic scheme. His ideas for church and palace architecture were to be disseminated in northern Italy by Giulio Romano (see fig. 47–10) and Jacopo Sansovino (in Venice).

1509 — He enlarges the choir of S. Maria del Popolo and designs Palazzo Caprini in Rome (ca. 1510).

1514 — Bramante dies in Rome. He was given a funeral in S. Peter's, where he was buried.

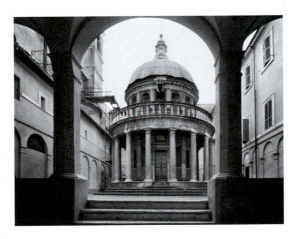

49–2. DONATO BRAMANTE. Tempietto, ca. 1502–12, monastery courtyard of S. Peter's in Montorio, Rome. Thought (incorrectly) to mark the spot of S. Peter's martyrdom, this small building looks like a reliquary and is meant to be seen framed by architecture (courtyard lacks the design Bramante intended). The design shows Bramante's study, measurement, and understanding of antique Roman monuments, but does not replicate an ancient building. Instead, it is a novel interpretation of ancient architecture filtered through Alberti's and Leonardo's designs as well as Piero's and Laurana's classicism (seen especially in their works for the Montefeltro court at Urbino). The Tempietto was commissioned by Spanish royalty: King Ferdinand II and Queen Isabella.

49–1 (top). Bramante's design for new S. Peter's as it appeared on a coin struck to commemorate the laying of the foundation stone in 1506. Bramante's architectural designs were broadly disseminated through engravings and medals.

Pope Julius II and Vatican Palace

During his papal tenure, Julius II (r. 1503–13)—choosing not to use the former quarters of his most hated predecessor, Pope Alexander VI (of the Borgia family)—refurbished the upper floor of the north wing in the Vatican Palace for his living quarters (see fig. 49–3). Here, he had staterooms and an antechamber and bedroom beside the small chapel that Fra Angelico decorated for Pope Nicholas V. Intent upon redecorating and finishing incomplete work in the staterooms (later known as the Stanze [rooms] of Raphael), he hired many master painters (Perugino, Sodoma, Peruzzi, Signorelli, Bramantino, Lorenzo Lotto, and Raphael), some

of whom worked for his uncle Sixtus IV. In the first decade of the Cinquecento, renovating the Stanze was an ambitious project, resembling the decorating of the Sistine Chapel in the 1480s, but on a smaller scale. Because the display of pomp and ceremony and having easy access to his quarters were important to Julius, he ordered two new staircases: the first replaced a staircase (torn down in 1506) that connected S. Peter's to the Sistine Chapel, but the second was entirely new. Called Bramante's *cordonata*, it was for grand processions winding from Julius' quarters to the Sistine Chapel and audience halls (one floor below). When Julius died (1513), the Stanza Heliodorus was nearly complete, and the *cordonata* reached the upper level within the year.

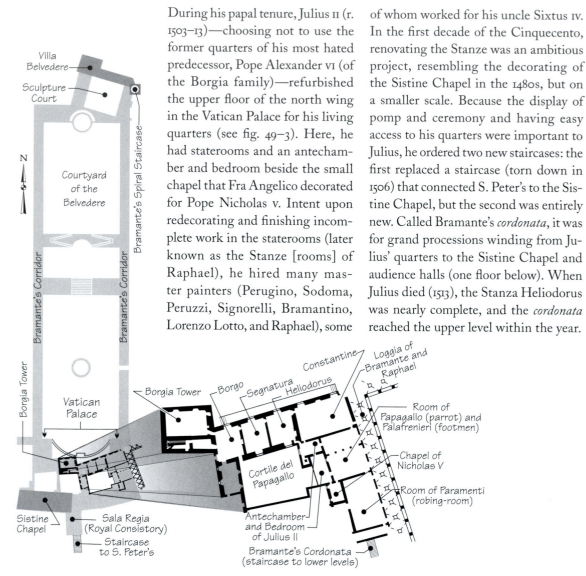

49-3. This diagram of the Vatican Palace enlarges the Stanze of Raphael and shows Bramante's grand courtyard of the Belvedere (begun in 1505, it was completed under Pius IV in 1563). Julius II employed Bramante to link the Vatican Palace with the Villa Belvedere, the retreat built by Pope Innocent VIII (completed 1487). For this project Bramante designed classical facades at both ends and two parallel corridors that would connect the buildings and provide level walkways over the uneven, steeply rising ground of Vatican Hill. The immense courtyard between the corridors was divided into three terraced plateaus, with the highest at the Villa Belvedere. Ramps and staircases connected the three levels, with a grotto designed for the second terrace and an exedra and gardens for the third. Next to the villa, Bramante created an open sculpture court with fountains and an orange grove, providing an attractive setting for Julius to display his collection of antique statues, among these the *Apollo Belvedere* (fig. 69–2), *Sleeping Ariadne* (then called Cleopatra) (fig. 46–3), *Laocöon and Sons* (fig. 51–11), and *Belvedere Torso* (fig. 47–2). The lowest terrace (near the palace) became an open-air theater, with ample space to hold tournaments and dramatic productions. Guests could watch events from the renovated wing, where they had ideal vantage points in the lavishly decorated Stanze of Raphael (these rooms are enlarged and labeled in the diagram: the Borgo, Segnatura, Heliodorus).

Raphael

In the final decade of his life, the ingenious Raphael (1483–1520) completed more prestigious projects than would any of his contemporaries. Among the factors contributing to his unique position in the history of Italian art was having a father who was the court painter in Urbino. This allowed the young boy to observe at an early age a range of works by notable artists working for the Montefeltro duchy (Flemish and Italian). But rather than remain secure in Urbino, Raphael traveled in the manner of journeymen painters. He emulated the popular and very busy Perugino, with whom he had early contact in Umbria, and garnered contracts from Perugino's patrons. In Florence, his art was dramatically changed with the study of Leonardo, Michelangelo, and Fra Bartolommeo. Of untold value to his career, however, was his relationship with Donato Bramante and the sponsorship of Popes Julius II and Leo X. Through them, he gained an elite Roman patronage that brought him universal fame, as did the broad distribution of engravings (by Marcantonio Raimondi) after his works. Hindsight shows that his Roman works are barometers of Cinquecento taste and that his art was a wellspring for many painters for more than three centuries. In his first Vatican Stanza, he created murals now considered to define High Renaissance style. But the decoration of his next three Vatican rooms display Mannerist traits, as do the works of close followers like Giulio Romano. During his lifetime, most literati and collectors thought that he was a better painter than Michelangelo. Sculptors, mostly, championed Michelangelo, valuing his draftsmanship and the *terribilità* of his figures; because Raphael's charming, graceful style looked much too easy to achieve, they argued that his work should not truly be considered Art. Still, making art look easy was paramount to Raphael's aesthetic, and perhaps his greatest skill.

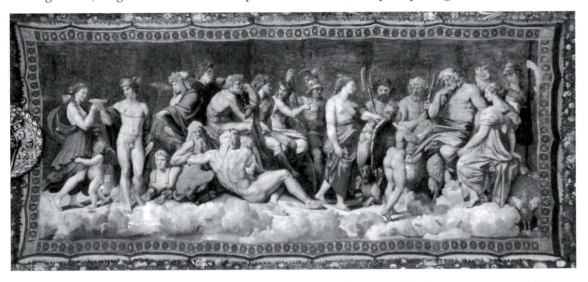

50-1. RAPHAEL SHOP. *Council of the Gods*, ca. 1517–18, Loggia of Psyche, Villa Chigi, Rome (see figs. 50–8, 50–10, 50–11). This fresco exemplies what Raphael's studio created under his guidance: muscular figures in motion, drapery that swings around bodies while falling into simple and complicated folds, and illusionism in the manner of Mantegna's and Filippino's most convincing trompe l'oeil. The grouping of gods is meant to resemble an antique Roman sculpture frieze, and the ceiling is painted to look like an outdoor pergola, with the mural showing two fictive awnings tacked to festoons of fruits, flowers, and vegetables. In this one, Olympians gather for Psyche's induction to their realm. From the right, they are Minerva (in armor), Juno (peacock), and Diana (moon in her hair). Beside Jupiter (eagle by his seat) are his brothers, Neptune (trident) and Pluto (Cerberus), with Cupid and Venus before Jupiter. Next is Mars (armor), Apollo (lyre), Bacchus (grapevines), Hercules (club), Vulcan (helmet), Janus (two-headed), Mercury (winged hat), and Psyche, with river gods seated in front (see Pagan Deities).

50-2 (above), 50-3 (opposite page). RAPHAEL. *Portrait of Agnolo Doni* and *Portrait of Maddalena Strozzi Doni*, ca. 1507, Agnolo panel, 25.7" x 18" (65 x 45.7 cm), and Maddalena panel, 25.7" x 18.1" (65 x 45.8 cm), both Pitti Palace, Florence. Maddalena's portrait is a quintessential picture of a Florentine patrician. Raphael adorned her with jewels symbolic of virtue and pleasure (the unicorn setting of her pendant symbolizes virginity and the large teardrop pearl, earthly love). Moreover, he clothed her in plump, unblemished milk-colored flesh, ideally suited for the finely crafted expensive silk taffeta dress she wears, befitting an aristocrat. In all likelihood, Raphael inflated Maddalena's ultramarine damask sleeves, making them excessively bouffant, to allude both to her ample fertility and to (cont., page 233)

1483 — Born in Urbino, Raffaello Sanzio (Santi) is the son of Magia di Battista di Niccolò (d. 1491), a tradesman's daughter, and Giovanni Santi, a merchant's son. From 1489 until his death (1494), Santi was a painter and writer of discourses at the Urbino court of Duke Guidobaldo I da Montefeltro (1472–1508).

1489 — Guidobaldo marries Elisabetta Gonzaga of Mantua (d. 1526); life at their court was immortalized by Castiglione in *Book of the Courtier*. Among the frequent guests were Raphael's future patrons: Pietro Bembo, Giuliano de' Medici, and Bernardo Dovizi (Bibbiena).

1501 — In Città di Castello, Raphael and Evangelista da Pian di Meleto finish *Coronation of S. Nicholas of Tolentino* (four fragments known) for Andrea Baroncio's family chapel, S. Agostino.

1503 — In Città di Castello, Raphael finishes an altarpiece for Domenico Gavari's burial chapel in S. Domenico (1503 is on the stone frame in the chapel). The *Mond Crucifixion* (named after an owner) imitates Perugino's altarpiece of ca. 1502 for S. Francesco al Monte, Perugia (National Gallery of Umbria, Perugia). Vasari noted that it would be seen as Perugino's if Raphael had not signed it (RAPHAEL / VRBIN / AS /.P.).

ca. 1503 — In Perugia, Maddalena degli Oddi owned a large Raphael altarpiece in S. Francesco al Prato, according to Vasari. The *Oddi Coronation of the Virgin* (Pinacoteca Vaticana) resembles Perugino's works: *Assumption*, Sistine Chapel (1480, destroyed 1536); and *Ascension*, S. Pietro Altarpiece, Perugia (ca. 1495). Three Marian panels formed the predella (Pinacoteca Vaticana), *Annunciation*, *Adoration*, and *Presentation*; these were influenced by Perugino's predellas for the Fano altarpiece (1497) and S. Pietro Polyptych (ca. 1500).

1504 — In Città di Castello, Raphael completes *Marriage of the Virgin* (Brera, Milan) for the Albizzini Chapel, S. Francesco. He signed and dated the work on the entablature and central arch of the temple (RAPHAEL VRBINAS / MDIIII). The setting recalls Perugino's *Delivery of the Keys* (Sistine Chapel) and closely imitates his *Marriage*, ca. 1503. However, Raphael's figures dominate the setting and are proportionally taller than the cylindrical temple behind them, which occupies far less space than Perugino's octagonal temple. Raphael's work signals his inclination to make extraordinary events appear factual and comprehensible and to describe holy figures as unblemished humans of larger-than-life stature.

ca. 1505 — In Perugia, Raphael completes several large altarpieces, including the Colonna Altarpiece (named after a 17TH–c. collector) for the convent choir of the nuns of S. Antonio da Padova (Metropolitan Museum of Art, New York), and the altarpiece for Bernardino Ansidei in S. Fiorenzo dei Serviti (National Gallery, London), with the year inscribed on Mary's cloak variously read as 1505 or 1507. By 1505, he adapted the figure types of Perugino with such fluid assimilation that the particular sources are difficult to discern. Before leaving Perugia, he began his first major fresco, *Holy Trinity with Saints*, in the Camaldolese monastery church of S. Severo. Beneath the *Trinity* he painted six Benedictine saints seated in a semicircular arrangement resembling Fra Bartolommeo's *Last Judgment* fresco in S. Maria Nuova, Florence. The lower half was finished by Perugino in 1521.

In Florence, Raphael paints the *Granduca Madonna* (Pitti Palace, Florence), named after Grand Duke Ferdinand III of Lorraine. X-radiographs reveal that the figures were originally in a room with a loggia open to the outdoors (likely painted away by Raphael). Mary's mood

and her closeness to Christ bear a kinship to Donatello's *Madonna and Child Tondo* (ca. 1457) for Siena Duomo.

ca. 1505/6 — In Florence, Raphael paints the first of several oil panels of the Madonna seated in a meadow with the infants Christ by her knee and John the Baptist by her side. *Madonna of the Meadow* (or *Madonna del Belvedere*) is dated along the neckline of Mary's gown, with the year interpreted as 1505 (M.C.V.) or 1506 (M.C.V.I.). Leonardo's works inspired Raphael, whose composition shows Leonardo's ideas about nesting full-length, monumental figures. Yet Raphael created softer, more affectionate people, and his natural settings are manicured and sunny. Filippo Baldinucci noted that this work was in the Taddei family until it passed through marriage to Ferdinand of Austria in the 17ᵀᴴ c. (Kunsthistorisches Museum, Vienna).

ca. 1506 — Raphael executes *Madonna of the Goldfinch* (also called *Madonna del Cardellino*). Executed for Lorenzo Nasi, a Florentine merchant and good friend of Raphael, the painting likely celebrated his marriage to Sandra Canigiani in 1506. During an earthquake (ca. 1547) that tumbled the Nasi house, the painting was severely damaged and has substantive repainting (Uffizi Gallery, Florence).

1507 — In Perugia, Raphael completes the *Entombment* (also known as the *Borghese Deposition*), 6'.5" x 5'9" (184 x 176 cm) for Atalanta Baglione's family chapel in S. Francesco al Prato (Villa Borghese, Rome), signed and dated on the stone step beneath Christ's right hand (RAPHAEL. / VRBINAS. / M.D.VII.). About 20 drawings of three different themes (Lamentation, Deposition, and Entombment) are all thought to be studies for the painting, suggesting the theme changed in the process of its creation. The first group of studies was inspired by Perugino's *Lamentation* (see Perugino 1495); drawings closest to the completed painting suggest a shift from the devotional, iconic arrangement of Perugino to a livelier, more dramatic narrative imitating antique relief sculpture. Elements of Michelangelo's work appear in Raphael's *Entombment*: Christ's physiognomy is similar to Christ in the *S. Peter's Pietà* and the pose of a woman attending the Virgin derives from his *Doni Holy Family Tondo*. Raphael designed a (lost) pinnacle and the predella with figures of *Faith*, *Charity*, and *Hope* (Pinacoteca Vaticana); pictured in tondos and flanked by putti, these simulate marble reliefs, with *Charity* resembling Michelangelo's *Pitti Madonna*.

ca. 1507 — Raphael became a respected portrait painter in Florence, completing pendant portraits for a prominent couple who married in 1504, Agnolo Doni and Maddalena Strozzi Doni (see figs. 50–2, 50–3). These panels mark a turning point in his art, with his signature no longer needed for the works to be recognized as his. In Florence, he learned to cultivate wealthy patrons, be selective about what he drew from his sources, and meld ideas he gleaned seamlessly into his unique invention. Inspiration for the Doni poses came from Leonardo's *Mona Lisa* (see fig. 48–1) and Perugino's *Francesco delle Opere* (1494), while the broad landscape vistas pay homage to Piero's portraits of *Federico* and *Battista* (see figs. 33–2, 33–3). In Florence Raphael also paints *La Belle Jardinière*, with full-length figures of the Madonna, Child, and infant Baptist in a landscape (Louvre, Paris). The panel is inscribed with Raphael's name (RAPHAELLO VRB) above Mary's foot and the date 1507 (MDVII) near Mary's elbow; it is identified with Vasari's account of the work Raphael left unfinished (a section of blue drapery completed by Ridolfo Ghirlandaio) that was sent to Siena.

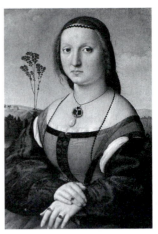

her husband's professional success in the cloth trade. A follower of Raphael, the Master of Serumido, painted monochromatic scenes illustrating two episodes of the classical myth Deucalion and Pyrrha on the backs of the Doni panels: *Zeus Sending a Deluge* (Agnolo's panel) and *The Rescue of Deucalion and Pyrrha* (Maddalena's panel). Michelangelo made a large, circular-shaped painting of the Holy Family for the Doni couple (see fig. 51–1).

GIOVANNA DA MONTEFELTRO. In a (lost) letter to Piero Soderini, head of the Florentine Republic, Giovanna wrote (in 1505) that, "Raphael, a painter from Urbino of considerable talent, would like to move to Florence." (Giovanna had married Giovanni della Rovere, Lord of Senigallia and brother of Julius II.)

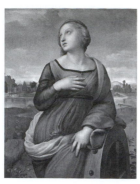

50–4. RAPHAEL.
S. Catherine of Alexandria, ca. 1507–8, oil on panel, 2'4.3" x 21.8" (71.5 x 55.7 cm), National Gallery, London. Raphael painted a sensuous Catherine, giving her a lifelike presence. Her twisting lower torso—sinuously animated by the writhing folds of her chemise—reverses the movement of her upper torso, as a rapturous spirit seemingly moves through her body. Her stance is harmoniously balanced, and the pose typifies Raphael's early experimentation with a figure type that was to recur often in his work. The type conflates Michelangelo's torsion, Perugino's serenity, and Leonardo's organic energy. Catherine's counterbalanced movements suggest fluidly shifting weight, comparable to that of *The Three Graces* (see fig. 50–5). Raphael again used the pose for the Vatican frescoes and his elegant sea nymph, *Galatea* (see fig. 50–9).

ca. 1506/1508 — Raphael paints *S. George and the Dragon* (National Gallery of Art, Washington, D.C.), displaying actions championed at the Urbino court—graceful in movement, the noble George effortlessly rises to defend truth, beauty, and good from evil. The commission likely came from this court, but some confusion surrounds its date and patronage. Raphael's name is inscribed on the breast strap of the horse (RAPHELLO /.v.), but the inscription seems added because it is not spelled in the customary way. Around George's left leg is a garter inscribed HONI, perhaps referring to Duke Guidobaldo's election into the Order of the Garter of England (the Order's motto is: HONI SOIT QUI MAL Y PENSE [Disgrace to the one who thinks of it]).

ca. 1507/8 — Raphael paints the devotional panel *S. Catherine of Alexandria* (see fig. 50–4). Shown as a statuesque saint, she stands alone beside rocky terrain and plants symbolic of her virtues. A lake and a couple of houses are in the distance, but no other visible signs of life appear. While looking over her shoulder, raising and tilting her head, she parts her lips as though responding to something unseen by the human eye. Although the wheel identifies her as the beautiful, royal maiden from Alexandria, Raphael has not portrayed a particular episode in this popular saint's life. Familiar narrative details that could place her in a specific legendary moment are absent: nothing refers to her debate with philosophers, denouncement of the Roman emperor Maxentius, or torture and death. Instead, Raphael visually alluded to her spiritual stamina that overpowered adversaries, portraying both the essence and ecstasy of Catherine. With her right shoulder pulling forward and the left receding, her enlarged left forearm, which is covered in blood-red silk, seems to push unnaturally into the foreground, an action symbolic of her stalwart conviction and triumph over the wheel. The serpentine figure became central to Raphael's mature period, as he used it to imbue figures with physical energy and spiritual presence.

Raphael paints a panel of Mary, Joseph, Elizabeth (or Anna), and the infants Christ and the Baptist, called the *Canigiani Holy Family* after its Florentine patron, Domenico Canigiani. The neckline of Mary's gown bears Raphael's signature (RAPHAEL VRBINAS), and the Baptist's banderole has John's words that introduce the adult Christ: ECC[E] [A]GN[VS] DEI (Behold the Lamb of God).

1508 — In Florence, Raphael completes an oil panel of the Madonna and Child, called the *Niccolini-Cowper Madonna* after former collectors. The date and an abbreviated signature (MDVIII. R. V. PIN.) are on the neckline of Mary's gown.

In Florence, Raphael is working on his only Florentine altarpiece commission, *Madonna del Baldacchino* (Pitti Palace, Florence), but left it incomplete when he went to Rome. Recent technical evidence indicates that Raphael prepared the ground and executed the underdrawing for the panel, but did little else.

Raphael creates two small panels, *S. George and the Dragon* and *S. Michael and the Dragon* (Louvre, Paris). Their identical measurements suggest they formed a diptych, but no documents record the artist, date, or patron, and the panels can be traced only to the mid–16TH c., when they were sold as a pair in Milan. Typically dated ca. 1504, the panels should be dated closer to 1508 on the basis of style: they have traits that appear in Raphael's Vatican work of 1509. Two other panels of the same size are also attributed to Raphael: *Allegory* (National Gallery,

London) and *Three Graces* (see fig. 50–5).

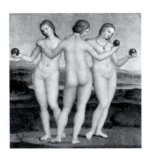

late 1508 — In Rome, Raphael works for Julius II in the papal apartments (see fig. 49–3). His work so impressed Julius that the entire room was reassigned to him (see figs. 50–6, 50–7).

1509 — Julius appoints Raphael to the office of writer of apostolic briefs, assuring a permanent stipend from the Church.

1510 — For Agostino Chigi, Raphael creates designs for two plates.

1511 — Raphael completes work in the Stanza della Segnatura, inscribing the date on the window embrasures. About this year, he begins the *Alba Madonna* (National Gallery of Art, Washington, D.C.).

1512 — For humanist Johann Goritz, apostolic protonotary (recorder of important papal events), Raphael completes an ex voto to S. Anna in S. Agostino, Rome (unveiled 26 July), showing the *Prophet Isaiah* (third-to-the-left pier in the nave), 8'2.5" x 5'1" (250 x 155 cm). The fresco has two inscriptions: the dedicatory plaque in Greek (to Anna, Mary, and Christ) and Isaiah's scroll in Hebrew, "Open the gates, so that the righteous nation that keeps faith may enter in" (Isa. 26:2). Muscular *Isaiah* derives from Michelangelo's Sistine prophets. Goritz contracted Andrea Sansovino's marble sculpture, *Virgin and Child with S. Anna*, to be placed under Raphael's fresco.

After driving the French out of Italy, Pope Julius II hires Raphael to paint the Room of Heliodorus.

ca. 1512 — Raphael paints *Portrait of Tommaso Inghirami* (original lost); copies are in the Isabella Stewart Gardner

Museum, Boston, and the Pitti Palace, Florence. As prefect of the Vatican Library, the humanist Inghirami was likely among Raphael's advisors for the decoration in the Vatican Stanze.

Raphael completes *Triumph of Galatea* for Agostino Chigi's villa (see fig. 50–9).

Sigismondo de' Conti (d. 1512), historian, friend, and private chamberlain to Julius, hires Raphael to paint an ex voto giving thanks for having survived the bombing of his native Foligno. Raphael's *Madonna di Foligno* (Pinacoteca Vaticana) was for the high altar in S. Maria in Aracoeli, Rome (in Foligno by late–16TH c.).

1513 — Raphael receives two payments for paintings in the room of Heliodorus from the treasury of Pope Leo x.

ca. 1513 — Raphael completes the highly illusionistic *Sibyls* on the entrance arch of Agostino Chigi's Chapel in S. Maria della Pace, Rome. Vasari considered the frescoes to be in the new style and the best and most beautiful of Raphael's works. Drawings were made for a (not executed) Resurrection altarpiece.

1514 — Pope Leo x appoints Raphael chief architect of S. Peter's.

By this year, Raphael has completed the *Sistine Madonna* (Gemäldegalerie, Dresden), 8'8.4" x 6'5.1" (265 x 196 cm). Unusual for his images of the Madonna and Child, Mary is a full-length, monumental (nearly life-size) figure, who is seemingly walking toward viewers. In the foreground are Ss. Sisto and Barbara, relics of whom are enshrined in S. Sisto, Piacenza, where the painting was on the high altar. In the

50–5. RAPHAEL. *Three Graces*, ca. 1508, panel, 6.8" x 6.8" (17 x 17 cm), Musée Condé, Chantilly. Raphael's model was likely an antique Roman statue sent to the Piccolomini Library in Siena Cathedral in 1502. It is thought that he worked there with Pintoricchio. Although the nature of his contribution to the library decoration is debatable, he could have known the statue. Yet his serene figures are not like the inert stone, but imbued instead with organic and inseparably fluid motions, each Grace seeming to shift weight from one leg to the other as her companions respond in kind. In antiquity, love and beauty were personified in the Three Graces, as was the threefold nature of generosity, described in the ancient Roman Seneca's *De beneficiis*; such topics were often discussed at the Urbino court of Elisabetta Gonzaga (see fig. V–4). Raphael's experience there prepared him for life at the papal court. Furthermore, Julius himself was related to the new duke of Urbino, Francesco I Maria della Rovere (r. 1508–16), who married Isabella d'Este's daughter Eleanora.

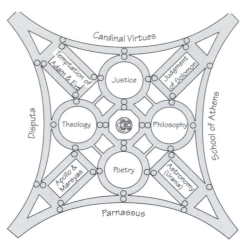

50–6. Ceiling diagram, Stanza della Segnatura, Vatican Palace. Like Perugino's Audience Hall in the Collegio del Cambio, Perugia (see fig. 42–5), this design is reminiscent of antique Roman ceilings (e.g., Nero's Golden House in Rome and Hadrian's Villa near Tivoli) and was planned before Raphael arrived in Rome. The sequence of his wall murals follows Bellori's order: *Disputà, School of Athens, Parnassus,* and *Cardinal Virtues,* with the exception that *Parnassus* likely came before *School of Athens* (see fig. 50–7).

50–7. Wall diagrams, Stanza della Segnatura, Vatican Palace. This was Julius' library and he signed papal bulls here in 1513; Paul III convened the *Signatura gratiae* (supreme tribunal) here.

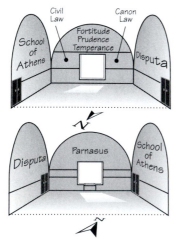

18ᵀᴴ c., the nun Oddone Ferrari of S. Sisto wrote that it was acquired at the dispersion of Julius II's collection, leading to the idea that it was meant for the tomb of Julius.

Raphael is working on the burial chapel of Agostino Chigi (d. 1520), S. Maria del Popolo, Rome (see fig. 46–1).

1515 — Leo X appoints Raphael the Keeper of Roman Antiquities and the Papal Architect. He also orders cartoons for a set of tapestries for the Sistine Chapel (see 1519); seven cartoons (colored drawings in gouache) survive (Victoria and Albert Museum, London).

1516 — Raphael completes *Portrait of Baldassare Castiglione,* author of *The Courtier* (see entry 1489). The poet Pietro Bembo praised the portrait in a letter (19 April 1516) to Castiglione, who took the painting with him to Mantua. About this year, Raphael also paints his *Portrait of Dona Velata* (Pitti Palace, Florence).

Cardinal Giulio de' Medici hires Raphael to design his villa in Rome (see Cinquecento History Notes 1516).

Raphael renegotiates his contract with the Poor Clares of S. Maria di Monteluce, Perugia: he and the Perugian Berto di Giovanni were hired in 1505 to create the high altarpiece of the convent church, using as their model

Ghirlandaio's *Coronation* (1486) in S. Girolamo, Narni.

1517 — According to the date beneath the fresco, Raphael finishes *Oath of Pope Leo III,* Stanza dell'Incendio.

Cardinal Giulio de' Medici hires Michelangelo and Raphael to execute altarpieces in competition. The works were intended for Giulio's benefice, Cathedral of Narbonne, France. Raphael began his *Transfiguration,* but sections of the lower half were unfinished at his death; assistants Romano and Penni completed the painting, which was placed in S. Pietro in Montorio in 1523 (Pinacoteca Vaticana, Rome). Michelangelo reassigned his contract to Sebastiano del Piombo, who executed *Resurrection of Lazarus,* ca. 1517–19, based on designs provided by Michelangelo. Sebastiano's painting was sent to Narbonne (National Gallery, London).

ca. 1517/18 — Raphael paints *Portrait of Leo X with Cardinals Giulio de' Medici and Luigi de' Rossi* (Uffizi Gallery, Florence), sent to Florence for the wedding of Lorenzo de' Medici, duke of Urbino, and Madeleine de la Tour Auvergne (see fig. 61–2). He also works on the Loggia of Psyche (see figs. 50–8, 50–10, 50–11), and paints *Portrait of Bindo Altoviti,* showing Mannerist traits (long neck, overly refined features).

1519 — Raphael decorates (1518/19) the Vatican Loggia (Loggia of Bramante and Raphael) (see fig. 49–3). In the Sistine Chapel, Leo X exhibits seven tapestries woven in Flanders (Pieter van Edingen Aelst's shop) from Raphael's cartoons. The three other tapestries arrived later, and were exhibited after Raphael's death.

1520 — Raphael dies on 6 April and is buried in the Pantheon the next day. The *Transfiguration* (see entry 1517) is placed over his bier.

Villa Chigi (Farnesina), Rome

Between 1505 and 1511, the Sienese architect and painter Baldassare Peruzzi (1481–1536) built a villa in suburban Rome for his fellow countryman, the influential banker Agostino Chigi (d. 1520). The land acquired for this project extended from the Via della Lungara (Bramante widened and straightened this major road for Julius II) along the Tiber's west bank. The villa's location made it amenable to exquisite social gatherings, with Chigi hosting lavish banquets in the grotto and dining loggia. Showing great extravagance, his expensive dining plates, at some dinners, were tossed into the Tiber after each course (unbeknown to guests, these were retrieved). With the major building construction carried out 1506–10, interior work was begun ca. 1509 by Peruzzi in the room called the Loggia of Galatea (see fig. 50–9). Chigi's family crest was placed in the center of the ceiling between two octagonally shaped frescoes depicting two constellations, each facing the east gardens. A winged image of Fame blowing her trumpet shares the field with the constellation of Perseus on the south end (he is depicted as a soldier raising his sword to decapitate the gorgon Medusa). On the north end is the constellation of the Great Bear, with Helice (or Callisto) driving the oxen-drawn chariot.

Variously combined in the hexagonal compartments are the 12 zodiacal signs and 7 celestial bodies (the planets appear as the Roman gods with whom they were linked). The alignment of planets and zodiacal signs on the ceiling plots Chigi's horoscope (b. 29 November 1466). Peruzzi painted an additional 14 frescoes of constellations in the triangular severies. Beneath these are nine lunette frescoes, with only one attributed to Peruzzi (a colossal head with the initial "B" to the left of the head, referring to Peruzzi's first name).

The other eight lunettes are by Sebastiano Luciani (del Piombo), the Venetian painter brought to Rome by Chigi in 1511. His scenes are from Ovid's *Metamorphoses* and portray themes of wind, flight, and birds, all symbolic of the element air. The imagery was thus fitting to this airy room that opened to the outdoors and was near gardens and birds and breezes from the Tiber. Opposite the garden entry to the Loggia of Galatea, two large wall murals depict the story of Galatea (for whom the room is named). The tragic Sicilian love theme can be found in the antique pastoral poems of Theocritus (Greek Sicilian) and Ovid (Roman), and the tale inspired modern verses by humanists like Politian (see Botticelli), who portrayed Galatea as preferring spiritual to physical love. Sebastiano painted the giant Cyclops *Polyphemus* dressed in a shimmering blue cloth, holding a shepherd's staff and syrinx, and looking over his shoulder toward the object of his great and unre-

50–8. BALDASSARE PERUZZI. North facade (front), Villa Chigi, ca. 1505–11, Rome. Compared to the Farnese Palace (see fig. 47–8), this is a suburban retreat and is closer in its design to the Medici Villa at Poggio a Caiano (see fig. 47–1). The Loggia of Galatea (see fig. 50–9) no longer has its original open-air setting: the five garden arches on the east side (see fig. 50–10) were closed in 1650.

50–9 (left). Loggia with Sebastiano's *Polyphemus* and Raphael's *Galatea*.

50–10 (below). Diagram of the ground floor, Villa Chigi, Rome.

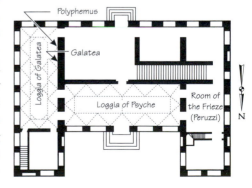

quited love, the sea nymph Galatea, whose image by Raphael appears in the next field. Riding on her dolphin-drawn chariot, Galatea is surrounded by nereids, hippocampi, mermen, and amorini (little Loves). Her true love, the handsome Acis, is not with her because he was murdered by the jealous Polyphemus, after which Galatea turned her lover into the river Acis in Sicily. Sensual and fleshy, robust figures in twisting, serpentine poses enliven the antique lore that intrigued both patron and guests. While the vault images pertain to air and sky, the wall imagery is devoted to land and water, gently reminding guests they were outside the city enjoying the bounty of the countryside and Chigi's largesse. Heavy flooding of his property in 1514 may have warranted postponing the execution of any more wall frescoes in this room, and Chigi died before the loggia could be completed.

However, decoration of the upper floor of the villa was started about 1515, with Baldassare Peruzzi working on perspectival designs for the grand salon.

The main entrance to the horseshoe-shaped villa was through the Loggia of Psyche (see fig. 50–11). Stone benches attached to the facade provided seating for guests who were entertained by theatrical productions held in the forecourt of the gardens. During such festive events, tapestries decorated the loggia, partly explaining why the ceiling frescoes look like awnings made of tapestries. Vasari noted that Chigi allowed Raphael and his mistress to stay in the villa while Raphael worked on the frescoes to ensure that the busy artist would be fully devoted to the project. Although designed by Raphael, the execution was carried out by his assistants (see fig. 50–1).

Loggia of Psyche, Villa Chigi, Rome

50–11. Ceiling diagram of the Loggia of Psyche, Villa Chigi, Rome. Raphael's designs for the loggia (ca. 1517–19) were inspired by Lucius Apuleius' story of Psyche in the *Golden Ass*. While Romano, Penni, and other assistants painted figures, Udine created the fruits and garlands. Tapestries (unexecuted) of Psyche's earthly life were likely planned for the loggia walls, still unpainted at Chigi's death. The Farnese bought Chigi's celebrated villa in 1578; it was called Farnesina (Little Farnese), distinguishing it from the palace the family owned across the Tiber (see fig. 47–8). By 1863, the villa belonged to the Spanish ambassador Ripalta. He restored it, added the ceiling in the upper floor salon, divided the lower dining hall into a vestibule and two rooms, and created an entry on the south.

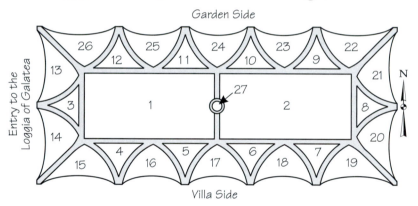

1	Marriage of Cupid and Psyche	15	Cupid with Trident (Neptune)
2	Council of the Gods	16	Amorini with Cerberus and Spear (Pluto)
3	Venus and Cupid	17	Amorini with Shield and Sword (Mars)
4	Cupid Directing his Servants	18	Cupid with Griffin (Apollo)
5	Ceres and Juno (interceding for Psyche) with Venus	19	Cupid with Caduceus and Winged Helmet (Mercury)
6	Venus in Chariot with Doves	20	Cupid with Panther and Grape Vines (Bacchus)
7	Venus and Jupiter	21	Cupid with Syrinx (Pan)
8	Mercury	22	Cupid with a Shield and Helmet (Minerva)
9	Psyche Transported by Cupids	23	Cupid with Shield (Perseus)
10	Venus and Psyche	24	Amorini with Crocodile and Harpy (Pluto)
11	Cupid Pleads with Jupiter	25	Cupid with Anvil (Vulcan)
12	Mercury and Psyche	26	Cupid with Lion and Seahorse (Juno)
13	Cupid with Bow	27	Crest of Julius II (oak and acorns of the della Rovere family)
14	Cupid with Thunderbolts and Eagle (Jupiter)		

When the casket of Michelangelo Buonarroti (1475–1564) arrived in Florence on 10 March 1564, it was placed in the Company of the Assumption, behind S. Piero Maggiore and near the town hall. Two days later, artists and townspeople gathered to pay homage, as they carried by torchlight the corpse of their native son to rest in the Franciscan church of S. Croce, in the quarter where the Buonarroti owned property (see fig. 62–7, #11). Some months later, in the funeral eulogy held across town in the Medici church of S. Lorenzo (14 July 1564), Varchi described Michelangelo as a great man possessing divine talent. His hyperbole reflected the broad fame of Michelangelo that would continue to increase over the following centuries. By the 1550s, the clever Michelangelo had largely shaped his own story, while his biographers, Giorgio Vasari (*Lives*, 1550 and 1568) and Ascanio Condivi (*Life*, 1553), embroidered his legend. Considering him a genius, Vasari wrote that God chose him as the one artist to bring truth and perfection to the arts. Today, his *David* (see fig. 51–4), *S. Peter's Pietà* (see fig. 51–3), and Sistine Chapel murals are icons of Italian art. Moreover, his fame is greater than perhaps Leonardo's; yet, his myth is greater than the sum of his accomplishments as a sculptor, painter, architect, and poet. What was perhaps most regrettable to the artist himself were the failed projects that he thought deeply about (*Julius Tomb*, facade of S. Lorenzo, *Florentine Pietà*). His disappointments instilled in his artistic personality the type of angst and melancholy that has intrigued artists and writers since Vasari. Romanticized biographies have continued the myth of Condivi, picturing Michelangelo as a genius, blessed with divine sensitivity and driven by unique vision. Having had no need of a master's guidance, his titanic brilliance was considered God-given. His fame grew exponentially as writers like Goethe reverently dedicated works to his memory. Only in the last decades have Michelangelo's life and works been more objectively evaluated in light of the newly cleaned and restored works, like the Sistine Chapel frescoes, and in reevaluating the written documentation with greater concern for the practices and values of his time.

1475 — Michelangelo (Michelangiolo) is born (6 March) the second of five boys to Francesca di Neri and Lodovico di Leonardo di Buonarroto Simoni, the podestà (mayor) of Caprese. In April, his family moved back to Florence, where he had a wet nurse in Settignano (near Florence), the daughter and wife of stonemasons.

51–1. MICHELANGELO. *Doni Holy Family Tondo*, ca. 1503–5, tempera and oil glazes on panel, 3'11.3" (120 cm), Uffizi Gallery, Florence. Though smaller than Fra Angelico and Fra Filippo Lippi's *Adoration of the Magi* tondo (see fig. 31–3), Michelangelo's tondo is more monumental, with his largest forms fully occupying the foreground. His training as a sculptor also distinguishes his work: here, the appearance of the cloth around Joseph's neck and the robe behind Mary's back shows outlined edges resembling the thickness of garments fashioned in carved stone, and the shadows and highlights on the drapery and flesh are in sharp contrast to each other, making the figures appear highly volumetric. Similar to Luca Signorelli's shepherds in the *Virgin and Child with Prophets* (see fig. 41–3), the distant figures of Michelangelo's tondo are also shown on barren ground, but here they are leaning and sitting on a fluted, truncated marble wall about three feet high. Although thought to represent angels, they are seemingly unaware of Mary and Jesus, and may instead represent the pagan world. Only young John the Baptist, wearing a hair shirt and carrying a cross, looks up at the holy figures from where he is standing in the middle ground. In portrayals of the holy family, Joseph is usually less dominant; but in this painting, he wears the colors (blue and yellow) of S. Peter and takes on a supportive and commanding patriarchal role. The frame is attributed to Baccio da Montelupo, who assisted Michelangelo on sculpture projects.

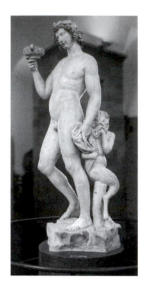

51–2. MICHELANGELO. *Bacchus and Satyr*, ca. 1496–97, marble, h. 6'7.5" (200.7 cm), Museo del Bargello, Florence. The figure is nude in the manner of antique statues, but the demeanor of the god more actively engages viewers than most Roman statues do. This fleshy, monumental figure shows the Olympian as tipsy, befitting his character. The glazed eyes, softly rounded shoulders, and relaxed body all amplify his swooning pitch and heavy-footedness. Tasseled with vines and grapes, his hair weighs heavily on his tiny head, which seems to nod as his body buckles. Behind Bacchus is a mischievous satyr stealing grapes from the god's wine sack, and beneath the satyr's hooves is an attribute of Bacchus, the skin of a panther.

1481 — Michelangelo's mother dies. Four years later (1485), his father remarried and Michelangelo moved to Florence to live with him in the S. Croce district.

1488 — Michelangelo's apprenticeship in the Ghirlandaio shop begins. Condivi wrote that he denied this, but his father signed a contract.

1489 — Michelangelo leaves the Ghirlandaio shop. He next trained as a sculptor, perhaps with several masters.

1490 — Michelangelo is Lorenzo de' Medici's guest at his palace (see fig. 63–2), where he stays until Lorenzo's death (1492). About this time he made two small marble plaques that are more like exercises (studies) than completed works: *Madonna of the Stairs* and *Battle of Centaurs* (both Casa Buonarroti, Florence). The bas-reliefs are remarkable for their wax-like surfaces and resemblance to antique Roman relief sculpture.

ca. 1492 — Condivi wrote that in exchange for dissecting corpses at the convent hospital of S. Spirito, Florence, Michelangelo carved a crucifix in wood for the prior. Vasari noted that this crucifix was placed above the main altar. The polychromed wooden *Crucifix*, h. 53" (134.6 cm), found at S. Spirito in 1962, is thought to be the crucifix they described (Casa Buonarroti, Florence).

1493 — Michelangelo executes a giant (lost) marble Hercules about 8 feet tall (Condivi and Vasari). Before 1529, it was acquired by the Strozzi and displayed in their palace. During the Siege of Florence (1529), the Signoria sold it to King Francis I, who had it installed at Fontainebleau; it disappeared in the 17TH c.

1494 — Michelangelo is invited by Piero (Lorenzo the Magnificent's son) to live in the Medici palace, but gave him only one commission, a snow statue (Vasari).

Michelangelo travels to Venice (Dürer and Perugino are there) and then to Bologna. He was a guest of Gianfrancesco Aldrovandi in Bologna, who secured a contract for him to complete the Shrine of Dominic (*Arca di S. Domenico*) in S. Domenico Maggiore (see Nicola Pisano ca. 1264), left unfinished when Niccolò dell'Arca died (1494). Michelangelo carved three figures for the sarcophagus lid: *Angel with Candelabrum*, *S. Petronius*, and *S. Proculus*; the last statue (perhaps begun by Niccolò) is now in poor condition (badly broken before 1572).

1495 — Lorenzo di Pierfrancesco de' Medici, nephew of the late Lorenzo the Magnificent and patron of Botticelli, commissions a (lost) marble statue of S. John the Baptist from Michelangelo.

ca. 1495 — Michelangelo carved a (lost) marble *Cupid* that resembled an antique type (Condivi, *Life*). In Rome, it was bought by the art dealer Baldassare Milanese, who tripled its price and sold it as an antique statue to Cardinal Raffaele Riario (nephew of Sixtus IV). Learning of the fraud, Riario demanded his money back, but also developed a respectful interest in Michelangelo's art. The statue was bought by Cesare Borgia, who sold it to Duke Guidobaldo da Montefeltro of Urbino. When Cesare ousted Montefeltro from Urbino, Isabella d'Este asked that Cesare send her Michelangelo's *Cupid*. Although the owners (the exiled Montefeltros) were then living in Isabella's palace, she refused to return the statue to them (the Mantua collections later passed to King Charles I of England; the *Cupid* was likely lost in the Whitehall fire of 1698).

1496 — Michelangelo is the guest of Cardinal Riario in Rome. From a marble

block bought by Riario, he carved a life-size *Bacchus and Satyr* (see fig. 51–2). By the early 1530s, the statue was recorded in the outdoor garden of Jacopo Galli, a wealthy banker friend and neighbor of Riario. Bought by Francesco de' Medici (1572), it was sent to Florence.

1498 — Cardinal Jean de Bilhères de la Lagraulas (d. 1499), abbot of S. Denis in Paris and priest cardinal of S. Sabina in Rome, hires Michelangelo to execute the *S. Peter's Pietà* for his tomb (see fig. 51–3). While Michelangelo's image of Mary is understood to represent the Mother of God, he made her uncharacteristically youthful—she looks even younger than her son. Vasari thought her youth referred to her virginity. She is also portrayed as the Bride and Daughter of God, as Giovanbattista Strozzi observed in his madrigal of 1549, composed when a copy of the *S. Peter's Pietà* was installed in S. Spirito, Florence. In his slumber-like pose, Christ would have reminded worshippers of the baby Jesus sleeping on his mother's lap. The sculpture is foremost meant to look like a living shrine, giv-

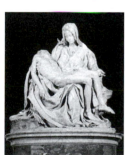

ing visual form to complex theological ideas concerning the Eucharist. In her great size Mary undoubtedly signifies her role as *Ecclesia* (the Church), and she holds Christ so that his body (the Holy Sacrament) can be more fully seen. Deeply chiseled and sweeping folds direct us both to Christ's wounds, signifying the redemption of humanity, and to the Virgin, personifying the Church. In 1499 the statue went into S. Petronilla, a Roman mausoleum beside the south transept of S. Peter's, where Cardinal Bilhères had his funerary chapel. In 1517 the statue was transferred to S. Peter's. In 1736 four broken fingers of Mary's left hand were replaced, and the statue underwent a major restoration in 1972 after it was severely damaged.

1500 — The brothers of S. Agostino, Rome, commission an altar panel. This is sometimes thought to be the *Entombment* (National Gallery, London), whose figures are derivative of his *S. Peter's Pietà* (Joseph of Arimathea) and *Doni Tondo* (Christ), showing the popularity of these works.

1501 — In Florence (May), Michelangelo is hired by Francesco Piccolomini to carve statues for the Piccolomini altar in Siena Cathedral. Andrea Bregno made the altar

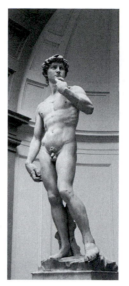

51–4. MICHELANGELO. *David*, 1501–4, marble, 14'3" (434.3 cm), Accademia, Florence. More than twice the size of *Bacchus*, the marble *David* is a colossus meant to be seen, not at ground level, but at a considerable height above eye level (where the figure's large hands and head and his short legs would appear less awkward), suggesting that the statue was originally intended for a cathedral buttress. In contrast, the marble *Bacchus and Satyr* are best viewed at eye level (and outdoors, where the god of wine can greet those enjoying a respite from the work-a-day world). While *Bacchus* is unclad, as was common for representations of antique gods, images of David were more commonly clothed, although Donatello's *David* creates a precedent for this figure nude (see fig. 21–5). Michelangelo likely envisioned *David* as his Florence masterwork; above all, it was surely meant to challenge Donatello's statues and to garner future contracts from the new, anti-Medici government.

51–3. MICHELANGELO. *S. Peter's Pietà*, 1498–99, marble, h. 5'8.5" (174 cm), since 1749 Chapel of the Crucifix, S. Peter's, Rome. In 1499 the *Pietà* (see LAMENTATION, Cinquecento Glossary) was his most polished marble to this date, with only the backside left rough because that side was apparently never intended to be seen. He signed his name on the sash that crosses over Mary's chest (MICHEL. ANGELVS. BONAROTVS. FLORENT. FACIEBA[T]). The inscription came sometime after it was finished, and to dispel any confusion about its authorship (Vasari). This is his only signed work; surely, he thought of the sculpture as demonstrating his vision and technical skill, and as a masterwork that could garner future Roman patronage for him. In its serenity his sculpture owes an incalculable debt to an overlooked inspiration: Pietro Perugino's *Pietà with Saints* (1493–97) for S. Giusto alle Mura, Florence (Uffizi Gallery, Florence).

51-5. MICHELANGELO. *Pitti Tondo*, ca. 1501–4, marble, 2'9.5" (85.1 cm), Museo del Bargello, Florence. As in the gilded wood frame Michelangelo designed for the *Doni Tondo* (see fig. 51–1), where the heads of angels or prophets project from the frame, reminders of the prophecy of the Messiah, in his *Pitti Tondo* he designed Mary's head to be the highest part of the marble relief, extending even above the frame. On her headdress is a winged head, likely a seraph (signifying divine love) or cherubim (divine wisdom). These are among the highest order (see ANGELS, Trecento Glossary). The presence of the tiny head must refer to Mary's ability to foresee Christ's Passion. Solemn and remote, she is like his pagan Sistine Sibyls. In this scene, tension is signaled by the frightened young Baptist (left), who appears in low relief, and has barely been roughed out. Like the *Taddei Tondo*, this work was also left unfinished.

(1481–85) and Pietro Torrigiano began one statue, *S. Francis*. Michelangelo was hired to finish Torrigiano's *S. Francis* and to carve 15 more statues; he made four altar statues (1501–4): *Peter*, *Paul*, *Gregory*, and *Pius*, each 4'2" (127 cm) tall.

Michelangelo carves the *Bruges Madonna*, h. 4' (121.9 cm), thought to have been originally intended for the Piccolomini altar, Siena Cathedral. It was purchased by the Mouscron for their family chapel in Notre Dame, Bruges (Condivi, *Life*).

The *operai* (supervisors) of Florence Cathedral hire Michelangelo to create the marble *David* (16 August) from the stone block abandoned by Agostino di Duccio (Donatello follower); the block was carved (finished 1504) in the palace courtyard of the board of supervisors.

1502 — Michelangelo receives a government contract to make a (lost) bronze David for Cardinal Pierre de Rohan; unfinished until 1508 (completed by Benedetto da Rovezzano and sent to France).

1503 — Michelangelo is hired by the *operai* of Florence Cathedral to make 12 marble Apostle figures. He began only *Matthew* (Accademia, Florence).

1504 — Michelangelo completes the marble *David* (see fig. 51–4). A committee of mostly artists met to discuss its placement (see Botticelli 1504). The final decision was for it to replace Donatello's *Judith* at the entrance to the town hall. Landucci (1436–1516) wrote in his journal that it took 4 days and 40 men to move the "giant" from the cathedral workshop to the town hall (unveiled 8 September 1504). A mob damaged the statue's left arm, hurling objects from palace win-

dows during the expulsion of the Medici (1527); Cosimo had the arm restored (1543). Replicas (19TH c.) were made for the town hall and Piazzale Michelangelo.

Michelangelo is hired to create a mural of the Battle of Cascina for the Room of Five Hundred, Town Hall, Florence. He worked on the cartoon in the Hospital of the Dyers in the church of S. Onofrio, transferring it to the council chamber before 1508. The cartoon later went to S. Maria Novella; however, by 1515 it was in the Palazzo Medici. About 1550, the cartoon was divided into fragments, dispersed, and eventually destroyed.

1505 — By this year he had executed three tondos of the Madonna and Child. The earliest is a marble (unfinished) tondo in low relief begun ca. 1501–2, the *Taddei Tondo* (Royal Academy of Fine Arts, London), named after the Florentine Taddeo Taddei. Vasari noted that Raphael made two paintings for Taddei; Raphael's knowledge of Michelangelo's *Taddei Tondo* seems evident in *Madonna of the Meadow* (see Raphael ca. 1505/6). Another marble tondo relief, called *Pitti Tondo*, for Bartolommeo Pitti (see fig. 51–5), may have been inspired by the images of seated prophets framed by tondos in Signorelli's *Medici Madonna* of ca. 1490 (Uffizi Gallery, Florence). The third is the *Doni Holy Family Tondo* (wooden frame by Baccio da Montelupo) (see fig. 51–1) for Agnolo Doni and Maddalena Strozzi (see figs. 50–2, 50–3). Leonardo's (lost) cartoon of the *Madonna, Child, and S. Anna* (see Leonardo 1501) surely inspired the active, tightly connected figures, yet Michelangelo's scene is more

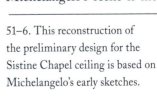

51-6. This reconstruction of the preliminary design for the Sistine Chapel ceiling is based on Michelangelo's early sketches.

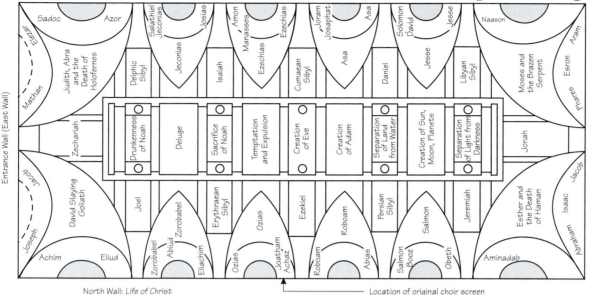

South Wall: *Life of Moses*

Sadoc · Azor · Salathiel Jeconias · Josias · Amon Manasses · Ezechias · Joram Josaphat · Asa · Solomon David · Jesse · Naason

Elzear · Judith, Abra and the Death of Holofernes · Delphic Sibyl · Jeconias · Isaiah · Ezechias · Cumaean Sibyl · Asa · Daniel · Jesse · Libyan Sibyl · Moses and the Brazen Serpent · Esron · Aram

Mathan

Entrance Wall (East Wall)

Zechariah · Drunkenness of Noah · Deluge · Sacrifice of Noah · Temptation and Expulsion · Creation of Eve · Creation of Adam · Separation of Land from Water · Creation of Sun, Moon, Planets · Separation of Light from Darkness · Jonah · Phares

Altar Wall (West Wall)

Jacob · David Slaying Goliath · Joel · Zorobabel · Erythraean Sibyl · Ozias · Ezekiel · Roboam · Persian Sibyl · Salmon · Jeremiah · Esther and the Death of Haman · Jacob

Joseph · Achim · Eliud · Zorobabel · Abiud · Eliachim · Ozias · Joatham Achaz · Roboam · Abias · Salmon Booz · Obeth · Aminadab · Abraham · Isaac

North Wall: *Life of Christ* — Location of original choir screen

agitated and the underpinnings of psychological tension more quickly seen.

Julius II calls Michelangelo to Rome (March 1505) to design his tomb.

1506 — Julius lays the foundation stone for S. Peter's (see fig. 49–1), delaying his tomb project. Michelangelo returns to Florence (April), but meets Julius in Bologna (November), where he created a larger-than-life bronze statue of him for a niche above the door of S. Petronio (installed February 1508). In 1511 the Bolognese attacked the statue and sold the bronze to Duke Alfonso I d'Este of Ferrara; he kept the head, but made a cannon of the rest, naming it *La Giulia*.

1508 — In Florence, Michelangelo buys three houses and a cottage on Via Ghibellina. He receives a contract from Gonfaloniere Pietro Soderini to create a statue of *Hercules and Cacus*, a companion piece to his marble *David* (the marble block did not arrive until 1525, and Pope Clement reassigned the contract to Bandinelli).

Julius II summons Michelangelo (by early April) to paint the Sistine ceiling. He signed a contract on 10 May 1508. Some of his early studies for the ceiling are com-

51–7. This diagram identifies imagery of the Sistine ceiling. It is thought that work proceeded in two stages, starting from the entrance: his first painting session in 1508–10 and his second, in 1510–12. Yet, the figures and the palette suggest that he divided the imagery into three groups: to each belong three narratives and the flanking Prophets and Sibyls in pendentives. In the first group (by the entrance) he designed smaller, tighter, more controlled forms than in the second or third, with the largest of all the figures, Jonah, above the altar. Ancestors of Christ appear in the lunettes (names on plaques), and their families appear in the severies above.

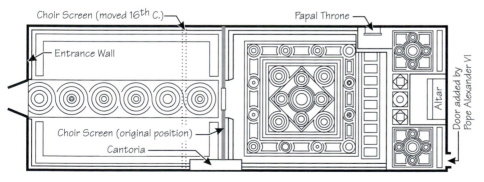

Choir Screen (moved 16th C.)

Papal Throne

Entrance Wall

Door added by Pope Alexander VI

Altar

Choir Screen (original position)

Cantoria

51–8. This diagram, based on Steinmann's, shows the Sistine Chapel floor, ca. 1479. The choir screen was moved after 1550 (see figs. 51–7, 51–13).

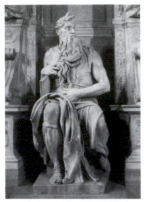

51–9. MICHELANGELO. *Moses*, ca. 1511, 1513–16, 1542–45, marble, h. 7'8.5" (235 cm), *Tomb of Julius*, S. Pietro in Vincoli, Rome. The significance of Moses is based on analogies drawn between the mission of the guardian of the Old Law and the role of pope as guardian of the New Law. Michelangelo depicted a more muscular and virile Moses than did artists before him. In the Sistine frescoes of the life of Moses, the patriarch is fully clothed in a gown and robe. This Moses instead wears no robe, has bare arms, and the flesh of his right knee is exposed. Both the boot strap and the deeply carved cloth that encircle his leg are remindful of the snakes coiled around the priest's legs in *Laocoön and Sons* (see fig. 51–11). As first planned, the tomb was intended to rise higher than Sixtus IV's tomb and to have many marble statues (see fig. 51–10).

prised of seated figures and geometrical designs (see fig. 51–6). Among his many sources for the geometrical patterns were the often-copied decoration in Nero's Golden House in Rome and Perugino's frescoes in the Collegio del Cambio, Perugia (see fig. 42–5). But the existing decoration in the Vatican Palace must also have made a lasting impression on Michelangelo: Pintoricchio's designs in the Borgia apartments, Raphael's ceiling for Julius II in the Stanza della Segnatura, and the floor pavement in the Sistine Chapel (the inlaid-stone patterns are both functional and decorative, with the round circles between the entry and choir screen corresponding to the processional route of the pope through the chapel). Michelangelo's final geometric designs for the ceiling visually relate the ceiling to the floor patterns and the liturgical function of the chapel (see figs. 51–7, 51–8). Michelangelo's ceiling images show the passage of time in both a broad and detailed manner. In the *Temptation and Expulsion*, he distinguished the appearance and demeanor of Adam and Eve before and after they disobeyed God's orders. Driven from Eden, they look older, more haggard and despairing. Inspired by Masaccio's *Expulsion of Adam and Eve* (Brancacci Chapel, Florence), these figures are made to look nearly demonic, especially with Adam's spiky hair and Eve's fearsome, scowling face. Those figures closest to the altar dominate the vaulted ceiling. In these narratives, that chronologically precede the creation stories of Adam and Eve, figures are much larger than are those near the entrance, making the figures in the altar area clear and readable from the entrance. Themes nearest the altar were also of special importance to the clergy. Celebrating God and his creation of life, the imagery alludes to the coming of the Messiah and the redemption of humanity. Above the altar is the only scene that does not look like an easel painting transferred

to the ceiling: in *Separation of Light from Darkness*, God is shown *di sotto in sù*, as though he is directly above the priest officiating at the altar. God's separation of light from darkness prefigures his separation of elect from the damned at the Last Judgment, a scene Michelangelo later painted on the altar wall.

1510 — Michelangelo completes half the Sistine vault, which was unveiled by Julius in August 1510 (Condivi, *Life*). In Bologna (late September 1510) he complained to Julius about the lack of money and instruction, and the conspiracies to steal his ideas.

1511 — Michelangelo is in Florence and Bologna, and resumes work in Rome (11 January), but stops (late February) because of delayed payment. An unveiling of the ceiling (mid August) showed the progress of his work (*Diary*, Paris de Grassis).

1512 — In July Alfonso d'Este of Ferrara, in Rome to make amends with Julius, climbs the scaffolding in the Sistine Chapel. Michelangelo completes the vault in October (letters), with the official unveiling on 31 October (Paris de Grassis).

1513 — Cardinal Giovanni de' Medici, 38 years old and born in the same year as Michelangelo, is elected pope.

On 6 May, Michelangelo signs a new contract for the Julius Tomb with the heirs. He begins three marble statues: *Moses* (see fig. 51–9), later installed in the wall tomb of Julius (1543) and the unfinished *Dying Slave* and *Rebellious Slave* (both Louvre, Paris). He worked on the tomb until 1516, moving his studio to Macel de' Corvi, a street near Capitoline Hill.

1514 — Michelangelo buys a house beside those purchased in 1508 (five in total), and

lives in the two largest, 1516–25. (When working on the Medici Chapel, 1525–34, he would live in the S. Lorenzo district.) He makes trips to the Carrara quarries and is hired by Metello Vari to carve the life-size marble *Resurrected Christ* for S. Maria sopra Minerva, Rome. A flaw in the first statue (abandoned in Rome, 1516) caused him to begin a second in Florence (1519–20); Pietro Urbano (his assistant) left before installing this statue in the church (1521), and Federigo Frizzi completed the installation and created the niche. When Vari asked for the abandoned statue, Michelangelo offered to make a third, but Vari accepted the second statue.

1516 — A new contract for the Julius Tomb is drawn up (8 July), decreasing the original 40 statues by half. About this year Michelangelo helps Sebastiano del Piombo with drawings and paintings, giving him some of his own.

In Florence Cardinal Giulio de' Medici (acting for Leo x) hires Michelangelo to design the facade of S. Lorenzo (competition announced in 1515). Although Baccio d'Agnolo made a wooden model after Michelangelo's design, he rejected it and made his own model.

1517 — Michelangelo buys marble from Carrara for the S. Lorenzo facade.

1518 — In Rome Michelangelo signs a contract (19 January) for the S. Lorenzo facade, Florence, that calls for 12 larger-than-life-size marble statues, 6 bronze figures, and 7 large reliefs (everything was to be finished by 1526). Michelangelo closed his Roman workshop, instructing that his cartoons be burnt.

1519 — Working on the tomb of Julius II, Michelangelo suggests to Leo x that a tomb be executed to Dante's memory. From the Medici he receives the com-

mission to design a new sacristy for the church of S. Lorenzo, Florence (see fig. 19–2). It was to contain tombs for six Medici: Lorenzo the Magnificent and his murdered brother, Giuliano; Dukes Lorenzo of Urbino and Giuliano of Nemours; and Pope Leo and Cardinal Giulio (see fig. 61–2). Michelangelo's sketch for the wall tomb of Lorenzo the Magnificent and Giuliano (see fig. IV–3) shows that he planned two coffins, with wall niches above for the statues of the *Medici Madonna* (center) and the Medici patron saints, *Cosmas* and *Damian* (on Michelangelo's designs, these two are by Montorsoli and Raffaello da Montelupo, 1533–34).

1520 — With no explanation, Leo x cancels Michelangelo's contract for the facade of S. Lorenzo, Florence.

1521 — Completing two tomb models for the Medici Chapel in S. Lorenzo, Michelangelo begins work in the chapel.

1523 — The heirs of Julius demand fulfillment of the Julius Tomb contract. Pope Hadrian vi supports their claim.

Giulio de' Medici (as the new pope, Clement vii) hires Michelangelo to design and supervise construction of the S. Lorenzo library in Florence.

1525 — Michelangelo and the heirs of Julius agree the tomb will not be freestanding, but braced against a wall.

Clement vii asks for a ciborium design for the Medici relics in S. Lorenzo. Michelangelo proposes a reliquary tribune be built against the inner facade.

1526 — Michelangelo sends to Rome a new and simpler design for the Julius Tomb, which is rejected by the heirs of Julius.

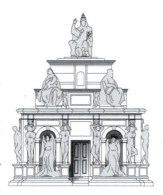

51–10. Reconstruction of the three-story tomb of Julius in the early stages of its design, ca. 1505. The apex figure is based on Antonio Pollaiuolo's statue of Innocent VIII (S. Peter's, Rome), and the other figures are based on drawings by Michelangelo for the early project and early statues for the project. *Moses* (see fig. 51–9), originally meant to be seen from about 12 feet below, appears here in the upper right corner.

51–11. *Laocöon and Sons*, 1ˢᵗ c. BCE (?), copy after original 1ˢᵗ c. CE (?), marble, h. 8' (244 cm), Vatican Museums, Rome. Found on the Esquiline Hill in 1506, the statue group was bought by Pope Julius and installed in the Villa Belvedere court (see fig. 49–3). This dynamic group attracted much attention after its discovery.

51–12. MICHELANGELO. *Victory*, ca. 1527, marble, 8'6.8" (260 cm), Palazzo Vecchio, Florence. Similar to Raphael's *Galatea* of about 1512, *Victory* is meant to show a light and airy quality that contrasts with the crudeness of his bound captive. Surface evidence suggests that Michelangelo worked out ideas while carving the contorted musculature of *Victory* and twice shifted the alignment of the body.

51–13 (opposite page). AMBROSIUS BRAMBILLA. Sistine Chapel, 1582, engraving. In 1535, while altering the west wall for painting the *Last Judgment*, the altar and papal throne were raised by more steps. The choir screen was moved beyond the cantoria ca. 1550–78.

1527 — Rome is sacked and the Medici in Florence are forced into exile (see Cinquecento History Notes 1527). Michelangelo stops working on the Medici tombs in S. Lorenzo. About this year he begins the marble *Victory* (see fig. 51–12). Intended for the lower level of the Julius Tomb (see fig. 51–10), it was later installed in the Florence town hall. Similar to images of the Archangel Michael subduing Satan, *Victory* seems to mystically rise. While his twisting body rotates upward he forces downward the crumpled, serpent-like foe.

1528 — Michelangelo is consulted about the colossal marble statue *Hercules and Cacus* by Bandinelli (Michelangelo had first been assigned the project in 1508). Set at the entry to the Palazzo della Signoria in 1534, it became the counterpart to Michelangelo's *David*.

1529 — Michelangelo serves the new Florentine republic as a military engineer and draws up plans to fortify Florence against repeated attacks by the Medici and their supporters attempting to return to Florence. In the summer months he inspected fortifications at Pisa, Livorno, and Ferrara. By late September, he left Florence (for Venice) before troops of the emperor and the pope (Neapolitan and Spanish soldiers) besieged Florence.

1530 — Clement VII (aided by Emperor Charles V) restores power to the Medici in Florence, placing Alessandro de' Medici in charge. Alessandro hired assassins to track down Michelangelo, who apparently took refuge in S. Lorenzo. Receiving a pardon and immunity from Clement, Michelangelo returned to work on the Medici Chapel, S. Lorenzo.

Michelangelo paints a (lost) *Leda* for Duke Alfonso I d'Este of Ferrara. However, the work was instead acquired by Antonio Mini in 1531. It was taken to the court of Francis I, where it was copied by Il Rosso (National Gallery, London). Michelangelo's *Leda and the Swan*, which was in Fontainebleau in the 1540s, was apparently destroyed for moralistic reasons during the reign of King Louis XIII of France.

Michelangelo creates the (unfinished) marble *Apollo* (Bargello, Florence) for Baccio Valori, a Medici follower who tracked down anti-Medici supporters. The statue was unfinished in Michelangelo's shop when he left Florence in 1534.

1531 — Michelangelo's father dies; his brother Buonarroto had died of the plague in 1529.

1532 — Michelangelo finishes the Tribuna delle Reliquie, S. Lorenzo (see fig. 19–2, #17), and enters negotiations about the Julius Tomb with Clement VII and the heirs of Julius. Another contract is drawn up, calling for only six statues.

1533 — At the small hill town of San Miniato al Tedesco, Michelangelo meets Clement VII, who is on his way to France. The two likely discussed the contract for the *Last Judgment* altar wall mural in the Sistine Chapel. Michelangelo sends presentation drawings to the patrician Tommaso Cavalieri, whom he met in Rome in 1532. Among the drawings, dated 1532–33, are images of Ganymede, Tityus, and Phaëthon.

1534 — Michelangelo moves to Rome, leaving the completion of the Medici Chapel to assistants. In the remaining 30 years of his life, he never returned to Florence. When Pope Clement VII died in this year, Michelangelo stopped working on the *Last Judgment* and resumed his work on the Julius Tomb.

1535 — Pope Paul III appoints Michelan-

gelo painter, sculptor, and architect for the Vatican Palace and confirms his commission for the *Last Judgment*. In the Sistine Chapel, Perugino's altar wall frescoes and his *Assumption of Mary* are destroyed (because the chapel was dedicated to Our Lady of the Assumption, these were important works; see Perugino, Sistine Chapel). The windows and the cornices of this wall were also eliminated to create a flat, unbroken surface for painting (see fig. 42–4).

1537 — Michelangelo becomes acquainted with Vittoria Colonna (d. 1547), widow of Ferrante d'Avalos, to whom he dedicates several works.

1538 — Michelangelo supervises the placement of the Marcus Aurelius equestrian statue on Capitoline Hill.

1539 — Michelangelo begins to carve *Brutus*, a bust Vasari thought was commissioned by Cardinal Niccolò Ridolfi, a supporter of the Florentine republic who had to leave Florence after the reinstatement of the Medici in 1530. The portrait shows Brutus as either the hero who inspired the revolt against the Tarquins, killing the last king of Rome, or the traitor who murdered Julius Caesar. According to the inscription (added later) on the base, the figure is unfinished.

1541 — Paul III unveils the *Last Judgment* in the Sistine Chapel (31 October). No other chapel in Rome was comparable to this one, built by Sixtus IV (see figs. 42–3, 42–4). To complete its decoration, Pope Leo x had earlier ordered tapestries from Raphael's designs; these textiles were first displayed in the chapel on 26 December 1519. Recording the event, Paris de Grassis, Papal Master of Ceremonies, wrote in

his Diary: "[Leo x] ordered his new, most beautiful, and precious pieces of tapestry to be hung, at the sight of which the whole chapel was stunned, and it was the universal judgment that there is nothing more beautiful in the world and the value of each is two thousand Ducats in gold." According to a contemporary art connoisseur, the Venetian Marcantonio Michiel, Raphael was paid 100 ducats for each cartoon (1,000 ducats in total), and each tapestry cost 1,500 ducats. For Raphael, the payments were nearly equal to his fee (1,200 ducats) for the murals in the Stanza dell'Incendio. Leo x's decision to have tapestries cover the undecorated, bare walls of the chapel followed the tradition of placing wall hangings in basilicas; but rather than geometric or floral designs, Raphael's were figural, providing a weighty presence at the eye level of worshippers. With Michelangelo's *Last Judgment*, the cycle of human existence on earth concludes with the second coming of the Messiah, a scene that directs attention to the altar. In contrast to his structured imagery of the vault and to the *all'antica* settings of Raphael's tapestry designs, Michelangelo included no man-made architecture in the *Last Judgment* and absolute order is missing in his vision of heaven. Struggle is everywhere apparent and chaos prevails, with the varying sizes of figures emphasizing the turmoil that is seeming to spill into the chapel. Viewers must surely have thought they were witnessing the event.

The Virgin Mary recoils, no longer the intercessor she was always shown to be, and Peter and John the Baptist, among the largest figures of the scene, flank Christ the Pantocrator, but at a much greater distance than they are normally shown.

COUNCIL OF TRENT. The council recommended (21 January 1564) elimination of the obscene parts of Michelangelo's *Last Judgment*. Daniele da Volterra and others began adding clothes to figures and repainting offensive parts: 10 figures received more clothing and 25 nude figures were dressed. Yet, not everyone agreed about the inappropriateness of the figures. In 1573, when Veronese was questioned by the Holy Office about the improprieties in his *Last Supper*, he referred to Michelangelo's fresco, saying that the figures of Christ, Mary, John, Peter, and the Heavenly Host were all shown nude, and in different poses and with little reverence. To this, the inquisitor responded that in scenes of the Last Judgment, in which garments are not presumed necessary, there was no need to paint them and that nothing about Michelangelo's work was unspiritual. The 1990s restoration of Michelangelo's *Last Judgment* removed Volterra's repaint, but Michelangelo's design is lost where the original surface was removed, as with Catherine of Alexandria (originally shown nude).

1542 — Michelangelo gets the last contract for the Julius Tomb, with these conditions: that he finish the statues *Moses* and *Leah* and that Raffaello da Montelupo finish the statue *Rachel*. He begins work on the frescoes in the Pauline Chapel, Vatican Palace, commissioned by Pope Paul III.

1544 — Work begins on Capitoline Hill according to the designs of Michelangelo, and Michelangelo completes the architecture for the Julius Tomb in S. Pietro in Vincoli, Rome.

1545 — Michelangelo completes *Conversion of Paul*, Pauline Chapel. In the same chapel, he began painting (1546) the *Crucifixion of Peter* (see 1542).

The statues for the Julius Tomb are installed in S. Pietro in Vincoli. In this year Michelangelo creates a *Crucifixion* drawing for Vittoria Colonna.

1547 — At the age of 71, Michelangelo is named head architect of S. Peter's, after Antonio da Sangallo the Younger's death. He quickly changed Sangallo's design. To quell the rumblings, Paul III made him solely in charge (1549). Paul had also hired him to complete the Farnese Palace (see fig. 47–8).

1552 — Michelangelo finishes the flight of steps for the Capitoline Hill and designs the stairs for the Belvedere Courtyard, Vatican. Pope Julius III confirms his appointment as chief architect of S. Peter's, as he had also done in 1550.

1553 — Michelangelo creates a *Pietà* for his own tomb in S. Maria Maggiore, Rome, but he abandoned the project (see fig. 51–14).

1555 — Paul IV engages Michelangelo to design the cupola of S. Peter's. His brother Gismondo and Francesco Amadori (servant and assistant for 26 years) both die.

1558 — Michelangelo begins a model for the cupola of S. Peter's.

1559 — Michelangelo sends a design to Florence for the Laurentian Library staircase and makes designs for two (unexecuted) Roman projects: S. Giovanni dei Fiorentini and the Sforza Chapel, S. Maria Maggiore.

1560 — Michelangelo designs a monument in honor of King Henry II of France for Queen Catherine de' Medici of France.

1561 — In Rome, Michelangelo designs a city gate for Pope Pius IV, the Porta Pia. He also works on the project to transform the Baths of Diocletian into the church of S. Maria degli Angeli. Pius confirmed all Michelangelo's appointments in 1562.

1563 — Artists in Florence found the first art academy (31 January). Members appoint Grand Duke Cosimo I and Michelangelo to head the academy.

1564 — Michelangelo devotes his attention to his last work, the (unfinished) *Rondanini Pietà* (Milan). He dies (18 February) in his house at Marcel de' Corvi in Rome. Attending to him were his friends Daniele da Volterra and Tommaso Cavalieri, his servant Antonio, and his doctors. His body was shipped back to Florence for burial in S. Croce.

51–14. MICHELANGELO. *Florentine Pietà*, ca. 1553, marble, 7'8" (233.7 cm), Museo dell'Opera del Duomo, Florence (called the *Florentine Pietà* because it was installed in the Duomo). Attacking the sculpture, Michelangelo struck Christ's left arm and leg, and left it unfinished. His pupil Tiberio Calcagni repaired the arm, made a replacement leg (missing), and completed the angel (also thought to represent Magdalene), who appears stylistically incongruous with the other figures. In 1561, Michelangelo gave the statue to his servant Antonio. The work shows a close relationship between mother and son, which is missing from the *S. Peter's Pietà*. Here, energy is expressed in the figures chiefly through the curving torso of Christ and the sharp angles of his limbs. Christ nearly slips from the grip of Nicodemus, yet they move together in such a harmonic and compressed way that the group is perceived as both high relief and sculpture in the round, while the complex psychological relationships of the figures is meant to be seen from different views.

Andrea del Sarto

Andrea del Sarto (1486–1530) was 13 years old when Leonardo returned to Florence in 1500. Michelangelo had just completed the *S. Peter's Pietà*, his Roman masterwork in marble; Perugino was completing frescoes at the Cambio in Perugia while finishing panels for the Certosa in Pavia and the abbey of Vallombrosa (outside Florence); and the 16-year-old Raphael was working in Umbria, perhaps in Perugino's shop. By 1501, Michelangelo was back in Florence, carving his colossal marble *David*, and Leonardo was designing his (lost) cartoon for the high altar painting (never executed) in the church of SS. Annunziata. Michelangelo's statue and Leonardo's cartoon made a lasting impression on young Andrea—just as they influenced Raphael upon his arrival in Florence about 1505. With the most valued artists gone from Florence by 1508 (Leonardo in Milan and Perugino, Raphael, and Michelangelo in Rome working for Julius II), Andrea earned important contracts. He soon became *the* master artist in town, charting a new course for Florentine painting. His religious patrons provided multiple commissions, his exotic frescoes in the Medici villa at Poggio a Caiano for Pope Leo X inspired a following, and his work for Francis I paved the way for Italian painters at Fontainebleau, where Il Rosso, Primaticcio, and Niccolò dell'Abate were to reap the benefits of royal patronage. While Vasari's generation praised and copied details of Andrea's work (often identifiable by his monogram of intersecting letter A's), baroque artists wholly emulated the careful balance of emotional strength and classical restraint of his monumental figure groups.

1486 — Andrea is born (16 July) to the tailor Agnolo di Francesco and Costanza di Silvestro.

1498 — Sarto's early training is uncertain. Vasari thought that he apprenticed as a goldsmith and then trained as a painter, staying in Piero di Cosimo's shop many years. The Anonimo Magliabecchiano notes that he assisted the painter Raffaellino.

1506 — In Florence, Sarto is hired to decorate the outer walls of Palazzo Guadagni, Piazza S. Spirito.

ca. 1507 — Sarto is hired to execute monochromatic murals in the Compagnia di S. Giovanni Battista dello Scalzo (Barefooted Brethern of the Fraternity of S. John the Baptist), Florence (see fig. 52–4), a confraternity to which he belonged; payments are recorded only from 1515 to 1526.

1508 — Sarto matriculates in the Arte dei Medici e Speziali (December), as did the painter Franciabigio (Francesco di Cristofano, 1484–1525), whom Vasari claimed was trained by Mariotto Albertinelli

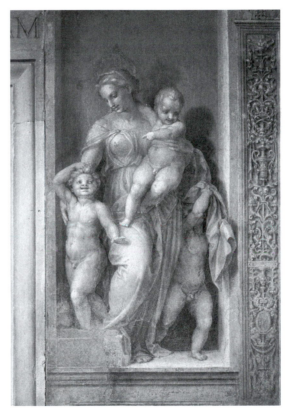

52–1. ANDREA DEL SARTO. *Charity*, ca. 1513, fresco, 6'4.4" x 2'9.9" (194 x 91 cm), Scalzo Cloister, Florence (see fig. 52–4). While Filippino's image of *Charity* (Strozzi Chapel, S. Maria Novella, Florence) impressed Sarto, whose grisaille figures are also meant to look like sculpture that has come to life, Sarto's figures appear more volumetric and organic than Filippino's. Sarto's figures are placed close to visitors, and in several instances some appear to be looking at visitors. His last works in the cloister are among his most solemn, grand, and memorable.

52–2. Atrium (small cloister, north view), SS. Annunziata, Florence. Votive offerings and effigies were housed here—the donations of Florentines and pilgrims venerating the miraculous *Annunciation*. Once open to the sky, the atrium was enclosed in the 1800s. Absent now are the sounds of chirping birds and windy rain, which would have filled the space, complementing Sarto's murals of Benizzi performing miracles outdoors. Gone as well are the painted wall pilasters framing the scenes; echoing the colonnade supports, these enhanced the depth of Sarto's illusionism. Wax effigies, once hung in the atrium, along with pilgrims milling about would also have lent extra palpability to Sarto's illusionism.

(1474–1515). Sarto and Franciabigio were to establish a workshop in the Piazza del Grano, near the southeast corner of the town hall.

1509 — Sarto paints the (destroyed) wax effigy of Duke Francesco Sforza of Milan and the frontal of the high altar in SS. Annunziata. His collaborator, Andrea di Cosimo Feltrini, is paid for work in the atrium.

1510 — Sarto completes episodes of the life of Filippo Benizzi in the small cloister of SS. Annunziata (see figs. 52–2, 52–3). Opinion varies about the order in which he executed the Benizzi murals, but they are all usually dated between 1509 and 1510.

ca. 1510 — Sarto and Franciabigio move to the Sapienza, where Jacopo Sansovino, Nanni Unghero, Rustici, and Tribolo are working. Vasari thought that Sansovino made wax sculptures for Sarto's figure studies.

1511 — Sarto is contracted to execute frescoes in the Vallombrosan convent of S. Salvi. On the underside of the arch in the refectory he painted *Trinity with Saints* and on the end wall the *Last Supper* (finished 1527). Feltrini and Sarto help Piero di Cosimo design floats for the carnival of the Carro della Morte.

1512 — About this year, Sarto completes and signs a large oil panel, *Annunciation*, for Taddeo da Castiglione's chapel in the Augustinian convent near the Porta S. Gallo. The work was transferred to S. Jacopo tra' Fossi after the Siege of Florence (1529); in 1627, it went to the chapel of Maria Maddalena of Austria in the Pitti Palace (Pitti Palace, Florence).

Sarto paints two monochromatic frescoes in the large cloister, SS. Annunziata: one was destroyed (18TH c.) and the other is a fragment. Sarto painted carts (1512–14) for the Arte de' Mercantini to use on S. John the Baptist's feast day. For carnival celebrations, the Compagnia del Diamante contracted decorations from Sarto, Andrea Feltrini, and Raffaello delle Vivuole (the wood-carver, il Carota).

1514 — By this year, Sarto executed two frescoes in SS. Annunziata that are stylistically distinct from the Benizzi series and for which he received more money: *Journey of the Magi* (1511–12) and *Birth of the Virgin* (the latter was his atrium masterwork). The *Journey* depicts the Magi—in their search for the Messiah—stopping at Herod's palace in Jerusalem. The entourage is shown milling outside the grand building, some laden with parcels and dressed in fabulous garments. Their small heads and long torsos were influenced by Sarto's partner, Franciabigio. Sarto's *Birth* shows a more harmonious relationship between figures and architecture than can be seen in *Miracle of the Relics*, and it pays homage to Ghirlandaio's *Birth of the Virgin* in S. Maria Novella, but reflects a greater interest in creating more statuesque figures that command large areas of space. Paramount to Sarto's stylistic change was his awareness of such contemporary Roman works as Michelangelo's Sistine murals and Raphael's frescoes in the Vatican.

1515 — Sarto signs a contract (14 May) with the nuns of S. Francesco de' Macci, Florence, for an altarpiece of the Madonna and Child crowned by angels and flanked by Ss. John the Evangelist and Bonaventure (Francis was later substituted). Vasari referred to the work as the *Madonna of the Harpies* (Uffizi Gallery, Florence). The painting has life-size images of the saints and took two years

to complete. On Mary's pedestal, he inscribed his name, the date (1517), and the opening words of a hymn to our Lady of the Assumption: AND. SAR. FLO. FAB. / AD SVMMV / REG[I]NA TRO / NV DEFER / TVR IN AL / TVM / MDXVII. Of his easel paintings, this was the most influential on the Bolognese painter Annibale Carracci (1560–1609) and his followers.

1517 — Sarto is credited for work in S. Maria Novella, including the mural *Triumphant Entry of Leo X*. He marries the widow Lucrezia di Bartolommeo del Fede (d. 1570) and receives a dowry of cash (150 fiorini), material goods, and a house (Via S. Gallo, Florence).

1518 — Sarto's father legally frees him. Francis I summons Sarto to Fontainebleau.

1519 — After some months at the French court, Sarto returns to Florence, with the understanding that he would return with his wife. However, he remained

in Florence. Vasari thought that Francis I sent him to Florence to acquire paintings and sculptures.

1520 — Sarto purchases land in the district of S. Michele Visdomini (near SS. Annunziata), planning to build a house and studio.

1521 — Pope Leo X hires Sarto, Franciabigio, and Pontormo to create frescoes in the Medici villa at Poggio a Caiano. Sarto painted *Tribute to Caesar*.

ca. 1522 — Sarto executes *Lamentation*, an oil painting (Kunsthistorisches Museum, Vienna).

ca. 1523 — Sarto executes *Holy Family with an Angel* on a panel for Lorenzo Jacopi (Prado, Madrid).

1524 — Sarto receives payment for *Pietà with Saints*, a panel ordered by Abbess Caterina di Tedaldo for the high altar of the convent, S. Pietro, Luco (north-

SS. Annunziata Atrium, Florence

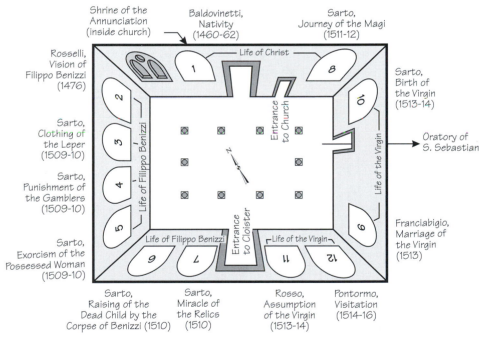

Shrine of the Annunciation (inside church)

Baldovinetti, Nativity (1460-62)

Sarto, Journey of the Magi (1511-12)

Rosselli, Vision of Filippo Benizzi (1476)

Life of Christ

Sarto, Birth of the Virgin (1513-14)

Sarto, Clothing of the Leper (1509-10)

Sarto, Punishment of the Gamblers (1509-10)

Life of Filippo Benizzi

Entrance to Church

Life of the Virgin

Oratory of S. Sebastian

Sarto, Exorcism of the Possessed Woman (1509-10)

Life of Filippo Benizzi

Entrance to Cloister

Life of the Virgin

Franciabigio, Marriage of the Virgin (1513)

Sarto, Raising of the Dead Child by the Corpse of Benizzi (1510)

Sarto, Miracle of the Relics (1510)

Rosso, Assumption of the Virgin (1513-14)

Pontormo, Visitation (1514-16)

52–3. This illustration of the atrium of SS. Annunziata in Florence (see fig. 52–2) identifies 12 frescoes created during a 50-some year span by six different artists. The church had a miracle-working Annunciation shrine, which was just inside the entrance to the church, on the other side of Baldovinetti's *Nativity*. Murals in the atrium depict stories of Christ, the Virgin, and the Servite Filippo Benizzi (see SERVITES, Duecento Glossary). The numbers in the lunettes propose a chronological order for the execution of the murals. During the time of Sarto, this cloister was like an artist's studio, and it afterward became a place where artists went to study masterworks. It thus became for painters what Michelangelo's Medici Chapel (New Sacristy, S. Lorenzo, Florence) was for sculptors.

Scalzo Cloister

Top labels (above diagram):
Beheading of the Baptist (1523) — Dance of Salome (1522) — Arrest of the Baptist (1517) — Baptism of the People (1517)

Left side labels:
Feast of Herod (1523)
Hope (1523)
Faith (1523)
Annunciation to Zacharias (1523)

Right side labels:
Preaching of the Baptist (1515)
Justice (1515)
Charity (ca. 1513)
Baptism of Christ (ca. 1511)

Bottom labels:
Visitation (1524) — Birth of Baptist (1526) — Franciabigio, Baptist Taking Leave of his Parents (1519) — Franciabigio, Meeting of Christ & the Baptist (1518)

Within diagram: Entrance — To Oratory → — Street Entrance

52–4. This illustration identifies the cloister frescoes by Franciabigio. All the others were done by Sarto (see fig. 52–1). The numbers reflect the chronological order of their execution. Changes to the once open-air cloister include the addition of vaults, lunettes, double columns, and glass enclosure (see fig. 52–5).

east of Florence). In the placement and mood of his figures, Sarto's work pays homage to Perugino's *Lamentation over the Dead Christ* of 1495.

ca. 1524 — Sarto creates sets for a production of Machiavelli's *Mandragola* for the Compagnia della Cazzuola (the Trowel). He was a member of this social group as well as the Compagnia del Paiuolo (Kettle), the dello Scalzo, and the del Freccione.

1525 — Sarto's name is in the books of the Company of S. Luke. He is hired to execute cartoons for the

52–5. West and north cloister walls (see fig. 52–4), Compagnia dello Scalzo, Florence. The court was originally open and the walkway around the cloister was lower and covered with flat timbers, making the space darker and the frescoes more intimate to those who entered the oratory.

spalliere in the town hall. In this year a Servite monk commissions a votive fresco, called *Madonna del Sacco*, over a doorway of the large cloister of SS. Annunziata. Vasari praised its perfection of line, grace, and color. Sarto is also awarded a contract to design new hangings for the Ringhiera (rostrum) of the Palazzo della Signoria.

1526 — Margherita Passerini hires him to paint the *Assumption* for S. Antonio dei Servi, Cortona, finished by 1529 (Pitti Palace, Florence).

1527 — Sarto completes the *Last Supper* (begun 1511), S. Salvi, Florence; the delay was caused by internal strife in the Vallombrosan convent. Living in the Visdomini district, Sarto makes his will (27 December).

1529 — Sarto enrolls in the Compagnia di S. Sebastiano. About this time he painted *S. John the Baptist*, which Duke Cosimo I had in his possession in 1553 (Pitti Palace, Florence).

1530 — Sarto prepares the walls and receives payments for frescoes of the Capitani of the Merchant's Tribunal in Florence. In this year Sarto dies (29 September) in Florence of the plague brought there by the imperial troops besieging the city in 1529. He was buried in a vault owned by the Compagnia dello Scalzo in SS. Annunziata.

Jacopo da Pontormo 53

Jacopo da Pontormo (1494–1557) has been viewed by some as a prematurely modern artist. In the 20ᵀᴴ c. his personality, perhaps more than his works, inspired a romanticized and sympathetic view of a troubled man. Vasari described him as moody and contemplative and thought that Jacopo spent undue time thinking about his work without lifting his brush to paint. Yet Pontormo never lacked contracts or wealthy patrons, the most famous of whom were two Medici popes and two Medici dukes. Part of his very good fortune came from being in Florence during the revival of ambitious Medici projects (the refurbishing of SS. Annunziata and S. Lorenzo). In early works, such as his *Visitation* (see fig. 53–3), he melded the monumental, sculptural forms of Sarto and Fra Bartolommeo with the robust and emotive figures of Michelangelo. Pontormo was living in Florence when Leonardo, Michelangelo, and Sarto reshaped its aesthetics, but he more closely studied Botticelli's lyrical style, as seen in his *Lamentation* (see fig. 53–1). Like Botticelli, he stayed close to Florence, where he survived the plague years and the onslaught of German and Spanish troops. Although his followers copied his pastel palette and fluid designs, no one duplicated his sensitivity for human states or spiritual experiences; nevertheless, he was nearly forgotten until the 20ᵀᴴ century.

1494 — Jacopo Carrucci is born at Puntormo or Pontorme (outside Empoli) to Alessandra and Bartolomeo di Jacopo di Martino Carrucci, a Florentine painter disciple of Domenico Ghirlandaio. His father died five years later (1499).

1504 — Jacopo's mother dies. He and his sister, Maddalena, are raised by their maternal grandparents.

1506 — With the death of his grandfather, Pasquale di Zanobi, Jacopo and Maddalena are looked after by their maternal grandmother, Mona Brigida, who sent Jacopo (1507) to live in Florence with a shoemaker relative named Battista (he was made a ward of the courts to protect his small estate). Maddalena remained in the village of Puntormo.

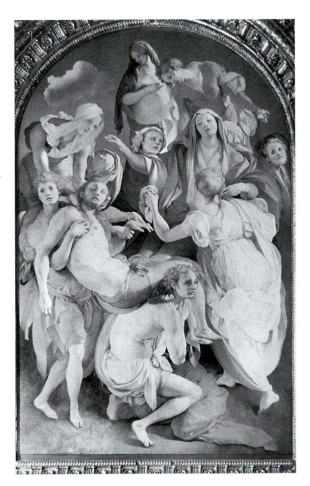

53–1. PONTORMO. *Lamentation*, 1528, oil on panel, 10'3" x 5'7" (312 x 192 cm), Capponi Chapel, S. Felicità, Florence. Like Michelangelo's *S. Peter's Pietà*, the Virgin is much larger than her Child. Though Christ does not recline in her lap, they are nevertheless connected. Her legs nearly touch those of her son, while her long, extended right arm majestically reaches out toward him. She, too, symbolizes the Church. The composition and the sense of unearthly beings (the youths carrying Christ may represent angels, who appear to be offering the body to worshippers) are reminiscent of the diaphanous, floating figures of the *Tassa Farnese* (see fig. 37–5) and of Botticelli's *Birth of Venus* (see fig. 37–4).

Vasari thought that Pontormo was placed in the shops of various master painters (Leonardo, Albertinelli, Piero di Cosimo, and Sarto). However, no other records verify his early training.

53–2. View of SS. Annunziata and Piazza Le Due Fontane. On the far right (east) is Brunelleschi's Ospedale degli Innocenti (see fig. 18–9), and in the background is the Annunziata. The entrance through the main door of the loggia leads to the atrium (figs. 52–2, 52–3), which was perhaps based on a model by Antonio di Ciaccheri Manetti after Michelozzo's design (1444–55). The arcaded entrance loggia harmonizes with Brunelleschi's loggia, but was not added to the Annunziata until 1599. In the center of the piazza is the bronze equestrian portrait of Grand Duke Ferdinando I de' Medici (cast in 1608) by Giambologna. Since the time of Piero de' Medici (Lorenzo the Magnificent's father), Medici patronage was directed to the church and the piazza.

1512 — Pontormo assists Andrea del Sarto at SS. Annunziata.

1513 — Pontormo executes a votive fresco of a hospital scene (detached 1856), painted in the women's corridor of the 14TH-c. Hospital of S. Matteo (now part of the Accademia). Pontormo's image shows charitable acts of a saintly woman and gives a glimpse of how hospital beds were arranged during his time. The *terra verde* fresco (poorly preserved) is reminiscent of Uccello's cloister images at S. Maria Novella; however, the figures and architecture are stylistically closer to Sarto's Benizzi frescoes (SS. Annunziata).

On the election of first Medici pope (Leo x), the Servites of SS. Annunziata place the Medici crest over the central arch of the outer facade of the church (see fig. 53–2). Feltrini, hired to gild and paint the crest, chose Jacopo to paint fresco figures of *Faith* and *Charity* supporting the crest (nearly indecipherable).

1514 — Pontormo paints the *Sacra Conversazione* fresco for the S. Lucy Chapel, S. Ruffillo, Florence, showing the enthroned Madonna and Child with Ss. Lucy, Agnes(?), Zacharias, and Michael (detached 1823, now SS. Annunziata).

In this year, Pontormo begins his

Visitation (see fig. 53–3). The lively operatic movements in his fresco capture the attention of viewers, which explains his growing appeal to religious patrons. Mary stands in the midst of a rich array of travelers. Women, children, and men of all ages are depicted in the fresco, which seems fitting to the Annunziata, where many votive effigies of pilgrims hung from rafters (some of these were life-size). In Pontormo's image an old and wise Elizabeth humbly kneels before her cousin and firmly grips her hand while acknowledging the special nature of the Child in Mary's womb. On the marble molding above the women are Old Testament figures (barely visible): emerging from the shadows is Abraham preparing to sacrifice his son Issac.

1515 — Pontormo paints the fresco *S. Veronica*, 10'1" x 13'6" (307 x 413 cm), in the pope's chapel in S. Maria Novella, Florence. The contract was originally given to Ridolfo Ghirlandaio, who turned it over to Pontormo. Sarto's influence shows in the use of clear, bright complementary colors, the ample drapery that falls from the canopy, and the energetic, twisting angels, whose poses are counterbalanced and whose gestures echo Veronica's. Jacopo had mastered the stark, sober monumentality of the popular Fra Bartolommeo, but the riveting intensity of Veronica's gaze is uniquely his own. This was one of his several important works for Leo x's visit.

Pontormo paints oil panels for the Carro della Moneta (Cart of the Mint). On S. John's Day, the cart carried offerings to the baptistery from the masters of the Florentine Mint. Pontormo's cart panels are preserved in the town hall, but their poor quality suggests they are substitutes of the original panels or have

undergone substantive repainting. During the carnival celebrations of 1515 and 1516, Pontormo painted three triumphal cars for the Compagnia del Diamante (Company of the Diamond), presided over by Giuliano de' Medici, duke of Nemours. He also painted cars for the Roman procession of the rival group, the Compagnia del Broncone (Company of the Barons), presided over by Lorenzo de' Medici, duke of Urbino.

Pontormo collaborated (1515–18) with Sarto, Bacchiacca, and Granacci in the decoration of Pier Francesco Borgherini's marriage chamber. In his *Joseph in Egypt*, Vasari identified Bronzino (Pontormo's assistant) as the young man on the steps (National Gallery, London).

1517 — Jacopo completely repaints an oil panel, *S. Quentin*, begun by a student, Giovan Maria Pichi, for the Observants of Borgo San Sepolcro. Vasari recorded seeing the painting in S. Francesco.

Pontormo's sister, Maddalena, dies.

1518 — Pontormo dates his *Sacra Conversazione*, S. Michele Visdomini, Florence, executed for Francesco Pucci, *gonfaloniere*. Only the design of the painting reflects Pontormo's hand.

1519 — With Sarto and Franciabigio, Pontormo shares a contract to paint the grand salon of the Medici villa, Poggio a Caiano (see fig. 47–1). He completed and signed the lunette fresco *Vertumnus and Pomona* (1519–21). Decoration was halted by the patron's (Leo x's) death, but Jacopo was later hired to complete additional work (he produced only cartoons and no other paintings).

1522 — Escaping the plague in Florence, Pontormo retires to the Certosa of Galluzzo, where he paints Passion frescoes in the great cloister: *Agony in the Garden* (1522–23), *Resurrection* (1523–24), *Christ before Pilate* (1523–24), *Road to Calvary* (1523–24), *Pietà* (1524–25).

1525 — Pontormo is inscribed in the Company of S. Luke, Florence. He paints *Supper at Emmaus* for the refectory of the Certosa, Galluzzo, and includes his self-portrait (right background).

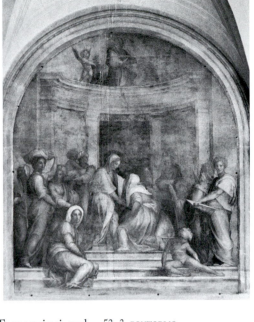

53–3. PONTORMO. *Visitation*, 1514–16, fresco, 12'10" x 11' (392 x 337 cm), Cloister, SS. Annunziata, Florence (see fig. 52–3, #12). Pontormo took about a year and a half to complete the *Visitation* fresco. Shown here are mothers and children, young and old men, a woman with a cane and another carrying a bundle on her head. All of these figures refer not only to the journey that Mary made to visit her cousin Elizabeth, but also to the travel of pilgrims to the Annunziata, where they venerated the miraculous shrine of the Servites. In these accompanying figures, pilgrims would likely have seen travelers like themselves.

1526 — For Lisabetta Tornaquinci and Girolamo della Casa, Pontormo executes a *desco da parto* to celebrate the birth of their child. Pontormo is inscribed in the guild of doctors and apothecaries.

1528 — Pontormo (assisted by Bronzino) completes work in S. Felicità begun in 1525 for Ludovico Capponi. He created four fresco tondos in the pendentives of the vault depicting bust-length portraits of the Evangelists: images of Luke and John (see fig. 53–4) are the earliest (1525–26) and those of Mark and Matthew, the latest (1526–28). His *Annunciation* fresco (1527–28) on the wall adjoining the altar shows Gabriel and Mary on each side of a window through which the warm, golden light from the setting sun enters the chapel; Gabriel's face is seemingly lit by both natural and spiritual light. For the altarpiece he created an oil panel, the *Lamentation* (see fig. 53–1), which in its irrational space is exemplary of his Mannerism. Often considered his masterwork, it shows his self-portrait (far right of fig. 53–1). Here, he designed twisting and agitated figures that give the sense of perpetual flux. Clothed in shimmering fabrics of shot-

53–4. PONTORMO.
S. John the Evangelist,
1525–26, fresco, 27.7" (70
cm), Capponi Chapel,
S. Felicità, Florence

Jacopo built a house on Via della Colonna (see 1528/29) that Vasari surely thought was unbefitting a Medici artist, especially because it lacked a proper studio. Vasari wrote: "[it had] rather the appearance of a building erected by an eccentric and solitary creature than of a well-ordered habitation, . . . [for to reach] the room where he used to sleep and at times to work, he had to climb by a wooden ladder, which, after he had gone in, he would draw up with a pulley." Vasari also noted that "in his dress and manner of life he was rather miserly than moderate; and he lived almost always by himself, without desiring that anyone should serve him or cook for him. . . . He never went to festivals or to any other places where people gathered together, so as not to be caught in the [crowd]; and he was solitary beyond all belief."

silk, they are like stage actors in a dramatic performance. Nothing is stable. Besides one solitary dark cloud, there is no hint of nature to suggest that these luminous figures are on earth. We can imagine instead that such delicate, nimble creatures partake of ethereal air and will disappear, fleeting as a vision.

ca. 1528/29 — Pontormo created the *Visitation* for S. Michele, Carmigiano. Focusing on four large figures (Elizabeth, Mary, and two other women), the work is like the Capponi *Lamentation* in its palette (pinks, greens, and oranges are dominant), emotive quality, and ambiguous space (the foreground figures seem irrationally distant from the two tiny background figures sitting on benches). He also paints *Martyrdom of S. Maurice* for the Ospedale degli Innocenti, Florence (from whom he acquired two lots on the Via Colonna in 1529). Before 1529, he painted the *S. Anna Altarpiece* (Louvre, Paris) for the Signoria.

1530 — Pontormo completes the oil panel *Penitent S. Jerome* (Niedersächsisches Landesmuseum, Hanover), which is similar in mood to Leonardo's *S. Jerome* (Pinacoteca, Vatican).

ca. 1534 — Pontormo completes *Noli me tangere* for Alessandro Vitelli. According to the Anonimo Magliabecchiano (1537–42), he executes a painting of *Venus and Cupid* (from Michelangelo's cartoon) for Bartolommeo Bettini. Alessandro de' Medici acquired a copy (Accademia, Florence), and Vasari made a couple of copies after the popular cartoon.

1534 —Pontormo paints an oil portrait of *Duke Alessandro de' Medici* (Philadelphia Museum of Art). It shows a strictly frontal view and a more lengthened format than appears in Raphael's portraits.

1536 — Pontormo and Bronzino complete (lost) decorations in the loggia of the Medici Villa at Careggi for Alessandro de' Medici.

1537 — Pontormo paints the portrait of the new duke, Cosimo de' Medici I, who hired him to decorate a loggia at the Medici Villa at Castello. Completed by 1543, the work was later whitewashed.

1545 — Pontormo collaborates on a major contract: cartoons (depicting the *Story of Joseph*) for tapestries in the Sala Duecento, Florence town hall.

1546 — Duke Cosimo I hires Jacopo to execute choir frescoes in S. Lorenzo, Florence. Although he worked on them for the next 10 years, they were still incomplete at his death. Bronzino finished his work (whitewashed in the 18TH c.).

1554 — Pontormo begins a diary. Its passages show the detailed care he gave to analyzing his health by recording not only his hours of sleep but also his consumption of food (type and quantity). Working at S. Lorenzo, he thought the job was harming his body: "Wednesday I did the rest of the putto and had to stoop uncomfortably all day so that on Thursday, I had a pain in my kidneys."

1557 — Pontormo is buried (2 January) under his *Visitation* fresco in SS. Annunziata (he had died one or two days before). His body was later transferred to the Chapel of S. Luke in the large cloister of the church. Of his principal assistants, Lappoli, Pichi, Naldini, and Bronzino (1503–72), the latter became the master who frequently worked for the Medici. Bronzino practiced what is considered the second phase of Mannerism, which lasted until the end of the century and was more popular than Pontormo's uniquely personal style.

Following the path of Andrea del Sarto, Rosso Fiorentino (1494–1540) also worked for the French crown. Yet he stayed in France and lived at court, whereas Sarto relinquished his position, returning to Florence. For his professional services, Rosso received a canonry and riches that far exceeded the monetary rewards granted most Italian artists—even those artists supported by the papal, ducal, or royal (Neapolitan) courts in Italy. Vasari praised Rosso for having achieved such status and observed that his good looks, gracious manner, and literate skills helped acquire royal patronage. In addition, he noted that Rosso was an accomplished musician and had a good understanding of philosophy. Rosso is presented as a model artist in the *Lives* not only for his facile imagination and talent as a draftsman, but also for his celebrated glory and exalted position at

a foreign court. Rosso's elegant style of Mannerism was well suited to the secular tastes of the French court, and his presence at Fontainebleau helped to reinforce the Italian tastes of King Francis i and his successors.

1494 — Giovanni Battista di Jacopo di Guasparre is born on 8 March in the Popolo of S. Michele Visdomini, Florence (baptismal record). Little else about his origins is known. By 1513 he was nicknamed il Rosso, "the redhead."

1513 — According to Vasari, Rosso studied Michelangelo's cartoon, the *Battle of Cascina*, but worked with few masters due to his inability to abide their styles. Vasari claimed that in his early work (a tabernacle fresco of a dead Christ commissioned by Pietro Bartoli), Rosso strived

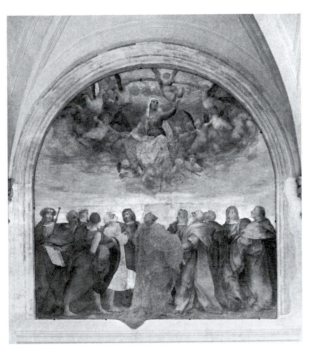

54–1. ROSSO FIORENTINO. *Assumption of the Virgin*, 1513–14, fresco, 10'11.5" x 10'7.7" (395 x 385 cm), SS. Annunziata, Florence. Cinquecento worshippers leaving the church of the Blessed Annunciation would see the Virgin being assumed into heaven (see ASSUMPTION, Quattrocento Glossary), surrounded by a mass of young frolicking nude angels with their arms linked as they encircle and transport Mary. Rosso's fresco turns the apocryphal gospel story into a living drama. The twist of Mary's body and her apparent movement makes her seem tangibly present, while her raised arm perpetually blesses everyone in the atrium. More than the figures in the other atrium frescoes, Rosso's apostles—through glance, an overlapping robe, and striding movements—are akin to milling crowds of pilgrims inside the atrium. Worshippers might even have imagined that they could hear a whirling hum emanating from the flapping angels' wings, as birds flew into the open court. What appears to be Mary's girdle (belt) is wrapped around the central angel. Blown by the frenzied movement of the angelic host, the sash flutters in the breeze and almost touches an apostle. The lively energy portrayed by these enthusiastic angels nearly racing around the Queen of Heaven suggests that Rosso studied the choir lofts of Donatello and of Luca della Robbia in the Florence Duomo. However, the image of a fluttering sash surely derives from Perugino's *Assumption* (see Perugino 1506), where two angels hold coiled belts above the heads of the apostles. Vasari would later discredit Perugino's painting, writing that it imitated early work and was out of vogue. Still, the Assumption theme had become closely linked to Perugino since his portrayal of the story in the tomb chapel of Pope Sixtus IV in Old S. Peter's (in 1477). Rosso could not have helped but study Perugino's work, if only to improve upon it.

ASSUMPTION OF MARY.
In Rosso's unusual *Assumption* (see fig. 54–1), the intense drama conveyed by the closeness of the apostles to Mary still retains a poignancy. Twelve earthbound, larger-than-life men are arranged here in patterns that visually enhance the sense that angels are moving and Mary is rising. Most scenes of the Assumption include Mary's tomb outdoors. Rosso eliminated everything but the figures and created an image that is similar to Perugino's *Assumption* (1504–6) that stood on the high altar of SS. Annunziata, although Rosso's is far more crowded and less serene than Perugino's. Leaning back, craning their necks, and pondering the mystical event, not one apostle in Rosso's painting lifts a hand into the rarified air around Mary, which makes the distance between the Virgin and the apostles seem beyond a human grasp, just as it does in Perugino's painting. While Rosso's *Assumption* gives a respectful nod to Perugino's, it also displays a boldly inventive and skillful design, traits that Vasari recognized in his work.

to create a bold image that was more monumental, graceful, inventive, and had more surprise than did the works of other painters working in Florence.

Although most of his paintings at SS. Annunziata, Florence, are now lost, Rosso worked there between 1513 and 1517, according to payment records. For painting the Medici arms (of Leo X and of Giuliano de' Medici), he was paid 5 lire and Andrea Feltrini 14 lire (5 September 1513). The Servites also paid Rosso for helping Baccio da Montelupo create a wax effigy of Giuliano de' Medici and for painting crests over doorways in the Servite general's chambers. In October and November he was paid for painting Lorenzo Pucci's arms over a doorway of the S. Sebastian Oratory (see fig. 52–3) (the Florentine Pucci had recently been created a cardinal by Pope Leo X). In November he began receiving payments for his atrium fresco, *Assumption of the Virgin* (see fig. 54–1), which took about seven months to complete and was probably valued at 16 gold florins in total (the amount later offered to Sarto to repaint Rosso's fresco, in 1515).

1514 — Rosso receives payments for the *Assumption* (see entry 1515). The fresco has extensive surface damage and large paint losses, lessening the illusionism that the final paint layers could have displayed. In addition, some figures have been heavily retouched.

1515 — The Servites pay Rosso (20 September) for painting arms at SS. Annunziata (although unidentified in the record, these were likely those of Pope Leo X).

It seems that the Servites disliked Rosso's *Assumption* (see fig. 54–1) because they contracted Sarto (16 June) to repaint it, which he apparently never did.

On 8 December, Rosso is paid for executing a triumphal arch for the entry into Florence of Pope Leo X (records of the Otto di Pratica). Rosso's ephemeral structure was highly praised by a contemporary.

1516 — Rosso is paid for executing ornamentation and arches at the Porta S. Gallo for the reentry of Pope Leo X.

1517 — Rosso is inscribed in the Arte dei Medici e Speziali (26 February).

An entry in the Servite records (17 August) notes a second commission in the atrium of SS. Annunziata for Rosso to paint a fresco near the entry to the Oratory of S. Sebastian (see fig. 52–3). Rosso was also given a strict ultimatum that if this fresco was not an improvement over his first fresco (*Assumption of the Virgin*), he would not be paid for his work and would have to return money received on account.

In Florence, Rosso is living on the Corso de' Tintori, near S. Croce.

1518 — Leonardo Buonafede orders an altarpiece for the church of Ognissanti, *Madonna and Child Enthroned with Ss. John the Baptist, Anthony Abbot, Stephen, and Benedict.* Apparently, the oil panel was found unacceptable and remained at S. Maria Nuova, where Buonafede was the director of the hospital (Uffizi Gallery, Florence). Final paint layers are missing in critical areas of the panel, which prohibits our understanding the effects Rosso intended.

1521 — Rosso signs and dates his *Descent from the Cross* (some areas appear incomplete). The altarpiece was commissioned for the chapel of the Confraternity of the Holy Cross (an oratory attached to S. Francesco) in Volterra (see fig. 54–2).

Dedicated to the Holy Cross and to the Virgin, the chapel already had frescoes of the Legend of the True Cross (see fig. 33–4) and stories of the Virgin and Christ on its walls. For his composition, Rosso likely studied Perugino's *Deposition* fresco (1517) in Città della Pieve and Jacopo Sansovino's *Deposition* of 1510 (Victoria and Albert Museum, London), a wax model Sansovino created for Perugino. Among the similarities in all these works is the depiction of three ladders.

1522 — For the Dei family chapel in S. Spirito, Rosso signs and dates an oil on panel altarpiece, *Madonna and Child Enthroned with Ten Saints*: RVBEVS FAC. MDXXII (Pitti Palace, Florence). Strips of wood were later added to all sides.

1523 — Rosso completes an altarpiece, *Marriage of the Virgin*, commissioned by Carlo Ginori for S. Lorenzo, Florence.

By 1523 Rosso completes the canvas painting of *Moses and the Daughters of Jethro* (see fig. 54–3), likely the one executed for Giovanni Bandini that Vasari mentioned. Compared with Botticelli's *Moses* (see fig. 37–1), Rosso's narrative is chaotic and filled with violent action, but lacks consistent realism; for instance, truncated limbs spill no blood. The muscular bodies are packed in a tight area, stacked vertically upon each other, and lack adequate space, so that the fist of Moses appears to strike the jaw of a man who should logically be some distance away. In the muscular bodies of the violent combatants, Rosso shows his knowledge of the antique *Belvedere Torso* (see fig. 47–2). The erudite Rosso

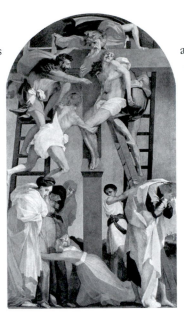

also inserted recognizable motifs from works of respected artists: the striding man with billowing cloth framing his head quotes from Michelangelo's *Deluge* (Sistine Chapel); the fallen men are like Uccello's dead soldiers (*Rout of San Romano*) and Michelangelo's *Battle of Centaurs* marble relief (Casa Buonarroti, Florence) and *Battle of Cascina* cartoon; the stereometric head (in the lower, right-hand corner) is like Signorelli's prone figures in the *End of the World* and *Antichrist* scenes in Orvieto Cathedral.

Late 1523 — Pope Clement VII promises renewed patronage, and Rosso moves to Rome with his assistant, Battistino, where he was to stay until the sack of the city (in 1527). Rosso is awarded a contract (April 26) to paint the chapel of Agnolo Cesi in S. Maria della Pace, Rome. But this commission did not go well. During this period Rosso executed engravings and drawings.

ca. 1526 — Rosso painted the *Dead Christ with Four Angels*, which is stylistically similar to his earlier painting, *Moses Defending the Daughters of Jethro* (see fig. 54–3). In both, some figures emerge from shallow space to frame the main subject, and all attention is focused on Moses and on Christ. However, Christ is noticeably larger than any other figure in the painting, and two angels seem nearly to disappear. Rosso took care to show that near the wound of Christ is the hand of one of the background angels, but the angel's body dissolves into the background so that attention rests solely on Christ and

54–2. ROSSO FIORENTINO. *Descent from the Cross*, 1521, oil on canvas, 11'2.3" x 6'7.1" (341 x 201 cm), Pinacoteca, Volterra. Rosso's portrayal of the theme is based on the tradition of showing the dead Christ being lowered from the cross, attended by his devoted followers (see DEPOSITION, Cinquecento Glossary). In contrast to Duccio's depiction of the Virgin Mary, shown kissing Christ as he is taken from the cross, and Angelico's, shown kneeling (see fig. 26–3), Rosso's Mary swoons, her head fallen onto her chest, her knees starting to buckle. Mary Magdalene, usually depicted clutching the cross, reaches over to support the Virgin. On the other side of the cross, John the Evangelist sobs, his face sinking into his hands. In this sorrowful scene, the greatest physical tension is in the upper part, where exaggerated gestures underscore the tragedy, as twisting and shouting men struggle to maneuver the corpse. Varying from tradition, Rosso fully shows Christ's face, the expression of which is remindful both of his torture on earth and of his triumph over death.

the Eucharistic message. Like Pontormo's *Lamentation* (see fig. 53–1), Rosso's *Pietà* was also created for an altar, and the emphasis, which is on on the nude flesh of Christ's dead body supported by angels, is similar to Pontormo's. Both artists were inspired by Michelangelo's *S. Peter's Pietà*. However, their images of Christ appear more mobile than Michelangelo's stone figure, and theirs are less stable: in Pontormo's, he seems about to change position and slide away, transported by angels. In Rosso's, Christ's foot seems to flex and his fingers seem to uncoil, suggesting that we are witnessing his Resurrection.

1527 — During the Sack of Rome, Rosso is taken captive and ill-treated by the Germans, according to Vasari; and Rosso's name is recorded among the prisoners held for ransom in the palace of Cardinal della Valle. He escaped and fled to Perugia, where he worked for Domenico di Paride Alfani, designing a cartoon, *Adoration of the Magi*. He afterward moved to Sansepolcro, joining the entourage of Lionardo Tornabuoni, who had recently escaped from the chaos in Rome.

1528 — Rosso receives a commission from the Compagnia of the Corpus Domini of Città di Castello to execute an oil painting, the *Resurrection* (with the Three Marys), for the price of 150 ducats. Injured by a roof that falls on him, Rosso returns to Sansepolcro. He later travels to Arezzo and receives a fresco commission to depict the Virgin Mary in the vault of the Madonna delle Lacrime.

1530 — While Florence is under siege, the Aretines attack the Florentine garrison in the Citadel, and Rosso returns to Sansepolcro. He later went to Venice.

1531 — Rosso travels to France, where he is well received.

1532 — Rosso's name first appears in the accounts of the Royal Buildings, where he is given the title Painter in Ordinary to the King (Francis I). Rosso receives a house in Paris, but spends most of his time at the Château de Fontainebleau. During his eight years at the French court, he was granted honors and appointed canon of the Church of the Holy Cross in Jerusalem. Among his assistants at Fontainebleau were Primaticcio and Niccolò dell'Abate.

1540 — Rosso dies of natural causes in France on 14 November.

Vasari erroneously wrote that Rosso died from self-administered poisoning in 1541. In his account, Rosso's suicide resulted from a dispute he had with Francesco Pellegrino, a Florentine guest staying with him in France: Rosso accused Pellegrino of stealing money and had him arrested and tortured. Steadfastly professing his innocence, Francesco was eventually released. Unable to prove the truth of his accusations when Francesco sued him for libel, Rosso killed himself by swallowing poison. Vasari contended that Rosso preferred ending his own life to suffering the humiliation and punishment that awaited him for bringing false charges against an innocent man. Like Leonardo, Rosso's body was buried in France, and unlike Michelangelo's, it was never shipped back to Florence.

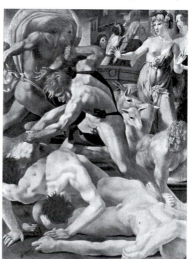

54–3. ROSSO FIORENTINO. *Moses Defending the Daughters of Jethro*, ca. 1523, oil on canvas, 5'3" x 3'10.5" (160 x 117 cm), Uffizi Gallery, Florence. Similar to the *Assumption* (see fig. 54–1), this painting focuses on human action, with minimal references to a location. It also exhibits what are considered Mannerist traits. The battling protagonists create a sense of constant flux although most figures are frozen in place. A woman, whose dress exposes her torso, raises both arms to ward off the enemy, but shows no fear on her face. The knowledgeable, well-read patrons of Rosso would have enjoyed his artifice and puzzling through the mysteries of his intriguing Moses scene. To whom, for instance, does the long arm in the foreground that runs parallel to the picture plane belong? In Botticelli's painting (see fig. 37–1), the daughters shown at the well are limited to two women, but Rosso shows five women, four of whom are fleeing in panic. The one who stays may be Moses' future wife, Zipporah.

Giulio Romano

Raphael's brightest pupil, Giulio Romano (ca. 1499–1546), was a painter, architect, and draftsman of considerable merit. His broad fame came partly from his connection to Raphael, but also because of his inventive versatility with antique forms. After Raphael's early death, Giulio completed several of Raphael's unfinished works, the most significant, the fresco cycle in the Stanza di Constantino, Vatican Palace. In the 11 years he served Raphael, first as his apprentice and then as his assistant, Giulio became familiar with Raphael's style and business practices. Like his master, he would record his ideas in many preliminary drawings and give the final designs to his students to carry out. Running his workshop in the manner of Raphael's, Giulio had his assistants create paintings while he supervised their work and applied the final touches. Leaving Rome about 1524, he gained a steadfast secular patron in Federico II Gonzaga (Isabella d'Este's son), who was crowned the first duke of Mantua in 1530. Giulio remained his court artist for about 16 years, until Federico's death (1540); they were approximately the same age, and their first contact had likely been in the Vatican, where the young Giulio was Raphael's apprentice and

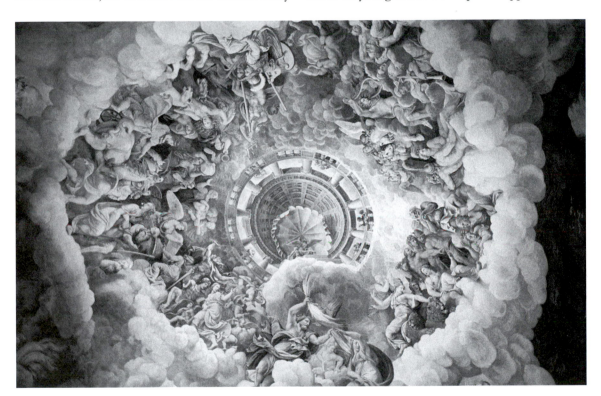

55–1. GIULIO ROMANO. *Battle of the Gods*, 1531–33, Room of the Giants, Palazzo Te, Mantua. This room is a fictive marvel, meant to be emotionally and intellectually stimulating, and Giulio's illusionism surprises, shocks, and amuses. Its dizzying effect is best understood when standing in the dead center of the room and looking upward. At the peak of the ceiling is Jupiter's throne on Mount Olympus, which is empty but for the eagle perched there: its fully outstretched wings allude to the forthcoming triumph of the Olympians. Thunderbolt-wielding Jupiter, king of the gods, is larger than anyone else in this cloudy sky. His anger and vengeful retaliation galvanizes the other gods, who gather to watch as he crushes the rebellious Titans—a bedraggled horde of unseemly brutes pictured on the walls (not shown here). It is impossible for visitors in this room to get away from them. Pelted and crushed by the tempest Jupiter conjures up, they seem already beaten senseless and far too near to our space. Acoustically, speech sounds are garbled in this room, thus heightening the sense of chaotic confusion the imagery produces.

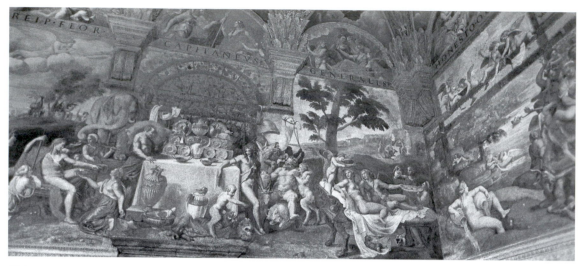

55–2. GIULIO ROMANO. *Banquet of Cupid and Psyche* (west wall) and partial view of the *Wedding Feast of Cupid and Psyche*, 1526–28, Room of Psyche, Palazzo Te, Mantua. Emperor Charles V dined in this banquet room. Adorning the walls are love adventures of the gods, with the story of Psyche above two entrances into the room and on the ceiling (the illusionism and *di sotto in sù* views are in the manner of Mantegna's ceiling in the Camera Picta in the town palace [see figs. 40–1, 40–4]). Providing added luxury to the room were Jacopo Sansovino's statue of *Venus* and a red leather panel with gilded columns. Shown in the jubilant banquet mural above are various gods: Apollo is seated (left of the table), Bacchus stands (right side of the table), drunken Silenus sits on a goat (propped up by a satyr), and Cupid and Psyche recline on the couch (between them is their future child, Voluptuousness), while Ceres pours water on Cupid's hand (sign of fertility) and Juno (goddess of childbirth) holds the basin.

Federico was a hostage of Julius (see Cinquecento History Notes 1510 and fig. V–2). Most notable of Giulio's Mantuan works are the architecture and the mural decoration of Palazzo Te, both exemplary of his style of Mannerism (see figs. 47–10, 55–1, 55–2).

ca. 1499 — Giulio Pippi is born in Rome, the son of a businessman. By 1509, Giulio was working as a young apprentice to Raphael in the Vatican Palace.

1516 — Raphael's *Coronation of the Virgin* (long overdue) is renegotiated; the painting was finished in 1525: Giulio is credited with the upper half and his partner, Penni, the lower (Pinacoteca Vaticana).

1517 — Giulio is responsible for the dado decoration in the Stanza dell'Incendio, Vatican Palace.

1518 — Giulio and other assistants of Raphael are paid (also in 1519) for work on the Vatican Loggia (see Raphael 1519). Giulio also executes the portrait of *Joanna of Aragon* (Louvre, Paris) under Raphael's signature; according to Vasari (*Lives*), Pope Leo X commissioned it as a gift for the King of France.

1520 — The inheritor of Raphael's shop, Giulio is selected (over Sebastiano del Piombo) to finish the Stanza di Constantino, Vatican (Raphael had barely begun work here before his death); Giulio creates grand, inventive frescoes (finished 1524). He also works on Villa Madama (see Cinquecento History Notes).

1524 — Coaxed to Mantua by Baldassare Castiglione, Federico's ambassador, Giulio is granted a house, citizenship, and special privileges and becomes supervisor of all Mantuan buildings. His responsibilities as Federico's court artist were broad and various, but his masterwork was the Palazzo Te, a retreat for Federico and mistress Isabella Boschetti.

1531 — Federico (now a duke) marries Maria Palaeologo, the choice of his mother, Isabella (d. 1539).

1544 — Giulio completes his house (Casa Pippi). Redesigning a building he bought in 1538, he places his studio on the ground level and living quarters above, painting frescoes of antique themes in the salon.

1546 — Giulio dies in Mantua.

Considered the Leonardo of Venice, and a painter as well as a musician, Giorgione (1477–1510) had a very brief career and died while still a young man. Far more enigmatic than Leonardo, his life has been romanticized and his art periodically reassessed (a couple of seminal paintings are thought to show the hand of Titian—*Sleeping Venus* and *Pastoral Scene*). Giorgione was the first Venetian to practice in the modern style, according to Vasari, who while praising Giovanni Bellini's art also thought that it represented an older tradition. Still, little firsthand information about Giorgione or his work is recorded, and Marcantonio Michiel's (ca. 1484–1552) listing of four works by him (*Boy with an Arrow*, *Three Philosophers*, *Tempest*, *Sleeping Venus*) is generally the nucleus on which a hypothetical oeuvre for Giorgione is based.

1477 — Giorgio (Zorzi in Venetian dialect) is born in Castelfranco, according to Vasari (*Lives*); he was first called Giorgione (big George) in 1548 by Paolo Pino.

ca. 1498 — Giorgione paints the large altarpiece for the Castelfranco Duomo. His main inspiration was Giovanni Bellini's images of the enthroned Madonna and Child (i.e., *S. Giobbe Altarpiece*).

ca. 1505/6 — Giorgione paints *Three Philosophers* (see fig. 56–1). Also among his most famous works created about this time is the *Tempest* (Accademia, Venice). It seems foremost to be a pictorial parallel to the *poesia* (pastoral poem) in contemporary Italian poetry concerning images of ARCADIA, or a Golden Age (see Cinquecento Glossary), as it shows the nuanced dynamism of nature. Giorgione's sensual painting does not describe a particular theme, event, or person (infrared reflectograms show that the standing male replaced a nude female figure), but is instead mostly about the

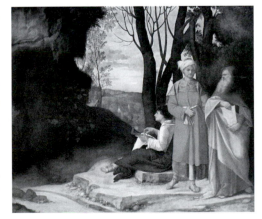

landscape, portraying the perpetual flux that exists in nature (storm clouds move across the sky, a lightning bolt appears in the distance, and a soundlessness permeates the foreground, where a nursing, almost naked woman stares at onlookers). Michiel noted that this painting was in Gabriel Vendramin's house in 1530. A wealthy patrician, Vendramin was an avid collector of classical art and literature.

ca. 1506 — About this time Giorgione created *Boy with an Arrow* (Kunsthistorisches Museum, Vienna), a work listed by Michiel, who saw two versions of it: one in the house of a Spanish merchant (Giovanni Ram), the other in that of Antonio Pasqualigo.

1506 — Giorgione paints the portrait called *Laura*, with the date of the painting based on the inscrip-

56–1. GIORGIONE. *Three Philosophers*, ca. 1505, canvas, 4'.7" x 4'8.9" (123.5 x 144.5 cm), Kunsthistorisches Museum, Vienna. Marcantonio Michiel saw the painting in M. Taddeo Contarini's house in 1525, and thought it depicted three philosophers contemplating the sun's rays; he identified it as a work of Giorgio da Castelfranco, finished by Sebastiano Veneziano (del Piombo). The theme is debated (argued as the Magi, Ages of Man, Mathematicians, Philosophers). The young man (who once had a headdress) is thought to be a portrait, but his identity is uncertain. The painting has been cut down on the left side (eliminating part of the cave), and infrared reflectograms and X-radiographs show that changes to the design were made, as was the custom of Giorgione. Originally, the old man was shown in profile, wearing a diadem with rays of light on his head, but even without the shining diadem he looks like Bellini's saints. The landscape and mood also seem inspired by the works of Bellini. However, Giorgione became a master of sensual and intimate scenes, and as such he influenced the facile, older artist (see figs. 44–2, 44–3).

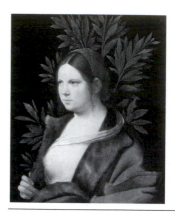
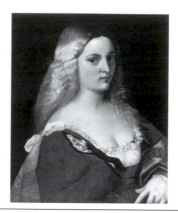
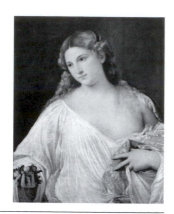

tion on the backside (see fig. 56–2). The painting was executed on canvas glued to wood (original support). In the early–18th c. the work was cut down into an oval format; later in the same century it was fashioned into a rectangular format (ten pieces of oak were added). It is uncertain how much of the original painting is lost, but the fingers of the woman's right hand were eliminated when the work was trimmed. Giorgione's *Laura* provided a portrait type for allegorical figures and images of future brides and Venetian courtesans (see fig. 56–3). Portraits of women by Palma Vecchio (ca. 1480–1528) also owed a debt to his greatest rival, Titian (see fig. 56–4).

1508 — Giorgione paints frescoes (now fragments) on the facade of the Fondaco dei Tedeschi (the German Exchange building), near the Rialto. By this year he has assistants working for him. Titian is also recorded working here (see Titian 1508).

ca. 1510 — Giorgione paints *Pastoral Concert*, or *Fête champêtre* (see fig. 57–4). He also paints *Sleeping Venus* (Gemäldegalerie, Dresden), about which Michiel wrote that Titian finished the landscape and a cupid (painted out in 1525). In the original design the cupid held an arrow and was sitting beside the feet of Venus, which would have provided a mythological context for the scene.

1510 — Giorgione dies of the plague in Venice. Isabella d'Este, eager to own a work by him, writes to her Venetian agent (10 October) for the purpose of acquiring a highly praised night scene, a Nativity, from the estate of the late Giorgione. (She was to learn that there were two versions in existence, both already in the hands of collectors.)

56–2 (left). GIORGIONE, *Laura*, 1506, canvas attached to panel, 16.1" x 13.3" (41 x 33.6 cm), Kunsthistorisches Museum, Vienna. Giorgione's painting of *Laura* was re-backed and the inscription on the reverse, although not original, was likely copied from the original: 1506 *adj. primo zugno fo fatto questo de man de maistro zorzi da chastel fr[ancho] cholega de maistro vizenzo chaena ad instanzia de misser giacomo* (on 1 June 1506 this was made by the hand of Giorgio of Castelfranco, colleague of Vicenzo Catena, on the instructions of Master Giacomo). The woman is unidentified, but behind her are laurel leaves (perhaps suggesting her name), after which the work gets its title. The wealth of laurel (infrared reflectograms and X-radiographs show that Giorgione originally had fewer sprigs) gives her the appearance of an allegorical *impresa* on a medal, without the inclusion of the motto (see IMPRESA, Cinquecento Glossary). Clothed in an expensive red fur coat, and with one breast exposed (a thin gown originally covered her chest), she may well be Giorgione's unique interpretation of Abundance.

56–3 (middle). Jacopo Palma Vecchio, *Portrait of a Woman (Violante)*, ca. 1515, oil on panel, 25.4" x 20" (64.5 x 50.8 cm), Kunsthistorisches Museum, Vienna. The modern nickname *(Violante)* derives from the two violets in the woman's bodice, perhaps a clue to her identity. In ancient myths violets were associated with lovers (in Christian imagery, with the virtue humility). Her provocative gaze (compared to Titian's quietly seductive Flora) has led to the thought that she is a courtesan.

56–4 (right). Titian, *Flora*, ca. 1520, oil on canvas, 31.1" x 27.9" (79 x 63 cm), Uffizi Gallery, Florence. Offering a spray of spring flowers, the woman has been nicknamed Flora, after the ancient goddess of flowers. Among the stories of Flora is that of Ovid (*Fasti*), with the nymph Chloris marrying Zephyrus and becoming Flora. In another tale, a courtesan named Flora gave her fortune to the Roman people; the Senate declared her a goddess and named the games Floralia after her. The painting is perhaps an allegory of marriage, spring, and sensual love.

Prince of painters, and perhaps the greatest Cinquecento portraitist, Titian (ca. 1490–1576) was awarded honors far beyond what most of his fellow artists could even contemplate. Two factors appreciably benefited him: having the position as official painter of Venice while enjoying the patronage of Italian and international courts (imperial and Spanish), and having a very long and productive career, like that of Bellini and Michelangelo. However, Titian was worldly and social and aspired to live as a noble. Vasari thought he studied with Bellini and Giorgione. While this may not be true, before Bellini's death Titian had already shown mastery of the old artist's translucent colored light and emotive landscapes. And Giorgione's female nudes provided an impetus for Titian's long series of sensual mythologies, made even more visually seductive by Titian's dynamic interweaving of thick and thin paint applications, with surfaces highly tactile and textural in his late art. His practice of revisiting paintings after a considerable time passed suggests a constant study and sensitivity to theme and process. During his lifetime he earned an enormously widespread fame. In the 17TH century, he became the ideal artist for Peter Paul Rubens and Diego Velázquez, both of whom were knighted and worked for Spanish royalty,

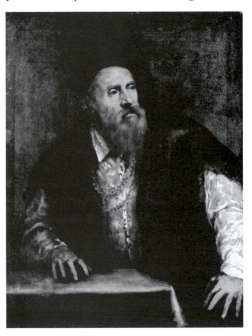

and Caravaggio, Poussin, and Rembrandt closely studied his style.

ca. 1490 — Tiziano Vecellio is born in Pieve di Cadore in the Dolomites to Lucia and Gregorio di Conte dei Vecelli. His relatives were chiefly soldiers and lawyers. Titian's nephew, Cesare Vecellio, became a writer (see Vittore Carpaccio 1479).

1508 — Titian works on frescoes for the facade of the Fondaco dei Tedeschi (see fig. 65–2, #7), a new building that replaced the former commercial warehouse of the Germans (burned to the ground in 1505). In this year Giorgione requests an evaluation of the payment for his Fondaco frescoes (see Giorgione 1508); Giovanni Bellini nominated members of the evaluating committee.

1511 — Titian paints three frescoes in the Scuola del Santo, Padua. Sebastiano (del Piombo), perhaps Titian's most serious rival at this time, leaves Venice to work for Sienese banker Agostino Chigi in Rome.

1513 — The cardinal-humanist Pietro Bembo invites Titian to Rome to work at the papal court of Leo x. Titian instead stays in Venice, where he offers his services to the state, requesting the office of *Senseria* of the Fondaco dei

57–1. TITIAN. *Self-Portrait*, ca. 1550, oil on canvas, 38" x 29.5" (96 x 75 cm), Staatliche Museen, Berlin. Rather than a marble ledge in the foreground, in the manner of an earlier self-portrait (National Gallery of Art, Washington, D.C.), the great portraitist Titian sits here at a small table, allowing onlookers to more fully see his left side. His intense focus and strong, undercut jaw denote Titian's particular features, and both areas appear more finished than the fingers, rendered as they are in a way that makes them seem to twitch. His status as Count Palatine is shown by his necklace and expensive garments; yet his silks and furs seem equally to express his social position and skill as a painter, and both distinguish him from the ordinary artisan. Similar to other works, Titian returned to this canvas several times, honing areas that emphasize his active intellect and perceptive skills.

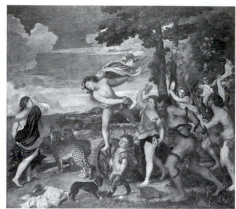

57–2. TITIAN. *Bacchus and Ariadne*, ca. 1523, canvas, Prado, Madrid. Titian may have worked very hard to receive his first painting contract for the *camerino* of Duke Alfonso d'Este of Ferrara (see entry 1516 and 1519). Bellini had been awarded the first *camerino* painting, his *Feast of the Gods* (see fig. 44–3), and it seems that Alfonso did not at that time have Titian foremost in his mind when he continued to commission artists. Instead, he wanted the Urbinite Raphael and Florentine Fra Bartolommeo to create paintings for him. Perhaps through Titian's insistence (he must also have pleased the duke with his work for him in 1516), he was hired to paint the *Worship of Venus* (see entry 1519). The painting here of Bacchus is the third work he created for the *camerino*, and with this one, the best of his *camerino* works, his mastery is evident. About the only thing remotely quiet in this painting are the two cheetahs who pull the chariot of Bacchus. Part of his enormous contribution to the depiction of mythologies is the throbbing life he infused in his characters.

Tedeschi (sinecure of the office of broker, which went with the position as official state painter). He has a workshop in the San Samuele area (see fig. 65–2, #8).

1514 — Titian paints *Sacred and Profane Love* (Borghese, Rome) for the marriage of Nicolò Aurelio, vice-chancellor of the republic, and Laura Bagarotto.

1516 — Titian is in Ferrara, where he creates a (lost) work for Duke Alfonso.

1517 — Titian is awarded the Senseria (see entry 1513), replacing Giovanni Bellini as the official painter of Venice.

1518 — Titian's *Assunta* (ordered in 1516) is finished for the Frari, Venice. He is at work on mythologies for Alfonso I d'Este's *camerino* in Ferrara; Bellini earlier painted *Feast of the Gods* for him (see fig. 44–3). Titian corresponds about the *invenzione* assigned to him with the humanist advisor Mario Equicola, who was attached to the court of Isabella d'Este at Mantua, and composed *invenzioni* for Alfonso's *camerino*. Equicola's *invenzioni* were based on the text *Imagines* by the Greek author Philostratus, which describes paintings of mythological subjects that the author had either imagined or seen in a villa.

1519 — In Ferrara Titian delivers *Worship of Venus* (Prado, Madrid), which he com-

pletes there, for Duke Alfonso d'Este's *camerino*. His design was apparently to be based on a drawing Fra Bartolommeo had done; however, Titian's painting shows a far more riotous and mischievous gathering of baby Loves. For this work, it seems that Titian had written instructions from the humanist Marco Equicola.

In this year he is commissioned to create the *Pesaro Altarpiece* (finished 1526) in S. Maria Gloriosa dei Frari, Venice. In the giant columns he created for Mary's heavenly court, Titian's work shows that he considered how worshippers could relate his pictorial setting to the actual architecture of the Frari, which has similar broad columns (X-radiographs show that he made several adjustments before he reached the final solution). The asymmetrical arrangement of the Madonna and Child on the steps enlivens the imagery and makes them seem more actively a part of devotional worship.

1520 — Titian makes a trip to Ferrara. He is also working in the Doge's Palace in Venice (see 1522).

1521 — Titian paints *Judgment of Solomon* for the Loggia del Capitanio, Vicenza.

1522 — The Council of Ten orders Titian to paint Bellini's (unfinished) *Humiliation of Emperor Frederick Barbarossa* for the Doge's Palace, to be finished by the following year (1523).

1523 — Titian delivers two works to Alfonso d'Este in Ferrara, *Bacchanal of the Andrians* and *Bacchus and Ariadne* (both Prado, Madrid), where he installed the works in his *camerino* (see fig. 57–2). Titian's textual sources for Bacchus and Ariadne were Ovid and Catullus.

1525 — Titian marries Cecilia, the

daughter of a barber from Cadore and the mother of his two sons.

1528 — Titian is in Ferrara.

1529 — Titian is in Mantua, where he paints the portrait of Federico Gonzaga (Prado, Madrid), the son of Isabella d'Este (Giulio Romano was then the court artist in Mantua).

Titian meets Emperor Charles V at Parma and would afterward create many works for him.

Michelangelo is in Venice for a short visit (September to October).

1530 — In this year a daughter is born (dies in 1561), and his wife dies.

Titian completes *Death of S. Peter Martyr* (begun 1526) for the Dominican church of Ss. Giovanni e Paolo, Venice.

1531 — Titian creates works for Duke Federico Gonzaga of Mantua (see entry 1536).

In Venice, Titian moves to the parish of San Canciano in the Cannaregio district (the painter Jacopo Bassano also lived in this parish). Titian would reside here in the same house for the rest of his life.

1533 — In Bologna, Emperor Charles V bestows knighthood of the Golden Spur on Titian, who turns down the emperor's offer to move to Spain.

1536 — Titian begins portraits of Duke Francesco delle Rovere of Urbino and his wife, Eleonora Gonzaga (daughter of Isabella d'Este).

Titian paints 11 portraits of Roman emperors for the Palazzo Ducale in Mantua (Giulio Romano solicited his help in carrying out the decoration of the Room of the Caesars). Correspondence between Duke Federico Gonzaga and Titian concerning the project attests to the esteem Titian enjoyed with the Mantuan court.

1538 — Titian paints *Venus of Urbino* (Uffizi Gallery, Florence), bought for the duke of Urbino, Francesco della Rovere.

In this year Titian finishes a large canvas (begun 1513; destroyed in the fire of 1577), *Battle at Cadore*, for the Great Council Hall, Doge's Palace. His *Senseria* is revoked, but reinstated in 1539.

1545 — In Rome, as the guest of Alessandro Farnese (nephew of Pope Paul III), Titian becomes an honorary citizen of Rome in 1546. He returns to his home in Venice in this year.

1547 — Titian is at the imperial court in Augsburg. In 1548, Philip (Charles' son) would call him to Milan.

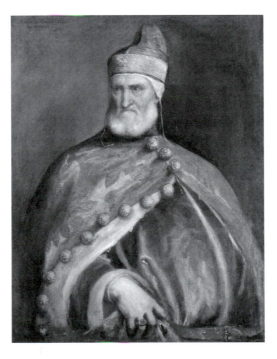

57–3. TITIAN.
Doge Andrea Gritti, 1544–45, canvas, 52.7" x 40.7" (133.6 x 103.2 cm), National Gallery of Art, Washington, D.C. So different from Giovanni Bellini's serene portrait of Doge Loredan (see fig. 44–1), Titian's Doge Andrea Gritti (1455–1538) seems fiercely alive and not to be crossed. Ironically, he had died some years before Titian painted this portrait of him (the years of his dogeship were 1522–38). Both a merchant and military general, and a noble by birth, Gritti fought successfully against the League of Cambrai to retrieve the town of Padua (see Venetian Monuments 1509). Titian pictured him as a man of purpose, an old soldier whose round belly has popped the buttons free from their fasteners. His years of military experience are evident here (captured in 1512 and taken prisoner to France for a year, he soon returned to the battlefield on both land and sea). Venice relied on his defense plans to secure the *terraferma*. Yet, as a doge, he had little time for all the protocol a dogeship demands, which Titian shows in his portrait of the sanguine hero.

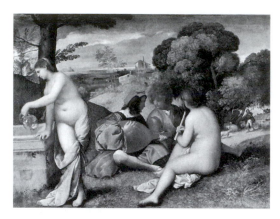

1550 — Titian is summoned to Augsburg and is back in Venice in 1551, where he is inducted into the Scuola Grande di S. Rocco.

1556 — In Venice, Titian begins two works for Philip II, now his primary patron, *Diana and Actaeon* and *Diana and Callisto*, sent to Spain in 1559 (see figs. 57–5, 57–7). These are among his most dramatic mythologies. Titian's *Death of Actaeon* (National Gallery, London), about which he wrote to Philip, was left unfinished. Titian's correspondence with Philip shows that the paintings were not commissioned by Philip and that through Titian's descriptions of them the artist secured Philip's desire to own the works.

1559 — Completing the *Rape of Europa* (Isabella Stewart Gardner, Boston), Titian writes to Philip II about sending it to him, but delayed this until 1562.

1564 — Titian is contracted to create paintings for the town hall of Brescia.

1566 — Titian requests the copyright to the prints of his work by Cornelius Cort. In Venice, Vasari consults with Titian about the works of his fellow artists for his new edition of the *Lives*. Titian, Palladio, and Tintoretto are inducted into the Florentine Accademia delle Arti del Disegno.

1569 — Titian requests the *Senseria* for son Orazio.

1571 — He sends a letter to Philip II, claiming to be 95 years old. Among his most emotionally provocative paintings are those of the 1570s including *Flaying of Marsyas* (National Gallery, Kreimsier) and *Nymph with a Shepherd* (Kunsthistorisches, Vienna).

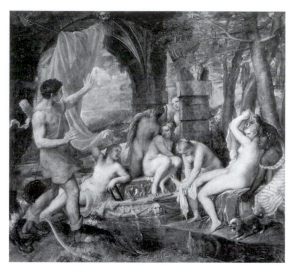

ca. 1575 — Titian begins the *Pietà* for his tomb (Accademia, Venice); left unfinished at his death, it was inherited by his student Palma Giovane (ca. 1548-1628), great-nephew of Palma Vecchio.

1576 — Titian and his son Orazio die of the plague in Venice (27 August); his house is ransacked. His estate is inherited by his only living child, Pomponio.

57–4 (left). TITIAN. *Pastoral Concert*, ca. 1510, canvas, 3'7.3" x 4'6.4" (110 x 138 cm), Louvre, Paris. (Infrared studies indicate changes to the position of the standing female, shape of the fountain, size of the lute, and face of the musician.) Traditionally attributed to Giorgione, the work is now often attributed instead to Titian (the poses and sensuality of the female nudes resemble the mythological figures of his later paintings, see fig. 57–5). The patron is unknown, but the multicolored hose of the musician suggests a reference to the Companies of the Hose (Compagnie della Calza), social fraternities of young Venetian nobles. Bucolic and peaceful (see ARCADIA, Cinquecento Glossary), the scene has an allegorical meaning, and is commonly thought to be linked to music and pastoral poetry of antiquity and the Renaissance.

57–5 (right). TITIAN. *Diana and Actaeon*, 1559, canvas, 6'3.3" x 6'9.5" (190.3 x 207 cm), National Gallery of Scotland, Edinburgh (on loan from the Duke of Sutherland Collection). Both this painting and *Pastoral Concert* (see fig. 57–4) are pictorial poetry (*poesie*), with the harmony of an arcadian paradise upset here when the unfortunate Actaeon stumbles into the private domain of Diana and her virgin nymphs, who are bathing. For his blunder, she'll soon splash water on him, turning him into a stag that his own dogs will kill.

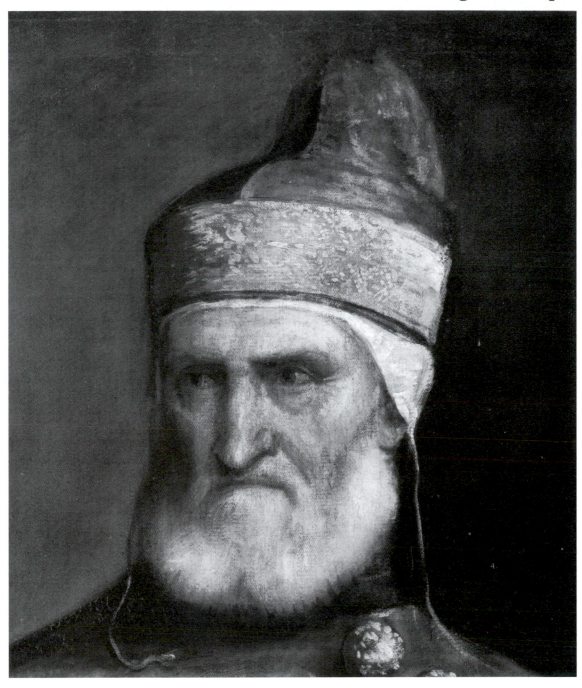

While Italian painters created oil paintings centuries before the time of Titian, the full potential of oil technique was not realized until his lifetime. In the 12th century, the monk Theophilus described how to make linseed oil (*De diversis artibus*); two centuries later, Cennino Cennini gave artists instructions for painting in oil on different surfaces, such as stone and metal, citing as his sources German

57–6. TITIAN.
Doge Andrea Gritti (detail of fig. 57–3), 1544–45, oil on canvas.

Oil Painting Technique

artists (*Il libro dell'arte*, ca. 1390). Nevertheless, oil painting did not become the primary technique of some Italian painters until the late–15TH century, and it was in Venice that it most quickly gained favor.

In his life of the Sicilian painter Antonello da Messina (ca. 1430–79), Vasari wrote that Johann of Bruges (Jan van Eyck) invented oil painting (he later credited Jan's brother, Hubert, with the discovery), which came about in his search to find a varnish that would allow paintings to dry in shade rather than in hot sun. According to Vasari, Jan found the perfect varnish by combining linseed and nut oils, a discovery that led him to mix his pigments with a combination of different oils, thereby achieving richly brilliant colors that needed no varnish; furthermore, he found that oil colors could be blended more smoothly than tempera colors. Jan's work so impressed Antonello that he went to Bruges to learn the secrets of the Flemish master; upon his return to Italy, he introduced oil technique to Venetian painters (he is recorded in Venice in 1475–76). Vasari's account may not be reliable, but after 1475 Giovanni Bellini increased his use of oils, enhancing the sense of illusionism and dewy atmosphere in his paintings. Giovanni's early works show his interest in describing specific times of day, but his late oil paintings more tangibly portray atmospheric effects of certain hours, such as dusk and dawn, with long shadows and strong golden light suggesting the day's end and soft pastel-streaked skies showing daybreak

(see fig. 44–3). Oil dries more slowly than tempera and is far more malleable, which suited Titian, who created fewer drawings than did Raphael and Michelangelo and reworked his ideas directly on his canvases (which is not done in tempera technique). Titian learned secrets of oil technique from Giorgione and Bellini, but more aggressively exploited its expressive qualities (see figs. 57–5, 57–7). Among the first impressionist painters, Titian described in his works the effects of light striking reflective objects, painting them with irregular patches of thick color (impasto, like paste) combined with transparent and semitransparent applications of color (glazes). Gritti's costume thus appears different if viewed from a distance rather than at close range: from a distance the dabs of thick impasto and glazing fuse into shiny, volumetric buttons on Gritti's chest and form a glittering brocaded silk band around his *corno* (cap) (see fig. 57–6).

In 16TH–c. Venice, canvas replaced wood as the preferred support for oil paintings, a logical choice in maritime Venice because of the large production of canvas sails for ships. For central Italian artists, the distinction between creating a painting on wood or on canvas made little difference to the appearance of the painting's surface, which was always made uniformly smooth, in the manner of creating a work in tempera technique. Giorgione and Titian, and especially Jacopo Tintoretto (1519–94), sought instead to create paintings with textured, relief-like surfaces, an effect achieved in previous centuries by the use of PASTIGLIA. Different also from tempera technique, Titian allowed the weave of his canvas to show through (seen in areas of Gritti's face) and left brushstrokes unblended. His brushes were larger than the tiny ones used by tempera painters, and his application and working of the paint sometimes involved a flat edge as well as his fingers or palms.

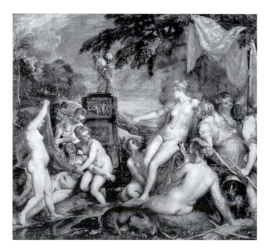

57–7. TITIAN. *Diana and Callisto*, 1559, oil on canvas, 6'1.7" x 6'8.8" (187 x 205 cm), National Gallery of Scotland, Edinburgh (on loan from the Duke of Sutherland Collection). This companion piece to *Diana and Actaeon* (see fig. 57–5) was designed to be placed to the right of that painting.

Leaving Fontainebleau in 1545, where he had been in the service of King Francis I of France for five years, the hot-tempered and abrasive goldsmith-sculptor Benvenuto Cellini (1500–71) returned to his native Florence. There he attracted the attention of young Duke Cosimo I de' Medici. Unfortunately for Cellini, Cosimo would often favor the art of Bandinelli, Tribolo, and Ammanati over his labor-intensive works, perhaps because Cellini was a troublesome and violent man. To his credit, he was a consummate draftsman searching for perfection. He believed that the study of life models was superior to studying ancient statues, plaster casts, or the designs of other artists. The great passion of his career was undoubtedly bronze. In Florence he produced two masterworks, *Perseus and Medusa* (see fig. 58–1) and the bust of *Cosimo I de' Medici* (see fig. 58–4). His autobiography boasts that his casting technique was superior to Ghiberti's and Donatello's. Written about 1558–62 (not published until 1728), his *Life* is now better known than the sum of his art works. Livelier than Vasari's biographies, it is a chatty, lurid account of his life and art that provides insights about his patrons and the culture of his day.

1500 — Benvenuto is born in Florence, the third child of Elisabetta Granacci and the musician and artisan Giovanni Cellini.

1504 — In Florence, Cellini's father is on the committee to decide where to install Michelangelo's marble *David*.

1513 — Cellini is in the goldsmith shop of Michelangelo Bandini (1459–1528), the father of Bac-

58–1. BENVENUTO CELLINI. *Perseus and Medusa*, 1545–54, bronze, statue h. 10'6" (320 cm), base h. 6'6.4" (199 cm), Loggia dei Lanzi, Florence. Cellini signed the strap that crosses over the chest of Perseus: BENVENVTVS CELLINVS CIVIS FLOR. / FACIEBAT MDLIII. (The statue was formally unveiled 27 April 1554.) Standing victorious over the contorted corpse of Medusa is Jupiter's son Perseus, holding a sword and the Gorgon's severed head, which issues bloody streams that writhe like serpents. The figures portrayed by bronze statuettes on the pedestal are identifiable by their attributes and the inscriptions (composed by Benedetto Varchi): beneath Jupiter (front) is TE FILI SI QVIS / LAESERIT VLTOR / ERO (If anyone harms thee my son, I will avenge them); beneath Minerva (right) is QVO VINCAS / CLYPEVM DO TIBI / CASTA SOROR (I, thy chaste sister, give thee the shield with which thou wilt conquer); beneath Mercury (back) is FRIS VT ARMA / GERAS NVDVS AD / ASTRA VOLO (That thou shalt bear thy brother's arms I fly naked to the heavens); beneath little Perseus and Danäe (left) is TVTA IOVE AC / TANTO PIGNORE / LAETA FVGOR (With Jove's protection and with such a pledge I go happily into exile). Two statuettes (*Mercury* and *Danäe*) were cast in 1552 and the other two (*Jupiter* and *Minerva*) in 1553, along with the wings of the helmet and the shallow relief attached to the loggia parapet. It portrays an event following the slaying of Medusa: Perseus saving Andromeda from the dragon. Andromeda has been chained by her parents to rocks at the seashore, the next sacrificial victim of the sea monster (her parents and townspeople are on the right). The distressed Andromeda lifts her arm over her head, and turns away from where Perseus appears in the sky. With his sword raised, he swoops down to slay the beast. In the niche above, Jupiter raises thunderbolts over his head, his gesture similar to Andromeda's (for information on the theme, see entry 1545).

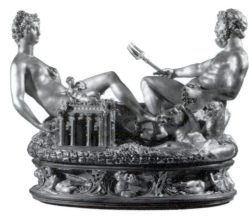

58–2. BENVENUTO CEL-
LINI. *Saltcellar of Francis
I*, 1541–43, gold, enamel,
and ebony, 10.3 x 13.1"
(26 x 33.3 cm),
Kunsthistorisches
Museum, Vienna. A
design for the saltcellar
was begun for Cardinal
Ippolito d'Este in 1540.
(Ippolito was the son
of Lucrezia Borgia
and Duke Alfonso I of
Ferrara. Alfonso had
commissioned works
for his *studiolo* from
the Venetian painters
Giovanni Bellini and
Titian and his court
painter Dosso Dossi.)
The commission for
Cellini's saltcellar was
taken over by King
Francis I when Cellini
went to France. The
gold table sculpture
was later a gift of King
Charles IX (grandson
of Francis I and son of
Queen Catherine de'
Medici of France) to
Archduke Ferdinand of
Tyrol. Ferdinand had
been the 20-year-old
Charles' proxy at his
wedding to Archduch-
ess Elisabeth in 1570.

cio Bandinelli (who
changed his name
from Bandini).

1516 — Due to a brawl,
Cellini is forced to leave
Florence. He moved
first to Siena, where he
worked for the gold-
smith Francesco Cas-
toro, and then to Bologna
and Pisa to study goldsmithing.

1519 — Cellini is in Rome, where he
works as a goldsmith, creating intricately
designed medals and jewels (most have
since perished).

1527 — During the Sack of Rome, he
helps defend the Castel S. Angelo from
imperial troops, killing the constable of
Bourbon and prince of Orange, accord-
ing to his *Life*. For Clement VII, he ex-
tracted jewels from the papal treasury so
that he could melt the gold for coinage.
He travels to Mantua and Florence.

1529 — Summoned by Clement VII,
Cellini is hired to create a (lost) jeweled
morse (brooch), with the second largest
diamond in the world (previously in Julius
II's morse that Clement melted down in
1527). For killing the man who murdered
his brother, he was pardoned by Clement,
who appointed him head of the papal
Mint. He held the position until 1534 (as
incisore, he made designs and stamps for
coinage), when he was removed for not
completing papal commissions.

1532 — After assaulting a broker in
Rome, Cellini flees to Naples.

1534 — Cellini flees Rome after killing
a Lombard goldsmith. He went to Flor-
ence to work for Alessandro de' Medici,
but first went to Venice with the sculptor
Tribolo, who sought work there.

1535 — In Rome, Cellini works for Pope
Paul III and makes medals for Duke
Alessandro de' Medici in Florence.

1538 — Paul III (on the instigation of his
natural son Pierluigi) has Cellini impris-
oned in the Castel S. Angelo for stealing
(unfounded) papal jewels entrusted to
him during the Sack. Pierluigi's wife
pleaded for Cellini, and Cardinal Ip-
polito d'Este secured his release in 1539.

1540 — In France, Cellini is employed
by Francis I (d. 1547), receiving 700 scudi
annually plus payment for his works. In
Paris, he would create a (lost) life-size
silver statue of Jupiter for Francis; 11 other
gods were contracted (never finished).

1542 — For the main entrance to Francis
I's palace at Fontainebleau, Cellini is told
to design a lunette above the doorway
depicting the genius of Fontainebleau;
the sculpture was destined for the portal
created by Gilles Le Breton (finished
1538). All that now remains of Cellini's
portal decoration, however, is the bronze
lunette relief *Nymph of Fontainebleau*.
The composition alludes to the legend in
which a hunting dog named Bleu discov-
ers the nymph of a spring in the forest.
Shown reclining in full-length across the
width of the lunette, the monumental
female nude resembles an ancient Ro-
man river god (see fig. 58–3). Embrac-
ing a large stag, an emblem of the king,
she has around her fawns, wild boars,
hunting dogs, and gushing spring water,
referring to the forest of Fontainebleau,
where Francis hunted. Cellini wrote of
his preference for creating figures from
life models, and he noted that his model
for this nymph had been his mistress.
He planned giant satyrs as door sup-
ports (never cast). Evidence of these
appears in a drawing and a small bronze
satyr (J. Paul Getty Museum, Malibu).
Inscribed on the drawing is Cellini's

description of the satyrs: ALLA PORTA DI FONTANA / BELLIO DI BRONZE P[ER] PIU / DI DUA VOLTE IL VIVO B[RACCIE]7 / ERANO DUA VARIATI (for the gate of Fontainebleau—of bronze, more than twice life-size: 7 braccie—there were two variants [of a satyr]). During Henry II's reign (1547–59), the court artist Philibert d'Orme installed Cellini's lunette above the main door of the Château d'Anet, and the nymph became identified as the goddess Diana.

In this year, Francis I makes Cellini a naturalized citizen, with the idea that he remain at his court in France.

1543 — For Francis I, Cellini completes his most famous gold sculpture, *Saltcellar of Francis I* (see fig. 58–2). The exquisite table accessory was designed to contain seasonings. Dominating the sculpture are two nude, reclining figures that face each other: Neptune, god of the sea, and Tellus, goddess of the earth. Beside Neptune is a small boat meant for holding salt and beside Tellus is a temple for holding pepper. Cellini's primary models were Michelangelo's Medici Chapel figures and Ghiberti's Adam and Eve on the Florence Baptistery east doors. The elongation and sinuous elegance of his figures are reminiscent of Rosso's and Primaticcio's works at Fontainebleau.

1545 — Cellini leaves France, partly due to his rivalry with artist Francesco Primaticcio (1504–70). In Florence, he creates a portrait bust of *Duke Cosimo de' Medici* in bronze (see fig. 58–4). Cosimo is portrayed as a fearsome commander, poised for battle in the tradition of late-antique imperial portraiture. No part of his body is relaxed. Instead, his raking glare and furrowed brow make him seem tense and ready to pounce. Cellini's technical virtuosity and intricate design are most evident in the precise details of

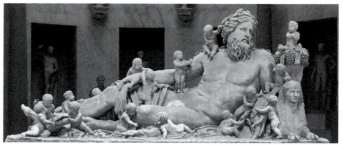

Cosimo's cuirass, and the snarling head on the duke's right shoulder sets the tenor for presenting the young man as an aloof and aggressive ruler, glowering as he clinches his jaw. Cellini was proud of this expressive portrait, which is larger than life-size. In his *Life*, he noted that he made clay studies for the portrait from life sittings. This was the first cast bronze he created in Florence, and he was convinced that he needed to experiment with Florentine clay so that he did not suffer the same problems Donatello had in casting his statues of *S. Louis of Toulouse* and *Judith*. (Cosimo's bust was cast by the bell-founder Zanobi di Pagno because Cellini did not yet have his own furnace.) Cellini told Duke Cosimo that he preferred the bronze portrait to *Perseus* (see fig. 58–1) because of the merit of its workmanship and bold lifelikeness. He no doubt expected Cosimo to marvel at his facility, but Cosimo was apparently displeased with the bust and did not publicly display it in Florence. He may have preferred Bandinelli's calmer portrayal of him, modeled also after imperial portrait busts (Bargello, Florence). Cellini's bust was sent off to Portoferraio on the island of Elba, where it was installed above the entrance to Cosimo's fortress (in 1557). The bust was shipped back to Florence in 1781. Cellini made another bust in marble ca. 1549 (De Young Museum, San Francisco).

According to his *Life*, the duke's bronze portrait was a trial piece for the large-scale bronze *Perseus and Medusa* (see fig. 58–1) that he was hired to create. Emblematic of the duke, the statue was

58–3. *River Nile*, copy of bronze Hellenistic original (?1ST or 2ND C. BCE), marble, 5'3.8" x 10'2" (162 x 310 cm), Vatican Museums (Braccio Nuovo), Rome. Discovered in Rome at S. Maria sopra Minerva in 1513, the river god statue was bought by Pope Julius II. It was restored during the reign of Pope Clement VII in 1524 (and in 1774). Cellini knew the statue from his stay in Rome, and the energy and complexity of this work appears in his *Saltcellar* (see fig. 58–2), where the large female nude personifies Earth, the source of pepper, and the large male nude, signifying the sea, the source of salt, is linked to Neptune because of the trident. On the base are reclining figures symbolic of the Seasons (or Winds) and Times (of Day).

intended as a companion piece to Donatello's *Judith and Holofernes* (see fig. 21–8), with both works set in the Loggia dei Lanzi. After making several small-scale models (in wax and bronze), a trip to Venice to study bronze casting, and the creation of a full-scale plaster model of the *Perseus*, Cellini cast the final sculpture in the furnace of his garden workshop in Via del Rosaio (now Via della Pergola), behind the Ospedale degli Innocenti. Cellini spent nine years on his *Perseus*. Delays were frequent because he had neither enough money nor assistants to complete the job in a timely manner. This was apparently due to the parsimonious nature of Cosimo and to Cellini's rivalry with the sculptor Bandinelli, who had the duke's favor and spoke ill of Cellini. Still, Cosimo approved Cellini's requests to make the statue of Perseus larger and to include the body of Medusa on the pedestal, thus enhancing the dramatic content. The ancient Roman poet Ovid was the source of the tale of Perseus, the son of the god Jupiter and the mortal Danäe. In his *Metamorphoses*, Ovid recounts that the chaste Danäe was locked in a tower by her father, King Akrisios of Argos, because it had been prophesied that his grandchild would murder him. In a shower of gold, Jupiter impregnated Danäe in the tower. Akrisios learned of the birth when Perseus was four years old; he then had his daughter and grandson cast into the sea, locked inside a chest. They were rescued, and Jupiter asked the gods to bestow gifts on his son, who received a sword (sickle-shaped), shield (from Minerva), and winged helmet and sandals (from Mercury). Protected by these, Perseus sought out and slew Medusa. Cellini's statues of *Perseus* (cast 1548) and *Medusa* (cast 1549) reflect his study of life models and the art of Michelangelo and Donatello, while the marble decoration and the elegant, thin figures of both the pedestal and the relief are more reminiscent of his work at Fontainebleau.

1546 — In Venice, Cellini studies bronze casting and is befriended by Titian and Jacopo Sansovino.

In Florence, he finishes the marble *Apollo and Hyacinth*, followed by *Narcissus* (finished 1548) (both Bargello, Florence). About 1550, he finishes the bronze bust, *Bindo Altoviti* (Gardner Museum, Boston).

1556 — Cellini is jailed for attacking a goldsmith.

1557 — Found guilty of sodomy, Cellini is fined and sentenced to four years imprisonment (changed to house arrest through Cosimo's intervention).

1558 — Beginning his *Life*, Cellini competed for the Neptune fountain project in the Piazza Signoria, Florence (in 1559), losing to Ammanati.

1562 — Cellini signs his marble, life-size *Crucifix* (S. Lorenzo, Escorial, near Madrid), h. 4'9.1" (145 cm). Cellini wrote that during his imprisonment (Castel S. Angelo), he had visions of the work. He meant it for the pier where he planned his tomb in S. Maria Novella, but problems arose with the Dominicans, and he was denied the space. Duke Cosimo acquired the *Crucifix* in 1565, but did not pay for it until 1570. After Cosimo's death (1574), his son and heir (Francesco I) sent it as a gift to Philip II of Spain.

1565 — Cellini creates seal designs for the Accademia, and writes treatises on sculpture (*Trattato della scultura*) and goldsmithing (*Trattato della oreficeria*). In 1567, he officially married his maid, Piera.

1571 — Cellini dies in Florence (13 February) and is buried in the Chapel of S. Luke, SS. Annunziata.

58–4. BENVENUTO CELLINI. *Duke Cosimo I de' Medici*, ca. 1545–47, bronze, h. 43.3" (110 cm), Bargello, Florence. This portrait was not Cosimo's favorite, and perhaps because of this he made the final payment only in 1570. Never fully appreciating Cellini's art, except his *Perseus and Medusa*, Cosimo nevertheless refused to let him move from Florence after 1545.

Were it not for the painter-architect Giorgio Vasari (1511–74), our knowledge of Italian Renaissance art and artists would be significantly lessened. Within twenty years, he produced two versions of his *Lives*, highlighting 300 years of Italian art. In both editions, he categorically considered Italian art superior to Northern and displayed great bias for Florentine art, especially Michelangelo's. Vasari's most highly valued work is his architectural design of the Uffizi (Offices) for Duke Cosimo I de' Medici.

1511 — The son of a potter, Giorgio Vasari is born in Arezzo (11 May).

1524 — After training in Arezzo with the French artist Guillaume Marcillat (see Signorelli 1519), Vasari is presented to Cardinal Silvio Passerini in Florence. While he was in Florence, he began a long relationship with two future patrons, Ippolito and Alessandro de' Medici. According to his own account (inaccurate), he also studied with Michelangelo (then working in S. Lorenzo).

1527 — With the Medici expelled from Florence (see Siege, Cinquecento History Notes 1529), Vasari returns to Arezzo; his father dies of the plague.

1529 — Vasari studies goldsmithing in Florence, Pisa, and Bologna.

1530 — In Bologna, Vasari witnesses Pope Clement VII's coronation of Emperor Charles V of Spain. Grandson and successor of Emperor Maximilian of Habsburg (d. 1519), Charles assumed the imperial title in 1519; he and Clement had reconciled their differences in 1529 (see Cinquecento History Notes 1529).

1531 — In Rome, Vasari works for Cardinal Ippolito de' Medici, the illegitimate son of Giuliano de' Medici, Duke of Nemours (see fig. 61–2).

1534 — Vasari is in the workshops of the painter Andrea del Sarto and the sculptor Baccio Bandinelli.

1537 — Vasari returns to Arezzo after Lorenzino de' Medici ordered the assassination of his cousin Duke Alessandro de' Medici (5 January). In the following year, Vasari went to Rome, then to Bologna in 1539.

1542 — Invited by the writer and satirist Pietro Aretino, Vasari travels to Venice, where he creates paintings based on sketches by Michelangelo. He created stage sets for Aretino's play and painted the ceiling of the Palazzo Corner-Spinelli.

1543 — Vasari returns to Rome, where on the suggestion of Paolo Giovio (see Cinquecento History Notes 1534) he begins writing his *Lives*. In this year, he travels to Lucca and Florence. In the following year (1544), he visited Naples.

1546 — In Rome, Vasari is hired to create murals depicting the life of Pope Paul III (Farnese) in the Sala dei Cento Giorni, Palazzo della Cancelleria. These frescoes show his Florentine Mannerist traits.

1550 — Vasari marries Niccolosa Bacci of Arezzo and publishes the first edition of his *Lives*.

1553 — In Rome, Vasari works on the Villa Giulia for Pope Julius III.

59–1. CRISTOFORO CORIOLANO. *Self-portrait of Vasari*, from the second edition of Vasari's *Lives* (Florence, 1568), wood engraving. Vasari considered himself a painter and architect from Arezzo, according to his inscription: GIORGIO VASARI PIT. ET / ARCHITET. ARETINO. Conscious of the garments displayed on the various artists he portrayed, Vasari appears in his self-portrait as the perfect courtier, confident and aristocratic in his manner.

1555 — In Florence, Duke Cosimo de' Medici hires Vasari to remodel the Palazzo Vecchio; he will become Vasari's lifelong patron.

1557 — Vasari is living in the S. Croce quarter of Florence.

1560 — In Florence, construction begins on Duke Cosimo's offices (Uffizi); this is Vasari's most defining architectural design.

1561 — In Pisa, Vasari remodels the Piazza dei Cavalieri.

1563 — In Florence (31 January), Vasari and other artists found the first art academy. In this year, he also begins the revision of his *Lives*.

1564 — In Florence, Vasari is put in charge of Michelangelo's funeral arrangements. He designs the artist's elaborate tomb in S. Croce, which was then executed by other artists.

1565 — In Florence, Vasari begins the corridor linking Duke Cosimo de' Medici's palace (Palazzo Pitti) with the old town hall (Palazzo Vecchio). In S. Maria Novella, he remodels the interior, removing the choir screen and installing tabernacles along the walls of the side aisles in the church.

1566 — Vasari travels to cities around Italy, including Venice, gathering material for his *Lives*. In Florence, he begins remodeling the interior of S. Croce, which entails removing the choir screen and adding side aisle tabernacles.

1570 — In Rome, Vasari is working for Pope Pius v, decorating chapels and working on the Sala Regia. Pius v inducted Vasari into the Knighthood of the Golden Spur of the Order of S. Peter (1571).

1572 — Vasari completes the wall murals in the Room of the Five Hundred, Palazzo Vecchio, Florence, and begins murals in the cupola of the Duomo.

1574 — In this year, Vasari dies in Florence while working on the Duomo murals; he is buried in the Pieve of S. Maria, Arezzo.

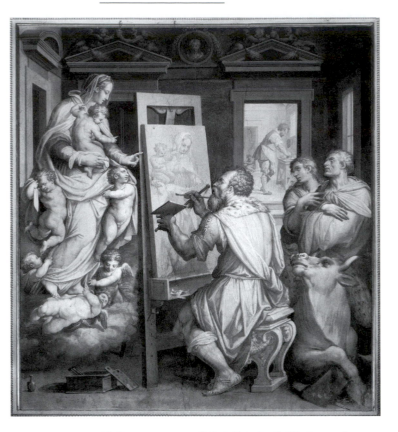

59–2. GIORGIO VASARI. *S. Luke Painting the Virgin*, ca. 1565, fresco altarpiece, Chapel of S. Luke (chapel was acquired by the Accademia delle Arti del Disegno in 1565; buried here are Pontormo, Franciabigio, and Cellini), SS. Annunziata, Florence. Vasari depicted himself as the painter-saint, who has brush, palette, and mahlstick raised, and is seated beside his symbol, the ox (see GOSPELS, Duecento Glossary). In the background are two artists in a studio (one stands and sculpts clay, while the other sits and draws). Vasari depicted Luke (and himself) as divinely inspired, an artist whose *disegno* came from the mind's eye (see DISEGNO, Cinquecento Glossary). Vasari's architecture is more valued now than are his paintings. Derivative as they are of designs of Michelangelo, Raphael, Rosso, and Bronzino, his paintings nevertheless show his studied draftsmanship and invention (see the discussion of drawings that follows). Nevertheless, the comprehensiveness of his *Lives* sets him apart in his own period, and as the first modern art historian and theorist of Italian art, his commentaries have provided fundamental information for the many studies on Italian art that have followed his.

Drawing/*Disegno*

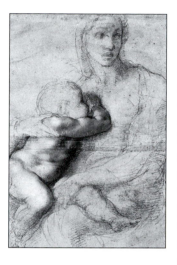

In Vasari's time, drawing was understood to be the foundation for the creation of any form of visual art. If philosophy was the mother of the liberal arts, then drawing was the mother of painting, sculpture, architecture, and other forms of visual creations. By the Cinquecento, drawings were considered collectible art, with some valued as much as paintings. Vasari was a collector himself, who owned drawings by Filippino and others. The following select terms concern basic materials and functions of Renaissance drawings.

PROCESS/TYPES OF DRAWINGS

MODELS — In the 15TH century, clay and wood models were used in shops to drape cloth over for drapery studies. Small-scale wax and clay sculptures were used for figure studies.

PENTIMENTI — Marks reflecting change in design.

WORKSHOP STUDIES — Such drawings were carried out for the purpose of experiment or training, with the hand of both the master and the student often on the same sheet.

UNDERDRAWING — These are preliminary sketches (on paper, panel, etc.), done in charcoal, metalpoint, or chalk (red or black), that describe the compositional design (see fig. 59–2).

CONTRACT/PRESENTATION DRAWING — A contract drawing is a finished compositional drawing made for the patron to approve as the agreed-upon design for the commissioned work. A presentation drawing is a highly finished drawing presented as a gift.

CARTOON — This full-size drawing was for directly transferring a design to the surface intended to be painted. Sheets of paper were often joined together to create cartoons (see fig. 59–3). The transfer was done in a couple of ways: by using a sharp instrument to incise the design onto the intended surface or by pricking holes in the design (*spolvero* technique) to create a stencil (see Fresco Technique). A cartoon could serve as a guide for the underpainting.

SQUARED DRAWING — This type of drawing was covered with a grid of lines to help transfer the design onto a larger surface. The targeted surface was squared proportionately to the smaller grid to aid in the transfer of the design.

MODELLO — A *modello* is a sketch for a work (usually a painting or sculpture) made in the same, or similar, medium.

DRAWING BOOKS

MODELBOOK — These books (pages were often bound together before use) were for creating highly finished, and usually colored, studies of nature (birds, plants, animals). They provided models for apprentices and for the direct transfer of ideas into another form, such as paintings.

SKETCHBOOK — These are bound sheets of paper that use sketches to record and work out ideas.

TACCUINO DI VIAGGIO — Such books of drawings were made by a traveling artist or shop, recording the art of the places visited.

RECTO/VERSO — The recto is considered the side with the more important designs of a double-sided drawing sheet (or the right side of an opened, bound book). The verso is considered to have the less important designs of a double-sided drawing sheet (this is the underside, or left side, of an opened, bound book).

MATERIALS

PAPER—Paper production in Italy (begun 13TH-c.) followed Chinese practices. Cotton (or linen) rags turned into pulp were boiled with size, put on a wire mesh frame, dried, and cut into sheets.

59–3. MICHELANGELO. *Madonna and Child*, ca. 1525, black and red chalks, ink, white heightening, 21.3" x 15.7" (54.1 x 39.6 cm), Casa Buonarroti, Florence. Created on two large sheets glued side-by-side, this is considered a cartoon, but no work has been linked to it. Mary's head was drawn first in profile looking at the nursing child, but her demeanor is now that of a watchful guardian.

Drawing
Disegno

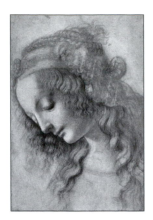 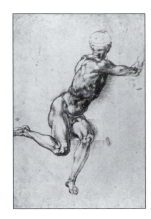

59–4. LORENZO DI CREDI. *Head of Young Woman*, ca. 1480s, metalpoint, pen and brown ink, brown wash, heightening with white gouache, 11.1" x 7.9" (28.1 x 19.9 cm), Uffizi Gallery, Florence. 59–5. MICHELANGELO. Study for the cartoon, *Battle of Cascina*, ca. 1505, pen and brush with two colored inks, white heightening, 16.7" x 11.3" (42.1 x 22.4 cm), British Museum, London. 59–6. RAPHAEL. Copy after Michelangelo's *David*, ca. 1505, pen and ink over black chalk underdrawing, 11.7" x 8.4" (29.5 x 21.2 cm), British Museum, London.

PREPARED PAPER — Using a brush, several coats of a colored ground were applied to paper. Cennini recommended that the ground combine white lead, powdered bone, and color (a mixture of terra verde, ochre, vermilion) and that it should be tempered with glue. After the ground dried, the surface was to be burnished. Tints were commonly rose, green, or gray-blue. *Carta azzurra* was colored with blue pigment (indigo) imported by the Venetians from Arabia.

CHARCOAL — Cennini recorded that coals were good for drawing and could be made from sticks of willow roasted in an airtight pot. Charcoal was best used for broad preliminary sketches on paper, panel, or wall, and the designs could be easily erased with feathers. Easily smudged, these drawings required a fixative.

BLACK CHALK — Comparing black chalk to charcoal, Cennini described the chalk as the product of a soft, very black stone of Piedmont. He noted that it could be sharpened with a penknife and that it was ideal for drawing when cut into sticks (see fig. 59–6). Red chalk (*sanguine*) is a mixture of iron oxide and clay (see fig. 59–3).

PASTELS — These are fabricated chalk sticks (dry pigments bound in a medium such as gum arabic).

INKS — Two types of black pigment were often used (bound in a medium of gum and water): lamp black (carbon particles from the smoke of burning oil) and iron gall (iron rust boiled with oak galls). The latter can have some cor-rosive effects on paper and will eventually fade to brown (see figs. 38–6, 59–5).

PEN — According to Cennini, the best quill pens for drawing were made from feathers plucked from the leading edge of a goose wing. They could be trimmed to a variety of shapes and thicknesses, giving rise to a wide range of types of line.

METALPOINT — Using a drawing utensil (stylus) having a metal point (lead, silver, gold, or copper), draw-ings were made on paper. Metalpoint (especially silver) can produce a fine gray-lined drawing on prepared paper. The texture of the prepared surface causes the silver to leave a deposit that tarnishes (see figs. 48–7, 59–4). Only lead could be used on both unprepared and prepared sur-faces, but the line is less fine than silver.

HEIGHTENING — White pigment (usually lead white) was brushed onto drawings to show highlights. Cennini wrote that after shading with washes on tinted paper, the design could be high-lighted by using a white lead well worked up with gum arabic (see figs. 59–3, 59–4, 59–5).

TECHNIQUE

HATCHING — In drawing, this is a series of parallel lines that help define volume, texture, light, and shadow. Cross-hatching refers to strokes that cross one another. An artist's strokes can show which hand is dominant (see fig. 59–6).

WASH — Diluted ink is brushed onto a drawing (pen and ink), usually to show the direction of light-ing and internal modeling (see fig. 59–4).

In a period when fame was accorded few women artists, Sofonisba Anguissola (ca. 1532/35–1625) received high praise from her contemporaries. She was one of the most inventive portraitists of the 16ᵀᴴ century, creating more than a score of self-portraits in her youth (see fig. 60–1). In the Renaissance, a woman who became an artist was typically trained by her artist father or artist husband; if she joined a convent, she was trained by an artist nun. None of these circumstances applies to Sofonisba. Born into the Cremona nobility, she and her sisters were educated in the liberal arts and given painting lessons in their youth. Her father, Amilcare, recognized Sofonisba's talent while she was still very young, and found a practical way for her to secure an appointment at court (his incentive was perhaps the need to provide dowries for six daughters, close in age). To further Sofonisba's career, Amilcare gave her self-portraits to people close to the Este and Gonzaga (see figs. V–2, V–3). Through his efforts, her accomplishments gained court attention, and she was invited to join the royal house of Spain in 1559, a turning point in her career; income from her appointment supported her family. Sofonisba married twice, acquired wealth, and as a noblewoman had far more advantages than any other woman painter of her time.

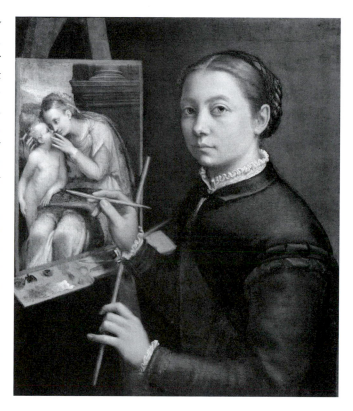

ca. 1532/35 — Born in Cremona, Sofonisba is the eldest of seven children (Elena, Lucia, Europa, Minerva, Asdrubale, and Anna Maria) born to Bianca Ponzoni and Amilcare Anguissola.

1546 — In Cremona, Sofonisba and her sister Elena are apprenticed to painter Bernardino Campi (ca.

60–1. SOFONISBA ANGUISSOLA. *Self-Portrait at the Easel*, ca. late 1550s, oil on canvas, 26" x 22" (66 x 55.9 cm), Museum Zamek, Lancut. During the course of her very early career, Sofonisba executed many self-portraits, this one created while she was in her twenties. It offers evidence of her artistic talent and aristocratic bearing. Such traits were invaluable for securing her position as lady-in-waiting to Queen Elisabeth of Spain (see fig. 60–2). Not long before Sofonisba painted this portrait, she had created two other almost identical, though smaller, paintings of herself at the easel (one painting was sold at Sotheby's in 1963, its current location unknown). While she neither signed nor dated this work, inscriptions on earlier self-portraits identify her: "Sofonisba Anguissola virgin from Cremona painted herself." In this self-portrait, the easel painting depicting the Madonna and Child is almost identical to the earlier two versions. Although no extant work has been identified with the painting pictured here, it is thought that the work existed, and its style imitates that of Antonio Allegri of Correggio, called Correggio. An important painter of northern Italy, Correggio (ca. 1489–1534) worked in Parma and Modena and for Federico II Gonzaga of Mantua (Giulio Romano's patron). Sofonisba would have known his work, as this portrait displays her mastery of his style. In contrast to Vasari's *S. Luke Painting the Virgin* (see fig. 59–2), she pictured herself not in the guise of the saint, but perhaps as the personification of painting, whose creation of a loving woman and child is remindful of pagan deities Venus and Cupid.

1508–1573); they lived three years in his household. Vasari thought that other sisters (Lucia, Europa, and Anna) were also disciples of Bernardino, whom he misidentified as Giulio Campi.

1549 — Sofonisba is trained by painter Bernardino Gatti (Campi moved to Milan in this year).

1551 — Sofonisba signs and dates *Portrait of a Nun* (Southampton City Art Gallery), perhaps a portrait of her sister Elena, who entered a convent in this year.

1554 — Sofonisba signs and dates a self-portrait, the earliest extant dated self-portrait by her (Vienna).

1555 — Sofonisba signs and dates *Chess Game* (Poznan), depicting three of her sisters playing a lively chess game, accompanied by an old woman servant. After visiting the Anguissola in Cremona, Vasari remarked that he had seen this painting and that it was especially natural and lifelike. The work is recorded in the collection of Fulvio Orsini, librarian of Cardinal Odoardo Farnese (see fig. V–5).

1557 — Sofonisba's father writes to Michelangelo in Rome, thanking him for his guidance and asking for one of his drawings from which Sofonisba could create an oil painting.

ca. 1559 — Sofonisba paints *Bernardino Campi Painting Sofonisba Anguissola* (Pinacoteca, Siena), a work displaying her ingenuity and accomplishment. Paying homage to her teacher, she portrays herself as a noblewoman, the first of her self-portraits in which she is clothed in rich, brocaded finery.

1559 — Invited to the Spanish court in Madrid, Sofonisba becomes a lady-in-waiting and an instructor of drawing and painting to Queen Elisabeth (died in childbirth, 1568), Philip's third wife (see fig. 60–2).

1561 — Having received a request for a portrait of the king from Bernardino Campi, Sofonisba writes that she had too many commitments to do one for him.

1573 — King Philip II arranges the marriage of Sofonisba to Fabrizio Moncada (d. 1578), son of the viceroy of Sicily. Elisabeth of Valois had set aside 3,000 ducats for Sofonisba's dowry. In Sicily, Sonfonisba had painting apprentices.

1579 — A year after the death of her first husband (1578), Sofonisba marries a Genovese sea captain, Orazio Lomellini, and moves to Genoa, where she continues to create portraits.

1615 — Sofonisba moves to Palermo, where she is visited by Anthony van Dyck.

1625 — Sofonisba dies in Palermo and is buried in S. Giorgio dei Genovesi.

60–2. SOFONISBA ANGUISSOLA. *Elisabeth of Valois*, ca. 1565, canvas, 6'8.8" x 4'.5" (205 x 123 cm), Museo del Prado, Madrid. Elisabeth, Queen of Spain (1545–68), was the daughter of Queen Catherine de' Medici and King Henry II of France (see figs. V–6, 61–2). Sofonisba traveled with Queen Elisabeth, and her position as lady-in-waiting preceded that of court painter; nevertheless, her skillful portrayal of monarchy as larger-than-life nobles appealed to the Spanish crown. This life-size, formal image of Elisabeth is distinct from the lively portraits of Sofonisba's own family that she created before entering the Spanish royal court. Dressed in regal apparel, Elisabeth holds in her right hand a miniature portrait of her husband, Philip II, suggesting that the painting records an event at which he was not present: in June and July, 1565, Elisabeth was in Bayonne, France, where she and a Spanish delegation met with the new king of France, Charles IX, and the queen mother (Elisabeth's brother and mother).

Patrons, Cities, and Deities

Part Five augments material covered in previous chapters, with the genealogies, maps, timelines, and diagrams intended here to highlight the lineage and leadership of select communes and lordly courts.

Patronage is the primary chord of this part, and the discussion of notable characteristics of three major cities—Florence, Venice, and Rome—will further explicate reasons for the creation of certain types of

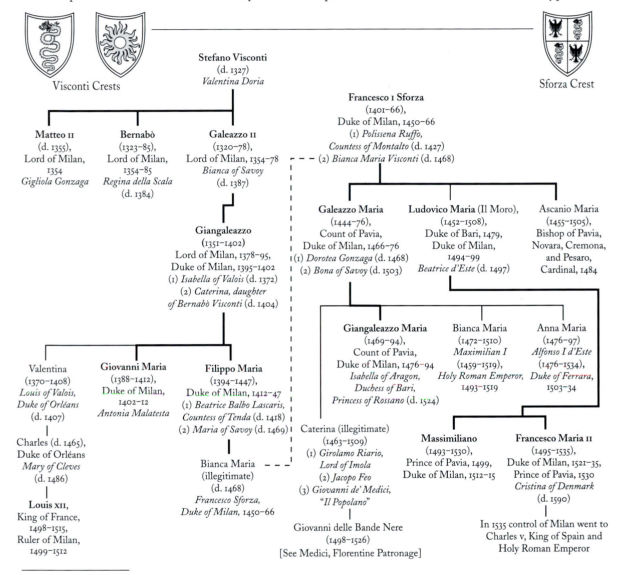

Visconti Crests

Sforza Crest

Stefano Visconti
(d. 1327)
Valentina Doria

Francesco I Sforza
(1401–66),
Duke of Milan, 1450–66
(1) *Polissena Ruffo,*
Countess of Montalto (d. 1427)
(2) *Bianca Maria Visconti* (d. 1468)

Matteo II
(d. 1355),
Lord of Milan,
1354
Gigliola Gonzaga

Bernabò
(1323–85),
Lord of Milan,
1354–85
Regina della Scala
(d. 1384)

Galeazzo II
(1320–78),
Lord of Milan, 1354–78
Bianca of Savoy
(d. 1387)

Giangaleazzo
(1351–1402)
Lord of Milan, 1378–95,
Duke of Milan, 1395–1402
(1) *Isabella of Valois* (d. 1372)
(2) *Caterina, daughter*
of Bernabò Visconti (d. 1404)

Galeazzo Maria
(1444–76),
Count of Pavia,
Duke of Milan, 1466–76
(1) *Dorotea Gonzaga* (d. 1468)
(2) *Bona of Savoy* (d. 1503)

Ludovico Maria (Il Moro),
(1452–1508),
Duke of Bari, 1479,
Duke of Milan,
1494–99
Beatrice d'Este (d. 1497)

Ascanio Maria
(1455–1505),
Bishop of Pavia,
Novara, Cremona,
and Pesaro,
Cardinal, 1484

Giangaleazzo Maria
(1469–94),
Count of Pavia,
Duke of Milan, 1476–94
Isabella of Aragon,
Duchess of Bari,
Princess of Rossano (d. 1524)

Bianca Maria
(1472–1510)
Maximilian I
(1459–1519),
Holy Roman Emperor,
1493–1519

Anna Maria
(1476–97)
Alfonso I d'Este
(1476–1534),
Duke of Ferrara,
1503–34

Valentina
(1370–1408)
Louis of Valois,
Duke of Orléans
(d. 1407)
|
Charles (d. 1465),
Duke of Orléans
Mary of Cleves
(d. 1486)
|
Louis XII,
King of France,
1498–1515,
Ruler of Milan,
1499–1512

Giovanni Maria
(1388–1412),
Duke of Milan,
1402–12
Antonia Malatesta

Filippo Maria
(1394–1447),
Duke of Milan, 1412–47
(1) *Beatrice Balbo Lascaris,*
Countess of Tenda (d. 1418)
(2) *Maria of Savoy* (d. 1469)

Bianca Maria
(illegitimate)
(d. 1468)
Francesco Sforza,
Duke of Milan, 1450–66

Caterina (illegitimate)
(1463–1509)
(1) *Girolamo Riario,*
Lord of Imola
(2) *Jacopo Feo*
(3) *Giovanni de' Medici,*
"Il Popolano"
|
Giovanni delle Bande Nere
(1498–1526)
[See Medici, Florentine Patronage]

Massimiliano
(1493–1530),
Prince of Pavia, 1499,
Duke of Milan, 1512–15

Francesco Maria II
(1495–1535),
Duke of Milan, 1521–35,
Prince of Pavia, 1530
Cristina of Denmark
(d. 1590)
|
In 1535 control of Milan went to
Charles V, King of Spain and
Holy Roman Emperor

V–1. House of Visconti and Sforza Genealogy (see figs. 17–2, 17–3). In 1395, Milan became a duchy under Giangaleazzo Visconti. His marriage to Isabella of Valois (sister of King Charles VI of France) inspired French fashion at the Milan court, and his daughter's marriage into the House of Orléans produced a future claimant (Louis XII) to the duchy (see fig. V–6). Among the most renowned 15TH-c. Italian *condottieri*, Francesco Sforza declared himself the new duke of Milan in 1450, with the collapse of the republican rule that followed the death (1447) of Filippo Maria Visconti. Francesco married (1441) Bianca Maria (Filippo's illegitimate and only child), and they fashioned a Visconti-styled court. But Francesco preferred Tuscan (the architect and sculptor Filarete) more than French artists, as did his son Ludovico, who invited Leonardo to Milan (1482), and for whom Leonardo was working when the troops of Louis XII of France (great nephew of Filippo Maria) invaded the city in 1499.

art for public and private display. By the late Quattrocento, alliances and hostilities among these three cities contributed to a constant shifting of control. Four families were integral to the never-ending

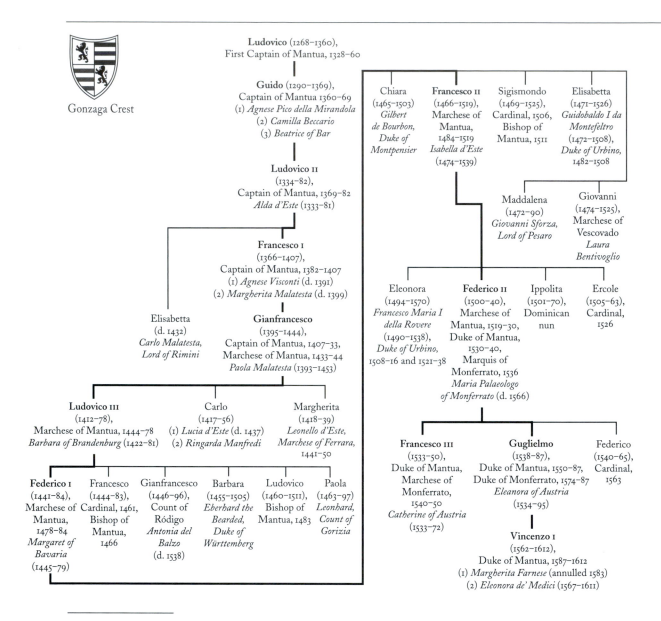

V–2. House of Gonzaga Genealogy. Not until 1530, during the reign of Federico II, did Mantua became a duchy, long after the court had become well known for its culture and *condottieri*. Gonzaga rule had been legitimated during the reign of Gianfrancesco, the first marchese of Mantua (Alberti dedicated the revised edition of *De pictura* to him); Gianfrancesco's son Ludovico III hired both Leon Battista Alberti and Andrea Mantegna (see figs. 40–1, 40–2, 40–4), setting in motion the taste for classical style in Mantua. The patronage of Ludovico II extended beyond Mantua, as well, for he donated funds (Florence owed him for military services) to rebuild the church of SS. Annunziata in Florence, insisting that Alberti be involved in the project (see Alberti, 1470). Ludovico's granddaughter-in-law, Isabella d'Este of Ferrara (see fig. V–3), had an enthusiasm for collecting art that would have surpassed Ludovico's had she possessed the funds available to him or to her husband, Francesco II, or to her son Federico II, who hired Giulio Romano to turn the stables on the island of Te into an extraordinary palace (see figs. 47–10, 55–1, 55–2). Emperor Charles V bestowed on Federico II, son of Isabella, the title of duke on 8 April 1530.

power struggle: the Visconti-Sforza of Milan, the Gonzaga of Mantua, the Este of Ferrara, and the Montefeltro of Urbino (for their genealogies, see figs. V–1 to V–4). Invested with land and titles due

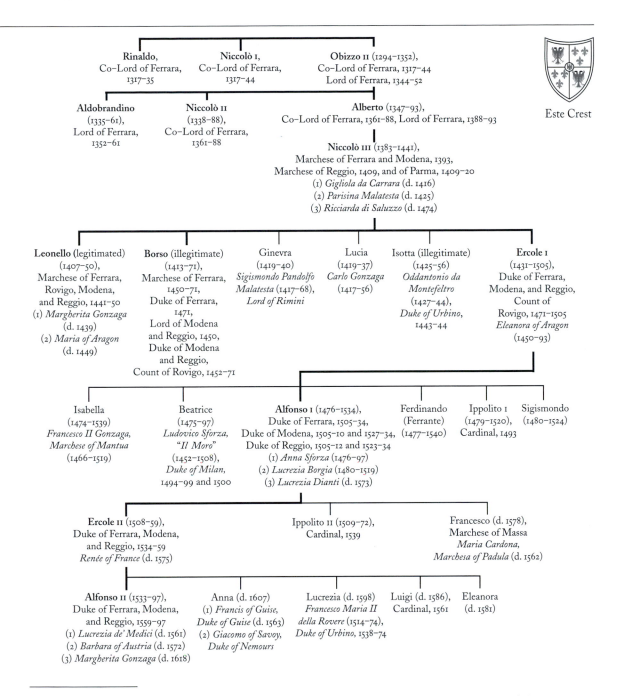

Este Crest

V–3. House of Este Genealogy. In 1471, during the reign of Borso d'Este, Ferrara became a duchy (see fig. 17–8). Borso was both a soldier and an art patron, as was his half-brother Leonello, who preceded him as ruler of Ferrara (see figs. 17–6, 17–7). Leonello's and Borso's employment of a range of artists to decorate the Este estates inspired their niece Isabella, who as the Marchesa of Mantua relentlessly pursued the services of many artists to decorate her *studiolo* and to expand her art collection (see figs. 40–5, 42–2). Perhaps in competition with his sister, Alfonso I hired artists who had also worked for Isabella, including Giovanni Bellini and Titian, both of whom created canvases for Alfonso's *camerino* (see figs. 44–3, 57–2).

to military victories and allegiance to the emperor or to the pope, these lordly families became powerful and significant patrons of art. Arranged marriages elevated the social status of these families of *condottieri*, but the marriages did not always make allies of the families. One upshot was disagreement over

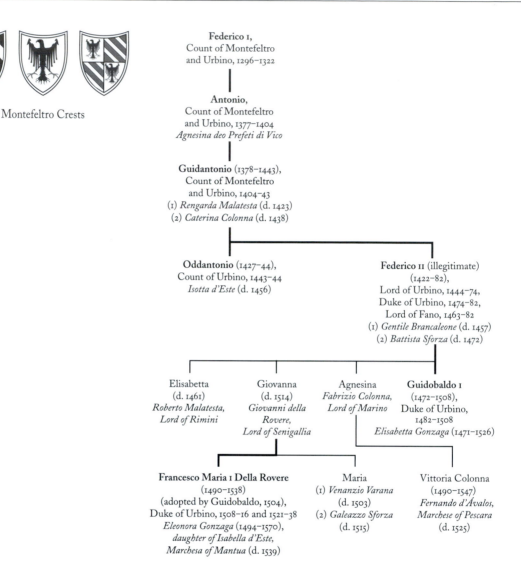

Montefeltro Crests

Federico I,
Count of Montefeltro
and Urbino, 1296–1322

Antonio,
Count of Montefeltro
and Urbino, 1377–1404
Agnesina deo Prefeti di Vico

Guidantonio (1378–1443),
Count of Montefeltro
and Urbino, 1404–43
(1) *Rengarda Malatesta* (d. 1423)
(2) *Caterina Colonna* (d. 1438)

Oddantonio (1427–44),
Count of Urbino, 1443–44
Isotta d'Este (d. 1456)

Federico II (illegitimate)
(1422–82),
Lord of Urbino, 1444–74,
Duke of Urbino, 1474–82,
Lord of Fano, 1463–82
(1) *Gentile Brancaleone* (d. 1457)
(2) *Battista Sforza* (d. 1472)

Elisabetta
(d. 1461)
Roberto Malatesta,
Lord of Rimini

Giovanna
(d. 1514)
Giovanni della
Rovere,
Lord of Senigallia

Agnesina
Fabrizio Colonna,
Lord of Marino

Guidobaldo I
(1472–1508),
Duke of Urbino,
1482–1508
Elisabetta Gonzaga (1471–1526)

Francesco Maria I Della Rovere
(1490–1538)
(adopted by Guidobaldo, 1504),
Duke of Urbino, 1508–16 and 1521–38
Eleonora Gonzaga (1494–1570),
daughter of Isabella d'Este,
Marchesa of Mantua (d. 1539)

Maria
(1) *Venanzio Varana*
(d. 1503)
(2) *Galeazzo Sforza*
(d. 1515)

Vittoria Colonna
(1490–1547)
Fernando d'Ávalos,
Marchese of Pescara
(d. 1525)

V–4. House of Montefeltro Genealogy. Federico II da Montefeltro (see figs. 33–2, 33–3), the famous *condottiere* and illegitimate son of Guidantonio, was created the *gonfaloniere* of the Holy Roman Church and the first Duke of Urbino by Sixtus IV in 1474. Admired and employed by the powerful city states of Milan, Florence, and Naples, the consummate humanist soldier brought stability and peace to his own court, which became a model of beauty through the efforts of many artists (Piero della Francesca, Francesco di Giorgio, Leon Battista Alberti, Paolo Uccello, Francesco Laurana, Justus of Ghent). Following his father's precedent, Guidobaldo hired Giovanni Santi (painter father of Raphael) and Baldassare Castiglione (1478–1529), who commanded a company of soldiers for him (in 1504). Considered the perfect gentleman at court, Castiglione later recalled in *Il libro del cortigiano* (Book of the Courtier) conversations that took place at the Urbino court during March 1507 (see Cinquecento History Notes 1528). When Guidobaldo died without heirs, the duchy passed to his nephew, Francesco Maria II della Rovere, a distant relative of Giuliano della Rovere (future Pope Julius II). Francesco married Eleonora Gonzaga, the niece of Duchess Elisabetta.

dynastic succession, as shown by the struggle over the duchy of Milan, which was taken over first by the French crown and later by the Spanish. By the middle of the Cinquecento, Venice was the only major city to remain a republic, and she would never suffer invasion from her enemies.

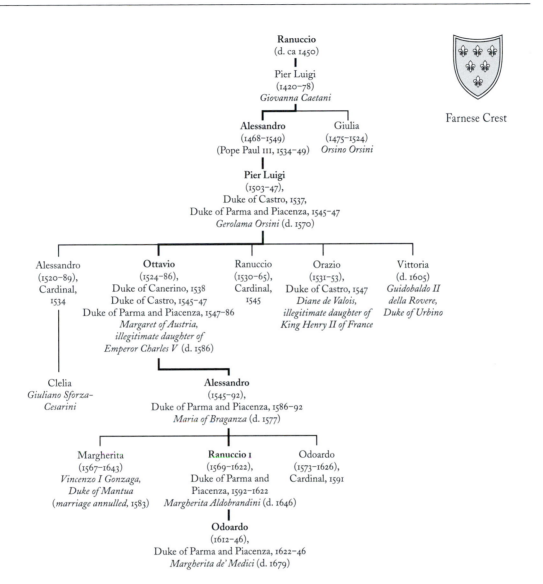

Farnese Crest

V–5. House of Farnese Genealogy. The most famous member of the Farnese family was Alessandro, who as a cardinal built a grand palace in Rome (see figs. 47–8, 47–9) and as Pope Paul III commissioned Michelangelo to complete the *Last Judgment*, begun under Pope Clement VII. In his early years in Rome, Alessandro fathered four children by his mistress, Silvia Ruffini; the first two were granted legitimacy by Pope Julius II (1505) and the other two by Leo X (1518). As pope, Alessandro acquired titles for his family. In 1537, he created the Duchy of Castro for son Pier Luigi (the family owned land here, given to grandfather Ranuccio for military service as the papal *gonfaloniere* of Eugene IV). Alessandro's boldest move was to make the Farnese ducal rulers of Parma and Piacenza in 1545. His grandson and namesake, Alessandro (d. 1589), whom he made a cardinal, became one of the most wealthy patrons of the arts in 16TH–century Rome (see Cinquecento History Notes 1534 and 1535).

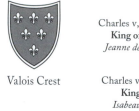

Valois Crest

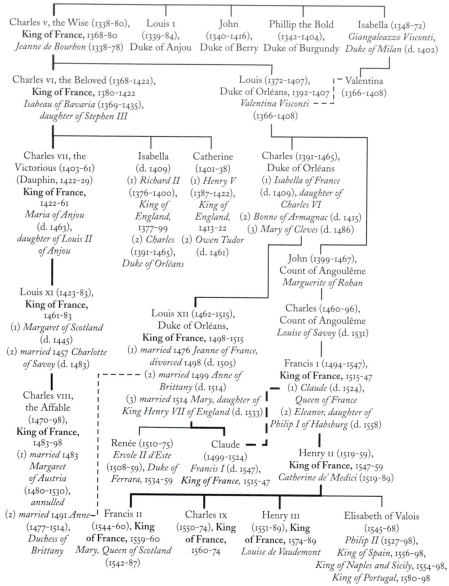

Charles v, the Wise (1338-80),
King of France, 1368-80
Jeanne de Bourbon (1338-78)

Louis I
(1339-84),
Duke of Anjou

John
(1340-1416),
Duke of Berry

Phillip the Bold
(1342-1404),
Duke of Burgundy

Isabella (1348-72)
Giangaleazzo Visconti,
Duke of Milan (d. 1402)

Charles vi, the Beloved (1368-1422),
King of France, 1380-1422
Isabeau of Bavaria (1369-1435),
daughter of Stephen III

Louis (1372-1407),
Duke of Orléans, 1392-1407
Valentina Visconti
(1366-1408)

Valentina
(1366-1408)

Charles vii, the
Victorious (1403-61)
(Dauphin, 1422-29)
King of France,
1422-61
Maria of Anjou
(d. 1463),
daughter of Louis II
of Anjou

Isabella
(d. 1409)
(1) *Richard II*
(1376-1400),
King of
England,
1377-99
(2) *Charles*
(1391-1465),
Duke of Orléans

Catherine
(1401-38)
(1) *Henry V*
(1387-1422),
King of
England,
1413-22
(2) *Owen Tudor*
(d. 1461)

Charles (1391-1465),
Duke of Orléans
(1) *Isabella of France*
(d. 1409), *daughter of*
Charles VI
(2) *Bonne of Armagnac* (d. 1415)
(3) *Mary of Cleves* (d. 1486)

John (1399-1467),
Count of Angoulême
Marguerite of Rohan

Louis xi (1423-83),
King of France,
1461-83
(1) *Margaret of Scotland*
(d. 1445)
(2) *married 1457 Charlotte*
of Savoy (d. 1483)

Louis xii (1462-1515),
Duke of Orléans,
King of France, 1498-1515
(1) *married 1476 Jeanne of France,*
divorced 1498 (d. 1505)
(2) *married 1499 Anne of*
Brittany (d. 1514)
(3) *married 1514 Mary, daughter of*
King Henry VII of England (d. 1533)

Charles (1460-96),
Count of Angoulême
Louise of Savoy (d. 1531)

Francis i (1494-1547),
King of France, 1515-47
(1) *Claude* (d. 1524),
Queen of France
(2) *Eleanor, daughter of*
Philip I of Habsburg (d. 1558)

Charles viii,
the Affable
(1470-98),
King of France,
1483-98
(1) *married 1483*
Margaret
of Austria
(1480-1530),
annulled
(2) *married 1491 Anne*
(1477-1514),
Duchess of
Brittany

Renée (1510-75)
Ercole II d'Este
(1508-59), *Duke of*
Ferrara, 1534-59

Claude
(1499-1524)
Francis I (d. 1547),
***King of France,** 1515-47*

Henry ii (1519-59),
King of France, 1547-59
Catherine de' Medici (1519-89)

Francis ii
(1544-60), **King**
of France, 1559-60
Mary, Queen of Scotland
(1542-87)

Charles ix
(1550-74), **King**
of France,
1560-74

Henry iii
(1551-89), **King**
of France, 1574-89
Louise de Vaudemont

Elisabeth of Valois
(1545-68)
Philip II (1527-98),
King of Spain, 1556-98,
King of Naples and Sicily, 1554-98,
King of Portugal, 1580-98

V–6. House of Valois Genealogy. Shown here are selected members of the French royal families who descended through the Valois line. A descendant of both the Valois and Angevin lines, King Charles viii of France invaded Italy in 1494 to claim the Neapolitan throne, a title his ancestors had held. But Charles was driven from Italy in 1495 (see Quattrocento History Notes 1494 and 1495). King Louis xii, Charles xii's successor, had blood ties to the Visconti of Milan; he invaded Italy in 1499, a claimant of the ducal throne of Milan (see Quattrocento History Notes 1499). Under Louis xii's reign, the French would control Milan until 1512 (see fig. V–1). Louis xii's successor, King Francis i (also a descendant of the Valois and Visconti lines), successfully recaptured Milan in 1515, but the French were expelled from Italy in 1523 and would lose their struggle for Milan to Emperor Charles v. In 1535, the Spanish took outright control of the duchy of Milan (see Cinquecento History Notes 1515, 1523, 1524, 1526, 1529, and 1535.). Although Francis had to relinquish all claims to territories in Italy, he never lost his fascination with Italian art. In his palace at Fontainebleau he employed Cellini, Il Rosso, Primaticcio, and others (see fig. 58–2).

Early Quattrocento Florence saw the influx of many artists from nearby towns and villages, brought there by the prospect of finding work, as the city was engaged in large communal projects. These ranged from the creation of bronze reliefs for the baptistery doors to the completion of the new cathedral and the execution of marble statues for its exterior. In addition, marble and bronze statues were being commissioned for the famous granary and shrine, Orsanmichele, that housed a miracle-working Madonna. Florence offered a variety of work for artists, and patronage took the form of corporate and private commissions for religious and secular purposes. Among the many Florentine patrons, one family stands out for their significant contribution throughout the century: the house of the Medici.

Three members of the Medici family were especially important to the social and political success the family enjoyed in their native Florence. Fame and prosperity came to them because as merchant-bankers they were very good business strategists; and they were living in a commune that measured its economic accomplishments by its banking and mercantile successes. Tradesmen like the Medici could never have attained the prominent social or political status they had in Florence if they had been living in towns governed by nobles (Venice) or titled rulers (Milan and Naples). Furthermore, they were neither aristocracy nor skilled *condottieri*, as were the lordly rulers of Ferrara, Mantua, and Urbino. Instead, Cosimo de' Medici talked about himself as a citizen among citizens (*popolani*), a representative of the people, and it was the structure of the Florentine government that made it possible for such men as the Medici to distinguish themselves. With its Guelph ties to the papacy and its tradition of successful banking houses (Peruzzi and Bardi), Florence produced families like the Medici who embraced the role of patron and protector of the city. Members of the House of Medici thus became notable patrons. They commissioned art for their private enjoyment (palaces and villas) as well as for the communal good (town hall and churches and [cont. page 290]

61–1. JACOPO PONTORMO. *Portrait of Cosimo the Elder de' Medici*, ca. 1518–19, wood, 33.9" x 25.7" (86 x 65 cm), Uffizi Gallery, Florence. Pontormo based his portrait on a medallion showing Cosimo de' Medici's head in profile. The medallion was made after the death of Cosimo and shows emblems of peace and liberty on the reverse. About 1474, Botticelli depicted this medallion in the hands of the sitter in his portrait, *Portrait of a Man with a Medal of Cosimo de' Medici* (Uffizi Gallery, Florence). Pontormo presents viewers with a nearly full-length view of a pensive Cosimo, seemingly reflecting on his role as the father of his family and country. The posthumous title granted to him in 1466 was for his contributions to Florentine liberty, and it reads: COSMVS MEDICES / PVBLICO DECRETO / PATER PATRIAE (Cosimo de' Medici is publicly decreed the Father of his Country). Granted two years after his death, the communal decree was inscribed on his tomb slab in S. Lorenzo, and appears abbreviated in the portrait in the initials inscribed on the chair back (COSM MED / ICES P.P. / P.). Next to Cosimo are laurel branches with a scroll entwined around them; the inscription is from Virgil ("when one is torn off, there is no lack of another"), and the branches and scroll refer to fame (laurel) and to the never-ending house of Medici.

61–2. This illustration identifies selected members of the House of Medici, whose crest has six *palle* (balls). In 1465 the Medici were granted the right by King Louis XI of France to include the royal fleur-de-lis on the family arms, and it was placed on one of the *palle* (see crest on the left); a crown was added in 1569 when Cosimo I became Grand Duke of Tuscany (see crest on the right). The darkened lines show the succeeding leadership of the House of Medici, with the names of the patriarchs in bold type.

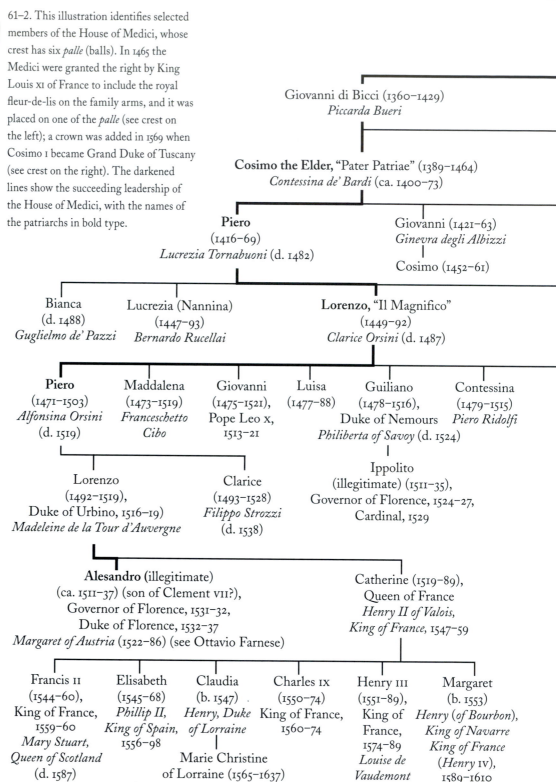

Giovanni di Bicci (1360–1429)
Piccarda Bueri

Cosimo the Elder, "Pater Patriae" (1389–1464)
Contessina de' Bardi (ca. 1400–73)

Piero
(1416–69)
Lucrezia Tornabuoni (d. 1482)

Giovanni (1421–63)
Ginevra degli Albizzi

Cosimo (1452–61)

Bianca
(d. 1488)
Guglielmo de' Pazzi

Lucrezia (Nannina)
(1447–93)
Bernardo Rucellai

Lorenzo, "Il Magnifico"
(1449–92)
Clarice Orsini (d. 1487)

Piero
(1471–1503)
Alfonsina Orsini
(d. 1519)

Maddalena
(1473–1519)
Franceschetto Cibo

Giovanni
(1475–1521),
Pope Leo X,
1513–21

Luisa
(1477–88)

Guiliano
(1478–1516),
Duke of Nemours
Philiberta of Savoy (d. 1524)

Contessina
(1479–1515)
Piero Ridolfi

Lorenzo
(1492–1519),
Duke of Urbino, 1516–19)
Madeleine de la Tour d'Auvergne

Clarice
(1493–1528)
Filippo Strozzi
(d. 1538)

Ippolito
(illegitimate) (1511–35),
Governor of Florence, 1524–27,
Cardinal, 1529

Alesandro (illegitimate)
(ca. 1511–37) (son of Clement VII?),
Governor of Florence, 1531–32,
Duke of Florence, 1532–37
Margaret of Austria (1522–86) (see Ottavio Farnese)

Catherine (1519–89),
Queen of France
Henry II of Valois,
King of France, 1547–59

Francis II
(1544–60),
King of France,
1559–60
Mary Stuart,
Queen of Scotland
(d. 1587)

Elisabeth
(1545–68)
Phillip II,
King of Spain,
1556–98

Claudia
(b. 1547)
Henry, Duke
of Lorraine

Marie Christine
of Lorraine (1565–1637)
Ferdinando I, Grand Duke of Tuscany – – – – – – – – –

Charles IX
(1550–74)
King of France,
1560–74

Henry III
(1551–89),
King of
France,
1574–89
Louise de
Vaudemont

Margaret
(b. 1553)
Henry (of Bourbon),
King of Navarre
King of France
(Henry IV),
1589–1610

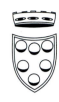

Averardo (called Bicci) d. 1363

Francesco
d. 1402

Lorenzo, "Il Vecchio" (1395–1440)
Ginevra Cavalcanti

Pierfrancesco the Elder (1430–76)
Laudomia Acciaiuoli

Carlo
(illegitimate)
(1430–92)

Lorenzo, "Il Popolano" (1463–1503)
Semiramide d'Appiano (d. 1523)

Giovanni, "Il Popolano"
(1467–98)
Caterina Sforza (1463–1509)

Pierfrancesco
(1487–1525)
Maria Soderini

Maria (illegitimate)
Leonetto Rossi

Luigi Rossi, Cardinal

Lorenzino
(1514–48)

Giuliano
(1453–78)

Lucrezia
(1470–?1550)
Jacopo Salviati

Giovanni delle Bande Nere
(1498–1526)
Maria Salviati (d. 1543)

Giulio (illegitimate)
(1478–1534),
Governor of Florence,
1519–23
Pope Clement VII,
1523–34

Francesca
(1482–1546)
Ottavio Medici

Maria
(1499–1543)
*Giovanni delle
Bande Nere*
(1498–1526)

Cosimo I
(1519–74),
Duke of Florence, 1537–69,
Grand Duke of Tuscany, 1569–74
(1) *Eleonora of Toledo* (1522–62)
(2) *Camilla Martelli* (d. 1590)

Alessandro
(1535–1605),
Pope Leo XI, 1605

Francesco I
(1541–87),
Grand Duke of Tuscany, 1574–87
(1) *Joanna of Austria* (d. 1578)
(2) *Bianca Cappello* (d. 1587)

Lucrezia
(1545–61),
*Alfonso II d'Este,
Duke of Ferrara*
(d. 1597)

Ferdinando I
(1549–1609),
Grand Duke of Tuscany, 1587–1609
Marie Christine of Lorraine (d. 1637)

Eleonora
(1567–1611)
*Vincenzo Gonzaga,
Duke of Mantua*
(d. 1612)

Marie
(1573–1642),
Queen of France
*Henry IV of Bourbon
King of France,* 1589–1610

Cosimo II
(1590–1621),
Grand Duke of Tuscany, 1609–21
*Maria Maddalena Habsburg
of Austria* (d. 1629)

convents). The overarching legacy of these three Medici was to change the structure of Florentine government by laying the foundation for their heirs to become titled rulers, with distant descendants becoming popes, dukes, and monarchs.

COSIMO DE' MEDICI (1389–1464) — Giovanni di Bicci (1360–1429) founded the family fortune on profits amassed from international banking. As heir to the family business, his son Cosimo quickly learned the family trade and political skills necessary to increase his family's status. Within four years of his father's death, Cosimo had become a major threat to many ambitious families in Florence; in 1433 he was forced from the city by the maneuvering of the Albizzi clan. After spending a year in Venice in exile, Cosimo was recalled to Florence in 1434. Once he was back in town, he formed exacting alliances with families that contributed to an expansive power base for his own family. He then began to transform the future of Florence. He funded scholars, founded libraries and schools, hosted popes, foreign dignitaries, and humanists, and repeatedly hired his favorite architects (Michelozzo), sculptors (Donatello), and painters (Fra Filippo Lippi and Fra Angelico). Medici funds helped to rebuild S. Lorenzo, the church and monastery of S. Marco, and the family palace on the Via Larga (see fig. 64–2).

PIERO DE' MEDICI (1418–69) — When Cosimo died, rival families sought to usurp power from the Medici. Piero the Gouty (Cosimo's heir) suffered from a crippling illness. His perceived weakness prompted a conspiracy in 1466 that was aborted, leading to the downfall of the wealthy Luca Pitti (see fig. 64–6) and bringing much-needed respect to Piero. Until his death, he maintained prominence for his family and diplomatically negotiated communal affairs. Politically shrewd, he was responsible for having the government bestow the title *Pater Patriae* upon the deceased Cosimo, an unprecedented honor for a private citizen in Florence. These words appear on Verrocchio's tomb slab in the family's parish church of S. Lorenzo, the rebuilding of which Piero's grandfather had spearheaded by hiring Brunelleschi to create a new sacristy for the church (now called the Old Sacristy). Piero was a patron of many artists (Gozzoli, Luca della Robbia, Donatello, Uccello,

and Michelozzo), and he secured funds for the expansion of the Servite church SS. Annunziata.

LORENZO DE' MEDICI (1449–92) — Lorenzo was twenty years old when he became the head of his family. In this year, he had a tournament staged (based on Luigi Pulci's poem *La Giostra di Lorenzo de' Medici*) to celebrate his engagement to Clarice Orsini of the powerful Roman family. Three days of celebrations were held at the new Medici palace, and the marriage took place at S. Lorenzo. But just as his father's authority had been challenged early in his tenure as head of the family, Lorenzo and his brother (Giuliano) were the victims of a conspiracy as well. In 1478 members of the Pazzi family attacked them after Easter mass in the Florentine Duomo (see Quattrocento History Notes 1478). Giuliano died and Lorenzo escaped. Florentines backed the Medici and, although both the papacy and Naples wanted to eliminate the power of the Medici in Florence, Lorenzo managed to negotiate a peaceful agreement first with Naples and then with Rome. During his tenure as unofficial head of state, he was called Il Magnifico in respect of his authority, for he had ties with every aspect of Florentine affairs. He was both a poet and a patron of literati, he brokered marriages and sent artists to work for important allies, and he encouraged Florentine families like the Sassetti, Tornabuoni, and Strozzi to commission art. For his own town palace he hired Pollaiuolo to paint panels and make small bronze figures; for his villa at Spedaletto he employed the best mural painters (Perugino, Ghirlandaio, Botticelli, Filippino Lippi), and for his new villa at Poggio a Caiano, he hired the gifted Giuliano da Sangallo to design and build it. The antiquities he inherited from his father and grandfather whetted his taste for precious antique objects (medals, vases, cups, bronze statuettes, gems, cameos, and jewels), and the collection he amassed became a wellspring for artists he employed. In 1494, two years after his death, Florence exiled his son Piero (known as the Unfortunate One), and Lorenzo was accused of having embezzled communal funds. After the French invaded Italy, a new government was ushered into Florence, headed by the Dominican preacher and reformer Savonarola, who was bent on reforming the city (see Quattrocento History Notes 1494, 1495, and 1497).

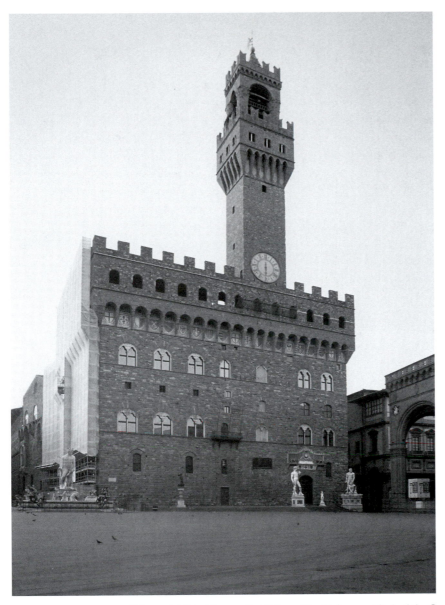

62–2. House of Anjou.

62–3. Guelph Party.

62–4. Ghibelline Party.

62–5. Papal Insignia.

62–6. Capitano del Popolo.

62–1. ARNOLFO DI CAMBIO. Palazzo dei Priori (now called Palazzo Vecchio), west side, built by Guelph government, 1299–1322, pietra forte, Florence. A corner of the Loggia dei Lanzi with the Palazzo degli Uffizi in the background is seen on the far right. In front of the palace is the large Piazza della Signoria, where the Dominican preacher Savonarola was executed (a plaque now marks the spot). The palace was built as the new town hall for the Guelph government, with the entrance on the north side. It housed the *gonfaloniere di giustizia* (captain or standard bearer of justice) and the *priori* (priors), elected from the trade guilds. When Florence became a republic, the palace was enlarged (1495–1511) on the east side to include a large audience chamber (Room of the Five Hundred). When Savonarola controlled popular opinion, an inscription was placed over the new main entrance (west side) declaring that Florence was under the rule of God. Following Savonarola's execution (1498), the marble statue of a nude *David* was created by Michelangelo and was placed beside the main portal in 1504. The crests (see figs. 62–2 to 62–6) and fifteen others (all 20 of these under the crenellations) bear insignia of city wards and religious and political factions.

62–7. The numbered monuments on this map of Florence are identified in the key below, each singled out for its importance to the period.

KEY TO MAP.

1. **Cathedral** (S. Maria del Fiore), called Il Duomo, replaced S. Reparata; new church dedicated to the Virgin, 25 March 1436

2. **Baptistery of S. John** (S. Giovanni) (see fig. 2–3), A. Pisano's doors (1330–36); Ghiberti's first doors (1403–24) and his second (1425–52)

3. **Cathedral Bell Tower** (Campanile), designed by Giotto (1334) and dedicated to the Redeemer; supervised by A. Pisano (1337–48)

4. **Florentine Abbey** (Badia Fiorentina), dedicated to the Virgin; built 978; rebuilt ca. 1284

5. **Oratory of S. Michael** (Orsanmichele), granary and shrine (see fig. 63–1)

6. **Bargello Palace** (Palazzo del Popolo and del Podestà, 13TH c.; del Bargello, 16TH c.), first town hall, built 1255–60, seat of chief magistrate, *capitano del popolo* (see fig. 62–6)

7. **Town Hall** (Palazzo dei Priori, 14TH c.; della Signoria, 15TH c.; Vecchio, 16TH c.) (see fig. 62–1)

8. **Loggia of the Priors** (Loggia dell'Orcagna, dei Priori, della Signoria, and dei Lanzi), built for outdoor ceremonies (1376–82)

9. **Palace of the Offices** (Palazzo degli Uffizi), begun Vasari 1559; finished Buontalenti 1580

10. **Church of the Holy Cross** (S. Croce) (see fig. 16–4)

11. **Buonarroti House** (Casa Buonarroti) (see Michelangelo)

12. **Church of S. Ambrose** (S. Ambrogio), oldest nunnery in town (Benedictine nuns installed by late–10TH c.); church rebuilt late–1200s; interior redesigned in the 1400s

13. **S. Mary Magdalene of the Pazzi** (S. Maria Maddalena di Cestello; degli Angeli; de' Pazzi), founded as a convent for penitent women (1257); given over to Cistercian nuns in 1321; given over to Cistercian monks in 1442

14. **S. Eligius** (S. Egidio), called New S. Mary (S. Maria Nuova), founded in 1286 by Folco Portinari as a hospital with a small church; church rebuilt 1418–20; Pope Martin v consecrated the church to the Virgin Mary (1420)

15. **Foundling Hospital** (Ospedale di S. Maria degli Innocenti) (see Brunelleschi)

16. **Church of the Most Holy Annunciation** (SS. Annunziata), Servite church (see Andrea del Sarto)

17. **Church and Convent of S. Mark** (S. Marco) (see Fra Angelico), founded 1299; rebuilt 1442 (Dominicans installed)

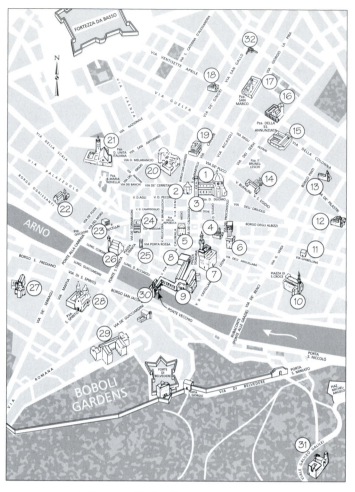

18. **Convent of S. Apollonia**, Benedictine nuns

19. **Medici-Riccardi Palace** (Palazzo Medici) (see fig. 64–2)

20. **Church of S. Lawrence** (S. Lorenzo), oldest church in town, enlarged 11TH c.; rebuilt 15TH c. (see Brunelleschi)

21. **New Church of S. Mary** (S. Maria Novella) Dominican, dedicated to Assumption of the Virgin (see Alberti)

22. **Church of All Saints** (Ognissanti), built 1251–60 by Umiliati monks; Franciscans installed 1561

23. **Rucellai Palace** (Palazzo Rucellai) (see fig. 64–4)

24. **Strozzi Palace** (Palazzo Strozzi) (see fig. 64–5)

25. **Davanzati Palace** (formerly Davizzi) (see fig. 64–1)

26. **Church of the Holy Trinity** (S. Trinità), Vallombrosan by 1077; became abbey (1183); redesigned (1250s)

27. **S. Mary of the Carmelites** (S. Maria del Carmine)

28. **Church of the Holy Spirit** (S. Spirito), built 1260s by Augustinian friars; rebuilt 15TH c. (see Brunelleschi)

29. **Pitti Palace** (Palazzo Pitti) (see fig. 64–6)

30. **Old Bridge** (Ponte Vecchio), oldest bridge in town

31. **Church of S. Minias** (S. Miniato al Monte) (see fig. 2–2)

32. **Pandolfini Palace** (Palazzo Pandolfini) (see fig. 64–7)

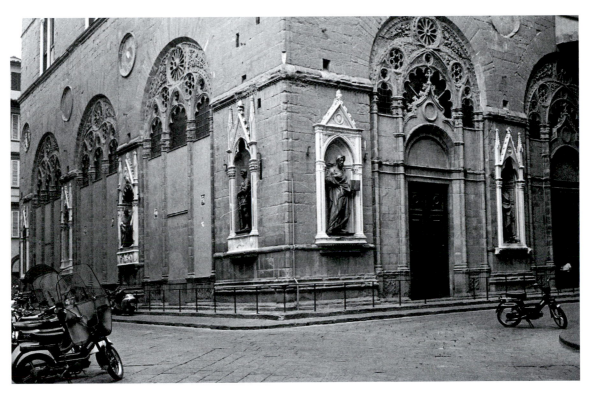

63–1. Orsanmichele, 1336–1404, sandstone, h. 133'6.3" x 73'5.9" x 108'11.1" (40.7 x 22.4 x 33.2 m), Florence. This view shows entrances to the corporate guild hall of Orsanmichele from the Via della Lana (see fig. 63–11), a street named for the wool guild (Arte della Lana). Florentine guilds paid for all but one of the fourteen exterior statues (and tabernacles) of the building. Between the two doors shown here is a tabernacle with the bronze statue of the patron saint of the wool guild (far right), Lorenzo Ghiberti's *Stephen,* who faces the guild palace. Occupying the two niches of the nearest corner pier are Donatello's *George* (the original marble statue was replaced by a bronze replica, executed in 1892) and Ghiberti's *Matthew,* a bronze statue for the guild of bankers (see fig. 63–13). Replicas now replace most of the statues, which are in museums in Florence at Orsanmichele, S. Croce, and the Bargello.

From the late–thirteenth through the fifteenth centuries, trade guilds were important to the patronage and governance of Florence. In 1282, it was formally decided that members of the legislative branch of the republican government of Florence were to be elected from guilds. These legislators, called priors, served two-month terms and came almost exclusively from the seven major guilds, although selection was also opened to members from five of the fourteen minor guilds. The seven greater or major guilds controlled Florentine business and municipal government, and these were comprised of judges, bankers, doctors, merchants of domestic and imported cloth, importers of spices, and manufacturers and refiners of wool and silk. Because of their fiscal soundness and prominence in government, the major guilds were called upon to support costly building programs: the Calimala guild (cloth merchants) took full responsibility for the baptistery, and the Lana guild (wool merchants) sponsored projects at the cathedral and the town hall. Each guild had a residence, rules for governance, patron saint, and banner that bore the emblem of the guild (see fig. 63–11). Florentine citizens could belong to more than one guild, and artists joined guilds regulating the materials of their trade. The sculptor Lorenzo Ghiberti, for instance, joined the guild of stonemasons to create works in marble and the smiths to execute works in bronze. Merchant

63–2. Guild crest of the judges (lawyers) and notaries (Arte dei Giudici e Notai). Their patron saint was Luke the Evangelist.

63–3. Guild crest of the merchants of imported cloth (Arte di Calimala). Their patron saint was John the Baptist (prophet and patron saint of Florence). Merchant-bankers like the Medici were in this guild.

63–4. Guild crest of the bankers and money-changers (Arte del Cambio). The patron saint was Matthew, the tax collector who became an apostle (and Evangelist).

63–5. Guild crest of the wool merchants (Arte della Lana). Their patron saint was the first Christian martyr, Stephen. On their crest is a lamb with a cross, emblem of the city's patron saint.

63–6. Guild crest of the silk manufacturers (Arte della Seta or Por S. Maria). Their patron saint was John the Apostle (and Evangelist).

63–7. Guild crest of the furriers (Arte dei Vaiai e Pellicciai). Their patron saint was the apostle James Major.

bankers, like Cosimo de' Medici (1389–1464), found it efficient to move fluidly within the major guilds to reap professional benefits and gain stronger representation in town government. During the fourteenth and fifteenth centuries, when Florentine government was controlled by such shrewd businessmen as the Bardi, Medici, Pazzi, Pitti, and Strozzi, communal art was sponsored and a lively competition was encouraged among bright young artists, like Nanni di Banco, Ghiberti, Brunelleschi, and Donatello. However, when Florence became a duchy (16TH c.) the political significance of guilds was eroded, and the guilds were suppressed by order of the Grand Duke of Tuscany, Peter Leopold of Lorraine (late–18TH c.).

In 1336, when it was decided to re-build the burnt-out granary and shrine that was Orsanmichele, the guilds were asked to sponsor the new building campaign, which proposed a three-story structure with an open arcade on the ground story. The old Orsanmichele had provided shelter for both the selling of commodities and devotion to the miracle-working shrine, called *Madonna delle Grazie* (see Andrea di Cione). About forty years after the new construction was begun, a decision was made to enclose the arcades and turn the lower floor exclusively into a church, thus dashing the plans for an open-air arcade (curtain

walls in the arches can be seen in fig. 63–1). Orsanmichele was completed in 1404. Two years later, twelve guilds (the seven major and five minor guilds) were given ten years in which to commission, finance, and oversee the construction of tabernacles and the creation of statues for the exterior niches (since the original assignment of niches in 1339, only four guilds had built and filled their tabernacles: wool, silk, doctors, and judges). If a guild failed to meet the new deadline, all rights to the designated space were forfeited. The medium and style of the statue were to be decided by the patron guild. Major guilds more often chose bronze statues and minor guilds typically commissioned marble statues; however, two major guilds purchased marble statues (doctors and furriers). All but one of the marble statues show that gilding (traces remain) was applied to areas of the drapery. Guild medallions were placed near tabernacles, and empty circular cavities show where such crests were installed. Minor guilds that were not assigned exterior piers were granted interior piers and wall space for commissioning images of patron saints.

MAJOR GUILD STATUES

GIUDICI E NOTAI (judges and notaries). The bronze *S. Luke*, ca. 1597–1602, was executed by Giovanni da Bologna, called Giambologna (1529–1608). It replaced Niccolò di Pietro Lamberti's marble *Luke*, 1403–6, 7'5" (226 cm), removed from the niche in 1601 (now Bargello, Florence). Giambologna's *Luke* is the last statue made for Orsanmichele.

CALIMALA (cloth merchants). This was arguably the most powerful guild in town; they sponsored works at the baptistery and their emblem appeared many places in Florence. The guild

was named after the street (within steps of Orsanmichele) where their warehouses were found, and their tabernacle has a prominent place on Via dei Calzaiuoli (see fig. 63–11), a main street street linking the cathedral and town hall. Their emblem (see fig. 63–3) has an eagle perched on bales of cloth. Lorenzo Ghiberti designed and cast the gilded bronze *S. John the Baptist*, 1413–16, 8'4.3"(255 cm); he also designed the tabernacle, executed by Giuliano di Arrigo Pesello, Albizzio di Piero, and Frate Bernardo di Stefano (ca. 1414–16).

CAMBIO (bankers and money-lenders). The Cambio purchased the niche for the statue of their patron saint from the bakers' guild in 1419. Lorenzo Ghiberti created the figure, the bronze *S. Matthew*, 1419–23, and also designed a new tabernacle for the statue (see fig. 63–13). Ghiberti's chief assistants for this project were Michelozzo di Bartolommeo (who later worked with Donatello), Jacopo di Piero, and Pagolo. Inscribed on Matthew's hem is the date 1420, referring to the completion date of the model (not the cast). When parts of the casting failed in 1421, the guild ordered them to be recast at the guild's expense.

LANA (wool). The wool industry was founded in Florence by the Umiliati monks of Lombardy who built the convent and church of Ognissanti (13TH c.). By the Trecento, the wool business was both thriving and critical to the city's economy. In 1331, the OPERA of the Duomo was placed under the protection of this very powerful guild (see Trecento Glossary). When the guild decided

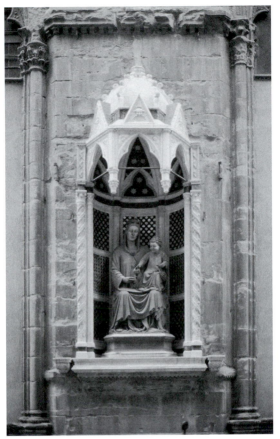

(16 April 1425) to replace the existing marble statue of their patron saint, the work of Andrea Pisano (ca. 1339), with a new gilded bronze statue, they hired Lorenzo Ghiberti to create *S. Stephen*, 7'6.5" (230 cm). He completed the model in 1427, and the statue was finished by 1 February 1429.

MEDICI E SPEZIALI (doctors and pharmacists). *Madonna of the Rose* (see figs. 63–8, 63–9) was created about 1399. This is the only tabernacle at Orsanmichele with a canopy and seated figures. The canopy shape and the Virgin's stern monumentality are meant to remind people of the miraculous *Madonna delle Grazie* inside Orsanmichele (see Andrea di Cione).

SETA (silk manufacturers). In the 15TH century, this guild was to eclipse the declining wool guild. Baccio da

63–8. SIMONE FERRUCCI DA FIESOLE *Madonna of the Rose* (now a replica), 1399, marble, h. 6'.9"(185 cm), Orsanmichele, Florence. The statue was commissioned by the guild of doctors and pharmacists (see fig. 63–9). It has been attributed to Pietro di Giovanni Tedesco and mistakenly identified as the lost Madonna and Child of Niccolò di Pietro Lamberti, a work commissioned for the Florence Duomo in 1395. Here, a regal Madonna presents a joyful Messiah, who holds a goldfinch (symbol of Christ's Passion) and takes a rose (symbol of Mary's purity) from the Virgin Mother's garland.

63–9. Guild crest of the doctors and pharmacists (Arte dei Medici e Speziali), the guild to which painters also belonged. The guild's emblem recalls the tradition that Luke the Evangelist (remembered as both a doctor and an artist) created an image of the holy couple after a vision he had of them.

63–10. Crest of the Guelph Party (see fig. 63–11). After gaining great prominence in Florence in the Trecento, they had lost most of their power by the mid–15TH c. and sold their niche to the Mercanzia in 1463. Donatello's *S. Louis of Toulouse* for the Guelph niche was sent to S. Croce about 1460.

Montelupo (1469–1535) created the bronze *S. John the Evangelist* in 1515, measuring about 7'6" (228.6 cm). Baccio received 300 gold florins for *S. John*, which replaced a smaller, marble statue (ca. 1377); the tabernacle niche was redesigned in 1414–16. Goldsmiths belonged to the guild of silk merchants. The emblem of the silk guild is a city gate called the Porta (Por) S. Maria, that dates back to the Roman settlement and is on the street leading to the workshops of the silk manufacturers.

VAIAI E PELLICCIAI (furriers). The marble statue of the patron saint, *James Major*, 5'8.9" (175 cm), created about 1422, is attributed to Niccolò di Pietro Lamberti

or alternatively to Bernardo Ciuffagni and Nanni di Banco. Marble reliefs of *S. James in Glory* (above the statue) and the *Martyrdom of S. James* (at the base of the statue) adorn the tabernacle.

NON-GUILD STATUES

GUELPH (political party supporting the papacy). About 1422–25, Donatello created for the Guelph Party (see fig. 63–11) the gilt-bronze sculpture, *S. Louis of Toulouse*, 8'9" (266 cm). He also designed the tabernacle, the largest at Orsanmichele and most fully antique in its pediment, fluted pilasters, spiral columns, carved garlands, winged putti, and antique Roman heads (see fig. 36–1).

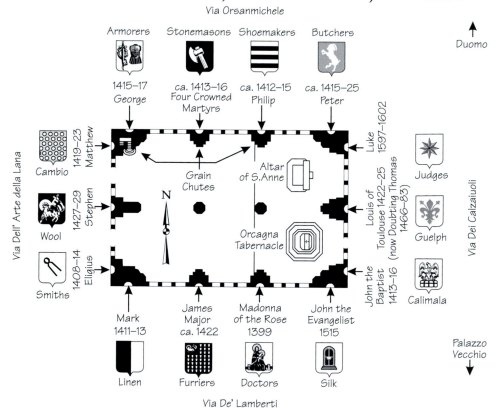

Exterior Tabernacles, Orsanmichele, Florence

63–11. This Orsanmichele plan shows the exterior tabernacles, with images of major guild crests and the names of patron saints beside the tabernacles. In two decades (1408–29), three sculptors created nine statues at Orsanmichele: Nanni (*Eligius*, *Philip*, and *Four Crowned Martyrs*), Ghiberti (*John the Baptist*, *Matthew*, and *Stephen*), and Donatello (*Mark*, *George*, and *Louis of Toulouse*). These commissions coincided with work for the baptistery (Ghiberti) and the Duomo (Nanni, Ghiberti, and Donatello).

<div style="border: 1px solid black;">

Minor Guild Crests, Orsanmichele, Florence

Butchers
(Arte dei Beccai), Peter

Shoemakers
(Arte dei Calzolai), Philip

Blacksmiths
(Arte dei Fabbri), Eligius

Stonemasons and woodworkers
(Arte di Pietra e Legname), Four Crowned Martyrs

Linen drapers, secondhand dealers, tailors (Arte dei Linaiuoli e Rigattieri), Mark

Armorers and swordmakers
(Arte dei Corazzai e Spadai), George

Innkeepers
(Arte degli Albergatori), Julian

Oil makers and cheese mongers
(Arte degli Oliandoli e Pizzicagnoli), Bartholomew

Leather workers and tanners (Arte dei Cuoiai e Galigai), Augustine

Vintners
(Arte dei Vinattieri), Martin

Harness makers
(Arte dei Correggiai), Holy Trinity

Timber merchants (Arte dei Legnaioli), the Annunciation

Locksmiths
(Arte dei Chiavaioli), Zenobius

Bakers
(Arte dei Fornai), Lawrence

</div>

63–12. In this illustration are crests of fourteen minor Florentine guilds, each identified by name and patron saint. There were about twenty-one primary guilds in 15ᵀᴴ–c. Florence (counting the seven major guilds), but the total number of guilds was subject to change. Gregorio (Goro) Dati's *Istoria* (ca. 1410), Book 9, briefly describes each guild, noting that the number of guilds and the trades within each fluctuated during the century. Although the minor guilds had less political clout than the major guilds, six of them owned tabernacles on the exterior of Orsanmichele. On the north side are the tabernacles of four of these: the butchers, shoemakers, stonemasons and woodworkers, and armorers and swordmakers. On the west side is the tabernacle of the blacksmith, and on the south side, that of the linen drapers, secondhand dealers, and tailors. The most important side of the building was on the main street, Via dei Calzaiuoli, the side closest to Orcagna's immense shrine that rises to the ceiling and houses the miracle-working *Madonna*.

MERCANZIA (merchants' tribunal). For the Mercanzia, Verrocchio created two bronze statues (Christ and Thomas), *The Incredulity of Thomas* (1466–83). The theme fit the tasks set before the tribunal (see fig. 36–1).

MINOR GUILD STATUES

BECCAI (butchers). Their crest shows a goat, and their patron saint was Peter. The sculptor responsible for the marble statue was perhaps Bernardo Ciuffagni,

following Brunelleschi's design. The statue is dated ca. 1415–25, and with its plinth stands 7'9.3" (237 cm). It was attributed to Donatello in the late–15ᵀᴴ c., and Vasari (16ᵀᴴ c.) thought it was a joint project contracted to Brunelleschi and Donatello. Brunelleschi (or Nanni di Banco) designed the tabernacle.

CALZOLAI (shoemakers). For this guild, Nanni di Banco created the marble *S. Philip*, 6'3.1" (191 cm), about 1412–15. Donatello apparently turned down the

same commission because the proposed payment was unacceptable to him.

FABBRI (blacksmiths). Their crest shows a tool of their trade. About 1408–14, Nanni di Banco created the marble *S. Eligius*, 6'3.3" (191 cm). The relief beneath the statue, also his work, represents a famous miracle of Eligius, who was also the patron saint of goldsmiths. While shoeing a horse, he removed the leg and miraculously replaced it after his work was finished, making the horse whole again.

PIETRA E LEGNAME (stonemasons and woodworkers). Four life-size marble statues stand in the guild niche, and these are Nanni di Banco's masterworks. Called *Four Crowned Martyrs*, they were created ca. 1413–16. Architects and sculptors belonged to this guild, and in the marble tabernacle relief Nanni carved four figures of sculptors in contemporary dress. Laboring in their workshop, they are building a wall, making a column shaft, carving a capital, and sculpting the figure of a nude male child.

LINAIUOLI E RIGATTIERI (linen drapers, secondhand dealers, tailors). Donatello was hired by the guild to create a marble *S. Mark*, which he completed 1411–13. Niccolò di Pietro Lamberti was appointed to design the niche (1410) and find and transport the marble from Carrara for the statue (1409). According to his contract, Donatello received the commission on 3 April 1411, and the statue was to be finished by 1 November 1412. Perfetto di Giovanni and Albizzo di Pietro were commissioned (1411) to execute the tabernacle. Conservation reports show that the hem and cuffs of the tunic and cloak had gilded highlights.

CORAZZAI E SPADAI (armorers and swordmakers). The guild crest displays armor and a sword, products of the guild's trades. Donatello's marble statue of the guild's patron saint, *George*, a legendary Christian soldier, dates to about 1415–17. For all its apparent stillness, the statue of George exudes monumental strength and courage, characteristics that are visibly apparent when the figure is viewed from below (see fig. 17–1). Installed in a corner niche (see fig. 63–1), it would seem that *George* was meant to stand guard over both the miraculous, enshrined *Madonna delle*

Grazie and the grain stored at Orsanmichele. For the preexisting Gothic-like tabernacle, Donatello designed highly illusionistic relief panels.

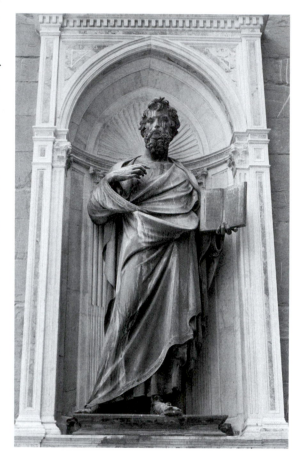

63–13. LORENZO GHIBERTI. *S. Matthew*, 1419–23, bronze, 8'10" (269.2 cm), Orsanmichele, Florence. *S. Matthew* is visibly dependent on such prototypes as antique Roman statues of orators, and his noble bearing was perhaps intended to remind Florentines of their legendary ancestors. Two stonemasons, Jacopo di Corso and Giovanni di Niccolò, were paid for work on the niche (in 1422). Two statuettes (now removed) were carved by Niccolò Aretino for the tabernacle top. More than other statues at Orsanmichele installed before 1425, Ghiberti's *Matthew* projects beyond the niche because of the shallowness of the niche (see also Donatello's *S. George*); the restricted depth of both tabernacles holding the statues of *George* and *Matthew* (see fig. 63–1) is due to the presence of an interior stairwell to the upper floors, where the commune stored grain. Ghiberti worked for three of the most powerful guilds (Calimala, Cambio, Lana) in Florence. The works of Ghiberti, Donatello, and Nanni at Orsanmichele inspired future generations, including Michelangelo, Cellini, and Giambologna.

In medieval and Renaissance Florence, middle-class artisans (shopkeepers, painters, sculptors) rented or sometimes owned apartments. However, poor families (combers, carders, weavers of wool) leased rooms in the working-class districts, could afford to live in only one or two rooms, and had to move frequently because of short-term leases. Only families of sizable wealth (nobles, merchants, bankers) purchased their own town houses or palaces. In these buildings, shops were on the ground level, the family lived on the upper floors, and the top floor—uncomfortably hot in summer months—was where servants lived. In the Palazzo Davanzati (see fig. 64–1) the great halls for gatherings and receptions faced the street, the dining rooms were adjacent to these halls, the bedrooms were near the back of the palace, and the kitchen (typically in the garret or attic) was on the fourth story. On the ground floor were storage areas and off the courtyard was a well from which buckets of water were drawn up by pulley through a shaft running through each floor in the palace. The owners also had the luxury of having latrines (near the bedrooms). Rooms in the Davanzati are still adorned with rich fresco decoration resembling tapestries, replete with lively foliate and figural motifs. Iron rings on the lower facade near the arched openings were for tying horses, and the long horizontal iron rods across the upper facade were for hanging objects, such as bird cages, wet clothes, festive banners, and leashes that tethered pet dogs and monkeys (see Masolino's fresco, *Raising of Tabitha*, Brancacci Chapel, S. Maria del Carmine, Florence). Ironwork next to the windows were for tapers and flagpoles. As was customary, the windows were covered not with glass, but with *impannate*, strips of oil-soaked linen stretched over wooden frames. After the Davanzati purchased the palace from the Davizzi (1578), they installed a huge family crest in the middle of the facade and created an open-air loggia on the top floor, thus changing the appearance of the original, crenellated roof. Before the addition of the loggia,

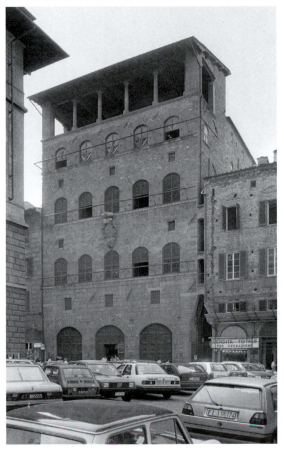

64–1. Palazzo Davanzati, begun ca. 1350, Florence. Crests of the families who owned the palace appear here at the upper left: the Davizzi (far left) and the Davanzati. A stairwell in the palace courtyard leads to five floors, with the living quarters on the upper levels. In the 15ᵀᴴ c., two (Davizzi) households comfortably resided in this tall palace, which has about twenty rooms in the private living quarters. The palace was built in an enviable part of town, as families such as the Salimbeni, Spini, Davizzi, Strozzi, and Davanzati owned the most highly prized land in Florence (near the Old Market and Orsanmichele). After Cosimo de' Medici (see fig. 64–2) returned to Florence from exile in 1434, he gained control of communal politics and managed to have many of his rivals (men like the wealthy Palla Strozzi) crushed by heavy taxes, whereby they lost valuable land holdings. For political reasons, Cosimo's grandson Lorenzo the Magnificent lifted the ban against the Strozzi and gave approval to a distant relative of Palla to build a palace in this part of town (see fig. 64–5).

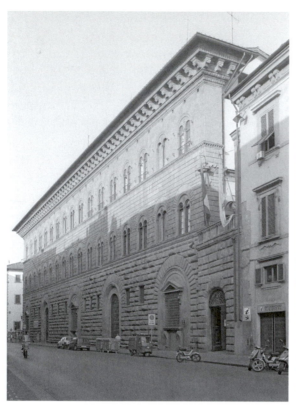

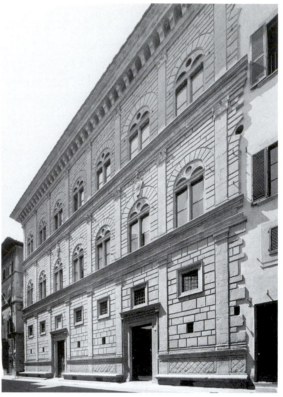

64–2 (above left). MICHELOZZO DI BARTOLOMMEO. Palazzo Medici (east side), begun ca. 1445, Florence. The original design had only one entrance to the palace from the Via Larga, which was in the center of the east side; the building was later expanded to the north, duplicating the original design. During the reign of Pope Leo x (great-grandson of Cosimo de' Medici) the exterior arches were enclosed, windows inserted (ca. 1517), and corbels designed by Michelangelo. Stone benches along the facades provided a waiting area for people having business with the Medici, while the private living quarters were off limits to the public.

64–3 (right). MICHELOZZO DI BARTOLOMMEO. Courtyard, Palazzo Medici, begun ca. 1445 (the Medici crest appears here on the left), Florence. The prominent, rusticated arches of the facade (see fig. 64–2) were substituted with more delicate arches in the courtyard, thus reflecting the difference between the public and private faces of the palace. Above the arcade is a frieze with sculptural medallions bearing the Medici crest and relief copies of antique gems and cameos, many executed after the highly prized originals acquired by the family (Cosimo and Piero).

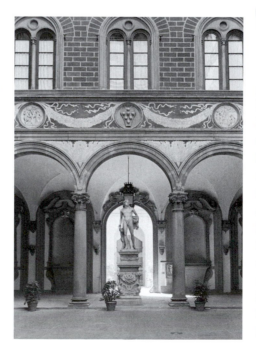

64–4 (above right). LEON BATTISTA ALBERTI. Palazzo Rucellai (and crest), begun ca. 1453–58 (built by Bernardo Rossellino, 1458–70), Florence. Like the Medici palace, there was only one street entrance to the Rucellai, originally in the center of the south side. Distinguishing this palace from the Medici are the engaged pilasters flanking mullioned windows on all stories, giving an *all'antica* look that is more elegant than the Palazzo Medici courtyard. Alberti's facade—too fancy for Quattrocento republican Florence—was not emulated (see Leon Battista Alberti).

the facade had a more uniform look (each story above the ground level has five large windows resting on a stringcourse, and all three upper stories were once equal in height). Although disrupting the regularity of the original design, the upper loggia mitigates the impression that the palace is squeezed into a row of tightfitting buildings and emphasizes the height of the palace, which is the tallest structure on the Via Porta Rossa. The surfaces of the stories vary: the first has smooth rustication, the second has a smooth stone facing, and the upper two stories are faced with rusticated ashlar. The tallest story is the ground level, which looks more fortified than the other stories. Yet, across town the rough-hewn ground level of the Palazzo Medici (see fig. 64–2), displaying a more expensive treatment of stones, seems more formidable and closely resembles civic buildings, like Palazzo Vecchio (see fig. 62–1).

Created for Cosimo de' Medici (now called the Elder to differentiate him from Cosimo 1), the Palazzo Medici ushered into Florence a new style of domestic architecture that became the model for Florentine town houses in the last half of the century. Designed by the architect-sculptor Michelozzo di Bartolommeo, the palace dominated the Via Larga. Rising about eighty feet above street level, it was taller than was then legally allowed. Through its great size and rustic appearance, the building expresses strength, power, and stability—traits ascribed to its owner, Cosimo. The massive stones on the ground level make it seem more like a civic bastion than a private residence. Yet it was built in the tradition of the Palazzo Davanzati, whose stories are distinguished from each other by the type and treatment of the facing stones; the differentiation between the stories is more noticeable in the Palazzo Medici, however, and the refined, classical-like mullioned windows derive from civic architecture, such as the Palazzo Vecchio. The inner court (see fig. 64–3) is also lighter and more elegant. Built of pietra serena (a gray sandstone) and white stucco (materials favored by Brunelleschi), the courtyard loggia appears antique-like in the use of classical motifs. Donatello's bronze *David* (see fig. 21–5) stood in the center of the courtyard (in 1469) and his bronze *Judith* (see fig. 21–8) in the garden

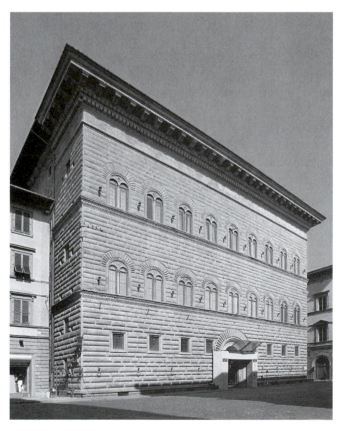

64–5. BENEDETTO DA MAIANO? (d. 1497). Palazzo Strozzi (east entrance) (and family crest), 1489–1536, Florence. The supervisor and chief stonemason (from February 1490) was Simone del Pollaiuolo (Il Cronaca, d. 1508), who may have designed the cornice and courtyard as well as the vaulting for the piano nobile (Cronaca was also working on the Hall of the Five Hundred of the town hall, 1495–98). This was the most magnificent town house in Quattrocento Florence. Rustication—intended to make palaces more stately, in the tradition of civic architecture—appears on all three stories, but the stonework is more refined than in the Palazzo Medici. Shops were excluded from the ground floor, the large courtyard is grander than those of earlier palaces, and elegantly crafted ironwork (for holding the reins of horses, torches, and banners) adorns each story. When Filippo died (1491), only the first story (up to the iron rings) was completed, but he had set aside money and land to be sold for its completion (it took another forty-five years to finish the palace).

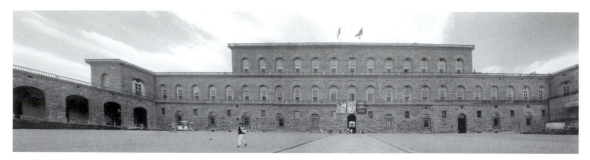

64–6. Palazzo Pitti (and Pitti's crest), ca. 1458–72, Florence. Brunelleschi is sometimes connected with the design of the palace (originally three stories tall and seven bays wide). About the same time that the Rucellai palace was nearing completion and three decades before the Strozzi was begun, Luca Pitti began his mansion across the Arno, melding the rustication of the Medici palace with the exacting regularity of the Rucellai. Luca's palace must have seemed like a town villa because of the stretch of land he owned around it and because of its distance from the center of town. In the 16TH c., it became the residence of the Medici ducal court, and the luxurious gardens behind the palace reached to the Porta Romana. The palace was several times expanded, with wings added in the 18TH and 19TH centuries.

beyond the loggia (in 1495). In Cosimo's lifetime, the most extraordinary room in the palace was the small chapel, which was also an audience-chamber.

About forty-five years after the Palazzo Medici was built, an even grander palace was begun in the older, fashionable center of Florence, near the Palazzo Davanzati. Here, the Palazzo Strozzi (see fig. 64–5) was erected as a freestanding house on a highly desirable plot of land. Resembling the Medici in its rustication, biforate windows, and projecting cornice, the treatment of the surface is, nonetheless, smoother and more refined, and the building is much taller, rising about twenty-five feet higher than the Medici. Built without large, rustic loggia arches that open onto the street, this oblong palace is more symmetrical, private, and inwardly contained. It seems that a major concern for the final design was to have a harmonic transition between the three stories of the facades. A garden was planned that would have extended south to the Via Porta Rossa, and the open piazza in front of the palace was cleared away after Filippo Strozzi—with Lorenzo de' Medici's approval—acquired land around the palace; Strozzi may have been modeling his palace partly after the Pitti Palace (see fig. 64–6). Yet Florentine town house gardens were not fully developed until the 16TH century, when the Boboli gardens were created for Medici dukes (see fig. 62–7, #29). Families like the Medici enjoyed town houses and the luxury of country houses upon which architects could lavish classical motifs and develop

exotic gardens. Not bound by restrictive communal building codes, Tuscan villa architecture of the late Quattrocento displays an enthusiasm for antique style that already thrived in cities like Venice, and would appear in 16TH–c. Florence and Rome in buildings like the Palazzo Pandolfini (see fig. 64–7) and the Palazzo Farnese.

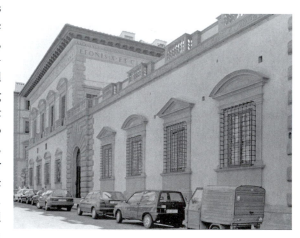

64–7. Palazzo Pandolfini (by Giovan Francesco da Sangallo on Raphael's design), ca. 1520, Florence. Built for Bishop Pandolfini, whose crest appears here, the palace distinguishes itself as the product of 16TH–c. Roman taste: heavily rusticated stones line the corners of the building and the entranceway, and large stone pediments and segmental arches articulate the windows in a manner similar to the Farnese Palace, Rome (see fig. 62–7, #32). In the spirit of the Pitti, this is a town villa, built not far from the city gate (Porta San Gallo).

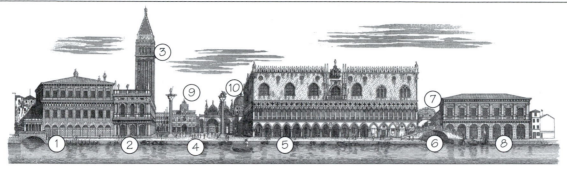

65-1. This 18TH-c. engraving shows the main entry by boat into Venice, where government buildings line the quay. Monuments pictured here in the foreground are (from the left): the Zecca (Mint), #1; Libreria Vecchia (old library), #2; Campanile (bell tower), #3; Piazzetta (in the small square are two giant columns supporting statues of Venice's patron saints, S. Theodore [left] and the Lion of S. Mark [right]; the Piazzetta ends at the Piazza S. Marco), #4; Doge's Palace, #5; Ponte della Paglia (Bridge of Straw), #6; Bridge of Sighs (1600), linking the Doge's Palace to the prison, #7; and the Prigioni Nuove (new prison), #8. In the middle distance are the clock tower (#9) and the domes of S. Marco (#10).

Isolated from the Italian mainland and situated on a cluster of islands, unique Venice is made up of about 100 tiny islands, many of which have been linked by footbridges. The city has one main thoroughfare, or waterway, the Grand Canal, and many small canals (*rios*). Only one square in town is called a piazza, that of S. Marco (see fig. 65–2, #11), with all the other squares, which are smaller in size, called *campi*.

The first lagoon dwellers left the mainland to escape periodic war and famine after the fall of the Latin empire (5TH c.), settling temporarily on the islands of Torcello, Malamocco, and Rialto (as Venice was first called), where they found security from marauding tribes. By the 7TH c. they had permanently settled into the lagoon, building houses on mudflats reinforced by wood pylons driven about two and a half stories into the seabed. The first communities in Venice chose the Rialto for its high ground. Here, a vital commercial center soon developed as goods from Europe, North Africa, and the Near and Far East were traded. This is where the first bridge was built across the Grand Canal (see fig. 65–2, #12); it remained for many centuries the only bridge across the giant, snaking waterway. In Venice, everyone traveled by water. People and goods were ferried up and down the canal and rios and shipyards produced all manner of boats, from gondolas (see fig. 65–2, #17) to large seafaring vessels (see fig. 65–2, #29).

Venice has historically had strong ties to the Byzantine empire (see CONSTANTINOPLE, Duecento Glossary), and a constant exchange of Greek commodities and people shaped the aesthetics of Venetian patronage as well as the technical abilities of artisans, especially those working in metal and glass, many of whom became talented mosaicists. While the taste for intricate patterns and tactile and reflective surfaces was never to fully disappear from Venetian art, painting techniques changed (in the late Quattrocento), and the influence of ancient Rome became pervasive in the pictorial imagery of the Cinquecento. The following chronological outline provides a framework for studying Venetian monuments.

421 According to tradition, Venice is founded on 25 March, the day of the Annunciation (Mary became an important saint of the city).

539 From Constantinople Belisarius (Byzantine Emperor Justinian's general) leads an army to overthrow Ravenna in a plan to reunite the empire; the Venetians helped by readying their harbors for Greek ships arriving with reinforcements.

551 Venetians help the Greek (Byzantine) empire by transporting Lombard mercenaries to Ravenna.

565 In Constantinople, sometime after 565, a formal agreement is made between the (cont. page 305)

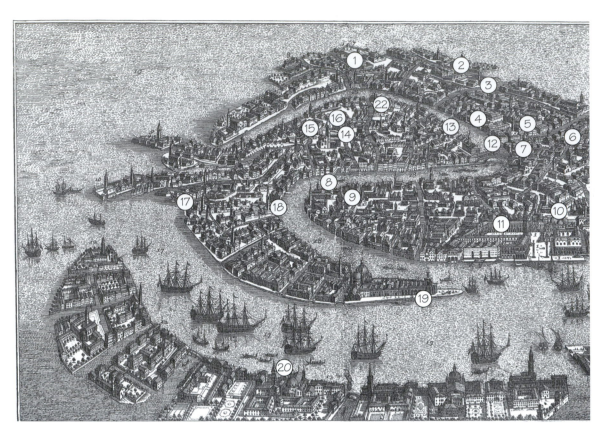

65–2. This 18TH–c. engraving shows Venice before it was linked to the mainland by a railway bridge (1846) and roadway (1932). Shaped like a fish, Venice is divided into six districts (*sestieri*). Select monuments are numbered on the map and identified within *sestieri* listed below. In the north are Isola di S. Michele, the cemetery island of S. Michael (#31), and the island of Murano (#32), where glassmaking became a specialty. In the water close to the Arsenal is the government barge, the *bucintoro* (#33): its upper deck was reserved for the doge and guests, with the galley and rowing stations on the lower deck.

—CANNAREGIO—

1 Jewish Ghetto
2 S. Mary of the Garden (Madonna dell'Orto)
3 Confraternity of Mercy (Scuola della Misericordia)
4 House of Gold (15TH c.) (Ca' d'Oro)
5 Church of the Holy Apostles (Santi Apostoli)
6 S. Mary of Miracles (S. Maria dei Miracoli)
7 German Merchants' Storehouse (Fondaco dei Tedeschi)

—SAN MARCO—

8 Church of S. Samuel (S. Samuele)
9 Church of S. Stephen (S. Stefano)
10 S. Mark's, the doge's chapel (S. Marco)
11 S. Mark's Square (Piazza S. Marco)

—SAN POLO—

12 Rialto Bridge
13 Fish Market (Pescheria)
14 S. Mary in Glory (S. Maria Gloriosa dei Frari)
15 Confraternity of S. Roch (Scuola di S. Rocco)
16 Confraternity of John the Evangelist (Scuola di S. Giovanni Evangelista)

—DORSODURO—

17 Gondola boatyard (Squero)
18 Confraternity of Mercy (Scuola della Carità)
19 Customs House
20 Church of the Redeemer (Il Redentore)
21 S. George the Major (S. Giorgio Maggiore)

—SANTA CROCE—

22 S. John Decapitated (S. Zan Degolà)

—CASTELLO—

23 Confraternity of S. Marco (Scuola di S. Marco)
24 Ss. John and Paul (Ss. Giovanni e Paolo)
25 Verrocchio's Equestrian Monument of Colleoni
26 S. Zaccaria
27 Confraternity of the Dalmatians (Scuola di S. Giorgio di Schiavoni)
28 S. Giovanni Bragora
29 Shipyards (Arsenal)
30 Cathedral of S. Peter (S. Pietro)

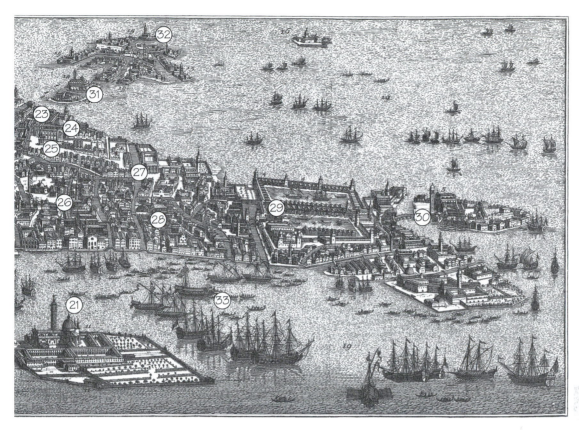

Byzantine empire and the Venetians, who were to receive military protection and trading privileges in exchange for their loyalty and service.

568 Lombards invade Italy. People from the mainland seeking shelter in the Lagoon settle with their bishops in Torcello (little tower), Malamocco, Grado, Carole, etc.

697 The first doge (duke) of the Venetians is elected.

807 The center of government (*dogado*) is formed on the island of Rialto.

828 About this year, S. Mark's relics are brought from Alexandria.

829 The church of S. Marco is begun on the model of the church of the Holy Apostles, Constantinople (S. Marco was reconstructed in the 10$^{\text{TH}}$ and 11$^{\text{TH}}$ centuries).

1054 Schism erupts between the Eastern and Western churches.

1063 Construction begins on new S.

Marco, the Doge's Chapel (two churches had previously been built on the same spot).

1082 The Golden Bull of the Byzantine Emperor grants Venetians commercial privileges in return for naval aid against the Normans.

1172 In Venice, the Communal Councils receive supreme power.

1177 Through Doge Ziani's mediation, a reconciliation between Pope Alexander III and Emperor Frederick Barbarossa takes place in Venice.

1204 Fourth Crusade sails from Venice and sacks Constantinople (see Duecento History Notes 1204). Venetians would recall the event as the beginning of their empire, with the doge now called (until 1261) "Lord of a Quarter and Half a Quarter of the Byzantine Empire."

1210 Between 1204 and 1210, Venice acquires Crete, Eu-

65–3 (below). *Four Horses of S. Marco*, life-size, gilt bronze (perhaps a quadriga from the Hippodrome, Constantinople), now S. Marco, Venice. Brought back as trophies of the 1204 sack of the city, these were placed high on the exterior of S. Marco. Few other bronze horses of antiquity survive, and these sculptures influenced most artists who saw them (see fig. 36–5).

boea, Koroni, Methoni (Modon), and the Cyclades.

1289 Engaged in her second war with Genoa (first war 1253), Venice is also at war with Ferrara.

1330 Building begins on the Franciscan Church of S. Maria Gloriosa dei Frari (see fig. 65–2, #14); ten years later, construction began on the present Doge's Palace (south side) (see fig. 65–1, #5).

1343 The Doge's Palace is extended; Venice fights the third Genoese War, and loses Dalmatia.

1385 War of Chioggia ends with Genoa surrendering (see Trecento History Notes 1385).

1386 Venice acquires Corfu and Nauplia (in 1388).

1403 Between 1403 and 1405, Venice acquires Bassano, Belluno, Padua, Verona, and Vicenza.

1409 Venice purchases his rights over Dalmatia from Ladislas of Naples.

1410 Venice battles with Sigismund of Hungary over Dalmatia. *Condottiere* Pandolfo Malatesta, lord of Brescia (succeeding his brother Carlo, lord of Rimini, as general of the Venetian forces) secures peace for Venice in 1413.

1414 Venice acquires Udine, controls the Veneto, and consolidates Friuli and Dalmatia.

1419 The first major decoration of the Great Council Hall, Doge's Palace, is completed.

1423 During the dogate of Foscari (d. 1457), Venice acquires Brescia, Peschiera, and Cremona.

1453 Constantinople falls to Sultan Mehmed II, ruler of the Ottoman Turks (see fig. 45–3). This sparks the arrival of Greeks in Venice and a revival of Byzantine influence.

1454 Peace of Lodi is reached (see Quattrocento History Notes 1454); Venice acquires Treviso, Fruili, Bergamo, and Ravenna. A wooden bridge is built at Rialto.

1469 First printing press is licensed in Venice.

1479 Gentile Bellini, an emissary of Venice, goes to Sultan Mehmed II's court in Constantinople.

1485 The body of S. Roch is brought to Venice and placed in the church of S. Rocco.

1489 Venice acquires Cyprus.

1493 Martin Sanudo (Venetian patrician, 1466–1536) writes *Laus urbis Venetae* (Praise of Venice).

1499 Vasco da Gama finds a route to India around Cape of Good Hope (a setback for Venice). Venice loses Modon, Lepanto, and Corone to Ottoman Turks, who advance toward Fruili.

1500 Jacopo de' Barbari publishes his *Pianta di Venezia* (View of Venice), a woodblock print. Leonardo is in Venice for a short time.

1504 Mathematician Luca Pacioli has his treatise, *De divina proportione*, published in Venice.

1505 Aldus Manutius (founder of the Aldine Press) publishes Pietro Bembo's *Gli Asolani* (dialogues of guests at Caterina Cornaro's villa at Asolo).

1506 Albrecht Dürer, Michelangelo, and Perugino are in Venice. Grand Council passes law requiring the registration of all male noble births (*libro d'oro*).

1508 Venice is at war with the League of Cambrai (see Cinquecento History Notes 1508). Fra Bartolommeo is in Venice.

1509 Andrea Gritti (future doge), battling the League of Cambrai forces, wins back Padua.

1510 Venice is ravaged by plague.

1514 Fire destroys much of the Rialto Market.

1516 The Senate approves a proposal that the Jews in Venice move to the Ghetto Nuovo (an islet with two connecting bridges to the city that could be closed off, which happened at curfew).

1517 Recapturing Verona (and Brescia earlier, in 1516), Venice regains control of territories on the mainland (terraferma) after becoming an ally of France against Spain and the papacy.

1523 Venice is an ally of Charles V against France. In 1528, Venice changed sides to support France.

1524 The wooden Rialto bridge collapses; it was rebuilt in stone (current one).

1525 Grand Council passes law requiring the registration of all noble marriages.

1527 After the Sack of Rome, Jacopo Sansovino goes to Venice (Aretino arrives from Mantua).

1529 Peace of Bologna ratifies imperial and Spanish control of Italy.

1536 Venice suffers from widespread plague, as she did again in 1556. (In 1575, the plague in Venice killed about 50,000 people.)

1567 El Greco arrives in Venice.

1569 Bad weather brings famine.

1570 Andrea Palladio publishes *Quattro libri dell'architettura* (Four Books of Architecture).

1571 In the Battle of Lepanto, Venice and papal forces defeat the Ottoman Turks, but in a treaty agreement Venice loses Cyprus (1573).

1577 The Great Council Hall is destroyed by fire.

1797 Venice is taken by the troops of Napoleon.

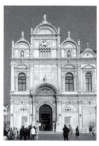
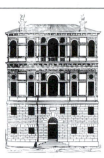

66–1. Palaces along the Grand Canal. 66–2. Pietro Lombardo, Portal, Scuola Grande di S. Giovanni Evangelista, 1478–81 (the *scuola* is the tall building, right). Insignia on the marble portal honor the patron saint, John the Evangelist, and venerated True Cross fragment (in the *albergo* [boardroom] were images of miracles of the relic; see fig. 66–6). 66–3. MAURO CODUSSI (replaced Pietro Lombardo in 1490), Scuola Grande di S. Marco. 66–4. Venetian Palace, after a design by Sebastiano Serlio (1475–ca. 1555), book IV on the orders (published Venice, 1537). Late 15ᵀᴴ–c. Venice began to change its Byzantine-Gothic appearance, as seen in the Doge's Palace (fig. 9–2), with 16ᵀᴴ–c. palaces and *scuole* incorporating classical orders and the symmetry of Serlio's design.

Venice was one of the very few Italian states fortunate enough not to be invaded by armies or to be overthrown by internal feuding, and she was never ruled by a despot (like the Sforza of Milan) or dynasty (like the Medici). In the late Quattrocento it was the printing hub of Europe and a major commercial center, attracting a broad spectrum of people, from businessmen and royalty to fishermen, scholars, and artists (the latter in search of gold and ultramarine). The city was both a pilgrimage site for the religious (relics of S. Mark) and a lively cosmopolitan emporium; just about anything could be purchased here.

In the early Cinquecento the Veneto-Byzantine appearance of the city began to change, with patrons choosing an *all'antica* appearance for their new palaces (called houses, or *case*, in Venice), especially those along the Grand Canal (see fig. 66–1). The taste for ancient Roman trappings was spirited by a new interest in classical art and literature, which was encouraged by local humanist printers, such as Aldus Manutius. Literati and corporate bodies alike began commissioning mythological themes, with figure painters like Giovanni Bellini, Giorgione, and Titian creating a new type of Venetian imagery. Venetian

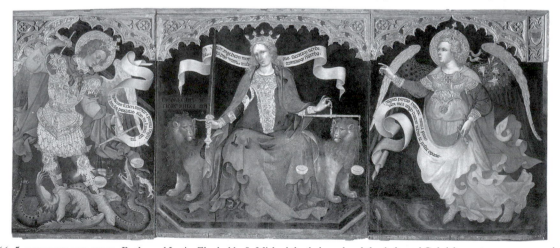

66–5. JACOBELLO DEL FIORE. *Enthroned Justice Flanked by S. Michael the Archangel and the Archangel Gabriel*, 1421, tempera on panel, 6'9.8" x 6'4.3" (208 x 194 cm), Accademia, Venice (made for the office of the Magistrato del Proprio in the Doge's Palace, Venice). The design combines French Gothic with a Byzantine taste for bright, textured surfaces similar to the palace design (see fig. 9–2). Venice cherished the emblem of Justice (her chair has the lions of S. Mark), who appears in sculpture of the Doge's Palace.

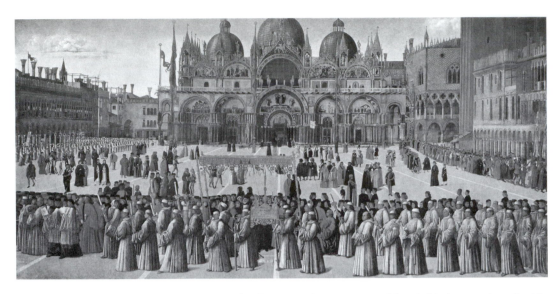

66–6. GENTILE BELLINI. *Procession in Piazza San Marco* (see fig. 65–2, #II), 1496, canvas, 12'3" x 44'10" in (373.4 x 556.9 cm), with two insertions (lower left and right), Accademia, Venice. This painting hung in the *albergo*, Scuola di S. Giovanni Evangelista, which owns a relic of the True Cross presented in 1369 by Philippe de Méziéres, Grand Chancellor of the Kingdom of Cyprus. This is one of 10 canvases that replaced earlier paintings the *scuola* considered old-fashioned (the new canvases show new miracles associated with the relic); Gentile's portrays an event of 1444. He signed and dated the painting on the pavement beneath the reliquary: MCCCCLXXXXVI / GENTILIS BELLINI VENETI EQVITIS-CRUCIS / AMORE INCENVS OPVS (1496, the work of Gentile Bellini of Venice, knight, afire with love of the Cross). The miracles associated with the True Cross were recorded in *Opuscolo dei Miracoli* (pubished 1590). In the foreground are *scuola* members (a red crosier on each white habit), surrounded by members of other *scuole*. To the far right is the doge, who has emerged with other officials from the Doge's Palace. The theatrical appearance of this spectacle would become common to pictorial imagery of the Cinquecento, where in this one piazza all the splendor of Venice seems to overflow. No other church in Venice would ever dare to match the richness of S. Marco.

scuole were lay confraternities formed for devotional and charitable purposes. While membership in the Grand Council was restricted to male nobles (who had voting rights only after the age of 25), citizens who were not noble (*cittadini*) could hold office in the *scuole*, which played an important and active part in the affairs of Venice (see fig. 66–6). There were six major (grande) *scuole*, each with its own meetinghouse and church. The houses typically had three main rooms: a large hall on the ground level, chapter room on the second level, and boardroom (*albergo*) for the use of the officers. Venice also had many smaller (*piccoli*) *scuole*, whose membership came from the citizen class and *popolani*. These can be divided into three types: those that were chiefly devotional, those of foreign communities (Germans, Dalmatians, Florentines, etc.), and those of the guilds (the large painters' guild had not only figure painters but also painters of glass, leather, furniture, books, masks, textiles, playing cards, etc.).

SCUOLA GRANDE DI S. MARIA DELLA CARITÀ — (Dorsoduro), founded in 1260 (Cannaregio), the flagellant confraternity moved to the Carità convent in the 1340s. The confraternity buildings now houses the Galleria Accademia.

SCUOLA GRANDE S. GIOVANNI EVANGELISTA — (S. Polo), founded in the Trecento (see fig. 66–3). As with the other *scuole*, it was suppressed in 1806, but was reformed (1929), and took back possession of the relic of the True Cross.

SCUOLA GRANDE DI S. MARCO — (Castello), founded in the Trecento. Now a hospital, it stands next to Ss. Giovanni e Paolo (Dominican).

SCUOLA GRANDE DELLA MISERICORDIA — (Cannaregio), founded ca. 1310, this is the most complete surviving example of a *scuola grande*.

SCUOLA GRANDE DI S. ROCCO — (S. Polo), founded in 1478; it became a *scuola grande* in 1489.

SCUOLA GRANDE DI S. TEODORO — (S. Marco), founded in the Cinquecento.

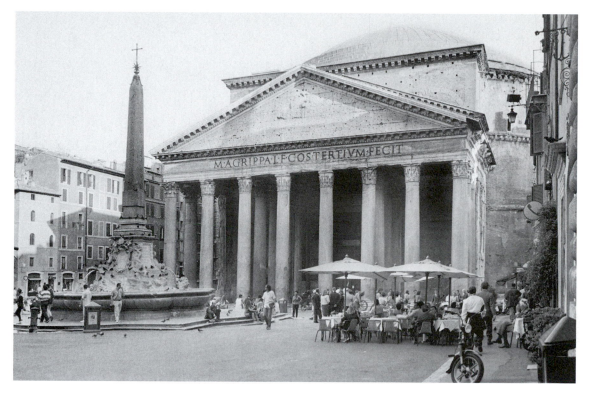

67–1. Pantheon (exterior view), 118–25, Rome. In the Renaissance, of the three most copied ancient Roman buildings (Pantheon, Colosseum, and Arch of Constantine), the Pantheon had a broad appeal because of the combination of a pediment porch and spherical dome. It was built by Emperor Hadrian (his design?) to replace the temple on this spot erected by Marcus Agrippa (son-in-law of Augustus, the first emperor) in 27 BCE. For his new temple, Hadrian retained Agrippa's dedicatory inscription (see porch entablature): M AGRIPPA L. F. COS.TERTIVM. FECIT (Marcus Agrippa the son of Lucius, three times consul, built this). Agrippa's temple in the district of Campus Martius commemorated the victory of Octavian at Actium, where Agrippa commanded Octavian's fleet. Hadrian's new temple, larger in scale and different in design than Agrippa's, has an enormous domed hall, a perfect sphere measuring 143 feet in diameter, with niches for statues of pagan gods. Officially closed in 399, the Pantheon was pillaged by barbarians during the next two centuries. In 609 it was converted to a church (dedicated to S. Mary of the Martyrs), and Pope Anastasius IV built a palace beside it in 1153. While the papacy was at Avignon (1309–78), it became a fortress in a city of warring lords (the Orsini and Colonna families), but restoration programs were initiated by Pope Martin V in the 1420s.

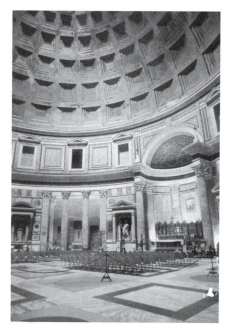

67–2. Pantheon (interior view), 118–25, Rome. Renaissance artists were impressed by both the design and size of the Pantheon. On the far left is the tomb of Raphael, the first and most famous artist to be buried inside; other artists later entombed here include Peruzzi, Vignola, and Annibale Carracci.

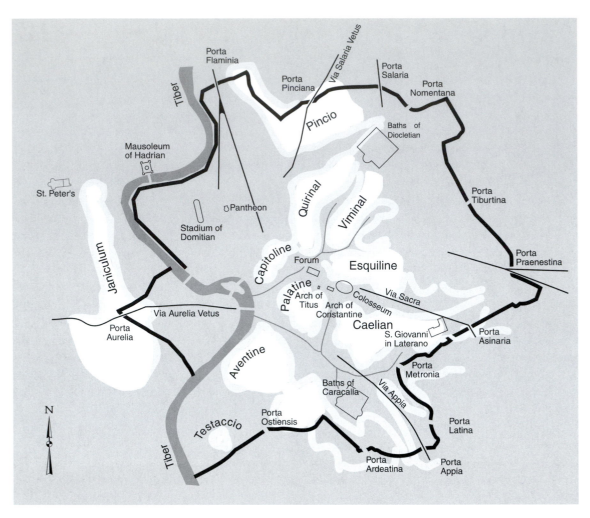

67–3. Map of Rome in the time of Constantine the Great. Shown are the hills, select monuments, and walls built by Aurelian (270–75) and Probus (276–82); the walls had 18 gates, some 300 towers, and were doubled in height by Maxentius (306–12). The old forum was found near the Capitoline and Palatine hills, with the Colosseum built close to the Golden House of Nero (rediscovered in the late–15TH c.). Constantine built S. Peter's and S. John of the Lateran (on the far west and southeast sides of the city); these buildings were to become two very important churches in the Renaissance.

Ancient Romans revered Venus, goddess of love and beauty, and Mars, god of war. According to Livy's legendary story of Rome, Mars raped the Alban princess Rhea Silvia—a Vestal Virgin and the last direct descendant of Aeneas of Troy (son of Venus and Anchises)—to keep the lineage of Aeneas from dying out. Rhea gave birth to twin boys, Romulus and Remus, whom her uncle (Amulius) took from her and left to die beside the Tiber. The newborns were saved by a she-wolf and woodpecker (both sacred to Mars) and raised by a shepherd named Faustulus. As adults, the twins set out to found a city on the spot of their rescue. But they quarreled over the location. Choosing to settle at the foot of the Palatine hill, Romulus received the gods' approval. When Remus mocked him (and the gods), Romulus murdered Remus. In this tradition, Rome was named after Romulus, its first king.

Cinquecento Italy had such passionate interest in antiquity that the style and themes of pagan writers like Lucian, Apuleius, Hesiod, and Ovid were imitated by contemporary poets, and Michelangelo and others created forgeries of antique sculpture. While most cities believed their citizens were descendants of ancient Romans, Rome had the most unbroken link to the past, and Pope Julius II and his immediate successors displayed unrestrained excitement over each new unearthing of pagan statuary. In this chapter are brief descriptions of selected deities and themes depicted by Renaissance artists.

CREATION — Greeks did not believe that their gods created the universe. It was the other way about: the universe created the gods. Before there were gods, heaven and earth existed; these were the first parents. The Titans were their children, and the gods were their grandchildren.

TITANS — Called the elder gods, Titans were the children of Uranus and Gaia. For untold ages, they were the supreme beings in the universe. They were of enormous size and of incredible strength. The most important was Cronus (Saturn), who usurped power from Uranus by castrating him. Cronus then ruled over the other Titans until his son, Zeus (Jupiter), dethroned him and seized power for himself and his brothers. Zeus did not banish the Titans, but gave them a lower place in the universe. According to Roman belief, after Jupiter (Latin for Zeus) ascended the throne, Saturn fled to Italy and brought in a Golden Age; it

was a time of perfect peace and happiness that lasted the duration of his reign.

Other Titans are Ocean (a river that encircled the earth), Tethys (the wife of Ocean), Hyperion (father of the sun, moon, and dawn), Mnemosyne (Memory), Themis (Justice), and Iapetus (among the sons of Iapetus are Atlas, who bore the world on his shoulders, and Prometheus, who was said to have created the first men and to have given them fire that he stole, and for which Zeus punished him).

OLYMPIANS — Of the gods and goddesses who succeeded the Titans, the Olympians were supreme, and Olympus was their home. It is described as a mysterious region, far above all the mountains. (In the following identifications of the Olympians, the Greek name is followed by the Latin name, which appears in parentheses.)

ZEUS (Jupiter) — Zeus fought the Titans with his two brothers (Hades and Poseidon), after which they drew lots for their share of the universe. The sea fell to Poseidon, the underworld to Hades, and heaven to Zeus, who also became the supreme ruler of the universe. He is the lord of the sky, the rain god, and the cloud-gatherer who wields the awful thunderbolt. His power is greater than all the other divinities together. His aegis (breastplate) bears the head of the Gorgon Medusa, considered frightful to behold; his bird is the eagle and his tree is the oak. His oracle is Dodana, who lived in the land of the oak trees, and Zeus revealed his will by rustling oak leaves, from which priests interpreted the god's desires.

68–1. GIAMBOLOGNA. *Architecture*, ca. 1580s, marble, Museo del Bargello, Florence. The Flemish sculptor Giambologna was born in Douai (1529), traveled to Rome, and in the 1550s settled in Florence, where he became a favorite of the dukes Cosimo and his son Francesco de' Medici. Giambologna was influenced by Cellini's work, yet his forms are generally more slender and refined. In this *all'antica* figure that resembles antique statues of Venus at her bath, with her clothing draped beneath her, only the attributes distinguish the figure as the personification of Architecture rather than the goddess Venus.

POSEIDON (Neptune) — A brother of Zeus, Poseidon ruled the sea. His wife, Amphitrite, was the granddaughter of the Titan Ocean. As lord of the sea, the god Poseidon gave the first horse to humans. Poseidon, the Earth-shaker, always carried a trident, which is a three-pronged spear; with it, he could shatter whatever he pleased.

HADES (Pluto) — Third in the hierarchy of the Olympians, Hades is the god of wealth and of the precious metals hidden in the earth. He had a miraculous cap or helmet that made whomever wore it invisible (Perseus wore the cap to slay Medusa). Rarely did Hades leave his dark realm to visit Olympus or the earth. His wife is Persephone (Proserpine), whom he carried away from the earth and made queen of the underworld. Hades was king of the dead—not death himself, whom the Greeks called Thanatos and the Romans called Orcus.

HESTIA (Vesta) — Hestia is a virgin goddess and the sister of Zeus. Although she has a less distinct personality than the other Olympians, she was important to everyday rituals. She is the goddess of the hearth—a symbol of the home—around which a newborn child must be carried before it can be received into the family. Every meal began and ended with an offering to Hestia. Each city had a public hearth sacred to her where the fire was never allowed to go out. If a new colony was founded, the colonists carried to the new city coals from the hearth of the Mother City, with which to kindle a fire on the new city's hearth. In Rome, six virgin priestesses called vestals attended her fire.

HERA (Juno) — Hera is both the wife and sister of Zeus. The Titans Ocean and Tethys raised her. She is the protector of marriage, and married women were her particular care. Ilithyia, her daughter, helped women in childbirth. The cow and the peacock are sacred to her. Argos was her favorite city. Zeus fell in love with many women. He tricked and coerced most of them, but it made no difference to Hera how reluctant or innocent they were. Never forgetting an injury, she treated each of his loves alike, with her implacable anger following them and their children.

ARES (Mars) — God of war, Ares is the son of Zeus and Hera, both of whom, Homer says, detested him. Homer called him murderous, bloodstained, the curse of mortals, and, strangely, a coward who bellowed with pain and ran away when wounded. The Romans liked Mars better than the Greeks liked Ares (see fig. 68-2). He never was to them the mean, whining deity of the *Iliad*, but a magnificent god in shining armor who was invincible. The warriors of the great Latin heroic poem the *Aeneid* do not rejoice to escape from him, as they do in the *Iliad*. Roman soldiers instead rejoiced when they saw that they were going to fall on the field of Mars, which they considered the field of renown. No cities worshipped Ares. The Greeks said that he came from Thrace, home of rude, fierce people in northeast Greece. His bird is the vulture and the dog is his animal.

ATHENA (Minerva) — Pallas Athena is the daughter of Zeus alone; she had no mother. Fully grown and clad in armor, she sprang from his head. In the earliest account of her in Homer's *Iliad*, she is a fierce and ruthless battle goddess. Elsewhere, she is warlike only to defend the state and the home from enemy attacks. She is preeminently the goddess of the city; she is the protector of civilized life, of handicrafts and agriculture. Athena was also the inventor of the bridle; it was she who first tamed horses for humans to use. Athena was the favorite child of Zeus. He trusted her to carry the awful aegis, his buckler, and his most devastating weapon, the thunderbolt. Writers describe her as gray-eyed or flashing-eyed. Of the three virgin goddesses, she is the chief. A chaste maiden (*Parthenos*), Athena's temple is the

68-2. GIULIO ROMANO. *Mars and Venus*, 1526–28, Room of Psyche, Palazzo Te, Mantua (see fig. 55-2, which shows another portion of this mural). Shown in the bath are gods symbolic of love and war, Venus and Mars, attended by Cupid and little Loves.

Parthenon and Athens is her special city. In late classical poetry, she embodies wisdom, reason, and purity. The olive (created by her) is her tree and the owl, her bird.

APOLLO (Apollo) — Phoebus Apollo, the son of Zeus and Leto (Latona), was born on the little island of Delos. Ancient Greek writers considered him the most Greek of all the gods. He is a beautiful figure in Greek poetry, a master musician who delighted Olympus as he played on his golden lyre. He is the lord of the silver bow, and the archer-god, praised for the accuracy of his aim. He is, as well, the healer, who first taught humans the art of healing. Believed to be the god of light in whom there was no darkness, he is the god of truth. Delphi, under towering Parnassus, where Apollo's oracle lived, plays an important part in mythology. Castalia is its sacred spring, Cephissus, its river. Delphi was considered the center of the world. Pilgrims traveled to it from foreign countries and from Greece, and no other shrine rivaled it. Its priestess delivered answers to questions asked by the anxious seekers of truth. A vapor rose from a deep cleft in the rock where she placed her tripod (a three-legged stool), and she went into a trance before she spoke.

APHRODITE (Venus) — Aphrodite is the goddess of love and beauty who beguiled all, gods and men alike. The laughter-loving goddess laughed sweetly or mockingly at those she conquered; irresistible, she stole away even the wits of the wise. Aphrodite was the daughter of Zeus and Dione in the *Iliad*. In later poems, she rose miraculously from the foam (Gk. *aphros*) of the sea; poets wrote that her name reflected her special birth. Her sea birth took place near Cythera, from where Zephyr wafted her to Cyprus (see fig. 37–4). Aphrodite was the wife of Hephaestus (Vulcan), the lame and ugly god of the forge. In one account, Mars and Venus had an affair that produced Cupid (see fig. 68–2). The myrtle is her tree and the dove is her bird; she is also sometimes associated with the sparrow and the swan.

ARTEMIS (Diana) — The twin sister of Apollo, Artemis is a daughter of Zeus and Leto. She is one of the three maiden goddesses on Olympus. She is both the goddess of wild animals and the chief huntswoman to the gods. As Apollo (called Phoebus) is linked to the sun, Artemis is associated with the moon, and called Phoebe and Selene (Luna in Latin). The cypress is sacred to her as are all wild animals, especially deer.

HEPHAESTUS (Vulcan) — God of fire, Hephaestus is the son of Zeus and Hera. However, it was more commonly thought that Hera alone miraculously gave birth to him in retaliation for Zeus having brought forth Athena from his own body. Among the perfectly beautiful gods, Hephaestus alone is ugly, and he is also lame. In Homer, he is highly honored: he is the worker for immortals (their armorer and smith), who made their dwellings, furnishings, and weapons. In his workshop he had handmaidens that he forged out of gold who could move, helping him in his work. He is a kindly, peace-loving god, as popular on earth as he was on Olympus. With Athena, he was active in the life of the city. The two were patrons of handicrafts: he was the protector of the smiths and she, the patroness of the weavers. When children were formally admitted to the city organization, the god of the ceremony was Hephaestus.

DEMETER (Ceres) — Demeter is the goddess of agriculture and of corn, and the Mother Goddess of the earth; she was a daughter of Cronus and Rhea. Her only daughter, Persephone (fathered by Zeus), was abducted by Hades and taken to the Underworld. Hades refused to let her return, but a compromise was reached and Persephone spent half the year (winter) in Hades and the other half (spring and summer) with her mother.

DIONYSOS (Bacchus) — Dionysos is the god of wine (see fig. 51–2), the son of Zeus and Semele. When Semele asked Zeus to reveal his true self, he appeared in brilliance and she was struck dead by lightning bolts. Zeus took the unborn baby from her womb and sewed it into his thigh until the fetus reached maturity; Dionysos was thus twice born. After his ascent to Olympus, he rescued Ariadne from Naxos.

HERMES (Mercury) — Zeus is his father and Maia, daughter of Atlas, his mother. He was graceful and swift of motion. On his feet are winged sandals;

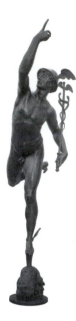

wings are also on his low-crowned hat, and his magic wand is the caduceus. He is the messenger of Zeus, who flew quickly to do the bidding of Zeus. Of all gods, he is the most cunning. When he was one day old, he stole Apollo's herds. Zeus made him give them back, and to win Apollo's forgiveness Hermes presented him with a lyre he had just invented. The god of commerce and the market, Hermes is the protector of traders. He is also the guide of the dead, the divine herald who leads souls down to their last home (see fig. 68–3).

GODS AND LESSER DEITIES OF EARTH

EARTH (Gaia, the All-Mother) — Earth is not really a divinity. Greeks and Romans gave her no human form.

PAN (son of Hermes) — Pan is a noisy, merry god. Part of him is human and part is animal: rather than human ears and feet, he is shown with the ears, horns, and hoofs of a goat.

SILENUS (son or brother of Pan) — Silenus was a son (or grandson) of Hermes. He was a jovial fat old man who sometimes rode an ass because he was too drunk to walk. He was associated with Dionysos when he was young and, after being his tutor, became a devoted follower, as shown by his perpetual drunkenness.

CASTOR — Castor and Pollux lived half their lives on earth and half in heaven. They were the sons of Leda and were the special protectors of sailors.

LEDA — Leda was the wife of Tyndarius of Sparta. With him she had two mortal children, Castor and Clytemnestra (Agamemnon's wife). With Zeus, who visited her as a swan, she had two immortal children, Pollux and Helen. Nevertheless, both brothers, Castor and Pollux, were often called the sons of Zeus.

SILENI — Hybrid creatures, sileni are part human and part horse. They walk on two legs, not four, and are often shown with the tail and hoofs, and sometimes the ears, of a horse.

SATYRS — Like Pan, satyrs are goat men and have their homes in the wild places of the earth.

OREADS — Oreads are nymphs of the mountains.

DRYADS (sometimes called Hamadryads) — Dryads are nymphs of trees whose lives were, in each case, bound up with that of their tree.

AEOLUS — Aeolus is the king of the winds; he lived also on earth. The four chief winds are Boreas (north wind), Zephyr (west wind), Notus (south wind), and Eurus (east wind).

EARTH BEINGS

CENTAURS — Half man and half horse, Centaurs were considered savage creatures with temperaments more like beasts than men. Yet one of them, Chiron, was especially kind and wise.

GORGONS — Gorgons are earth dwelling, dragonlike, winged creatures with snakes for hair; their look could turn people to stone. While two are immortal (Stheno and Euryale), one is mortal (Medusa). Medusa is usually referred to as the Gorgon. When Perseus slew Medusa, blood spewed from her neck giving birth to Pegasus (winged horse) and Chrysaor, the progeny of Poseidon.

GRAEAE — Sisters of the Gorgons, the Graeae are three gray women who were born old (they were never infants). The three of them have but one eye and one tooth, which they share. Their parents were Ceto and Phorcys (a son of the sea and the earth).

SIRENS — Living on an island in the sea, the Sirens had irresistably enchanting voices. Their singing lured sailors to a death at sea by being smashed against rocks. No one who heard them survived.

MOIRAE — Also known as the Fates (or Parcae), Moirae were thought to assign evil and good to humans at birth. After the period of Homer, three Moirae were named, the sisters Clotho, Lachesis, and Atropos. They controlled human life by threads: Clotho was the spinner who spun the threads, Lachesis disposed lots, assigning to each human a destiny, and Atropos carried shears that cut the thread at death.

68–3 (top). GIAMBOLOGNA. *Hermes* (Mercury), ca. 1590, bronze, Museo del Bargello, Florence. In the 1590s, this figure adorned a fountain in the Villa Medici in Rome. The god is depicted here as though in flight, poised on the breath of Aeolus; his wand signifies that he is a divine messenger.

753 Founded about this time, Rome will be ruled by kings.

510 Kings of Rome are expelled (Tarquin the Proud, the last king). A republic was founded, ruled by two consuls elected annually.

264 Rome wages wars with Carthage.

214 Rome wages war with Greece (214–146).

146 Rome destroys Carthage in the last of three wars (Punic Wars).

70 The poet Virgil (d. 19 BCE) is born. His works (*Aeneid, Gregorics, Eclogues*) were especially popular in the Renaissance.

59 Rome conquers Gaul (France), a conflict lasting about 58 years. The historian Livy (d. CE 17) is born; his *Ad urbe condita* (History of Rome), a legendary account, illustrates types of moral behavior that became models in 15TH–c. art.

55 Julius Caesar invades Britain; in 44 he became a dictator.

44 Julius Caesar is murdered by Brutus Cassius.

43 The poet Ovid (d. CE 17) is born; his *Metamorphoses* and *Fasti* (Festivals) were highly popular in the Renaissance.

31 In the Battle of Actium, Gaius Octavius (Octavian) defeats the forces of Marc Anthony and the Egyptian queen, Cleopatra. Octavian became the first emperor of Rome; the title "Augustus" (reverend) was bestowed upon him by the senate (see fig. 69–1). He was called *Princeps*, the first citizen of Rome.

14 Emperor Augustus dies in Rome.

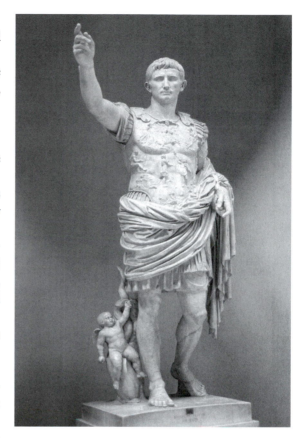

69–1. *Augustus of Primaporta*, early 1ST c. CE, copy of bronze original of the late–1ST c. BCE, marble 6'8" (203 cm), Vatican Museums, Rome (the statue was found at Primaporta in the country villa of Augustus' wife, Livia). Adopted by his great-uncle Julius Caesar, Augustus (born Gaius Octavius), a brilliant strategist and shrewd politician, was decreed the first emperor of Rome. His reign supported building programs and religious reforms and stressed duty to family and state, and he hired the Latin poet Virgil to trace his ancestory to the Trojan prince Aeneas (son of the goddess Venus and mortal Anchises). Virgil's epic poem, the *Aeneid* (26–10 BCE), describes the era of Augustus as a revival of the golden age, providing both peace and prosperity for Rome's citizens. From the time of Augustus, emperors were accorded special honors. His heirs (the Julian line), and those emperors who followed them, would claim to be descended from—and watched over by—the gods (see fig. 69–3). In this memorial statue, Augustus is a barefooted commander, displaying traits associated with the gods Apollo (see fig. 69–2) and Mars. He wears a cuirass, holds a baton (removed after the restoration of the statue), and has the appearance of a victorious hero. Next to Augustus is the pagan god Cupid, shown riding on a dolphin. In the Renaissance, dolphins appear in depictions of Christian and pagan themes. They are attributes of the goddess Venus, the sea god Neptune, and the Nereid Galatea. In Christian art, they are symbolic of the death and resurrection of Christ and commonly appear in tomb imagery.

23 About this time Pliny the Elder (d. 79) wrote *Historia naturalis* (History of Nature and Art), which inspired artists like Leonardo.

30 About this time Jesus of Nazareth is crucified in Jerusalem.

64 Nero persecutes Christians (the first mass persecutions).

98 Trajan (d. 117) begins his reign, during which time the Roman Empire was to reach its greatest expansion.

266 Diocletian divides the empire into four parts (two East and two West).

307 Constantine (d. 337) begins his reign. Defeating Maxentius at the Milvian Bridge (312), he then became ruler of the two western parts (see CONSTANTINE, Duecento Glossary).

313 With the Edict of Milan, Christians can practice their religion without persecution.

324 Constantine rules the whole empire; he builds a second capital, which is named after him (see CONSTANTINOPLE, Duecento Glossary).

395 The empire is split into two parts, the Eastern (Byzantine) and the Western (Latin).

402 Honorius moves the capital of the Latin Empire to Ravenna.

410 Goths sack Rome.

476 The Latin Empire ends when Romulus Augustulus is deposed (see CHARLEMAGNE, Duecento Glossary).

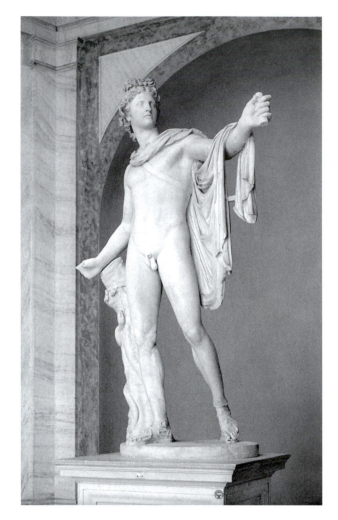

69–2. *Apollo Belvedere*, early 2ND c. CE (?) (thought to be a Roman copy of a lost Hellenistic bronze), marble, 7'4" (223.5 cm), Vatican Museums, Rome. Pope Julius II had the statue moved (between 1505 and 1509) from the garden of S. Peter in Chains, Rome, to a niche in Bramante's Cortile del Belvedere (see fig. 49–3).

SELECT ROMAN EMPERORS			
JULIO–CLAUDIAN LINE	**FLAVIANS** (cont.)	**SEVERANS**	**GENERALS** (cont.)
Augustus (27 BCE – CE 14)	Domitian (81–96)	Septimius Severus (193–211)	Maximinus (308–14)
Tiberius (14–37)	Nerva (96–98)	Caracalla (211–17)	Constantine the Great (306–37)
Caligula (37–41)	Trajan (98–117)		Theodosius I (378–95)
Claudius (41–54)		**GENERALS**	
Nero (54–68)	**ANTONINES**	Aurelian (270–75)	**WESTERN EMPIRE**
	Hadrian (117–38)	Tacitus (275–76)	Honorius (395–423)
FLAVIANS	Antoninus Pius (138–61)	Probus (276–82)	Romulus Augustulus (475–76)
Vespasian (69–79)	Marcus Aurelius (161–80)	Diocletian (285–305)	
Titus (79–81)	Commodus (180–92)	Maxentius (306–12)	

69–3. This chart identifies select Roman emperors, with key events in Roman history cited above. Renaissance popes were spiritual leaders, and in the city of Rome they aspired to become secular leaders in the spirit of the ancient Roman emperors.

Crests of Renaissance Popes

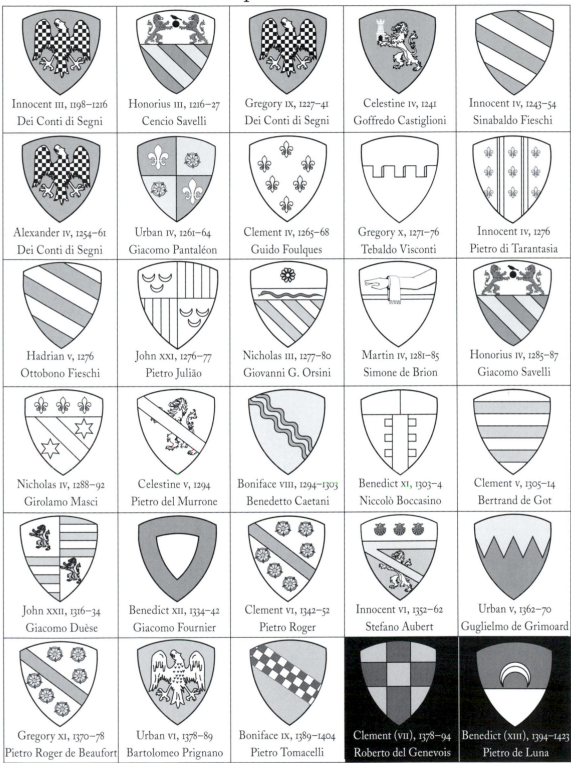

Innocent III, 1198–1216 **Dei Conti di Segni**	Honorius III, 1216–27 **Cencio Savelli**	Gregory IX, 1227–41 **Dei Conti di Segni**	Celestine IV, 1241 **Goffredo Castiglioni**	Innocent IV, 1243–54 **Sinabaldo Fieschi**
Alexander IV, 1254–61 **Dei Conti di Segni**	Urban IV, 1261–64 **Giacomo Pantaléon**	Clement IV, 1265–68 **Guido Foulques**	Gregory X, 1271–76 **Tebaldo Visconti**	Innocent IV, 1276 **Pietro di Tarantasia**
Hadrian V, 1276 **Ottobono Fieschi**	John XXI, 1276–77 **Pietro Julião**	Nicholas III, 1277–80 **Giovanni G. Orsini**	Martin IV, 1281–85 **Simone de Brion**	Honorius IV, 1285–87 **Giacomo Savelli**
Nicholas IV, 1288–92 **Girolamo Masci**	Celestine V, 1294 **Pietro del Murrone**	Boniface VIII, 1294–1303 **Benedetto Caetani**	Benedict XI, 1303–4 **Niccolò Boccasino**	Clement V, 1305–14 **Bertrand de Got**
John XXII, 1316–34 **Giacomo Duèse**	Benedict XII, 1334–42 **Giacomo Fournier**	Clement VI, 1342–52 **Pietro Roger**	Innocent VI, 1352–62 **Stefano Aubert**	Urban V, 1362–70 **Guglielmo de Grimoard**
Gregory XI, 1370–78 **Pietro Roger de Beaufort**	Urban VI, 1378–89 **Bartolomeo Prignano**	Boniface IX, 1389–1404 **Pietro Tomacelli**	Clement (VII), 1378–94 **Roberto del Genevois**	Benedict (XIII), 1394–1423 **Pietro de Luna**

69–4. This chart identifies popes, the years of their reign, and their family names and crests. The backgrounds of the last two entries are reversed to show that Clement VII and Benedict XIII were considered antipopes (see fig. 69–5).

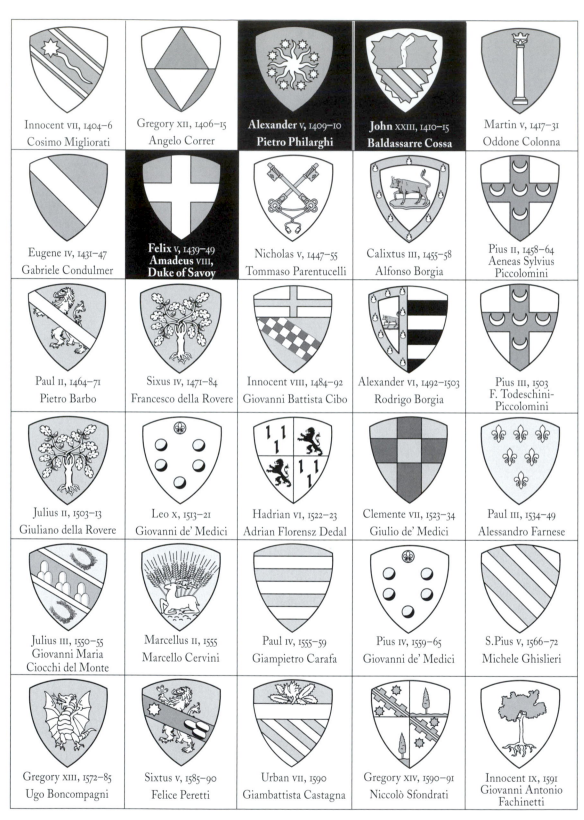

Innocent VII, 1404–6 Cosimo Migliorati	Gregory XII, 1406–15 Angelo Correr	**Alexander V, 1409–10 Pietro Philarghi**	**John XXIII, 1410–15 Baldassarre Cossa**	Martin V, 1417–31 Oddone Colonna
Eugene IV, 1431–47 Gabriele Condulmer	**Felix V, 1439–49 Amadeus VIII, Duke of Savoy**	Nicholas V, 1447–55 Tommaso Parentucelli	Calixtus III, 1455–58 Alfonso Borgia	Pius II, 1458–64 Aeneas Sylvius Piccolomini
Paul II, 1464–71 Pietro Barbo	Sixus IV, 1471–84 Francesco della Rovere	Innocent VIII, 1484–92 Giovanni Battista Cibo	Alexander VI, 1492–1503 Rodrigo Borgia	Pius III, 1503 F. Todeschini-Piccolomini
Julius II, 1503–13 Giuliano della Rovere	Leo X, 1513–21 Giovanni de' Medici	Hadrian VI, 1522–23 Adrian Florensz Dedal	Clemente VII, 1523–34 Giulio de' Medici	Paul III, 1534–49 Alessandro Farnese
Julius III, 1550–55 Giovanni Maria Ciocchi del Monte	Marcellus II, 1555 Marcello Cervini	Paul IV, 1555–59 Giampietro Carafa	Pius IV, 1559–65 Giovanni de' Medici	S.Pius V, 1566–72 Michele Ghislieri
Gregory XIII, 1572–85 Ugo Boncompagni	Sixtus V, 1585–90 Felice Peretti	Urban VII, 1590 Giambattista Castagna	Gregory XIV, 1590–91 Niccolò Sfondrati	Innocent IX, 1591 Giovanni Antonio Fachinetti

69–5. This chart identifies popes (reigning 1404–1591) and their family crests. Three reversed backgrounds show antipopes (Alexander V, John XXIII, and Felix V) (for the Great Schism, see 1414, Council of Constance, Quattrocento History Notes).

Bibliography

PRIMARY SOURCES: RENAISSANCE TEXTS

Alberti, Leon Battista. *On Painting*. Trans. Cecil Grayson. London: Phaidon, 1972. Reprint, with introduction and notes by Martin Kemp. London: Penguin, 1991.

———. *On Painting and Sculpture*: *The Latin Texts of De Pictura and De Statua*. Ed. Cecil Grayson. London: Phaidon, 1972.

———. *Ten Books on Architecture*. Trans. J. Leoni. 1755. Reprint, London: Dover, 1986.

———. *On the Art of Building in Ten Books*. Trans. Joseph Rykwert, Neil Leach, and Robert Tavernor. Cambridge, Mass.: MIT Press, 1988.

———. *The Family in Renaissance Florence* (*I Libri della Famiglia*). Trans. Renée Neu Watkins. Columbia, S.C.: Univ. of South Carolina Press, 1969.

"Anonimo Magliabechiano," *Il codice Magliabecchiano*. Ed. Karl Frey. Berlin, 1892.

Biringuccio, Vannoccio. *Pirotechnia* (Pyrotechnics). Trans. Martha Teach Gnudi and Cyril Stanley Smith. 1942. Reprint, Cambridge, Mass.: MIT Press, 1966.

Bisticci, Vespasiano da. *The Vespasiano Memoirs: Lives of Illustrious Men of the XV^TH Century*. Trans. William George and Emily Waters. London: Routledge, 1926.

Castiglione, Baldassare. *The Book of the Courtier*. Trans. Leonard E. Opdycke. New York: Scribner's, 1903.

Cellini, Benvenuto. *The Autobiography of Benvenuto Cellini*. Trans. George Bull. Rev. ed. London: Penguin, 1998.

Cennini, Cennino d'Andrea. *The Craftsman's Handbook* (*Il libro dell'arte*). Trans. Daniel V. Thompson, Jr. 1933. Reprint, New York: Dover, 1954.

Colonna, Francesco. *Hypnerotomachia Poliphili* (The Strife of Love in a Dream). Trans. Joscelyn Godwin. London: Thames and Hudson, 1999.

Condivi, Ascanio. *The Life of Michelangelo*. Ed. Helmut Wohl; trans. Alice Sedgwick Wohl. Baton Rouge: Louisiana State Univ. Press, 1976.

Filarete. *Treatise on Architecture*. Trans. J. R. Spencer. 2 vols. New Haven, Conn.: Yale Univ. Press, 1965.

Ghiberti, Lorenzo. *I Commentarii*. Ed. Lorenzo Bartoli, Florence: Giunti, 1998.

Guiccardini, Francesco. *The History of Italy*. Ed. and trans. Sidney Alexander. London: Macmillan, 1969.

Landucci, Luca. *A Florentine Diary from 1450 to 1516, Continued by an Anonymous Writer Till 1542*; *Notes by Iodoco Del Badia*. Trans. Alice de Rosen Jervis. London: J. M. Dent, 1927.

Leonardo da Vinci. *Leonardo da Vinci on Painting: A Lost Book* (*Libro A*). Ed. Carlo Pedretti. Berkeley: Univ. of California Press, 1964.

———. *Leonardo on Painting*: *An Anthology of Writings by Leonardo da Vinci with a Selection of Documents Relating to His Career as an Artist*. Eds. Martin Kemp and Margaret Walker. New Haven, Conn.: Yale Univ. Press, 1989.

Machiavelli, Niccolò. *The Prince*. Ed. and trans. Daniel Donno. New York: Bantam Books, 1981.

———. *History of Florence and of the Affairs of Italy, from the Earliest Times to the Death of Lorenzo the Magnificent*. Trans. Hugo Albert Rennert. New York: M. W. Dunne, 1901.

Manetti, Antonio di Tuccio. *The Life of Brunelleschi by Antonio di Tuccio Manetti*. Ed. Howard Saalman. University Park: Pennsylvania State Univ. Press, 1970.

Meditations on the Life of Christ: An Illustrated Manuscript of the Fourteenth Century. Trans. Isa Ragusa and Rosalie B. Green. Princeton, N.J.: Princeton Univ. Press, 1961.

Michelangelo. *Complete Poems and Selected Letters of Michelangelo*. Ed. R. N. Linscott; trans. Creighton Gilbert. 2^ND ed. New York: Random House, 1965.

———. *The Letters of Michelangelo*. Ed. and trans. E. H. Ramsden. Palo Alto, Calif.: Stanford Univ. Press, 1963.

Ridolfi, Carlo. *The Life of Titian*. Ed. Julia Conaway Bondanella; trans. Julia Conaway Bondanella and Peter Bondanella. University Park: Pennsylvania State Univ. Press, 1996.

Serlio, Sebastiano. *Sebastiano Serlio on Architecture*. Trans. Vaughan Hart and Peter Hicks. 2 vols. New Haven, Conn.: Yale Univ. Press, 1996–2001.

Theophilus. *On Divers Arts*. Trans. John G. Hawthorne and Cyril Stanley Smith. New York: Dover, 1979.

Two Memoirs of Renaissance Florence: The Diaries of Buonaccorso Pitti and Gregorio Dati. Ed. Gene Brucker; trans. Julia Martines. New York: Harper and Row, 1967.

Vasari, Giorgio. *Lives of the Most Eminent Painters, Sculptors, and Architects.* Trans. G. du C. De Vere. 10 vols. London: Medici Society, 1912–15.

———. *The Lives of the Artists.* Trans. Julia Conaway Bondanella and Peter Bondanella. Oxford: Oxford Univ. Press, 1991.

———. *Vasari on Technique.* Ed. G. Baldwin Brown; trans. Louisa S. Maclehose. New York: Dover, 1960.

Villani, Giovanni. *Croniche Fiorentine* (Florentine Chronicle). Selections of first nine books edited by Philip H. Wicksteed; trans. Rose E. Selfe. London: Archibald Constable, 1906.

Voragine, Jacobus de. *The Golden Legend: Readings on the Saints.* 2 vols. Trans. William Granger Ryan. Princeton, N.J.: Princeton Univ. Press, 1993.

PRIMARY SOURCES: ANTHOLOGIES

Baldassarri, Ugo, and Arielle Saiber, eds. *Images of Quattrocento Florence: Selected Writings in Literature, History, and Art.* New Haven, Conn.: Yale Univ. Press, 2000.

Chambers, David. *Patrons and Artists in the Italian Renaissance.* Columbia, S.C.: Univ. of S. Carolina Press, 1971.

———, and Brian Pullan, with Jennifer Fletcher. *Venice, A Documentary History, 1450–1630.* Oxford: Blackwell, 1992.

Elmer, Peter, Nick Webb, and Roberta Wood, eds. *The Renaissance in Europe: An Anthology.* New Haven, Conn., and London: Yale Univ. Press in association with Open Univ., 2000.

Gilbert, Creighton E. *Italian Art, 1400–1500: Sources and Documents in the History of Art.* Evanston, Ill.: Northwestern Univ. Press, 1992.

Glasser, Hannelore. *Artists' Contracts of the Early Renaissance.* New York: Garland, 1977.

Holt, Elizabeth, ed. *A Documentary History of Art.* Vols. 1 and 2. 1947. Reprint. Garden City, N.Y.: Doubleday, 1957.

Klein, Robert, and Henri Zerner. *Italian Art, 1500–1600: Sources and Documents in the History of Art.* Englewood Cliffs, N.J.: Prentice Hall, 1966.

Waldman, Louis A. *Baccio Bandinelli and Art at the Medici Court: A Corpus of Early Modern Sources.* Philadelphia: American Philosophical Society, 2004.

PART ONE: DUECENTO ITALIAN ART

Bellosi, Luciano. *Cimabue.* New York: Abbeville, 1998.

Bourda, Louise. *The Franciscans and Art Patronage in Late Medieval Italy.* New York: Cambridge Univ. Press, 2004.

Cannon, Joanna, and Beth Williamson, eds. *Art, Politics, and Civic Religion in Central Italy, 1261–1352.* Aldershot, England: Ashgate, 2000.

Carli, Enzo. *Giovanni Pisano, Il Pulpito di Pistoia.* Milan: Giorgio Mondadori, 1986.

Cassidy, Brendan. *Politics and Civil Ideals in Italian Sculpture, c. 1250–1400.* London: Harvey Miller, 2007.

Cole, Bruce. *Italian Art, 1250–1550: The Relation of Renaissance Art to Life and Society.* New York: Harper and Row, 1987.

Garrison, Edward B. *Italian Romanesque Panel Painting: An Illustrated Index.* Florence: Leo S. Olschki, 1949.

Hetherington, Paul. *Cavallini: A Study in the Art of Late Medieval Rome.* London: Sagittarius, 1979.

Moskowitz, Anita F. *Italian Gothic Sculpture, c. 1250–1400.* Cambridge: Cambridge Univ. Press, 2000.

———. *Nicola Pisano's Arca di San Domenico and Its Legacy.* University Park: Pennsylvania State Univ. Press, 1994.

Pope-Hennessy, John. *Italian Gothic Sculpture.* 4TH ed. London: Phaidon, 1996.

Schevill, Ferdinand. *Medieval and Renaissance Florence.* 2 vols. New York: Harper and Row, 1963.

Schmidt, Victor M., ed. *Italian Panel Painting of the Duecento and Trecento* (Studies in the History of Art 61). Washington, D.C.: National Gallery of Art, 2002.

Tomei, Alessandro. *Pietro Cavallini.* Milan: Silvana, 2000.

Tronzo, William. *Italian Church Decoration of the Middle Ages and Early Renaissance.* Bologna: Nuova Alfa, 1989.

Warner, Marina. *Alone of All Her Sex: The Myth and the Cult of the Virgin Mary.* New York: Alfred A. Knopf, 1976.

White, John. *Art and Architecture in Italy, 1250–1400.* 3RD ed. New Haven, Conn.: Yale Univ. Press, 1993.

PART TWO: TRECENTO ITALIAN ART

Baccheschi, Edi, and Andrew Martindale. *The Complete Paintings of Giotto.* New York: Abrams, 1966.

Baldini, Umberto, et al. *Primavera: The Restoration of Botticelli's Masterpiece.* New York: Abrams, 1986.

Barolsky, Paul. *Giotto's Father and the Family of Vasari's Lives.* University Park: Pennsylvania State Univ. Press, 1991.

Baxandall, Michael. *Giotto and the Orators: Humanist Observers of Painting in Italy and the Discovery of Pictorial Composition 1300–1450*. Oxford: Clarendon, 1971.

Beck, Eleonora M. *Giotto's Harmony: Music and Art in Padua at the Crossroads of the Renaissance*. Florence: European Press Academic Publishing, 2005.

Beck, James. *Jacopo della Quercia*. New York: Columbia Univ. Press, 1991.

Bellosi, Luciano. *Duccio: The Maestà*. London: Thames and Hudson, 1999.

Bomford, David, Jill Dunkerton, Dillian Gordon, and Ashok Roy. *Art in the Making: Italian Painting Before 1400*. London: National Gallery, 1989.

Borsook, Eve. *The Mural Painters of Tuscany from Cimabue to Andrea del Sarto*. 2ND ed. Oxford: Oxford Univ. Press, 1979.

Boudra, Louise, and Anne Dunlop, eds. *Art and the Augustinian Order in Early Renaissance Italy*. Aldershot, England: Ashgate, 2007.

Cole, Bruce. *Giotto: The Scrovegni Chapel*. New York: Braziller, 1993.

———. *The Renaissance Artist at Work, from Pisano to Titian*. New York: Harper and Row, 1983.

———. *Agnolo Gaddi*. Oxford: Clarendon, 1977.

———. *Giotto and Florentine Painting, 1280–1375*. New York: Harper and Row, 1976.

Derbes, Anne, and Mark Sandona. *The Cambridge Companion to Giotto*. New York: Cambridge Univ. Press, 2004.

Goffen, Rona. *Spirituality in Conflict: Saint Francis and Giotto's Bardi Chapel*. University Park: Pennsylvania State Univ. Press, 1998.

Kessler, Herbert L., and Johanna Zacharias. *Rome 1300: On the Path of the Pilgrim*. New Haven, Conn.: Yale Univ. Press, 2000.

Kreytenberg, Gert. *Orcagna's Tabernacle in Orsanmichele, Florence*. New York: Abrams, 1994.

Ladis, Andrew, ed. *Giotto and the World of Early Italian Art*. 4 vols. New York: Garland, 1998.

Larner, John. *Culture and Society in Italy, 1290–1420*. New York: Scribner's, 1971.

Martindale, Andrew. *Simone Martini: Complete Edition*. New York: New York Univ. Press, 1988.

Meiss, Millard. *The Great Age of Fresco*. New York: Braziller, 1970.

———. *Giotto and Assisi*. New York: Norton, 1960.

———. *Painting in Florence and Siena After the Black Death*. 1951. Reprint, New York: Harper and Row, 1964.

Moskowitz, Anita Fiderer. *The Sculpture of Andrea and Nino Pisano*. Cambridge: Cambridge Univ. Press, 1986.

Norman, Diane. *Painting in Late Medieval and Renaissance Siena (1260–1555)*. New Haven, Conn.: Yale Univ. Press, 2003.

———. *Siena and the Virgin: Art and Politics in a Late Medieval City State*. New Haven, Conn.: Yale Univ. Press, 1999.

Origo, Iris. *The Merchant of Prato: Francesco di Marco Datini*. London: J. Cape, 1957.

Panofsky, Erwin. *Renaissance and Renascences in Western Art*. 1960. Reprint, New York: Harper and Row, 1969.

Rowley, George. *Ambrogio Lorenzetti*. 2 vols. Princeton, N.J.: Princeton Univ. Press, 1958.

Satkowski, Jane. *Duccio di Buoninsegna: The Documents*. Ed. Hayden B. J. Maginnis. Athens, Ga.: Georgia Museum of Art, 2000.

Starn, Randolph. *Ambrogio Lorenzetti. The Palazzo Pubblico, Siena*. New York: Braziller, 1994.

Stubblebine, James H. *Assisi and the Rise of Vernacular Art*. New York: Harper and Row, 1985.

———. *Duccio di Buoninsegna and His School*. 2 vols. Princeton, N.J.: Princeton Univ. Press, 1979.

Syson, Luke, et al. *Renaissance Siena: Art for a City*. London: National Gallery Company, 2007.

Volpe, Carlo. *Pietro Lorenzetti*. Milan: Electa, 1989.

Welch, Evelyn S. *Art and Society in Italy, 1350–1500*. Oxford: Oxford Univ. Press, 1997.

White, John. *Duccio: Tuscan Art and the Medieval Workshop*. New York: Thames and Hudson, 1979.

Wisch, Barbara, and Diane Cole Ahl, eds. *Confraternities and the Visual Arts in Renaissance Italy*. Cambridge: Cambridge Univ. Press, 2000.

PART THREE: QUATTROCENTO ITALIAN ART

Ahl, Diane Cole. *Benozzo Gozzoli*. New Haven, Conn.: Yale Univ. Press, 1996.

———, ed. *The Cambridge Companion to Masaccio*. Cambridge: Cambridge Univ. Press, 2002.

Ames-Lewis, Francis. *The Intellectual Life of the Early Renaissance Artist*. New Haven, Conn.: Yale Univ. Press, 2000.

———. *Drawing in the Italian Renaissance Workshop*. London: Victoria and Albert Museum, 1983.

———. *Drawing in Early Renaissance Italy.* New Haven, Conn.: Yale Univ. Press, 1981.

Baldini, Umberto, and Ornella Casazza. *The Brancacci Chapel.* New York: Abrams, 1992.

Baron, Hans. *The Crisis of the Early Italian Renaissance.* Rev. ed. 2 vols. Princeton, N.J.: Princeton Univ. Press, 1966.

Barriault, Anne B. *Spalliere Paintings of Renaissance Tuscany.* University Park: Pennsylvania State Univ. Press, 1994.

Baxandall, Michael. *Painting and Experience in Fifteenth-Century Italy: A Primer in the Social History of Pictorial Style.* 2ND ed. New York: Oxford Univ. Press, 1988.

Becherer, Joseph Antenucchi, et al. *Pietro Perugino: Master of the Italian Renaissance.* New York: Rizzoli, 1998.

Beck, James. *Masaccio: The Documents.* Locust Valley, N.Y.: J. J. Augustin, 1978.

Bennett, Bonnie A., and David G. Wilkins. *Donatello.* Oxford: Phaidon, 1984.

Berenson, Bernard. *Italian Painters of the Renaissance.* Rev. ed. London: Phaidon, 1969.

———. *Italian Pictures of the Renaissance.* 7 vols. London: Phaidon, 1957–68.

Bomberg, David, ed. *Art in the Making: Underdrawings in Renaissance Paintings.* London: National Gallery, 2002.

Boorsch, Suzanne, et al. *Andrea Mantegna.* Ed. Jane Martineau. New York: Metropolitan Museum of Art and Royal Academy of Arts, London, 1992.

Borsook, Eve. *Francesco Sassetti and Ghirlandaio at Santa Trinità, Florence: History and Legend in a Renaissance Chapel.* Doornspijk, Netherlands: Davaco, 1981.

Boskovits, Miklos, and David Alan Brown. *Italian Paintings of the Fifteenth Century* (The Collections of the National Gallery of Art, Systematic Catalogue). New York: Oxford Univ. Press, 2003.

Brown, Patricia Fortini. *Venetian Narrative Painting in the Age of Carpaccio.* New Haven, Conn.: Yale Univ. Press, 1988.

Brucker, Gene. *Renaissance Florence.* New York: John Wiley, 1969.

Burkhardt, Jacob. *The Civilization of the Renaissance in Italy.* Trans. S. G. Middlemore. Oxford: Phaidon, 1965.

Butterfield, Andrew. *The Sculptures of Andrea del Verrocchio.* New Haven, Conn.: Yale Univ. Press, 1997.

Cadogan, Jeanne K. *Domenico Ghirlandaio: Artist and Artisan.* New Haven, Conn.: Yale Univ. Press, 2000.

Calvesi, Maurizio. *Piero della Francesca.* New York: Rizzoli, 1998.

Christiansen, Keith. *Andrea Mantegna: Padua and Mantua.* New York: Braziller, 1994.

———. *Gentile da Fabriano.* Ithaca, N.Y.: Cornell Univ. Press, 1982.

———, et al. *From Filippo Lippi to Piero della Francesca: Fra Carnevale and the Making of a Renaissance Master.* New York: Metropolitan Museum of Art in association with Yale Univ. Press, 2005.

———, Laurence B. Kanter, and Carl Brandon Strehlke. *Painting in Renaissance Siena, 1420–1520.* New York: Metropolitan Museum of Art, 1988.

Clark, Kenneth. *Piero della Francesca.* New York: Phaidon, 1951.

Cole, Bruce. *Masaccio and the Art of Early Renaissance Florence.* Bloomington, Ind.: Indiana Univ. Press, 1980.

———. *Piero della Francesca: Tradition and Innovation in Renaissance Art.* New York: Harper Collins, 1991.

Cordaro, Michele, ed. *Mantegna's Camera degli Sposi.* Milan: Electa, 1993.

Covi, Dario A. *Andrea del Verrocchio: Life and Work.* Florence: Olschki, 2005.

Debby, Nirit Ben-Aryeh. *The Renaissance Pulpit: Art and Preaching in Tuscany, 1400–1550.* Turnhout, Belgium: Brepols, 2007.

Dunkerton, Jill, Susan Foister, Dillian Gordon, and Nicholas Penny. *Giotto to Dürer: Early Renaissance Paintings in the National Gallery.* New Haven, Conn.: Yale Univ. Press with National Gallery Publications, London, 1991.

Edgerton, Samuel J. *Pictures and Punishment: Art and Criminal Prosecution during the Florentine Renaissance.* Ithaca, N.Y.: Cornell Univ. Press, 1985.

Eisenberg, Marvin. *Lorenzo Monaco.* Princeton, N.J.: Princeton Univ. Press, 1989.

Eisler, Colin. *The Genius of Jacopo Bellini: The Complete Paintings and Drawings.* New York: Abrams, 1989.

Ettlinger, Leopold D. *Antonio and Piero Pollaiuolo.* New York: Phaidon, 1978.

Field, J. V. *Piero della Francesca: A Mathematician's Art.* New Haven, Conn.: Yale Univ. Press, 2004.

Frick, Carole Collier. *Dressing Renaissance Florence: Families, Fortunes, and Fine Clothing.* Baltimore, Md.: Johns Hopkins Univ. Press, 2002.

Geiger, Gail L. *Filippino Lippi's Carafa Chapel, Renaissance Art in Rome.* Kirksville, Mo.: Sixteenth Century Journal Publishers, 1986.

Gilbert, Creighton. *A Renaissance Image of the End of the World: Fra Angelico and Signorelli at Orvieto.* University Park: Pennsylvania State Univ. Press, 2001.

Goffen, Rona. *Giovanni Bellini.* New Haven, Conn.: Yale Univ. Press, 1989.

———. *Piety and Patronage in Renaissance Venice: Bellini, Titian, and the Franciscans.* New Haven, Conn.: Yale Univ. Press, 1986.

Goldner, George R., and Carmen C. Bambach, with Alessandro Cecchi, et al. *The Drawings of Filippino Lippi and His Circle.* New York: Metropolitan Museum of Art, 1997.

Gombrich, Ernst H. *Norm and Form: Studies in the Art of the Renaissance.* London: Phaidon, 1966.

Gordon, Dillian. *National Gallery, London: The Fifteenth-Century Italian Paintings.* London: National Gallery Company, 2003.

———, and Luke Syson. *Pisanello: Painter to the Renaissance Court.* New Haven, Conn.: Yale Univ. Press, 2001.

Grafton, Anthony. *Leon Battista Alberti: Master Builder of the Italian Renaissance.* New York: Hill and Wang, 2000.

Hartt, Frederick, Gino Corti, and Clarence Kennedy. *The Chapel of the Cardinal of Portugal, 1434–1459, at San Miniato in Florence.* Philadelphia: Univ. of Pennsylvania Press, 1964.

Henry, Tom, and Laurence Kanter. *Luca Signorelli, the Complete Paintings.* New York: Rizzoli, 2002.

Herzner, Volker. *Italian Renaissance Sculpture in the Time of Donatello.* Detroit, Mich.: Detroit Institute of Arts, 1985.

Holmes, Megan. *Fra Filippo Lippi: The Carmelite Painter.* New Haven, Conn.: Yale Univ. Press, 1999.

Hood, William. *Fra Angelico at San Marco.* New Haven, Conn.: Yale Univ. Press, 1993.

Humfrey, Peter, and Martin Kemp, eds. *The Altarpiece in the Renaissance.* Cambridge: Cambridge Univ. Press, 1990.

James, Sara Nair. *Signorelli and Fra Angelico at Orvieto: Liturgy, Poetry, and a Vision of the End of Time.* Aldershot, England: Ashgate, 2003.

Janson, H. W. *The Sculpture of Donatello.* 2 vols. Princeton, N.J.: Princeton Univ. Press, 1975.

Joannides, Paul. *Masaccio and Masolino: A Complete Catalogue.* New York: Abrams, 1993.

Kanter, Laurence B. *Botticelli's Witness: Changing Style in a Changing Florence.* Boston: Isabella Stewart Gardner Museum, 1997.

Kemp, Martin. *Behind the Picture: Art and Evidence in the Italian Renaissance.* New Haven, Conn.: Yale Univ. Press, 1997.

Kennedy, Ruth W. *Alesso Baldovinetti: A Critical and Historical Study.* New Haven, Conn.: Yale Univ. Press, 1938.

Krautheimer, Richard, and Trude Krautheimer Hess. *Lorenzo Ghiberti.* 2ND ed. Princeton, N.J.: Princeton Univ. Press, 1970.

Kristeller, Paul O. *Renaissance Thought and Its Sources.* New York: Columbia Univ. Press, 1979.

Lavin, Marilyn Aronberg. *Piero della Francesca: San Francesco, Arezzo.* New York: Braziller, 1994.

———. *Piero della Francesca.* New York: Abrams, 1992.

———. *The Place of Narrative: Mural Decoration in Italian Churches, 431–1600.* Chicago: Univ. of Chicago Press, 1990.

Lewine, Carol F. *The Sistine Chapel Walls and the Roman Liturgy.* University Park: Pennsylvania State Univ. Press, 1993.

Lightbown, Ronald W. *Carlo Crivelli.* New Haven, Conn.: Yale Univ. Press, 2004.

———. *Piero della Francesca.* New York: Abbeville, 1992.

———. *Sandro Botticelli.* New York: Abbeville, 1989.

———. *Andrea Mantegna: With a Complete Catalogue of the Paintings, Drawings, and Prints.* Oxford: Phaidon, 1986.

———. *Donatello and Michelozzo: An Artistic Partnership and Its Patrons in the Early Renaissance.* 2 vols. London: Harvey Miller, 1980.

———. *Botticelli.* 2 vols. Berkeley: Univ. of California Press, 1978.

Lincoln, Evelyn. *The Invention of the Italian Renaissance Printmaker.* New Haven, Conn.: Yale Univ. Press, 2000.

Luchs, Alison, ed. *Italian Plaquettes* (Studies: History of Art 22). Washington, D.C.: National Gallery of Art, 1989.

Mack, Rosamond E. *Bazaar to Piazza: Islamic Trade and Italian Art.* Berkeley: Univ. of California Press, 2002.

Martines, Lauro. *The Social World of the Florentine Humanists 1390–1460.* Princeton, N.J.: Princeton Univ. Press, 1963.

McHam, Sarah Blake, ed. *Looking at Italian Renaissance Sculpture*. Cambridge: Cambridge Univ. Press, 1998.

Meilmann, Patricia, ed. *The Cambridge Companion to Titian*. New York: Cambridge Univ. Press, 2004.

Munman, Robert. *Optical Correction in the Sculpture of Donatello*. Philadelphia: American Philosophical Society, 1985.

Musacchio, Jacqueline Marie. *The Art and Ritual of Childbirth in Renaissance Italy*. New Haven, Conn.: Yale Univ. Press, 1999.

Neilson, Katharine B. *Filippino Lippi: A Critical Study*. Cambridge, Mass.: Harvard Univ. Press, 1938.

Nuttall, Paula. *From Florence to Flanders: The Impact of Netherlandish Painting, 1400–1500*. New Haven, Conn.: Yale Univ. Press, 2004.

Olson, Roberta J. M. *The Florentine Tondo*. Oxford: Oxford Univ. Press, 2000.

Pincus, Debra, ed. *Small Bronzes in the Renaissance* (Studies: History of Art 62). Washington, D.C.: National Gallery of Art, 2001.

Poeschke, Joachim. *Donatello and His World*. Trans. Russell Stockman. New York: Abrams, 1993.

Pope-Hennessy, John. *Italian Renaissance Sculpture*. 4TH ed. London: Phaidon, 1996.

———. *Luca della Robbia*. Ithaca, N.Y.: Cornell Univ. Press, 1980.

———. *The Complete Works of Paolo Uccello*. 2ND ed. London: Phaidon, 1959.

Radke, Gary M., et al., eds. *Verrocchio's David Restored: A Renaissance Bronze from the National Museum of the Bargello, Florence*. Atlanta, Ga.: High Museum of Art, 2003.

Riess, Jonathan B. *Luca Signorelli: The San Brizio Chapel, Orvieto*. New York: Braziller, 1995.

———. *The Renaissance Antichrist: Luca Signorelli's Orvieto Frescoes*. Princeton, N.J.: Princeton Univ. Press, 1995.

Roberts, Perri Lee. *Masolino da Panicale*. Oxford: Clarendon, 1993.

Roettgen, Steffi. *Italian Frescoes*. 2 vols. New York: Abbeville, 1996–97.

Ruda, Jeffrey. *Fra Filippo Lippi: Life and Work with a Complete Catalogue*. New York: Abrams, 1993.

Rubin, Patricia Lee. *Images and Identity in Fifteenth-Century Florence*. New Haven, Conn.: Yale Univ. Press, 2007.

———, and Alison Wright, with Nicholas Penny. *Renaissance Florence: The Art of the 1470s*. London: National Gallery, 1999.

Saalman, Howard. *Filippo Brunelleschi: The Buildings*. University Park: Pennsylvania State Univ. Press, 1993.

Sale, Russell. *Filippino Lippi's Strozzi Chapel in Santa Maria Novella*. New York: Garland, 1979.

Scher, Stephen K., ed. *The Currency of Fame: Portrait Medals of the Renaissance*. New York: Abrams and Frick Collection, 1994.

Shullman, Ken. *Anatomy of a Restoration: The Brancacci Chapel*. New York: Walker, 1991.

Spike, John T. *Masaccio*. New York: Abbeville, 1995.

Tempestini, Anchise. *Giovanni Bellini*. Milan: Electa, 2000.

Thomas, Anabel. *Art and Piety in the Female Religious Communities of Renaissance Italy: Iconography, Space and the Religious Woman's Perspective*. New York: Cambridge Univ. Press, 2003.

———. *Painter's Practice in Renaissance Tuscany*. Cambridge: Cambridge Univ. Press, 1995.

Thornton, Peter. *The Italian Renaissance Interior 1400–1600*. New York: Abrams, 1991.

Venice and the Islamic World, 828–1797. New York: Metropolitan Museum of Art and Yale Univ. Press, New Haven, Conn., 2007.

Welch, Evelyn. *Shopping in the Renaissance: Consumer Cultures in Italy, 1400–1600*. New Haven, Conn.: Yale Univ. Press, 2005.

Westfall, Carroll William. *In This Most Perfect Paradise: Alberti, Nicholas V, and the Invention of Conscious Urban Planning in Rome, 1447–55*. University Park: Pennsylvania State Univ. Press, 1974.

White, John. *The Birth and Rebirth of Pictorial Space*. 3RD ed. London: Faber and Faber, 1987.

Wohl, Hellmut. *The Paintings of Domenico Veneziano: A Study in Florentine Art of the Early Renaissance*. New York: New York Univ. Press, 1980.

Woods-Marsden, Joanna. *The Gonzaga of Mantua and Pisanello's Arthurian Frescoes*. Princeton, N.J., Princeton Univ. Press, 1988.

Wright, Alison. *The Pollaiuolo Brothers: The Arts of Florence and Rome*. New Haven, Conn.: Yale Univ. Press, 2005.

PART FOUR: CINQUECENTO ITALIAN ART

Ames-Lewis, Francis. *The Draftsman Raphael*. New Haven, Conn.: Yale Univ. Press, 1986.

Anderson, Jaynie. *Giorgione: The Painter of "Poetic Brevity."* Paris and New York: Flammarion, 1997.

Bambach, Carmen C. *Drawing and Painting in the Italian Renaissance Workshop: Theory and Practice, 1300–1600.* Cambridge: Cambridge Univ. Press, 1999.

———, et al. *Leonardo da Vinci: Master Draftsman.* New York: Metropolitan Museum of Art, 2003.

Barcilon, Pinin Brambeilla, and Pietro C. Marani. *Leonardo: The Last Supper.* Chicago: Univ. of Chicago Press, 2001.

Barolsky, Paul. *Faun in the Garden: Michelangelo and the Poetic Origins of Italian Renaissance Art.* University Park: Pennsylvania State Univ. Press, 1994.

Baskins, Cristelle Louise. *Cassone Painting, Humanism, and Gender in Early Modern Europe.* Cambridge: Cambridge Univ. Press, 1998.

Beck, James. *Raphael: The Stanza della Segnatura.* New York: Braziller, 1993.

Blunt, Anthony. *Artistic Theory in Italy, 1450–1600.* Oxford: Clarendon, 1966.

Brown, David Allan. *Leonardo da Vinci: Origins of a Genius.* New Haven, Conn.: Yale Univ. Press, 1998.

———, and Sylvia Ferino-Pagden. *Bellini, Giorgione, Titian, and the Renaissance of Venetian Painting.* Washington, D.C.: National Gallery of Art, 2006.

———, and Jan van Nimmen. *Raphael and the Beautiful Banker: The Story of the Bindo Altoviti Portrait.* New Haven, Conn.: Yale Univ. Press, 2005.

———, et al. *Virtue and Beauty: Leonardo's Ginevra de' Benci and Renaissance Portraits of Women.* Washington, D.C.: National Gallery of Art, 2001.

Burke, Peter. *The Italian Renaissance: Culture and Society in Italy.* 2ND ed. Princeton, N.J.: Princeton Univ. Press, 1999.

———. *The Fortunes of the Courtier: The European Reception of Castiglione's Courtegiano.* University Park: Pennsylvania State Univ. Press, 1996.

Campbell, Lorne. *Renaissance Portraits.* New Haven, Conn.: Yale Univ. Press, 1990.

Campbell, Stephen, and Stephen Milner. *Artistic Exchange and Cultural Translation in the Italian Renaissance City.* New York: Cambridge Univ. Press, 2004.

Chapman, Hugo, Tom Henry, and Carol Piazzotta. *Raphael: from Urbino to Rome.* London: National Gallery Publications, 2004.

Cheney, Liana de Giorolami, Alicia Craig Faxon, and Kathleen Lucey Russo, eds. *Self-Portraits of Women Artists.* Aldershot, England: Ashgate, 2000.

Ciapelli, Giovanni, and Patricia Rubin. *Art, Memory, and Family in Renaissance Florence.* New York: Cambridge Univ. Press, 2000.

Clark, Kenneth. *Leonardo da Vinci.* Rev. ed. London: Penguin, 1988.

———. *The Drawings of Leonardo da Vinci in the Collection of Her Majesty the Queen at Windsor Castle.* 2ND ed. 3 vols. Rev. with the assistance of Carlo Pedretti. London: Phaidon, 1968.

Cole, Bruce. *Titian and Venetian Painting.* Boulder, Colo.: Westview, 1999.

Cropper, Elizabeth. *Portrait of a Halberdier.* Los Angeles: Getty Museum, 1997.

De Vecchi, Pierluigi, and Gianluigi Colalucci. *Michelangelo: The Vatican Frescoes.* New York: Abbeville, 2000.

Ettlinger, Leopold. *Raphael.* London: Phaidon, 1987.

Ferino-Pagden, Sylvia, and Maria Kusche. *Sofonisba Anguissola: A Renaissance Woman.* Washington, D.C.: National Museum of Women in the Arts, 1995.

Fermor, Sharon. *Piero di Cosimo: Fiction, Invention, and Fantasia.* London: Reaktion, 1993.

Franklin, David. *Painting in Renaissance Florence, 1500–1550.* New Haven, Conn.: Yale Univ. Press, 2001.

———. *Rosso in Italy.* New Haven, Conn.: Yale Univ. Press, 1994.

Freedburg, Sydney J. *Painting in Italy, 1500–1600.* Harmondsworth, Middlesex: Penguin, 1990.

———. *Andrea del Sarto.* 2 vols. Cambridge, Mass.: MIT Press, 1963.

Friedlaender, Walter. *Mannerism and Anti-Mannerism in Italian Painting.* 1957. Reprint, with introduction by Donald Posner. New York: Schocken Books, 1965.

Gallucci, Margaret A. *Benvenuto Cellini: Sexuality, Masculinity, and Artistic Identity in Renaissance Italy.* New York: Palgrave Macmillan, 2003.

Goffen, Rona. *Titian's Women.* New Haven, Conn.: Yale Univ. Press, 1997.

Hale, J. R. *Artists and Warfare in the Renaissance.* New Haven, Conn.: Yale Univ. Press, 1990.

Hall, James. *Michelangelo and the Invention of the Human Body.* New York: Farrar, Straus and Giroux, 2005.

Hall, Marcia B., ed. *Michelangelo's Last Judgment.* New York: Cambridge Univ. Press, 2004.

———. *After Raphael, Painting in Central Italy in the Sixteenth Century.* Cambridge: Cambridge Univ. Press, 1999.

————. *Raphael's School of Athens.* Cambridge: Cambridge Univ. Press, 1997.

————. *Renovation and Counter-Reformation: Vasari and Duke Cosimo in Sta Maria Novella and Sta Croce, 1565–1577.* Oxford: Clarendon, 1979.

Hartt, Frederick. *Michelangelo.* New York: Abrams, 1984.

————. *Giulio Romano.* 2 vols. New Haven, Conn.: Yale Univ. Press, 1958.

Hayum, Andrée. *Giovanni Antonio Bazzi—"Il sodoma."* New York: Garland, 1976.

Hibbard, Howard. *Michelangelo.* 2ND ed. New York: Harper and Row, 1985.

Italian Women Artists from Renaissance to Baroque. Washington, D.C.: National Museum of Women in the Arts, 2007.

Jones, Ann Rosalind, and Peter Stallybrass. *Renaissance Clothing and the Materials of Memory.* Cambridge: Cambridge Univ. Press, 2000.

Jones, Roger, and Nicholas Penny. *Raphael.* New Haven, Conn.: Yale Univ. Press, 1986.

King, Margaret L. *Humanism, Venice, and Women.* Aldershot, England: Ashgate, 2005.

Ladis, Andrew. *Victims and Villains in Vasari's Lives.* Chapel Hill, NC: Univ. of North Carolina Press, 2008.

Land, Norman E. *The Viewer as Poet.* University Park: Pennsylvania State Univ. Press, 1994.

Landau, David, and Peter Parshall. *The Renaissance Print, 1470–1550.* New Haven, Conn.: Yale Univ. Press, 1994.

Lucinat, Cristina Acidini. *The Medici, Michelangelo, and the Art of Late Renaissance Florence.* New Haven, Conn.: Yale Univ. Press, 2002.

Macinelli, Fabrizio, ed. *Michelangelo: The Sistine Chapel: The Restoration of the Ceiling Frescoes.* Trevico: Canova, 2001.

Marani, Pietro C. *Leonardo da Vinci: The Complete Paintings.* New York: Abrams, 2000.

Motture, Peta, ed. *Large Bronzes in the Renaissance* (Studies: History of Art 64). Washington, D.C.: National Gallery of Art, 2003.

Nash, Jane C. *Veiled Images: Titian's Mythological Paintings for Philip II.* Philadelphia: Associated Univ. Presses, 1995.

Natali, Antonio. *Andrea del Sarto.* New York: Abbeville, 1999.

Nicholl, Charles. *Leonardo da Vinci: Flights of the Mind.* New York: Viking Penguin, 2004.

Oberhuber, Konrad. *Raphael: The Paintings.* New York: Prestel, 1999.

Panofsky, Erwin. *Problems in Titian, Mostly Iconographic.* New York: New York Univ. Press, 1969.

————. *Studies in Iconology: Humanistic Themes in the Art of the Renaissance.* 1939. Reprint, New York: Harper and Row, 1962.

————. *Meaning in the Visual Arts.* Garden City, N.Y.: Doubleday, 1957.

Partridge, Loren W. *The Last Judgment: A Glorious Restoration.* New York: Abrams, 1997.

Pilliod, Elizabeth. *Pontormo, Bronzino, and Allori: A Genealogy of Florentine Art.* New Haven, Conn.: Yale Univ. Press, 2001.

Poeschke, Joachim. *Michelangelo and His World: Sculpture of the Italian Renaissance.* New York Abrams, 1996.

Pollard, John Graham. *Renaissance Medals.* Assisted by Eleonora Luciano and Mary Pollard. Vol. 1. Washington, D.C.: National Gallery of Art, 2007.

Pon, Lisa. *Raphael, Dürer, and Marcantonio Raimondi: Copying and the Italian Renaissance Print.* New Haven, Conn.: Yale Univ. Press, 2003.

Pope-Hennessy, John. *Italian High Renaissance and Baroque Sculpture.* 4TH ed. London: Phaidon, 1996.

————. *Cellini.* New York: Abbeville, 1985.

————. *The Portrait in the Renaissance* (Bollingen Lecture Series 12). Princeton, N.J.: Princeton Univ. Press, 1966.

Robertson, Claire. *Il Gran Cardinale: Alessandro Farnese, Patron of the Arts.* New Haven, Conn.: Yale Univ. Press, 1992.

Rosand, David. *Painting in Sixteenth-Century Venice: Titian, Veronese, Tintoretto.* Cambridge: Cambridge Univ. Press, 1997.

————. *Titian and the Venetian Woodcut.* Washington, D.C.: National Gallery of Art, 1976.

Rowland, Ingrid D. *From Heaven to Arcadia: The Sacred and the Profane in the Renaissance.* New York: New York Review of Books, 2005.

Rubin, Patricia Lee. *Giorgio Vasari: Art and History.* New Haven, Conn.: Yale Univ. Press, 1995.

Rylands, Philip. *Palma Vecchio.* Cambridge: Cambridge Univ. Press, 1990.

Satkowski, Leon. *Giorgio Vasari, Architect and Courtier.* Princeton, N.J.: Princeton Univ. Press, 1993.

Seznec, Jean. *The Survival of the Pagan Gods: The Mythological Tradition and Its Place in Renaissance Humanism and Art*. 1953. Reprint, Princeton, N.J. Univ. Press, 1972.

Shearman, John. *Raphael's Cartoons in the Collection of Her Majesty the Queen and the Tapestries for the Sistine Chapel*. London: Phaidon, 1972.

———. *Mannerism*. Harmondsworth, Middlesex: Penguin, 1967.

———, and Marcia B. Hall, eds. *The Princeton Raphael Symposium: Science in the Service of Art History*. Princeton, N.J.: Princeton Univ. Press, 1990.

Smyth, Craig H. *Mannerism and Maniera*. Locust Valley, N.Y.: J. J. Augustin, 1961.

Steinberg, Leo. *The Sexuality of Christ in Renaissance Art and Modern Oblivion*. 2ND ed. Chicago: Univ. of Chicago Press, 1996.

Thornton, Dora. *The Scholar in His Study: Ownership and Experience*. New Haven, Conn.: Yale Univ. Press, 1997.

Tucker, Richard A. *Inventing Leonardo*. Berkeley: Univ. of California Press, 1994.

Wethey, Harold E. *The Paintings of Titian*. 3 vols. London: Phaidon, 1969–75.

Wind, Edgar. *Pagan Mysteries in the Renaissance*. New York: Norton, 1958.

Woods-Marsden, Joanna. *Renaissance Self-Portraiture: The Visual Construction of Identity and the Social Status of the Artist*. New Haven, Conn.: Yale Univ. Press, 1998.

PART FIVE: PATRONS, CITIES, AND DEITIES

Aikema, Bernard, and Beverly Louise Brown, eds. *Renaissance Venice and the North: Crosscurrents in the Time of Bellini, Dürer, and Titian*. New York: Rizzoli, 2000.

Ames-Lewis, Francis, ed. *The Early Medici and Their Artists*. London: Birbeck College, 1995.

———. *Cosimo, "Il Vecchio" de Medici, 1389–1464*. Oxford: Clarendon, 1992.

Barzman, Karen-edis. *The Florentine Academy and the Early Modern State*. Cambridge: Cambridge Univ. Press, 2000.

Bober, Phyllis Pray, and Ruth O. Rubinstein. *Renaissance Artists and Antique Sculpture: A Handbook of Sources*. New York: Oxford Univ. Press, 1986.

Brown, Alison. *The Medici in Florence: The Exercise and Language of Power*. Florence: Leo S. Olschki, 1992.

Brown, Clifford. *Isabella d'Este in the Ducal Palace in Mantua: An Overview of Her Rooms in the Castello di San Giorgio and the Corte Vecchia*. Rome: Bulzoni, 2005.

Brown, Patricia Fortini. *Private Lives in Renaissance Venice: Art, Architecture, and the Family*. New Haven, Conn.: Yale Univ. Press, 2004.

———. *Art and Life in Renaissance Venice*. New York: Prentice Hall, 1997.

Brucker, Gene A. *Renaissance Florence*. Berkeley: Univ. of California Press, 1983.

Bull, Malcolm. *The Mirror of the Gods: Classical Mythology in Renaissance Art*. New York: Oxford Univ. Press, 2005.

Burke, Jill. *Changing Patrons: Social Identity and the Visual Arts in Renaissance Florence*. University Park: Pennsylvania State Univ. Press, 2004.

Campbell, Stephen J., *The Cabinet of Eros: Renaissance Mythological Painting and the Studiolo of Isabella d'Este*. New Haven, Conn.: Yale Univ. Press, 2006.

———, ed. *Artists at Court: Image Making and Identity 1300–1500*. Boston: Isabella Stewart Gardner Museum, 2005.

Clarke, Georgia. *Roman House–Renaissance Palaces: Inventing Antiquity in Fifteenth-Century Italy*. Cambridge: Cambridge Univ. Press, 2003.

Clarke, Paula. *The Soderini and the Medici: Power and Patronage in Fifteenth-Century Florence*. Oxford: Clarendon, 1991.

Coffin, David. *The Villa in the Life of Renaissance Rome*. Princeton, N.J.: Princeton Univ. Press, 1979.

Cole, Alison. *Virtue and Magnificence: Art of the Italian Renaissance Courts*. New York: Abrams, 1995.

Cox-Rearick, Janet. *Dynasty and Destiny in Medici Art*. Princeton, N.J.: Princeton Univ. Press, 1984.

Dixon, Annette. *Women Who Ruled: Queens, Goddesses, Amazons, in Renaissance and Baroque Art*. London: Merrell, 2002.

Fenlon, Iain. *The Ceremonial City: History, Memory and Myth in Renaissance Venice*. New Haven, Conn.: Yale Univ. Press, 2008.

Fiorani, Francesca. *The Marvel of Maps: Art, Cartography and Politics in Renaissance Italy*. New Haven, Conn.: Yale Univ. Press, 2005.

Fusco, Laurie, and Gino Corti. *Lorenzo de' Medici, Collector of Antiquities*. New York: Cambridge Univ. Press, 2005.

Goldberg, Edward L. *Patterns in Late Medici Art Patronage*. Princeton, N.J.: Princeton Univ. Press, 1983.

Goldthwaite, Richard A. *Wealth and the Demand for Art in Italy 1300–1600*. Baltimore: Johns Hopkins Univ. Press, 1993.

———. *The Building of Renaissance Florence: An Economic and Social History*. Baltimore, Md.: Johns Hopkins Univ. Press, 1980.

———. *Private Wealth in Renaissance Florence, A Study of Four Families*. Princeton, N.J.: Princeton Univ. Press: 1968.

Goy, Richard J. *Building Renaissance Venice: Patrons, Architects, and Builders c. 1430–1500*. New Haven, Conn.: Yale Univ. Press, 2008.

Hall, Marcia, ed. *Rome*. Cambridge: Cambridge Univ. Press, 2005.

Hersey, George L. *Alfonso II and the Artistic Renewal of Naples, 1485–1495*. New Haven, Conn.: Yale Univ. Press, 1969.

Hollingsworth, Mary. *Patronage in Renaissance Italy: From 1400 to the Early Sixteenth Century*. Baltimore, Md.: Johns Hopkins Univ. Press, 1994.

Holmes, George. *Rome and the Origins of the Renaissance*. Oxford: Clarendon, 1986.

Howard, Deborah. *The Architectural History of Venice*. Rev. and enlarged ed. New York: Yale Univ. Press, 2002.

———. *Venice and the East: The Impact of the Islamic World on Venetian Architecture, 1100–1500*. New Haven, Conn.: Yale Univ. Press, 2000.

Kent, Dale. *Cosimo de' Medici and the Florentine Renaissance: The Patron's Oeuvre*. New Haven, Conn.: Yale Univ. Press, 2000.

Kent, F. W. *Lorenzo de' Medici and the Art of Magnificence*. Baltimore, Md.: Johns Hopkins Univ. Press, 2004.

———, and Patricia Simons, with J. C. Eade, eds. *Patronage, Art and Society in Renaissance Italy*. Oxford: Clarendon, 1987.

Klapisch-Zuber, Christiane. *Women, Family, and Ritual in Renaissance Italy*. Chicago: Univ. of Chicago Press, 1985.

Langdon, Gabrielle. *Medici Women: Portraits of Power, Love, and Betrayal in the Court of Duke Cosimo*. Toronto: Univ. of Toronto Press, 2007.

Lawrence, Cynthia, ed. *Women and Art in Early Modern Europe*. University Park: Pennsylvania State Univ. Press, 1997.

Lillie, A. *Florentine Villas in the Fifteenth Century: An Architectural and Social History*. New York: Cambridge Univ. Press, 2005.

Martin, John, and Denis Romano, eds. *Venice Reconsidered: The History and Civilization of an Italian City-State, 1297–1797*. Baltimore, Md.: Johns Hopkins Univ. Press, 2000.

Martines, Lauro. *April Blood: Florence and the Plot Against the Medici*. New York: Oxford Univ. Press, 2003.

Millon, Henry A., and Vittorio Magnago Lampugnani, eds. *The Renaissance from Brunelleschi to Michelangelo: The Representation of Architecture*. Milan: Bompiani, 1994.

O'Malley, Michele. *The Business of Art: Contracts and the Commissioning Process in Renaissance Italy*. New Haven, Conn.: Yale Univ. Press, 2005.

Reiss, Sheryl E., and David G. Wilkins, eds. *Beyond Isabella: Secular Women Patrons of Art in Renaissance Italy*. Kirksville, Mo.: Truman State Univ. Press, 2001.

Roover, Raymond de. *The Rise and Decline of the Medici Bank 1397–1494*. Cambridge, Mass.: Harvard Univ. Press, 1963.

Rosand, David. *Myths of Venice: The Figuration of a State*. Chapel Hill: Univ. of North Carolina, 2001.

Rosenberg, Charles M. *The Este Monuments and Urban Developments in Renaissance Ferrara*. Cambridge: Cambridge Univ. Press, 1997.

Rubinstein, Nicolai. *The Palazzo Vecchio 1298–1532: Government, Architecture, and Imagery in the Civic Palace of the Florentine Republic*. Oxford: Clarendon, 1995.

Stinger, Charles L. *The Renaissance in Rome*. Bloomington, Ind.: Indiana Univ. Press, 1985.

Trexler, Richard C. *Public Life in Renaissance Florence*. New York: Academic Press, 1980.

Verheyen, Egon. *The Palazzo del Te*. Baltimore, Md.: Johns Hopkins Univ. Press, 1977.

Wackernagel, Martin. *The World of the Florentine Renaissance Artist: Projects and Patrons, Workshop and Art Market*. Trans. Alison Luchs. Princeton, N.J.: Princeton Univ. Press, 1981.

Welch, Evelyn S. *Art and Authority in Renaissance Milan*. New Haven, Conn.: Yale Univ. Press, 1995.

Zervas, Diane Finiello. *The Parte Guelfa, Brunelleschi, and Donatello*. Locust Valley, N.Y.: J. J. Augustin, 1988.

Index

32 36 59 72 73 85 91 92 95
97 98 101 102 103-08
115 116 117 137 161
162 165 184
297 104

58 88 283 487 457 465 512

Original Sin 15–16 (ORIGINAL SIN, glossary), 189, 200, 221, 226

Orsini, Clarice (wife of Lorenzo de' Medici, d. 1487) 105, 158 (entry 1469), 163–64 (entry 1469), 288 (fig. 61–2), 290

Orsini, Fulvio (librarian to Cardinal Odoardo Farnese) 280

Orsini, Giordano, Cardinal 119, 121, 122 (entry ca. 1430), 141 (UOMINI FAMOSI, sidebar)

Orsini, Napoleone, Cardinal (60, 61 [entries ca. 1315, 1330s] Pietro Lorenzetti frescoes, S. Francesco, Assisi)

Orsini, Virginio (condottiere of Bracciano, near Rome) 158 (sidebar), 160 (Antonio Pollaiuolo letter to, entry 1494)

Ospedale (see Hospital)

Ovid 215 (entry 1556), 311, 315 (entry 43 BCE); 204, 237, 274 (Metamorphoses); 204, 264 (Fasti)

—P—

Pacioli, Fra Luca (from Sansepolcro, studied mathematics in Venice, d. 1517) 167 (Botticelli), 171 (Summa, entry 1494), 227 (entry 1499/1500: writes De divina proportione, includes Leonardo's designs), 306 (entry 1504)

Painters' guild, Florence (see Guilds, Florentine, Arte dei Medici e Speziali)

Palaeologo, Maria (wife of Federigo II Gonzaga, d. 1566) 262 (entry 1531), 282 (fig. V–2)

Palaeologus, Michael VIII, Byzantine emperor (1258–82) 7

Palaeologus, Emperor John VIII (reigned 1425–48) 127 (figs. 27–1, 27–2, Pisanello medal), 128 (entry 1438)

Palestrina, Giovanni Pierluigi da (famed composer from Palestrina, d. 1594) 214 (entry 1551), 215 (sidebar)

Palladio, Andrea (renowned Venetian architect, 1508–80) 268 (entry 1566), 306 (entry 1570)

Palma, Giacomo, Il Giovane (Venetian painter, great-nephew of Palma Vecchio, d. 1628) 268 (entry ca. 1575)

Palma, Jacopo, Il Vecchio (Venetian painter, d. 1528) 268 Portrait of a Woman 264 (fig. 56–3)

Pan (son of Hermes) 187 (Court of Pan, fig. 41–1), 188, 314 (PAN)

Pandolfini (Florentine family) 141 (acquire Villa Carducci, entry 1451), 142 (fig. 30–2), 292 (fig. 62–7, #32), 302 (palace of Bishop Pandolfini, fig. 64–7)

Panicale, Masolino da (see Masolino)

Pantheon, Rome 309 (figs. 67–1, 67–2), 310 (fig. 67–3)

Pantocrator 17, 19, 20, 26, 37, 49, 125, 139, 189, 247

Pantocrator, images of
(Coppo) 19 (fig. 3–2), 20 (fig. 3–3)
(Lorenzo Maitani) 37 (fig. II–7)
(Giotto) 49 (fig. II–2)
(Fra Angelico) 189 (fig. 41–4)
(Michelangelo) 247 (fig. 51–13, entry 1541)

Papal State 38, 75, 82, 89, 90 (PAPAL STATE, glossary), 200

paper 78 (entry 1465), 178 (fig. 38–6), 218 (CARTELLINO), 228 (fig. 48–7), 277 (PAPER; fig. 59–3), 278 (PREPARED PAPER)

paragone 214 (entry 1546) (see also Varchi, Benedetto)

Parenti, Marco 145 (ordered cassoni from Veneziano), 163

Parentucelli, Tommasso (see Nicholas V, Pope)

Passau, Treaty of 214 (entry 1552)

Passerini, Margherita 252 (patron of Sarto, entry 1526)

Passerini, Silvio, Cardinal 275 (entry 1524)

Passignano (Vallombrosan monastery) 174 (entry 1476)

Passion of Christ 3, 14 (FLAGELLANTS, glossary), 15 (MEDITATIONS ON CHRIST, glossary), 46 (PASSION, glossary), 51–52 (Giotto's Passion scenes, figs. 11–3, 11–4), 55 (Duccio's Passion scenes, fig. 12–3), 60 (entry 1329), 62 (entries 1338, 1344), 87–88 (LAST SUPPER, glossary), 140 (sidebar), 219–20 (FLAGELLATION, glossary), 255 (entry 1522), (see also Instruments of Christ's Passion)

pastels 278

pastiglia 90 (PASTIGLIA, glossary), 110 (Gentile's use of), 270

Pater patriae (honorific of Cosimo de' Medici) 78 (entry 1466), 163 (entry 1467 and fig. 36–3), 287 (fig. 61–1), 290

patron 90 (PATRON, glossary)

Paul, Saint (martyred in Rome) 26 (ca. 1278; sidebar), 46 (Hymn on Christian Love, VIRTUES, glossary), 120 (fig. 25–2)

Paul II, Pope 78 (entry 1464 and sidebar), 79 (entry 1471), 318 (crest, fig. 69–5)

Paul III, Pope (see also Farnese, Alessandro) 125 (Pauline Chapel, entry 1445), 213, 214, 236 (fig. 50–7), 246–47 (Last Judgment, entries 1535, 1541), 248 (Pauline Chapel, entry 1542; S. Peter's, Michelangelo chief architect of, entry 1547), 272 (patron of Cellini, entry 1535; jails Cellini, entry 1538), 275 (Vasari's frescoes of, entry 1546), 318 (crest, fig. 69–5)

Paul IV, Pope 181 (fig. 39–3, Carafa Chapel, S. Maria Sopra Minerva, tomb of), 215 (Index of Forbidden Books, entry 1557), 216 (death of Paul, entry 1559), 248 (Michelangelo's cupola of S. Peter's, entry 1555), 318 (crest, fig. 69–5)

Pavia, Gusnasco da (agent of Isabella d'Este) 227 (entry 1501)

Pazzi (Florentine family) 93 (patronage of Chapter House, S. Croce, Florence, entry 1429), 140 (entry 1445), 294

Pazzi Conspiracy 79–80 (entry 1478; fig. 17–10), 140 (entry 1440), 169 (Pazzi family conspirators, Francesco, Jacopo, Renato, entry 1478), 290

Peace of Augsburg 215 (entry 1555)

Peace of Cateau–Cambrésis 216 (entries 1559, 1560)

Peasants' Revolt 212 (entry 1524)

Pecci, Giovanni (Tomb of) 105 (entry 1428)

Pelago, Fra Lorenzo da (stained-glassmaker) 132 (fig. 28–2)

Pellegrino, Francesco 260 (guest of Rosso Fiorentino in Fontainebleau, entry 1540)

pen 278

Penni, Giovan Francesco (Raphael assistant, collaborator of Giulio Romano, d. after 1528) 236 (entry 1517), 238 (fig. 50–11), 262 (entry 1516)

pentimenti 277

Pepin the Great (father of Charlemagne) 38

Peregrinationes (see Breydenbach)

Perseus (pagan hero) 103, 237, 238 (fig. 50–11, #23), 271 (fig.

58–1), 273, 274 (Ovid), 312 (HADES), 314 (GORGONS)
Perseus and Medusa 103 (Cellini's statue in the Loggia dei Lanzi, Florence), 271 (fig. 58–1), 273–74 (entry 1545)
perspective 90 (PERSPECTIVE, glossary)
Perugino, Pietro (Pietro Vanucci) 159 (fresco, Chapel of Sixtus IV, S. Peter's, entry 1484), 163 (Verrocchio shop, entry 1466), 170 (contract for Sala dei Gigli, entry 1482; view of room, fig. 42–8), 171 (judges Duomo facade designs, entry 1491; *Vision of S. Bernard*, entry 1489), 177 (Villa Spedaletto), 182 (evaluates frescoes), 187 (trained with Signorelli), 189 (Cappella Nuova, Orvieto), 190 (dining with Bramante, Rome), 191–98 (chapter on), (232, 233 influence on Raphael, entries 1503, 1507), 241 (influence on Michelangelo, fig. 51–3), 252 (influence on Andrea del Sarto, entry 1524), 257 (Vasari's criticism of); Sistine Chapel 192 (SISTINE CHAPEL, sidebar), 194–95 (figs. 42–3, 42–4), 247 (entry 1535); *Delivery of the Keys to Peter* 163, 191 (fig. 42–1), 232 (entry 1504); frescoes, Sala d'Udienza, Collegio del Cambio, Perugia 194 (entry 1500) and 196–97 (figs. 42–5 to 42–7); *Combat Between Love and Chastity* 193 (fig. 42–2), 194 (entry 1505)
Peruzzi, Baldassare (Sienese architect and painter, d. 1536) 230 (Vatican Palace), 237–38 (Villa Chigi, Rome, figs. 50–8 to 50–10), 309 (entombed in Pantheon, Rome)
Peruzzi, family of (Florentine bankers) 40–41 (entry 1346), 42 (entry 1397), 48 (entry 1320)
Pesellino, Francesco di Stefano (Florentine painter, grandson of Pesello, d. 1457) 133, 144, 145 (entry 1457), 146
Pesello, Giuliano d'Arrigo (Florentine painter, d. 1446) 67 and 138 (designs for tombs in Florence Duomo), 295
Peter, Apostle 8 (entry 1298), 14 (GOSPELS, glossary), 16 (POPE, glossary), 46 (INSTRUMENTS OF CHRIST'S PASSION, sidebar), 64 (entry 1357), 87–88 (LAST SUPPER, glossary), 115 (fig. 24–1), 116 (Brancacci Chapel), 117 (fig. 24–2), 118 (fig. 24–3), 119 (fig. 25–1), 120 (fig. 25–2), 139 (fig. 30–1), 140 (LAST SUPPER, sidebar), 191 (*Delivery of the Keys to Peter*, fig. 42–1), 229 (Tempietto, fig. 49–2), 239 (relationship between Joseph and Peter, Michelangelo's *Doni Holy Family Tondo*, fig. 51–1), 297 (see BECCAI)
Peter Leopold of Lorraine, Grand Duke of Tuscany (late–18TH c.) 294 (Florentine guilds suppressed)
Peter Martyr, Saint (fought heretics and was murdered; shown in Dominican habit and with sword, knife, or hatchet in his skull, d. 1252) 53 (entry 1285), 124, 177, 267
Petrarca (see Petrarch)
Petrarch (1304–74) 3, 39 (entry 1304), 40 (entry 1341), 44, 47, 57, 142 (fig. 30–2), 155, 169, 175 (*De viris illustribus*)
Petrucci, Borghese (son of Pandolfo, expelled from Siena 1516; back in power briefly 1522–24) 190 (entry 1509)
Petrucci, Pandolfo (1487 took control of Siena, abdicated to sons, d. 1512) 190
Phaedrus (see Plato)

Philip, Apostle 8, 139 (fig. 30–1), 140 (LAST SUPPER, sidebar), 182 (figs. 39–4, 39–5), 296 (fig. 63–11), 297 (fig. 63–12)
Philip II, King of Spain (1556–98) 214–15 (marries Mary Tudor, entry 1554), 216 (marries Elisabeth of Valois [for portrait, fig. 60–2], entry 1560; Madrid new capital, entry 1561; builds Escorial, entry 1563), 267 (calls Titian to Milan, entry 1547), (268, 270 patron of Titian, figs. 57–5, 57–7; entries 1556, 1559, 1571), 274 (Cellini's *Crucifix*, entry 1562), 280 (arranges marriage of Sofonisba, entry 1573, and is pictured in portrait by Sofonisba, fig. 60–2), 286 (V–6)
Philip IV, King of France (1285–1314) 39 (entries 1307, 1309), 40 (entries 1307, 1309)
Philostratus (Greek writer) 215, 266 (*Imagines*, entry 1518)
Piagnona (bell of S. Marco Convent, Florence) 82 (entry 1498)
Piamonte, Giovanni (painter, worked at Arezzo) 152 (fig. 33–4)
Pianta di Venezia (see Barbari, Jacopo de')
Piccinino (*condottiere*) 75 (entries 1436, 1440)
Piccolomini, Aeneas Silvius (see Pius II, Pope)
Piccolomini, Francesco (see Pius III, Pope)
Piccolomini, Vittoria 190 (marriage to Borghese Petrucci, entry 1509)
Pichi, Giovan Maria (painter, student of Pontormo) 255, 256
Pico della Mirandola, Giovanni (d. 1494) 80 (entry 1488, *Heptaplus* and *Oration on the Dignity of Man*)
Pienza 77 (entry 1462, the town of Corsignano fashioned into)
Piero della Francesca (Piero di Benedetto) 77, 141 (*Madonna del Parto*), 144, 145, 149–52 (chapter on), 153, 159, 170, 187 (Signorelli in shop), 188 (*Flagellation*), 191, 192; *Baptism of Christ* 84 (fig. 18–2), 85, 150, 170; Legend of the True Cross frescoes, S. Francesco, Arezzo 67, 149, 150, 152 (fig. 33–4), 156; *Empress S. Helena and the Discovery of the Crosses and Miracle of the True Cross* 149 (fig. 33–1); *Battista Sforza* 150 (fig. 33–2), 228, 233; *Federico da Montefeltro* 151 (fig. 33–2)
Pietro di Puccio (painter, worked in Pisa, Orvieto, active late–14TH c.) 155 (Gozzoli completes frescoes of, entry 1467)
Pierozzi, Antonino (see Antoninus)
Pietà 220 (LAMENTATION, glossary)
Pietà, images of
 (Michelangelo, S. Peter's) 241 (fig. 51–3)
 (Michelangelo, Florentine) 248 (fig. 51–14)
Pietro, Anichino di (German artist) 103 (in street brawl with Donatello, entry 1401)
pinnacles 24 (POLYPTYCH; fig. 4–7)
Pintoricchio, Bernardo (Bernardino di Betto) (Perugian painter, d. 1513) 179, 190 (dining with Bramante), 192, (194–95 Sistine Chapel frescoes, figs. 42–3, #2 and 42–4, #10), 244 (influence on Michelangelo, entry 1508)
Piombino 227 (entry 1503, Leonardo at work on fortifications of)
Piombo, Sebastiano del (Sebastiano Luciani) (Venetian painter, d. 1547) 205, 212–13 (appointed to papal office, entry 1531), 236 (entry 1517, *Resurrection of Lazarus*), 237 (*Polyphemus*, fig. 50–9), 245 (entry 1516), 262 (entry 1520),

263 (*Three Philosophers*, fig. 56–1), 265 (entry 1511)

Pippo Spano (nickname of Filippo Scolari, *condottiere*, d. 1426) 121 (Masolino, entries 1425, 1426), 129 (fig. 28–1, Scolari coat of arms), 142 (Villa Carducci, fig. 30–2)

Pisanello (Antonio Pisano) 72, 76, 77, 127–28 (chapter on), 183 (at Mantua), 206; *Marchese Leonello d'Este of Ferrara* 76 (fig. 17–6), 77 (fig. 17–7); *Medal of Emperor John VIII Palaeologus* 127 (fig. 27–1), 128 (fig. 27–2); *Don Iñigo d'Avalos* 128 (figs. 27–3, 27–4)

Pisano, Andrea (9, 43, 45 reliefs of Virtues by follower of), 38, 96, 97, 102, 103, 295; Florence Baptistery: *Scenes of John the Baptist* 11 (fig. 2–3), 39 (fig. 9–1), 46, 83

Pisano, Giovanni 2, 30, 31–32 (chapter on), 36, 52 (Scrovegni Chapel, Padua), 54; Pulpit, S. Andrea, Pistoia 31 (fig. 8–1), 31–32 (entry 1301); *Prophets*, facade, Siena Cathedral 31, 32 (fig. 8–3)

Pisano, Nicola 4, 6 (Arca di S. Domenico Maggiore, Bologna), 29–30 (chapter on), 31, 32, 36, 47, 56, 62; Pulpit, Pisa Baptistery 29 (fig. 7–1), 30

Pistoia, Lunardo di Matteo Ducci da (goldsmith) 91 (entry 1399)

Pitti (wealthy Florentine family) 294

 Bartolommeo 242 (fig. 51–5; entry 1505)

 Luca (merchant and politician, d. 1472) 78 (revolt against Piero de' Medici, entry 1466), 93 (Brunelleschi's villa for, entry 1430), 292 (Florence palace, fig. 62–7, #29)

Pitti Palace, Florence 302 (fig. 64–6)

Pius II, Pope (Piccolomini, Enea Silvio) 76 (entry 1443), 77 (entry 1458), 78 (death of, entry 1464), 148 (entry 1459), 151, 154, 184 (in Mantua), 318 (crest, fig. 69–5)

Pius III, Pope (Francesco Todeschini Piccolomini) 209, 235 (fig. 50–5), 241–242 (patron, Piccolomini altar and library, Siena Cathedral, entry 1501), 318 (crest, fig. 69–5)

Pius IV, Pope (Giovanni Angelo Medici) 216 (entry 1562, reconvenes Council of Trent), 248, 318 (crest, fig. 69–5)

Pius V, Pope (Michele Ghislieri) 10, 216 (election of, entry 1566), 276 (patron of Vasari, entry 1570), 318 (crest, fig. 69–5)

Pizzolò, Niccolò (Paduan painter, partner of Mantegna, d. 1453) 183–84 (Ovetari Chapel, Eremitani, Padua)

plague (see also Black Death) 33, 62, 75, 154, 155, 212, 252, 255, 268, 275

Platina (Sacchi, Bartolomeo) (Lombard humanist, became librarian of Sixtus IV, d. 1481) 72 (entry 1420), 160, 210 (Vatican librarian successor of, entry 1510)

Plato (Greek philosopher) 46 (*Republic:* VIRTUES, glossary), 72 (entry 1423, *Phaedrus*), 79 (entry 1469, *Dialogues*)

Platonic Academy, Florence 78–79 (entry 1467)

Plethon (Greek scholar) 75 (entry 1438)

Pliny the Elder (d. 79) 316 (*Historia naturalis*)

Pluto (Hades) 204 (fig. 44–3), 231 (fig. 50–1), 238 (fig. 50–11, #2, #16, #24), 312 (HADES)

poesia 263, 268

Poggio a Caiano (Medici villa at) 181, 217 (fig. 47–1), 237,

251 (entry 1521, Sarto, Franciabigio, Pontormo at), 255

Politian (Poliziano, Angelo) (Florentine humanist and tutor of Medici children) 80 (entry 1480), 168 (entry 1475, *Stanze per la giostra di Giuliano de' Medici*), 170 (entry ca. 1485), 171 (fig. 37–4), 174 (sidebar), 181 (entry 1488), 237

Poliziano, Angelo (see Politian)

Pollaiuolo, Antonio del 141, 157–60 (chapter on), 161, 173, 188, 189, 192; Cardinal of Portugal's Chapel, S. Minato al Monte, Florence: frescoes and *Ss. Vincent, James, and Eustace* 157 (fig. 35–1), 158 (entry 1467); *Hercules and Antaeus* 158 (LABORS OF HERCULES, sidebar), 159 (fig. 35–2), 162 (compared to Verrocchio's *Putto with Dolphin*, fig. 36–2); Pope Sixtus IV's Tomb 158, 159, 160 (fig. 35–3)

Pollaiuolo, Piero del 157–60 (chapter on), (163, 168 Virtues, Mercanzia Palace, Florence), 170 (Sala dei Gigli), 175; *Coronation of the Virgin with Saints*, S. Agostino, S. Gimignano 153 (fig. 34–1), 159 (entry 1483)

Pollaiuolo, Simone del (see Cronaca)

polyptych 24 (POLYPTYCH; fig. 4–7)

Pontormo (Jacopo Carucci) 171, 218, 251, 253–56 (chapter on); Capponi Chapel, S. Felicità: *Lamentation* (panel) 253 (fig. 53–1), 260; *S. John the Evangelist* (fresco) 255, 256 (fig. 53–4); *Visitation*, SS. Annunziata 254, 255 (fig. 53–3), 256; *Portrait of Cosimo the Elder de' Medici* 287 (fig. 61–1)

Poor Clares (see clerical orders, Poor Clares)

pope 16 (POPE, glossary)

Porta clausa 86 (HORTUS CONCLUSUS, glossary)

Porta, Giacomo della 220

Portinari Altarpiece (by Hugo van der Goes) 290 (Tomasso Portinari commissioned altarpiece for S. Egidio, fig. 62–7, #14)

Portinari, Tomasso 89 (sidebar) (see also *Portinari Altarpiece*)

Poseidon (see Neptune)

Poussin, Nicolas (French painter, d. 1665) 265

predella 21, 24 (POLYPTYCH; fig. 4–7), 55 (Duccio's *Maestà*, sidebar)

prepared paper 278

Presentation in the Temple and Purification of the Virgin (Candlemas), Feast of (2 February) 42 (instituted 1372), 61

Presentation in the Temple and Purification of the Virgin, images of

 (Nicola Pisano) 29 (fig. 7–1)

 (Giotto) 52 (fig. 11–4)

 (Duccio) 54 (fig. 12–2)

 (Ambrogio Lorenzetti) 61 (fig. 14–3), 62 (fig. 14–4, D)

 (Ghiberti) 83 (fig. 18–1)

 (Gentile da Fabriano) 109 (predella panel, fig. 22–1)

 (Ghirlandaio) 176, 177, 178 (figs. 38–3, 38–4, 38–5)

Primaticcio, Francesco (Bolognese painter, sculptor, architect, worked at French court, d. 1570) 218, 249, 260 (entry 1532), 273 (entries 1543, 1545), 286

Principatibus, De (The Prince) (see Machiavelli)

Prisciani, Pellegrino (humanist scholar at Ferrara court, d. 1518) 78 (fig. 17–8), 79 (entry 1471)

Combat Between Love and Chastity, fig. 42–2), 196 (Perugino, Cambio ceiling, planet *Venus*, fig. 42–5), 219 (*Venus Standing on a Tortoise*, fig. 47–7), 231 (Raphael, *Council of the Gods*, fig. 50–1), 238 (Raphael, Loggia of Psyche, fig. 50–11, #1, #2, #3, #5, #6, #7, #10), 310, 312 (Giulio Romano, *Mars and Venus*, fig. 68–2), 313 (see APHRODITE)

Venus *pudica* 170

Verino, Ugolino (humanist) 157, 167

Verona, Guarino da (scholar at Ferrara court) 77 (fig. 17–7), 78 (fig. 17–8)

Verona, Paolo da (embroiderer) 158

Veronese (Venetian painter, d. 1588) 247

Verrocchio, Andrea del 70, 85 (*Baptism of Christ*) 107, 159, 161–66 (chapter on), 169–70 (influence on Botticelli), 174, 179, 188, 191 (Perugino in shop), 192, 224; *Incredulity of Thomas* 70, 87, 161 (fig. 36–1) 162, 179, 296 (fig. 63–11), 297; *Lady with a Bunch of Flowers* 165 (entry ca. 1475), 224, 225 (fig. 48–4); *Memorial Plaque to Cosimo de' Medici*, S. Lorenzo 163 (fig. 36–3); *David* 162, 164 (fig. 36–4), 165; *Putto and Dolphin* 162 (fig. 36–2), 164; *Tomb of Giovanni and Piero de'Medici*, S. Lorenzo, Florence 70 (fig. III–2); *Equestrian Monument to Bartolomeo Colleoni* 86, 162, 165 (fig. 36–5)

Vesalius, Andrea 214 (*De humani corporis fabrica*, 1543, fig. 46–4)

Vespucci 167, 168, 169 (Botticelli, entry 1480), 170 (Botticelli's *Venus and Mars*, entry 1482), 174 (Ghirlandaio, entry 1480)

Vesta (Hestia) 312 (HESTIA)

Vestal Virgin 310, 312 (HESTIA)

Vices 33, 34 (fig. II–2), 35 (fig. II–3), 46 (VICES, glossary), 246 (Virtue triumphant over Vice, fig. 51–12; entry 1527)

Victor, Saint 55, 62, 180

Vignola, Jacopo (1507–73, architect, theorist) 220, 309

Villa d'Este (Tivoli, near Rome) 215, 222

Villa Gallina (near Florence) 159

Villa Lemmi (near Florence) 171

Villa at Castello (near Florence) 188, 256

Villa Spedaletto (near Volterra) 171, 177, 180, 192

Villani, Filippo 175 (entry 1482)

Villani, Giovanni (Florentine banker, chronicler famous for his *Cronica*, d. 1348) 3 (sidebar), 11 (fig. 2–3), 19 (fig. 3–2), 41 (entry 1346), 48 (entry 1337), 63 (fig. 15–1)

Virgil 3 (sidebar), 7 (fig. 1–3), 215 (inspiration for LE IMAGINI, entry 1556), 287 (inscription from, fig. 61–1); *Aeneid* 312 (ARES [Mars]); *Aenid, Eclogues, Gregorics* 315 (entry 70 BCE)

Virgin Hodegetria 5 (fig. 1–1), 8 (fig. 1–5), 16 (VIRGIN HODEGETRIA, glossary), 17–18 (entry 1261), 23 (sidebar), 47 (fig. 11–1)

Virtues (see also Cardinal Virtues, Theological Virtues) 33, 34, 35 (fig. II–3), 39, 44–45 (CARDINAL VIRTUES, sidebars), 46 (VIRTUES, glossary), 66 (entry 1386), 246 (Virtue triumphant over Vice, fig. 51–12; entry 1527)

Visconti, Azzone 48 (patron of Giotto in Milan)

Visconti, Federigo, Archbishop 30 (patron of Nicola Pisano)

Visconti, House of (rulers of Milan) 71 (entry 1402), 72 (crests, fig. 17–2), 73 (entry 1427), 128 (support of Alfonso of Aragon, KINGDOM OF NAPLES, sidebar), 281 (family tree)
 Bianca Maria (illegtimate daughter of Filippo Maria, wife of Francesco Sforza, d. 1468) 73 (fig. 17–3), 75 (marriage to Sforza, entry 1441), 281 (fig. V–1)
 Filippo Maria (third Visconti duke of Milan, 1334–1447) 72 (expansion and successful war, entries 1419, 1424; wins battle at Anghiari, entry 1425), 73 (fights Florence, entries 1427, 1431; fig. 17–3), 74 (peace, entry 1435), 75 (Milan at war, entry 1436), 76 (death of, entry 1447), 127 (patron of Pisanello, entry 1424), 281 (fig. V–1)
 Giangaleazzo (married Isabella of Valois, became first Visconti duke of Milan, second marriage produced two heirs, 1351–1402) 71 (death of, entry 1402), 72 (strife follows his death, fig. 17–2)
 Giovanni Maria (second duke of Milan, brother of Filippo Maria, 1388–1412) 72 (murder of, fig. 17–2)

Visitation, images of
 (Andrea Pisano) 39 (fig. 9–1)
 (Ghirlandaio) 177 (fig. 38–4)
 (Pontormo) 251 (fig. 52–3, #12), 255 (fig. 53–3)
 (Sarto) 252 (fig. 52–4, #15)

Visitation, Feast of (2 July) 42 (instituted 1387)

Vitruvius 141 (*De architectura*), 229

Vivarini, Alvise (Venetian painter, son of Antonio, d. ca. 1505) 203, 206 (entry 1507)

Vivarini, Antonio (Venetian painter, d. 1484) 86 (*Madonna and Child with Saints*, fig. 18–4), 143, 184 (in Padua), 199

Vivuole, Raffaelo (see Il Carota)

Volterra, Daniele da (painter) 247, 248

Volto Santo 16 (VOLTO SANTO, glossary; fig. 2–16), 179

Voraigne, Jacobus de 8, 11, 84, 85, 118, 152 (*Golden Legend*)

Vulcan (Hephaestus) 231 (fig. 50–1), 313 (HEPHAESTUS)

—W—

wash 278

Weyden, Rogier van der (Flemish painter, d. 1464) 77

—X—

Xavier, Francis, Saint 213 (entry 1534)

—Z—

Zagonara, rout of 72

Zenobius, Saint (Bishop) 96 (fig. 19–3, #9), 102, 136, 143, 146, 148, 175, 177, 180 (entry 1486), 198 (fig. 42–8), 297

Zeus (see Jupiter)

Zeuxis (Greek painter) 168, 171, 186

Ziani, Doge 305

zodiac 47 (Giotto, entry 1309), 196 (Perugino, fig. 42–5), 237 (Peruzzi, Loggia of Galatea, Villa Chigi, fig. 50–9)

Zoppo, Marco (painter, d. ca. 1478) 199

Picture Credits

Locations of works appear in the captions for the illustrations. Sources for illustrations and copyright credits are given below. Numbers are figure numbers unless otherwise indicated.

Map Bradshaw/Schneider art. I-1 to I-4 Schneider. 1-1 Gift of Mrs. Otto H. Kahn, Image courtesy of the Board of Trustees, National Gallery of Art, Washington. 1-2 to 1-3 Bradshaw. 1-4 Schneider. 2-1 to 2-3 Schneider. 2-4 to 2-9 Bradshaw/Schneider art. 2-10 to 2-15 Schneider. 2-16 Bradshaw/Schneider art. 3-1 to 3-3 Bradshaw/Schneider art. 4-2 to 4-7 Bradshaw/Schneider art. 5-1 Bradshaw/Schneider art. 6-1 Bradshaw/Schneider art. 7-1 to 7-2 Schneider. 8-1 to 8-3 Schneider. II-1 Schneider. II-2 to II-5 Bradshaw/Schneider art. II-6 to II-7 Schneider. II-8 Bradshaw/Schneider art. II-9 Schneider. 9-1 Schneider. 9-3 to 9-4 Schneider. 10-1 to 10-3 Schneider. 10-4 Bradshaw/Schneider art. 10-5 to 10-8 Schneider. 11-2 to 11-4 Bradshaw/Schneider art. 12-1 to 12-3 Bradshaw/Schneider art. 12-4 Andrew W. Mellon Collection, Image courtesy of the Board of Trustees, National Gallery of Art, Washington. 13-1 Bradshaw/Schneider art. 14-1 Schneider. 14-2 Scala / Art Resource, NY. 14-3 Scala / Art Resource, NY. 14-4 Bradshaw/Schneider art. 15-1 to 15-2 Bradshaw/Schneider art. 16-1 Bradshaw. 16-2 Bradshaw/Schneider art. 16-3 Image courtesy of the Board of Trustees, National Gallery of Art, Washington. 16-4 Schneider. III-1 to III-2 Schneider. 17-1 Schneider. 17-2 to 17-5 Bradshaw/Schneider art. 17-6 Samuel H. Kress Collection, Image © Board of Trustees, National Gallery of Art, Washington. 17-7 Samuel H. Kress Collection, Image © Board of Trustees, National Gallery of Art, Washington. 17-8 Bradshaw. 17-9 Bradshaw/Schneider art. 17-10 Schneider. 17-11 Bradshaw/Schneider art. 18-1 Schneider. 18-3 Schneider. 18-4 Cameraphoto Arte, Venice / Art Resource, NY. 18-6 Bradshaw/Schneider art. 18-7 Schneider. 18-8 Bradshaw/Schneider art. 18-9 Schneider. 19-1 Schneider. 19-2 to 19-3 Bradshaw/Schneider art. 20-1 to 20-3 Schneider. 20-4 Bradshaw/Schneider art. 20-5 Schneider. 21-1 to 21-8 Schneider. 22-1 Scala / Art Resource, NY. 23-1 Scala / Art Resource, NY. 23-2 Scala / Art Resource, NY. 24-1 Scala / Art Resource, NY. 24-2 Scala / Art Resource, NY. 24-3 Bradshaw/Schneider art. 25-1 Scala / Art Resource, NY. 25-2 to 25-3 Bradshaw/Schneider photos and art. 26-1 Schneider. 26-2 Bradshaw/Schneider art. 26-3 Schneider. 27-1 HIP / Art Resource, NY. 27-2 Erich Lessing / Art Resource, NY. 27-3 Samuel H. Kress Collection, Image © Board of Trustees, National Gallery of Art, Washington. 27-4 Samuel H. Kress Collection, Image © Board of Trustees, National Gallery of Art, Washington. 28-1 Image copyright © The Metropolitan Museum of Art / Art Resource, NY. 28-2 Bradshaw/Schneider art. 28-3 Bradshaw. 29-1 Erich Lessing / Art Resource, NY. 29-2 Schneider. 29-4 to 29-5 Schneider. 30-1 Schneider. 30-2 Bradshaw/Schneider art. 31-3 Samuel H. Kress Collection, Image courtesy of the Board of Trustees, National Gallery of Art, Washington. 31-4 Bradshaw/Schneider art.

32-1 Schneider. 32-2 Bradshaw/Schneider art. 33-4 Bradshaw/Schneider art. 34-1 to 34-2 Schneider. 34-3 to 34-4 Bradshaw/Schneider art. 35-1 Schneider. 35-2 Scala / Art Resource, NY. 35-3 Bradshaw/Schneider art. 36-1 to 36-2 Schneider. 36-3 Bradshaw/Schneider art. 36-4 to 36-6 Schneider. 37-1 Scala /Art Resource, NY. 37-5 Alinari / Art Resource, NY. 38-1 Schneider. 38-2 Bradshaw/Schneider art. 38-3 Schneider. 38-4 Bradshaw/Schneider art. 38-5 Schneider. 38-6 © Copyright the Trustees of the British Museum. 39-1 to 39-2 Schneider. 39-3 Bradshaw/Schneider art. 39-4 Schneider. 39-5 Bradshaw/Schneider art. 40-1 to 40-2 Schneider. 40-3 Bradshaw/Schneider art. 40-4 Schneider. 40-5 Réunion des Musées Nationaux / Art Resource, NY. 41-1 Bildarchiv Preussischer Kulturbesitz / Art Resource, NY. 41-2 Bradshaw/Schneider art. 41-4 Bradshaw/Schneider art. 42-1 Scala / Art Resource, NY. 42-3 to 42-7 Bradshaw/Schneider art. 42-8 Alinari / Art Resource, NY. 44-3 Widener Collection, Image courtesy of the Board of Trustees, National Gallery of Art, Washington. IV-1 to IV-2 Schneider. 46-1 Schneider. 46-3 Schneider. 47-1 to 47-2 Schneider. 47-3 to 47-6 Bradshaw/Schneider art. 47-8 to 47-11 Schneider. 48-1 Réunion des Musées Nationaux / Art Resource, NY. 48-2 Alisa Mellon Bruce Fund, Image courtesy of the Board of Trustees, National Gallery of Art, Washington. 48-4 Schneider. 48-7 Corel Great Works of Art. 49-1 Bradshaw/Schneider art. 49-2 Schneider. 49-3 Bradshaw/Schneider art. 50-1 Schneider. 50-6 to 50-7 Bradshaw/Schneider art. 50-8 to 50-9 Schneider. 50-10 to 50-11 Bradshaw/Schneider art. 51-1 Scala / Art Resource, NY. 51-2 to 51-5 Schneider. 51-6 to 51-8 Bradshaw/Schneider art. 51-9 Schneider. 51-10 Bradshaw/Schneider art. 51-11 to 51-12 Schneider. 51-14 Schneider. 52-1 to 52-2 Schneider. 52-3 to 52-4 Bradshaw/Schneider art. 52-5 Schneider. 53-1 to 53-4 Schneider. 54-1 Schneider. 55-1 to 55-2 Schneider. 57-3 Samuel H. Kress Collection, Image courtesy of the Board of Trustees, National Gallery of Art, Washington. 57-6 Samuel H. Kress Collection, Image courtesy of the Board of Trustees, National Gallery of Art, Washington. 58-1 Schneider. 58-2 Erich Lessing / Art Resource, NY. 58-3 to 58-4 Schneider. 59-2 Scala / Art Resource, NY. 59-3 to 59-6 Corel Great Works of Art. 60-1 Erich Lessing / Art Resource, NY. 60-2 Erich Lessing / Art Resource, NY. V-1 to V-6 Bradshaw/Schneider art. 61-2 Bradshaw/Schneider art. 62-1 Schneider. 62-2 to 62-7 Bradshaw/Schneider art. 63-1 Schneider. 63-2 to 63-7 Bradshaw/Schneider art. 63-8 Schneider. 63-9 to 63-12 Bradshaw/Schneider art. 63-13 Schneider. 64-1 to 64-7 (photos) Schneider; (crests) Bradshaw/Schneider art. 66-1 to 66-2 Schneider. 66-5 Scala / Art Resource, NY. 67-1 Bradshaw/Schneider art. 67-2 to 67-3 Schneider. 68-1 to 68-3 Schneider. 69-1 to 69-2 Schneider. 69-4 to 69-5 Bradshaw/Schneider art.